Korean Art 1900-2020

PUBLISHER
Youn Bummo

EDITORIAL BOARD
Cho Soojin, Chung Moojeong, Kang Soojung,
Kim Hyunsook, Kim Inhye, Kwon Heangga,
Liu Jienne, Park Mihwa, Park Youngran,
Shin Chunghoon, Song Sujong

ADVISORY BOARD
Charlotte Horlyck, Shin Chunghoon,
Sohl Lee

EDITOR
Helen Jungyeon Ku

EDITORIAL ASSISTANT
Kim Hamin, Chang Seoyoun, Kim Jiyoung

TRANSLATION
Helen Cho, Jangtongbang, Kim Hyunkyung,
Kim Jeonghye, Kim Jeongyoon, Park Eunah,
Vicki S. Kwon

COPYEDITING
Luke Houston, William Sharp, Woo
Hyokyung

PROOFREADING
Jangtongbang

DESIGN
Workroom

DESIGN ASSISTANT
Im Hayoung

PRINTING AND BINDING
Top Process

This is an English version of
Hanguk misul 1900–2020
(September 2021, MMCA).

First published on September 30, 2022

PUBLISHED BY
National Museum of
Modern and Contemporary Art, Korea
30 Samcheong-ro, Jongno-gu,
Seoul, 03062, Korea
www.mmca.go.kr

© 2022 by contributors, artists, copyright
holders and MMCA, Korea

ISBN 978-89-6303-334-1

This book is printed on MOORIM PAPER,
ARTIZEN (Extra White) 105g/m².

With special thanks to AMOREPACIFIC Museum of Art (APMA), ARARIO Museum, Arko Art Center, Art Sonje Center, Busan Museum of Art, Cheonggwanjae, Choi Man Lin Museum, Chosun Ilbo, Cincinnati Art Museum, Daejeon Museum of Art, Design Korea Museum, Dolbegae, Dong-A Ilbo, Gallery Hyundai, Gwangju Biennale Foundation, Gwangju National Museum, Gyeonggi Ceramic Museum, Hyundammungo Foundation, Institute for Peace Affairs, Institution of Modern Bibliography Collection, Johyun Gallery, Jongno Public Library, Joshibi University of Art and Design, Kim Sechoong Museum, Kimchongyung Museum, Kimdaljin Art Archives and Museum, Korea University Library, Korea University Museum, Korean Sport & Olympic Committee, Korean Martyrs' Museum, Korean Movie Database, Korean Nature Artists' Association-YATOO, Lee Juhong Library House, Leeum Museum of Art, Leeungno Museum, Library of Korean Studies, Academy of Korean Studies, Museum of Photography, Seoul, Nam June Paik Art Center, Namnong Foundation of Culture, National Library of Korea, National Museum of Korea, National Museum of Modern Art, Tokyo, National Palace Museum of Korea, PKM Gallery, Samuel P. Harn Museum of Art, University of Florida, Seoul Shinmun, Seoul Metropolitan Government, Seoul Museum of Art (SeMA), Seoul Museum of History, Seoul National University Library, Seundja Rhee Foundation, Suncheon City, Suwon Museum of Art, University Art Museum, Tokyo University of the Arts, Whanki Foundation·Whanki Museum, Woljeon Museum of Art Icheon, Woonbo Foundation of Culture, Yonsei University Museum, Yoo Youngkuk Art Foundation, Youlhwadang

Sponsored by Supported by In cooperation with

Korean Art

1900 – 2020

CONTENTS

PART 4 DEMOCRATIZATION AND THE PLURALIZATION OF ART

PART 5 GLOBALISM AND CONTEMPORARY KOREAN ART

Korean Art: Dynamism and Expansion

PUBLISHING *KOREAN ART 1900–2020*

History has always been newly described with different interpretations from new perspectives. This makes history a sort of conversation between the past and present. However, modern and contemporary Korean history is marked by numerous trials and tribulations, and this has made the writing of Korean history a challenging task and writing Korean art history is no exception. Since the late nineteenth century, the Korean Peninsula had undergone immense upheaval, including the forcible opening of its harbors to foreign powers, Japanese colonial rule, Korean War, and the division of the nation. As a forcefully divided nation, Korea went through unimaginable suffering. The Korean War, for instance, led to the destruction and theft of countless works of art and created highly subjective ideological terms unique to Korea, such as *weolbuk jakga* (artists who went to the North) or *wollam jakga* (artists who came to the South). For these reasons, it is nothing short of daunting to systematically describe a history of Korean art over the past 120 years, as this field encompasses an immensely diverse range of genres, styles, and artists. In this respect, the political limitations of existing in a divided nation continues to hamper the study of Korean modern and contemporary art history today.

In spite of these limitations, those of us at the National Museum of Modern and Contemporary Art, Korea (MMCA), have resolved ourselves to meet the epochal challenge of writing and publishing a history of Korean modern and contemporary art. With this book, we are proud to harvest the fruits of years of our work at the museum. This book is presented to readers through the diverse perspectives of art experts from various fields and disciplines, who have each striven to describe the rich tapestry of Korean art history in relation to the significant works of each era. In this sense, this book aims to reflect the latest art historical scholarship while resolving existing terminological issues that have long plagued the field of Korean art. For instance, instead of using obsolete, geographically, and culturally deterministic idioms such as "Eastern painting" (*dongyanghwa*) or "Western painting" (*seoyanghwa*), this book progressively deploys terms such as "ink painting" and "oil painting" to specifically categorize art works by medium and genre. And, to suitably conclude this innovative, totemic analysis, the last chapter focuses on the achievements of contemporary Korean artists on the domestic and international stage today. This exhaustive overview of Korean art also contains sections dedicated to specific movements including the Korean Women's Art Movement and Interdisciplinary Arts to offer a comprehensive view that encompasses various practices in the field of modern and contemporary art.

In *Korean Art 1900–2020*, periodization is a pivotal key behind the

development of this book. The text discusses art works in detail to properly delineate each era and identify the characteristics and significance of each period within the context of Korean art history. Chronologically, Part 1 deals with the period from early modernization in the late nineteenth century to liberation from Japanese colonial rule in 1945. While the colonial period can certainly be defined as an era of injustice and cultural distortion, this period also demonstrated the progressive coexistence of traditional artistic practices and the development of "new art" approaches received from abroad, as well as the formation of new art communities and institutions, all of which resulted in distinctive changes to the face of national visual culture. Part 2 focuses on the 1940s and 1950s, revolving the division of the peninsula. The Korean War gave rise to the transnational idea of "diaspora art" whose seeds were initially sown during colonial rule, as Koreans lived, studied, and worked extensively in the metropole of Tokyo and beyond. Following independence, the newly created South Korea embraced anti-communist culture, and academism initially became the mainstream art form of the establishment, propagated through annual events like the National Art Exhibition (Gukjeon). In contrast, North Korea focused on socialist realism and the ideas of *Juche* (Self-reliance) art. In this context, this book actively includes an examination of North Korean visual culture within its holistic history of modern and contemporary Korean art.

Part 3 examines art during the era of Korea's modernization from the 1950s to the 1970s. This was the age of postwar recovery, which ushered in new environments and new approaches such as Experimental Art and Dansaekhwa. As Korean artists made their way overseas, the styles and practices favored by Korean artists underwent significant changes. While traditional Korean artists attempted to reform ideas of ink painting to render such as the national art form, the mainstream had already moved in favor of the modernist approaches common to the wider postwar international art world. Part 4 focuses on art in the 1980s, a moment in history when dissident art and the socio-political role of cultural production came into the national populist spotlight, as the military dictatorship faltered and then finally fell to the democratic movement. Minjung art in particular was a unique phenomenon that highlighted and expanded into a range of issues such as reunification, labor rights, the environment, and women's liberation. In this context, many young artists arose alongside other political activists in the democratization movement to lend their support. But at the same time, the latter half of the decade witnessed the Korean government's full opening up of the national borders for international travel in and out of the country to coincide with the 1986 Asian Games and the 1988 Seoul Olympics, setting the stage for the changes that would come in the 1990s. Part 5 deals with Korean art's joining into the trajectory of the global contemporary art world. Regular event exhibitions such as the Gwangju Biennale were launched in this period, with an increased range of foreign exhibitors invited to Korea or Korean artists participating actively in international art world. The globalization of Korean art after the 1988 Seoul Olympics created a new creative environment, with an exponential increase in the number of Korean artists active overseas and the range of their transnational activities. Most notably, video artist Paik Nam June (1932–2006) was active in Europe and the United States, and prior to Paik were Lee Ungno (1904–89) who put a contemporary spin on the traditional ink paintings in Paris, and Kim Whanki (1913–74) who made a name for himself in New York with his series of abstract dot paintings. The commercial art market also flourished in this period, expanding the scope of art in South Korea. These accomplishments set the stage for an even more diverse range of creative endeavors in the 2000s and beyond.

KOREAN ART AND SOCIETY IN THE TWENTIETH CENTURY

The turbulent twentieth century was an era of novel transformation and change in Korean art. The Joseon Dynasty bowed to international pressure in the 1880s

and opened up its ports to foreign powers. In 1910, the nation was occupied by Imperial Japan, followed by nearly half a century of colonization. Korea was liberated in 1945, but this fragile moment of peace was quickly shattered by the Korean War in 1950. In the first half of the twentieth century, Koreans were exposed to Western art through primarily Japanese mediation. The traditional status afforded to elite Korean art genres, such as *seohwa* (calligraphy and ink painting), was gradually replaced with an appreciation for idea of *misul*, an entirely new word in the Korean language which directly corresponded to the [Western] notion of fine art. The transition reflected the social deconstruction of literati painting culture, which was considered a refined art practiced by scholarly artists. This sudden disengagement with tradition marked a significant change within the Korean art world, as calligraphy slowly lost preeminence in the national cultural arena. However, the expansion of the art world also gave rise to new public galleries. In this context, even religious paintings and statues, which had been traditionally sealed away in temple shrines and storerooms, were reinterpreted as artistic treasures and brought out on public display.

Until the nineteenth century, Chinese philosophy was the dominant ideology in Korea. The Chinese legacy was replaced by Japanese cultural ideas during colonial rule in the first half of the twentieth century. Then, when the United States military government took charge of the post-liberation period, and Korea was subsequently divided after the Korean War, American culture became the mainstream context that defined the second half of the century in South Korea. This period coincided with the rapid industrialization of the nation, undertaken by a succession of military dictatorships and was replaced with liberal democracy in 1987. Although the twentieth century was a lengthy period of sociopolitical upheaval, these years were also a time of collective cooperation as the people of Korea sought a national identity, and a time of unprecedented transformation and development as Koreans fought with their lives to establish a mature democracy that upheld peace and human rights. As a measure of this immense transition, South Korea became the first country to go from being a recipient to a donor of international aid. Today, South Korea is often counted as one of the top ten economies in the world while Korean popular culture and the arts have joined the international mainstream. South Korean democracy has developed to the point that in the twenty-first century, citizens peacefully impeached and ousted their own president. The national art community has also gone through extensive transformation, successfully staging Korean art within the international art community.

KOREAN AESTHETICS AND CONTEMPORARY ART
The influx of countless modernist art movements over a short period led to much trial and error on the part of Korean artists during the first half of the twentieth century, but it also served as the foundation for the establishment of a diverse, thriving art community. Korea produced its first generation of nationally significant oil painters in the 1910s, and many art associations were launched in the following decade. The colonial Japanese government established an annual art event titled the Joseon Art Exhibition (Joseon misul jeollamhoe), which during the colonial era offered the only government-sponsored venues for displaying and presenting art. This period can therefore be summarized as the age of colonial government-led art, but at the same time, the 1920s also witnessed the emergence of numerous progressive, revolutionary art associations such as the Korean Proletarian Artist Federation (KAPF), led by Kim Bokjin (1901–40). One of Korea's first modern sculptors, Kim participated in a wide range of artistic practices and was one of the leading figures in the Korean art community at the time. He was persecuted by the Japanese empire for his progressive political activities and was arrested, dying at a young age following five years of imprisonment. The tragic death of this artist who resisted colonization still inspires many Koreans today. On the other hand, Kim Yongjun

(1904–67), who had initially promoted a class-based proletarian art, ultimately became an ardent supporter of the new literati painting theory. He furthered a theory of traditional Korean aesthetics called *godam miron*. This artistic ideas of elegance and loftiness developed in Joseon art was taken up by many scholarly artists in Korea during the mid-twentieth century. This stood in stark contrast to the position taken by Kim Bokjin, a staunch critic of aesthetic ideas such as 'local color' propagated by the Japanese empire. Agricultural scenes were highly encouraged by Japanese officials, whose intention was to romanticize and simplify the idea of rural Korean society to turn people's minds away from the reality of colonial oppression. A nefarious intention which clearly demonstrates the limitations of the official cultural discourses promoted during the colonial period.

Japanese folk-art scholar Yanagi Muneyoshi, who had a keen interest in Korean art, stated that such was defined by the "beauty of sorrow." The Korean scholar Ko Yuseop (1905–44) also attempted to define an idea of the national aesthetic using abstract descriptions such as "artless art," "unplanned planning," and "childlike adulthood." From a broad perspective, both Ko Yuseop and Kim Yongjun took a similar stance to Yanagi. They were among the many scholars who initially attempted to define Korean aesthetics using terms like "simplicity," "humility," or "naturalism." However, looking back at the immense diversity of Korean art production, it is obvious that such reductive claims were entirely unfounded; indeed, the very act of defining five thousand years of art history with a single term seems problematic in and of itself. Nevertheless, if I had to choose one word to describe Korean art, it would perhaps be *unimpeded*. One of Korea's greatest thinkers and artistically minded figures is the Silla-era Buddhist monk Wonhyo who believed that only those who were unimpeded in all respects might escape the cycle of life and death, and he devised songs and dances based on this philosophy to pass on to the people at large. The aesthetics of unimpeded continue to be represented across a wide range of works in contemporary Korean art. A concept one might also propose for the purpose of defining Korean contemporary art is that of "excitement" (*sinmyeong*), which became particularly popular in connection with the art activism of the 1980s. The contemporary slogan "Dynamic Korea" adopted by the national government, although applicable more to pop culture than fine art, stems from a similar ideological background.

THE DYNAMICS AND POSSIBILITY OF KOREAN ART TODAY

The artist Lee Jungseop (1916–56), originally from North Korea, came to South Korea and produced his works as a refugee, suffering great pain at this forced separation from his family. Lee's works can be defined by the idea of panvitalism, the theory that all living things are part of a single universe. The children and fishes in his paintings are connected as equal beings, as his art shows that all lives have equal weight and are mutually involved and sustaining, as in the Buddhist doctrine of dependent origination. The Korean War left countless lives and destruction in its wake. However, a deep respect for life arose in the wake of this tragic war and became a guiding force in Korean art. This thought of harmony, which could also be explained in relation to the idea of cosmopolitanism, demonstrates the Korean people's will for peace despite the numerous invasions and political turmoil that has defined the modern history of the nation.

In the twenty-first century, South Korea has demonstrated its historical penchant for both dynamic social transformation and total self-contradiction. An IT powerhouse boasting sky-high smartphone adoption rate and unparalleled technological innovation, South Korea nonetheless struggles with the world's lowest birth rates and highest suicide rates. Yet what cannot be understated is that Korea remains a divided nation, in which the two Koreas ideologically confront each other over an uneasy political truce. Nevertheless, the rapid

transformations achieved by South Korea have drawn the attention of the world, and the art field is no exception to this success. This unique social, historical, and cultural complexity of Korea, I believe, is the very foundation that serves to nourish the diversity and expanding nature of Korean art today.

Korean artists, through the force of their unconditional effort and with their hearts unimpeded, continuously break down boundaries of genre and seek out new creative horizons. Korean art, once limited as the preserve of only elite intellectuals [aptly demonstrated by the *Painting of a Lofty Scholar Contemplating Water* in the Joseon Dynasty], is now a thriving field that extends beyond national borders and attempts to discover new formal principles from a universal perspective. In this context, Paik Nam June's masterpiece *The More, The Better* (1988) in the collection of the MMCA, evokes the powerful idea of nomadism. This inspirational notion of cultural nomadism provokes contemporary Korean art to play a valuable role as an influential wellspring of contemporary global culture. After more than a hundred years of national turmoil, contemporary Korean art is reborn once again and offered to you here as an inspirational source of peace and life; 'Dynamic Korea' indeed.

Youn Bummo
Director of the National Museum of Modern and Contemporary Art, Korea

FROM "CALLIGRAPHY AND PAINTING" TO "FINE ART"

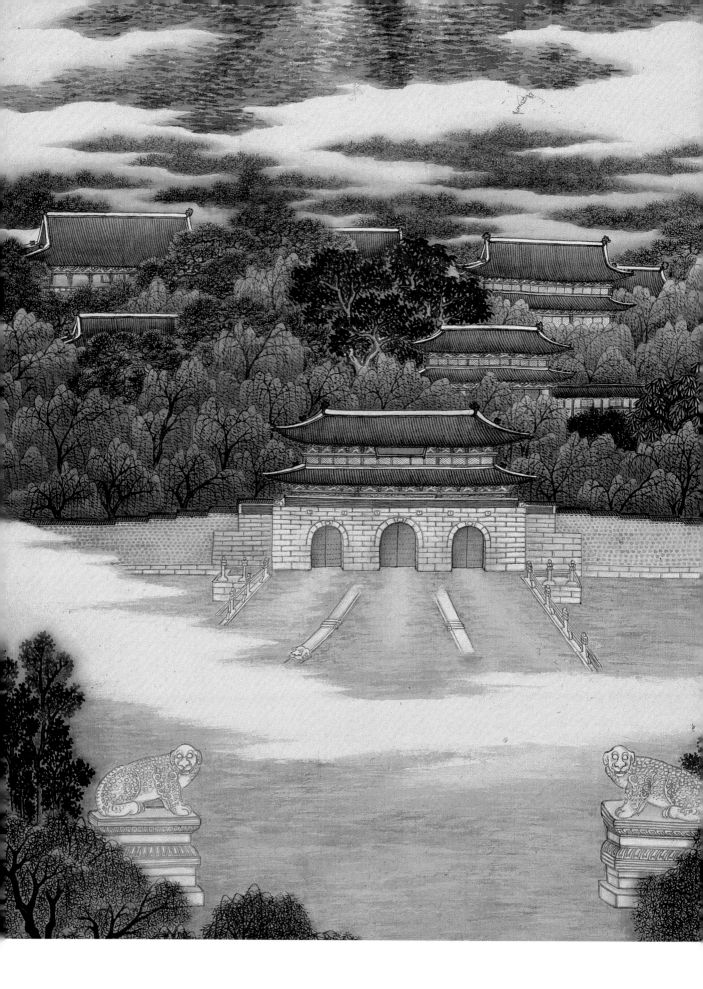

An Jungsik, *Spring Dawn at Baekaksan Mountain*, 1915, Ink and light color on silk, 197.5×63.7 cm

Kim Inhye

In the nineteenth century, a period known for the global expansion of empires, Korea was one of the last countries in the world that was able to choose to remain closed to foreigners. Neighboring Japan had begun conducting trade with the Netherlands through the port of Nagasaki in the seventeenth century. Starting with the forced opening of some of its other ports by the American Commodore Matthew Perry in 1853, Japan quickly became fully engaged in the modernization of its society. This process was further accelerated by the Meiji Restoration in 1867 which created substantial turmoil in Japanese civil society as the feudal system of governance was overhauled. In turn, Korea, had witnessed how Imperial Qing China had been resistant to officially diplomatically engaging with the West and had subsequently become a violent arena for competition between foreign powers after the Opium Wars against England (1840–60). Both these regional contexts understandably encouraged Korea's caution in opening to international engagement in the diplomatic and cultural arenas.

The reign of King Gojong began at a time when a group promoting enlightenment and another insisting on national isolation were in ideological conflict. Gojong, who was rather active in international diplomacy, began to sign commercial treaties with several countries. The first was the Treaty of Ganghwa in 1876, which was compelled by Japan. In the 1880s, Gojong concluded treaties with America in 1882, England and Germany in 1883, Italy and Russia in 1884, and France in 1886.

The central figures in the Enlightenment Group at the time were the bureaucratic *jungin* (middle people), particularly *yeokgwan* (interpreters), who were discontented with the rigid caste system of the Joseon Dynasty (made up of the *yangban* nobility, the *jungin* middle class, the *sangmin* commoners, and the *cheonmin* outcastes) and had familiarized themselves with world affairs through their early experience with Qing China and Japan. As interpreters, the *yeokgwan* joined the Joseon diplomatic envoys dispatched to Qing China. They were granted the privilege of engaging in trade during their stay in China. Since these interpreters were well versed in business and accomplished in foreign languages, they were quick to grasp the international political landscape and to embrace new cultures. Oh Gyeongseok, the father of celebrated artist Oh Sechang, was among this group. Oh Gyeongseok studied the Silhak (Practical Studies) introduced by Park Jega and was appointed as a Yeokgwan in 1846. Visiting China thirteen times, he acquired many new books, including *Haiguo tuzhi* (Illustrated Treaties on the Maritime Kingdoms) and *Yinghuan zhilue* (A Short Account of the Maritime Circuit). He introduced to Korea the progressive thinking expounded in these new books. He also promoted the education of able children from *yangban* families by supporting Park Gyusu, who trained early Enlightenment Group intellectuals such as Kim Yunsik, Kim Okgyun, Park Yeonghyo, and Yu Giljun.

In 1881, Kim Yunsik, who had been educated under the patronage of Oh Gyeongseok, organized a group of envoys (*yeongseonsa*) consisting of talented young students like An Jungsik (1861–1919) and Cho Seokjin (1853–1920), in order to learn advanced technology in Tianjin in China. At the time, the Joseon Dynasty government was in the process of signing commercial treaties with foreign countries. The Yeongseonsa stayed in Tianjin for only a year, but it offered young An Jungsik an opportunity to experience a new culture and develop a lifelong friendship with Cho Seokjin despite their eight-year age gap. This eventually led to their founding of the Calligraphy and Painting Society (Seohwa misulhoe) in 1911. The Calligraphy and Painting Society became a cradle for modern Korean painting and produced a great many of the first generation of painters who pursued a modernist transformation of Korean painting, including Kim Eunho (1892–1979), Lee Youngwoo (1902–52), Lee Sangbeom (1897–1972), Noh Soohyun (1899–1978), and Byeon Gwansik (1899–1976).

Oh Sechang passed the interpreters' examination at the age of twenty. He served as a leading figure in the Enlightenment Group at the end of the nineteenth century, a period marked by upheavals. In 1886, he served as a

clerk at the Office of Culture and Information (Bangmunguk), the first state-run modern publishing office, and as a reporter with the first Korean modern newspaper, *Hanseong Sunbo*. In 1902, Oh Sechang defected to Japan for political reasons. He later returned to Korea and devoted himself to promoting press freedom and boosting the publishing industry in an effort to enlighten the common people in the years before the country was completely colonized by Japan. He served consecutively in the posts of president of the *Mansebo* newspaper and the *Daehan Minbo* bulletin. Oh also wrote biographies of artists from the Silla Kingdom and published the *Bibliographical Dictionary of Korean Calligraphers and Painters* (Geunyeok seohwajing), a compilation of works and related materials. These activities by Oh were prominent steps toward the development of Korean art history.

An Jungsik assisted Oh Sechang in his diverse activities. An drew illustrations for a magazine dealing with the Patriotic Awakening Movement in which Oh was involved, and he asked his best pupil Lee Doyoung (1884–1933) to create an editorial cartoon for the cover of *Daehan Minbo*, a bulletin for the Association of Great Korea (Daehan Hyeophoe) that Oh produced. An and Lee drew the frontispieces and illustrations for modern magazines, including *Bulgeun jeogori* (1912), *Aideul boi* (1913), and *Cheongchun* (1914). All of these were published by Choi Namseon, a close friend of Oh Sechang and another leading intellectual of Korea's port opening period. Through engagement with the press and publication, they utilized their talents to edify the general public, expand knowledge, and promote patriotism.

After the Sino-Japanese War (1894) and Russo-Japanese War (1904), Japan entered into an alliance with England (1902 and 1905) and a treaty with America (1905). Japan then came to sign the Protectorate Treaty with the Korean Empire (Eulsa Neugyak) in 1905. This completely deprived the Korean Empire of its diplomatic rights, which signaled the beginning of rule by the Japanese resident-general. As a result, the Patriotic Awakening Movement arose throughout the country, even though it failed to alter the general situation. A large body of books intended to promote patriotism, including *An Essential Reader for Youths* (1907) illustrated by An Jungsik, were published and became enormously popular. However, all of these books were banned by the Tonggambu (Residency-General). Due to a coercive publication law enforced in 1909, most media and publishing activities were curbed. The *Daehan Minbo* bulletin that Oh Sechang passionately supported was forcibly discontinued in 1909 as well. Until the March First Independence Movement in 1919, Japan imposed military rule and even elementary school classrooms were occupied by Japanese agents armed with swords.

Ko Huidong (1886–1965) began working as a clerk in the Ministry of the Royal Household (Gungnaebu) in 1904 where he interpreted French and translated documents. While working there, Ko witnessed at first hand the circumstances that followed the Protectorate Treaty between Korea and Japan, which was concluded in November 1905 inside the royal palace. Ko subsequently fell into despair and left his post. In 1909, he went to Japan and became the first Korean student admitted to the Western-style Painting Department at the Tokyo School of Fine Arts (Tokyo Bijutsu Gakkō). Three years after returning to Korea in 1915, Ko joined An Jungsik and Cho Seokjin in establishing the Calligraphy Calligraphy and Painting Association (Seohwa hyeophoe), an improved version of the previous Calligraphy and Painting Society. Oh Sechang was one of the thirteen founders of the association and An Jungsik was selected as its first president. However, in 1919, soon after the inauguration of this first Korean modern art association, the March First Independence Movement errupted. Oh Sechang joined the thirty-three leaders of the movement and was imprisoned. An Jungsik was interrogated for helping Oh. He was eventually released but ended up dying in October 1919 from the aftereffects of his interrogation. Ko Huidong later became both an artist and a politician and played a pivotal role in several Korean art organizations, including the Calligraphy and Painting

Association.

Kim Kwanho (1890–1959), Kim Chanyoung (1893–1960), and Rha Hyeseok (1896–1948) followed in Ko's footsteps and studied Western-style painting at the Tokyo School of Fine Arts and the Women's School of Fine Arts in Tokyo (Tokyo Joshi Bijutsu Gakkō). However, unlike Ko, who reverted to *hangukhwa* (Korean painting) immediately after returning home, they continued to produce Western-style paintings in spite of the social and political complications. These first-generation artists who studied in Tokyo are remembered as pioneers who remained engaged in art-related activities despite the adversity they faced at the time. By doing so, they laid the foundation of modern art in Korea.

The end of the First World War in Europe coincided with the promotion of the concept of "national self-determination" by the U.S. president Woodrow Wilson and a yearning for freedom in Korea. The March First Independence Movement was a series of voluntary nonviolent nationwide anti-Japanese demonstrations and a landmark event that should be remembered in world history. Later, Saitō Makoto was appointed as the new governor of Korea, and he proclaimed a policy of so-called 'cultural rule' that adopted appeasement measures.

Under this "cultural rule," the number of Korean students who went to Japan to study art increased exponentially. Afraid that Korean students in Japan would study politics or economics and return to Korea as social thinkers or independence activists, the Japanese government encouraged them to focus on arts and culture fields. It was inevitable that around the 1930s many of the young Koreans who had studied abroad returned home and accelerated the development of the art field.

The painters who studied in Japan in the 1920s and 1930s include Lee Qoede (1913–65), Choi Jaiduck (1916–?), Chang Ucchin (1917–90), Kim Whanki, Yoo Youngkuk (1916–2002), Mun Haksu (1916–88), Lee Jungseop, and Kim Byungki (1916–2022). They displayed their individual artistic visions using diverse painting styles. Notably, some of them experimented with the Surrealism (Mun Haksu and Lee Jungseop) and Abstractionism (Kim Whanki and Yoo Youngkuk) advocated by avant-garde painters in Japan during the 1930s and 1940s.

Around this time, the Joseon Art Exhibition was launched in Korea with substantial support from the Japanese Government-General. This large-scale art exhibition was held annually from 1922 through 1944. Before the Joseon Art Exhibitions, art students in Korea learned Western-style painting in art classes at public schools that were equivalent to today's middle and high schools, or at private academies founded by the pioneering first-generation modern painters or Japanese painters who resided in Korea. Since there were no art universities, art museums, or other art contests in Korea, an award at the Joseon Art Exhibitions was the key means by which professional Korean artists could exhibit their work. Thus, many home-grown painters, including Seo Dongjin (1900–70), Lee Insung (1912–50), Kim Chongtai (1906–35), and Kim Junghyun (1902–53), actively participated in these exhibitions.

On the other hand, some artists referred to the Joseon Art Exhibitions as the exhibitions of the Japanese Government-General of Korea and boycotted all art events held as part of Japanese colonial policy. At first, most of the era's artists specializing in Korean painting took part in the Joseon Art Exhibitions, but their participation gradually declined. Emerging artists who returned to Korea after studying in Japan also began to refuse to involve themselves with the Joseon Art Exhibitions. During the late 1920s and the early 1930s, advocates from the Korean Proletarian Artist Federation (KAPF) art movement avoided participation as well.

The number of leftist artists who took up the traditions of anarchism and socialism and were inspired by the success of the Russian Revolution in 1917 grew rapidly in Korea. These artists intentionally deviated from the traditional categories of fine arts and instead focused on utilizing widely replicable mediums such as printmaking. They also developed genres such as theater and

film that were more orientated toward the general public. Moreover, these leftist artists formed an international network with proletarian activists in Russia, Japan, China, and Korea under the captivating slogan of "Workers of the world, unite!" To them, liberation from class distinctions was the fundamental issue rather than any type of nationalism.

While these leftist artists looked to Russia, many other rising artists at the time were inspired by France. Some first-generation oil painters who had studied in Japan, including Lee Chongwoo (1899–1981), Rha Hyeseok, and Paik Namsoon (1904–94), frequented ateliers in Paris and were already presenting their works at salons in the 1920s. Pai Un-soung (1900–78) went to Germany via Japan, studied oil painting for the first time in Berlin in the 1920s, and was active as a painter in France in the 1930s. In the case of Gilbert Pha Yim (1901–50?), after fleeing to Manchuria to evade Japanese persecution following his participation in the March First Independence Movement, he went to the U.S. and studied Western-style painting there in the 1920s. The experiences of these artists who had lost their country resulted in a global expansion of the activities of Korean artists.

During the Japanese colonial era, the social infrastructure supporting the work of fine art artists was very weak. Many of these artists had studied abroad to hone their skills but came to develop their own distinctive painting styles only after Korea's liberation and the Korean War. Most of the modern artists with whom we are familiar in Korean painting, Western painting, and sculpture are such cases.

Grounding themselves in professional education yet pursing individualistic styles, these artists endeavored to become painters in the modern sense. The self-esteem and pride of this generation was explicitly expressed in Lee Qoede's *Self-Portrait in Traditional Coat* (late 1940s), which was produced immediately after the country's liberation from Japan. Painters of this generation can be viewed as imposing a shared duty upon themselves, albeit to varying degrees and using different methods. This collective mission was to determine how to keep traditional Korean aesthetics in harmony with new Western art trends. Each using their own specific means, the painters responded in their works to the question of how historical elements such the aesthetics of simple white porcelain, the imagination and vigorous spirit of ancient Koreans as seen in tomb murals of the ancient Korean kingdom of Goguryeo, the elegant lines of ink-and-wash paintings, and the modest and amiable styles of the Joseon Dynasty could be incorporated into the oil painting forms introduced from the West.

There were also artists during the Japanese colonial era who were passionate about fields other than fine art. They engaged in printmaking, art publishing, advertising, design, photography, and film, and created a direct impact on the visual experiences of the public.

After the March First Independence Movement in 1919, Japan began to impose the so-called "cultural rule." The Japanese Government-General of Korea at first allowed freedom of speech and the press to some degree. Accordingly, private newspaper companies operated by Koreans were launched, including the *Chosun Ilbo* and *Dong-A Ilbo*. At this time, newspaper companies were considered a space where the greatest intellectuals could gather. Journalists who used to be poets and novelists and worked together in an editorial room with painters who were in charge of illustrations. Some talented painters worked for the *Chosun Ilbo*, *Dong-A Ilbo*, and *Maeil Sinbo* and produced illustrations for serialized novels published in the newspapers. These painters include An Seokju (1901–50), Lee Sangbeom, Noh Soohyun, Jung Hyunwoong (1911–76), Lee Seungman (1903–75), and Kim Gyutaek (1906–62). In addition to newspapers, their attendant journals, various literary magazines, magazines for children, and even bulletins of proletarian groups were swiftly published. The task of producing illustrations and frontispieces for these magazines and bulletins all fell to painters.

During Korea's Enlightenment period, the press and publishing industry flourished as a means of promoting patriotism among Koreans and raising their

intellectual resources in order to protect the country. Likewise, during the Japanese colonial era, the vast majority of newspapers, magazines, and books were published with a goal of enabling the general public to support themselves, cultivate their bodies and minds, and enlighten themselves. The conception of intellectuals who insisted on maintaining respect for Joseon culture and sustaining the national spirit despite having lost their sovereignty led to the development of the printing and publishing culture.

However, with the Sino-Japanese War in 1937 and the 1941 attack on Pearl Harbor further escalating World War II, a so-called "era of militarism" began. The freedom of speech and the press in Korea was completely eradicated. In August 1940, the *Chosun Ilbo* and *Dong-A Ilbo* newspapers were forcibly abolished. With the introduction of the slogan "Japan and Korea as one entity" (*naeseonilche*), Koreans were forced to adopt Japanese names and were forbidden to use Korean language in schools. Artists were also coerced to join at least one organization associated with the Japanese government and produce paintings or illustrations romanticizing. The early 1940s can be viewed as one of the most appalling periods of the twentieth century, whether in the history of Korea in general or just the history of Korean art.

Colonial society is commonly based on the premise of a twofold and paradoxical social system. Under these conditions, the choices given to artists who cherished freedom were extremely limited. In a note, Kim Hyangan, the wife of the poet Yi Sang and later the wife of the painter Kim Whanki, wrote that "in the era we lived in, no one could ever be happy under the deplorable conditions of the colonial rule."

A Transformation in Traditional Korean Painting

Kang Mingi

THE ENTRY INTO THE MODERN ERA

Historically, the modern era is associated with a growing sense of autonomy among the public resulting from the collapse of feudal and caste systems in the eighteenth century. Opposition to political, economic, and social injustice, perception of social realities, and an expanded interest in social change all altered artists' activities. In the field of Korean art history, a clear timeframe for what we can call the modern era has not been set. Recently, however, many Korean art historians have begun regarding the modern era as the period of roughly seventy years ranging from the initiation of the Korean Empire in the 1890s, through the period of Japanese colonial rule and subsequent liberation to 1957, which is considered as heralding the start of the contemporary era. The Joseon Dynasty initially pursued a closed-door policy in foreign relations, but ultimately began an attempt at modernization in order to cope with the changing international circumstances. After being forced by Japan to open its ports in 1876, the Joseon government signed trade treaties with the United States, China, England, Germany, Italy, Russia, and France. Moreover, state-led enlightenment policies were implemented in an effort to embrace new materials and technologies in various fields, including astronomy, geography, shipbuilding, medical science, agriculture, chemistry, mining, and the military. The promotion of a modern public education system created opportunities that were less determined by social status and accelerated the nation's transition to a modern society. *Dohwa* (drawing and painting) classes included in the national curriculum that adopted Western educational precepts featured pencil drawing rather than traditional ink-and-color painting with brushes, leading to a rapid increase in the number of oil painters. These developments in art education brought significant changes to the established practices of ink painting.

By the end of the nineteenth century, the new cities that formed around ports and the transportation infrastructure based on railways and roads linking urban and industrial centers further facilitated the transition to a modern society. The national capital had long served as a cultural hub, but local culture developed and exchanges between different cities increased in the modern era. These changes accelerated the push towards modernization. The proclamation of the Korean Empire by King Gojong (1852–1919) in 1897 signaled Korea's emergence as a modern autonomous nation. It also meant that the country entered a period of social and cultural upheaval, breaking away from its Sino-centric worldview and undergoing a full-scale introduction of a new modern cultural purview.

In order to examine the changes that took place in traditional Korean painting from the premodern period to the modern era, this chapter examines the deviation from the literati tradition of "capturing the spirit" (*saui*) as a philosophical shift and explores the acquisition of systematic art education as a methodological change. It further scrutinizes painting styles that departed from idealized views of nature and instead pursued the authenticity of a real-scenery (*silgyeong*). It also addresses changes in art appreciation that took place with the introduction of the Western exhibition system. A key context here is that these changes occurred in large part during the period of Japanese colonial rule (1910–45). In this respect, Korea's modern era unfolded in concert with the processes of colonialization and the national struggle for independence.

A DEPARTURE FROM THE LITERATI CULTURE OF CAPTURING THE SPIRIT

The greatest changes in traditional Korean painting began with the abandonment of the notion of the need to capturing the spirit of the artist and subject matter within the painted image that resulted from conceptual concerns based on the historical convergence of calligraphy (*seo*) and painting (*hwa*) within the discourse of literati ink painting. The longstanding view of calligraphy and painting as instruments for literati self-refinement and suitably sophisticated hobbies had to change in the modern era as the public, particularly the newly rising bourgeoisie, came to join the traditional literati class in their appreciation for calligraphy and painting. This emergent, diverse group of afficionados consisted of merchants, officials, and teachers who had received a substantive education despite their social status and were also of reasonable financial means. They longed for change while still enjoying traditional literati culture. However, stimulated by concepts introduced from the West such as rational positivism, liberal thought, and a respect for individuality, skepticism of traditional elitist literati culture began to spread. Accordingly, "*seo*" (calligraphy) came to be separated from "*hwa*" (painting). The word "*hwa*" was gradually substituted by new terms like *hoehwa* (modern painting) or *dongyanghwa* (Eastern-style

or East Asian ink painting), whereas calligraphy was relegated to its own domain. This shift in the perception of calligraphy and painting did not appear at the beginning of modern era, however. Despite the drastic changes that took place at the end of the nineteenth century, traditional Korean painting circles generally preferred to maintain the long-standing literati approaches and concerns. In this respect, one important characteristic of modern Korean art is the dominant position maintained until around 1910 by the genres of landscape, historical figure, and the Four Gentlemen (bamboo, plum, orchid and chrysanthemum) painting executed in the literati ink style favored during the Joseon era.

Known for founding major painting lineages in ink-and-color painting that endure even today, An Jungsik (1861–1919) and Cho Seokjin (1853–1920) are considered as master painters of the modern era whose art practice was rooted in late Joseon painting, but whose work served as a bridge to modernity.[1] In 1881 these two painters, both in their twenties, accompanied a Korean delegation known as Yeongseonsa to Tianjin, China, where they studied English and the drawing techniques of Western-style art.[2] Their visit provided them with the opportunity to learn about the West and experience the changing worldview within East Asia. The *Banquet Celebrating the Signing of the Treaty*

1 An Jungsik, *Landscape*, 1912, Ink and color on silk; ten-panel folding screen, 155.5×39 cm each panel

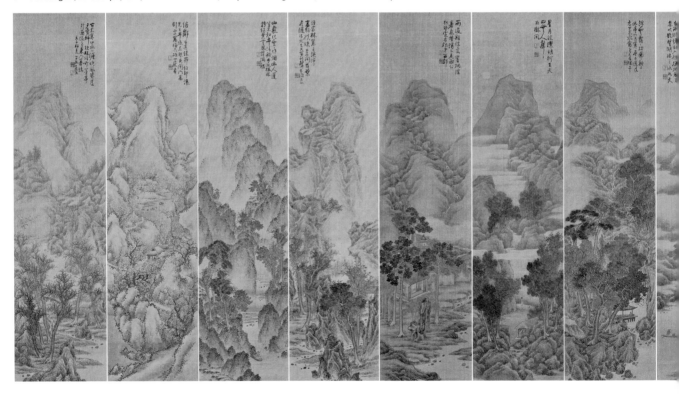

between Joseon and Japan painted by An Jungsik in 1883, after he returned to Korea, is a documentary work recording a historical event. This painting individually depicts each of the participants at the conclusion of the treaty of 1883 and illustrates the items and food on the table in a highly detailed and realistic manner. However, outside of a few specific examples, the influence of Western painting within this work is not obvious. The depiction of the banquet cuisine in this painting corresponds to the description in Percival Lowell's *Chosun, the Land of the Morning Calm* written during his stay in Joseon in the winter of 1883. "In the center of the table stood the *chef-d'oeuvre*, to which all the other dishes were merely satellary adjuncts. It rose out of a bowl somewhat larger than its fellows . . . It was intended for a very superior work of art . . . It was a noble dome-capped cylinder."[3] In this painting, An Jungsik employs a traditional inverted perspective by portraying the figures at the front and at the back in an equal size.

The folding screen *Landscape* (1912) by An Jungsik depicts the vastness of nature unfolding in zigzags from the foreground to the background. It shows a standardized composition in which the background takes up half of the picture plane. 1 The screen portrays an idealized version of nature reflecting the literati notion of *wayu* (viewing the scene virtually, as if traveling through the landscape while reclining) by applying several layers of brushstrokes to overlapping mountains and adding numerous so-called "moss dots" (*taejeom*) to their edges. Such illustrations of the four seasons follow in the standard landscape painting style that enjoyed considerable popularity during the Joseon Dynasty. This demonstrates how An created works based on the traditions of calligraphy and painting rather than being simply influenced by his travels abroad and his study of Western painting. Such a depiction of landscape as a conceptual image of utopia and the playful wielding of ink as a medium built on the traditional unity of poetry, calligraphy, and painting dominated Korean painting until the 1910s. An Jungsik and his colleagues who made impromptu paintings of purely imagined scenes drawn from nature were sometimes criticized for their stereotyped mannerism. However, their works reflect the preference of the time for conventional painting themes and styles over more individualistic approaches to painting. The target viewers for these paintings still enjoyed traditional literati culture and maintained its ethos unaffected by the changes taking place elsewhere.

In contrast, Lee Sangbeom, a disciple of An Jungsik, clearly presents the transformation from the ink-and-wash calligraphy and painting as a means to capture the spirit to the twentieth century categories of modern painting or Eastern-

2 Lee Sangbeom, *Early Winter*, 1926, Ink and color on paper, 152×182 cm

style painting in his *Early Winter* (1926). 2 Painted in 1926, this work was mounted on a Western-style frame rather than a traditional handscroll or folding screen. This shift in how paintings were mounted was encouraged to make it easier to display works in public exhibitions. Also noteworthy in Lee's *Early Winter* is the lack of accompanying colophons (*jebal*) reflecting upon the contents of the painting, leaving only the artist's sobriquet, Cheongjeon, and his seal. These changes became common in the early 1920s. Around this time the transformation in traditional Korean painting was being completed through the dissolution of the theory that calligraphy and painting are identical and share one common origin and the departure from the literati culture stressing the use of ink and brush. This appears to be a result of the emergence of a new class of painters and the diversifying artistic tastes of a rising group of consumers who accepted new forms of scholarship and emerged as a new audience for art. These painters and their supporters belonged to a generation who studied Western-style still life drawings rather than traditional calligraphy and painting which required more mediums such as ink, brush, and paper.

The rupture between calligraphy and painting can also be observed in the teaching methods of the Gyeongseong School of Calligraphy and Painting (Gyeongseong seohwa misulwon) established by Yun Yeonggi (1833–1927) in 1911. This school offered art education through two separate departments for calligraphy and painting and maintained separate staff for each. Additionally, the Joseon Art Exhibition hosted by the Japanese Government-General of Korea included a calligraphy section distinct from its Eastern-style painting section from the time of its founding in 1922. In this regard, it is notable that the Four Gentlemen painting was initially integrated into the Eastern-style Painting section, but from the third exhibition (1924) through the tenth (1931), it was part of the Calligraphy section. For the eleventh exhibition (1932), the Calligraphy section, which included Four Gentlemen, was abolished and replaced by a craft section.

THE BEGINNING OF MODERN ART EDUCATION

Art (drawing and painting) classes were added to the primary school curriculum in Korea in 1895. These classes emphasized practicality and functionalism and revolved around copying examples. According to Park Hwirak, the fundamentals of drawing and painting at the time were based on directly seeing shapes, practicing drawing them, and developing familiarity with designs in order to draw them properly and capture

the beauty of the forms. These remained the stated objectives throughout the early introduction of drawing and painting within the Korean education system.[4]

An Jungsik's personal studio, known as Gyeongmukdang (or Gyeongmukheon) Hall, played a significant role in ink-and-color painting education in the modern era. Gyeongmukdang Hall was founded when he named his *sarangbang* (a reception and study room), "Gyeongmukdang" after returning to Korea from exile in Japan in 1901.[5] Lee Doyoung (1884–1933) was the first student An taught at Gyeongmukdang Hall, and Ko Huidong (1886–1965), Korea's first Western-style painter, studied traditional ink-and-color painting at Gyeongmukdang before setting off to study abroad. Gyeongmukdang served not only as a learning space, but also as an informal style *sarangbang* where officials, scholars, and art enthusiasts in Hanseong (the capital of Joseon and present-day Seoul) would gather to enjoy poetry, calligraphy, and painting. Late-nineteenth-century painting manuals from China were used as the primary textbooks for calligraphy and painting. These publications include *Haishang mingren huagao* (Sketches by Shanghai masters), *Dianshizhai conghua* (Collected paintings of Dianshizhai), *Shi zhong hua* (Painting in poetry), and *Gujin mingren huagao* (Sketches by ancient and contemporary masters). Since copying teachers' works was considered an essential practice, teachers exerted a profound impact on their students. In this respect, teaching in calligraphy and ink painting aimed to encourage students to recreate and master old models rather than foster creativity.[6]

Although drastic changes were being initiated in modern painting circles in the late nineteenth century, many painters continued to work in a traditional literati ink painting style even through the 1910s and preferred to sustain elite literati culture rather than keeping pace with the changes of the times. However, they did not necessarily disregard the dynamic political transformations taking place around them in society. Painters in the turbulent late nineteenth century contributed significantly to exploring and embracing modern systems of knowledge and organization while serving as overseas diplomats. Moreover, they assumed a practical role in the implementation of enlightenment policies as professional technicians who studied photography, geography, chemistry, and shipbuilding. Despite this social role, they strongly advocated for tradition through the production of calligraphy and painting. This can be regarded as one of the characteristics of modern Korean painting. Another distinctive feature of modern Korean painting in the early twentieth century was the system of apprenticeship education. The apprenticeship style of learning offered at

3 Cho Seokjin, *Wild Geese*, 1910, Ink on paper, 125×62.5 cm

4 Lee Yongwoo, *Tranquility after the Rain*, 1935, Ink and color on silk, 137×110.5 cm

Gyeongmukdang was inherited and developed by the Gyeongseong School of Calligraphy and Painting founded in 1911 by Yun Yeonggi and Bang Handeok (1846–1913) in Duseok-dong in the north of Gyeongseong (present-day Junghak-dong, Jongno-gu, Seoul). From the start, the school aimed to sustain tradition and provide opportunities for younger students through art education. To achieve this goal, it established the Calligraphy and Painting Society (Seohwa misulhoe) in 1912 and began to nurture young artists in both disciplines.[7] This Society maintained a staff of teachers that included An Jungsik, Cho Seokjin, Jung Daeyu (1852–1927), Kang Piljoo (1852–1932), Kang Jinhee (1851–1919), and Kim Eungwon (1855–1921), while Lee Doyoung served as a teaching assistant. The Society can also

be viewed as a form of royal art institution since it was funded by the Yiwangjik (Office of Royal Household) that managed affairs related to the Yi royal family of the Joseon Dynasty. ⯀3 Graduates of the school included Oh Ilyoung (c. 1890–1960), Lee Yongwoo (1902–52), Lee Hanbok (1897–1944), Lee Yonggeol, Kim Eunho (1872–1979), Park Seungmoo (1893–1980), Noh Soohyun (1899–1978), Choi Wooseok (1899–1964), and Lee Sangbeom (1897–1972). All these artists would go on to become notable figures representing modern Korean ink painting. ⯀4

The Calligraphy and Painting Society consisted of separate Painting and Calligraphy departments, marking a break from the traditional education system based on the unity of calligraphy and

5 Lee Sangbeom, Jung Daeyu, An Jungsik, Kim Eungwon, Noh Soohyun, Kim Eunho, Lee Hanbok, Choi Wooseok, Kang Jinhee, Kang Piljoo,
Paintings Produced by Ten Painters, 1917, Color on silk; ten-panel folding screen, frame: 219.5×487 cm, image: 163.5×36.8 cm each

painting. It became a modern art education institution, with each department offering a three-year course. Several similar institutions founded in the following years instituted a system similar to the Calligraphy and Painting Society. The Gyeongseong School of Calligraphy and Painting and the Calligraphy and Painting Society appear to have initially been in operation simultaneously. However, only the Calligraphy and Painting Society is mentioned after 1916, suggesting that it was the main educational institution after this point. The Society was officially disbanded in June 1920.[8]

Western Beauty was produced by Kim Eunho in 1915 while studying in the Calligraphy Department of the Calligraphy and Painting Society, after he had previously graduated from the Painting Department, and a review in the *Maeil Sinbo* newspaper stated that it demonstrated a spirit surpassing that of many mature artists.[9] Choi Wooseok, who was about to graduate from the Society, created a similar painting entitled *Beauty*.[10] This suggests that students at the Calligraphy and Painting Society may have taken a class that taught pictorial realism, as conveyed within Western-style paintings, although some critics also considered that these works were simply individualistic efforts on the part of Kim and Choi.[11] Choi and Lee Yongwoo are known to have together attended a drawing class taught by Ko Huidong, but the details are difficult to determine. Choi's submission of an oil painting to the first exhibition of the Calligraphy and Painting Association (Seohwa hyeophoe) in 1921 also suggests that there was training in Western pictorial realism taking place at the Calligraphy and Painting Society.[12] Although An Jungsik and Cho Seokjin, both teachers at the Calligraphy and Painting Society, instructed their students based

on Chinese painting manuals and their own works, they also stressed the importance of drawing the subject matter as it is (*sasaeng*). In a similar vein, their students were able to apply a new, *sasaeng*-based painting style to real-scenery ink landscapes in the early 1920s. Accordingly, the teachers at the Calligraphy and Painting Society are presumed to have emphasized the importance of an ink-and-color painting education that also included figure and *sasaeng* drawings and sketching influenced by the tradition of Western pictorial realism, and impressed upon their students the advantages of learning these new techniques. A ten-panel folding screen *Paintings Produced by Ten Painters* (1917) is a joint work by professors and students from the Society. From right to left, this important piece includes paintings and poems by Lee Sangbeom, Jung Daeyu, An Jungsik, Kim Eungwon, Noh Soohyun, Kim Eunho, Lee Hanbok, Choi Wooseok, Kang Jinhee, and Kang Piljoo. 5 Both established and younger painters collaborated here to address popular themes of the time.

In 1915, slightly later than the Calligraphy and Painting Society, the Calligraphy and Painting Research Institute (Seohwa yeonguhoe) was established by Kim Kyujin (1868–1933). Kim taught calligraphy to Imperial Prince Yeong and maintained close ties with the royal family of the Korean Empire. Kim's institute was a three-year program equipped with Calligraphy and Painting Department. It was housed inside Korea's first commercial art gallery, Gogeum Seohwagwan, literally meaning a gallery of ancient and modern calligraphy and painting. In contrast to the Calligraphy and Painting Society, the Institute accepted female students as well, however, the male and female students were taught at

different hours. Among the female students were professional painters, the wives of high-ranking officials, Japanese women, and *gisaeng* (professional female entertainers), which indicates that the institute enjoyed considerable popularity.[13] Kim Kyujin was a progressive figure who also studied photography, opened the Cheonyeondang Photo Studio (Cheonyeondang sajingwan), and produced photographic portraits of King Gojong. However, given that most of his surviving works are ink bamboo paintings, Kim may have implemented traditional educational methods at the Calligraphy and Painting Research Institute. *Orchid, Bamboo, and Strange Rock* was created by Kim Kyujin as a reference work for the first Joseon Art Exhibition in 1922, and is considered a masterpiece of the period that is 190 centimeters in height. A commemorative photograph of Kim Kyujin standing next to this painting much taller than himself was published in the press. Rather than ink, Kim noted that he painted this work using deep-colored pigments (*jinchae*) including malachite for the bamboo leaves, in an effort to refresh his own mind and body.[14] Kim's painting demonstrates that painters of the time, including An Jungsik, Cho Seokjin, and Kang Piljoo, possessed a complete mastery of both the East Asian traditions of realistic color painting as well as literati ink painting which captures the essence of the subject matter.

Among the institutions established in the 1920s were the Songdo Research Institute of Calligraphy and Painting (Songdo seohwa yeonguhoe), the Calligraphy and Painting Academy (Seohwa hagwon) affiliated with the Calligraphy and Painting Association, the Goryeo Art Research Center (Goryeo misul yeonguwon), and the Gyeongseong Women's School of Art (Gyeongseong yeoja misul hakgyo). All these institutions contributed to the development of ink-and-color painting. The method of copying painting manuals and classic calligraphic works and paintings continued from the Joseon period into the modern era. The continuation of this style of education may have resulted from an awareness of the tasks at the time, including the developments in the fields of traditional and modern calligraphy and ink painting, the scholastic study of Eastern and Western art, and the increased scholarly interest in the history of the Silla and Goryeo periods. All of these intellectual currents contributed to a general concern with the progressive development and maintenance of Korean cultural traditions that fed directly into the development of modern Korean art. In the 1930s, besides the above-mentioned institutions, Kim Eunho's Nakcheongheon Studio, Lee Sangbeom's Cheongjeon Art Studio, and the Yeonjinhoe Association established by Huh Baeklyun (1891–1977) in Gwangju, Jeollanam-do

6 Huh Baeklyun, *Landscape*, 1926,
Light color on paper, 156×65 cm

Province served as further cradles of education which supported the emergence of numerous other painters who contributed to the transformation of modern and contemporary painting.

FROM AN IDEALIZED VIEW OF NATURE TO A CONCERN WITH REALISM

The social and political changes taking place at the end of the nineteenth century seriously impacted the traditionalist ink-and-color painting community and brought changes that were different from those of the premodern period in the ways of seeing nature and visual representations. Traditionally in East Asian art, views of nature were founded upon

notions of contemplation, *wayu*, and seclusion, all of which fundamentally shaped the development of landscape painting. In terms of significant subject matter, landscapes had long formed a cornerstone of East Asian ink painting. Within this tradition, a painterly tendency to highlight lines rather than colors continued across all painting genres, including landscape painting, figure painting, bird, flower, and animal painting, and paintings of the Four Gentlemen. Within this tradition, a painterly tendency to highlight lines rather than colors continued across all painting genres, including landscape painting, figure painting, bird, flower, and animal painting, and paintings of the Four Gentlemen.

The dynamics of modernization in the late nineteenth century resulted in more frequent contact with Western nations, active foreign trade through open ports, and the formation of larger cities in the provinces. These developments transformed the perspectives of both artists and audiences in terms of the appropriate subject matter for landscape painting, which had traditionally focused on mountains and rivers. Moreover, the introduction of naturalism and realism from Western art exerted an influence across Korean visual culture and society as a whole. These changes affected the perceptions and attitudes of audiences and consumers of art and changed the traditional notion of idealized nature. The elite ink painting circles were grounded upon the idea

that calligraphy and painting share the common origin and had been content to remain within the longstanding conceptual practice of capturing the spirit. However, they began to chart a new course of depicting the subject matter as it is and mundane subject matter from everyday life based on a creative attitude of making objective sketches from life. These changes can be seen as first reflected in paintings from the 1910s, but it was only in the early 1920s that artists actively sought out new painting techniques to feature within their work.

Traditional landscape painting reflecting an idealized view of nature, as seen in An Jungsik's *Landscape*, was replaced by 'real-scenery' landscape painting that employed a linear perspective taken from Western-style painting, as demonstrated in Lee Sangbeom's *Early Winter*. In the latter, the colophons that were traditionally added to a schematized, idealized landscape painting began to disappear, and realistic everyday landscapes began to be sketched out as the basis of composition. A comparison between An's *Landscape* and Lee's *Early Winter* indicates the shift from a depiction of the vastness of nature to a more close-range description displaying a sense of depth that is distinct to Western painting. Like Lee's *Early Winter*, Huh Baeklyun's *Landscape* (1920) received an honorable mention at the fifth Joseon Art Exhibition in 1926. **6** This painting depicts a transition in nature in which light clouds are depicted as moving into the distance while rain clouds are rolling in,

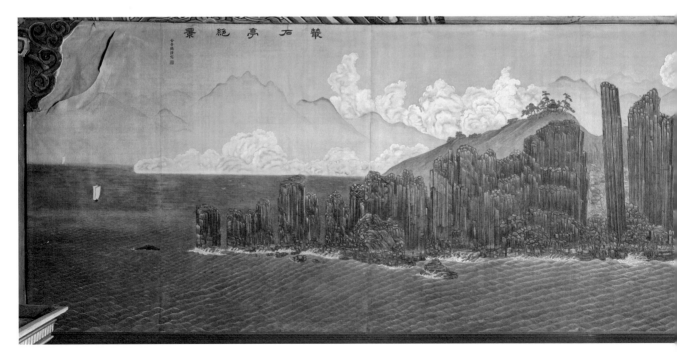

7 Kim Kyujin, *Wonderful Views of Chongseokjeong Pavilion*, 1920, Color on silk, 195.5×882.5 cm

following the classical style of the Chinese painter Mi Fu (1051–1107). Kim Bokjin, who was engaged with the Korean Proletarian Artist Federation (KAPF), harshly criticized Huh's application of the traditional style of the Southern School of Chinese painting, given the contemporary concern with moving towards new art forms and practices, claiming that "it has nothing to do with modern people."[15] Although this comment primarily reflects Kim's personal perspective, it also reveals that Huh Baeklyun, who is widely regarded as a master of modern and contemporary Korean painting, also once received negative evaluations in the public arena. Indeed, the fact that Huh won second place at the first Joseon Art Exhibition (at which no first place was awarded) marks a distinct transformation in the traditional painting art world. In the early 1920s, traditional ink landscape painting experienced an overall change. An interest in creative practice based on specificity and realism rather than imagined scenes and the expression of spirit was growing at the time. In art, sketching from everyday life and an objective concern with representation led to the increased visualization of actual landscapes and everyday objects, and this "new" approach came to replace the traditional notion of landscape painting prevalent within East Asia.

In 1920, Kim Kyujin, the founder of the Calligraphy and Painting Research Institute, created *Picturesque Landscape of the Myriad Things on Geumgangsan Mountain* and *Wonderful Views of Chongseokjeong Pavilion*, two striking masterpieces commissioned to adorn the walls of Huijeongdang Hall in Changdeokgung Palace. 7 Huijeongdang Hall had been rebuilt following a fire in 1917 and served as the office of Emperor Sunjong. Among palace wall paintings, these two are unique as examples of magnificent real-scenery landscape paintings applying deeply colored pigments that reflected the tastes of Emperor Sunjong. The emperor requested mural paintings in a "pure Korean style," so Kim Kyujin explored Geumgangsan Mountain, which has long been considered a sacred peak and has provided a popular theme for painting since the eighteenth century, then created these masterpieces each over 880 centimeters long. They were Kim's first and last monumental real-scenery landscape paintings, demonstrating the remarkable skills of the artist, who published books on calligraphy and had been primarily celebrated for his work as a literati painter.

Created by Noh Soohyun in the 1920s, *Fresh Verdure* stands out among the paintings of the time for its overwhelming size at 204 centimeters high and 312 centimeters wide. 8 There are no records of this work being submitted to exhibitions, and the precise reason why it was created remains unknown. Nonetheless, given that Noh devoted his life to producing landscape paintings in ink and light color, *Fresh Verdure* is an unusual addition to his oeuvre. At the same time, however, it is an

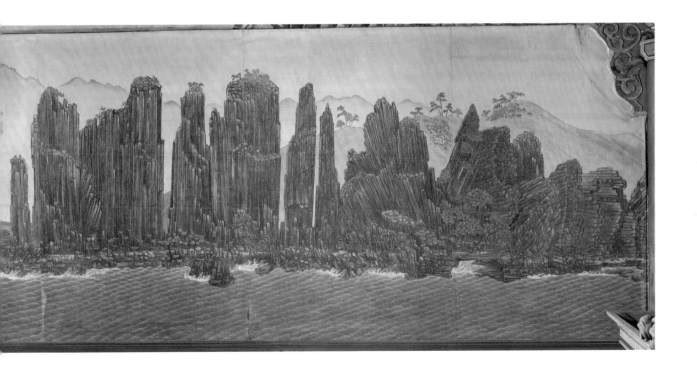

experimental work that reveals a shift in Noh's career from the traditional painting style that he learned at the Calligraphy and Painting Society to a real-scenery style in the early 1920s. In this painting, Noh portrays a magnificent landscape using extremely detailed brushstrokes and multiple perspectives rather than a fixed perspective based on a single point. Because of its enormous size, the painting was stored for a long time folded up into squares. The colors remain vivid, however, and its size suggests that the painting might have been intended for display in a public building rather than a private space.

In a similar vein, figure painting departed from the narrative tradition that had been popular since the late nineteenth century and began to depict ordinary, everyday matters. The mid-1910s witnessed the emergence of a demand for taking "new yet familiar pleasure in the vivid subject matter of the everyday world" and "rendering it from life by studying its characteristics and merits."[16] This growing demand accelerated the transformation in traditional Korean painting. In this climate, an artist was now required to possess an unrestrained imagination and eschew old approaches through a bold, original expressive manner, to create new practices in painting based on the depiction of the real world.[17]

Two-Panel of Folding Screen of Deer and Pines (1918) produced by Kim Eunho was an early example of his narrative figure painting that once belonged to the collection of Changdeokgung Palace. [9] Known as a painter with a rising reputation when he created this work, Kim graduated from the Painting Department of the Calligraphy and Painting Society in 1915 and from its Calligraphy Department in 1917. By 1918, while still in his twenties, he had accrued recognition for his portrait of a king. He was already celebrated among the era's leading artists and was known for demonstrating particular maturity in his depiction of trees and figures. Along with the *Twelve-panel Folding Screen of Daoist Immortals* from the same year, this screen was commissioned by the Korean imperial court and assigned to Changdeokgung Palace. Some of his paintings of female figures from the 1920s demonstrate a transformation in his figure painting from idealized depictions to

8 Noh Soohyun, *Fresh Verdure*, 1920s, Ink and color on silk, 204×312 cm

9 Kim Eunho, *Two-Panel of Folding Screen of Deer and Pines*, 1918,
 Color on silk, 159.5×52.5 cm (each panel)

10 Kim Eunho, *Folk Dancers Dressed as Buddhist Nuns*, 1922,
 Ink and color on silk, 272×115 cm

more realistic and everyday subjects. *Folk Dancers Dressed as Buddhist Nuns* (1922) which earned Kim fourth place at the first Joseon Art Exhibition is currently in the collection of the Samuel P. Harn Museum of Art in Gainesville, Florida, U.S.[18] **10** Kim also developed modern imagery for the genre of figure painting by adapting the traditional theme of a beauty under a tree. Moreover, his elegant and delicate female figures portrayed in *Contemplation* (1923) and *A Woman Reading Fortune of the Day* (1927) established Kim as the most popular painter of the moment. Paintings of beautiful women enjoyed considerable popularity at the time, as they met the demands of the era in that they depicted

11　Kim Junghyun, *Springtime*, 1936, Color on paper; four-panel folding screen, 106×54.2 cm each panel

quotidian people in everyday scenes. The growth of public competitions and the general public's growing appreciation for art led to the promotion of popular painting themes such as beautiful women, a preference for color ink and wash painting over monochrome ink painting, and a predilection for large-scale works.

After winning a prize in the Western painting section in 1933 and in both the Eastern and Western-style painting sections of the Joseon Art Exhibition in 1934, Kim Junghyun received special awards in both sections in 1936. His wins were exceptional since he was not a professional painter. Instead he worked in the Civil Construction Department of the Japanese Government General of Korea and had mastered painting independently. *Springtime* (1936), for which Kim won a special award in the Eastern-style painting section, is particularly noteworthy as a large-scale four-panel folding screen and also remarkable as a figure painting of a group of eight people as opposed to more conventional versions depicting only one or two subjects. **11** Each figure in *Springtime* appears to be absorbed in his or her own interests rather than interacting with one another, a characteristic of folk-style figure painting popular in the 1930s. Kim Eunho's and Kim Junghyun's figure paintings aptly demonstrate one of the aspects of the transformation in modern art in that they illustrate everyday scenes from daily life.

THE INTRODUCTION OF THE EXHIBITION SYSTEM AND NEW APPROACHES TO THE DISPLAY OF PAINTINGS

The introduction of the Western exhibition system played the most significant role in fueling the transformations taking place in traditional Korean painting during the modern era. As the exhibition system became established, art came to be perceived as something that could be enjoyed by the general public as well as the social elites. This shift became a key element of the modern art scene. Traditional monochrome ink and ink and color paintings had been appreciated and circulated within particular elite erudite groups as a means of self-realization and in the pursuit of intellectual refinement, but with the coming of modernity they became products to be enjoyed by the general public within open exhibition spaces. The development of mass media, including newspapers and magazines, also contributed to the popularization of art, allowing the public to share information through the regular publication of news and discourse on the art world. Accordingly, artists were aware of the unavoidable burden that their work were the object of public's appreciation and should stimulate public's tastes, which led to substantive changes in the painting styles.

Public exhibitions began to be held in Korea around 1905. The concept of the public exhibition was introduced by the returning Korean delegations who were dispatched to Japan, the U.S., the UK, and France and visited modern expositions and

museums at the end of the nineteenth century. A historically significant moment in the introduction of the exhibition system into Korea was the Joseon Industrial Exhibition in Commemoration of the Fifth Year of Japanese Colonial Rule (Sijeong onyeon ginyeom Joseon mulsan gongjinhoe; Joseon Industrial Exhibition in short) convened in 1915. The Joseon Industrial Exhibition aimed to provide a comprehensive review of the Japanese administration, the development of industrial culture, and social progress under Japanese rule. In an overt effort to legitimize Japanese colonization, the Joseon Industrial Exhibition focused on showcasing numerous exhibits related to modern civilization in order to impress the general Korean public. In this respect, it fundamentally served as a vehicle for political propaganda. It featured old and new objects and displays ranging

12 Lee Youngil, *Country Girl*, 1928, Color on silk, 152×142.7 cm

A TRANSFORMATION IN TRADITIONAL KOREAN PAINTING

from archaeological artifacts from the periods of Three Kingdoms through to Joseon in the main art exhibition hall, to works by numerous contemporary Korean and Japanese painters in a supplemental art exhibition hall. Notably, the works displayed in the supplemental art exhibition hall were prize-winning pieces selected through a judging process. Considering that large numbers of people visited the Joseon Industrial Exhibition, these works must have interested both viewers and painters. Therefore, the Joseon Industrial Exhibition demonstrated that art was not simply a cultural phenomenon that was enjoyed by social elites but an attraction for the general public.

In the late nineteenth century Korea, many ink paintings and calligraphic works were still being appreciated within traditional Korean contexts of display and appreciation rather than within Western-style public exhibitions. Literary gatherings that prevailed among the literati of educated bourgeois (*yeohang munin*) in the late nineteenth century were emblematic of such practice of appreciation. This type of literary gatherings, at which members of a coterie promoted friendship; appreciated poetry, calligraphy, and painting; enjoyed drinking tea and refreshments; and refined their aesthetic discernment in a natural setting, continued well into the first half of the twentieth century. For example, the Calligraphy and Painting Gathering at Useongak Hall (Useongak seohwahoe) held by Jang Jiyeon (1864–1921) in 1909 and the commemorative gathering of Nanjeonggye held in 1913 at Chokseongnu Pavilion in Jinju were modern literary gathering in which literati, calligraphers, and painters from different regions came together to display and enjoy ancient poems, paintings, and calligraphic works, in addition to producing their own work inspired by the event.[19]

Such an approach to the appreciation of calligraphy and painting was adopted by Yun Yeonggi's Giseong Art Institute (Giseong seohwahoe) and the Gyonam Association for Research on Poetry, Painting, and Calligraphy (Gyonam seohwahoe or Gyonam seohwa yeonguhoe) founded by Seo Byeongo (1862–1935). These offered an opportunity for artists to meet, study calligraphy and painting, and exhibit their artworks in regional cities like Pyeongyang and Daegu. In the 1910s and 1920s, however, paintings and calligraphic works were often exhibited on a single predetermined day and some were sold after being created on the spot. Such system of operation was built based on the example of Japanese calligraphy and painting gatherings. Particularly in Korea, personal exchanges among the participants in calligraphy and painting gatherings were considered important. Visitors paid an entry fee and sometimes received paintings and calligraphic works as gifts. The fact that they could watch calligraphers and painters creating their works in person and buy what they wished must have held a great appeal to those who would attend such events. Calligraphy and painting gatherings were announced through notices in local newspapers usually a day or two before they were held, but sometimes two or three weeks in advance. Some painters personally hosted gatherings to encourage greater attendance by officials and citizens. Such gatherings were smaller than the exhibitions held at rented halls. Since private social gatherings attracted people who were interested in calligraphy and painting and facilitated a greater range of personal exchanges, they were preferred by many celebrated calligraphers and painters, including Yun Yeonggi, Kim Kyujin, Kim Eunho, Huh Baeklyun, Kim Yunbo (1865–1938), and Kim Yutak (1875–1940). Such celebrated artists were able to hold calligraphy and painting gatherings throughout the country. Research on these calligraphy and painting gatherings has revealed that despite their apparent lack of influence within the development of Korean art and standing within the historical canon, Yun, Kim Yunbo, and Kim Yutak enjoyed considerable popularity at the time.

Events under the title of *sisa* were still held in the 1910s. However, these were gatherings for writers and calligraphers only and excluded painters, which is indicative of the separation that was taking place between calligraphy and painting. By the 1930s, the number of calligraphy and painting gatherings had begun to decrease noticeably. The primary reasons for the decline are probably that most of the impromptu works created at these gatherings were ink paintings which failed to address the public's changing taste and also the fact that it had become so easy to view and purchase finished products at exhibition halls. In the 1910s, large-scale exhibitions were frequently held for painters from the Calligraphy and Painting Society. Moreover, the Joseon Industrial Exhibition, considered to be Korea's first art competition, had successfully allowed the general public to become familiar with elite art by displaying painting in its supplemental exhibition hall. Nonetheless, until the early 1920s, paintings and calligraphic works were still being produced on the spot at many exhibitions in Korea.

The first exhibition held by the Calligraphy and Painting Association (formed in 1918 by calligraphers and painters) in 1921 and the Joseon Art Exhibition hosted by the Japanese Government-General of Korea in 1922 played a significant role in the development of the exhibition system. These two exhibitions led to a range of further multiple group and solo shows, making the general public aware of the utility and value of exhibitions as an introductory platform to art. The Calligraphy and

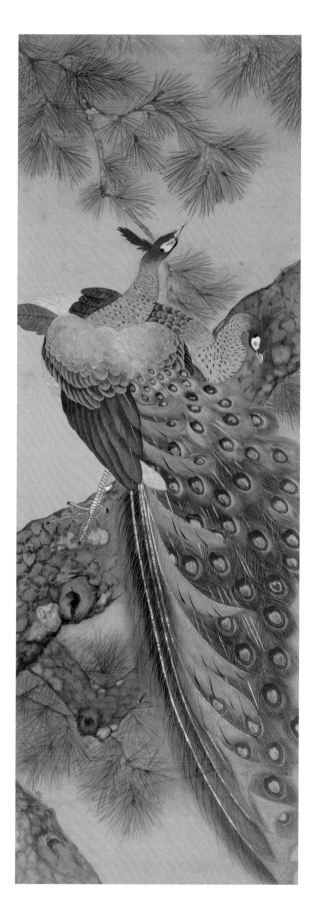

Painting Association Exhibitions and Joseon Art Exhibition were significant in that they offered a wide range of people, who had perhaps previously only seen one or two paintings at a single time, an opportunity to view a group of works by leading contemporary painters in a single hall, thus contributing to the popularization of art.[20]

At these exhibition halls, painters came face-to-face with their new audiences and directly witnessed how their works were received by the general public. This brought about a dramatic change in the traditional forms of art appreciation preferred by writers and artists. Most of the viewers were from the emerging middle class who had received a modern education and whose art tastes were sophisticated and secular. The exhibition reviews in newspapers and magazines discouraged painters from creating their works in the refined manner of the literati. These professional painters had to confront the reality of the changes occurring in traditional Korean painting circles. In this new environment, while the exhibition was being implemented in the early twentieth century, those who achieved satisfactory results came to reign as popular artists, whereas those who failed to do so were gradually left behind. In this regard, the transformation that occurred in traditional Korean painting was directly linked to the introduction of the public exhibition system.

A CHALLENGE TO KOREAN MODERNISM
A critical awareness of social reality would ultimately be crucial to the development of modern art and culture in Korea. However, up until the early 1920s, traditional forms of art that had been created within the standardized manner of a literati class well versed in classical poetry, calligraphy, and paintings continued to reflect a highly recognizable selection of iconography and styles rather than privilege any display of individualistic creativity or originality. Those who appreciated these paintings shared the same tastes. For them, a painting was considered emblematic of the refined leisure culture of the literati class, who maintained the notion of an idealized aesthetic discernment and emphasized the didactic utility of historically valorized themes.

As the rational positivism, liberalism, and respect for individuality that developed in the West came to influence the traditional Korean painting community, the privileging of landscape paintings that presented an idealized outlook on nature and the idea of "*wayu*" depicted in each work began to change. The emergence of new architectural and civic technology, roads, the automobile, and railroads that accompanied the formation of large cities transformed the traditional focus of ink landscape painting on idealized imagery

of mountains and water into a new landscape style. In figure painting, narrative themed works maintained their popularity for a considerable time. However, figure painting also soon came to be imbued with the spirit of the times, as artists corresponded to the public demand for finding new yet familiar pleasure in the vivid depiction of subject matter from the everyday world. Beautiful women in quotidian scenes or ordinary people going about their daily activities became the two main subjects. Furthermore, colophons, which had been a major compositional and conceptual concern within ink painting, were longer inscribed, and calligraphy and painting respectively formed an independent genre. Lee Young-il (1903–84), who was noted for his bright color paintings, received a special prize at the eighth Joseon Art Exhibition in 1929 with *Country Girl* (1928). 12 This painting, however, was criticized at the same time for it being a mere illustration of the "impressions derived by a young urban elite from his trip [to the countryside]." Another notable painter of this period was Jung Chanyoung (1906–88), one of Lee's disciple. Jung, just as her teacher, received special prizes several times at the Joseon Art Exhibition during the 1930s. She became one of the most celebrated women painters of the time and secured her position in the art scene of the Korean painting. *Peacocks* (1930s) is her representative work that has survived to this day. 13

The tastes of the newly emerging class of bourgeois art aficionados, who favored a sensuous aesthetic conveyed through more modern, quotidian subject matter and novel painterly techniques, ushered in the end of the traditional theory that painting is identical to calligraphy. The public awareness of art gained through the exhibition system indicated that artistic production had moved into a realm totally separate from that of the premodern period. The painters of the time who were leading the transformation of the traditional Korean painting art world were fully aware of the changing social contexts of art and culture during this period of social upheaval, and accordingly pioneered a new approach to their artistic practice corresponding to the changes taking place in society.

1 For recent studies on An Jungsik, see Choi Kyounghyun, "Geundae seohwagyeui geojang anjungsik: Jeontongui gyeseunggwa dojeon, geurigo hangye" [An Jungsik, Master of Modern Korean Calligraphic Painting: Continuity of Tradition, Challenge, and Limitations], *Journal of Korean Modern & Contemporary Art History* 38 (2019): 7–32 and Choi Youl, "An jungsik haengjang" [Life history record after death of An Jung-sik], *Inmul misul sahak* 13 (2017): 201-259.

2 Cho Eunjung, "Geundae jisiginui gyoyuwa misul: Goyeongcheol, anjungsik, joseokjinui yeongseonsa hwaldongeul jungsimeuro" [Friendship and Art of Modern literaty; Activities as a member of Yeongseonsa], *Journal of Korean Modern & Contemporary Art History* 38 (2019): 269–291.

3 Percival Lowell, *Nae gieok sogui joseon, joseon saramdeul* [Chosön, the Land of the Morning Calm], trans. Jo Gyeongcheol (Goyang: Yedam, 2001), 201.

4 Park Hwirak, *Hangukmisulgyoyuksa: Misulgyoyuk 100nyeonui heureum (1895–1995)* [The History of Art Education in Korea One Hundred Years of Art Education (1895–1995)] (Goyang: Yekyong, 1998), 23–26.

5 For more information on Gyeongmukdang, see Kang Mingi, "Hakseupgwa gyoyuui gonggan: anjungsigui gyeongmukdang" [A Space for Learning and Friendship: An Jungsik's Gyeongmukdang], in *Geundae seohwaui yoram, gyeongmukdang* [Gyeongmukdang: A Cradle of Modern Calligraphy and Painting], exh. cat. (Seoul: Korea University Museum, 2009), 146–155.

6 For a more detailed discussion on modern art education, see Kang Mingi, "Geundae sumukchaesaekwadanui geojangdeul: Anjungsigeseo byeongwansikkkaji" [Great Masters of Modern Ink and Color Painting: From An Jungsik to Byeon Gwansik], in *Gyeseunggwa byeonhwa: Hangukgeundae sumukchaesaekhwa* [Succession and Transformation: Modern Korean Ink and Color Painting], exh. cat. (Incheon: Songam Art Museum, 2015), 61–72.

7 The Calligraphy and Painting Society has been discussed in the following studies: Lee Gu-yeol, *Hangukgeundaemisulsango* [A Study on Modern Korean Art] (Seoul: Eulyu munhwasa, 1972), 23–55; Hong Sun-Pyo, *Hanguk geundaemisulsa* [Modern Korean Art History] (Seoul: Sigong art, 2009), 106-115; and Kim Soyeon, "Hanguk geundae jeonmun seohwagyoyugui seondo, seohwamisulhoe" [Leading Role of the Seohwa Misulhoe in the History of Korean Art Education], *Art History Forum* 36 (2013): 117–139.

8 According to an article on the second page of the *Maeil Sinbo* newspaper published on June 19, 1920, the Calligraphy and Painting Society was disbanded for the following reasons: "First, Jung Daeyu and Kang Piljoo [who led the Society] after the death of three painters (Kang Jinhee, An Jungsik, and Cho Seokjin) are famous calligraphers but cannot be acclaimed as painters, and since Kim Soho (Kim Eungwon) is the only painter in the Society, he alone cannot continue to teach painting. Second, because members of the Society were unwilling to come together to learn collectively the attendance rate of students gradually fell, and the Society was about to be disbanded last fall. Therefore, the Society currently faces being disbanded. It will remain open for this month and then close for good at the end of the month."

9 *Maeil Sinbo*, January 27, 1916, 3.

10 *Maeil Sinbo*, March 20, 1918, 3.

11 Kim, "The Leading Role of the Seohwa Misulhoe," 40.

12 Along with Rha Hyeseok and Ko Huidong, Choi Wooseok submitted Western-style paintings to the first exhibition of the Calligraphy and Painting Association in 1921. See the article in *Maeil Sinbo*, April 2, 1921, 3.

13 Kim, "The Leading Role of the Seohwa Misulhoe," 51–58.

14 *Maeil Sinbo*, May 21, 1922, 3.

15 *Chosun Ilbo*, June 7, 1925, 3.

16 Lee Gwangsu, "Donggyeongjapsin" [News from Tokyo 3], *Maeil Sinbo*, November 2, 1916, 1.

17 Byeon Yeongro, "Dongyanghwaron" [A Discourse on Eastern-style Painting], *Dong-A Ilbo*, July 7, 1920, 4.

18 The existence of *Folk Dancers Dressed as Buddhist Nuns* and other Korean paintings in the collection of the Samuel P. Harn Museum of Art was first discovered in 2004. They were introduced in Volume 12 of *Wolgan Misul* published in 2005.

19 Kang Mingi, "Iljegangjeomgi hangukgwa ilbonui seohwahoe yeongu: Jeontongui gyeseunggwa jaepyeon" [A Study of Korean and Japanese Art and Calligraphy Venues in the Modern Period (1910–1945)], *Journal of ART History* 28 (2014): 283–309.

20 "Seohwahyeopoejeollamhoeui choil" [Beginning of the Exhibition of the Calligraphy and Painting Association], *Dong-A Ilbo*, April 2, 1921, 3.

The Emergence of New Art Forms and the Reorganization of the Art Institutions During the Colonial Period

Mok Soohyun

THE FORMATION OF NEW GENRES OF ART

From the end of the nineteenth century, the influx of information on Western art gradually increased in Korean art circles. In the turn of the twentieth century, the art circles witnessed the advent of new art forms that valued viewing objects and expressing them from the Western perspective. One fundamental change that the Korean art circles had undergone was that the term *seohwa* (calligraphy and ink painting), which had been considered a unified entity, was replaced by the concept of '*misul*' in the early twentieth century. This new term was used in reference to the modern Western notion of "art," as encompassing the realms of painting, sculpture, and crafts.

The Joseon Industrial Exhibition in Commemoration of the Fifth Year of Japanese Colonial Rule (Joseon Industrial Exhibition), which opened in 1915, perhaps first initiated a new understanding of art, or *misul*, as comprised of painting, sculpture, and craft. This event also institutionalized the division of painting into Eastern and Western styles. It followed the notion that techniques such as oil painting and pencil sketching, along with pictorial conventions such as linear perspective, were inherently associated with the art of "Western" Europe and that the medium of ink painting was quintessentially East Asian, particularly in relation to the literati traditions of calligraphy and "mountain and water" landscape painting. The Joseon Industrial Exhibition spanned the precincts of Gyeongbokgung Palace and introduced art forms including Western oil painting and Eastern ink painting as well as sculpture and various crafts to the general public. Moreover, newspapers covered stories extensively about Ko Huidong, who became the first Korean Western-style painter, and Kim Kwanho, who

followed Ko and went to study at the Tokyo School of Fine Arts and received a special award at the Ministry of Education Fine Arts Exhibition in Japan (Munbuseong misul jeollamhoe) in 1916.

The curriculum for art education in public schools included *dohwa* (painting and drawing) and focused on creating drawings and sketches based on objective observation. Since no professional art education institutions had been established, people who wished to specialize in such practices often went to Japan, Europe, or the United States to study art and broaden their oeuvre. Many of them returned to Korea and attempted to teach the new art practices, styles and techniques they learned. For example, Ko Huidong and Lee Chongwoo worked as art teachers at the Hwimun Uisuk Academy and Boseong School, respectively. Others established private art education institutions and promoted Western art practices. For instance, Kim Kwanho and Kim Chanyoung founded the Sakseonghoe Painting Research Institute (Hoehwayeonguso sakseonghoe) in their native city of Pyeongyang in 1925. The Sakseonghoe Painting Research Institute offered a two-year program both in ink painting and oil painting. Graduates from this institute included Choi Yeonhae, Kwon Myeongdeok, Park Youngseun, and Hyeon Rheeho, who all received honorable mentions at the Joseon Art Exhibition. Another notable artist-educator was the sculptor Kim Bokjin. After returning from Japan in 1925, he served as an art teacher at Baejae High School and as a lecturer in the Ceramics Department at Gyeongseong Girls' Commercial School and Gyeongseong Industrial School. He also taught sculpture in the Art Department of the Young Men's Christian Association (YMCA), contributing to the development of figurative sculpture in Korea.

To a large degree, this "new art" (*sin misul*) was influenced by the art world of Japan, the colonizer.

However, Korean artists maintained in their work a connection to the traditional Korean ideas about aesthetics and art. Moreover, rather than limiting themselves to the art world of Japan, Korean artists also strove to study and experience Western art practices firsthand in Europe and America. Overall, art production during this period gradually became enriched by the increasing exposure of Korean artists to contemporary art movements and trends.

THE STUDY OF WESTERN-STYLE PAINTING IN JAPAN

Many of the artists who wished to learn about the practices common to new modern forms of art, went abroad to study. The largest number of Korean students went to Japan, and many of those who left for Japan in the early years studied at the Tokyo School of Fine Arts. Since the Tokyo School of Fine Arts only accepted male students at the time, female artists studied at private art schools for women.

The Tokyo School of Fine Arts offered a program consisting of two-year general courses and three-year specialized courses in painting, sculpture, and design. The painting specialization was divided into Japanese-style painting and 'Western-style' oil painting, while the design school covered various forms of crafts and design, including architectural decoration. According to the surviving school records, from the establishment of the Tokyo School of Fine Arts in 1896 through to 1937, 228 Koreans entered the school but only sixty-five graduated. Of this number, four Koreans entered the Japanese-style Painting Department and two graduated, while 176 Koreans entered the 'Western-style' Oil Painting Department and forty-five graduated. Eleven Koreans, including Kim Bokjin, graduated from the Sculpture Department. Of the remainder, Lim Sookjae and Lee Soonsuk were alumni of the Design Department and Kang Changgyu graduated from the Crafts Department.[1]

Among the initial students from the school to achieve success, the *Maeil Sinbo* newspaper published on March 11, 1915 made a feature report on Ko Huidong as Korea's first Western painter. Born into a family of official interpreters, Ko Huidong graduated from the Hanseong French School. He initially served as an interpreter in the Ministry of the Royal Household, but in 1907 he left his post. In 1909 he became the first Korean student to enter the Tokyo School of Fine Arts through the sponsorship of the government of the Korean Empire. When he was a student at the Hanseong French School, he saw one of the teachers, Leopold Rémion, working with oil paints on a canvas. It seems that the government of the Korean Empire had initially invited Rémion from France to establish a craft school, but the plan fell through and he instead ended up teaching French at the Hanseong French School. Ko Huidong went on to major in Western style oil painting at the Tokyo School of Fine Arts and graduated in March 1915. His graduation works included *Sisters* (1915), which was published in *Maeil Sinbo* newspaper, and *Self-Portrait* (1915), which is now in the collection of the Tokyo School of Fine Arts (present-day Tokyo University of the Arts, Art Museum). Another *Self-Portrait* (1915) depicting Ko holding a fan is in the collection of the MMCA and is known to have been produced around the same time. **1**

In 1915, Ko Huidong also submitted a portrait of a *gisaeng* (a female professional entertainer) named Chaegyeong to the Joseon Industrial Exhibition held at Gyeongbokgung Palace. This figure painting and his self-portrait differ from conventional Joseon-era figure paintings in that they illustrate real people going about their daily routines rather than idealized figures. For instance, in one self-portrait Ko portrayed himself on a hot summer day with his shirt unbuttoned and a fan in hand, creating an image that perhaps was intended to reflect his nature as a free spirit. Moreover, Ko also attempted to project an idea of himself as a modern intellectual and artist in this painting by depicting a Western style oil painting and leather bound books behind him.[2] Ko's self-awareness was also reflected in the illustration of himself as a young man taming a tiger on the cover of the first issue of *Cheongchun* magazine published by Choi Namseon in October 1914.

Kim Kwanho was the second Korean student to study at the Tokyo School of Fine Arts. His extraordinary talent was recognized at the Joseon Industrial Exhibition where he won a silver prize in 1915 while still in school. Among the graduation works he created, *Sunset* (1916) was selected as the most outstanding and was entered into the permanent collection of the Tokyo School of Fine Arts (currently it is housed in the Tokyo University of the Arts, Art Museum).[3] **2** In the autumn of the same year, *Sunset* was submitted to the Ministry of Education Fine Arts Exhibition in Japan hosted by the Japanese government and received a special award, drawing a great deal of attention. In this painting, two women are standing with their backs to the viewer against the background of a dusky sunset at Neungnado Island, a scenic location within Kim's hometown of Pyeongyang. One of the two women is washing her hair while the other is drying herself with a towel, and here Kim offers a natural depiction of the human body, creating harmony between the figures and the background. *Sunset* employed a common Japanese academic painting style that was popular at the time. The novelist Lee Gwangsu, who was studying at Waseda University in Japan at that time, conveyed the news

2 Kim Kwanho, *Sunset*, 1916, Oil on canvas, 127×128 cm

of Kim's award to the Korean public, and compared Kim's achievement to passing a state examination during the Joseon period.

Kim Kwanho's receipt of a special award at the art exhibition hosted by the Japanese government was reported in Korean newspapers, but no image of *Sunset* was published since it depicted naked women. Until the Joseon period, female figures were hardly ever depicted as a subject in painting. Seeing, let alone drawing, a woman in the nude was not permitted in Joseon by the codes of Confucian morality. A nude painting, however, was an approach from 'Western-style' art education based on the practice of realistically depicting the human body. The Tokyo School of Fine Arts, along with other modern institutions, therefore adopted this approach, and drawing and exhibiting paintings of a nude at an art school was considered a new and different way of viewing of the human figure. In 1923, Kim Kwanho submitted another nude painting entitled *Lake* (1923) to the second Joseon Art Exhibition. This work was not published in the newspaper either, but it captivated audiences at the exhibition hall and received a fervent response.

3 Kim Chanyoung, *Self-Portrait*, 1917,
Oil on canvas, 60.5×45.5 cm

Kim Chanyoung also studied at the Tokyo School of Fine Arts, where he submitted *Self-Portrait* as a graduation work in 1917. This is his sole surviving piece. ⟨3⟩ Unlike the self-portraits of Ko Huidong and Kim Kwanho, Kim Chanyoung's work depicts himself in a melancholic mood against a backdrop of a dark red sky at sunset. Moreover, it strikes a romantic atmosphere through a contrast between light and shade and rough brushstrokes compared to the smooth brushstrokes found in the portraits of Ko Huidong and Kim Kwanho. Kim Chanyoung taught Western-style painting to students at the Sakseonghoe Painting Research Institute in Pyeongyang along with Kim Kwanho. He was not professionally active as a painter, however. Instead, he engaged himself in theatre and literary art, which suggests that people at the time pursued a synthetic arts. In the early 1920s, while he served as an editorial member of literary magazines, including *Pyeheo*, *Changjo*, and *Yeongdae*, Kim Chanyoung published articles on modern art. Moreover, he created a frontispiece illustration for a Western poetry anthology compiled by Kim Eok entitled *Dance of Anguish*, the design of which was influenced by Art Nouveau.[4]

KOREAN PAINTERS OUTSIDE JAPAN AND KOREA

Since the mid-1920s, some painters left for Europe and the United States to learn Western art at firsthand.

Lee Chongwoo was one of them and he went to Paris after graduating from the Tokyo School of Fine Arts. In Japan, Lee had adopted an impressionist painting style in the manner of the Pleinairisme, but in Paris he studied under a Russian painter and learned classical realism. His resulting works demonstrated his solid compositions and realistic portrayals. Examples of this include *Self-Portrait* (1923), a graduation work from the Tokyo School of Fine Arts, and others that he painted in Paris, including *A Portrait of Mrs. X* (1926), *A Portrait of a Friend* (1926), and *Still Life with a Doll* (1927). His *Nude (Man)* from 1926, depicting a robust male body in profile using smooth brushstrokes, is a rare example of a Korean painting of a male nude from the time. ⟨4⟩ After returning to Korea in 1928, Lee held solo shows, participated in exhibitions hosted by the Calligraphy and Painting Association, and was involved in education as an art teacher at Jungang High School.

Male artists in Korea and Japan were encouraged to pursue art as a new modern concept, whereas crafts were considered more important in arts for female artists. While the Tokyo School of Fine Arts emphasized sculpture, traditional Japanese art and 'Western' oil painting, the art curriculum at the Women's School of Fine Arts in Tokyo centered on embroidery and craft. Nevertheless, Rha Hyeseok, the first Korean female artist, managed to major in Western style oil painting at the Women's School of Fine Arts. After graduating, Rha returned to Korea in 1918, taught painting at girls' schools, and produced a vast body of paintings. In 1921, she held a solo exhibition in the *Gyeongseong Ilbo* newspaper company's Naecheonggak Hall. Among her works from the early 1920s, those that were submitted to the Joseon Art Exhibition can be identified through the exhibition catalogs. For example, the second Joseon Art Exhibition catalog includes an illustration of her *South Gate of Bonghwangseong Fortress* (1923), which took fourth place in the exhibition. In the early 1920s, Rha Hyeseok lived in Manchuria along with her husband, who had been appointed as vice-consul of Andong County in Manchuria. Her works from this period were created in a Post-Impressionist manner characterized by solid compositions and robust brushstrokes. In 1927, she went on a journey around the world and resided in Paris for year. From then on, her works were more subjective and expressive, embracing Fauvist sentiments and style.[5] *Self-Portrait* (c. 1928) is the classic example from this period. ⟨5⟩ Rha was an early feminist activist and

4 Lee Chongwoo, *Nude (Man)*, 1926,
Oil on canvas, 78×62 cm

leader of the "*sin yeoseong*" (new women) movement in Korea. New women movement reflected the desire for personal emancipation and social freedom increasingly felt by middle class and educated women in the 1920s and 1930s. Rha also wrote the novel *Gyeonghui* and the essay "Confessions After a Divorce" about her own marital experience.[6]

Paik Namsoon, Chun Kyungja, and Park Rehyun (1920–76) followed in the footsteps of Rha Hyeseok and studied at the Women's School of Fine Arts in Japan. Paik majored in 'Western-style' oil painting, while Chun and Park focused on Japanese painting. Jang Sunhee (1893–1970) and Park Eulbok (1915–2015), who also graduated from the Women's School of Fine Arts, served as craft artists while teaching embroidery at girls' schools after returning to Korea. Paik Namsoon left her studies at the Women's School of Fine Arts halfway through the program and returned to Korea. Back at home, she worked as a teacher and participated in the Joseon Art Exhibition between 1925 and 1927, and in 1928, she left for Paris to continue her study. Paik's works received an honorable mention at the Le Salon des Artistes Français and at the Fauvist-oriented Salon des Tuileries. However, no works from this period are extant today. In Paris, Paik Namsoon met and married Gilbert Pha Yim, who was visiting the city

for his research. The couple returned to Korea in 1930 and held an exhibition *Western-style Painting by Husband and Wife Gilbert Pha Yim and Paik Namsoon* in November of the same year. Paik unfortunately ceased to paint after her husband went missing during the Korean War. *Paradise* (c. 1936) is her sole surviving work produced before 1945 and is considered Paik's one of most important works for her attempt to add a Koreanness to oil painting. [6] In *Paradise*, Paik used oil paint in the classical East Asian format of an eight-panel folding screen. Moreover, as its title implies, *Paradise* depicts a utopian landscape, and it is rendered using the three-distance perspective typical of East Asian ink landscape painting. Unlike the one point perspective, the three-distance perspective allows viewers to experience three different views of landscape—level distance (the viewer looking down from the high ground), high distance (the viewer looking up from the low ground), and deep distance (the viewer looking through the mountain to the back)—in a single painting. The water, mountains, houses, and trees are all portrayed as if they are painted with opaque watercolors rather than layers of oil paints, thus creating effects of light and shade.

Gilbert Pha Yim, the husband of Paik Namsoon, was a painter who departed dramatically from academism, the dominant style of the time. His break from academism is probably a result of his unusual art education. Unlike his contemporaries who studied in Japan, Yim went first to China then moved to America. He studied at the School of the Art Institute of Chicago and Yale University. At Yale, Yim seemed to have pursued religious painting. However, only a few of these works are extant today which depict simplified objects with broad surfaces in strong brushstrokes. *Herblay Scene* (1930) [7], which he painted while living in Herblay on the outskirts of Paris with his wife Paik, recalls the Post-Impressionist style in that the characteristics of objects are simplified and their forms are rendered with colors.[7] After returning to Korea with Paik, Yim served as a teacher at Osan School in Jeongju, Pyeongannam-do Province. Lee Jungseop was one of his students at Osan School. After his capture by North Korean forces during the Korean War, his whereabouts have been unknown. Very few of his works survive.

Unlike other Korean artists in Europe, who mainly preferred to go to Paris, Pai Unsoung studied art at the Academy of Arts, Berlin (Akademie der Künste; present-day Berlin Berlin University of the Arts (Universität der Künste)) from 1925. After finishing his study there, he held solo exhibitions in Berlin, Czechoslovakia, Poland, and Austria. As Lee Chongwoo, who was studying in Paris at the time, Pai submitted his woodcut print entitled *Self-Portrait* to the Salon d'Automne

in 1927 and received an honorable mention. In 1933, he submitted three works created in the same year, *Jungle*, *A Portrait of a Lady*, and *Self-Portrait*, to the Warsaw International Print Exhibition in Poland and won first prize.[8] Compared to his contemporaries, Pai was remarkably active internationally. Nevertheless, his style was not congruent with the mainstream modernist trends that dominated in Europe at the time. In Berlin, salon-style art coexisted alongside expressionist and avant-garde works. In contrast, Pai produced figure or folk oil paintings in a realistic style using colors traditional to Korea as well as woodblock prints with simple compositional lines. At a solo exhibition held in 1935 at the Museum of Ethnology,

Hamburg (present-day Museum am Rothenbaum–Kulturen und Künste der Welt), Pai captivated viewers with his "distinctive compositions, flawless depictions of the human body, and light use of color derived from East Asian ink wash painting."[9] This is demonstrated by *Family* (1930–35), one of his definitive works. 8 The figures depicted wearing *hanbok* (traditional Korean clothing) drew attention from European viewers due to their exoticism, but his light coloring earned him further recognition. Considering that his family's poor financial circumstances had forced him to live apart from his family from the age of fifteen while working for Baek Ingi to assist his son and given the adversity he faced working abroad, the scene in this paintings

5 Rha Hyeseok, *Self-Portrait*, ca. 1928, Oil on canvas, 63.5×50 cm

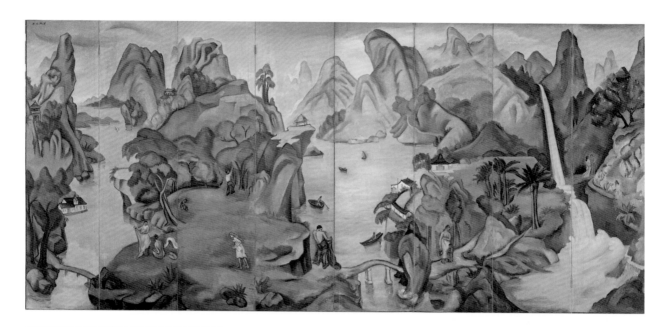

of his family with his mother at the center appears to have been conjured from Pai's imagination.

These artists who were active in Europe in the 1920s adopted a view point that differed from those working within the Japanese art world. However, whether they received formal education in Europe like Pai Un-soung and Gilbert Pha Yim or cultivated their skills in artists' atelier as in the case of Lee Chongwoo, or studied in Japan like Paik Namsoon and Rha Hyeseok, all of them tended to embrace realism or Post-Impressionism rather than their contemporaneous art movements from Europe. Some of them acquired Expressionist painting style as well. Such tendency was prompted. This was because the avant-garde art movements that were developing within the contexts of the European society and art history was foreign to Korean artists, who were encountering basic oil painting techniques for the first time. Paik Namsoon and Pai Un-soung, in particular, attempted to utilize traditional Korean aesthetics within their oil painting practice, particularly in terms of their use of color and treatment of space. This concern to create artwork using the medium of oil painting, but driven by their own specific national aesthetic tradition is in line with the emergence of a great number of artists inside Korea who pursued the development of a Korean-style oil painting based on Korean sentiments from the 1930s onward, when oil painting had secured a dominant place in the Korean art world.

The distinctive religious paintings of Chang Louis Pal (1901–2001), who graduated from the Tokyo School of Fine Arts and then studied art history and aesthetics at Columbia University in America starting in 1922, can be understood in this context. Chang began his career as an art educator in 1946, teaching at Seoul National University. He was not a prolific artist, but he produced several religious paintings inspired by his devout Catholicism. Some of his religious paintings include *Fourteen Apostles* (1925–27), which depicts twelve disciples of Christ plus Paul the Apostle and Saint Barnabas displayed at the central altar of Myeongdong Cathedral in Seoul; *Saint Andrew Kim Daegeon* (1920), a portrait of the first Korean Catholic priest; and *St. Columba Kim Hyo-im and Her Sister St. Agnes Kim Hyo-ju* (c. 1925) 9 , an image depicting two sisters martyred in Korea in 1839. The last two paintings illustrate figures holding religious emblems representing martyrs, such as a lily or a sword, but while wearing traditional Korean coat, hat, jacket, and skirt. The distinct use of color in these works also demonstrates Chang's desire to specifically reference the traditional Korean color painting.

SCULPTURE, DESIGN, AND CRAFT PRODUCTION

While many new and diverse experiments were occurring in painting in the 1920s, few artists working in the fields of sculpture and crafts were pursuing such innovative work. Part of the reason for this intellectual focus on painting was that historically, ink painting was acknowledged as a refined and scholarly literati pursuit in Korean society, while the production of sculpture and crafts (such as lacquerware or ceramics), were reserved for artisans. Therefore, a far greater institutional transformation was required to accommodate the modernization of sculpture and craft.

Kim Bokjin accelerated this transformation in sculpture. Kim studied sculpture at the Tokyo School of Fine Arts and returned to Korea in 1925. While artisans in the past were classified by the materials they used, such woodworkers and metalworkers, Kim applied a wider range of mediums in his work, such as clay, plaster, and bronze. Through this expansion of materials, he paved the way for the further development of modern sculptural practices in Korea. Kim regularly submitted works to the Imperial Academy of Fine Arts Exhibition (Teikoku bijutsuin bijutsu tenrankai) in Japan and the Joseon Art Exhibition in Korea. He also founded an art institute at the YMCA Regular School (Jeongcheuk gangseupwon) and taught sculpture to Gu Bonung (1906–52), Jang Ginam, Lee Gukjeon, and other students.

Kim Bokjin created a range of portrait sculptures, including the bust *Three Years Ago* (1922), which is probably a self-portrait, as well as sculptures of a leftist writer Hong Myeonghui and Ahn Changho, a prominent Korean independence activist, both from 1927. Unfortunately, none of these have survived. Among his figurative sculptures are *A Study of a Nude* (1925) and *A Standing Woman* (1926), which respectively received a special award at the Joseon Art Exhibition and an honorable mention at the Imperial Academy of Fine Arts Exhibition. Although the idea of representing the human body as the subject of artwork derived from the West, Kim strove to realize sculpture that was unique to Korea. This was particularly evident in his portrayals of the female body, in which he expressed the figure, body proportions, and even the sentiment of a Korean woman. They did not follow the idealized Western conventions of human sculptural form. Kim not only worked as a sculptor, but also led art and cultural initiatives such as the new theatrical movement started in 1923 by the Towolhoe Association and the proletarian art movement. He was soon imprisoned for his activities as a member of the Korean Communist Party. After being released from prison in 1932, he expanded the range of subject matter in his

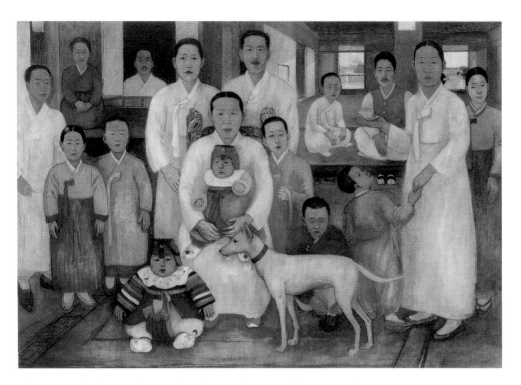

福天
者隆九
天主隆二三五
명치신동례형 † 스네그아·바놈골김·六三天主隆
B.B.V.V.ET·M·M.COLVMBA·AGNES KIM. 三九致命

8 Pai Un-soung, *Family*, 1930–35
 Oil on canvas, 140×200 cm

9 Chang Louis Pal, *St. Columba Kim Hyo-im and*
 Her Sister St. Agnes Kim Hyo-ju, c. 1925,
 Oil on canvas, 72.7×50 cm

sculpture from human figures to Buddhist deities. In 1936, he sculpted the Grand Maitreya Buddha at Geumsansa Temple. In doing so, Kim Bokjin widened the scope of modern sculpture by carrying on with the traditional theme of sculpture. However, he died young in 1940 while working on a massive cement sculpture of Maitreya Buddha over thirty-three meters high at Beopjusa Temple. He failed to complete this project that he had begun in 1939. After the liberation of Korea in 1945, Kim's disciples, including Yun Hyojoong (1917–67), Jang Gieun (1922–61), and Yim Cheon (1908–65), continued to work on this cement sculpture, which was eventually completed in 1963. The work was dismantled and removed from the site in 1987 due to the risk of collapse caused by corrosion of the internal metal rod. It was replaced with a bronze sculpture of Maitreya Buddha produced by Choi Kiwon.

New concepts and categories of crafts encompassing wood furniture, mother-of-pearl lacquerware, metalwork, and ceramics emerged in the modern era. Crafts had been understood as functional items manufactured by trained artisans of lowly social statue. However, beginning in the early 1900s it began to be perceived as a field that could enrich and strengthen national culture in response to the modern changes occurring across society.[10] As the traditional artisanal system of production declined at the end of the nineteenth century, the imperial court of the Korean Empire established the Hanseong Craft Workshop (Hanseong misulpum jejakso) in 1908 to carry on the legacy of elite Joseon period craft production. By creating exquisite craftworks and submitting them to expositions, the workshop contributed to boosting the Korean industry. Later, during the Japanese colonial era, the Hanseong Craft Workshop was renamed the Yiwangjik (Office of the Royal Household) and adopted a production system that separated the process of design from that of manufacture.[11] It was only in the 1920s that professional designers began to emerge in Korea.

During this process of separation between design and production, Lim Sookjae established himself as a professional designer. Lim majored in design and studied modern concepts in design at the Tokyo School of Fine Arts, and he soon put what he learned into action. His designs were built upon simplified sketches of natural objects and were inspired by the pedagogy of the time that emphasized crafts as art. As a case in point, *Designs of Bookcases and Decorative Craftworks* (1928), his graduation project from the Tokyo School of Fine Arts, successfully captured the decorative appeal of Art Nouveau. *Animals and Plants Design* (1920) and *Deer Design* (1928) in the collection of the MMCA demonstrate his tendency to illustrate simplified

plants and animals inside circles and squares. After graduating from the Tokyo School of Fine Arts and returning to Korea in 1928, Lim founded Doansa in Anguk-dong, Seoul where he worked on developing a new approach to design, as a separate professional field to traditional crafts. Moreover, he contributed an "Craft and Design" for the *Dong-A Ilbo* newspaper and delivered lectures to promote the importance of design before making hand-made crafts.[12] His design principles and actual designs were realized into works. Lim Sookjae later took charge of designs for mother-of-pearl lacquerware at the Joseon Craft Workshop (Joseon misulpum jejakso) formerly the Craft Workshop of the Yiwangjik. *An Inlaid Lacquer Small Dining Table* (1928) is an example of Lim's interest in combining new and traditional motifs. **10** The top of this table shows a Joseon Dynasty-style peony design, while its legs are adorned with decorative scrollwork in an Art Nouveau style.[13]

As crafts became an independent genre of art in the 1920s and 30s, some craftsmen began consider themselves as artists. For instance, Kim Bongryong (1902–94) from Tongyeong, the center of mother-of-pearl lacquerware production, studied lacquering and mother-of-pearl inlaying at a traditional workshop. In 1925, he submitted his *Large Flower Vase* to the International Exhibition of Modern Decorative and Industrial Arts in Paris, France. He also participated in the Joseon Art Exhibition with his works. After the liberation of Korea, Kim was still producing works extensively and later recognized as a holder of mother-of-pearl inlaying technique, which is designated as National Intangible Cultural Heritage. Another craftsman to be recognized from this period is Kang Changgyu. Kang went to Japan and studied at the Okayama Craft School. He also graduated from the Lacquering Department of the Tokyo School of Fine Arts in 1935. Kang accrued a reputation by submitting works to the Joseon Art Exhibition and the Imperial Academy of Fine Arts Exhibitions. He established himself as a modern artist who succeeded the tradition of dry lacquering method that had been discontinued in the late Joseon period. One of his distinctive works include *Dry-lacquered Tray* with its top panel and pedestal facetted.

It is worth noting that women were still engaged mainly in embroidery while men were mostly involved in metalworking, woodworking, and lacquering. This was because embroidery had traditionally been considered the primary craftwork or pastime for women and that art education for women were centered on embroidery and sewing even in the modern era. Most girls learned embroidery at girls' schools, and those who wished to major in art had to go to Women's School of Fine

Art in Japan since art schools, such as the Tokyo School of Fine Arts, accepted only male students. Moreover, unlike the Tokyo School of Fine Arts which offered diverse courses including Japanese-style painting, Western-style oil painting, sculpture, crafts, and design, Women's School of Fine Art prioritized sewing and embroidery as major degree, alongside a secondary focus on Japanese-style painting and oil painting. More than 180 Koreans studied at the Women's School of Fine Arts in the early twentieth century. Most of them majored in embroidery and sewing, with the exceptions of Rha Hyeseok, who learned Western-style painting, and Park Rehyun and Chun Kyungja, who studied Japanese painting. Other notable women in this context include both Jang Sunhee and Park Eulbok, who were active both as professional craft artists and educators teaching embroidery at schools.[14] After majoring in embroidery and Japanese painting at the Women's School of Fine Arts 11 , Jang Sunhee returned to Korea in 1925 and established the Joseon Women's Institute of Handicrafts (Joseon yeoja giyewon) which primarily taught embroidery. This effort led to the establishment in 1945 of the educational art institution Yerimwon at Ewha Womans University, which covered subjects such as Western-style oil painting, East Asian painting, and embroidery. Like Jang Sunhee, Park Eulbok studied embroidery at the Women's School of Fine Arts. After returning to Korea in 1937, Park began her career as an educator by teaching embroidery at Holston Girls' School. She also worked as a professional embroiderer, submitting her works to the Joseon Art Exhibition.

10 Lim Sookjae, *An Inlaid Lacquer Small Dining Table*, 1928,
 Wood, mother-of-pearl, 30×51×51 cm

11 Jang Sunhee, *Quail*, 1924,
 Embroidery; silk fabric, silk thread, 19.2×24.9 cm

THE ESTABLISHMENT OF INSTITUTIONS TO SUPPORT THE ART EXHIBITION

The institutional establishment of the modern Korean art world during the colonial period was directly linked to the formation of specific venues and events for art exhibition designed to encourage public appreciation and engagement. While *seohwa* in the premodern era was primarily produced and enjoyed by close friends at small private gatherings, art, across both traditional and new genres in the modern era was appreciated by large numbers of people in a public space. As mentioned above, the first official exhibition in Korea where art was experienced in this manner was the Joseon Industrial Exhibition held in 1915. The Japanese Government-General of Korea hosted this exhibition to show off its achievements in agriculture and industry in commemoration of the fifth year of colonial rule. Art was presented in the thirteenth section of the exhibition, and a specific art hall was built within the precincts of Gyeongbokgung Palace, the venue for the

Joseon Industrial Exhibition, to display paintings, calligraphy, Buddhist sculptures, and ceramics of the Joseon Dynasty. New artworks were also displayed in Gangnyeongjeon Hall (the former king's quarters) and other wooden halls nearby. The Joseon Industrial Exhibition classified art into several genres, including Western-style oil painting, East Asian painting, and sculpture. East Asian painting, an unprecedented term and unfamiliar genre at the time, was subdivided into ink and wash painting, ink and light color painting, and calligraphy. Meanwhile, Western-style oil painting was further sectioned into oil painting and watercolor painting. Ko Huidong, who had just returned to Korea after graduating from the Tokyo School of Fine Arts, submitted a work to the

Western painting section of the Joseon Industrial Exhibition. Kim Kwanho, who was still attending the school, also took a part at the same exhibition and received a silver medal.

Public art exhibitions in the fullest sense were established in Korea with the Joseon Art Exhibition hosted by the Japanese Government-General of Korea in 1922. The Joseon Art Exhibition aimed to enhance the production and reception of art on the peninsula and allowed participation by Koreans, Japanese, and anyone else who had lived in Korea for more than six months. In the early years, many more Japanese people submitted works to the exhibitions than did Koreans, most of whom were unacquainted with such large-scale public exhibitions. These exhibitions, however, did serve as a gateway for many Korean art students who had few chances to present their works due to the lack of profession art schools in Korea. In the beginning, the Joseon Art Exhibition was divided into sections for East Asian ink painting, Western oil and watercolor painting, calligraphy and Four Gentlemen painting (bamboo, plum, orchid, and chrysanthemum), and sculpture. Over time the calligraphy and Four Gentlemen section was gradually scaled back. In 1932, calligraphy was abolished first and the Four Gentlemen painting was absorbed into the East Asian painting section. In the same year, craft section was newly established. This genre division then became considered institutionally customary in the Korean art world. The Joseon Art Exhibition continued through 1944 and incubated numerous artists. However, since the exhibition was hosted by the Japanese Government-General of Korea, the Joseon Art Exhibition strongly showed the characteristics of a Japanese government-sponsored exhibition and those of a regional art exhibition within Imperial Japan, including an emphasis on Korea's local color or exoticness. Therefore, some artists boycotted such state exhibitions operated by the Japanese Government-General. Instead, they participated in exhibitions held by art coteries like the Calligraphy and Painting Association(1921–36), Nokhyanghoe Association (1928–31), and Association of the Graduates of the Tokyo School of Fine Arts (Dongmihoe, 1929–30).

From 1921, the non-governmental Calligraphy and Painting Association began to host exhibitions centering around Korean calligraphers and painters. Their exhibitions served as art contests for the Korean art community as a counterpoint to the Joseon Art Exhibition. The exhibition was held for fifteen years until 1936. Many artists also began holding solo exhibitions. For example, Kim Kwanho held a solo exhibition in Pyeongyang in 1916, and Rha Hyeseok held her solo exhibition in the *Gyeongseong Ilbo* newspaper company's Naecheonggak Hall on March 18 and 19, 1921. Rha Hyeseok was already a famous female artist and novelist, and her exhibition was a great success drawing more than 5,000 visitors over the two days.

Since there were no customized exhibition halls in the 1920s, exhibitions were often held at the auditoriums of schools or newspaper companies. Even the Joseon Art Exhibition, in early days, were hosted at the Hall for the Product of Commerce and Industry and the library of the Japanese Government-General of Korea. From 1929, they shows were held in a building constructed for the Joseon Exposition (Joseon bangnamhoe) within the precincts of Gyeongbokgung Palace. In 1938, an art museum was built in the rear garden of the palace and it was used as an exhibition hall for the Joseon Art Exhibition through 1944. In addition to the annual Joseon Art Exhibition, the Seokjojeon Hall at Deoksugung Palace also functioned as a venue for contemporary art during the colonial period. The Hall was originally built for the ruling family of the Korean Empire in the manner of a large-scale colonnaded neo-classical western residence. However, in 1933, it was converted into an exhibition hall for the work of modern Japanese art. Moreover, in the 1930s, privately owned galleries were established in Mitsukoshi Department Store and Hwashin Department Store in the middle of Gyeongseong to house solo or special exhibitions.[15] These exhibitions were opened to anyone who paid the admission fee, thus prompting the popularization of art, and they offered viewers new opportunities to enjoy cultural life.

1 Yoshida Chizuko, *Kindai higashiajia bijutsu ryūgakusei no kenkyū: Tōkyō Bijutsu Gakkō ryūgakusei shiryō* [A Study on Modern East Asian Art International Students: Historical Records on International Students at the Tokyo School of Fine Arts] (Tokyo: Yumani shobō, 2009).

2 Cho Eunjung, *Chungok Ko Huidong: Gyeokbyeongi geundae hwadan, han misulgaui chosang* [Chungok Ko Huidong: A Portrait of a Modern Artist in a Period of Upheaval] (Paju: Culture books, 2015).

3 Kim Huidae, "Kim Kwanhoui haejilnyeok yeongu" [A Study of *Sunset* by Kim Kwanho], in *Hanguk misurui jasaengseong* [Autonomy of Korean Art] (Paju: Hangil art, 1999), 495–518.

4 Kim Hyunsook, "Kim Chanyeong yeongu: hanguk choichoui modeoniseuteu misulga" [A Study on Kim Chanyoung: Korea's First Modernist Artist], *Journal of Korean Modern & Contemporary Art History* 6 (1998): 133–174 and Kwon Heangga, "1920nyeondae kim chanyeongui pyojihwa" [Frontispiece Drawings by Kim Chanyeong in the 1920s], *Geundae seoji* 9 (2014): 571–590.

5 Kim Hyunwha, "Hanguk geundae yeoseong hwagadeului seogumisurui suyonggwa jaehaeseoke gwanhan yeongu: Na Hyeseokgwa Baek Namsuneul jungsimeuro" [A study on the acceptance and reinterpretation of Western art by female Korean modern painters: A focus on Rha Hyeseok and Paik Namsoon], *Asia yeoseong yeongu* 38 (1999): 117–151.

6 Lee Gu-yeol, *Na Hyeseok: Geunyeo, bulkkotgateun saengaereul geurida* [Rha Hyeseok: The Woman Who Drew Her Fiery Life] (Paju: Seohae munjip, 2011).

7 Lee Jihui, "1920–1930nyeondae pari yuhak jakga yeongu" [Study on Korean artists studied in Paris in the 1920s and 1930s], *Inmul misul sahak* 8 (2012): 179–218.

8 Since Pai Un-soung crossed into North Korea in 1950, he was active only in the North after this point. Pai was little known until 1988 in South Korea when the ban on referencing the work of artists who defected to North Korea was lifted. When forty-eight works by Pai were discovered in 1991, Korean art historians began to shine further new light on his career. See Kim Migeum, "Bae Unseongui Ureopcheryu sigi (1922–1940) hoehwa yeongu" [A Study on Pai Unsoung's Paintings During His Years in Europe, 1922–1940], *Hanguk geunhyeondae misulsahak* 14 (2005): 125–167.

9 M.R.K., "Ein Koreanisher Kunstler in Deutshland," *Hamburger Frendenblatt*, no. 81 (March 22, 1935), Kim Mi-Geum, ibid, 148.

10 Jang Jiyeon, "Nonseol gongyegamyeon baldal" [Editorial: Encouraging the Development of Crafts], *Hwangseong Sinmun*, April 25, 1900.

11 In 1913, the Hanseong Craft Workshop was placed under new management and renamed the Craft Workshop of the Yiwangjik. In 1922, the workshop was sold to a Japanese industrialist and transformed into a corporation under the new title of the Joseon Craft Workshop, Inc. The products made here included craftworks for the Yi Royal Household and luxurious souvenirs. For more information on the Craft Workshop of the Yiwangjik, see Suh Jeemin, "Yiwangik misulpum jejakso yeongu: Unyeonggwa jejakpumui hyeongsik" [A Study on the Yiwangjik Craftwork Manufactory: The institution and its craftwork] (master's thesis, Ewha Womans University, 2015).

12 Lim Sookjae, "Gongyewa doan" [Craft and Design], *Dong-A Ilbo*, August 16 and 17, 1928.

13 Roh Junia, "Geondae dijain gaenyeomgwa yangsikui suyong: Donggyeong misul hagkyo doangwa yuhaksaeng imsukjaereul jungsimeuro" [Adoption of Modern Design Concept and Style: Sook-Jae Lim and his Works], *Misul*

iron gwa hyeonjang 8 (2009): 7–31.

14 For more information on Jang Sunhee and Park Eulbok, see Kwon Heangga, "Misulgwa giyesai: Yeojamisulhaggyo chulsinui yeoseongjakkadeul" [Between Art and Craft: Female Artists who Graduated from the Women's School of Fine Arts in Japan], in *The Arrival of New Women*, exh. cat. (Goyang: Misul munhwa, 2017), 225–240 and Kwon Heangga, "Jangseonhuiwa Joseon yeoja giyewon," [The Embroiderer Sun-hee Jang and Chosun Women Crafts Institution," *Hanguk geunhyeondae misulsahak* 38 (2019): 163–189.

15 Mok Soohyun, "1930nyeondae gyeongseongui jeonsi gonggan" [The Exhibition Space in Kyungseong during the 1930s], *Hanguk geunhyeondae misulsahak* 20 (2009): 97–116.

The KAPF Movement: Art for People and Art for Social Revolution

Seo Yuri

NEW CHALLENGES: THE KAPF ART MOVEMENT

Korean artists began to take on new social and political challenges in the 1920s. Many were attempting to create art that would go so far as to completely change colonial period society on the peninsula. As an extension of this, the KAPF art movement was launched in 1925. The initials KAPF stand for the Korea Artista Proleta Federacio (Korean Proletarian Artist Federation in Esperanto). As the use of proletariat (meaning laborers and farmers in the case of Korea) in the name suggests, the KAPF was an organization formed by individuals who pursued an artistic practice to foment a social revolution grounded in communist political principles. Among the artists who joined the KAPF were sculptor Kim Bokjin, screenwriter An Seokju, film director Kang Ho (1908–84), playwright Lee Sangchoon (1910–37), writer Lee Juhong (1906–87), painter Jung Habo (1908–41), filmmaker Chu Jeokyang (1911–?), painter Park Jinmyeong (1915–47), and art critic Lee Gapgi (1908–?). Most of them were in their twenties during the period when the KAPF was most active in the 1920s.

At the time, both communism and socialism were eagerly embraced by many Koreans for several reasons. First of all, it served as an ideology of enlightenment that encouraged the development of modern education, the social system, individual consciousness, and revolutionary political and creative activity. It offered an intellectual standpoint that facilitated an understanding and criticism of colonization in relation to imperialist aggression. It also set forth the notion that class inequalities between the rich and the poor, landowners and tenant farmers, and factory owners and laborers were social conditions to be challenged rather accepted, and furthermore presented a vision for a better future society.

KAPF artists not only noted the creative possibilities of art but aimed to exceed these existing boundaries. As cultural producers, they were not satisfied with simply creating art works for consumption, but desired to use their practice to criticize social injustice and offer a new vision for the world through their activities. To that end, they organized art exhibitions, produced and distributed propaganda materials like posters, flyers, and pamphlets, and created art to be distributed through mass media, including newspapers, magazines and cinema. KAPF visual artists were therefore engaged in a diverse range of creative genres from graphic design to film directing. They were part of the modernist avant-garde in that they considered all visual mediums as useful practices, such as mass-print and other technologically advanced media like radio or cinema, in order to transcend the social restrictions common to traditional art practices. They strove to serve as social activists who could usefully enlighten the public by delivering political messages. They did not regard their activism in various mediums as a secondary activity inferior to the creation of fine art such as painting or poetry. Rather, KAPF artists enthusiastically coordinated and conducted these social activities to directly engage with the public and change the world around them.

While they assumed a critical and resistant nationalist stance against colonization, KAPF artists also maintained an international perspective in that they carried out cultural exchanges and fostered anti-imperialist solidarity with other socialist artists in Japan and embraced the use of the new approaches to photography, cinema and design that were emerging from within the Soviet Union. However, the artistic activities of the KAPF were conducted under the constraints of strict state censorship, overseen by the Japanese Government-

General of Korea. In this respect, KAPF artists were often arrested and imprisoned for violations of the publishing or security laws, a circumstance of persecution and repression that needs to be taken into consideration when critically examining the artistic activities of the organization.

THE ESTABLISHMENT OF THE KAPF AND EARLY PUBLICATIONS

Socialist and communist ideologies were introduced to Korea in the late nineteenth century but they were only fully accepted in the 1920s following the Russian Revolution in 1917 and the March First Independence Movement in 1919.[1] In the 1920s, the revolutionary furor inspired by the March First Independence Movement inspired various social and political efforts to transform colonial Korean society. Critically orientated newspaper and magazine articles and publications became increasingly available in the Korean language when controls on censorship were eased by the Japanese Government-General in the 1920s. Pro-independence sentiments were running high and led to the launch of enlightenment movements for the young, women, farmers, and laborers and the establishment of large-scale nationalist organizations such as the Singanhoe in 1927. The fervor of these movements influenced the establishment of Korean Communist Party in April 1925 and that of the KAPF in August of the same year.[2]

The creation of the KAPF was led by the Yeomgunsa, a group formed by six young men, including the writer Song Yeong and the printworker Lee Jeokhyo in 1922. Yeomgun refers to a cluster of flames, or a small fire. This organization with its passionate name was involved in activities aimed at the actualization of a modern and equal society. These activities included singing in a choir at events to support the Hyeongpyeongsa, an organization of butchers who advocated for the abolition of feudal social discrimination to participating in the planning of an event for International Women's Day. The Yeomgunsa members formed the KAPF together with people from another writers' and artists' organization called PASKYULA (a combination of letters from the Romanized names of its members, including Park Yeonghui, An Seokyeong, Kim Hyeongwon, Yeon Haknyeon, Lee Iksang, Lee Sanghwa, and Kim Ki-jin). The political orientation of PASKYULA was more moderate than that of Yeomgunsa, and the group centered around artists who had returned to Korea after studying in Japan.

The most significant figure among the PASKYULA writers and artists who joined the KAPF was Kim Bokjin, the first Korean sculptor to become critically celebrated for the creation of

1 Cover image by Kim Bokjin, *Munye Undong*, February 1926

sculptural works directly inspired by Western art.[3] He joined the KAPF along with other PASKYULA members, including the artist An Seokju and the novelists Park Yeonghui and Kim Ki-jin. Kim Bokjin was a versatile artist who presented sculptures at the Joseon Art Exhibition and created theater environments and stage sets for the Towolhoe theater company. He was arrested for his activities as an executive member of the Korean Communist Party and imprisoned for five years from 1928 until 1933. At that time when the KAPF was most active, Kim Bokjin was unable to engage in artistic activities. His works include figurative busts created for public exhibition, commemorative portrait sculptures, and Buddhist sculptures for temples. The range of this work demonstrates the broad extent of creative practice both before and after his imprisonment.

This cover design for the KAPF's bulletin *Munye Undong* from 1926 was created by Kim Bokjin. ⎯1⎯ The title means a movement for art and literature. It features a modernist sensibility arguably absent from contemporaneous artworks made for exhibitions, in that the typeface of the Chinese characters used for the bulletin title is

constructed of geometric shapes reminiscent of mechanical devices, while the cover also consists of constructivist-style symbols, such as a spring, an arrow, and a triangle. Kim also contributed an article entitled "Contemporary Art with an Emphasis on Subjectivity" to the magazine, which introduced the new styles of Futurism, Cubism, and Constructivism that had emerged after Impressionism. Like Kim Bokjin, An Seokju had an interest in progressive modernist styles and produced frontispiece illustrations for *Geunu*, a bulletin of the female organization Geunuhoe, and *Daejung Gognon*, a monthly magazine. The KAPF artists, therefore, became interested in the innovative qualities of modernist art and conceived of art for the proletariat, a rapidly expanding social class in the growing Korean industrial society.

CRITICISM AND DISPUTE OVER PROLETARIAN ART

Kim Bokjin also contributed to enriching the discourse on art by publishing reviews and editorials. The publication of literary magazines and the establishment of literary and academic sections in newspapers fueled the art discourse in the 1920s. The emergence of a proletarian theory of art encouraged a departure from the dispute over classical aesthetics and the incorporation of social, hierarchical, political, and historical values into art. This theory further questioned what roles artists should play in the political and social condition.

Kim Bokjin was interested in the relation between art and society and presented the article "An Outline of Korean Art as a Reflection of Korean History" for the magazine *Gaebyeok* in 1926.[4] In this article, Kim reviewed Korean art history according to historical materialism's view that changes of economic base affect superstructure such as art and religion. He criticized how Korean artists must have historically been aware of human suffering and social inequality, but had failed to reflect on these problems and had instead consistently opted to work in the service of the privileged elite. In another article "A Draft of the Declaration for a Bare Art." published in the *Joseon Jigwang* magazine in 1927, Kim refuted the idea that art could transcend social hierarchies and political issues in a capitalist society, declaring that he would instead advocate for the creation of proletarian art, namely a naked art stripped of such aesthetic falsehoods.

Around the same time, the artist Kim Yongjun authored the articles "A Theory on Proletarian Painting" and "Criticism of Proletarian Art" in the *Chosun Ilbo* newspaper in May and June of 1927. His arguments differed from the theories of Kim Bokjin and sparked considerable controversy.[5] Kim Yongjun advocated for expressionist art while

maintaining a more anarchist individualism. He argued that artwork without any aesthetic value could not be viewed as proletarian art. His argument was criticized by the KAPF writer Yim Hwa for its perspective championing the idea of "art for art's sake."[6]

This historical debate raised many artistic philosophical questions such as: what kind of relationship art should have with social movements and whether art and politics could coexist. They fundamentally questioned whether there are values or domains intrinsic to art or whether artists could even exist separately from society or politics. Their arguments over art, society and politics both broadened and deepened the public understanding of art and prompted artists to reflect themselves by questioning what kind of works would be ethical to produce.

THE PROLETARIAN ART EXHIBITIONS IN SUWON AND IN JAPAN

The holding of a Proletarian Art Exhibition in Suwon in 1930, instead of Gyeongseong (present-day Seoul), may be regarded as unusual. This exhibition showed the process by which regional spontaneous enlightenment movements converted to the proletarian cultural movement. The exhibition was held in Suwon because it was easier to avoid censorship by the police in this city than in Gyeongseong. Suwon is located just twenty kilometers to the south of Seoul. It developed into a substantive regional city when the Seoul-Busan railway was constructed in the early twentieth century. After the KAPF was formed in Seoul, branches were established in additional regions such as Pyeongyang and Gaeseong. Park Seunggeuk, a novelist and a leader of youth associations and peasant union movements in the region of Suwon, set up the Suwon branch of the KAPF and led the hosting of the Proletarian Art Exhibition there. Jung Habo and Lee Sangdae supported the exhibition. The Suwon branch of the KAPF succeeded in hosting literary lectures, proletarian theater performances, and the first Korean Proletarian Art Exhibition at the Hwaseong Academy, a night school. The exhibition took place on March 29–30, 1930. [2]

This Proletarian Art Exhibition in Suwon originally featured a total of 140 artworks, but seventy of them were confiscated by police during the exhibition. The exhibition was kept under surveillance by plainclothes policemen.[7] The titles and contents of the works, both those displayed and the confiscated ones, can be identified through police documents. Among the displayed works were three oil paintings by Lee Sangdae respectively depicting factory landscapes, laborers, and a

2 *Proletarian Art Exhibition* held in Suwon, *Jungwoe Ilbo*, April 1, 1930

Proletarian Culture (KOPF).

Jung Habo submitted the painting *Court Day for the Korean Communist Party* to the second Proletarian Art Exhibition in Japan, which was held in 1929 by the Japan Federation of Proletarian Arts (NAPF), the predecessor of the KOPF.[8] This painting depicts a trial in September 1927 in which 101 members of the Korean Communist Party were charged. The trial process was covered extensively by newspapers over the course of a month. A controversy arose over public attendance at the trial, and it created a dramatic scene in which about 500 people, including family members of the defendants, gathered around the courtroom. This event helped to present a populist image to the general public in Korea of Communist intellectuals resisting Japanese forces and stimulated the sympathies and interest of many students. According to comments by a Japanese worker who viewed Jung Habo's work at the exhibition, "this painting validates the truthfulness of the liberation slogans of the oppressed."[9] Choi Seyeong presented the painting *This Is a Strike* (1930) at the third Proletarian Art Exhibition, while Park Jinmyeong produced a painting entitled *Celebrating the Unity between the Japanese and Korean Proletariat* depicting the bonds between Japanese and Korean laborers for the fourth exhibition. Then, at the fifth Proletarian Art Exhibition, the writer Park Seokjeong showed the painting *Pay Koreans an Equal Wage* to directly criticize Japan's colonial employment policies. The whereabouts of these paintings are unknown, and so their existence can be confirmed only by their documented titles.

Jung Habo, originally from Pyeongyang, returned to Korea after submitting his work to the Japanese Proletarian Art Exhibition and then actively helped with the hosting of the Proletarian Art Exhibition in Suwon. There was a failed attempt to hold a Proletarian Art Exhibition in Gyeongseong in August 1930. While arguing art as an "absolute product of subconscious sentiments," Jung also contributed to bolstering proletarian art theory by writing a review for the *Chosun Ilbo* newspaper which advocated for social and materialistic art based on Marxist aesthetics and criticized the characters of Baengman Oil Painting Association formed by Kim Yongjun.[10] Park Jinmyeong was a talented artist who received an honorable mention at the *Dong-A Ilbo* newspaper's Exhibition of Works by Male and Female Students across Korea while still attending Joongdong High School. He also submitted works to the exhibitions hosted by the Calligraphy and Painting Association and Joseon Art Exhibition held in (and after) 1934, where he received numerous honorable mentions.

portrait of Vladimir Lenin. Some paintings featured a laborer carrying a hammer over his shoulder or a combination of Communist symbols, such as a sickle, star, hammer, and saw-toothed wheel. Cartoons by Kang Ho that addressed the jobless issues were not allowed to be exhibited. Other confiscated paintings portrayed radical scenes such as a strike and a figure holding a red flag to as if to enrage a crowd. According to the list of works included in the exhibition, many were not paintings but photographs of famous leftist intellectuals, such as Marx, Lenin, Rosa Luxemburg, and Alexandra Kollontai. There were also photographs, pictures, cartoons, and illustrations cut from several magazines. The KAPF artists highly valued images from the mass media and prioritized the delivery of ideological and critical messages, rather than the display of original art works. The Proletarian Art Exhibition in Suwon also displayed works indicating the exchanges between Korean and Japanese proletarian artists, including posters of Japanese proletarian art exhibitions and posters from Japanese left-wing theater groups.

KAPF artists were also very active in Tokyo since censorship over proletarian art there was relatively relaxed, and they were freely able to associate with Japanese Communist artists. In this regard, while the Proletarian Art Exhibition was held just once in Korea, it was held five times in Japan. The Proletarian Art Exhibitions in Tokyo featured four Korean artists including Jung Habo, Choi Seyeong, Park Jinmyeong, and Park Seokjeong. Of these individuals, Jung Habo, Park Jinmyeong, and Park Seokjeong were all members of the KAPF, while Park Seokjeong served as the head of the Korean Committee of the Japan Federation of

3 Lee Sangchoon, *Nitrogenous Fertilizer Factory*, 1932 (reproduced by Jung Hasu in 2019), Woodcut on paper

ART ACTIVITIES IN THE MASS MEDIA: NEWSPAPER ILLUSTRATIONS

KAPF artists actively engaged in producing works to be used in mass media publications such as newspapers and magazines. Despite the challenges of censorship and confiscation, the use of mass media allowed an opportunity to engage with a broad public and enabled the mass transmission

of ideology. The KAPF art movement wished to propose to the public a perspective through which they could perceive the truth and provide them with the power to envision a new world. Art activities in the mass media were generally performed in collaboration with writers.

As a case in point, Lee Sangchoon produced prints for the illustrations of the serialized novel *Nitrogenous Fertilizer Factory* written by Lee Bukmyeong (1910–?) and published in the *Chosun Ilbo* newspaper on May 29 and 31, 1932.[11] The factory in question was built by the Japanese industrialist Noguchi Jun in Heungnam, Hamgyongnam-do Province. Lee Bukmyeong worked at this factory and wrote a novel that addressed the harsh working environment of the laborers and the difficulty they faced in forming a labor union. In the story when the workers tried to form a union, the factory owner fired them. The protagonist resisted the dismissal, but in the end died from a disease caused by hard labor, and torture by the police. On the May Day immediately after his funeral, however, the laborers staged a protest displaying their solidarity and created a deafening noise in defiance. Only two installments of this novel were published, as the series ended up being suspended.

Lee Sangchoon provided illustrations for Lee Bukmyeong's novel that vividly depicted the facilities inside the nitrogen fertilizer factory and the laborers working there. Lee Sangchoon skillfully portrayed the rough, crude interior of the factory and the muscular bodies of the workers using an intaglio print technique. The illustration for the first episode shows workers carrying nitrogen fertilizer made from a mixture of sulfuric acid and ammonia on a cart inside a dark and stuffy factory filled with giant pipes and gear wheels. The illustration for the second episode features the protagonist Munho heading towards a cafeteria outside the workplace together with his coworkers as the lunch siren goes off. 3 Munho with his muscular forearms and worker's cap bears an expression of determination.

Lee Sangchoon, the creator of these prints, was from Daegu in Gyeongsangbuk-do Province. He was well-known for establishing the artist organization Yeonggwahoe (1927–29) along with the artist Lee Gapgi and the writer Sin Gosong, who were also both from Daegu. He also organized more than three Yeonggwahoe exhibitions.[12] Lee Sangchoon developed an interest in social and community issues while actively participating in the Working Adolescent Association (in 1924), Adolescent Alliance (in 1927), and Youth Alliance (in 1928) in the Daegu region. According to Sin Gosong's recollection, Lee Sangchoon expressed an interest in avant-garde art after a visit to Japan. He designed frontispieces for books of literature

including *Collection of the Seven KAPF Writers and Collection of Novels about Farmers*, both of which were published by the KAPF. He also took part in street theater in Daegu and the KAPF theatrical group Singeonseol and published its bulletin *Yeongeuk Undong*. His engagement in such a wide variety of activities was characteristic of KAPF artists. However, his frequent arrest and imprisonment did serious damage to his health, and he died at the age of twenty-eight.

ART ACTIVITIES IN THE MASS MEDIA: FRONTISPIECE DRAWINGS AND ILLUSTRATIONS FOR MAGAZINES

KAPF artists are known to have produced numerous flyers and posters for labor groups and events, but there are few surviving examples.[13] Artists and writers with the KAPF endeavored to publish magazines that would enlighten the public. Along with its bulletins, the KAPF published numerous magazines that introduced Communist ideas, which were popular among students as a new form of critical thought. KAPF artists produced frontispieces and illustrations for these magazines that portrayed subject matter such idealized images of Communist society, as well as images of progressive figures.

A KAPF bulletin titled *Jipdan* was published twice. The meaning of the title is a group of people. This magazine proclaimed itself to be a companion for the millions of laborers in Korea. The intense-looking red characters that spelt "*jipdan*" on the frontispiece were designed to catch the reader's eye, and the smiling laborer wearing a hat adorned with stars against the backdrop of an industrial factory presents an upbeat atmosphere.[14] While this frontispiece image presented a vision for a future society, the illustration depicting a group of protesting laborers suggests action that should be carried out in the present. The illustration was by Lee Sangchoon, and the photo collage frontispiece is also presumed to be his work. [4]

Jipdan aimed to introduce basic socialist ideas and the pioneering systems of the Soviet Union to its readers. In an effort to impart socialist knowledge, it contained articles that lucidly explained the notion of class and the history and meaning of May Day, as a celebratory day dedicated to the workers of the world. Texts that introduced the social conditions in Soviet Russia, including details about its education system, met readers' interests about life in communist society. These positive articles and the frontispiece images brimming with hope indicated how communist industrial society was perceived at the time as a utopian vision.

The frontispiece of the magazine *Sidae Gongnon* was designed by the KAPF member Chu Jeokyang

4　Cover image & illustrations by Lee Sangchoon, *Jipdan*, June 1932

5　*Flag of the Labor Union*, Cover image by Chu Jeokyang, *Sidae Gongnon*, September 1931

to reflect modern sensibilities. 5 The title of the magazine means contemporary public forum. Chu Jeokyang joined the KAPF in 1930 as an artist and designed a stage for a small traveling theatre in 1932. He also created the visual devices as art director for movies made by Seoul Kino, a film production company. *Sidae Gongnon* proudly announced that its objective for its proletarian readership lay in "examining the issues facing the entire world while maintaining a critical stance on behalf of the proletarian class and critiquing domestic events from the standpoint of the avant-garde of a new era."[15] The editor of this magazine was Kim Yuyeong, the director of the film *Wheel of Fire* about a labor dispute.

The use of photo collage combining cut-and-paste photographs and alphanumeric characters and the handling of the reverse shading in the square box in the frontispiece of *Sidae Gongnon* reflect the Constructivist style common to Soviet graphic design. The male figure wearing clothes with a star attached to the chest is holding a flag. According to the title of the image, *Flag of the Labor Union*, the figure is presumably a leader of Union. A zeppelin airship made from a collage of letters symbolizes the future society created by modern science, and the translation of the title into Esperanto on the right provides an international sense. This interesting frontispiece shows the proletarian society of which the KAPF artists dreamed, overlapping with a futuristic vision of an industrial society that retains a cutting-edge sense of modernism.

ENLIGHTENMENT ACTIVITIES FOR PROLETARIAN CHILDREN: SINSONYEON AND BYEOLLARA

Artists and writers from the KAPF worked to publish magazines that could also enlighten children and teens. *Sinsonyeon* and *Byeollara* are leading examples of such magazines designed for proletarian children. Lee Juhong, Jung Habo, and Kang Ho all produced frontispieces and illustrations for them. KAPF writers such as Song Yeong, Sin Gosong, Kwon Hwan, and Yim Hwa were also actively engaged in publishing these magazines.

Sinsonyeon magazine published its first issue in 1925. The title signifies new boys. When a large number of KAPF writers joined its editorial board in the 1930s, the nature of the magazine changed markedly as reflected in the frontispiece for the March edition of 1933. 6 It features a group of boys in working clothes in front of a factory. Their furious yet resolute facial expressions are depicted using simple and swift brushwork. Some of them are gazing back at laborers who are leading a strike and standing on the roof of a factory. Others are clenching their fists while reading propaganda

6 Cover image by Lee Juhong, *Sinsonyeon*, March 1933

7 Cover image by Sin Baegyun, *Sinsonyeon*, May 1931

leaflets, expressing their support of the strike. This frontispiece challenges readers to think about a rather serious subject, namely participation in labor action, while using brisk cartoonish brushwork.

KAPF member Lee Juhong, the creator of this frontispiece, produced other frontispieces and illustrations for *Sinsonyeon* and was also responsible for editing the magazine. Born in

Hapcheon, Gyeongsangnam-do Province, Lee studied in Japan and was actively involved in producing art for several books and magazines in addition to *Sinsonyeon* and *Byeollara*, including *Bipan*, *Pungnim*, and *Yadam*. As well as being an artist, he was a writer for teenagers who created novels and published critiques of proletarian children's literature. His frontispieces for *Sinsonyeon* often presented the figure of a proletarian boy as a powerful worker and a leader of the masses.

Sinsonyeon included proletarian children's poems sent in by teen writers from across the country. These poems criticized the gap between the rich and the poor or described the realities in farming villages and factories. *Sinsonyeon* also contained critiques advocating a departure from the bourgeois literary viewpoint of children as angels and instead called for the production of purposeful militant works. The frontispieces for *Sinsonyeon* sometimes visualized the resistance pursued within proletarian literature, as seen in the frontispiece of the May 1931 edition featuring the face of a boy holding out his hands resolutely and shouting loudly.‾7‾ The author of this frontispiece was the young painter Sin Baegyun, who had earned an honorable mention at the Joseon Art Exhibition in 1926. Artists like Sin sometimes created images for the frontispieces of *Sinsonyeon* instead of KAPF artists. In broader terms of social connectivity, the magazine also served as a means through which boys and girls interested in proletarian art and literature could exchange letters and communicate with each other.

THE HOLDING OF PROLETARIAN CHILDREN'S ART EXHIBITIONS

Byeollara was a children's magazine whose illustrations and frontispieces were produced by Kang Ho and Jung Habo from the KAPF. The title of the magazine means a country of stars. The small frontispiece drawing produced by Kang Ho for the January–February edition of 1931 shows an impressive image of a boy dashing along while carrying a sickle. As implied by the title *What Is There to Fear?*, this image could be read as depicting something rebellious and dangerous.‾8‾ Another illustration by Kang Ho captures the tension in the body of a young messenger who is also secretly transporting flyers for a strike. According to Lee Juhong, Kang's work successfully conveyed the specific emotive content that would interest proletarian children.

The publisher of *Byeollara* also held Proletarian Children's Art Exhibitions. Along with displaying artworks, these exhibitions contained theatrical performances. Such shows were like school festivals where students could show off their talents. They were particularly focused on students who

8 *What Is There to Fear*, Cover image by Kang Ho, *Byeollara*, February 1931

9 Aengbonghoe, *Our Joyous Day*, *Byeollara*, July 1932

10 Kang Ho, *Underground Village*, Dan Sei Weekly, April 1931

could not enter regular schools due to poor family circumstances and instead had to study at night schools or special training schools while also working.

The Proletarian Children's Art Exhibition held July 2–3, 1932 displayed paintings and crafts on many themes along with literary works including calligraphy, essays, and children's songs. *A Laborer Installing Railway Tracks* by a student at Baeyeong Academy was described as the most outstanding work for its firm brushstrokes and great spirit. A rural landscape painting by a Neungin Academy student was also singled out as a particularly sophisticated work. The exhibition also featured handicrafts by female students, including paper cut-outs. The KAPF artists and writers emphasized the importance of these creative activities that encouraged the value of a modern art education and offered an opportunity for students to present their works and have them to be appreciated.

Besides the Proletarian Children's Art Exhibitions, the choral Sprechchor play *Our Joyous Day* was performed by the children's theatrical group Aengbonghoe. 9 Sprechchor refers to a performance style of shouting out short lines in unison with accents and tones like a slogan and was considered a fitting means of propaganda and instigation at socialist assemblies. A photograph of *Our Joyous Day* being performed shows boys with headbands gallantly shouting lines in unison on the stage on the second floor of a theater. *Our Joyous Day* was a short play designed to encourage students who had learned how to sing and create art with only a minimum of resources to show off at school festivals the talents they had honed in the face of considerable challenges.

The Proletarian Children's Art Exhibitions hosted by the publisher of *Byeollara* also featured children's magazines produced by the Japanese KOPF, including *Shōnen Senki*, *Tomodachi*, and *Pioniru*. The editorial staff of the publisher of *Byeollara* was in contact with the New Educational Research Institute affiliated with the KOPF. They also attempted to bring in and distribute *Uri Dongmu*, a bulletin published by Park Seokjeong of the KOPF's Korean Committee. However, the attempt failed when some of the editorial staff working for the publisher of *Byeollara*, including Lee Sangchoon and Sin Gosong, were arrested.

THE PRODUCTION OF THEATRICALS AND FILMS

Rather than confining themselves to fine art activities, KAPF artists participated in creating stage sets for theatres and directing and producing films. This involvement in a wide variety of different genres is characteristic of KAPF activities.

Kim Bokjin, for instance, took part in theatrical performances by the Towolhoe company while producing sculptures for the Joseon Art Exhibition and designing frontispieces for *Munye Undong*. Similarly, Lee Sangchoon engaged in Yeonggwahoe exhibitions, produced illustrations and frontispieces, and participated in making stage sets for theatres. Kang Ho was involved in film production, signboard production, and art for publications. Jung Habo also produced stage sets for local theatre companies and wrote a prose piece entitled "A Stage Designer's Thoughts." The KAPF writer Yim Hwa also worked as a film actor.

Plays and films were boisterous spectacles at the tme, as they offered a rare chance for recreation, and easily triggered strong, emotive responses from the public. Perhaps for this reason the KAPF began to actively engage in theater and film in the early 1930s when the group underwent a reorganization of its direction and structure. As more artists working in theatre and film joined the KAPF with this shift in focus, the organization came to be composed of departmental alliances of art, theatre, film, music, and literature in 1931.

At present in Korea, only a niche audience enjoys theater. At the time, however, in colonial period Korea plays gained immense popularity as an innovative art form that showcased modern innovations and perspectives and populist themes. The immediacy of the vividly spoken words and the innate pleasure taken in watching the live performance and accompanying dance and music made plays appealing to all groups of people. In this context, associations of children, young people, laborers, farmers, and religious organizations in several regions launched the amateur play movement to create and perform plays non-professionally. Most of these amateur plays were original works. While early versions of such plays were usually themed on modern social concerns like the eradication of illiteracy, or melodramatic works without political content, later productions were often amateur proletarian plays driven by socialist themes addressing specific labor and class issues.[16] Given the continued popularity of local theatre, the KAPF artists continued to create and perform theatrical works based on these matters.

Megaphone and Singeonseol were the main theater companies connected personally to KAPF. There were also theatrical organizations in Pyeongyang, Hamheung, Haeju, and Daegu that were members of the KAPF. Chu Jeokyang and Lee Sangchoon participated in Megaphone upon its establishment in May 1932. It staged an one-act play entitled *Megaphone* and also *Self-defense* by Song Yeong. Touring performances of these plays were also put on in Incheon. *Megaphone* was a short Sprechchor play, while *Self-defense* was a satirical

drama ridiculing the bourgeoisie through a story in which a factory owner who became frightened by a laborers' strike took up the study of martial arts but ended up becoming an object of ridicule instead.

The theatre company Singeonseol was established in August 1932, and Lee Sangchoon and Kang Ho worked in its art department. In 1933, Singeonseol performed *All Quiet on the Western Front*. Only a blurred photograph from a newspaper shows the stage set which is presumed to have been created by Lee Sangchoon. In his article published in the Singeonseol bulletin, *Yeongeuk Undong*, Lee Sangchoon argued that the proscenium arch (the frame separating the audience from the stage) should be removed and an innovative stage inviting the audience into the play should be used instead to encourage conceptual interaction.

As the most modern and popular art form, film naturally interested KAPF artists. Immediately after its establishment in November 1930, Cheongbok Kino, the film department of the KAPF, produced the film *Underground Village* in 1931. It was an adaptation of *A Growing Crowd* written by Sin Eungsik. Kang Ho directed the film and the actors included Kang Chunhui, Lee Jeongae, and the writer Yim Hwa. **10** The plot revolves around the lives of slum residents driven out by a factory owner who was trying to build a new factory, laborers who were fired and attempted to strike, and the various activities of concerned intellectuals and a daughter of the factory owner. Based on a melodramatic script, the film was shot in a slum in Sindang-ri outside Gwanghuimun Gate. The print media covered the construction of a temporary building set and the casting of extras for a final scene in which around 500 people whipped into a rage went rushing toward the factory owner's house. A photograph of the director Kang Ho and stills from the film were published several times in newspapers, raising people's expectations. However, it was never released or screened in theatres.

Kang Ho, the director of *Underground Village*, was a leading figure in the KAPF's efforts to produce films.[17] He is known to have studied at Kyoto Prefectural School of Painting, Japan. He actively engaged in other forms of visual art by drawing illustrations and frontispieces for magazines published by KAPF artists and producing signboards for stores. Kang Ho joined the Korean Film Art Association early on and participated in the production of the film *Dark Road* (1929) in Jinju, Gyeongsangnam-do Province. In a newspaper interview conducted at the time of the filming of *Underground Village*, Kang stated that such independent small-scale films for laborers and farmers were needed more than large-scale commercial films.

To promote their preferred type of films,

Kang Ho and Chu Jeokyang of Cheongbok Kino established a group Dongbang Kino in December 1932. It serially published the scenario *Trigger* in the *Chosun Ilbo* newspaper about a strike in a rubber factory and then tried to make the story into a film. Moreover, the group was involved in theatrical and film activities by releasing the bulletin *Yeonghwa Budae* in 1932 and continuing the publication of *Yeongeuk Undong*.

THE SIGNIFICANCE OF KAPF ACTIVITIES AND THEIR LEGACY IN KOREAN ART HISTORY

After the Singeonseol Event in which the Japanese Government-General of Korea arrested numerous KAPF artists and writers in 1935, the activities of KAPF artists were restricted, not least as the public dissemination political messages were increasingly legally restricted by the colonial authorities. The KAPF artists did not completely abandon the direction of their art activities, however. Jung Habo, Park Jinmyeong, and Lee Sangchoon formed the Plastic Arts Research Institute and attempted to study a new realism and hold exhibitions. Park Jinmyeong and Lee Sangchoon joined other artists, including Chu Jeokyang, Kang Ho, and Kim Ilyeong, to establish the Advertising Art Agency in 1936 and sought work in commercial areas. They not only designed advertisements and sign boards of shops, but they also created illustrations of books and stage settings of plays. However, the war situation worsened throughout the Second Sino-Japanese War up until Korea's liberation in 1945, and the activities of the KAPF artists eventually came to a halt.

The KAPF artists were progressive in that they endeavored to create artwork for popular industrial society rather than limiting themselves to producing fine art for elitist exhibitions. They also attempted to integrate their ideas about the arts into a diverse range of genres and mediums, including theater, film, and mass media. Moreover, they suggested a new social role for artists in that they critiqued the poor social conditions and inequality related to colonialism and capitalism and strove to enlighten people by presenting a revolutionary vision of a liberated, equal, independent, and happy industrial society. They are noteworthy as not simply artists, but as radical intellectuals who attempted to address their social responsibilities as cultural producers.

After Korea's liberation, the activities of the KAPF led to various efforts by a new generation of artists who resolved to reestablish the nation and shared the ideological inclination of the KAPF members. Many artists, including Kim Bokjin and Lee Sangchoon, had died, but the KAPF's art activities laid the foundations for the organization

of the North Korean art community in the late 1950s. In South Korea, the names of artists who defected to the North, including some from the KAPF, and any record of their activities were deleted from official histories for decades as part of an anti-communist purge, and only resurfaced after the ban on such was lifted in 1988. The KAPF artists' engagement in diverse realms beyond traditional art as they worked to address their perception that art could reflect social issues and aim for egalitarian progress also provided a basis for the many political art movements of the 1980s in South Korea.

1 The March First Independence Movement was the grand scale protest movement by Korean people calling for independence from Japanese colonial rule.

2 For more information on the establishment of the KAPF and its activities, see Choi Youl, *Hanguk Hyeondae misul undongsa* [History of Korean Contemporary Art Movements] (Paju: Dolbegae, 1994).

3 For more information on Kim Bokjin's life and artistic career, see Youn Bummo, *Gimbokjin yeongu: Ilje gangjeomba joso yesulgwa munye undong* [A Study on Kim Bokjin: Plastic Arts and Literary Movements under the Japanese Colonial Rule] (Seoul: Dongguk University Press, 2010).

4 Youn Bummo and Choi Youl, *Gimbokjin jeonjib* [Collected Works of Kim Bokjin] (Seoul: Cheongnyeonsa, 1995).

5 Choi Youl, "Peurolletaria misul nonjaeng" [A Dispute over Proletarian Art], in *Hanguk geundae misul bipyeongsa* [The History of Modern Korean Art Criticism] (Paju: Youlhwadang, 2001), 68–75.

6 Yim Hwa, "Misul yeongyeoge jaehan juche ironui hwangnip" [The Establishment of a Theory of Independence in the Art Realm], *Chosun Ilbo*, November 20–24, 1927.

7 Kida Emiko, "Suwon peurolletaria misul jeollamhoereul tonghae bon misul gaenyeom" [The Proletarian Art Exhibition in Suwon An Example of How the Art Has Been Interpreted in Modern Korea], *Journal of Korean Modern & Contemporary Art History* 11 (2003): 77–108.

8 Kida Emiko, "Hanil peurolletaria misul undongui gyoryue gwanhayeo" [About the Exchanges between Korean and Japanese Proletarian Art Movements], *Art History Forum* 12 (2001): 59–81.

9 Okamoto Tōki and Matsuyama Fumio, *Nihon puroretaria bijutsushi* [History of Japanese Proletarian Art] (Tokyo: Zōkeisha, 1967), 38.

10 Jung Habo, "Baengman yanghwahoeui jojikgwa seoneo-neul bogo" [Upon Witnessing the Formation and Declaration of Baengman Oil Painting Association], *Chosun Ilbo*, December 26, 1930.

11 For more information on the fusion of ideas about literature and the fine arts in the KAPF, see Ki Heykyung, "1920nyeondae misulgwa munhagui gyoryu yeongu— Kapeu hyeongseong gwajeongeul jungsimeuro" [A Study on the Exchanges between Art and Literature in the 1920s: A Focus on the Formation Process of the KAPF], *Journal of Korean Modern & Contemporary Art History* 8 (2000): 7–37.

12 On Lee Sangchoon, see Lee Minyeong, "Peuropaganda yeongeuk mudaeui mihakjeok giwon: Isangchungwa guseongjuui" [The Aesthetic Origins of the Propaganda Stage: Lee Sang-Chun and Constructivism], *Journal of Korean Literary History* 68 (2018): 267–293 and Daegu Foundation for Culture, *Daegu Art Legend: Ri Sang-Choon* (Daegu: Daegu Foundation for Culture, 2019).

13 For more information on the re-examination of the KAPF art activities by artists who went to the North Korea, see "Kapeu sigiui misul hwaldong-jwadamhoe" [A Symposium: Art Activities during the KAPF Period], *Joseon Misul*, April 1957.

14 Seo Yuri examines the covers of socialist magazines in her book, *Sidaeui eolgul: Japji pyojiro boneun geundae* [The Faces of Magazines in Modern Korea: Iconography, History and Politics] (Seoul: Somyong Publishing, 2016).

15 "Urideurui koseu—sidae gongroneun ireoke haengjin-hara" [Our Course: Voicing Current Public Opinion as Follows], *Sidae Gongnon*, first issue, September 1931, 1.

16 Lee Seung-hee, "Peurosoingeugui jeongchijeok su-haengseonggwa geu gieok" [Pro-amateur Theatrical, the Political Performativity and Its Memory], *Daedong munhwa yeongu* 64 (2008): 153–184 and Yoo Minyoung, *Hanguk*

geundae yeongeuksa [History of Modern Korean Theatre] (Seoul: Dankook University Press, 1996).

17 For more information on Kang Ho's activities, see Hong Jisuk, *Bugeuro gan misulsagawa misul bipyeonggadeul* [Art Historians and Critics Going to North Korea] (Seoul: Kyungjin Publishing, 2018), 277–316.

The Acceptance of Modern Art and the Indigenization of Oil Painting

Kim Hyunsook

EXPANSION OF OIL PAINTING IN COLONIAL KOREA

Starting in the early 1920s, department stores including Chōjia, Minakai, Mitsukoshi, and Hwashin opened along the main streets of Gyeongseong (the colonial period name for present-day Seoul). Theaters, teahouses, and cafes were thriving as well. Young people fascinated by images of the West they encountered in imported films yearned to have a chance to experience the modern trends they saw sweeping the world. In the newly established department stores, they were able to purchase new products imported from Japan and the West. In this context, a new generation of aspiring artists who favored the sensations and sentiments typical of this modern era, largely chose to practice oil painting rather than traditional ink painting, as a means to visually represent these new trends.

When the first generation of Western-style painters who had studied at art schools in Japan during the 1910s and the early 1920s returned home, they endeavored to train a younger generation of artists by establishing private art institutes, including Goryeo Painting Association (Goryeo hwahoe), Goryeo School of Art (Goryeo misulwon), Towol Art Research Institute (Towol misul yeonguhoe), and the Sakseonghoe Association. Due to financial difficulties, however, these institutes failed to remain in operation for long. Nevertheless, they strove to train the next wave of artists by offering young painters a basic art education through drawing and watercolor classes and by encouraging them to submit works to art competitions like the Joseon Art Exhibition, and that hosted by the Calligraphy and Painting Association. A number of the young artists who graduated from these private art institutes also entered art schools in Japan, including the Tokyo School of Fine Arts, Imperial Art School (Teikoku Bijutsu Gakkō), Pacific Art School in Japan (Taiheiyō Bijutsu Gakkō), Academy of Culture (Bunka Gakuen), and Japanese Art School (Nihon Bijutsu Gakkō). After returning from their studies abroad many of these individuals then worked as professional artists.

A small handful of artists also studied in the West and then returned to Korea. They include Chang Louis Pal, who studied art at Columbia University in America; Gilbert Pha Yim, who graduated from the Yale School of Art at Yale University in America, then visited Europe and returned to Korea in 1930; and Pai Un-soung who went to Germany in 1923, graduated from Academy of Arts, Berlin (present-day Universität der Künste Berlin), was active particularly in Germany and France, and returned home in 1940. However, for most Koreans, whether as artists or audiences, their initial engagement with Western-style oil painting was facilitated mainly through Japanese operated education and art institutions. Artists, such as Chang, Yim and Pai, made significant contributions to the diversification of the art scene in terms of the channels through which oil painting was introduced. Gilbert Pha Yim presented his works at solo exhibitions and exhibitions hosted by the Mogilhoe Association[1] and the Calligraphy and Painting Association after his return in 1930. While serving as an art teacher at the Osan School founded by anti-Japanese nationalist Lee Seunghun, Yim taught Mun Haksu and Lee Jungseop, who went on to become major figures in Korean art. Lee Chongwoo, Rha Hyeseok, and Paik Namsoon also travelled to Europe where they gained first-hand experience of Western art and played an instrumental role in furthering the Korean art scene in the 1930s.

A vast body of art organizations were established by the early 1930s, including

the Yeonggwahoe Association (1927–29), Changgwanghoe Association (1927–28), Nokhyanghoe Association (1928–31), Baengman Oil Painting Association (Baengman yanghwahoe; 1930), Dongmihoe Association (1929–30), and Hyangtohoe Association (1930–35). In and after the mid-1930s, the Mogilhoe Association (1934–39), Korean Art Association in Tokyo (Jaedonggyeong misul hyeophoe, 1937–43?; formerly, the Baeguhoe), and the SPA Research Institute of Oil Painting (SPA Yanghwa yeonguso; 1935–?) were formed. Most of these were small groups, with the exception Dongmihoe Association, the association of the graduates of the Tokyo School of Fine Arts, and Korean Art Association in Tokyo, a gathering of graduates from the Imperial Art School. However, they set up affiliated research institutes to nurture the younger generation and engaged in promotional activities by holding group art contests. When the outbreak of the Second Sino-Japanese War in 1937 and the Pacific War in 1941 led the country into a state of war, limitations were imposed on the activities of these organizations. Despite these restrictions, notable rising artists, including Lee Qoede, Lee Jungseop, Jin Hwan (1913–51), and Choi Jaiduck, formed the New Artists' Association (Sin misulga hyeophoe; 1941–44). This broad collection of artists initiated a marked improvement in the range of oil painting techniques and styles, and helped to establish a strong interest in local subject matter and sensibilities within the modern Korean art world.

Although the profession of art criticism was yet to be established in Korea in the 1920s, some painters engaged in critical writing on modern art. So, in the 1920s, Kim Chanyoung, An Seokju, and Kim Bokjin began producing artworks while simultaneously writing art reviews. From the 1930s and before Korea's liberation from Japan, Kim Yongjun, Sim Yeongseop (1902–47), Yoon Hee-soon, Jung Hyunwoong, Kim Whanki, and Jo Woosik also produced art criticism. These artists provided leadership in the Korean oil painting community by reviewing artworks and exhibitions and publishing theories on national art, proletarian art, new art, local art (鄉土美術) Aisan art, and avant-garde art.[2]

The Acceptance and Development of European Modern Art

After the positive reception afforded to pleinairisme (open-air painting) in the 1910s, the oil painting circles in Korea reached a turning point when several young artists began to explore the Post-Impressionism being driven by Paul Cézanne and Vincent Van Gogh as well as the Fauvism and German and Austrian Expressionism. From the early 1920s, Kim Chanyoung, who had embraced modernist culture while studying in Japan during the Taishō period (1912–26), began to publish writings that advocated for modern art in the wake of Post-Impressionism.[3] In the following years, other writers, including Byeon Yeongro, Yim Janghwa, No Jayeong, and Ko Hanyong, published essays that briefed about Futurism, Cubism, Symbolism, and Dada. Soon after, newly rising artists, who were well-versed in Post-Impressionism as represented by Cézanne, Van Gogh, Paul Gauguin, and Henri Matisse and their succeeding art movements, began creating works using modern visual vocabulary.

The process of embracing and developing modern art in Korea continued over two decades from the mid-1920s until Korea's liberation from Japan. It started with a positive reception for Cézanne's work, then Expressionism, as understood relative to the work of Van Gogh, and Fauvist painting. In the early phase of this encounter during the mid- to late 1920s, artists expanded their knowledge by obtaining information from Japanese artists active in Korea and from short essays and plates included in art books and magazines published in Japan and in domestic newspapers and magazines. An Seokju, Lee Seungman, Yoon Sang-yeol, and Lee Changhyeon, who were all ideologically influenced by Kim Bokjin, leader of the Korean Proletarian Artist Federation (KAPF), were all notable young artists who exhibited Expressionist approaches in their work. Around the year 1930, rather than blindly attempting to practice all forms of Western modernism, artists who studied in Japan and witnessed the Japanese encounter with Western oil painting, began to search for particular Korean creative expressions in oil painting. In the late 1930s, works displaying this distinctive expressions began to appear. From the mid-1930s, many young Korean artists who had personally experienced the avant-garde movement in Japan during their studies returned home and started to introduce new forms of surrealist and abstract art to Korea, and the development of local modernist painting took a new turn.

The Influence of Cézanne in Korea from the Mid-1920s to the Late 1920s

At the fourth Joseon Art Exhibition in 1925, a student named Kang Sinho (1904–27) from a city of Jinju who had just graduated from Hwimun High School and attended Tokyo School of Fine Arts for a month, unexpectedly took fourth prize for a still-life. This painting demonstrates that Kang had a basic understanding of Cézanne's approach to still-life painting, in which objects are constructively arranged in the composition and depicted from multiple perspectives. At the fifth exhibition in the following year, Kang won a special prize with his

1 Lee Insung, *Arirang Pass*, 1934, Watercolor on paper, 57.5×77.8 cm

still-life *Chair*. This work also displays the influence of Cézanne in the structural perception of the interrelations among objects. Besides Kang's entry, many works in the style of Cézanne, including *Still Life* by Lee Changhyeon and *Self-Portrait* by Jang Seokpyo, received prizes. In particular, *Self-Portrait in Winter* by Jang Seokpyo was considered similar to Cézanne's *Self-portrait* with regards to the pose of the sitter, the composition, and the geometrically patterned background. These prize-winning paintings suggested the new direction being taken within Korean oil painting.

The towering mountain, geometrically simplified houses, and stable composition in *Summer on Seto Inland Sea* (1933) by Lee Insung (a significant painter from Daegu) while studying in Japan showed the clear influence of Cézanne's *Mont Sainte-Victoire* (c. 1904–06). Similarly, in Lee's *Arirang Pass*, which won him first prize at the twenty-second Japanese Watercolor Painting Exhibition held in 1934, the triangular mountain, simplified cubic shacks, layers of blue, orange, and green colors, along with the overall composition all reflect the influence of Cézanne. $\overline{1}$ While Lee faithfully followed the style of Cézanne in *Summer on Seto Inland Sea* with its solid and stable composition, he tried to apply a more individual approach in *Arirang Pass* by including original touches such as the horizontal juxtaposition

of bright colored lines and the compositional introduction of rhythmical curves.

The towering triangular mountain peak and simplified roofs in *Scenery of Namsan Mountain* (1931) by Kim Yongjun also recall the composition of *Mont Sainte-Victoire*. However, here Kim depicted soft, gentle curves in the thatched roofs; swift, rhythmical lines in the tiled roofs; and thick, powerful lines in the tree trunks; all of which completely diverge from Cézanne's typical contour. In this respect, Kim's work is arguably more reminiscent of the energetic and elegant brushstrokes of ink-and-wash painting. This approach reflects the fact that by around 1930 Korean artists, such as Kim Yongjun, were referencing compositional and stylistic precedents from Western modern art while also employing painterly techniques common to the East Asian tradition of ink painting.

Expressionism: From the Early 1930s
to the Late 1930s

The presence of European modernism in Korea first became pronounced in the mid-1920s as various artists started to privilege the influence of Cézanne in creating their own work. However, this focus on Cézanne failed to lead to the adoption of a more

2 Lee Seungman, *Symphony of Hunger and Love, Dong-A Ilbo*, January 1, 1925

3 Gil Jinseop, *Face, Dong-A Ilbo*, October 26, 1934

schematized exploration and theorization of the relations and structures among objects, in terms of how they might be depicted in modern painting.[4] This is possibly because Korean artists at this moment were particularly influenced by Cézanne's use of color rather than his analytical approaches to painting. Then, in the early 1930s, a widespread interest in European Expressionist painting, and particularly in projection of emotional response, became increasingly prevalent. For instance, the painter and art critic Kim Yongjun defined himself and other artists who submitted works to the second exhibition hosted by Dongmihoe Association as 'expressionistic Romantics.' The participants at this show included Yim Hakseon (1904–?), Gil Jinseop (1907–75), Lee Byungkyu (1901–74), Lee Madong (1906–81), Kim Eungjin (1907–77), Hong Deuksun (1910–?), and Hwang Suljo (1904–39). Kim Yongjun subdivided them into several categories by viewing Lee Byungkyu, Lee Madong, and Hong Deuksun as belonging to Post-Impressionism; Yim Hakseon, to the Picasso school; and Kim Eungjin who submitted *Pierrot*, to the emotional Expressionist school. In making these choices, Kim collectively referred to Post-Impressionism, Expressionism, and Fauvism as the Expressionist schools.

Proletarian art found many followers in Korea from the mid-1920s through the early 1930s. Artists who associated with this political movement preferred figurative Expressionist painting styles, such as those used by soviet artist Kazimir Malevich in his early work, in an effort to expose the conditions facing the young, the poor, and laborers, and to fight on their behalf by attempting to influence reforms in society. In *Longing* by An Seokju, the gloomy eyes of a young man gazing at the sky with a craned neck and a black, gigantic shadow in the background represent the gap between people's hope for the future, and the grim reality Korea faced as a colony of Japan. Lee Seungman's *Symphony of Hunger and Love* (1925) is an avant-garde work filled with complex lines and forms, and was created under the banner of the socialist KAPF art movement.[5] **2** Hwang Suljo produced *Chimney Cleaner* (c. 1931) a piece submitted to the second exhibition hosted by the Dongmihoe Association, after the KAPF modified the intellectual course of its social engagement in 1927, adopting the slogan "from the weapon of the arts towards the arts of the weapon." In this work, Hwang strove to promote the will to fight for social reform by emphasizing a resistant and heroic image of the working class.

Among the artists who applied the Expressionist styles, which began to pervade the Western-style painting scene in Korea around 1930, Jang Seokpyo was regarded as a leading follower

4 Gu Bonung, *Portrait of a Friend*,
1935, Oil on canvas, 62×50 cm

5 Gu Bonung, *Loquat and Cherry (Grapes)*,
1927, Oil on canvas, 43×47 cm

THE ACCEPTANCE OF MODERN ART AND THE INDIGENIZATION OF
OIL PAINTING

6 Lee Insung, *On an Autumn Day*, 1934, Oil on canvas, 96×161.4 cm

of Van Gogh, and Hwang Suljo who portrayed himself expressively in *Self-Portrait* with red eyes, recalling the self-portraiture of Van Gogh, is considered another advocate of Van Gogh.[6] And, in the painting *Face* that was submitted to the thirteenth exhibition of Calligraphy and Painting Association in 1934, Gil Jinseop created another highly expressive type of portrait, featuring a sharp jawline and defiant eyes that show the cynical and aggressive characteristics of the sitter. In Gil's work, the face, bisected by color, and the simplified background evince the influence of

modern painting style of Matisse. ⎯3⎯ No image has survived of Kim Yongjun's *A Heretic and a Triangle Person*, which he submitted to the first exhibition of Dongmihoe Association in 1930. However, a review written at the time mentions a fish depicted above the head of a heretic, and it also claimed the painting expressed a spirit of strong resistance against the absurdities of life. Given this review, Kim's painting is presumed to have been created in a similar spirit to that of Gil's *Face*. Regarding the expressive quality of Kim's work, Lee Hagwan also commented that the dark and heavy colors, thick

on the same style by Satomi Katsuzo (1895–1981), a leading figure in Japanese Fauvism. On the other hand, the elegant line that depicts the man's nose, drawn with a single stroke of the brush, arguably reflects Gu's determination to creatively adapt the precedents of Western modernism and reinterpret such relative to the tradition of East Asian painting. This perspective can also be seen in Kim Yongjun's *Scenery of Namsan Mountain*. In a similar context, members of the Mogilhoe Association and the Calligraphy and Painting Association, including Gil Jinseop, Kim Yongjun, and Hwang Suljo, all portrayed male figures in their work as uncompromising young intellectuals of the Japanese colonial era, as did An Seokju in his work *Longing* and Gu Bonung in his *Portrait of a Friend*.

In his book *Pungnyu sesigi* (A record of refined seasonal customs, 風流歳時記) (1977), Lee Seungman described Lee Changhyeon as the first artist to experiment with Fauvism in Korea. However, this cannot be verified since none of Lee's works have survived. Among the entries by Korean artists to the Joseon Art Exhibition, the earliest verifiable example of a Fauve style is *Small Still Life Painting* (1927) by Yoon Sang-yeol, which received an honorable mention at the sixth exhibition. Considering that both Lee and Yoon maintained a close relationship with Kim Bokjin and An Seokju as they produced sets for theatrical performances, they likely shared many art books and artistic materials imported from Japan.

In addition to *Small Still Life Painting* by Yoon Sang-yeol, Gil Jinseop's *Still Life* submitted to the second exhibition hosted by the Dongmihoe Association in 1931 and Gu Bonung's *Loquat and Cherry (Grapes)* (c. 1927) show a bold composition with a bird's-eye view, simplified forms, multiple perspective viewpoints, bright and vivid colors, and a flat, decorative spatial organization, all of which are characteristic of Fauvist still-life painting. [5] Gu Bonung, in particular, is considered a leading figure who experimented in Fauvism in Korea during the modern era. While none of the works produced by Lee Changhyeon, Yoon Sang-yeol, and Gil Jinseop in a Fauvist style are extant today, Gu Bonung left several paintings such still-life paintings and figure paintings from the late 1920s through the early 1930s.

On an Autumn Day by Lee Insung won a special prize at the thirteenth Joseon Art Exhibition in 1934. It was inspired by a short visit to his hometown while studying in Japan. The topless woman is reminiscent of a figure depicted in *Maternité II* (1899) by Paul Gauguin. The red soil and group of plants, including a drooping sunflower, corn, reeds, and cactuses under intense sunlight indicate that the woman may be standing in a field in the warm, southern region of Korea. [6] Japanese

and bold lines, and gloomy picture plane made it appear as if it had been unearthed from a tomb.

Portrait of a Friend (1935) by Gu Bonung depicts a pale-faced, bearded figure smoking a pipe and wearing a hat askew. This is a portrait of the poet Yi Sang, who maintained various eccentric behaviors and was considered the definitive decadent of his time. [4] This portrait presents Yi with pale skin and red lips against a dark blackish-green backdrop using rough lines. It appears to have been modeled after *Man Smoking a Pipe* (1900) by the French Fauvist Maurice de Vlaminck or the painting titled *Woman*

7 Kim Whanki, *Rondo*, 1938, Oil on canvas, 61×71.5 cm

people at the time perceived blue skies and red soil to be characteristic of Korea, and the primitivist depiction of the woman in this scene was probably intended to specifically appeal to colonial Japanese notions of Korean exoticness and social backwardness. This painting, therefore, is likely a depiction of an area on the outskirt of Daegu, Lee's hometown in the south of Korea. However, given its title, *On an Autumn Day*, which specifies only the season, it may be irrelevant to ponder the nationality of the figures in the painting or the place where they stand. The fertile yet barren field, in which the semi-naked woman appears, is imbued with a blend of the perspective of the painter viewing his home country of Korea from Japan (or Tokyo), and the Orientalist perspective of a Japanese colonizer.

Abstract and Surrealist Art: From the Late 1930s to the Early 1940s

Abstract and Surrealist art were championed in Korea by students, including Kim Whanki, Yoo Youngkuk, Lee Kyusang (1918–64), Mun Haksu, and Lee Jungseop, who were active in the Japanese avant-garde group Free Artists' Association (Jiyū bijutsuka kyōkai) from the late 1930s until the early 1940s. In 1940, the *Gyeongseong Exhibition of the Association of Art Creators in Celebration of the 2,600th Anniversary of the Founding of Japan* was held at Bumingwan Theater in Seoul. It was a traveling exhibition of the Art Creators' Association (Bijutsu sōsakka kyōkai), which was formerly the Free Artists' Association. While the exhibition did not draw much attention in Korean painting circles at the time, it is still meaningful in that it introduced the contemporary avant-garde art being created in Korea and Japan around this time to the Korean

8 Yoo Youngkuk, *WORK 404-D*, 1940 (reproduced by Yoo Lizzy in 2002), Mixed media, 90×74 cm

public on a large scale.

At the end of the 1930s, Jung Hyunwoong and Jo Woosik began to publish writing that briefly introduced Surrealist art to Korean audiences. Jo Woosik, Kim Hageon (1915–51), Kim Jongnam (1914–86), and other artists also submitted Surrealist artworks to exhibitions held by the Art and Culture Association (Bijutsu bunka kyōkai) in Japan. In 1939, Surrealist photography was introduced to Korea through a two-person exhibition by Jo Woosik and Joo Hyeon.[7]

Kim Whanki returned to Korea after graduating from the Art Department at Nihon University in Tokyo and holding a solo exhibition in 1936. Even after his return, Kim remained active among the Japanese avant-garde by submitting an abstract painting entitled *Air Beacon* (1937) to the first exhibition of the Free Artists' Association run by Japanese artists in Japan of which he was a member.

In Korea, he published writings on abstract art and held a solo exhibition in 1940. Kim's *Rondo* (1938) represents the structure of the musical form "rondo" in which a principal theme alternates with one or more contrasting melodies. Here, the curving forms of a human body are repeatedly inserted between red, blue, yellow, white, and black color planes in an orderly rhythm. Created in Korea, this painting is historically significant in that it is considered to mark the beginning of Korean abstract painting. [7]

Yoo Youngkuk, another member of the first generation of Korean abstract artists along with Kim Whanki, graduated from the Art Department of the Academy of Culture in Japan in 1938. In the same year Yoo received an award from the Free Artists' Association and was invited to join the association as a member. Yoo submitted a white relief work of cut-and-paste veneer boards with a smooth and glossy surface entitled *WORK 404-D*

(1940) to the fourth *Osaka Exhibition of the Association of Free Artists* held at the Osaka Municipal Museum of Art.[8] [8] While Kim Whanki began with an image of an actual object and gradually moved on to pure abstraction, Yoo Youngkuk pursued an art practice influenced by the mode of international Constructivism embraced by Abstraction-Création, an association of abstract artists in Paris.

THE INDIGENIZATION OF OIL PAINTING

In the early twentieth century, oil painting became a primary medium within Korea art. This process started with the acceptance of visual techniques and then shifted to integrating more of the styles and aesthetic approaches common to European art of the twentieth century. By the 1930s, a phenomenon occurred which has been referred to as the indigenization of oil painting. This term is broadly understood as reflecting the promotion of local color through the Joseon Art Exhibition and the subsequent pursuit of Joseon-style or East Asian-style oil painting by non-mainstream Modernist painters.

The Local Color of the Joseon Art Exhibition
Over the years, the state-run Joseon Art Exhibition experienced an increase in the number of participating artists and expanded accordingly. From the mid-1920s through the mid-1930s, the so-called Okdongpae, a group of home-grown artists including Kim Chongtai, Lee Seungman, Yoon Sang-yeol, and Kim Junghyun, spurred innovation with their use of novel colors and compositions, as demonstrated in the works they submitted to the Joseon Art Exhibition.[9] In and after the 1930s, many Koreans who had studied in Japan were now active in Korea, marking a generational shift in the main figures in the local art scene. This new group included artists such as Kim Insoong (1910–2001), Kim Man-hyeong (1916–84), Shim Hyungkoo (1908–62), and Son Eungsung (1916–79). The winners of the Joseon Art Exhibition in and after the latter half of the 1930s can be largely divided into those who practiced the Academist painting style embodying colonial modernity and pursuing the beauty of harmony and balance, and those who interpreted local Korean subject matter in a lyrical manner. Artists including Kim Chongtai, Lee Insung, and Kim Junghyun who had caused a new sensation in art scene gradually began to apply subject matter in a more conservative Classical style. This shift reflected the Joseon Art Exhibition's emphasis on local themes.

The judges of the Joseon Art Exhibition placed a premium value on works that they felt successfully engaged in the expression of local color of Korea. Based on Japan's principle of extending its domestic systems and institutions to its colonies, Korea was regarded as a satellite province of Japan. In this context the criterion for selecting prize-winning works at the Joseon Art Exhibition, as a state-run competition within a colonialized state, lay in how well artists displayed an idea of local color, in order to emphasize and manifest Japanese conceptions about Korean characteristics. This policy of encouraging the expression of local colors at the Joseon Art Exhibition resulted in a prevalence of folk themes—as manifested in depictions of thatched cottages, arrays of *onggi* storage pots, white clothing, women washing clothes, women carrying babies on their backs, and old men smoking pipes—and this tendency led painters only to focus on diversifying themes such as *gisaeng* (professional female entertainers). In this context, a considerable number of non-mainstream artists criticized the manner in which this identified Korean people as primitive and retrogressive. They also questioned the utility of any idea of "local color" that merely sough to perpetuate an understanding of Korea based on agrarian stereotypes, and instead endeavored to seek images that they considered embodying the true, modern local color of Korea.

Kim Chongtai was a self-taught painter who received no formal art education neither in Korea nor abroad but became the first Korean recommended artist in the Western oil painting section of the Joseon Art Exhibition by repeatedly wining special awards. In *Yellow Jeogori* (1929), the bright yellow of a *jeogori* (jacket) contrasts with the black color plane of the background. Here, Kim applied ink-and-wash painting techniques to an oil painting by adding a thin layer of paint spread like ink to the point that the texture of the canvas becomes visible. Details were cursorily depicted with large, swift brushstrokes. His application of ink-and-wash painting techniques to the oil painting *Yellow Jeogori* held great appeal for viewers. [9] *Flowers on a Chair*, which Kim submitted to the tenth Joseon Art Exhibition in 1931, sought a bolder and more energetic spirit captured in a single brush stroke.

Another self-taught painter, Kim Junghyun is often placed in the same group as Kim Chongtai since both came to art through self-study and established themselves as painters via the Joseon Art Exhibition. Kim Chongtai caught the public eye with his transparent colors, energetic lines, and bold, fresh compositions. Kim Junghyun was nominated for a special award for his works depicting the folk beauty of the human ponderous body. Along with Lee Insung, who became a recommended artist at the Joseon Art Exhibition like Kim Chongtai, Kim Junghyun was closely tied with the government and represented the tastes of

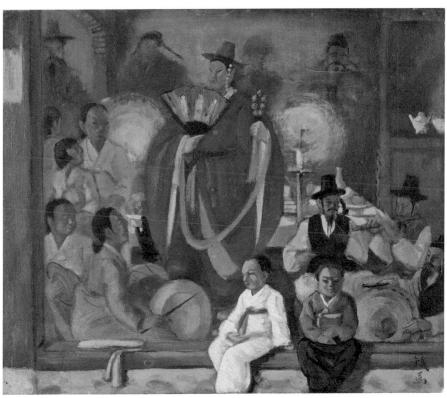

10 Kim Junghyun, *Shaman*, 1941,
 Oil on silk on panel, 41×49 cm

THE ACCEPTANCE OF MODERN ART AND THE INDIGENIZATION OF
 OIL PAINTING

the Joseon Art Exhibition for local color. However, unlike Lee, who absorbed modern art and helped to shape urban-like locality in a sophisticated manner, Kim Junghyun's work was based upon images of the Korean common people that played into Japanese ethnic stereotypes of their strong facial structure with protruding cheekbones, skin roughened by exposure to strong sunlight, and robust physique. He also chose daily domestic, agrarian and social activities as his subject matter.

Shaman by Kim Junghyun received an honorable mention at the twentieth Joseon Art Exhibition in 1941. It is a genre painting that depicts a female shaman and other figures in a primitive setting using the five cardinal colors. **10** In the image, some of the performers seem unable to absorb themselves in the Korean shamanic ritual (*gut*), while other figures seem lost in their own private worlds. This painting is notable in that it is a depiction of village *gut* performed under Japanese colonial rule, when such shaman rituals were prohibited and repressed for it was regarded as superstitious practices that could strengthen the sense of community among Koreans.

While the Korea-trained painter Kim Junghyun established in his work a stereotype of local people based on colonial Japanese notions of exotic Korean physique, Kim Insoong, who studied Western oil painting at the Tokyo School of Fine Arts, replaced the face and body frame of Koreans with those considered to be more typical of Westerners. From the late 1930s through the early 1940s, Kim Insoong, Shim Hyungkoo, Kim Man-hyeong, and Park Youngseun emerged as award-winning artists in the oil painting section of the Joseon Art Exhibition. They had studied art in Japan and pursued the academist painting style preferred within government-organized exhibitions. Among them, Kim Insoong was the most prominent in such government-run exhibitions. In his work he portrayed city people leading sophisticated and comfortable daily lives and fully enjoying the abundance of modern civilization. Kim's *The Melody of Spring* features a scene in which a woman is depicted wearing a modern-style *hanbok* (traditional Korean clothing), while gentlemen clad in neat Western clothes are appreciating a cello performance. Due to the painting's harmonious representation of modern urban cultural flavor, elegant colors, and stable composition, *The Melody of Spring* is considered both a masterpiece of Kim Insoong, and a classic work in the preferred style of the state-organized Joseon Art Exhibition.

The Pursuit of Korean Oil Painting

Yoon Hee-soon, Kim Yongjun, and Kim Bokjin critiqued the "abnormal taste for local [color]"

apparent within the Joseon Art Exhibition, not least as such works centered on the use of primitive folk colors (such as yellow *jeogori*, the five cardinal colors, and primary colors) and indiscreet subject matters. These artists further insisted that Korean artists should seek what true local color of Korea is. As a case in point, Yoon Hee-soon refused any subject matter that may be believed to represent an atmosphere of defeat, including desolate mountains and forlorn fields. He then asserted that only energetic, unrestrained, and lively local color should be created, as exemplified by the iron wall-like mass of rock in the Inwangsan Mountain or the depiction of red soil against clear skies and the sun. In contrast, Kim Yongjun argued that the true Korean sentiment lay not in the depiction of fundamental colors (such as red, green, yellow, and navy) or in the subject matter of traditional customs, but in an aesthetic marked by simplicity and grace.

In the manifesto of the Baengman Oil Painting Association, founded in Tokyo in 1930, the group's leader Kim Yongjun referenced the names of celebrated European painters, including Vincent Van Gogh, Pablo Picasso, Marc Chagall, Georges Rouault, and Wassily Kandinsky, and ended the statement by writing that "a members of Baengman is about to step onto the desert from the time before the birth of Christ once again by following in the footsteps of pioneers such as Van Gogh, with his passion, and Picasso, with his multiple colors."[10] With this manifesto Kim Yongjun employed the study of artworks by Western masters of modern art as a means to mark a beginning of a new era for Korean painting.

The associations of Nokhyanghoe and Dongmihoe, both established around 1930, served as catalysts for the synthesis of the Korean local color theory with broader ideas of an Asiacentric art theory.[11] Sim Yeongseop, Kim Yongjun, and Gu Bonung who supported the Asiacentric art theory, also embraced modernist European art, including Symbolism, Expressionism, and Fauvism, yet strove to discover a legacy for modernism within traditional Korean art.

While studying at the Pacific Art School in Japan, Gu Bonung distinguished himself by becoming the first Korean to win an honorable mention at an exhibition held by the Nikakai Association, serving as a founding member of the Baengman Oil Painting Association and holding two solo exhibitions. Another side of the avant-garde artist Gu can be observed in his critique entitled "After Reviewing the Cheongguhoe Association Exhibition" (1933). In this writing, he advocated for Western art's convergence with the East Asian spirit and expounded the greatness of this "Eastern" spirit, citing Gauguin's experiences in Tahiti, the impact of African art on Picasso, and the inspiration

Francis Picabia drew from Chan (Seon in Korean) Buddhism as examples of the creative possibility of this combination. Gu's work submitted to the opening exhibition of the Mogilhoe Association immediately after his return from Japan in 1933 drew comments for its bold composition and color and swift brushstrokes recalling those deployed by literati painters, and its other creative elements. At this time, Gu himself opened an antique store Ugodang, which further demonstrates his concerns as both an avant-garde artist and an advocate for Asian traditional art and culture.

Submitted to Moksihoe Association (formerly the Mogilhoe Association) in 1937, *Manpa* depicts "Buddha Subjugating Mara and Attaining Enlightenment under the Bodhi Tree," the sixth scene from the *Eight Great Events of the Life of the Buddha* that explains the life of Shakyamuni Buddha. The demon Mara, a woman, and a monster all appear and disturb the Buddha's entrance to nirvana. In this painting, Gu used ink, paper, and a brush and chose a theme and subject matter indicative of Asian culture, a contrast with his avant-garde tendencies of the early 1930s. He also employed swift, sharp, and dynamic lines such as those extending upwards from the lower-right of the picture plane. Along with *Ascetism* from 1935, *Manpa* is considered another notable work that well reflects the Asiacentric art theory, which privileged calligraphy as the apex of East Asian art and attempted to succeed the use of line, ink, and composition from literati painting in a creative manner.

As discussed above, Kim Yongjun foresaw that Western modern art would divert to Asian art because the subjective and personal expression on which Symbolism and Expressionism was based was similar to the concerns of subjectivity and spirituality found in Asian art. Around 1940, Kim fully embraced to ink-and-wash painting as his primary practice. His *Pure Interest in a Scholar's Study* (1942) continued the tradition of still-life painting of vessels and flowering plants (*gimyeong jeoljido*) which was significantly developed by Jang Seungeop (1843–97) and had been popular until the early twentieth century. However, he departed from its distracting schematic compositions and sought instead a simpler aesthetic in this painting. [11] As such, in this painting, the vast void background, the simple signature and seal, the brush lines in the unfolded book, and the celadon bottle with crackled, clear glaze reflect the modest but dignified life of an intellectual. This work embodies the thoughts and artistic viewpoint of Kim Yongjun at this moment, as he tried to separate himself from the shallowness and corruption of the period in which he was living, by turning to the spirit of the literati.

An Apple Orchard (1937) by Oh Chiho (1905–82) was produced during a period in which Oh was deeply impressed by the brilliant light and the lively natural scenery of his surroundings

11 Kim Yongjun, *Pure Interest in a Scholar's Study*, 1942,
Ink and color on paper, 29×43.5 cm

12 Oh Chiho, *A House Facing South*, 1939,
Oil on canvas, 80×65 cm

FROM "CALLIGRAPHY AND PAINTING" TO "FINE ART"

13 Mun Haksu, *A Landscape with Airplane*, Shown at the third Free Artists Association (May 21–30 1939, Ueno Park, Japan), *The Unified Korea*, no. 369 (September 2014)

14 Lee Jungseop, *Full Moon*, 1940. Image from Choi Youl, *Lee Jungseop* (Paju: Dolbegae, 2014)

while recovering from a critical illness. Here, he attempted to try the coloring technique of applying dots of color that he had learned from studying Van Gogh's *The Pink Orchard* (1888). In doing so, he came to realize that an Impressionist painting style could be appropriate for depicting the natural scenery of Korea. *A House Facing South* (1939), a work he produced two years later, can be understood as an updated version of *An Apple Orchard* in which the influence of Van Gogh remains strong. It nostalgically portrayed an image of Korean natural scenery surrounded by bright, warm light and clear air. 12 The blue sky, bluish-purple shadow of an old tree, girl in a red dress poised to step out of

the door, yellow earthen wall in the sunlight, and white dog dozing under the sun were all relatable images for Koreans and could be imprinted in their hearts as classic imaginings of a hometown.

House (1936) by Kim Whanki is an abstract painting that broke up the architectural elements of a traditional Korean house (*hanok*), such as the gate, windows and doors, stairs, and stone wall, into the basic elements of the plastic arts (such as lines, colors, and planes) and reconstructed them two dimensionally. At the time, Hasegawa Saburō, a leader of Japanese abstract art, had elevated the status of East Asian classic art to a valuable source for creating avant-garde art and not as retreated or outdated material.[12] Kim Whanki turned this understanding of the classical East Asian aesthetic tradition as a grand cultural achievement into a particular focus on traditional Korean culture. This became a fundamental idea underpinning Kim's art practice, as can be seen in *House* and many other of his works, such as *Jars* (1936), *The East* (1936), and *Window* (1940), as well as his paintings of ceramics from the 1950s.

Both Mun Haksu and Lee Jungseop went to Osan School in Jeongju, Pyeonganbuk-do Province and the Academy of Culture in Tokyo. They also attracted attention at the exhibition of Free Artists' Association, but their paintings struck an odd contrast. While Mun mostly painted Mongolian horses galloping across an imagined Asian steppe, Lee depicted oxen indigenous to Korea. In Mun's *Landscape with an Airplane* (1939), which was submitted to the third exhibition of the Free Artists' Association, a pair of horses (one white and the other black) and a pair of one-horned black oxen appear to confront each other in a desolate and vast field. A dazed-looking woman in *hanbok* with a baby on her back is standing in between them, and an airplane is flying across the sky. 13 Mun's painting appears to be illustrating a symbolic vision representing the political disquiet of the period, as Japan had just established the Empire of Manchuria and the Second Sino-Japanese War had broken out. In the following year, Mun submitted a painting entitled *Punishing Chunhyang* (1940) to the fourth exhibition of the Free Artists' Association. Here, he reinterprets *The Tale of Chunhyang*, a traditional Korean musical storytelling (*pansori*), in the dream-like manner of Chagall. Similar to *Landscape with an Airplane*, horses and oxen provide mythical apparitions and a woman with a baby on her back is present alongside a thatched cottage. Here, the two main figures, Chunhyang and Yi Mongryong, emerge in a vast wilderness below the horizon, creating an evocative work intended to arouse the sentiments of Korean audiences.

Lee Jungseop, who often painted Korean oxen, also explored the vernacular world of traditional

THE ACCEPTANCE OF MODERN ART AND THE INDIGENIZATION OF OIL PAINTING

folk narratives in his work. His *Full Moon* submitted to the *Gyeongseong Exhibition of the Association of Art Creators in Celebration of the 2,600th Anniversary of the Founding of Japan* in 1940 depicts a bird flapping its wings with its mouth wide open and pointed towards the full moon, a woman bathed in moonlight, and an animal with large, naïve eyes. 14 They are interacting with each other while enjoying the innocence and richness of the primitiveness. This painting is one of Lee's early works that exhibits his animistic worldview which recalls attributes of the nature that remain hidden beyond the unconsciousness.

Both Lee Jungseop and Jin Hwan painted native Korean oxen, but whereas Lee's oxen were not regionally specific, Jin singled out those from his hometown of Mujang in Gochang, Jeollabuk-do Province. While the image of the ox offered by Lee can be considered an embodiment of explosive energy or intimate connectivity with people, Jin Hwan's yellow ox is a peaceful herd animal. Jin's work, *A Pond* (1942) in the collection of the National Museum of Modern and Contemporary Art, Korea (MMCA) illustrates a bird flying with wings stretched out and oxen standing on the diagonal grazing below cumulus clouds. 15 The bird and clouds in the sky are depicted from a level-distance perspective, while the oxen on the ground are captured from a bird's-eye view. The entire space is then fragmented using the multiple perspectives of East Asian ink painting, thereby reflecting modern aesthetic values.

With the outbreak of the Second Sino-Japanese War in 1937 and the Pacific War in 1941 plunging Korea into a state of international conflict, limitations were imposed on the activities of art organizations. In the face of these restrictions, prominent rising artists, including Lee Qoede, Lee Jungseop, Jin Hwan, Mun Hakjin, and Choi Jaiduck, formed the New Artists' Association of and held exhibitions. The leader of the New Artists' Association of was Lee Qoede. Whereas Lee Jungseop, Jin Hwan, and Mun Haksu attempted to arouse lyrical sentiments in viewers by grounding their paintings in the folk narratives of Korea, Lee Qoede created depictions more faithful to reality through the exploration of historical sources. Through this process he endeavored to induce the traditional spirit of Korean art and infuse it with a modern aesthetic.

Lee Qoede was particularly interested in the Western art movements before the twentieth century, such as Renaissance classicism and Romanticism, and endeavored to find out Korean beauty by studying Joseon-era portraits, genre paintings, and paintings of beautiful women.[13] Lee's *Portrait of a Woman* (1943) is a monumental figure painting of a woman in *hanbok* sitting upright against a folding screen with an image of a horse freely running across a field. 16 This portrait is characterized by facial features rendered in fine lines with a brush and an elegant color contrast between the apricot jacket and sky-blue skirt. As with *Portrait of a Beauty* by Sin Yunbok (1758–?), the woman in the tight jacket that reveals the lines of her chest and arms is beautiful, dignified, intellectual, and sensual. This portrait, modeled after Lee's wife, can be paired with his *Self-Portrait in Traditional Coat*. These works can be considered as definitive Korean portraits of a couple from the mid-twentieth century. They portray a married pair of modern Korean intellectuals who took pride in their culture and held on to a sense of national identity while living through the Japanese colonial period and the years of chaos right after Korea's liberation.

WARTIME REGIME ART AND ANTI-JAPANESE ARTISTS

The Joseon Art Exhibition newly established the president's award for the Korean Federation for Total Mobilization of National Spirit (Gungmin jeongsin chondongwon Joseon yeonmaeng) in 1940 which indicates how strictly the wartime cultural regime was imposed on art production. Art organizations such as the Joseon Artists' Association (Joseon misulga hyeophoe) and Dangwanghoe Association, actively participated in the war effort. Moreover, since participation in the militaristic art exhibitions supporting the Japanese war effort, such as the *Peninsula Behind the War Art Exhibition*, *Holy War Art Exhibition*, and *The Final Battle Art Exhibition* was encouraged, the number of artists who were willing to openly support the war increased.[14]

In 1940, the word "free" was removed from the title of the Free Artists' Association in Japan, which served as a stronghold for Japanese avant-garde artists. As implied by the elimination of the word "free," avant-garde art was now fully suppressed and denigrated under the fascist wartime social and cultural restrictions. This decline and corruption of avant-garde art was explicitly revealed in the change of course by Jo Woosik. Jo had previously advocated for the avant-garde spirit in his work and created Surrealist photography, but at this point he began to criticize avant-garde art for being a corruption introduced by Western culture and the outcome of mental bankruptcy. He instead came to emphasize the legitimacy of New System Art.

As opposed to the numerous artists who internalized the theory of "Japan and Korea as one entity" and voluntarily collaborated with the Japanese after the outbreak of the Second Sino-Japanese War, there were equally many artists who were uncooperative and resistant toward Japan.

15 Jin Hwan, *A Pond*, 1942,
Oil on canvas, 24.5×66.4 cm

16 Lee Qoede, *Portrait of a
Woman*, 1943, Oil on canvas,
70×60 cm

THE ACCEPTANCE OF MODERN ART AND THE INDIGENIZATION OF
OIL PAINTING

During this period when artists were frequently mobilized on behalf of the government, a group of anti-Japanese artists worked to sustain the independent Korean national spirit and cultural legacy, and tried not to get drawn into the trend to collaborate. After the magazine *Munjang* was abolished in 1941, Kim Yongjun moved to the outskirts of Seoul to avoid any involvement in pro-Japanese cooperation by living the life of a hermit. Gil Jinseop, who had also taken part in the publication of *Munjang*, held a solo exhibition in Pyeongyang in 1942. In this exhibition, Gil presented gray-toned paintings depicting desolate rural areas and the miserable lives of local residents, violating the government's instruction to illustrate only optimistic lives, or what they called "rearguard art." Kim Whanki withdrew from the Art and Culture Association, after the group had turned entirely toward the production of wartime regime art and did not take part in any pro-Japanese activities. Members of the New Artists' Association, including Lee Qoede, Lee Jungseop, Jin Hwan, and Mun Haksu, all of whom refused to participate in wartime government-led art organizations and exhibitions like the Joseon Art Exhibition, are also regarded as anti-Japanese artists.

1 The Mogilhoe Association, formerly the Baengman Oil Painting Association, was founded in Tokyo, Japan and consisted of graduates from art schools there. Members of the Mogilhoe refused to submit their works to the government-operated Joseon Art Exhibition. They instead participated in exhibitions hosted by the Calligraphy and Painting Association, which were seen as a counter to the Joseon Art Exhibition. For more information on the exhibitions of the Mogilhoe and the works by its members, see Kim Hyunsook, "Gubonungui jakpumeul tonghae bon modeonijeum suyongui ilye" [The Acceptance of Modernism as Seen through Works by Gu Bonung], *Journal of ART History* 11 (1997): 129–152 and Ki Hyekyung, "Mogolhoe yeongu: Modeonijeumgwa jeontongui gilhang mit sangbo" [A Study of Mogilhoe: Contention and Supplementation of Modernism and Tradition], *Art History Forum* 12 (2001): 35–58.

2 For more information on the history of modern Korean art criticism, see Choi Youl, *Hanguk geundae misul bipyungsa* [History of Modern Korean Art Criticism] (Paju: Dolbegae, 2001).

3 Kim Chanyoung, "Hyeondae yesurui daeaneseo: Hoehwae pyohyeondoen 'poseuteu modeonjijeumgwa kyubijeum'" [Alternatives for Modern Art: Post-Impressionism and Cubism in Painting], *Changjo*, January 1921.

4 For more information on the acceptance of Post-Impressionism in Korea, see Lee Aeseon, "1920–30nyeondae hangugui hugi-insangjuui suyong yangsang: Kim Jugyeongui Pol Sejane daehan insigeul jungsimeuro" [Kim Chukeung's Perception of Cézanne: The Aspects of Acceptance of Post-Impressionism in the 1920s and 1930s], *Art History Forum* 49 (2019): 12, 171–191.

5 On the shift in the activities of the KAPF, see Park Seonggu, "Iljeha (1920nyeondae jungban–1930 nyeondae cho) peurolletaria yesul undonge gwanhan yeongu: KAPF gyeongseong bonbuwa donggyeong jibuui daeripjeok yangsangeul jungsimeuro" [A Study on the Proletarian Art Movement during the Japanese Colonial Era (from the Mid-1920s through the early 1930s): Conflicts between the KAPF Headquarters in Gyeongseong and the KAPF Branch in Tokyo] (Master's Thesis, Seoul National University, 1988).

6 In his article, Lee Hagwan introduced Hwang Suljo as a passionate painter like Van Gogh. See Lee Hagwan, "Joseon hwaga chongpyeong" [A General Review of Korean Artists], *Donggwang* 21 (1931): 65–72.

7 Jo Woosik and Joo Hyeon held a two-person exhibition in the gallery at Keijo Imperial University (Gyeongseong jeguk daehak) in July 1939. They presented surrealist abstract photographs. For more information on avant-garde photography at the end of the Japanese colonial era, see Kwon Heangga, "Jayumisulga hyeopoewa jeonwi sajin: Yuyeonggugui gyeonju sajineul jungsimeuro" [Jiyu Bjutsuka Kyokai Exhibition and the Avantgarde Photography: Focused on Youngkuk Yoo], *The Journal of Aesthetics and Science of Art* 51 (2017): 159–200. Regarding the Korean avant-garde art of the 1930s, see Kim Youngna, "1930 nyeondae jeonwi geurupjeon yeongu" [A Study on the Avant-garde Groups in the 1930s], *20 segi hanguk misul* [20th Century Korean Art] (Goyang: Yekyong, 1998), 63–142.

8 For more information about Yoo Youngkuk's early abstract art, see Jung Youngmok, "Yuyeonguui chogi chusang, 1937–1949" [Early Abstract Paintings of Yoo Youngkuk], *The Journal of Art Theory & Practice* 3 (2005): 173–193.

9 Okdongpae refers to a group of artists who socialized at the painter Lee Seungman's traditional Korean house (*hanok*) of a hundred rooms in Ogin-dong. These artists

included Lee Seungman, Yoon Sang-yeol, Kim Bokjin, Kim Junghyun, and Kim Chongtai. This site was so active from the late 1920s through the early 1930s that Gu Bonung divided the art community of the time into the Okdongpae and graduates from the art schools in Tokyo.

10 Kim Yongjun, "Baengman yanghwahoereul maendeulgo" [Upon Establishing the Baengman Oil Painting Association], *Dong-A Ilbo*, December 23, 1930.

11 Kim Hyunsook, "Hanguk geundae misureseoui dongyangjuui yeongu: Seoyang hwadaneul jungsimeuro" [Orientalism in Korean Modern Art] (PhD diss., Hongik University, 2001).

12 Hasegawa Saburō, "Zenei bijutsu to toyo no koten" [Avant-garde Art and Eastern Classics], *Mizuho* 384 (1937): 146–158.

13 Kim Hyunsook, "Yikwaedaeui sujipjaryoreul tonghae bon Yikwaedae jakpumui imiji chamgo yangsang" [The Several Aspects of Image Reference in Lee Qoede's Painting—Research on the Artist's Archive], *Korea Bulletin of Art History* 45 (2015): 191–213.

14 For more information about the art world and the co-operation of Korean artists with the Japanese war effort at the end of the colonial era, see Kim Yongcheol, "Iljeui chimnyak jeonjaenge hyeomnyeokan misulgadeul" [Artists who Cooperated in Japan's Wars of Aggression], *Hanguk misul 100nyeon* [100 Years of Korean Art], ed. National Museum of Modern and Contemporary Art (Paju: Hangilsa, 2006), 372–385.

The New Visual Culture of Photography and Print Media

Kwon Heangga

The initial conception of "art" that was institutionally established in Korea during the first half of the twentieth century was limited to painting, sculpture, and crafts. Compared to the current classification system of collections at the MMCA, which spans painting, sculpture, and crafts but also photography, design, architecture, multimedia art, and calligraphy, the scope of what was considered art in the modern era was extremely narrow. In the modern times, the general public, who had great access to newspapers and magazines filled up with illustrations, comic strips, advertisements, and photographs, perceived the world through these images they saw in everyday life than high, elite art presented in art museums. On the one hand, print art, a practice newly emerged in the modern era, served as a forum where public desires and tastes could intersect directly with the work of educated artists directly, beyond the elite art world, and provide a platform for new cultural practices and new forms of visual communication. Photography, however, offered a major new avenue for the visual expansion of public ideas and access to information through the reproduction of images in mass media. This power to influence was based on the belief that photography was a tool for accurate and objective documentation. In this respect, an examination of the process of the introduction and refinement of populist visual media such as illustration, cartoon, and photography offers an opportunity to look at the structure of modern visual culture in colonial period Korea beyond the elite art world.

THE INTRODUCTION OF PRINT TECHNOLOGY AND THE DEVELOPMENT OF VISUAL MEDIA

The modern era was a revolutionary period in which the methods of mass communication transitioned from text-oriented to visual-oriented media. The emergence of mass media, such as in the form of newspapers and magazines, led to the development of visual attractions both on the printed pages of publications and beyond. These forms of modern visual culture ranged from photography, illustration and advertising, to film, theatre, exhibition, and large-scale corporate retail, the experience of which provided a new way for people to perceive the world in the modern era. Typographic printing techniques and photography arguably played the most significant role in bringing about these changes.

The Office of Culture and Information (Bangmunguk), a government-owned printing office established in 1883, introduced typographic printing to the Korean public for the first time. Typographic printing using mechanized means and a lead type rather than a manual process of pressing woodblocks fueled mass publication. From 1883 to the 1900s, books, newspapers, and magazines in the true modern sense emerged with the introduction of typographic, stone lithographic, and copperplate printing. Nevertheless, printing in this period still centered on text since imagery such as photography and illustration had to be produced and printed separately.

Around 1920, mass media featuring visual images such as photographs, illustrations, cartoons, and advertisements became widely available. The Japanese Government-General of Korea adopted cultural politics as their governing strategy at this point, and for the first time during the Japanese colonial period, private newspapers were published in Korean along with over 200 different magazines. Printing technology also advanced, and offset printing came to be widely used in addition to letterpress, lithographic stone, and copperplate printing. By the 1930s, the printing industry had

grown into an important industrial field. The publishing industry was now flourishing with the development of wholesale and retail distribution systems, transportation, and telecommunications networks that accompanied the revitalization of Korea's capital economy following Japan's annexing of Manchuria. The three major newspapers of the day—the *Dong-A Ilbo*, *Chosun Ilbo*, and *Chosun JoongAng Ilbo*—all launched magazines targeting various social demographics, opening what people called the "era of the newspaper company magazines." In the competition to secure readers, these newspaper companies utilized visual images in their publications. The names of the illustrators and photographers, who designed the magazines' frontispieces, cuts, and layout, were credited in the table of contents. The introduction of Process printing technology in 1935 enabled paintings by artists to be published on the covers of magazines in a clearer and more realistic manner through multicolor printing.[1] At this time the assignment among cartoonists, illustrators, and book designers was not clearly defined, and artists took advantage of the situation to test different means of visual expression that were not conceivable in fine art. During the colonial period, Koreans were only able to experience these new forms of visual culture through the veil of Imperial Japanese censorship as it harnessed its greater capital and more advanced technology to support the promotion of its governing strategies. In turn Korean people appropriated this new technology to their own ends whenever possible, at times resisting and at other times assimilating Japanese concerns. The visual culture of modern-era printing and publishing in Korea goes beyond a simple history of the development of visual media technology. Instead, it should be understood within a multi-layered context encompassing imperialism and colonialism, an explosion in the practices of capitalist consumption and production alongside the quotidian desires for freedom and expression, and the formation of modern Korean identity.

ILLUSTRATIONS, CARTOONS, AND IRON-PEN PHOTOGRAPHY

Saphwa is a Korean term used to indicate pictorial representation that is inserted into reading matter such as books, newspapers, and magazines to facilitate an understanding of the text. Such expositive illustrations were also produced in the pre-modern era, as seen in the illustrated Buddhist manuscripts and the pictorial documentations of the royal ceremonies and rites, such as illustrated depictions (*doseol*) and explanatory diagrams (*dohae*) in Royal Protocols (*uigwe*). These forms of pre-modern illustrations were printed with

woodblocks and therefore produced only in small numbers. However, *saphwa* in the modern era can be considered as a new visual medium in that such items were mass-produced and distributed to serve broad communicative functions. The first *saphwa* to be published in Korean domestic mass media was *Map of the World* in the first issue of *Hanseong Sunbo* in October 1883. It was the first Korean modern newspaper and the official gazette of Joseon published by the government's printing office, Office of Culture and Information. Since then, advertising images were included in newspapers at times, but beginning with the foundation of the *Daehan Minbo* in 1909 *saphwa* began to be published regularly in newspapers.[2] *Daehan Minbo* newspaper was founded by the patriotic enlightenment organization, Association of Great Korea, and from its first issue, it published a woodblock-printed editorial cartoons regularly on its front page. This first *saphwa*, illustrated by Lee Doyoung, depicts a man wearing a Western-style suit and a top hat and stating: "We will examine the state of affairs and draw the soul of the nation together to become an institution that listens to the voices of the people and provides reports on a wide range of matters." **1** The illustration conveys to the public in a clear and approachable manner the aim and mission of the newspaper, which was to achieve national solidarity and contribute to the dissemination of knowledge. This *saphwa* takes the form of a single-panel cartoon with "挿畫" (*saphwa*) printed in Chinese characters at the top of the illustration. The illustrations that were subsequently published were editorial cartoons portraying biting satire of the chaotic circumstances that followed and preceded Imperial Japan's colonization of Korea. **2** These illustrations are considered Korea's first political cartoons.[3] Lee Doyoung, who had studied calligraphy and painting under An Jungsik, pioneered the production of imagery in such printed publications. Lee's editorial cartoons in the *Daehan Minbo* exhibit the characteristics of this early stage of development when the concepts of *saphwa* and *manhwa* (cartoon) were intertwined. But by the 1920s, *manhwa* had become conceptually independent from *saphwa*.

Kim Dongseong was a journalist who contributed to the institutional establishment of the concept of *manhwa* and editorial cartoons in newspapers in the first half of the 1920s. After studying in China, Kim moved to the U.S. in 1909 where he majored in pen and ink illustration at the Ohio State University. From 1918 onward, he began to be known as a "punch artist," that is, a cartoonist. A founding member of the *Dong-A Ilbo* newspaper, Kim began to actively publish satirical political cartoons. "What Comes after the Suppression?" **3** is a typical example of his satirical commentary on current events. In this cartoon, he

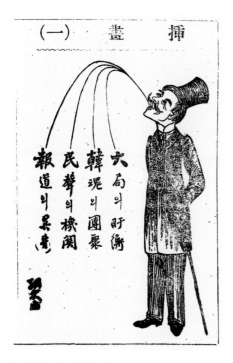

1 Illustrations by Lee Doyoung,
 Daehan Minbo, June 2, 1909

2 Lee Doyoung, "A Civilized March,"
 Daehan Minbo, June 24, 1909

3 Kim Dongseong, "What Comes
 after the Suppression?,"
 Dongmyeong, December 1922

addressed the continued repression of the media by political authorities despite the Japanese claim to be supporting cultural development and expression in Korea. In this context, such suppression included the confiscation of more than 105 newspaper articles, not to mention a ban on their publication, the further deletion of articles, and arrest of many reporters.[4] Kim had been frequently publishing editorial cartoons sharply critiquing the policies of the Japanese Government-General of Korea and its programs of cultural politics, media suppression, and economic and labor exploitation. However, as the publication of editorial cartoons became increasingly difficult in the mid-1920s due to the suppression of the press, Kim introduced the cartoon series *How to Draw Cartoons* [4] and taught the theory and practice of cartooning to An Seokju, Noh Soohyun, and Lee Sangbeom at the Calligraphy and Painting Association. The fact that these three figures became leading print illustrators in the 1920s and 30s suggests that the impact of Kim Dongseong should be reexamined not only in terms of the early history of cartoons but of illustration.

Interestingly, when newspaper cartoons emerged as a highly popular genre of creative political expression in the mid-1920s, the term *manhwa* was being used interchangeably with various expressions connected to photography and painting, such as "iron-pen photography" (*cheolpil sajin*) and "picture story" (*geurim iyagi*). In fact, when Kim Dongseong transferred to the *Chosun Ilbo* newspaper, he entitled his correspondence column "Cheolpil sajin." In this context, the term *cheolpil* refers to an awl-shaped pen used for scratching away waxed stencil paper when mimeographing. It was frequently used as a metaphor for newspaper media at that time. However, in referring to his cartoons as "iron-pen photography," Kim implied that newspaper cartoons reproduce reality just as photographs do, and that cartoonists are in their own way conveying an image of critical truth to the public. This perspective could be taken to further imply that photographs, cartoons, and illustrations were all accepted as visual media that objectively conveyed reality. Whereas photographs produce an objective image visible to the camera lens, cartoons reveal the hidden truth behind. Given the medium's possibility for veracious political commentary, it is perhaps unsurprising that when the Security Maintenance Law was enacted and the Japanese Government-General of Korea's suppression and censorship of the press intensified, it became

increasingly difficult to publish political cartoons in newspapers and magazines. Therefore, from the late 1920s to the 1930s, cartoons in Korea were mainly comprised of social conditions, popular topics, and foreign illustrations, rather than national political satire.

Satirical cartoons that focused on social conditions gained the greatest popularity among the public during the modern. An Seokju had drawn a cartoon with strong political connotations for the magazine *Gaebyeok* in 1924, but he switched to social satirical cartoons and illustrations for newspaper serial novels in the wake of heightened censorship. In particular, *Manmun Manhwa*, [5] which he contributed regularly in the *Chosun Ilbo* newspaper since the late 1920s, took the perspective of a flaneur sauntering about Gyeongseong (present-day Seoul) to address the experience of modern life in a colonial city, and reflect on how Koreans engaged in new customs and trends based around consumerism.[5] An Seokju's *Manmun Manhwa* delivered values and messages on the themes of modern daily lives, such as sexual and consumer desires and people's view on generations and marriage, among other customs, through his visual language.

A TESTING GROUND FOR NEW PERSPECTIVES: ILLUSTRATIONS IN SERIAL NOVELS

During the 1920s and 1930s when the distinction between *saphwa* and *manhwa* became increasingly marked, illustrations for serial novels in newspaper attracted the most attention on the part of the graphic artists and the public. At the time, serial novels significantly impacted newspaper subscription rates. Their illustrations were as important to readers of the serials as the plot of the novel since they caught their attention prior to reading any text. Moreover, advertisers, who provided a major source of income for newspapers, often made their decisions to buy ads based on the quality of the illustrations in the serial novels. Newspaper companies sought to enhance the quality of such illustrations by hiring renowned artists.[6] For this reason, illustrators were perceived at the time as illustrators for serial novels. Along with the painter and calligrapher Kim Changhwan, who began his career as an illustrator at the *Maeil Sinbo* newspaper in 1921, An Seokju, Noh Soohyun, Lee Sangbeom, and Lee Seungman in the 1920s, and Jung Hyunwoong and Kim Gyutaek in the mid-1930s became the most renowned illustrators.

The most prominent serial novel illustrator of the 1920s was An Seokju. Together with Kim Bokjin, An was a leader of the proletarian art movement of the 1920s, as indicated by their joint formation of the literary group PASKYULA in 1923 and the Joseon Cartoon Club (Joseon manhwa gurakbu) in 1925. An worked across various realms of visual media as an illustrator, cartoonist, screenwriter, and film producer. Beginning with illustrations for a serial novel published in the *Dong-A Ilbo* newspaper in 1920, An was responsible

4 Kim Dongseong, "How to Draw Cartoons 2: Heads," *Dongmyeong*, March 1923

5 An Seokju, "Opinion: Modern Girls' Effort to Doll Up," *Chosun Ilbo*, February 5, 1926

for numerous illustrations in major daily newspapers. An's notion of the populist cultural and political potential of print was reflected in his view that, "to popularize painting, cartoons and illustrations should be further developed, in preference to art for art exhibitions. Just as novels and plays have fallen behind cinema, cartoons and illustrations will come to replace newspaper editorials."[7] In this respect An considered illustrations and cartoons as a more effective form of communication for busy modern people and workers.

For An, cartoons were a very useful medium to make topical and socially satirical comments, while newspaper illustrations provided him with a platform for stylistic experiments. In fact, he applied multiple techniques when making illustrations without being limited to a particular style, embracing many diverse styles including academicism, Art Nouveau, Symbolism, Futurism, Abstraction, and cinematic convention. For example, *Bulkkot*, Lee Geukseong's Korean translation of Kikuchi Kan's novel *Hibana* features a figurative female nude, while his illustrations for Na Do-hyang's *A Young Man's Life* include an image of a femme fatale style woman with a snake wrapped around her body, evoking Symbolist art. Additionally, the depiction of a nude female figure in Yi Kwangsu's novel *Rebirth* was rendered in a Cubist style. An at times expressed the divided desires of humans through such cubistic compositions, comprised of fragments of the hands, feet, mouth, and face, and at other times presented cinematic closeups of the face, to allow the viewers to explore the psychology of the protagonist, or created feelings of tension through a closeups on parts of the body such as the hand or foot.[8] 6 In using ideas from Classicism, Art Nouveau, Symbolism, Cubism, and montage from cinema, An Seokju's illustrations provided the public with an expanded range of perspectives that had not been possible within the realm of fine art in the 1920s.

With the rise of full-fledged newspapers and magazines in the 1930s, social perceptions about illustrators and illustrations also changed. The term *saphwa* came to be defined by the English words "illustrate" and "illustration," embodying the meaning "to make clear" and "to exemplify." Examples of *saphwa* were perceived not simply as drawings or paintings explaining something that has been written in the text, but as works of art in themselves.[9] The profession of illustrator became a preferred occupation among the public, and the realities and problematic issues within newspaper illustration production and its art world began to be discussed.[10]

Jung Hyunwoong was a leading figure in the establishment of illustration as art form in the

6　An Seokju, "Haniya," *Maeil Sinbo*, December 11, 1926

public imagination. Jung had begun his career as an oil painter through exhibiting in the Joseon Art Exhibition but joined the Advertising Department of the *Dong-A Ilbo* newspaper in 1935 and eventually came to be in charge of the illustrations for Lee Mu-yeong's serial novel *When the Sun Rises in the Distance*. 7 When artist, art critic, and art historian Kim Yongjun wrote an overview of the Korean art world in 1935, he highlighted Jung Hyunwoong's illustrations as one of the most notable innovations of the year.[11] From then until 1940s, Jung engaged in a vast range of activities including the creation of illustrations and book designs. He caught readers' attention with his use of montage, precise drawing and realism, as well as for his diverse painterly perspectives that included steeply elevated or bird's-eye views and closeups, none of which had been seen in the works of preceding illustrators.[12] In this regard, Jung Hyunwoong's illustrations were greatly influenced by film techniques. He had long been a cinephile, even writing reviews of Hollywood films while he was a student. He believed that modern art was moving in the direction of Sergei Eisenstein's cinematic theory of montage; going beyond a focus on simple single point perspective in its reproduction of modern reality.[13]

Another characteristic of the illustrations by Jung Hyunwoong is that many of the featured figures are modelled upon idealized "Western," rather than Korean physique, perhaps inspired by the images of Hollywood stars whose movies were increasingly popular in Korea. In particular, in the romance novels portraying urban love stories between men and women, while the characters are Korean people living under Japanese colonial rule with accordingly defined modern desires and internal conflicts, the figures depicted in the

illustrations appear to be of an idealized Western proportion. For example, an illustration in "Flower Patterns of the Century" depicts a scene in which the female protagonist experiences boredom with the academic painting on display while visiting the Joseon Art Exhibition on her day off. In this illustration, the heroine has body proportions like those of an idealized Western woman, proportions which in turn mirror the image of the nude woman portrayed in the academic style painting hanging in the gallery. **8** This is the way that human figures were often depicted in illustrations during the modern era and can be observed not only in the works of Jung Hyunwoong, but also An Seokju and Kim Gyutaek. In this respect, the illustrations in popular novels that were published in newspapers and magazines in the 1920s and '30s served as screens on paper. Here, illustrations provided a voyeuristic space where readers, essentially the modern public, could read and project their desires as well as a fantasy space beyond the realities of colonial life.

THE INTRODUCTION OF PHOTOGRAPHY

Sajin, which now corresponds to photography in Korean, was originally a visual cultural term that has been used since the twelfth century to denote "portraits intended to capture not only the outer appearance but also the spirit of the sitter" as well as a verb meaning to draw such portraits. What can be understood from the fact that *sajin* became the preferred translation of the English term "photography" is that the introduction of photographic technology was closely related to the traditional discourse of art. This translation

came from the early practice of taking portraits in a photo studio. A Joseon delegation to China in 1864 had their pictures taken in the studio of the Russian legation in Beijing. Yi Hang-eok, an official in the delegation, recorded the act of taking photographs as "sajin" in his diary of the journey to Beijing, *Diary of a Journey to Yen*. Here, he referred to the developed photograph as a "*hwabon*" meaning a manual for painting.[14] He also described the scene of the taking of the portraits as a photographer with a black cloth draped over his head standing in front of a large camera and chanting a spell to make an image form on the glass in an upside-down manner. This process was perceived as a remarkable magical experience of painting a portrait. In this way, the word *sajin*, signifying portraiture, came to be used as a translation for "photography" with the introduction of photographic technology in the 1880s.

Kim Yongwon, Ji Woonyoung, and Hwang Chul were pioneers of the introduction of photography. They shared a background as calligraphers and painters and as intellectuals affiliated with the Enlightenment Group (Gaehwapa). In the summer of 1883, Kim Yongwon brought the Japanese photographer Shunosuke Honda to the Jeo-dong neighborhood in Hanseong (present-day Seoul) and established a photo studio they named Chwaryeongguk.[15] In February 1884, Ji Woonyoung returned to Korea after studying photography in Japan and took the first photograph of King Gojong in March, together with Percival Lowell. In the same year, Hwang Chul returned to Korea after taking up photography in Shanghai, China, and renovated the study in his home in the Daean-dong neighborhood (present-day Songhyeon-

7 Jung Hyunwoong, "When the Sun Rises in the Distance," *Dong-A Ilbo*, November 21, 1935

8 Jung Hyunwoong, "Flower Patterns of the Century," June 1938

dong, Jongno-gu), in Seoul to set up a photo studio. He took photos of people, palaces, and government offices. Hwang Chul believed that the new photographic reproduction technology could replace the function of the Royal Bureau of Painting (Dohwaseo). Therefore, when he was accused of revealing national secrets through his photographs, he appealed to King Gojong to abolish the Royal Bureau of Painting and replace painting with photography.[16] Although his appeal was rejected, from then onwards, photographic portraits began to be used instead of painted images when establishing diplomatic ties with other countries. Furthermore, photographs came to be recognized by the public as a powerful technique of reproduction, to the point that rumors began to circulate claiming that the materials for photographs were obtained by digging into the eyes of children. Since then, the realistic representations in the photographs served as a catalyst for social enlightenment, and an advanced visual cultural language that has provoked substantive change in the parallel traditions of painting.

1883 was not only the year in which the Chwaryeongguk photography studio was established, but it also marked the introduction of modern printing technology with the opening of the Office of Culture and Information. However, both the Office of Culture and Information and Chwaryeongguk were destroyed during the attempted coup d'etat in December 1884 known as the Gapsin Jeongbyeon. Despite this setback, Kim Kyujin pressed on with the practice of this new visual technology, following the successes of the first generation of photographers. Kim was in charge of the management of the ceremonial rites of the imperial court at the Ministry of the Royal Household (Gungnaebu) and studied photography in Japan. He took a photographic portrait of Emperor Gojong in 1905 and sent it to the United States. However, when Gojong was forced to abdicate and Emperor Sunjong ascended to the throne in 1907, Kim quit his government post to establish the Cheonyeondang Photo Studio. In 1910, he opened the Hanseong Art & Sculpture Company in the same building to process copper and zinc plates for photography and teach photographic printing techniques.[17] Furthermore, he operated the Gogeum Calligraphy and Painting Gallery from around 1913, which commissioned and sold calligraphy and paintings. This demonstrates how in the early twentieth century, when photo studios began to be established, the painters worked as photographers and photo studios functioned as art galleries.

Kim Kyujin's *Photograph of Hwang Hyeon* (1909) captures the intellectual Hwang one year before he wrote a death poem and committed suicide following the Japanese annexation of Korea in

1910. 9 At the lower part of the photo mount is written "韓國京城.天然堂寫眞館金圭鎭" (Kim Kyujin from the Cheonyeondang Photo Studio in Gyeongseong, Korea), an inscription designed to elevate the identity of the photographer as the artist responsible for the production of the image. At the upper right is a further inscription, "梅泉五十五世小影" meaning that this is a small portrait of Hwang Hyeon at age fifty-five, the appearance of which is deliberately in accordance with the customs of traditional Korean portraiture. At the time, the characters "影" (yeong) and "眞" (jin) were also commonly used in reference to portraiture. *Portrait of Hwang Hyeon* (1911) is his another portrait painted by Chae Yongshin based on Kim's photograph. On its back is an inscription "辛亥五月上澣金馬從二品行定山郡守蔡龍臣臨眞" which reads that Chae Yongshin, who had served as the magistrate of the county of Jeongsan as a minor second-rank official, painted it after a portrait in the early part of the fifth lunar month in 1911. 10 Here, the term portrait (眞) in the inscription implie a photograph. Chae Yongshin's portrait was produced after Hwang had committed suicide, so Chae referred to the photograph when painting the face but made changes in the clothing. These two

9 Kim Kyujin, *Photograph of Hwang Hyeon*, 1909, 15×10 cm

10 Chae Yongshin, *Portrait of Hwang Hyeon*, 1911, Color on silk, 120.7×72.8 cm

FROM "CALLIGRAPHY AND PAINTING" TO "FINE ART"

works usefully demonstrate the transition that took place in early portrait photography, and how these were marked by the influence of traditional portrait paintings.

As commercial photo studios became more prevalent from the 1910s onwards, portrait photographs became a part of everyday life. The subject matter now ranged from the "picture brides" who immigrated to Hawaii, to graduation albums, identification pictures, mugshots, and photojournalism. Given this expansion, there might have been some question over whether the traditional portraiture would vanish. However, portrait painting, which had been exclusive to the ruling class during the Joseon Dynasty in accordance with Confucian culture, did not disappear in modern society even when photography became commonplace. They continued to be produced for religious purposes and for the emerging bourgeoise. Chae Yongshin, who had achieved fame by painting the portrait of the emperor during the Korean Imperial era, survived as a professional portrait painter by meeting the demands of the public during the Japanese colonial period. He operated the Chaeseokgang Office of Painting (Chaeseokgang dohwaso), which provided customized services by producing portraits based on requested clothing and poses upon receiving photographs from clients by mail. The photograph eliminated the need for clients to visit the studio in person, and clients demanded photo-like realism.

ART PHOTOGRAPHY

From the introduction of photography in the 1880s up until the 1910s, calligraphers and painters took a leading role in the development of photography techniques. However, starting in the 1920s there was a division between artists and photographers as photography circles were independently formed among commercial and amateur photographers.

In the late 1920s, the art world in Korea pursued Eastern or Joseon-style modernism that privileged individual subjectivity and diverted from the photo-like mechanical representation. For artists pursuing modernism, if their work was evaluated as being "like a photograph," this meant that it was simply a mechanical reproduction of reality that their forerunners practiced and a manner that they should overcome.[18] At this time, a movement toward art photography emerged in the photographic community that regarded the medium as a tool for subjective expression rather than a technique for the objective reproduction of subjects. Yesul sajin, meaning "art photography" in Korean, was originally a collective term for the "pictorial photography" that was popular in Japan between the 1890s and 1920s. It is characterized by the use of various printing methods such as the pigment printing process to create a painting-like effect on the final object/image. This concept was introduced to Korea by Japanese photographers who operated photo studios in Korea in the 1900s. Afterwards, a related form of art photography began to emerge among Korean commercial photographers in the 1920s. In 1926, the Gyeongseong Photographers Association (Gyeongseong sajinsa hyeophoe), organized by commercial photographers in Gyeongseong (present-day Seoul), began carrying out independent research on art photography through various study groups. Shin Nakkyun, who had returned to Korea in 1927 after studying at the Tokyo Institute of Photography, popularized a variety of new printing methods and photography theories through his lectures at the Gyeongseong Photographers Association and at the YMCA, and by writing actively. He introduced the pigment printing process as a method for imbuing artistic value into photography, a medium that had previously been perceived as nothing more than a mechanical technique for documenting objects.[19]

In the late 1920s, the number of amateur photographers increased vastly as photography emerged as a component of modern leisure culture among the middle class with the introduction of small Japanese, German, and American cameras, particularly the Vest Pocket Kodak Camera and dry plate film from the Eastman Kodak Company of the United States. Art photography led by such amateur photographers became increasingly widespread in the 1930s. Jeong Haechang, who had returned to Korea after majoring in German at the Tokyo School of Foreign Languages and studying photographic chemistry and pigment printing processes became the first person to hold a solo exhibition of art photography in Korea in 1929. At the four subsequent solo exhibitions he held between this point and 1939, he displayed some 500 photographic works, including photographs of everyday scenery, allegorical still-life photographs featuring arrangements of objects such as dolls and skulls, and composite photographs. He attempted to incorporate elements of traditional painting, for example, impressing seals onto photographs as if they were ink paintings and attaching photographs to fans or folding screens.[20] However, his effort to fully establish the artistic value of photography within the Korean art world, as equivalent to the practice of painting, was interrupted by the outbreak of war. Following Korea's independence from Japan, Jeong changed direction and began to study seals on paintings and ancient calligraphy and paintings of East Asia. However, Jeong's work during the Japanese colonial period fueled the development of art photography among amateur photographers in the 1930s.

The numerous photography competitions hosted by newspaper companies also pioneered the development of photography as an accepted art form in the 1930s. The Joseon Photography Exhibition sponsored by the *Gyeongseong Ilbo* newspaper and the Summer Landscape Photography Competition (1937–40) sponsored by the *Chosun Ilbo* newspaper were the most influential of these photographic awards. In Korea, where there was no professional photography school, these newspaper photography competitions were the only gateway to professional recognition and success. In particular, the Joseon Photography Exhibition co-organized by the *Gyeongseong Ilbo* newspaper (the official media outlet of the Japanese Government-General of Korea) and the Joseon Federation of Photography (Jeon joseon sajin yeonmaeng, 1934–43) was the most prestigious competition for amateur photographers. At the time, the main stylistic requirements for submissions to the competitions were that they be printed using the pigment process, or feature a painting-like composition focusing on the harmony of light and shade. 11 However, in the early iterations, these competitions also assimilated aspects of what was known as *sinheung sajin*, or "new photography." *Sinheung sajin* was a term derived from the Japanese translation of the German *Neue Sachlichkeit* photography, referring to a modernist photography movement of the mid-1920s aimed at remaining faithful to the physical reproducibility that could be achieved with cameras and lenses. Attempts to diversify the perspectives and framings traditionally used by photography, which was a feature of the 'new photography' movement, included extreme close-ups, an elevated view of objects taken from above, and low-angle views, were all characteristic of the range of photographs submitted to the first few years of competitions. 12 In terms of subject matter, landscape photography was common to such a degree that it was considered that art photography equaled landscape photography. Most of the landscape photography portrayed rural, pastoral, and local sceneries. This concern was closely related to the screening criteria of the competitions at the time, which emphasized the local color of Korea, one of important guidelines that shaped the character of the Joseon Art Exhibition. Under the wartime censorship system of the late 1930s, photography competitions began to privilege submissions that depicted idealized charming Korean autumn and winter landscapes. The major figures in early-art photography, including Kim Jeongrae, Park Pilho, Seo Sunsam, Yi Hyeongrok, Limb Eungsik, Jeong Doseon, Choi Kyebok, and Hyun Ilyeong, all participated in these competitions. With the rise of realism and documentary photography following Korean independence from Japanese colonial rule,

the competition-style photography of the 1930s came to be referred to as "salon photography." It was criticized as an enervated, passive form of photography that depicted on romanticized notions of natural beauty, ignoring the reality of the nation, and thereby an approach that needed to be left behind or overcome.[21]

In terms of the global history of photography, the period from the 1920s to the 1930s following the First World War witnessed the rise of several aesthetic innovations in photography as an art form. From the photomontages of John Heartfiled in Germany, the proletarian experimental photography of Russian constructivism, *Neue Sachlichkeit* photography in Germany, and the photoplastics, typophotos, and photograms of László Moholy-Nagy at the Bauhaus to surrealist photography, the medium emerged as a quintessentially modernist mode of creative expression and a means to achieve a new manner of portraying reality. These innovative movements diverted from the art photography of the Pictorialism that aimed to beautify the subject matter and strove to explore the essence of photography and its potential for expression as a new medium for realism.

Photojournalism began to rapidly develop with improvements to photographic printing along with the development of gravure printing in the 1920s. It provided a further mediatic platform to realize this shift in the function of photography, offering a means to covey the reality of the world beyond the viewer's immediate experience. Even in Korea, photographs embracing diverse compositional perspectives and serial montage images were considered as "modern" illustrative approaches within mass media and became commonplace in the late 1920s and 1930s. They could be found in socialist magazines, film and cinema periodicals, pictorial journals, in advertisements (such as for the Japanese Ajinomoto seasoning or Reto Cream cosmetics), and even in students' graduation albums. For example, the photomontage featured in the graduation album of the students of Boseong High School 13 clearly demonstrates how this visual culture was used in everyday life as a tool for expression. This montage, featuring Namdaemun Gate in the center, is surrounded by swirling images of the Stone Pagoda at Wongaksa Temple, trains, the Hangang Railway Bridge, vertical smokestacks, and modern architectural constructions. This resulting composite image represents the feelings of awe and affection that these students had about the colonial city of Gyeongseong. Such a mode of expression was completely distinct from that of the painting-like photographs that provided the constant fare within official photography competitions and exhibitions. The form of the student's composition was likely made possible by the fact that the expansion of

11 Limb Eungsik, *Homeward Route*, 1935, Gelatin silver print on paper, 25×32.5 cm

12 Choi Kyebok, *Relaxed Fisherman*, 1937, Gelatin silver print on paper, 22.7×29.5 cm

THE NEW VISUAL CULTURE OF PHOTOGRAPHY AND PRINT MEDIA

13 Photomontage from the thirteenth graduation album of Boseong High School in 1935

14 Yoo Youngkuk, *Photograph No. 3*, 1942, Postcard, 8.5×13.4 cm

perspective had already become internalized within the public through the printed media constantly encountered in everyday life. On the other hand, photographs that sought to be recognized as art at competitions were encouraged, if not required, to adopt the grammar of "new photography," such as the deployment of high or low-angle shots. However, it was difficult for them to suggest any radical new perspectives or modes of expression to capture reality, as it was time when the system of approbation was designed to endorse on works that engaged in the romantic and contrived aestheticization of the landscape of colonial Korea and domestic wartime society. In the late 1930s, formative experiments such as photograms and photomontages were pursued by artists, Jo Woosik, Ju Hyeon, and Yoo Youngkuk, all of whom had participated in an exhibition by the Japanese avant-garde art group Association of Free Artists (Jiyū bijutsuka kyōkai), and by photographers Limb Eungsik and Park Pilho, but they rapidly returned to classicism or switched direction when the nation was put on a war footing.[22] 14

VISUAL CULTURE UNDER A NEW PUBLICATION SYSTEM

With the outbreak of the Sino-Japanese War in 1937 and the subsequent launch of the Pacific War, Japan and Korea pursued total national mobilization. After Japan introduced a new system of colonial governance in August 1940, the Korea Federation for Total National Mobilization was formed in October to support the establishment of the system. Accordingly, all cultural activist groups and media organizations, including the publishing houses,

were merged under strict government control. Submissions to the Joseon Photography Exhibition and Joseon Art Exhibition were explicitly required to promote and support the war.

The Japanese Empire perceived the Greater East Asian War as a war of ideas and used publications, or "paper bullets" as they called it, for mobilizing the public extensively. Although the publication of most of the magazines that had been issued in the 1930s had to be halted due to a shortage of paper, war propaganda magazines such as *Bando jigwang*, *Sinsidae*, *Sogungmin*, *Gajeong jiwu*, and *Bangsong jiwu* were published and distributed in large quantities. Photographs, illustrations, and frontispieces actively served as war propaganda. Many artists who professionally worked in illustration, including Jung Hyunwoong, Kim Eunho, Park Youngseun, Lee Insung, Kim Gyutaek, Lee Seungman, Kim Man-hyeong, Shim Hyungkoo, and Hong Ubaek, contributed frontispieces and other material to such publications. 15

From 1938 onward, photography competitions required that submissions reflect the social and political climate of the time, and official jurors demanded that the photography community should create only documentary photos of everyday life that were sympathetic to the war effort. In this context, photographs capturing the enthusiasm of people at the home front set against late-autumn and winter landscapes were recommended, whereas those that could have a negative effect on military discipline, strategies, and tactics or depress the morale of soldiers were strictly prohibited.[23] And, with the start of the 1940s, art photography was replaced by press photography. Paradoxically, this period of conflict was when the photography

FROM "CALLIGRAPHY AND PAINTING" TO "FINE ART"

world witnessed the greatest development of photojournalism in the years prior to Korea's independence from Japanese colonial rule.[24]

As can be seen from the fact that the Korean term for photography originated out of portraiture and that the first artists to introduce this technology were calligraphers and painters, photography was perceived from its outset as an advanced medium that could substitute established forms of art. During the Japanese colonial era, photography established itself as a new medium that was able to compete with painting. Although its recognition as an art form was restricted due to the particular circumstances of the colonial art world, the experience of Korean photographers traveling the country with their cameras, portraying the unique character of the nation and the era served as a starting point for the development of Korean photography as a fully-fledged means of artistic expression.[25] Although advocates of documentary photography after Korea's independence in 1945 sharply criticized those photographers who engaged

in the creation of imagery that was detached from reality, the desire to pursue photography as a means of creative personal expression also remained constant in their practice. However, up until the early 1960s, many conservative voices within the Korean art world continued to question how photography could be considered an art form, given the technical simplicity of the act of taking a photography via the click of button. In this respect, acknowledging photography as one category in elite art world was not easy. While photography was temporarily included in the National Art Exhibition starting in 1964, it was only after the 1990s that the boundary between photography and other more fine art became effectively blurred within elite institutional contexts.

15 Cover image by Jung Hyunwoong, *The Light of the Peninsula*, June 1941

1 Editorial Board on the seventieth Anniversary of Bojin-jae, *Bojinjae 70nyeonsa: 1912–1982* [Seventy Years of Bojinjae: 1912–1982] (Seoul: Bojinjae, 1982), 37–42.

2 Hong Sun-Pyo, "Hanguk gaehwagiui saphwayeongu" [A Study on the Illustrations of the Period of Modernization in Korea], *Art History Forum* 15 (2002): 257–293; Hong Sun-Pyo, "Gyeongseongui sigakmunhwa gongramjedo mich yutonggwa gwanjungui tansaeng" [The System of Spectatorship and Dissemination of Visual Culture and the Birth of the Spectator in Gyeongseong] in *The Visual Culture and Spectators in Modern Gyeongseong* (Seoul: Center for Art Studies, Korea, 2018), 33–52.

3 Choi Seoktae, "Idoyeong yesurui geundaeseong: aegukgyemong misul [Modernity in the Art of Lee Doyoung: Patriotic Enlightenment Art]" in *Anthology of Korean Modern Art* (Seoul: Hakgojae, 1992), 363–384; Chung Heechung, "Hanguk geundae chogi sisamanhwa yeongu 1909–1920" [A Study on Korean Cartoons of Early Modern Ages 1909–1920], *Journal of Korean Modern & Contemporary Art History* 10 (2002): 131–132.

4 Choi Youl, "1920nyeondae minjok manhwa undong—kimdongseonggwa anseokjureul jungsimeuro" [The National Cartoon Movement in Korea in the 1920s—Focusing on Kim Dongseong and An Seokju], *Yeoksa bipyeong* 2 (1988): 277–282.

5 Shin Myeongjik, *Modeon ppoi gyeongseongeul geonilda—manmun manhwaro bon geundaeui eolgul* [Modern Boys Sauntering around Seoul: The Faces of Modernity Seen through Manmun Manhwa] (Seoul: Hyunsil Publishing, 2003).

6 An Seokju et al., "Sinmun soseolgwa saphwaga" [Newspaper Novels and Illustrators], *Samcheolli*, August 1934. For the relationship between newspaper novels and illustrators, see the exhibition catalogue *Encounters Between Korean Art and Literature in the Modern Age*, ed. MMCA (2021).

7 An Seokju, "Ilga ireon" [One Remark per Household], *Byeolgeongon*, September 1930; "Yesulgaui gajeong: Saphwagaro yumyeonghan anseokju ssiui gajeong" [An Artist's Home: The Home of Renowned Illustrator An Seokju], *Jungoe Ilbo*, December 7, 1926.

8 Kang Minseong, "Hanguk geundae sinmun soseol saphwa yeongu: 1910–1920nyeondaereul jungsimeuro" [A Study on the Novel Illustrations in the Korean Modern Newspaper: From 1910s to 1920s] (master's thesis, Ewha Womans University, 2002); Lee Yourim, "An Seokju sinmun soseol saphwa yeongu" [A Study on the Newspaper Novel Illustrations of An Seokju] (master's thesis, Ewha Womans University, 2007); Gong Seongsu, "Nudeu sapwawa singminji yukcheui jaehyeon: 1920nyeondae sinmun yeonjae soseol saphwareul jungsimeuro" [The Nude Illustration and the Colonial Body Represented: Focusing on Works of the 1920s Newspaper], *Sangheo Hakbo* 57 (2019): 15–45; Chung Heechung, "1920nyeondae sinmun yeonjae soseol saphwawa modeoniti: Inchae pyohyeoneul jungsimeuro" [Illustrations of Newspaper Serial Novel and Modernity in 1920s: Focusing on Human Body Expression] *Art History Forum* 48 (2019): 135–156.

9 Jung Hyunwoong, "Saphwagi" [A Brief Essay on Illustration], *Inmun Pyeongnon*, March 1940.

10 Yoon Hee-soon, "Sinmun saphwa pyeongyeon" [A Short Essay on Newspaper Illustrations], *Dong-A Ilbo*, April 9, 1932; Yoon Hee-soon, "Sinmun soseorui saphwae daehaya" [Regarding Illustrations of Newspaper Novels], *Maeil Sinbo*, October 12–22, 1933.

11 Kim Yongjun, "Hwadan ilnyeonui dongjeong (ha)" [Korean Painting Circles over the Year (II)], *Dong-A Ilbo*, December 28, 1935.

12 Choe Riseon, "Jeong hyeonungui jakpum segye yeongu" [(A) Research on Jung Hyunwoong's artistic achievements] (master's thesis, Seoul National University, 2005); Kwon Heangga, "Gokyesawa hwagaui jahwasang: Jeong hyeonungui jakpum segye yeongu" [The Self-portraits of an Acrobat and Artist: The Works of Jung Hyunwoong during the Period of Japanese Occupation] in *Sidaeui nun* [The Eye of the Periods] (Seoul: Hakgojae, 2011), 77–114.

13 Jeong Heonung, "Misul" [Art], *Bipan*, May 1938.

14 Choi In-jin, *Hanguk sajinsa: 1631–1945* [A History of Korean Photography: 1631–1945] (Seoul: Noonbit Publishing, 1999), 36–51; Park Juseok, "Sajingwaui cheot mannam: 1863 nyeon yeonhaengsa iuiik ilhaengui sajin balgul" [A Study on the Origin of Korean Photography], *AURA* 18 (2008): 50–61.

15 "Chwaryeongguk," *Hanseong Sunbo*, February 14, 1884.

16 Youn Bummo, "Hangukui sajin doipgiwa seonguja hwangcheol" [The Period of the Introduction of Photography in Korea and Its Pioneer Hwang Chul] in *Hanguk geundae misul: Sidae jeongsingwa jeongcheseongui tamgu* [Korean Modern Art: A Study on Time Spirit and Identity] (Paju: Hangil Art Museum, 2000), 75–102.

17 "Hanseong misul jogaksa" [The Hanseong Art & Sculpture Company], *Hwangseong Sinmun*, June 23–29, 1910.

18 Kim Yongjun, "Ekseupuresonijeume daehayeo" [On Expressionism], *Hakjigwang* 28 (1928); Kim Chukeung, "Nokhyangjeoneul apdugo: Geurimeul eotteoke bolkka" [Before the Nokhyangjeon Exhibition: How the Works Should Be Viewed], *Chosun Ilbo*, April 5, 1931.

19 Shin Nakkyun, *Sajinhak gaesul* [Introduction to Photography] (Seoul: Chung-Ang University Press, 1977).

20 Lee Kyungmin et al., *Byeogui yechan, geundaein jeonghbaechangeul malhada* [Talking About a Modernist, the Devotee of the Mundane: Jung Hae Chang] (Archive Books, 2007).

21 Yu Jihyeon, "Iljesidae yesul sajinui gaenyeomgwa yesulsajingaui insik" [The Concept of Art Photography and the Perception of Art Photographers during the Period of Japanese Occupation], *Art History Forum* 12 (2001): 105–125; Lee Kyungmin, "Hanguk geundae sajinsa yeongu: Sajinjedoui hyeongseonghwa jeongae" [A Study on the History of Modern Korean Photography] (PhD diss., Chung-Ang University, 2011); Kim Hyeonji, "Hanguk geundaegi yesulsajinui jeongaewa sajin gongmojeonui jeongchak: Joseon sajin jeollamhoereul jungsimeuro" [A Study on the Development of Art Photography and Photography Contest : Centering on Joseon Photography Exhibition], *Journal of Korean Modern & Contemporary Art History* 34 (2017): 35–62.

22 Choi In-jin, "Misulsajinui seonguja, yuyeongguk seonsaeng" [Yoo Youngkuk, the Pioneer of Art Photography], *Yoo Youngkuk Journal*, April 2004, 95–104; Kwon Heangga, "Jayumisulga hyeophoewa jeonwi sajin: Yuyeonggukui gyeongju sajineul jungsimeuro" [Jiyu Bjutsuka Kyokai Exhibition and the Avantgarde Photography: Focused on Youngkuk Yoo], *The Journal of Aesthetics and Science of Art* 51 (2017): 159–200.

23 "Neutgaeul, chogyeourui jayeonmi kamerareul deuridaegie jeolhoui gyejeol" [The Perfect Season to Capture the Natural Beauty of Early Winter and Late Autumn], *Gyeongseong Ilbo*, November 4, 1937; Yamazawa Sanjo, "Jeonhwangiui sajin: Bisangsigukgwa jeonhwanui jeolhoui gihoe (ha)" [Photography during the Period of Transition: A Golden Opportunity for Change during Extraordinary Times (II)], *Gyeongseong Ilbo*, April 30, 1938.

24 Seo Yuri, "Maesin sajin sunbo, joseone jeonjaengeul hongbohada—jeonsichejeha sajinhwabo japjjui pyoji imiji yeongu" [Maesin Sajin Sunbo Promotes War in Joseon: A Study on the Cover Images of Photography Magazines under the Wartime System], *Geundae Seoji* 10 (2014): 368–403.

25 Kim Gyewon, "Singminji sidae 'yesulsajin'gwa punggyeong imijiui saengsan" [Yesul Sajin (Fine Art Photography) and the Production of Landscape Images in Colonial Korea], *Art History* 39 (February 2020): 271–301.

ART IN A TIME OF WAR AND DIVISION

Lee Jungseop, *Bull*, 1950s, Oil on paper, 26.5×36.7 cm

"On August 15, Japan surrendered unconditionally. This has changed our
world. It is liberation. No more [Japanese] schools or anything."
—From Lee Donghoon's diary of 1945.

The independence gained by Korea on August 15, 1945 signifies a new historic
moment and the birth of a new nation. Artists quickly realized that this new
world was one in which they could publicly pursue their own creative agendas.
Although liberation came abruptly, many artists who had lived secluded lives
during the Japanese occupation came back out into the world and sought to
proactively develop their ambitions. They started to work in various contexts,
including not only exhibitions but also within art education and publishing.
As a result, while they celebrated independence and the establishment of a new
government, artists also dreamt of assisting in the creation of a new society and
in contributing to the construction of a new cultural identity for the nation.

The process started with the formation of the Central Council of
Constructing Korean Culture led by Kim Chukeung (1902–81), Gil Jinseop, and
Jung Hyunwoong on August 18, 1945. This was an organization of artists from
the genres of literature, visual arts, film, and music, with Ko Huidong elected
as its Chair. The Korean Art Construction Headquarters (Joseon misul geonseol
bonbu) was established as its affiliated organization, where 187 artists joined as
members. In September 1945, a group of radical socialist artists organized the
Korea Proletarian Art Federation, putting political ideology at the forefront as
it sought to denounce reactionary art. This organization succeeded the Korean
Proletarian Artist Federation (KAPF) that was disbanded during the Japanese
occupation. In this fashion, until the Republic of Korea was established in 1948,
artists throughout the peninsula established various organizations of disparate
political standpoints to each assert their own arguments. Initiated with the
Central Council of Constructing Korean Culture in August 1945, the Korean
Art Association (Joseon misul hyeophoe) was organized that same year in
November. The name was later changed to Great Korean Art Association (Daehan
misul hyeophoe) in 1949. In 1946, many groups including the Independent
Art Association, Korea Sculptor Association, Korean Artist Federation (Joseon
misulga dongmaeng), and Korean Plastic Arts Federation (Joseon johyeong yesul
dongmaeng) were formed. The establishment and development of different
organizations was closely associated with the opposing political ideas of the
artists associated with each respective group. The nature of this opposition
intensified and resulted in severe conflict between the ideological left and the
right when the trusteeship of Korea was divided up equally between China, the
Soviet Union, the U.K. and the U.S. at the Moscow conference in December 1945
for an indefinite period of up to five years. Aside from the organizations with
explicit political views there were also groups such as the Korean Calligraphy
and Painting Association of Peers (Joseon seohwa dongyeonhoe), the Dangu Art
Academy (Dangu misulwon) which aimed to exclude Japanese painting and seek
new direction for the tradition of East Asian ink painting, and the Association
of Korean Industrial Artists (Joseon saneop misulga hyeophoe). Such movements
were also witnessed in provincial regions, leading to the establishment of the
Gyeongju Artists Association (Gyeongju yesulga hyeophoe), the Association of
Daegu Colleague Painters (Daegu hwauhoe), the Mokpo Art Federation (Mokpo
misul dongmaeng), and the Mokpo Academy of Art (Mokpo misulwon).

The political turmoil that followed in the aftermath of independence—the
division into two Koreas, and the ideological conflicts between capitalism and
socialism, and social conservatives and liberals—pushed many artists to more
intensively search for a means through which to manifest their concerns. Even
amid the chaos of the various conflicting associations and organizations, artists
right after independence proactively organized and participated in exhibitions to
show the types of work and ideas that they had been prevented from presenting
in the previous years. The first large scale exhibition was the *Art Exhibition in
Celebration of National Independence*, the first exhibition organized by the Korean

Art Construction Headquarters, held at Seokjojeon Hall of Deoksugung Palace from October 20 to 30, 1945. This exhibition, featuring 132 works by ninety-seven artists from all over the country, was organized in just two months, but was considered a successful event in marking the foundation of the country. Several other large-scale exhibitions to mark independence were held nationwide through 1950 under the collective title of the *Art Exhibition in Celebration of National Independence*. Within these exhibitions, artists from across the country submitted works intended to celebrate independence and the establishment of the new state and its government.

Aside from such large-scale exhibitions, solo shows were also organized around the idea of nation, along with smaller group shows by artists who shared not only a common political ideology but similar aesthetic concerns. The most representative example of such shows were those of the New Realism Group, an organization which was created to support the development of new formal approaches in artistic practice. This group held three exhibitions between the end of the Second World War and 1953.

The new expectations for national progress were commonly expressed by the younger generation in the Post-liberation era, especially in the field of education. Here many artists joined to help with the most urgent prosaic situations such as the production of Korean language textbooks, securing building faculties to improve the school environment for teaching, and the high illiteracy rate. Korean textbooks were needed from elementary and middle school to institutions of higher education, and artists proactively participated in producing such textbooks for the new generation of students. The Korean Artist Federation and the Korean Plastic Arts Federation, formed in February 1946, and the Korean Art Alliance (Joseon misul dongmaeng) that resulted from a merger of these two groups, led various educational movements to provide art education throughout the country.

The support for new emerging artists could only happen through the parallel establishment of tertiary level art colleges. And in this regard, in October 1945, Ewha Womans University opened its Art Department with the aim to foster young scholars. The educational ideology of Ewha Womans University that underpinned the foundation of the Art Department was to clear out the intellectual vestiges of Japanese colonialism, establish the identity of national art (*minjok misul*), and help to build a democratic country. Seoul National University followed by establishing its own Art Department in 1946, before Hongik University in 1949, developments that paved the way for other art colleges nationwide. As students graduated from these new schools across the country, the 1960s became the foundation for the beginning of the Korean contemporary art scene. Aside from such formal art institutions, many alternative institutes including Gyeongseong Art Academy, Seongbuk Painting Academy, Korean Art Research Institute, and Gyeongju Art School were also established in the post-independence period, serving as the platform for nationwide educational efforts and the basis for discovering new regional artists.

In the meantime, spreading new ideas about art practice, philosophy and political ideology through the Korean language became dramatically easier in the independence period as the restriction on publications was lifted. There was an immediate explosive increase of publishing companies, rising to 847 publishing houses in 1949. This phenomenon led artists to realize the significance of printed art, pushing them to express their creative desires encompassing various ideologies and genres. Artists turned their attention to the publication of not only textbooks but also magazines, liberal arts books, and literature by drawing book covers and magazine frontispieces. The illustrations for magazines such as *Sinsedae*, *Shincheonji*, and *Jubo Minjujuui* depicted historic moments and manifested the joy of independence. For example, they would portray specific images that embodied the will and longing for independence during the Japanese occupation, including that of the March First Independence Movement. Through various events and publications celebrating the first anniversary of independence

in 1946, artists produced large numbers of works that directly referenced the liberation. In relation to literature, artists focused on illustrations and graphic art that expressed their ideological perspectives while also reflecting the concerns of the writers. In magazines, many artists presented drawings and prints that evocatively and emotively reflected their desire to remove the remnants of colonial culture and construct a new, independent idea of national culture, while others concerned themselves with expressing ideas about the conflict between capitalist and socialist ideologies. The publications of this period showcased both avantgarde styles and more traditional subject matter and techniques, gradually building a new sense of the times relative to visual culture. However, with the establishment of the South Korean government in 1948 and the National Guidance Alliance in 1949, many artists focused on the mass-production of print works that promoted anticommunist perspectives and championed the superiority of the South Korean social and cultural environment. As a means of contributing to the reconstruction of national society, visual materials such as posters, currency, stamps, and textbooks were produced in large quantities for distribution at regional and national levels, and all served to celebrate the establishment of the new government and the ongoing construction of national culture.

The first step to culturally establishing an identity as a new nation lay in reorganizing the art scene. This process began when the U.S. Military Government took over the Government-General's education and management bureau in December 1945. In parallel to the establishment of the numerous artists organizations discussed above, the government hosted the Korean Comprehensive Arts Exhibition in 1947, an exhibition that aimed to propagate a notion of social stability based on the promotion of anticommunist doctrine through art. After the establishment of the South Korean government in 1948, the government also initiated the National Art Exhibition to further foster the development of the Korean art world and support its artists. The first exhibition was held in 1949. As in the case of the Joseon Art Exhibition of the Japanese Colonial period, the exhibition was composed of five sections: ink painting, oil painting, sculpture, craft, and calligraphy, and the artists and the art works were selected by a specifically appointed jury. The state-organized exhibition was designed to advocate for far right perspectives, anticommunism and nationalism. In spite of this, the Presidential Prize-winning *Neighborhood of a Bare Mountain* (1949) by Ryu Kyungchai forecast the advent of abstraction as the chosen style of the new generation of Korean artists in the post-war period. Around this time, the government also established the National Art Exhibition and changed the Joseon Government-General Museum into the National Museum of Korea. Whereas the state-organized exhibitions were created to support the development of national contemporary art, the establishment of a national museum further reflected the state policy to promote cultural confidence within the newly born country through reference to the historical traditions of Korean visual culture.

While the South Korean art scene moved toward building the identity of a new nation, advocating for national art forms, spreading anticommunist ideology, and establishing academic state-organized exhibitions and art institutions under the U.S. Military Government, the North Korean art scene followed a similar trajectory through its close relationships with the Soviet Union.

In November 1945, North Korea and the Soviet Union established the Korea-Soviet Culture Association and developed various cultural exchange projects. Artists from the Soviet Union introduced socialist artistic approaches to North Korean artists, helping them to learn about the utility of socialist realism as the appropriate manner through which to visually represent the political ideology of their government, and the social and cultural progress of their state. The North Korean Federation of Literature and Art (Bukjoseon munhak yesul chong dongmaeng) was established in 1946 and hosted the National Art Exhibition

of Democratic People's Republic of Korea (Gukga misul jeollamhoe) in August 1947. However, at this time the number of professional artists working in North Korea was ostensibly limited to merely the twenty or so members of the Art Federation, an affiliated body of the North Korea Literature and Art Federation. In this respect, one of the most urgent tasks were to build an institutional foundation to foster the development and education of more artists. In 1948, the subcommittees of the Federation were composed of painting, sculpture, crafts, and stage art. As they gathered artists from all over the country and organized exhibitions, publication projects, and lectures, the Federation was able to create a unified institutional system. The following year in 1949, the National Art School (Pyeongyang Art School), featuring the three Departments of Ethics, Sculpture, and Painting, was established while art institutes opened in regions of Haeju, Sinuiju, Chongjin, Hamhung, and Wonsan. Art institutes were also established in Pyeongyang, Chongjin, Hamhung, Wonsan, Sinuiju, and Nampo. Through this effort a great number of new artists were introduced to the art scene, and the number of Federation members increased to 688 by the year 1949.

However, the Korean War (1950–53) brought about great changes to the South and North Korean art worlds. Artists who defected to and from North Korea led to the reorganization of personnel within each respective scene that would later substantively propel the developments of South Korean and North Korean art worlds. Creative freedom continued to be restricted for many artists due to the political conflicts after independence, but also for reasons of immigration during the colonial days, moving to and from North Korea during and after the civil war, and following the division of the nation in the aftermath of the conflict. Experiencing poverty, discrimination, and war concurrently, many artists broke away from their original locales of activity around Korea. This led to a generation of displaced artists in the post-war period who had migrated extensively both within the peninsula and internationally to realize their professional and personal ambitions.

As such, the work of artists across Korea immediately after independence was reflective of the confusion that followed liberation, the ideological struggle, and the building of new national institutions for the new generation, turmoil that directly impacted the stability of the art world. The extreme conflict of ideology between communism and capitalism, the Korean War, the expansion of internal and external migration, and rapid social reforms led to the loss of many works and documents. In this context one problem in examining Korean modern art before the 1960s is the lack of surviving artworks. There is therefore difficulty in historically grasping the art historical reality of the period between independence and the establishment of Korean government. The restriction of access to the work and historical record of artists that defected to North Korea after the Korean War, which was lifted only in 1989, was another great obstacle that severely limited art historical research into this period. However, more recently historians have started to carry out research to connect the disparate elements of information that have been scattered over the world, presenting the potential for new interpretations and analysis of the era. Today, the period is now no longer a temporal space of chaos that is difficult to historically analyze, but now recognizable as a furnace of creativity in which various conflicting ideas of change and reform coexisted and combined to create the foundations for Korean Art in the post-war world.

Art in an Era of Reform: Beyond the Crisis of Liberation and the Korean War

Shin Soo-kyung

On this day of liberation, as my long-sealed mouth opens and the cords binding me are released, I feel as bewildered as a baby in front of a dazzling feast table set for his [or her] first birthday, not knowing what to say or do. I feel greedy, wanting to do so many things. However, I have failed to do any of them as I ran out of energy after suffering from a severe illness and I ran into obstacles everywhere I went.[1]

SINGING THE JOYS OF LIBERATION

The above editor's comments, taken from the first issue of *Sincheonji* magazine published in 1946 vividly convey the tumult of emotions, including joy, bewilderment, thrill, and fear, that were aroused by the liberation of Korea. How did the artists of the time reflect on and convey the moment of national liberation that Koreans had been awaiting for thirty-five years? Their emotions in response to liberation were expressed within a wide range of mediums.

On the cover of the fourth issue of Sinsedae magazine, a special edition issued to celebrate the first anniversary of Korea's liberation, Oh Chiho, an oil painter, evoked the visual imagery of *gwangbok* (lit. glorious recovery; Korea's liberation from Japan) as rays of light spreading in all directions. <u>1</u> This frontispiece drawing by Oh, who was well-known as a leader of Korean Impressionism, was in a new style compared to his work from the Japanese colonial era. After Korea's liberation, many artists wished to start everything anew. Oh attempted to produce works embodying the ideals and issues of the time in a new way that departed from his earlier style. The frontispiece drawing arguably does not capture the emotions triggered by the liberation as precisely as the writing does. However, the large flag at the center of the drawing and the cheering crowds waving Taegeukgi (South Korean

1 Cover illustration by Oh Chiho, *Sinsedae*, September 1946

flags featuring the emblematic *yin* and *yang taegeuk* symbol) viscerally demonstrate the public longing for a new era and a new country.

Although liberation came suddenly, Koreans had been struggling for independence throughout the Japanese colonial era. *Independent Movement* painted by Lee Ungno in 1945, in the year of liberation, appears to suggest that Koreans were able to regain control of the country because they were united and cried out together for independence, just as they had during the March First Independence

2 Lee Ungno, *Independent Movement*, 1945,
Ink and color on paper, 50×61 cm

3 Kang Yong-un, Spring, 1947,
Oil on paper, 45×38 cm

4 Cover illustration by Son Yeonggi, *Jubo Minjujuui*,
August 1946

Movement in 1919. [2] Lee had broken away from idealistic traditional literati painting while studying in Japan, from which point he began to employ an elaborate realistic style in his work. When Korea was liberated from Japan, he began to vividly depict scenes from the life that he witnessed around him. By portraying a historical event, *Independent Movement* differs from Lee's other paintings produced by sketching from life. Nevertheless, the outlining of the figures in light ink and the addition of color is typical of Lee's style from the Japanese colonial era. In particular, the numerous people drawn with swift lines as if sketching, enliven the painting and allow viewers to feel like they are standing at the scene and participating in the March First Independence Movement. Despite its small size, the painting does not appear small since the picture plane is filled with crowds clamoring for independence while being confronted by Japanese law enforcement. In its totality Lee's image portrays the March First Independence Movement as one the greatest collective national efforts in the history of Korea.

It is intriguing that Oh Chiho's illustration of liberation on the cover of the fourth issue of *Sinsedae* and Lee Ungno's *Independent Movement* carry similar iconography in terms of crowds clamoring for liberation, as if liberation and the independence movement constitute the same thing. And, as shown in these two images, images of crowds are often found in the art of the liberation period.

After completing a course in oil painting at the Imperial Art School (Teikoku Bijutsu Gakkō) in 1944, Kang Yong-un was appointed as an art teacher at Chonnam Girls' High School in Gwangju in 1947. In the same year, he presented his abstract work *Spring* at the New Education Exposition. Kang's watercolor painting *Spring* is imbued with movement recalling the burgeoning of a new life and bright colors reminiscent of spring flowers. [3] Kang does not here depict forms of light in detail as Oh Chiho does in his magazine frontispiece. Nonetheless, the picture plane of *Spring* with its harmonizing primary colors exudes a sense that spring that has come once again.

While Oh Chiho was more literally expressing the joy of liberation, Son Yeonggi, a young artist and an active member of the socialist orientated Korean Art Alliance illustrated his strong desire to free himself from the restraints of the establishment on the cover of the fourth issue of *Jubo Minjujuui* that was published in 1946 as a special issue to celebrate the first anniversary of Korea's liberation from Japan. [4] This frontispiece drawing portrays the moment of a large hammer striking a chain coiled around the globe. The close-up image of a figure in the foreground, the strong black and white contrast, and the light shining as the chain is cut recall

5 Kim Mansul, *The Liberation*, 1947, Bronze, 73×35×29 cm

the cover illustration of a New Year issue of *Joseon nodong*, the bulletin of the Korean general labor federation in Japan (Jae Ilbon Joseon nodong chong dongmaeng), from 1926. The Korean General Labor Federation in Japan was formed on February 22, 1925 and actively engaged in mass struggle. Below the illustration on the cover of the 1926 New Year issue of *Joseon nodong* is the famous phrase: "Workers of the world unite. You have nothing to lose but your chains!" This phrase represents a call to stand up to Japanese oppression and obtain freedom. Such iconography from the 1920s as a magazine cover from the liberation period because it corresponds to the revolutionary mood of the time. In other words, the feelings of the 1920s, when progressive ideas began to take root, directly resembled, and to some degree prefigured, the atmosphere charged with hope that developed immediately after the liberation, as artists and intellectuals attempted to contribute to the construction of the new nation. [4]

Another work depicting this historical moment in 1945 is *The Liberation* produced in July 1947 by Kim Mansul, a sculptor active in Gyeongju. [5] As its title implies, *The Liberation* likens Korea's

liberation from Japan to a man slightly bending his upper body and using all his force to undo the ropes wound around him. Most sculptures created during the liberation period were made of fragile materials such as plaster or cement so there are few remaining examples. Fortunately, the original plaster of *The Liberation* by Kim Mansul survived the Korean War and based on this original plaster, the sculpture was recast in bronze in the late 1960s.

Born in 1911, Kim Mansul studied sculpting with Kim Bokjin for two years and continued studying at the sculpture research institute of Hinago Jitsuzo in Tokyo before the liberation. When Korea was freed from Japanese rule, Kim returned to his hometown of Gyeongju. He was active there and in other parts of Gyeongsangbuk-do Province and submitted work to the Commemorative Art Exhibition for Welcoming the Occupation by the U.S. Army hosted by Gyeongju Artists Association at the Gyeongju National Museum from October 1 to 10, 1945. The thick, ropy forearms and firm facial expression in Kim's *Liberation* reveal a resolution to escape from Japanese rule, as demonstrated in Son Yeonggi's cover illustration on the fourth issue of *Jubo Minjujuui.*

Works representing Korea's liberation often portrayed the imagery of a restored light, a returned season, or the resolute physical gesture of breaking away from restraints. However, most such works were produced a year or so after liberation. This is probably because liberation arrived so suddenly and the act of transforming the joy of freedom into art would take a period of greater reflection.

THE ART WORLD AFTER THE LIBERATION: A SEARCH FOR THE ESTABLISHMENT OF A NATIONAL ART

The first issue that Korea faced after its liberation on August 15, 1945 was the establishment of a new nation. The so-called liberation period (1945–48) that began immediately upon the collapse of the Japanese empire, and ended with the division of the country into demarcated territories in the North and South, was dominated by the longing to engage in the building of a new and independent nation. At this moment, artists seriously questioned the identity of Korean art and searched for and discussed ways to establish a new national art. In this sense, the liberation period can be perceived as an era of reform imbued with a will to revolutionize national art production.

On August 18, 1945, the third day after Korea's liberation, the Central Committee for the Construction of Korean Culture (Joseon munhwa geonseol jungang hyeopuihoe) that brought together artists throughout the country was formed in the south of the Korean Peninsula. An affiliated

organization Korean Art Construction Headquarters was soon established. One hundred eighty-seven artists from across various fields, excluding several people considered as collaborators because they had promoted the Japanese colonization of Korea, joined the Korean Art Construction Headquarters. Ko Huidong was nominated as the president. However, according to the historical records of the time, the Korean Art Construction Headquarters is presumed to have been led by Jung Hyunwoong, the secretary-general in charge of administrative matters, Gil Jinseop, the head of the Propaganda Art Department, and Kim Chukeung, the chairman of the Western-style Painting Department. The Korean Art Construction Headquarters aimed to contribute to developing national culture as a part of the project of founding a new nation. The organization consisted of six sections: ink painting, oil painting, sculpture, crafts and design, children's art, and propaganda art. The establishment of children's art and propaganda art sections indicates how the Korean Art Construction Headquarters served as an art organization that emphasized not only the fine arts, but also education and the public function of art.

The propaganda art section was established to facilitate the management of the Korean Art Construction Headquarters and to efficiently publicize the activities of its members. Lee Qoede wrote in "Exhausted Passion in the Art World" that the propaganda art section was the first to be formed among the six sections of the Korean Art Construction Headquarters, in association with the activities of the Preparatory Committee for the National Construction of Korea.[2] The section coordinated a wide range of activities for a commemorative event held to celebrate the occupation of Korea by the Allied Forces on September 18, 1945. These included the decoration of the venue and city for the celebration, the production and dissemination of flags, the development of slogan designs, the production of banners and flyers, the organization of a parade, and the production of portraits of the heads of state of the Allied Forces.

A Children's Art Department was established since education was considered as one of the most urgent tasks of the time. Before liberation from Japan, Koreans were not allowed to freely speak or write in the Korean language. Accordingly, the illiteracy rate at the time reached a full seventy percent of the population. Then, when the Japanese left the peninsula, Korea faced a shortage of teachers and the education infrastructure was poor. In this context, the publication of Korean textbooks was an overriding issue. Since a considerable number of artists who worked as art teachers belonged to the Korean Art Construction Headquarters, the

organization prioritized education. This interest in education led to the establishment of Art Departments at universities. As a case in point, before its official reorganization, Ewha Womans University initiated a Department of Art under the *Yerimwon* (the precursor of the present-day Arts College) in October 1945. On August 23, 1946, Seoul National University was officially founded under Korean control, and an Art Department was created at the College of Arts on September 18 of the same year. In August 1949 Hongik University also established the Art Department and began to train art students. As can be seen, immediately after Korea's liberation, these universities came to be equipped with art departments and began training artists. As a result, the Korean art world after the Korean War was led by a generation who had graduated from domestic universities.

On September 15, 1945, about a month after the establishment of the Korean Art Construction Headquarters, a number of young radical artists who were dissatisfied with the Korean Art Construction Headquarters' noncommittal attitude toward change formed the Korean Proletarian Art Federation (KAPF) in an attempt to reestablish the Korean Proletarian Artist Federation, which had been dissolved during the Japanese colonial era. Lee Juhong, a children's book writer, served as the chairman of the Korean Proletarian Art Federation. This organization centered around Kang Ho and Park Jinmyeong, who were members of the KAPF, as well as Park Munwon, a rising art critic. The mission statement of the KAPF clearly declared its ideology and stance on denouncing reactionary art and promoting proletarian art. Moreover, it actively engaged in public activities, including participation in the *Photo and Cartoon Exhibition in Celebration of the Russian Revolution* and the *Anti-Fascist Street Exhibition*.

Following Korea's liberation, the Korean art world was largely divided between the different political ideologies promoted by the Korean Art Construction Headquarters and the Korean Proletarian Art Federation. Apart from these two organizations, several other art organizations were formed after liberation, including the Korean Calligraphy and Painting Association of Peers, in which Son Jaehyeong served as chairman; Dangu Art Academy, which rejected Japanese-style painting and promoted new ink-and-color painting; and the Association of Korean Industrial Artists that was created by Han Hongtaik and other artists as a need for industrial art arose. There were also a number of regional organizations, including the Mokpo Art Federation, Gyeongju Artists Association, Association of Daegu Colleague Painters, and Gyeongbuk Art Group.

The Korean Art Construction Headquarters and the KAPF differed in ideology and in the inclinations of their members. Nevertheless, during the liberation period, both organizations emphasized communication with the public, as demonstrated by the activities of the propaganda art section of the Korean Art Construction Headquarters and the street art exhibitions of the Korean Proletarian Art Federation. These two organizations co-existed for more than a month. The Korean Art Construction Headquarters ended up being dissolved on October 30, 1945 after holding the *Art Exhibition in Celebration of National Independence* at Seokjojeon Hall in Deoksugung Palace. This exhibition showcased 132 works by ninety-seven members of the Korean Art Construction Headquarters in various fields such as painting, sculpture, craft, and industrial art. Moreover, in a special room in the Seokjojeon Building, a small fundraising show for helping compatriots harmed in the war was held. This exhibition was criticized as simply offering a display of old works. However, it drew more than 20,000 visitors and was significant as the first exhibition held by Koreans after liberation.

The fact that the Korean Art Construction Headquarters consisted of artists with different political orientations was bound to produce internal ideological conflict among its members. As the nation became increasingly divided into the leftist socialists and communists and right-wing social conservatives, the leftist cultural organizations sought to consolidate. On November 20, 1945, Ko Huidong formed the Korean Art Association and announced its political neutrality. However, after the Moscow Conference in December 1945, in which the U.S., the U.K. and the U.S.S.R. attempted to negotiate the geo-political organization of the postwar world, the Korean Art Association was divided into a left and right wing, marking the start of a new chapter for the Korean art world.

THE RESOLUTION OF THE 1945 MOSCOW CONFERENCE AND DIVISION IN THE ART WORLD

The ideological and organizational conflicts between the left and right, as well as between the North and the South, arose because Korea's liberation was not achieved through local resistance, but by foreign forces. The division of the Korean Peninsula started with the occupation of the regions north and south of the thirty-eighth parallel by, respectively, the Soviet Union and the United States under the pretext of the disarmament of the Japanese forces. Immediately after liberation, the South failed to resolve issues regarding the establishment of self-government. In mid-December 1945, distorted news about the Moscow Conference spread throughout the country. At the end of

December, the *Dong-A Ilbo* newspaper published articles for several days about the Soviet Union's supposed claim of trusteeship and the United States' alleged support for immediate independence.[3] The media coverage caused an intensification of the protests against the trusteeship plan.[4] However, on January 2, 1946, the Central People's Committee of People's Republic of Korea issued a statement that "the decision of the Moscow Conference of the three foreign Ministers is a progressive decision that ensures the liberation of the Korean people and [the Committee] fully supports its decision." On the same day, the Communist Party announced its support for the conference's decision. Since then, disputes among disparate political parties over the establishment of a provisional government and trusteeship escalated.

Jung Hyunwoong's illustration for a piece of writing by Kim Inho in the first issue of *Sincheonji* demonstrates the social atmosphere of the time. 6 In this image, four animals growl at each other over a piece of meat, but the meat is already being snatched away by a giant fist with a fork that represents the Allied Forces, comprised of the U.S., the Soviet Union, China, and the U.K. Below the illustration is a comment that admonishes political parties for bickering while being blinded by selfish interests and desires and points out the need for their "strict self-criticism and self-reflection." This comment suggests that the four animals in the illustration allude to the different political factions blindly pursuing their own interests.

With the conflict between the left and right over national trusteeship escalating, the Korean Art Association, the largest art body in the south at the time, could not remain above the political storm. Violating the Korean Art Association's creed on political neutrality, its president Ko Huidong joined an emergency national meeting led by Rhee Syngman on February 1, 1946. In response, Kim Chukeung, Lee Insung, Park Youngseun, and Oh Chiho withdrew from the Korean Art Association in mid-February of 1946. Subsequently, all members of the Korean Proletarian Art Federation joined several other rising artists to form the Korean Artist Federation on February 23, 1946. The Korean Artist Federation was led by oil painters and appointed Kim Chukeung as its chair and Park Munwon as secretary-general. The new organization particularly valued art theory and education as part of its ethos, probably due to the influence of the chairman Kim Chukeung, who had been engaged in art education for some time.

Thirty-two other established artists who had quit the Korean Art Association joined to create the Korean Plastic Arts Federation on February 28, 1946, along with a number of independent artists. The centrist Korean Plastic Arts Federation covered a diverse range of genres including painting, sculpture, and architecture and eventually developed into a large-scale art organization consisting of eighty-nine members. In May 1946, it published the first issue of its bulletin, *Jobyeong Yesul*, to offer a discourse on art. Both the Korean Artist Federation and the Korean Plastic Arts Federation adopted a creed emphasizing artistic enlightenment and the popularization of art and sought ways to put their beliefs into practice. The art popularization theory advocated by these two organizations came closer to fruition when they jointly established the Korean Art Alliance on November 10, 1946. The Korean Art Alliance led a variety of activities in support of art popularization, including traveling art exhibitions. Roughly 1,000 members eventually joined its fifteen regional branches. The Korean Art Alliance discussed specific methods for art popularization related to art genres, methods of production, education, and institutional formation, and actively utilized prints, illustrations, posters, and cartoons to communicate with the public.

The Korean Art Alliance was short lived, however. When the United States Army Military Government in Korea (USAMGIK) issued the "Registration of Political Parties" order in February 1946, its intention to oppress left-wing art organizations, including the Korean Art Alliance, became clear. The deaths of Park Jinmyeong, the vice-chairman of the Korean Art Alliance, on May 22, 1947 and its chairman Yoon Hee-soon just three

6 Illustration by Jung Hyunwoong, Text by Kim Inho, "The Shogunate and the Rebellion of the People: Divisions on the Left and Right Are Self-Destructive," *Sincheonji*, January 1946

days after on May 25 also weakened the Korean Art Alliance. Moreover, in June 1947, twenty leading artists of the organization, including Lee Qoede, the vice-chairman Lee Insung, the Western-style Painting Department head Park Youngseun, and the Propaganda Art Department head Han Hongtaik, withdrew from the Korean Art Alliance in protest over the organization's shift to the left. They instead established the Korean Art and Culture Association (Joseon misul munhwa hyeophoe). In November 1947, the Korean Art Alliance officially declared its members' refusal to enter Korean Comprehensive Arts Exhibition convened by the USAMGIK's Department of Education, which resulted in the dissolution of the Korean Art Alliance.

THE EMERGENCE OF GRAPHIC ART IN RESPONSE TO PUBLIC INTEREST

During the liberation period, politics came to subsume all else. Even the activities of artists were centered on art organizations that represented their respective political views. Records of the political manifestoes and art theories that each organization embraced still remain, but few actual artworks have survived. In the meantime, Korea's liberation facilitated the recovery and foregrounding of *Hangul* (Korean alphabet) and the abolishment of various restrictions on publications, thus leading to a surge in the number of publishers.[5] This change in the publishing industry was accompanied by an emphasis on the importance of graphic art.[6] As such, artists could now vent their long-suppressed desire for expression through print media. Their frontispiece drawings and illustrations for the vast body of books, magazines, and newspapers published to meet the demands of the time, orientated to critiquing colonialism and reconstructing a native Korean culture provide invaluable insight into the art scene of the liberation period.

Jung Hyunwoong was an artist who understood the value and function of graphic art better than anyone. A prodigious talent since youth, immediately after liberation, Jeong took on heavy responsibility as the secretary-general of the Korean Art Construction Headquarters. He also served as an editor and illustrator of *Sincheonji* magazine (first issued in January 1946), an author of comic books for children, and as a book designer. He bound sixty volumes of books in the years after liberation, including *Three-headed Buddha*, a remarkable memoir from the liberation period written by O Kiyeong. This work by O was originally published in *Sincheonji* magazine when Jeong served as its chief editor. Jeong later supervised its publishing in book form.

The cover image for *Three-headed Buddha* [7] was based on a phrase in the book.[7] At the time, the general social mood was that the entire political left-wing were viewed as radicals; the right, as reactionaries; and those who belonged to neither were considered opportunists, and it was said that Korean society after liberation consisted purely of radicals, reactionaries, and opportunists. Jung Hyunwoong represented this situation in Korean society through his illustrations across the front and back covers. Each of the trisected surfaces shows three vertically aligned Buddha heads facing left, right, and center, representing a leftist, rightist, and centrist. Jung also added three arrows indicating the Buddhas' eye, ear and mouth to highlight seeing, hearing, and speaking. These arrows embody the wish for national unification as achieved through a unification of the left and the right and successful negotiations between the North and the South. At a time when the conflicts between the United States and the Soviet Union, the left and the right, and the South and the North were intensifying, Jung Hyunwoong's illustration was based on the centrist assertion of seeing, hearing, and speaking together rather than fighting fire with violent fire. This cover image captures Jung's subjective interpretation of the intentions of the author O Kiyeong, who believed that the centrist position, while perhaps impractical and idealistic, was in the best interest of the Korean people.

Kim Yongjun is another representative designer of graphic art produced during the liberation period. Kim's *Essays of Kim Yongjun* released in 1948 by the publisher Eulyoo Munhwasa is a highlight of Korean essay writing. Its publication shows the quality of graphic art of the liberation period. [8] When Seoul National University was officially established on August 23, 1946 and the Division of Art was created at the College of Arts on September 18 in the same year, Kim was appointed as a professor. However, less than a month after its foundation, Kim, Gil Jinseop, and Kim Whanki submitted their resignations after twenty students were expelled from the school due to a class boycott movement opposing the national university plan. Later, Kim Yongjun published *Essays of Kim Yongjun*, which included twenty-nine essays on his hobby of collecting antiques, his everyday life, and nature. The publication of *Essays of Kim Yongjun* was charged with a realization of the frustrating reality in which Kim and his colleagues who hoped to pursue the pure appreciation of art and protect national culture had no place as artists or educators.

Kim Yongjun's awareness and sensitivity are demonstrated in *Essays of Kim Yongjun*, including the front and back covers indicating the nature of the book, the title lettering, a self-portrait depicting his state of mind, and his hand-drawn illustrations. The front cover depicting an orchid

7 Cover illustration by Jung Hyunwoong, Text by O Kiyeong, *Three-headed Buddha* (Seoul: Seonggaksa, 1948)

8 Text & cover illustration by Kim Yongjun, *Essays of Kim Yongjun* (Seoul: Eulyoo Publishing, 1948)

that Kim cultivated for enjoyment uses a drawing technique called *baimiao* in Chinese or *baengmyo* in Korean that applies fine ink outlines, shading, and wash. The orchid contrasts with the title lettering of "近園隨筆" (Essays of Kim Yongjun) written in clerical script with dark ink. The distinctive script used for the title lettering combines the last line of an inscription from the Epigraph of the tombstone of King Gwanggaeto's tomb with the horizontal lines ending in a noticeable triangular tail of the clerical script of Han China. It conforms nicely with the back cover, which is adorned with an inscription carved on the bottom of a bronze bowl from Houchong Tomb, the site where the first excavations by Korean archaeologists were undertaken after liberation in May 1946. This indicates Kim Yongjun's broad knowledge of art history and his interest in epigraphy. The

inscription on the bronze bowl is related to Chusa Kim Jeonghui's ancient clerical script that Kim Yongjun considered the classical ideal. In this light, *Essays of Kim Yongjun* reveals the aesthetic sense Kim cultivated while producing and designing a great number of books in working as a book binder and as an editor of *Munjang* magazine in the 1930s. It also reflects the nationalist art theory that Kim pursued as a member of All Korean Writers' Association.

Apart from books, many examples of frontispiece drawings have survived from magazines where artists with a similar political stance shared their ideas about various issues during the liberation period.[8] In particular, cover images created by Park Munwon, Son Yeonggi, and Choi Eunseok, who served as members of the Korean Art Alliance, not only represent the ideology that the magazines espoused, but also portray the liberation period in detail. As a case in point, a cover illustration by Park Munwon on an extra edition of *Munhak*, the bulletin of the Federation of Korean Writers (Joseon munhakga dongmaeng), depicts a militant reformer standing on a podium and agitating a crowd with his gestures. [9] This cover illustration is accompanied by the title "Special Edition on People's Resistance" clearly written in red. The dynamic strokes and upward-looking perspective emphasize the propagandistic nature of the image.

During the liberation period, sketches and prints emerged as genres considered suitable for expressing realistic, figurative images, and several magazine frontispieces came to feature sketches. For example, there is the frontispiece produced by Choi Eunseok for the May issue of *Sin Joseon* in 1947. Here, a large flag flutters among a crowd of people with diverse facial expressions. [10] The flag alludes to an agitator who promotes a political ideology to the public, like the reformer in the cover illustration by Park Munwon. In a similar vein, a frontispiece produced by Son Yeonggi, a classmate of Choi from the Hwimun High School, using woodcut print for the April issue of *Sin Joseon* in 1947 portrays a speaker raising his hand in response to enthusiastic cheers from a crowd. [11] With its evident propagandistic nature and rough woodcut style, this image has been noted as a classic example of the art of the liberation period. The dynamism in the title lettering of "Sin Joseon" and the propagandism portrayed through the images on the covers clearly display the nature of the magazine.

As discussed above, young artists working in print media during this chaotic liberation period of ideological conflict often used motifs such as a flags, crowds, or activist fighters. In contrast, the older generation of artists, including Gil Jinseop, Kim Man-hyeong, Lee Qoede, Choi Jaiduck, and Kim Whanki, who had studied in Japan and led the Korean art community in the 1930s, utilized more traditional subject matter such as ceramics, horses, roof tiles, and peonies to decorate magazine covers. [12] However, some artists from the older generation, such as Kim Chukeung and Oh Chiho, boldly broke away from the existing framework and endeavored to establish a new national artistic approach. Graphic art from the liberation period that manage to strike a harmony between traditional subject matter and avant-garde art demonstrate that the era was a dynamic time characterized by the search for change and new possibilities.

THE ART WORLD AFTER THE ESTABLISHMENT OF THE GOVERNMENT OF THE REPUBLIC OF KOREA: VISUALIZING THE WISH FOR NATIONAL UNITY

On August 15, 1948, the Republic of Korea was established in the southern part of the Korean Peninsula. On September 9 of the same year, the Democratic People's Republic of Korea was proclaimed in the north. In South Korea, the right-wing pro-American politician Rhee Syngman was elected as the first president, which led to a gradual escalation of the ongoing ideological conflict. After the establishment of the Government of the Republic of Korea, all the activities of the South Korean Workers' Party and its affiliated organizations were suspended. Oh Chiho retired to the countryside. Some artists, such as Gil Jinseop went to North Korea, while other artists who had joined leftist organizations were arrested. When the Korean Art Alliance fell dormant with the suppression of leftist groups, the Korean Art Association led by Ko Huidong named itself as the successor of the Calligraphy and Painting Association, the first art organization of the modern era, and was renamed the Great Korean Art Association. Regarding itself as representative of all art organizations in South Korea, the Great Korean Art Association negotiated with the USAMGIK for space in the Namsan Assembly Hall building in Seoul, the place where Japanese citizens had operated the Art Club (Misul gurakbu) before liberation, to house the association's headquarters and an affiliated Korean Art Research Institute. The Great Korean Art Association claimed to advocate for purity in art. However, due to its anti-communist perspective, it cooperated with the government to implement ideologically driven art policies during the Korean War. The association continued to expand its institutional power until the mid-1950s.

The Rhee Syngman government was never truly considered legitimate by the majority of the population, and experienced constant military and

political turmoil with the Jeju April 3 Uprising and the Yeosu-Suncheon Rebellion on October 19, 1948. As a response, it enacted the National Security Law on December 1, 1948, to help overcome the constant social conflicts caused by leftist agitators and establish civil order. A few months later, in April 1949, the government formed the National Guidance League under the pretext of enlightening and guiding recent converts who had abandoned the socialist cause. The National Guidance League proclaimed that it aimed to offer leftists who seemed capable of reform a chance to convert, and assured people that it would "protect and guide" them. However, its real purpose was to locate and neutralize socialists and those sympathetic to their ideas. Many artists who belonged to left-

wing art organizations before the establishment of the government of the Republic of Korea joined the National Guidance League. These converted artists produced anti-communist posters for display at weekly street exhibitions and were forced to participate in a variety of cultural activities that propagandized against communist ideology and championed the new South Korean system.

The majority of artists who joined the National Guidance League were members of the Korean Plastic Arts Federation and the Korean Art Alliance. The style of nationalist art that the Korean Plastic Arts Federation pursued is characterized in Yoon Hee-soon's *Studies on Korean Art History*. According to Yoon, "the art of the new world is art that speaks to the masses." For him, such art should "depart from

13 Chung Chong-yuo, *Yoon Hee-soon Sick in Bed*, 1947,
Ink on paper, 21×30 cm

14 Chung Chong-yuo, *Year of the Ox*, 1948, *Seoul Weekly*, January 1949

the surrealist trends created by a denial of reality that lasted for thirty-six years and [achieve] a new realism that boldly faces what is happening."[9] The realist aesthetic theories of Yoon were most successfully embodied in artworks by Chung Chong-yuo and Lee Qoede. The works by these two artists represent the mainstream approach taken by the Korean art community during the liberation period.

Yoon Hee-soon Sick in Bed was an impromptu creation by Chung Chong-yuo after visiting an ailing Yoon on April 28, 1947. It demonstrates the relationship between Yoon and Chung. 13 Despite its small size, this sketch-like painting executed in rough brushstrokes embodies Chung's affectionate feelings for Yoon, with whom he served together in various art organizations.

Born in 1914 in Geochang, Gyeongsangnam-do Province, Chung Chong-yuo spent his childhood at several temples in Gyeongsang-do Province due to his family circumstances. He left to study in Japan with the aid of the head abbot of Haeinsa Temple in Hapcheon. In 1934, he entered Osaka School of Fine Arts (Osaka Bijutsu Gakkō), where Yano Kyōson, a master of Japanese Nanga (Southern school painting), served as principal. While still in school, Chung became a pupil of Lee Sangbeom and participated in the Cheongjeon Art Studio Exhibition, which was hosted by Lee's disciples. From 1936 through 1944, Chung received repeated honorable mentions and a special award at the Joseon Art Exhibitions. In 1939, he won the

Changdeokgung award for his ink wash painting *Snow in March* and was lauded for his artistic skills.

Chung Chong-yuo served as the head of the Ink painting section at the Korean Plastic Arts Federation and the Korean Art Alliance after Korea's liberation. He received the Democratic National Front Award at the first Korean Art Alliance Exhibition held from December 8 through December 14, 1946. He was well versed in ink and color paintings on various themes, including landscapes, bird-and-flower, figures, and Buddhist art. He held *Solo Exhibition of Eastern-style Paintings by Cheonggye Chung Chong-yuo* from December 2 through December 9, 1948. He held another solo exhibition displaying his ink paintings at the U.S. Public Information Office in Busan from July 18 to July 31, 1949.

Among the works featured at his first solo exhibition, *Year of the Ox* impressed many viewers as a painting that successfully exhibited the critically perceived optimal characteristics of Korean art during the liberation period. 14 Only a black-and-white plate of this painting from an edition of the *Jugan Seoul* newspaper survives.[10] The poet Park Inhwan highly praised Chung's *Year of the Ox* and his solo exhibition, saying that the painting was the "warrior who rescued the deep-rooted spirit of ink painting from crisis" and calling the exhibition the "greatest harvest of the year."[11] In early 1949, Park Munwon asserted that *Year of the Ox* by Chung, *Distress* (1948) by Lee Qoede, and *Blue Sky* (1948) by Kim Kichang "foregrounded several important questions regarding the establishment of a national art."[12] In *Year of the Ox* in *Jugan Seoul*, two oxen fill the picture plane as they silently walk in a storm while leaning on each other. These oxen symbolize the many Korean people who have overcome challenges and lived through dire circumstances. Yoon Heesoon's review of *Year of the Ox* at the time mentioned that in this work, Chung Chong-yuo had succeeded in achieving a "new realism that boldly faces what is happening."[13] In his review, the poet Lee Suhyeong described *Year of the Ox* as achieving a harmony between revolutionary romanticism and socialistic realism, continuing that "by using animals, [this painting] stirs a sense of the reality that all people of today are experiencing and are trying to develop in their lives."[14] The revolutionary romanticism in Chung's *Year of the Ox*, which emerged as the forbearer of a critically privileged idealistic art style during the liberation period, also improves the understanding of another of his paintings, *The People in Kosong Assisting the Front* that won him a gold medal at the National Art Exhibition of Democratic People's Republic of Korea in Pyeongyang in 1958 after he moved to North Korea.

When the Korean War broke out in 1950, Chung Chong-yuo, who had been a member of the Korean Art Alliance, left for North Korea before the Second Battle of Seoul on September 28. In North Korea, Chung was acclaimed as a master of the nationally privileged art form of Chosonhwa (North Korean colored ink painting), earning the titles "Laudatory Artist" in 1974 and "People's Artist" in 1982 for his contributions to the establishment and development of Chosonhwa. *The People in Kosong Assisting the Front* stands over five meters high and depicts people working their way through a blizzard while transporting ammunition and food to the front lines. This painting shares thematic and compositional affinities with *Year of the Ox*. Both paintings highlight the concept of moving forward by overcoming obstacles and compositionally frame a severely bent tree branch in the foreground. As a precursor to works of *Juche* art in the 1970s, *The People in Kosong Assisting the Front* shows that the realistic aesthetics embraced by Chung Chong-yuo in his *Year of the Ox* during the liberation period were sustained in Chosonhwa.

Like Chung Chong-yuo, Lee Qoede served as a member of the painting section of the Korean Plastic Arts Federation and as head of the Oil painting section of the Korean Art Alliance. In June 1947, he formed the Korean Art and Culture Association in pursuit of the establishment of a true national culture. Two months later, Lee hosted the first Korean Art and Culture Association Exhibition at the Dong Hwa Gallery. He submitted *Announcing Liberation (People I)* to the second exhibition, which was held in April 1948. At the third exhibition, which took place in November 1948, he presented a series of works reflecting the current zeitgeist, including *Blue Sky* and *Distress*, a work produced to address the U.S. military's bombing of Dokdo Island. Unlike other painters whose activities were curbed relative to the wider governmental suppression of leftist activities, Lee Qoede continued to produce artworks. This is likely to be because he had established the influential Korean Art and Culture Association, and so was able to organize and hold prominent exhibitions four times through 1949. However, at the end of 1949, Lee joined the National Guidance League and was involved in programs aimed at promoting Socialism. When the Korean War broke out, as a member of the reestablished Korean Art Alliance, he participated in a project for producing a portrait of Kim Il Sung. Lee Qoede entered the war by joining the People's Volunteer Army, but was taken prisoner by the South Korean armed forces. He ended up being held in a prisoner-of-war camp on Geojedo Island. When an agreement on the exchange of prisoners was signed between South and North Koreas in 1953, Lee chose to be sent to North Korea.

Lee Qoede has been long overlooked in the study of South Korean art but returned to the

spotlight when works held by his wife Yu Gapbong were shown to the public at the Shinsegae Gallery in October 1991. This exhibition stimulated interest in artists who moved to North Korea and inspired a reevaluation of art produced during the liberation period. After the ban on artists who chose the North after liberation was lifted in 1988, the sensation caused by Lee Qoede's works also led to renewed interest in his older brother Lee Yeoseong. Lee Yeoseong supported the ideology of nationalist socialism. He had studied the history of Joseon costume and produced historical paintings based on close research of such dress in the late 1930s. Immediately before Korea's liberation from Japanese rule, Lee Yeoseong joined the Korean National Foundation League. With liberation from Japan, he made his debut on the political scene by serving as the head of the cultural and propaganda units of the Preparatory Committee for the National Construction of Korea. Actively engaged in politics with Yeo Unhyeong, Lee Yeoseong was a leading figure in the center-left cultural community. After Yeo was assassinated in 1947, Lee led the Working People's Party and made efforts to create a coalition between the left and right.[15] He also organized the North-South Joint Conference which was held in Pyeongyang in April 1948, participated in the South Korean Congress of People's Deputies held in Haeju in 1948, and was elected as a representative to the first North Korean Supreme People's Assembly.

When Lee Yeoseong went to North Korea in 1948, Lee Qoede produced a painting series entitled People that embodied his wish for national reconciliation. The People series, including Announcing Liberation, depicted diverse aspects of the liberation period, portraying figures in different forms of motion using dynamic compositions. The figures depicted running, falling, hugging, or standing resolutely recall the phrase "let's stick together, get tangled, and try not to fight" in a letter that Lee Qoede wrote to Jin Hwan after liberation. These dynamic depictions appear to illustrate the radical ideological and social changes taking place during the liberation period within the art community. Lee Qoede's depictions of groups of distorted bodies are presumed to reflect this turbulent era, which was marked by a major crackdown on leftists amidst the ideological conflict between the left and right. They also signify the division of the Korean Peninsula caused by the establishment of separate governments, after the brief moment of joy that followed independence and the end of the Japanese colonial era.[16]

It is intriguing that Lee Qoede's People series mainly depicts muscular male figures. This contrasts with his works from the periods when he studied in Japan and worked as a member of the New Artists' Association, which focused on mainly female figures. The narrative sequence in People IV, the finest example from the series, starts from the compositional point of a terrified child with a woman looking at him in the lower right corner of the painting, and develops on to the left. [15] The right half of the painting features a scene of pandemonium, with people biting each other or hitting each other with rocks, broken dishes, a flash of light alluding to explosion, and clouds of smoke. Moving away from this world of fear and despair, the viewer's eye lands upon a man struggling to help a fallen woman to get up and other figures taking care of and relying on each other in the center of the painting. The left half of the painting shows people moving forward. People IV illustrates the process of transforming a world of darkness, disorder, despair, and confusion into a liberated world of luminance, order, and hope. It thus resonates with a message of creating a better world by overcoming current difficulties and achieving national unity.[17]

One of the reasons why Lee Qoede's People series drew such a great deal of attention was that it consisted of large groups of realistically depicted nudes, something unprecedented in Korean art. At the time of its release, his People series was criticized for its resemblance to Western medieval religious paintings in the depiction of the faces and bodies, and for its stylistic foundation in Renaissance art and French Romantic painting.[18] For instance, in People I and People II the female figures depicted dashing along as if they are about to soar away are reminiscent of The Birth of Venus (1485) by Sandro Botticelli. Lee Qoede's interest in Botticelli is testified to by the materials he collected.[19] In this light, the argument that the growing interest in Western classical art that apparently blossomed during the liberation period impacted Lee's People series can be considered valid.[20] Moreover, Park Munwon, who was the most prominent left-wing art theorist during the liberation period (1945–50), associated Lee's works as related to those of the French artist Théodore Géricault (1791–1824), in which sense the compositions of the People series also draw upon the Romantic painting manner of the nineteenth century.[21] In a narrow sense, Lee Qoede was influenced by the interests dominant within the Japanese art community from his student days, and through this context he was introduced to French art. In particular, Lee's relationship with Fujita Tsuguharu (1886–1968), who led the production of Pacific War painting as the star of the pro-Imperial propagandist "holy war" art group is noteworthy.[22] Furthermore, Lee's interest in Mexican mural painting is also embedded in his "People" series, attesting to the combination of diverse styles that informed the creation of these works.

Although not deployed within narrative painting, as in Lee Qoede's works, images of hyper-masculine male figures can be widely found in graphic art from the liberation period. Male bodies expressed both the sheer physical power of the idealized new Korean citizen, and the strength of the national labor force, as, for instance, in the cover illustrations by Park Youngseun for the first issue of *Hyeopdong* or by Choi Jaiduck for *Uri Munhak*, the bulletin of the Federation of Korean Writers. This preference for hypermasculine imagery likely resulted from the perceived appropriateness of the form as a means to represent the dynamism of the liberation period, which was characterized by radical social change and political struggle, and optimism for the future.

Similar to the way that pictures portraying the dynamic movements of idealized male figures served to reflect the turbulent social times, images of crowds of people were a natural subject matter for artists of the liberation period. At the time, large masses of people often gathered to make their voices heard, whether protesting against the procession to welcome the allied forces, or over the decisions made during the 1946 Moscow Conference. The frequent use of images of groups of people holding flags or banners on the covers of magazines was a journalistic response to the situation at hand, and a reflection of the period, during which numerous assemblies were being held.

Lee Qoede's *Self-Portrait in Traditional Coat* depicts the artist himself standing proudly against a backdrop of typical Korean mountains and streams while wearing a *durumagi* (traditional Korean long coat). 16 Despite its use of oil paint, here the image strikes an Asian mood through the harmony between the lines in the folds of the coat, gently sloping mountains below a blue sky, and use of bright colors. This self-portrait presents a contradictory image of Lee wearing a traditional Korean coat with a Western fedora while holding a palette with oil paints in one hand and an Asian-style brush in the other. He may have been expressing his own confusion over his identity. Nonetheless, his firmly sealed lips and large eyes staring directly at the viewer reveal his determination. Moreover, the traditional Korean coat and the backdrop of Korean nature can be interpreted as his intention to become a painter who illustrates the realities experienced by the Korean people.

Artists of the liberation period, including Lee Qoede, often addressed mural painting as an ideal format for the popularization of art. An article recording a conversation between Lee Qoede and Park Munwon mentions Diego Rivera, the master Mexican mural painter.[23] Kim Man-hyeong and Park Munwon also emphasized the educational and

15 Lee Qoede, *People IV*, late 1940s,
Oil on canvas, 177×216 cm

ART IN AN ERA OF REFORM: BEYOND THE CRISIS OF LIBERATION AND THE
KOREAN WAR

16 Lee Qoede, *Self-Portrait in Traditional Coat*, late 1940s, Oil on canvas, 72×60 cm

popular nature of mural painting in their writing and viewed Mexican mural painting as an ideal model form of art.[24] According to Park Munwon, Lee Qoede is "an unusual painter who has charted a new path with his painting techniques and created an appropriate style for producing mural paintings or masterpieces."[25] Considering this statement and the rather exaggerated masculine bodies and dynamic compositions in Lee's *People* series, Lee's series is presumed to have been undertaken as step toward the fully-fledged production of mural paintings. After moving to North Korea, Lee achieved his objective in 1958 by producing a mural painting for the interior of the thirteen-meter-high Friendship Monument for the Chinese People's Volunteer Army.

THE KOREAN WAR AND THE REORGANIZATION OF ART WORLD

On June 25, 1950, the Korean War broke out. Streams of refugees created mayhem in Seoul, and many artists moved either north or south,

abandoning the centers of their former activities. Accordingly, the new terms of *wollam* and *wolbuk* emerged, meaning artists who went from the North to the South and those who went from the South to the North. Moreover, Soviet socialist realist art was introduced in the north whereas modernist Western art, often from America, was promoted in the south. This in turn led to a reorganization of the Korean art world.

Three days after the Korean War broke out, the North Korean People's Army captured Seoul and the imprisoned socialist artists were released. They in turn rallied other artists from the disbanded Korean Art Alliance, and the Alliance was reestablished. Park Munwon was elected chairman of the new Korean Art Alliance, and Jung Hyunwoong became the secretary-general. Members of the organization at this point (including Kim Man-hyeong, Chung Chong-yuo, Lee Seokho, Lee Geonyeong, Lee Palchan, Choi Jaiduck, Lee Qoede, Pai Un-soung, Yun Jaseon, and Jeong Onnyeo) were mobilized to produce propaganda paintings and portraits of Kim Il Sung and Joseph Stalin. On September 28, 1950,

these artists left for the North by following the People's Army who retreated immediately before the UN and South Korean forces recaptured Seoul through the Battle of Incheon. The majority of the artists who failed to flee had to turn to creating portraits at the Seoul Art Workshop in exchange for food rations. Most of the artists who went north were members of leftist art organizations like the Korean Art Alliance. In many cases, the reason for their move to the North was that due to their known prior membership of the National Guidance League they thought it likely that they would likely be severely punished by South Korean authorities.

Following the outbreak of the Korean War, military and police forces in the regions south of Pyeongtaek, excluding Seoul, indiscriminately detained and summarily punished members of the National Guidance League. In this context, the artists who had joined the National Guidance League had no choice but to leave for North Korea out of fear of being sentenced to forced labor during the war. Many of those who went north had no choice but to leave their families in the south.

Before the establishment of a national government in South Korea, people in the southern and northern regions of Korea could move relatively freely across the border. Thus, there were relatively few cases at that time of groups of people going north. The first well-known artist who went to North Korea was Kang Ho in July 1946, who was also recognized as a movie director and stage designer. Sculptors Kim Jeongsu and Jo Gyubong left for the North Korea in late July 1946 at the invitation of the Preparatory Committee for the Construction of the Liberation Monument in Gangwon-do Province, under the umbrella of North Korean Interim People's Committee. Kim Chukeung, who was strongly committed to promoting education, went north in October 1946 and was appointed as the principal of the Pyeongyang Art School established in September 1947. Additionally, Lee Yeoseong and Gil Jinseop participated in the South Korean Congress of People's Deputies held in the North Korean city of Haeju in 1948 and never returned.

But by far the largest number of people who went to North Korea did so during the Korean War. It is difficult to discern whether these people left voluntarily or were abducted. Several artists chose the North because of changes in the political circumstances on the Korean Peninsula. In so doing, they followed their ideological sympathies for socialism or communism, the repression and disadvantages they suffered due to their political opinions, and other reasons such as family ties. However, even before the outbreak of the Korean War, leftist artists had been targeted for persecution. In October 1949, the Ministry of Education ordered the removal of leftist writers' literary works from middle- and high-school textbooks since they were believed to contradict the national ideology.[26] The Ministry of Education also banned the sale of works by writers who had moved to North Korea, and the publishing and sale of books that were thought to promote socialist or communist ideology. Until the ban on the works of artists who went to the North was lifted in 1988, any artists who went north were simply framed as artists who betrayed the South Korean system, chose the North Korean system, and moved the focus of their activities to North Korea. Any mention of these artists was considered taboo.

Thirty years after the Korean War, street demonstrations by students and resistance among the general populace inspired by the May 18 Gwangju Democratization Movement in 1980, which continued nationally into the late 1980s. Given the apparent thawing in Cold War relations between the West and the Communist Bloc, the South Korean government sought inter-Korean talks towards the end of the decade. And, in accordance with shifts in government policies, on October 27, 1988 the Ministry of Culture and Public Information lifted the ban on the works of cultural producers, including artists, who went to the North.

However, also at the time of the Korean War, a number of artists moved to the South as they sought freedom from a repressive communist environment filled with fear, violence, and hatred. Several painters who pursued modernist styles in their work, including Han Mook, Hong Jongmyoung, Choi Youngrim, Hwang Yooyup, Ham Daejung, Lee Jungseop, Park Kosuk, and Lee Soo-auck, went to South Korea and became part of the new national modern art community. Moreover, modernist painters such as Kim Whanki, Yoo Youngkuk, Lee Kyusang, and Chang Ucchin, formed a group and held exhibitions in shelters during the war. The advent of the United States as a regional hegemon served as momentum for the rapid development of modernism in Korean art world, and the U.S. naturally instilled capitalist and anti-communist ideology in Koreans through its various cultural programs.

1 For the original text, see the editor's comments in the first issue of *Sincheonji*, published in 1946.

2 In "Exhausted Passion in the Art World," Lee Qoede states the following: "When soldiers were still going around pointing guns at people after the liberation, the Propaganda Art Department became the first artist group. Subsequently, the Korean Art Construction Headquarters was established under the umbrella of the Central Committee for the Construction of Korean Culture and aimed to create a national art." See Lee Qoede, "Gogaldoen jeongyeorui misulgye" [Exhausted Passion in the Art World], *Minseong* (August 1949): 84.

3 The *Dong-A Ilbo* newspaper first published an article on this topic on December 27, 1945 under the title "The Soviet Union's claim for trusteeship under the pretext of the occupation of Korea as divided by the thirty-eighth parallel and the United States' claim for immediate independence." Related articles on trusteeship continued to be published in the *Dong-A Ilbo* and *Chosun Ilbo* newspapers at the end of 1945.

4 Seo Joongseok, "Gyeokdongui haebanggwa byeonhyeok, bundangwa jeonjaengui apeum" [Liberation and Revolution in Turbulent Times and the Tragedy of Division and War], in *Hanguk misul 100nyeon* [100 Years of Korean Art], ed. MMCA (Paju: Hangilsa, 2006), 404.

5 There were only forty-five publishers in 1945, the year of liberation, but 847 publishers had registered with the Publication Department of the Bureau of Public Information by August 1949. See O Yeongsik, *Haebanggi ganbaengdoseo chongmongnok 1945–50* [A Complete Catalogue of Books Published during the Liberation Period 1945–50] (Seoul: Somyong Publishing, 2009), 19.

6 Interest in printed art escalated at the time. In "Daejungsaenghwalgwa hoehwa" [Painting and the Life of the General Public], in *Johyeong Yesul* published in May 1946, Kim Man-hyeong argued for the "distribution of printed matter" since illustrations of newspapers and magazines were easily accessible by the general public and prints could be reproduced at low cost. Park Munwon reviewed the provincial touring exhibition hosted by the Korean Art Alliance in 1948, stating: "An art popularization movement through printed art is important as it serves an educational function and gives artists valuable lessons in understanding the public through experience and in solving issues during the process of creation." (Park Munwon, "Misurui samnyeon" [Three Years of Art], *Minseong* (1948): 42) In a similar vein, Jung Hyunwoong asserted the importance of printed art in his article "Teureul dolpahaneun misul" [Art that Breaks down Barriers] in *Jugan Seoul* published in December 1948.

7 The original text for this phrase in *Sincheonji* (July 1946; 382-384) is as follows: "The father who belongs to the right is a reactionary, and the son who belongs to the left is a radical. If the mother and daughter-in-law remain quiet, they are opportunists. If the mother and daughter-in-law change sides, each following their husband, this family will be clearly divided into reactionaries and radicals. Will this be a good or bad omen for the family?"

8 For more detailed information on frontispiece drawings in magazines from the liberation period, see Shin Soo-kyung, "Wolbukwaga jakpumeul jungsimeuro bon haebanggi japji pyoji" [Magazine Covers during the Liberation Period with a Focus on Works by Painters Who Defected to North Korea] in *Geundai seoji: The Second Half-Year of 2016*, vol. 14 (Seoul: Somyong Publishing, 2016): 360–395.

9 Yoon Hee-soon, "Joseon misulsa yeongu–minjok misurui daehan dansang" [Study of Joseon Art History—Thoughts on National Art], *Seoul Shinmun*, 1946; republished in Yoon Hee-soon, *Joseon misulsa yeongu* [Study of Joseon Art History] (Paju: Yeolhwadang, 2001).

10 Park Inhwan, "Chung Chong-yuo dongyanhwa gaeinjeoneul bogo" [A Review on Chung Chong-yuo's Solo Exhibition of Ink Paintings], *Jayu Sinmun*, December 12, 1948.

11 Park Munwon and Lee Qoede, "Minjokmunhwasuribeul wihan sinin giseong rillei (1)" [The Relay of Rising and Established Artists for the Establishment of a National Culture (1)], *Joseon JoongAng Ilbo*, February 10, 1949.

12 According to Lee Suhyeong, *Year of the Ox* shows that the "oxen, which willingly sacrifice themselves and are obedient despite being treated badly, unleash a blinding rage and resist to save their lives." This comment fully explains the message of the painting. See Lee Suhyeong, "Hoehwayesul isseoseoui daejungseong munje-choegeun jeollamhoeeseoui sogam" [Issues of Popularity in Painting: Thoughts on Recent Exhibitions], *Sincheonji* (March 1949): 175.

13 Yoon Hee-soon, "Joseon misulsa yeongu–minjok misurui daehan dansang," 187.

14 Lee Suhyeong, "Hoehwa yesure isseoseoui daejungseong munje: Choegeun jeollamhoeeseoui sogam" [Issues of Popularity in Painting: Thoughts on Recent Exhibitions], 168–176.

15 For more information, see Shin Yongkyun, "A study on Lee Yeo-seong's political thought and art history research" (PhD diss., Korea University 2013).

16 Shin Soo-kyung, "Ikwaedaeui haebanggi haengjeokgwa gunsang yeonjak yeongu" [Lee Qoede's activities during the liberation period and *The Crowd* series], *Misulsawa munhwayusan* 5 (2016): 11.

17 Hong Jisuk interpreted Lee Qoede's *People* series as an embodiment of the worldview of his neutral contemporaries, particularly the center-left grouped around Yeo Unhyeong, rather than as a reflection of Lee's private narratives. In other words, Hong asserted that the series reflects a longing for unity and reconciliation in a totally disrupted world. See Hong Jisuk, "Haebanggi junggganpa yesurindeurui segyegwan: Ikwaedae gunsang yeonjageul jungsimeuro" [Moderate Artist's World View in Liberation Era—focused on the Lee Qoede's *People* series], *Review of Korean Cultural Studies* 46 (2014): 397–429.

18 Choi Eunseok, "Misul: baegyeokaeya hal ssaronjuui" [Art: Salonism to Be Rejected], *Munhwa Ilbo*, April 20, 1947 and Kim Yongjun, "Munhwa illyeonui hoego: Singyeonghyangui jeongsin" [The Culture of the Year in Retrospect: The Spirit of a New Trend], *Seoul Shinmun*, December 29, 1948.

19 Kim Hyunsook, "Ikwaedaeui sujipjaryoreul tonghae bon ikwaedae jakpumui imiji chamgo yangsang" [Aspects of Referential Images for Lee Qoede's Works as Seen through His Collected Materials], *Korean Bulletin of Art History* 45 (2015): 191–213.

20 Chung Hyung-min analyzed Lee Qoede's *People* series in detail by connecting it to the religious iconography in Michelangelo's masterpieces, including the ceiling painting in the Sistine Chapel and the *Last Judgement*, which was considered a model for studying the human body in Japanese art circles. Chung further inferred that Lee Qoede might have learned about religious painting through his relationship with Chang Louis Pal, who was Lee's teacher at Hwimun High School. In doing so, he revealed that Lee Qoede visualized historical or allegorical themes through the conventions and iconography of religious painting. See Chung Hyung-min, "Hangukgeundaehoehwaui dosang yeongu" [A Study on Iconography in Modern Korean Painting], *Journal of Korean Modern & Contemporary Art History* 6 (1998): 357–372.

21 Park Munwon, "Rieollijeumgwa romaentisijeumui mun-je: changgonggwa jonaneul jungsimeuro" [Issues of Re-alism and Romanticism: A Focus on *Blue Sky* and *Distress*], *Saehan Minbo*, December 1948.

22 Kim Kyeonga, "(The) figure group paintings of Que-de Lee" (master's thesis, Seoul National University, 2003). The 'holy war' refers to a war painting or war documen-tary painting. Fujita's Subjects of the Japanese Empire Residing in Saipan Island, Show Your Fidelity, a painting based on the American army's attack that resulted the death of 30,000 Japanese defending soldiers and 10,000 civilians in September 7, 1944 resembles Lee Qoede's People series in several aspects including its composi-tion, color, and how it depicts figures. The overall tone of both paintings is dark with a brownish shade. The small-scale depictions of bombs exploding and people gathered in groups situate in the background. At the front, several large-scale figures pose dynamically. One can also find the resemblance between Lee and Fujita in a frightened child and a cup laying around the floor in both paintings.

23 During a conversation with Park Munwon in early 1949, Lee Qoede elaborated on how Rivera endeavored to find materials. This indicates that at the time Lee Qoede was well aware of and deeply interested in the Mexican mural painting movement. Shin Soo-kyung, "A Con-servation between Lee Qoede and Park Munwon for the Establishment of a National Art" in *Geundai seoji: The Sec-ond Half-Year of 2018*, vol. 18 (Seoul: Somyung Publishing, 2018): 591–592.

24 Kim Man-hyeong, "Daejungsaenghwalgwa hoehwa: Misuljeongchaege gwanhan han gaeui geonui" [Painting and the Life of the General Public: A Proposal for Art Policy], *Johyeong Yesul* (May 1946): no page.

25 Park Munwon, "Misurui samnyeon" [Three Years of Art], 42.

26 "Mungyobu, gukgainyeome baechidoeneun jungdeung-gyogwaseo naeyongeul sakjehagiro gyeoljeong" [The Ministry of Education decides to eliminate content chal-lenging national ideology from middle- and high-school textbooks], *Chosun Ilbo*, October 1, 1949.

Socialist Realism and Juche Art: The Formation of North Korean Art in 1945–67

Hong Jisuk

LET US MOVE TOWARDS AND LEARN FROM SOVIET ART[1]

An understanding of the process of the formation of North Korean art after Korea's liberation from Japanese rule requires a close examination of the art exchanges between North Korea and the Soviet Union. North Korean art took as its basis the study and internalization of Socialist Realist art promulgated within the Soviet Union and obtained from this approach a dynamism that drove change and growth within the incipient national art world. The Soviet army that had occupied North Korea officially withdrew on December 25, 1948. However, with the signing of the North Korea-Soviet Union Agreement on Economic and Cultural Exchange on March 17, 1949, the bonds between the two countries were strengthened. After the Korean War, they maintained these close ties at least until the late 1950s.[2] During this period, North Korean artists strove to create new socialist art by learning from art of the Soviet Union. This concern is reflected in the remarks made by Jeong Gwancheol, Chair of the central committee of the North Korean Artist Federation, in his congratulatory speech during the first Competition of All-League Soviet Artists, convened in Moscow in 1956: "Our Korean artists' research [and] adoption of your monumental achievements in Socialist Realism . . . has properly contributed to [producing] a powerful ideological weapon."

During the so-called "Democracy Construction" period designated by North Korean historians as falling between August 1945 and June 1950, North Korea and the Soviet Union embarked on a wide variety of exchange projects. These projects were led by the North Korea-Soviet Cultural Association (Jo-So munhwa hyeophoe) established in November 1945 as an affiliate of the All-Union Society for Cultural Relations with Foreign Countries (VOKS).

Starting with the Exhibition for Artists in the Moscow District held in Pyeongyang in 1947, small and large scale exhibitions were held to introduce the art of socialist states like the Soviet Union. Moreover, Soviet artists visited North Korea and taught Socialist Realism to artists. Additionally, young North Korean artists such as Park Gyeongran, Ji Cheongryong, Kim Linkwon, and Kim Jaehong studied in the Soviet Union and learned Socialist Realism at the Repin Academy of Art or the Surikov Art Institute. Numerous North Korean artists also studied the art of the Soviet Union through photographs and critiques of artworks featured in literary magazines. Among the vast body of publications imported from the Soviet Union, the magazines "Ogoniok" (Огонёк) and "Iskusstvo" (Искусство) were the reference works most frequently consulted by North Korean artists. In addition, artists read Korean translations of writing by Soviet artists published in the Korea-Soviet Cultural Association's bulletins such as *Jo-so Chinseon* and *Jo-so Munhwa*. These translated texts were also printed within bulletins of the North Korean Federation of Literature and Art, including *Munhwa Jeonseon* and *Munhak Yesul*.

What specifically did North Korean artists learn from Soviet art during this time? Soviet artists taught that, first of all, new Socialist Realism should be propagandistic. As a case in point, in his article "Sahoejuui reallijeume daehayeo (About Socialist Realism)" which was translated into Korean and published in *Jo-so Chinseon*, the Soviet painter German Nedošivin argued that Socialist Realism "promotes patriotism, pure love between young men and women, hatred for social and national repression, and the pure joy of maternity." He further stated that a main task for socialist artists was to mingle with the public, visually capture and express the power and emotions of

working people, and thus contribute to the socialist revolution and the construction of a socialist state.¹ In this light, Nedošivin emphasized that artists should paint themes such as the "labor of workers and agricultural commune members, the lives of Soviet children, and unforgettable moments in history, along with portraits of national leaders, representatives of the Soviet intelligentsia, and heroes of the Soviet Union and of socialist labor." North Korean artists faithfully responded to such demands and incorporated these themes in their works. Such themes can further be identified through the list of artworks compiled by Jeong Gwancheol, the chairman of the central committee of the North Korean Korean Artist Federation, as representative works of the North Korean art world from 1945 through 1949.³

North Korean artists learned more from Soviet art than just new themes. They were trained in how to paint these themes in Soviet styles as well. Soviet artists taught their Korean peers not to draw reality as it appeared, but to find the essential, critical, fundamental, and representative substance within reality and depict that instead. According to Soviet artists, those who could find this would feel the joy and passion of working people and could depict in their work the course of the progressive development of communist society.

Soviet artists further asserted that artists should portray in their works what they experienced and felt firsthand. They denounced the attitude of simply attempting to depict reality in a photographic manner, as such a pursuit of only a faithful reproduction of visual phenomena as was the aim of Naturalism and bourgeois Formalism. The Socialist Realism that they aimed for instead was a practice based on revolutionary romanticism, namely art promoting a change in reality or envisioning a bright future. Early North Korean artists called such Socialist Realism "Refined Realism." As Andrei Zhdanov asserted, Socialist Realism is art seeking "not to depict [life] in a dead, scholastic way, not simply as 'objective reality,' but to depict reality in its revolutionary development" and in this respect it should function as the "ideological remodeling and education of the working people in the spirit of socialism."⁴

THE NATIONAL ART SCHOOL AND NORTH KOREAN ART ALLIANCE

The most urgent task that North Korean artists faced immediately following Korea's liberation from Japan was to establish an institutional framework for art.⁵ More than anything else, fostering the development of new artists was considered essential.

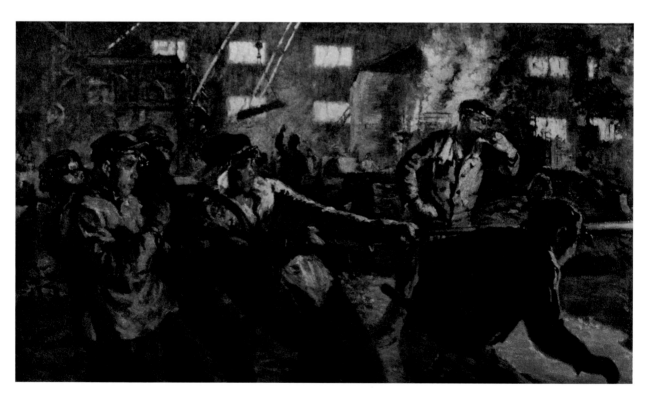

1 Jeong Gwancheol, *Steelmakers*, 1957, Oil on canvas, 116×198 cm

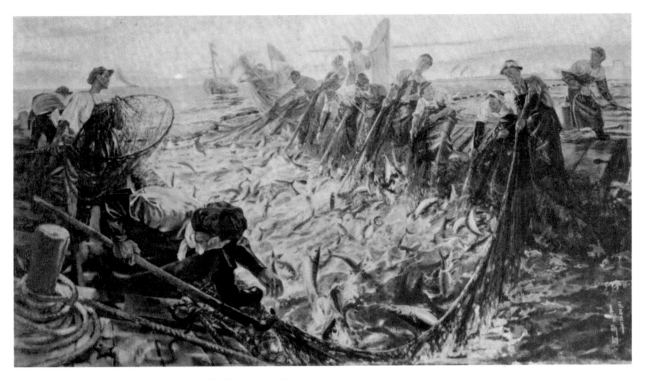

2 Hwang Taenyeon, *Cheers from the Sea*, 1954–55, Oil on canvas, 120 *ho*

After liberation, only about twenty professional artists were active in North Korea, and they could not keep up with the rapidly increasing demand for their labor. Moreover, the cultivation of skilled artists could not be accomplished in only a short period of time. In accordance with these needs, the National Art School (Pyeongyang Art School) was established on March 1, 1949. As one of fifteen universities that were established in North Korea through 1950, the National Art School consisted of three Departments: Painting, Sculpture, and Descriptive Geometry.[6] In addition to the National Art School, art research institutes were constructed in different regions in a further effort to train more artists. According to the *Joseon jungang nyeongam* (North Korean Central Yearbook) published in 1950, art research institutes were established in five districts: Haeju, Sinuiju, Cheongjin, Hamheung, and Wonsan. Jeong Gwancheol viewed these research institutes as "the most appropriate organizations for fostering talented artists among the masses of working people and [provide] much-needed facilities." Aside from art research institutes, art workshops were established in Pyeongyang, Cheongjin, Hamheung, Wonsan, Sinuiju, and Nampo. Amateur artists were trained at these art research institutes and art workshops instead of at art universities where specialized education was offered.[7] [2] Owing to the efforts of these art

research institutes and art workshops, the North Korean Art Alliance (Bukjoseon misul dongmaeng), which was established with twenty members on September 27, 1946, grew into a larger organization with 688 members by 1949.

The North Korean Art Alliance was a subordinate body of the North Korean Federation of Literature and Art. In 1946, the North Korean Federation of Literature and Art consisted of four federations, the Literature Federation (chaired by Lee Giyeong), Theatre Federation (chaired by Song Yeong), Music Federation (chaired by Kim Dongjin), and Art Federation (chaired by Seonu Dam). There were also three committees: the Movie Committee (chaired by Ju Ingyu), the Dance Committee (chaired by Choi Seunghui), and the Photo Committee (chaired by Lee Munbin). In 1948, the North Korean Federation of Literature and Art was reorganized to incorporate the Literature Federation (chaired by Lee Giyeong), Theatre Federation (chaired by Park Yeongho), Music Federation (chaired by Lee Myeonsang), Art Federation (chaired by Seonu Dam), Photography Federation (chaired by Lee Munbin), and Dance Federation (chaired by Choi Seunghui). Around 1948, there was a surge in its membership that required a further subdivision of the organization's divisions, and in the case of the Art Federation, more specialized department sub-committees were established in 1948. They

consisted of a Painting Department (chaired by Seonu Dam), Sculpture Department (chaired by Mun Seoko), Craft Department (chaired by Jang Jingwang), and Stage Design Department (chaired by Jeong Sunmo). The organization of department committees under the federation changed constantly on an ad hoc basis.

The North Korean Art Alliance was responsible for organizing and managing central and local art communities. It planned, managed and assigned a wide range of art projects. Its duties included the holding of lectures and classes to educate artists, the dispatch of artists to different regions for field work and practice, and the operation of the National Art Exhibition of Democratic People's Republic of Korea which was held on national holidays (starting with the first iteration in Pyeongyang in August 1947). The rapid formation and expansion of the North Korean Art Alliance indicates that after Korea's liberation, art in North Korea quickly was placed under the exclusive control of the government. In a society where the state manages art, determining an artists' status was also the state's responsibility. On June 4, 1952, the title "Laudatory Artist" was designated by ordinance from the North Korean Supreme People Assembly's standing committee. In 1956, the sculptor Mun Seoko (1904–73) was awarded the title "Laudatory Artist" by the North Korean Supreme People Assembly's standing committee. In the following years, several artists, including Jeong Gwancheol and Seonu Dam (1904–84), were also granted the title of "Laudatory Artist." On July 27, 1961, the North Korean Supreme People Assembly's standing committee established the title "People's Artist" as the greatest accolade available to North Korean artists. Jeong Gwancheol was the first artist to be granted the title of "People's Artist." Afterwards, large numbers of artists, including Chung Chong-yuo and U Chiseon, were bestowed this title.

NORTH KOREAN ART AFTER THE KOREAN WAR

The Korean War began with a southward incursion by the North Korean People's Army on June 25, 1950 and ended with the signing of an armistice on July 27, 1953. It left indelible scars of violence and division across the peninsula, and the war also greatly impacted North Korean art, especially in relation to the reshuffling of significant personnel within the North Korean art world following artists moving to either the South or the North. Numerous experienced artists left for the North around 1950 and quickly entered the heart of the North Korean art world, which had been suffering from a shortage of professional talent. These new arrivals became heavily involved in the establishment of North Korean art. In institutional terms, for instance, the emergence of graphic art following this period is noteworthy. In March 1951, the North Korean Art Alliance was renamed the Korean Artist Federation and its departmental committees were reorganized. At that time, a Graphics Department was first established (it was renamed Publishing Art Department in the early 1960s). According to Jung Hyunwoong, Chairman of the new Graphics Department, graphics is a "word collectively referring to the art reproduced through printing" and includes engravings, illustrations, bindings, and posters. From early on, Soviet artists had placed emphasis on graphic art as an agile and effective form of visual communication and "one of the origins of the Soviet Union's plastic arts." In North Korea, however, graphics emerged as a significant and independent core genre when the political utility of propagandistic printed material was demonstrated in 1951 during the Korean War. [3]

In the North Korean art world of the 1950s, some advocates criticized the emergence of graphics and questioned its apparent lack of artistic merit. However, graphic artists, including Jung Hyunwoong, asserted that it was not to be considered a subordinate or inferior to practices such as oil painting or sculpture, and strove to elevate it to being "an independent genre with a firm footing" equivalent to painting. The mode of graphic art that emerged as a significant independent genre in the 1950s functioned as a platform through which North Korean artists embraced and actualized the speed, ubiquity (through mass production), and popularity that modern industrial society demanded from contemporary visual culture. Moreover, the strained relations between painting and graphics that remained throughout the 1950s and 1960s actually triggered a creative interchange between the two fields. On the one hand, graphic artists attempted to improve the artistry of their work by embracing painterly elements. [4] While on the other, the full-scale replication and reproduction of arkworks for mass consumption that took place around 1960 was linked to the popularization of graphics. Through this process, the producers and consumers of art adjusted to a new populist notion of visual culture that was repetitive rather than unique, immediate in everyday life rather than distant and rarely encountered, and impactful rather than contemplative.

DISPUTE OVER LYRICISM: SCHEMATISM AND REVISIONISM

Even after the Korean War, North Korea and other socialist nations, including the Soviet Union, continued to engage in relatively active artistic

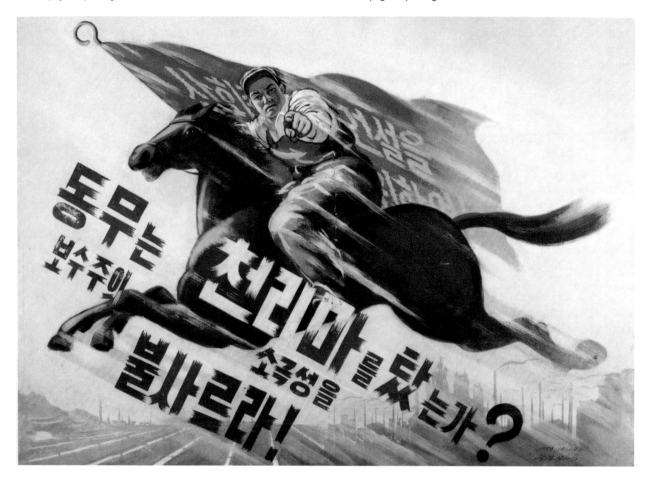

exchanges.[8] Particularly in the late 1950s, North Korean artists responded with sensitivity to the ongoing dissolution of classical Soviet aesthetics after 1956 following the death of Joseph Stalin in 1953 and Nikita Khrushchyov's criticism of dogmatism during his speech at the twentieth party conference in 1956. North Korean artists reinterpreted and reevaluated the Soviet Union's traditional approach to Socialist Realism, which they had previously embraced uncritically, particularly in the bulletin *Joseon Misul* first published in 1957 by the central committee of the Korean Artist Federation. In this process, the assertion that aesthetic demands were as important in art as political (propaganda) demands was accepted for a while. At the time, a considerable number of North Korean artists objected to the schematism and dogmatism that supported the depiction of predetermined topics through certain fixed aesthetic approaches. Instead, they highlighted the possibility of artists' subjective individuality and lyricism in relation to the creative interpretation of nature and life. Accordingly,

당신들이 추천한 후보자들에게 찬성 투표하라

whenever artists gathered to engage in conversation, at least one of them mentioned the accompaniment of a poem to a painting. The critic Kim Changseok described an artist's subjective thoughts and feelings presented within an artwork as "artistic vision." In such an atmosphere, the contexts and formats within North Korean art in the late 1950s diversified. For example, landscape painting, which had previously been deemed as an anachronistic bourgeois genre, drew special attention in North Korea during the late 1950s, when it came to be regarded as a lyrical art form through which artists could voice their creative ideas. According to Jo Ingyu, Chairman of the Critique Department of the Korean Artist Federation, landscape painting bears distinct characteristics that differentiate it from genre and figure painting. Among these characteristics is "a relatively broad range of direct influences from the artist's emotions, thoughts, and aesthetic ideals." **5**

However, there were those who criticized this revisionist trend that emphasized an artist's subjectivity. Many of them disparaged the approach for overly highlighting personal subjectivity and asserted that such an approach would undermine the integrity of Socialist Realism. In the early 1960s, lyricism was considered as indispensable in realistic art. Nevertheless, this version of lyricism was, according to Mun Haksu: "not something subjectively abstracted and it differed from outdated [traditional/bourgeoise notions of] lyricism." As Mun Haksu argued, this preferred approach to lyricism was to reflect "the vibrant lives built within socialist revolutions and the construction of socialism." Thus, North Korean art acquired a distinctive language that stressed the subjectivity and individuality of artists but at the same time required them to abide by certain standards, themes and conceptual concerns. Such language imposed a set of double restraints on artists, as it constantly emphasized lyricism and individuality, but a prescriptive form of such, based on firm perspectives and ideas. The following statement by the painter Hwang Heonyeong in 1962 perhaps best demonstrates a notion of the appropriate inspirational social circumstance that might inspire a lyrical response from North Korean artists: "Seeing the once-filthy Daedonggang Riverside turning into a park for working people with a row of apartments built along it, how can we not compose a poem about the joy of life in nature!"

CHOSONHWA AS A NATIONAL STYLE
The major change in North Korean art in the late 1950s was to strengthen the position of Chosonhwa (literally meaning 'Korean painting'), referring to traditional Korean ink painting. **6** The term "*dongyanghwa*" (lit. Eastern painting) had been commonly used until the early 1950s but almost vanished in and after the mid-1950s. **9** In its place, the new term Chosonhwa suddenly appeared. At the twenty-second standing committee of the Korean Artist Federation in 1957, the existing Painting Department was divided into a Chosonhwa Department (chaired by Kim Yongjun) and an Oil Painting Department (chaired by O Taekgyeong). The primary objective of the Chosonhwa Department was to establish Chosonhwa as a national art practice in accordance with the slogan "Socialistic Content and National Style" demanded by Socialist Realism.

What was this "national style" that Socialist Realism demanded? Early socialist literary theorists viewed 'style' in art as something irrelevant to the people. At the time, Kazimir Malevich's argument that "the new era of revolution should be represented as a new and revolutionary art form" prevailed. However, this position weakened during the Stalinist era. Instead, the view that "a true revolution starts not with an art style but with the social use of an art style" became dominant. Thus, the application of a given style rather than the creation of new styles emerged as a goal. **10**

Artists probed how to use existing styles on behalf of the global revolution. Accordingly, cultural heritage and national styles came to take on a special meaning in socialist art. Since the masses were already comfortable with them, traditional national styles played a role in mitigating and concealing the incongruities of socialist content, which was imbued with the 'foreign' Soviet approach of revolutionary romanticism. According to Maxim Gorky, national styles were valuable as an "accessible form to quickly and easily convey and disseminate socialistic ideology and sentiments to people."

How did North Korean artists understand the national styles demanded by Socialist Realism? One viable alternative was Chosonhwa, namely a form of traditional Korean painting. However, there was strong resistance against naming this genre as the official national genre of art. In North Korea during the 1940s and 1950s, many artists perceived Chosonhwa to be a vestige of the pre-modern era. In particular, several oil painters, including Kim Jukyung and Seonu Dam, sought to develop an official national form of oil painting, that highlighted emotional content and characteristics distinctive to Korea. Their argument failed to take root, however, and around 1957 there was growing support for Chosonhwa. In his 1957 article "For the Advance of Our Art," Kim Yongjun, the chairman of the Chosonhwa Department of the Korean Artist Federation, criticized "the mistaken tendency to try and make oil painting act as a host to our art"

5 An Sangmok, *Part of Promenade on the Banks of the Taedong River*, 1959,
Chosonhwa, 49×196 cm

6 Han Yeongsik, *Gim Satgat*, 1957,
Plaster

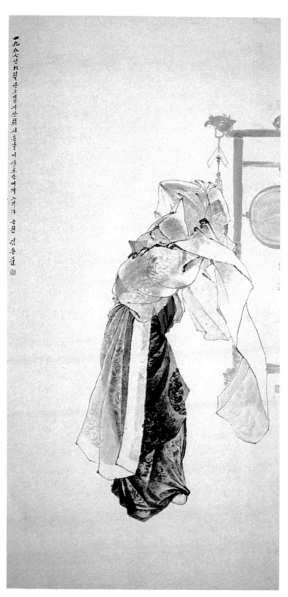

7 Kim Yongjun, *Dance*, 1958,
Chosonhwa, 170×89 cm

SOCIALIST REALISM AND JUCHE ART: THE FORMATION OF NORTH KOREAN
ART IN 1945–67

as an error of radicals on the left and declared the exclusive standing of Chosonhwa as the national genre of art.[11] [7]

The establishment of Chosonhwa as the official genre of art led to issues regarding the precise characteristics of Chosonhwa that North Korean artists could pursue. Several artists held heated discussions over whether the essence of Chosonhwa resided in line or color, and whether ink-and-light-color painting or color painting was its purest expression. Ultimately, color painting prevailed. The argument here was that the bold use of color was required if the new generation of North Korean artists were to divorce themselves from the traditional themes of Korean painting, such as landscape and bird-and-flower imagery, and vividly depict the scenery of a modern industrial society. In the "Conference to Support Spiritual Elevation in the field of the Plastic Arts" held by the Korean Artist Federation on November 20, 1959, Jo Ingyu, the chairman of the Critique Department of the Korean Artist Federation, strongly criticized the "view that simply attributes the features differentiating Chosonhwa from other painting genres to [the use of] lines." He further insisted on resisting any inclination to produce monochrome ink or light color paintings and actively supported the production of vividly colorful works. In 1961, Chung Chong-yuo defined color painting as a type of painting that was appropriate for the portrayal of reality, noting that "color painting can best correspond to the contemporary need to depict people's lives, intentions, and emotions." From the mid-1960s, a new generation of painters in North Korea therefore championed a form of Chosonhwa that made full use of a colorful palette to depict the impression or impact of events, places and figures in real life.

In the 1960s, North Korean artists pursued the modernization of Chosonhwa once it had secured its place as the national genre of art. In other words, they endeavored to "innovate [Chosonhwa] to cater to the modern aesthetic demands of the people." As part of these efforts by North Korean artists, the view that Chosonhwa embodied a "simple and vivid" mode of aesthetics was established. Moreover, intense expression was emphasized as a stylistic feature that could reinforce this standpoint. According to the painter Jeong Changmo, this meant a "figurative principle for capturing the essence and the most significant elements of an object and depicting them in the simplest and most vivid manner."[12] After defining the characteristics of Chosonhwa, North Korean artists worked to develop them as standards for artistic production. The nineth National Art Exhibition held in 1966 accordingly exhibited a vast body of colored ink paintings, including *Big Catch* by Chung Chong-

yuo, *Pine Tree* by Lee Seokho, *Women in Namgang Village* by Kim Uigwan, *Grandfather on the Nakdonggang River* by Ri Chang, *Smelters in the Steel Works* by Choi Kyegun [8], and *Spring in North Manchuria* by Jeong Changmo. After visiting this National Art Exhibition, Kim Il Sung issued a statement titled "Let Us Develop Our Art into Revolutionary Art [Using] National Style and [Delivering] Socialist Contents," stressing the need for artists to refine North Korean art based on the genre of Chosonhwa. In the era of so-called *Juche* art in the 1970s, Chosonhwa maintained a dominant position as the basis of North Korean art. At this time, all fields of artistic expression, including oil painting, sculpture, publishing art, stage design, craft, and industrial art, were intended to display the conceptual characteristics and aesthetic principles of Chosonhwa as the nationally representative genre, in accordance with the respective features of each respective field. Art education was completely geared towards Chosonhwa, and artists from every field were obligated to participate in lectures on Chosonhwa that aimed to "ensure that all artists are independently active but well-versed in the approaches that define Chosonhwa."

THE CHOLLIMA STATUE AND INDUSTRIAL ART

In the spring of 1961, the production of a statue of a *chollima* (mythical winged horse) fourteen meters high (forty-six meters including the base) and sixteen meters long was completed on the Mansudae Hill in Pyeongyang. This work depicts a male worker and a female farmer riding on a galloping *chollima*. [9] Kim Jeongsu, one of the sculptors who participated in its production, described how the worker holds the reins in his left hand and raises the "Red Letter" in his right high toward the sky while the young farmer with a kerchief around her head holds an armful of rice sheafs close to her chest, leans forward, and gazes across a vast field. Here, the worker represents a reformer of labor practices and is designated as a leader of the Chollima Movement, a national drive to promote economic development launched in the late 1950s. His counterpart, the female farmer similarly symbolizes an agrarian leader also involved in this effort, working to increase grain production to a million tons, while the *chollima* horse itself signifies the spirit and speed of the movement to which it lends its name.[13]

The *chollima* statue was a visual embodiment of the ideals of the North Korean regime in the 1960s as it attempted to promote the development of North Korea into a prosperous and powerful socialist industrial state through labor intensification. These social changes influenced

8 Choe Kyegun, *Smelters in the Steel Works*, 1966,
Oil on canvas, 143×233 cm

the structure of North Korean art as well. In 1965, the Craft Department of the Korean Artist Federation was renamed the Craft and Industrial Art Department. Around 1965, it was divided into an Industrial Art Department and a Craft Department. The emergence of the Industrial Art Department around this time suggests that industrial design took on practical significance in North Korea as a field of art stressing practicality as well as ideological and artistic value.[14] Jang Manhui led the expansion of North Korean industrial art in the 1960s. Born in Geochang, Gyeongsangnam-do Province, Jang studied at the Dyeing Department of Kyoto City Specialist School of Painting (Kyoto-shiritsu Kaiga Senmon Gakkō) during the Japanese colonial era. Based on his work experience at a Japanese topographical material production company named Yoneyama Studio, Jang established the General Art Studio. He worked there as an industrial designer until leaving for North Korea in 1960 on a so-called "return ship."[15] Serving as both an artist and theorist, Jang Manhui contributed to building a foundation for North Korean industrial art.

The *chollima* statue not only represents the social changes taking place under the North Korean regime in the 1960s, but also reflects a radical shift in the production system for artworks. The statue was the result of collaboration within the *chollima* sculpture production group, which was divided into three sub-groups. Thirty-two established sculptors joined twelve graduates and fifty-two students from the sculpture departments of art universities in the final stages of its production. Among the established sculptors were O Seongsam (head of the Chollima sculpture production group), Yoo Jinmyeong (leader of the first sub-group), Kim Jeongsu (leader of the second sub-group), Jo Gyubong (leader of the third sub-group), Song Yeongbaek, Han Yeongsik, Lee Seong, Kim Gyopil, An Sangguk, Hyeon Changbeom, Lee Gukjeon, Hwang Eungryeop, Park Gyeongryong, Kim Jeok, Ji Cheongryong, Park Seunggu, and Song Jinseong. Immediately after the completion of the *Chollima Statue*, Kim Jeok wrote in *Joseon Misul* that he realized the greatness of collectivist spirit and the power of the group through this collaborative process and learned the true meaning of the phrase "one for all and all for one." The collaborative creative measures first employed in the production of monuments like the *chollima* statue were then broadly adopted across other fields of production, including painting. As a case in point, the painting *Today's Glory* from 1961 was a collaborative work

9 *Chollima Statue*, Cover illustrations by Chollima Sculpture Production Group, *Joseon Misul*, May 1961

North Koran art of the 1970s institutionally systemized the collaborative creation practices established in the 1960s. The establishment of the Mansudae Art Studio as a base for collaborative creation was a symbolic event. It has been asserted that the Mansudae Art Studio was formed in 1959 and earned a reputation as the leading studio for North Korean art in the 1970s. However, in actuality the Mansudae Art Studio was established for the creation of the Mansudae Grand Monument sometime between 1972 and 1973. Nevertheless, since a majority of the members of the Mansudae Art Studio had participated in the previous production of the *chollima* statue, some North Korean historians have supported an earlier date for its founding. Accordingly, the date of its establishment has been officially designated as November 17, 1959, the day Kim Il Sung first revealed a draft of the *chollima* statue.

NORTH KOREAN ART AFTER 1967

Between late 1967 and early 1968, *Joseon Misul*, the bulletin of the Central Committee of the North Korean Artist Federation, was discontinued. It was replaced by the art magazine *Joseon Yesul*, which was the bulletin of the central committee of the North Korean Federation of Literature and Art. The discontinuation of *Joseon Misul* meant the end of an era during which the standards, values, and systems of art were formed through discussion, and the inception of a period in which the mass production of artworks according to pre-existing standards, values, and systems was emphasized. This shift in art production was inseparable from the contemporaneous construction of the North Korean social, cultural, economic, and political system under the exclusive leadership of Kim Il Sung, based on *juche* ideology. After the 1970s, North Korean art began to promote the construction of *juche* art under the aegis of *juche* ideology. In this respect, North Korean art critics of today refer to the 1970s as the 'golden age of *juche* art.' However, from the perspective of many art historians outside of the isolated socialist state, North Korean art from the 1970s onward was marked by an excessive trend toward rigidity and uniformity based on the established principles of Chosonwha, when compared to the relative variety of artistic approaches to be found during previous periods. Paradoxically, this concretization of a vividly colorful but formally simple approach to Juche art suggests that North Korean artists from the 1950s and 1960s had finally attained an approach to their art that was 'socialist in content and national in style,' a manner that nonetheless began through the process of passionately studying and mastering the Soviet tradition of Socialist Realism.

by thirteen artists from the creation group in the Chosonhwa Department of the Korean Artist Federation. Included in this group were Lee Seokho, Kim Yongjun, Lee Palchan, Lee Geonyeong, Kim Ikseong, Lee Hanbok, and Park Yeongsuk. This painting, produced to commemorate the completion of the vinylon factory in Heungnam was the first collaborative Chosonhwa work to be executed in the spirit of so-called 'refined collectivism.' Collaborative creation groups emphasized the 'individuality of each companion', but the process fundamentally collectivized individuality. Artists involved in such collaborative processes, therefore, should model themselves on the idea of "a group of fighters struggling in unison to achieve a single goal" (like the riders of the *chollima* statue). In 1961, Gil Jinseop, who served as the vice-chairman of the central committee of the Korean Artist Federation, argued that a demand for one individual's preferred outcome within the process of collaborative creation would lead to failure, but an approach properly reflecting all the people's lives "cannot fail to achieve oneness."

1 This title is a quote from Kim Changseok, "Ssoryeon misuleul hyanghayeo baeuja" [Let Us Move towards and Learn from Soviet Art], *Joseon Misul* 11 (1959): 5.

2 The popularity of Soviet culture during this moment, can be confirmed in taking a broader look at North Korean society and culture. Russian language came to be included as a mandatory subject in the curriculum of higher-level middle schools in 1947 and at lower-level middle schools in 1948. In 1949, Russian also became a required language for admission to Kim Il Sung University, replacing English. According to Wada Haruki, "the large ribbons that girls wear in their hair and street trees painted with white coal disinfectant below the middle of the trunks are commonly seen in the Soviet Union." Haruki also recounts that "buildings along the streets are constructed in the Soviet style with stores and offices on the first floor and apartments on the second and higher floors." Haruki, *Bukjoseon: yugyeok dae gukgaeseo jeonggyu-gun gukgaro* [North Korea: From a Country with Guerrilla Troops to the Country with a Regular Army], trans. Seo Dongman and Nam Gijeong (Seoul: Dolbegae, 2002), 135. North Korean artists at the time commonly used Russian art terms like *etyud* (study), *risunok* (drawing), *nabrosok* (rough sketch), *molbert* (easel), and *grafik* (graphic art). This widespread use of Russian art terms ended in the early 1960s when the North Korean regime required people to change Russian loan words into pure Korean terms.

3 This list includes *Textile Factory in Sariwon* by Kim Hageon, *Light a Wick (Aoji Coal Mine)* by Park Young-ik, *Forged Steel (Seongjin Steel Works)* by Han Sangik, *Carbide Factory (Bongung Chemical)* by Lee Soo-auck, *Haeju Machinery Factory* by Jeong Boyeong, *Rice Plantation (Buri Farm)* by Jeong Gwancheol, *General Kim Il Sung* by Choi Yeonhae and Seonu Dam, and *Achievements of General Kim* by Kim Chukeung. Jeong Gwancheol, "Misul dongmaeng 4nyeonganui hoegowa jeonmang" [Review of the Four Years of the The North Korean Art Alliance and Its Prospects], *Munhak Yesul* 8 (1949): 87–88.

4 Andrei Zhdanov, "Soviet Literature: The Richest in Ideas, the Most Advanced in Literature," in *Saboejuui hyeonsiljuuiui gusang* [Concepts of Socialist Realism], trans. Jo Manyeong (Seoul: Taebaek, 1989), 21–22.

5 One of the important institutional frameworks established in the 1940s and 1950s was the National Central Art Museum. The National Central Art Museum established on September 28, 1954 was modeled after the National Pyeongyang Art Museum founded in August 1948 and opened to the public on November 8, 1957. Seonu Dam, a standing member of the central committee of the Korean Artist Federation, assumed the position of the first director of the museum. After moving to a new building completed in 1961 on Kim Il Sung Square, the National Central Art Museum was renamed the North Korean Art Museum in August 1964 according to Directive No. 687 of the Cabinet. As an institution for educating working people on communism and artistic refinement, the North Korean Art Museum is the sole art museum in North Korea that encompasses a wide variety of both traditional and contemporary art, ranging from replicas of mural paintings from the Goguryeo Kingdom tombs to Chosonhwa paintings. It includes various types of art as well, including Chosonhwa, oil painting, graphic art, sculpture, and crafts.

6 In October 1952, the National Art School was expanded and reorganized as Pyeongyang Art University. At present, Pyeongyang Art University offers a three-year specialty course, a four-year-and-six-month university course, a two-year researcher course, and a three-

year doctoral course. It consists of seven departments (Chosonhwa, Painting, Sculpture, Graphic Art, Crafts, Industrial Art, and Social Sciences) and provides thirty classes.

7 A case in point is Hwang Taenyeon (1926–96), an oil painter. Hwang was a laborer who did not receive a specialized education in art. During the liberation period, he worked as a salesman at the Cheongjin Steel Complex and at an art workshop in Hamgyeongbuk-do Province. Upon winning second place at the National Art Exhibition for his *Celebration from the Sea*, Hwang advanced within the central art community. In his later years, he was given the title "Laudatory Artist." Ri Jaehyeon named Hwang as an example of the rising artists being fostered at the art workshop led by Tak Wongil, Jo Ingyu, Rim Baek, and Ri Unsa in Hamgyeongbuk-do Province immediately after Korea's liberation. Ri Jaehyeon, *Joseon ryeokdae misulga pyeonram* [A Handbook of Successive Korean Artists, Enlarged Edition] (Pyeongyang: Munhak yesul jonghap chulpansa, 1999), 464. Some artists from art research institutes entered the elite art world through admission to Pyeongyang Art University. Examples include, Ri Maeklim from the Cheongjin Art Research Institute, Jang Hyeoktae from the Hamheung Art Research Institute, and Ryu Jaegyeong from the Nampo Art Workshop.

8 Among the artists who engaged in art exchanges between North Korea and the Soviet Union after the Korean War is Pen Varlen, a Russian-Korean painter dispatched to North Korea in 1953 by the Soviet Union Ministry of Culture. While staying in North Korea between 1953 and 1954, Pen was involved in establishing and improving systems and education programs at Pyeongyang Art University. In his writing published in 1957, Jeong Gwancheol stated that "Pen Varlen, the comrade and painter dispatched by the Soviet Union in 1953, not only provided essential aid in [designing] teaching programs for the [Pyeongyang] Art University over the course of a year, but also greatly contributed to developing Socialist Realism art in North Korea." See Jeong Gwancheol, "Widaehan 10wol hyeokmyeonggwa wurinara sasiljuui misurui baljeon" [The Great October Revolution and the Development of North Korean Realist Art], *Joseon Misul* 5 (1957): 6.

9 For example, in writing published in 1952, Gil Jinseop described Kim Yongjun's painting as a work produced "in the compositional style of *dongyanghwa*." See Gil Jinseop, "Joguk haebang jeonjaeng misul jeollamhoe pyeong" [A Review on the Fatherland Liberation War Art Exhibition], *Munhak Yesul* 9 (1952): 106.

10 Boris Groys, "Educating the Masses: Socialist Realist Art," in *Art Power* (Cambridge: MIT Press, 2008), 145.

11 The adoption of Chosonhwa as an official national style was also likely impacted by overseas viewers' interest in Chosonhwa during the Joseon Art Exhibition that traveled to Poland, Czechoslovakia, Romania, and Bulgaria from October 1957 through June 1958 and the *Socialist State Plastic Art Exhibition* held in Moscow in December 1958. According to Kim Jeongsu, who supervised the Joseon Art Exhibition in Romania, "Chosonhwa and craftworks that passed on and extended national tradition in the right direction were greatly extoled by the people in this country [Romania]." He further mentioned that Chosonhwa paintings, in particular, including *Sunflowers* and *Scenery of Vietnam* by Lee Seokho and *Dance* by Kim Yongjun, "attracted the attention of young Romanian artists and became subjects for their research." Kim Jeongsu, "Rumaniya inmindeurui saranggwa jijireul badeun joseon misul" [Korean Art Loved and Supported

by the People of Romania], *Joseon Misul* 7 (1958): 42–43.

12 Jeong Changmo, "Hyeoksineroui jihyang–joseonhwaeseo chaesaekhwa munjereul jungsimeuro" [Aiming for Revolution: A Focus on Color Painting in Chosonhwa], *Joseon Misul* 9 (1965): 19.

13 Kim Jeongsu, "Wuri sidaeui gisangin cheonrima dongsangui sasang yesulseonge daehayeo" [About the Ideological and Artistic Values of the *Chollima* Statue, the Spirit Our Time], *Joseon Misul* 5 (1961): 12–14.

14 The links between art, trade, and industry had been discussed extensively since the 1920s in Korea. The term 'Industrial Art' was commonly used in the art world before Korea's liberation. Immediately after the liberation, the North Korean Industrial Art Association was formed in Seoul. However, it was only in the 1960s that industrial art came to fulfill practical functions and the term came to carry a distinct social meaning under the North Korean regime.

15 In a report on the Commemorative Conference of the tenth Anniversary of the Establishment of the Democratic People's Republic of Korea (DPRK) held in September 1958, Kim Il Sung declared that the DPRK would "compensate Korean residents in Japan for all the conditions that are incurred upon returning to their homeland and leading a new life here." In response to Kim Il Sung's declaration, Vice Premier Kim Il presented the specific conditions provided to returning Korean residents of Japan in his announcement on September 16, 1958. In February 1959, a letter was published in the art magazine *Joseon Misul* in which the extended standing committee of the Korean Art Association in Japan (Jaeil joseonin misulhoe) wrote about the prompt action needed for the return of Korean residents in Japan. In June 1959, the Korean general labor federation in Japan (Jae Ilbon Joseon nodong chong dongmaeng) was formed. The return program for Korean residents in Japan was initiated with the first return ship heading from Japan to Cheongjin on December 14, 1959. Between 1959 and 1965, several Korean artists living in Japan, including Kim Seunghui, Cho Yanggyu, Jang Manhui, Han Uyeong, Kim Bohyeon, Pyo Sejong, and Park Ildae, went to North Korea. Among them, a few artists, such as Kim Seunghui, Kim Bohyeon, and Pyo Sejong, successfully settled in North Korea and are still treated courteously as veteran North Korean artists. However, the majority of them, including Cho Yanggyu, Han Uyeong, and Park Ildae, were shunned by the mainstream art world in North Korea in the late 1960s, and their whereabouts are still unknown.

Art of the Korean Diaspora

Park Soojin

The modern history of large scale organized Korean emigration started in the mid-nineteenth century. This history may be relatively short in relation to that of other contexts around the world, but within this relatively short historical period, the Korean people nonetheless sought adaption to various political, economic systems of numerous countries through emigration.

In basic terms, there is a marked difference between the large-scale migration to Russia, China, and Japan that occurred from the mid-nineteenth century until the Second World War, and the later post Korean war migration to the U.S. and Canada after the 1960s. To broadly simplify, Korean emigrants in the nineteenth and early twentieth century were mostly farmers and lower-class citizens, pushed to leave the country due to situations such as famine and the disenfranchisement and exploitation that accompanied colonization. By contrast, post-war Korean emigrants were often motivated to migrate through financial and personal opportunity and ambition and the group comprised of many aspirational middle-class and educated citizens from urban regions. Another difference is that migrants prior to the Korean War mostly moved to neighboring countries due to issues of immediate need and transport infrastructure, whereas post-war emigrants were able to move to geographically further regions such as the Americas and Europe.[1] Given the diverse range of geographical destinations and historical, social and cultural contexts that have informed the global scope of Korean emigration over the last 150 years, the conditions met by the Korean diaspora in their new countries of residence have differed greatly according to the precise circumstance of their migration.

Given this vast range of contexts the geographic scope addressed in this text is confined to regions neighboring the Korean Peninsula, specifically China, Japan, and various nations of the former Soviet Union. Within these regional contexts this essay will address the long-term trajectory of artistic production by the Korean diaspora from the nineteenth to the late twentieth century. The reason for focusing on these regions is that they have provided the most historically longstanding destinations for migrants, and outside of North America they contain the biggest diasporic populations of ethnic Koreans.

From the 1860s till the start of the Japanese occupation in 1910, peasants and laborers regularly crossed the northern border to move to China and Russia to flee from famine, poverty, and bureaucratically enacted social oppression in Korea. The Koreans that moved to provinces like Manchuria in China and Primorsky Krai in Russia, made new lives for themselves by cultivating agricultural lands in areas that had not granted them any official entry or residential status. Then, during the Japanese occupation from 1910 to 1945, many political refugees and freedom fighters also moved to China, Russia, and the U.S. to organize independence movements, while peasants and laborers who were deprived of their land and means of livelihood under the Japanese rule often migrated to Manchuria and Japan. With the Manchurian Incident of 1931 and proclamation of Manchukuo as an independent state in 1932, Japan organized a massive group migration of Korean people to Manchuria for the purpose of developing the region. With the outbreak of the Sino-Japanese War in 1937 and Japanese entry into the Second World War in 1941, many colonial Koreans moved to Japan as laborers to further support Japanese military production, while many others were forcefully conscripted for frontline service across the Japanese Empire as soldiers and workers. This led to a rapid

increase in Koreans residing in Japan, reaching a population of 2.3 million in August 1945. The number rapidly decreased after Japan's defeat in the war, to around 0.6 million in 1947.[2]

Migration related discourses emerged worldwide in the mid-1990s. With the dissolution of the Soviet Union, grand discourses of ideology apparently disappeared from a world once polarized by the conflicts of the Cold war. Instead, issues of environmentalism, ethnic division, and gender identity emerged as the new keywords through which to understand contemporary society. Amid this new context of globalization, the world has witnessed a great increase in migration everywhere, and "diaspora" became a crucial idea in helping to interpret contemporary society. Today, human movement around the globe has become faster and more ubiquitous. In this context, many migrants are no longer so anxious to return to their homeland. Often, they identify themselves with neither their 'mother' country nor the country they currently reside in, and thus new discourses questioning the concepts of race, ethnicity, and identity have developed. In this context, rather than focusing on nostalgic ideas of loss and displacement, the new tendency is to positively read the new meanings produced in the process of migration and the cultural diversity that is generated. And, for many academics involved in the study of migration, the focus of discussion has shifted from the issue of social assimilation to a more global perspective, considering the worldwide context of border crossing.[3]

In this context of privileging people's diverse experiences of migration and their individual notions of national belonging, is difficult to explain with a single theory the experiences of all Koreans that have left the peninsula. This is due both to their varied backgrounds and motives for leaving, and not to mention that the various countries in which they settled have different political, economic, social and cultural circumstances. However, while the migrant experience is individual and unique, migrants also share much common ground, relative to which some general ideas can be stated. In this regard a discussion of their experiences offers a chance to consider the patterns of experience that can recur under certain conditions.[4]

As such, this text explores the lives and work of migrant artists relative to a critical consideration of history and social conditions. If we are to say that the lives of these Korean migrants are a historical outcome unique to the pressures of the modern world, reviewing retracing their footsteps is arguably crucial to expand the horizon of Korean art history today.[5]

THE ART OF JAEIL (在日) KOREANS

The term Jaeil (在日), as applied by Korean people to the Korean diaspora in Japan, literally means "staying in Japan," which implies the permanently 'unsettled' status of the Korean diaspora on the neighboring archipelago. In precise terms of their national identity, while all Jaeil Korean artists by definition live, or lived, physically in Japan, some have remained Korean citizens, some as Joseon citizen,[6] and some have become Japanese citizens, as the term can even be applied to the second or third generation diaspora of ethnic Koreans in Japan. In the post war period, the organizations in support of their rights are also divided into the Republic of Korean Residents Union in Japan (hereafter Mindan), with its ties to South Korea, and the General Association of Korean Residents in Japan (hereafter Chongryon), with its ties to the North.

If history is something that can be addressed politically, then an art work, as the unique product of a person's independent perspective and lived social experience, does not necessarily accord with history. In this respect, acknowledging the unique history and situation of Jaeil Koreans, living as 'foreigners' within Japan potentially for multiple generations, allows one to better observe the context of Jaeil Korean art. The art of diasporic Jaeil Korean artists could be said to simultaneously reflect the art of South Korea and North Korea, and also that of Japan. To narrate a simple narrative within a historical framework of the twentieth century, the first generation of migrant artists, in the early colonial period, was focused on Korea, building Korean artists collectives and creative orientations amidst a desperation that they should defiantly group together relative to their marginalized national identity. The second generation sought to adapt to Japanese culture as ethnic outsiders within a monoethnic society, and explored how they could creatively and professionally prosper within, while the third and fourth generations benefitted from a stronger sense of their settled place within Japanese society, and in creative terms have concentrated more on building objective identities of themselves relative to a 'global' perspective.

The first period could be said to extend from the late 1940s to the 1960s when the first generation of Jaeil Koreans, that is Korean migrants during the colonial period who had decided to, or had to, settle in Japan in the long term, actively produced realist works centered around Jaeil art associations. During this period, Japan was witnessing the rise of realist art critical of traditional Japanese society, and Japan's role in the Second World War. Japan's defeat in 1945 not only caused the Japanese citizenry great economic suffering but also pushed many into a state of dire psychological crisis. In this post-war context, many

Japanese artists visited working class districts and industrial areas, and witnessed the scenes of the demonstrations held against the U.S. military occupation of Japan. This was to gain a direct notion of the feeling of turmoil that was sweeping the nation to inform their art, and as a result of such experiences, many artists created paintings of industrial scenes such as factories and coal mines, in order to reflect the life and struggle of everyday people. In such circumstances, many realist artists also emerged from within the ranks of the Jaeil Korean community, who along with their Japanese peers also desired to reflect the reality of society in their practice. In this context, the works of Cho Yanggyu, Chun Hwahwang, and Peak Ryeng were published in the catalogue of the exhibition *Realism in Postwar Japan 1945-1960* organized by the Nagoya City Art Museum in 1998, affirming their status within postwar realist art in Japan.

A list of significant Jaeil Korean artists after Independence might include figures such as Chun Hwahwang, who portrayed the bleak atmosphere of Korea after independence; Kim Changduk, who served as Head of the Central Art Department of the Federation of Korean Writers and Artists in Japan (Jae ilbon joseon munhak yesulga dongmaeng; hereafter, Moonyedong) and participated in the organization of the Japan Action Art Association as a member since its foundation; Song Youngok, who focused on the division of the Korean Peninsula and the discrimination and poverty faced by Jaeil Koreans; Peak Ryeng, who was the key figure

1 Cho Yanggyu, *Sealed Warehouse*, 1957, Oil on canvas, 162×130.5 cm

producing theory and critique within the Jaeil art community; Cho Yanggyu who started out by portraying the isolation of working people, and then defected to North Korea after he built his status as a postwar realist artist in Japan **1**; and Chae Joon, who serially published satirical political cartoons based on his unique sense of form and sharp critical consciousness.

Artists of this period shared a sense of nationalist resistance against discrimination in Japan and a yearning for the reunification of Korea, resulting in them initiating and participating in Jaeil artist organizations. The first Jaeil Korean art organization was the Jaeil Joseon Artists Association, formed in 1947. In 1953, the Jaeil Joseon Art Association was organized, through which the journal *Joseon Art* was published. In 1959, the Federation of Korean Writers and Artists in Japan was formed and became a central element in the Jaeil art world. In 1961, Federation of Korean Writers and Artists in Japan and Mindan artists gathered and opened the first and second annual group shows. These had a considerable impact on the formation of Jaeil Korean art history, and the *Jaeil Joseon Artist Catalogue* published in 1962 provides crucial information on the early activities of Jaeil artists. Jaeil Korean artists of the time presented their works not only through the Jaeil Korean organizations but also in various Japanese exhibitions that supported the notion of creative freedom, contemplating and working together with like-minded Japanese artists.

The second period was from the 1970s to the 1980s, when Jaeil Korean artists were not affiliated with any specific organization and produced modernist works, also standing out within the Japanese art scene. In the 1960s, the Japanese art scene gradually grew as the postwar recovery got underway and economic conditions stabilized with the Tokyo Olympics and Japan's joining of the UN. In the late 1960s, resistance culture quickly spread throughout the younger generation, including students' resistance against the historic 1951 Security Treaty Between the United States and Japan, and avant-garde movements against traditional culture unfolded throughout all genres of art. As the influence of western culture became stronger, it was around this period that the Mono-ha[7] movement emerged as a new direction for Japanese art in response.

Around this moment the second period of significant new development with Jaeil art started and continued from the 1970s to the 1980s. Within this second period, the most significant Jaeil Korean artists were often not affiliated with any specific organization and produced modernist works, also standing out within the Japanese art scene. A range of important representative Jaeil artists of the second period could be considered as follows. Quac Insik, who pioneered creative investigations of materiality from as early as early 1960s, before the rise of Mono-ha **2**; Kwak Duckjun, who questioned social conventions through various media including painting, installation, print, photography, and performance; Takayama Noboru, who is recognized as a member of Mono-ha and often employed railroad ties in his art to signify those who had met anonymous deaths; Moon Seunggeun, who interacted with the Gutai group and won the 1969 artist publication award at the International Young Artists Exhibition and participated in the 1977 Modern Print Grand Prize Exhibition with his highly experimental works; and Son Ah-Yoo, who sought to affirm the materiality of objects and the meaning of existence through the lines, colors, and spaces revealed through repetitive bodily action.

It is worth also noting that the critical realist approach taken by the Moonyedong continued until the 1990s within the Jaeil art scene. Moonyedong artists in Japan were employed by the North Korean state to create propaganda art as the national ideology of Juche 'self-reliance' was established alongside cult of personality based on Kim Il Sung and Kim Jong Il in North Korea proper during the 1970s. This tendency eventually led to ideological conflicts among Moonyedong artists who were used for propaganda activities in North Korea while resided in Japan, a liberal democratic county. This struggle marks the third period during which Moonyedong activities dwindled in the 1980s and the Jaeil art world witnessed a generation shift to those artists who refused the seriousness of such ideologically extreme ideas. In this new context, notions of style, expression and subject matter gradually changed to include what Jaeil artists considered as appropriately reflective of their diasporic national sentiment. These interests included subject matter such as *nong-ak* (Korean traditional music performed by farmers) and traditional folk games that were presented through Moonyedong's Jaeil Joseon Central Art Exhibition and the Goryeo Art Association, established in 1981.[8]

Representative artists of the third period could be considered as: Kim Sokchul, who established the Goryeo Art Association in Osaka and portrayed Korean national turmoil within his work; Hong Sungik, who rose to fame within the Japanese art scene by winning an award at the Pacific Art Exhibition; and Kim Yongsuk, who questioned the significance of human beings role within the universe. Members bridging the next generation and serving important roles of within the emergent Jaeil Korean AREUM Art Network that come to prominence in the 1990s were: Fungsok Ro, who portrayed the narrative of history and humans;

2 Quac Insik, *Work*, 1962, Glass on panel, 72×102 cm

Park Ilnam, who departed from realism and worked in abstraction using the five cardinal colors; and Li Younghun, who used paper and ink to imply notions of tradition and historicity within his practice.

The subsequent fourth period of Jaeil art could be considered as the 1990s de-ideologization era, when the third and fourth generations fully broke free from the subjective limits that had dominated the work of the previous generation and came to observe their situation from a more objective viewpoint, perceiving themselves as peripheral subjects within Japanese society. They rejected facing the confrontational reality between North Korea and South Korea and their marginalization within Japan, and instead used their creative practice to reimagine themselves as members of a global society. Rather than be bound by the notion of nation or political ideology, they sought to creatively embody ideas of their identities and sentiments through reflecting on their daily lives.

The subject matter within their artwork became more universal and varied, while the use of media also diversified as Jaeil artists started to regularly incorporate photography, installation, and video in their work. This was due to not only a generational shift but also diversification in the international art scene. This more nuanced approach to conveying contemporary 'global' Jaeil concerns can be read through the work of Kim Youngsuk ⎯3⎯, who investigated the idea of identity as through various media such as video, installation, and photography; and that of Kim Aesun, who explored individual notions of the everyday and universal life; and Kim Insook, whose documentary photographs of Jaeil elementary and middle school students at Joseon schools portray the artist's wish to see a Japanese society free from discrimination. One can read the confusion and conflict of fundamental identity within the works of Lim Youngsil, Ha Jhonnam, Kang Jongsuk, Kang Sungho, Cho Kang-rae, Kim Myunsik, Song Junnam, and Nam Hyojun; and

3 Kim Youngsuk, *Rice*, 2005 (Reproduced in 2009), Rice, dimensions variable

additionally the detailed and docile contemplative
landscape through Koh Sang-hyuk's works, who
was a member of AREUM Art Network.

In the early 2000s, movements that eschewed
extreme ideological bias and were orientated
toward social harmony, rapidly spread throughout
a diverse range of overseas Korean societies,
stimulated by the shift in politics between South
and North Korea including the first inter-Korean
summit in 2000 and the related historic meetings
enabled for Korean families separated by the DMZ.
Relative to this developing context, in the Jaeil
art scene, AREUM Art Network was organized
in 1999 following Moonyedong and the Goryeo
Art Association. AREUM Art Network hosted the
first AREUM exhibition in 1999 and the second in
2002. The third Areum exhibition was held over
three months in the cities of New York, Seoul,
Tokyo and Kyoto from 2004 to 2005. The Network
also published four editions of *Neo-Vessel AREUM*,
catalogues produced in the format of a magazine.
The Network brought together entire Jaeil art scene,
regardless of whether the artist was from a Korean
orientated practice or a Japanese, building solidarity
among the overseas Korean art scene. This change
was the result of Jaeil artists' proactive movement
to break free of the idea that Jaeil Korean society
in Japan is merely the byproduct of the Japanese
colonial rule of Korea, and instead they sought

to position themselves as autonomous subjects.
However, since the impetus of the third Areum
exhibition in 2004, the organization's activities
have practically stopped. This attests to the fact
that the Jaeil society is having greater difficulties
finding a singular cultural pivot, while also
demonstrating that the approaches of Jaeil artists
have become more universal and individualized
as they have sought to break free of the anxiety
and sense of isolation produced by their peripheral
cultural position in Japanese society.

GORYEOIN ART IN THE COMMONWEALTH OF INDEPENDENT STATES

In the mid-nineteenth century, many thousands
of poor peasants within the Joseon Empire started
to move to the Far Eastern regions of Russia's
Priomorsky Krai in an attempt to flee famine and
poverty in Korea. The Soviet Union embraced these
people, termed Goryeoin, for their potential help
to increase the state's agricultural productivity,
as the Korean peasantry were very familiar with
practices such as rice farming. Then, in 1937, under
Stalin, around 170,000 Goryeoin were tragically
and forcefully relocated from the far east of Russia
to the arid deserts of Central Asia. The old and the
infirm lost their lives traveling in dire conditions
on trains for over a month and deprived of the

freedom to relocate to other areas of the Soviet Union, the Goryeoin were forced to survive by cultivating the arid environment around them.

It was not until 1956 that minority groups across the Soviet Union, including Goryeoin, finally restored their citizenship and full rights. After the dissolution of the Soviet Union (1922–91) in 1991, the Goryeoin, who were incorporated into the Commonwealth of Independent States [CIS], were once again marginalized by the major ethnic groups of each republic seeking independence. Speaking primarily Russian after years of cultural oppression and perceiving Priomorsky Krai as their homeland, the Goryeoin of the former Soviet Union were faced with a new era in the 1990s, as they attempted to negotiate their diasporic circumstances and notions identity within the various emergent nations of the CIS. Today, within the many republics that constitute the CIS, are around five hundred thousand Goryeoin. Of this number, the vast majority reside in Kazakhstan, Uzbekistan and Russia, while smaller minorities live in Kyrgyzstan and Ukraine.[9]

In April 1932, the Central Committee of the communist party of U.S.S.R. adopted a famous resolution "On the Restructuring of Literary and Artistic Organizations," privileging the standardized style of adopting the socialist ideology.[10] Henceforth, artists produced "socialist realism" art that encouraged and yearned for a Soviet society. The subject of art slowly diversified after Stalin's death in 1953, and art took on various shapes with reformations including the Perestroika and Glasnost periods as well as the dissolution of the Soviet Union.

The first generation of Goryeoin consists of those who were born in the Far East of Russia and spent their childhoods there, or those who started studying art around the time of the forced relocation in 1937. This generation studied classic and academic Realism and were well-versed in techniques such as three-point perspective and anatomy drawing, which were considered new to them at the time. They produced socialist realist art that reflected Soviet ideology and often also attempted to represent their own unique perspectives on nationalism and identity. Representative artists of this generation include

4 Pen Varlen, *Portrait of Kim Yongjun*, 1953, Oil on canvas, 51×71.8 cm

Pen Varlen, who was a professor of art at the Ilya Repin Leningrad Institute of Painting, Sculpture and Architecture and from 1953 to 1954 worked as consultant for North Korea's Pyeongyang University of Fine Arts under the orders of the U.S.S.R. Ministry of Culture 4; Kazakhstan's Hennyun Kim, who studied at the Leningrad Institute (1929–36) before Pen. Hennyun Kim was forcefully relocated in the 1937 purge of Goryeoin, but created numerous celebratory portrayals of Goryeoin workers; Mikhael Petrovich Kim, who primarily worked in painting landscapes, but also engaged in mosaic and stage design; Nikolai Park, a realist artist from Uzbekistan who studied in Russia during the 1940s; and Nikolai Sergeevich Shin, a merited Uzbekistan Art Academy artist who thematically focused on Korean diaspora history and the tragic migratory experiences of the Goryeoin in Russia. 5

The second generation of Goryeoin artists were the first group to speak Russian as their first language. They were educated after the death of Stalin and before the Perestroika-Glasnost era (1985). During this period various new modes of expression, techniques and styles emerged within Soviet art, as it became more influenced by international art trends and a new generation of painters emerged. While each of these artists pursued different painterly subjects and themes, they were similar to the previous generation artists in that most had initially received classical soviet art education. In this respect, prior to the Soviet era, European academic was not a mainstream art world concern within Central Asia. It was only in the late 1930s that a new educational system was implemented while local art schools and art galleries also opened. Among this generation, some artists were able to study in cities such as Leningrad and Moscow while most went to local schools, where the level of education was relatively high, thanks to teachers who had been escaped from the Great Patriotic War (1941–45).[11] In this context, of increased education for the citizenry of the Soviet Union, in March 1938, a regulation mandating the Russian language in every school was enacted, and so many young Goryeoin gradually lost their fluency in Korean.

Kazakhstani Goryeoin artists of this generation include Boris Petrovich Park, who achieved an exceptional range of accomplishments in the graphic art sector and received acclaim from the Soviet government; Viktor Vasilievich Mun, who imaginatively invested his imagery of everyday life with a universal impression; Sergei Duhaevich Kim, who observed the irregularities of life to express the devastation common to everyday society during the fall of communism 6; Svyatoslav Dusunovich Kim, an illustrator who addressed the issue of human identity and who also achieved great success

in book design; Boris Mikhaelovich Lim, who portrayed objects in an almost monochromatic manner; Mikhail Timofeevich Park, a painter and novelist who moved to urban Russia from Central Asia; and Elena Mikhaelovna Tyo, who remained faithful to the classical notions of beauty and conveyed warmth and harmony in her painting.

In the works of Uzbekistan Goryeoin artists, the theme of nature, a privileged focus common to philosophy and art, always implies an outlook toward the outside world. For Uzbek Korean art researcher R. Egemyan, despite all turbulence and agitation of fate, the sense of belonging that comes from ethnic traditions associated with nature does not change, and that it is very much how Goreyoin artists can say that they 'confide' in nature rather than 'paint' nature.[12] Such traits can be witnessed in the practice of Anatoly Ligay, whose work focused on images of farmers working in the fields; Vladimir Kim, who painted natural themes in an expressionist manner; and Iskra Shin, who portrayed landscapes of mountains using layers of paint, in order to reflect the mystic and dynamic changes of the natural world. 7 Finally, there is Nickolay Pak, who presented abstract images that were distilled from inspirational ideas taken from nature.

Due to their strong decorative interest in using bright colors and expressionist brushstrokes, Other Uzbek Goryeoin artists also often engaged in experiments of line, plane, and space. Representative artists in this respect are Vladimir Kim, who primarily painted decorative and sophisticated mythical subjects, still life compositions, and portraits; Lana Lim, who mixes the background and object into poetic expressions; and Tatyana Lee, who paints images of the natural and archaeological sites of the Silk Road in a strong expressionist manner.

While both nations are located in Central Asia, at the intersection of Eastern and Western culture, there is a great difference between the arts of Kazakhstani and Uzbek Goryeoin artists. While most paintings are figurative in both countries, the works of Kazakhstani Goryeoin are often founded upon notions of the nomadic spirit and composed of expressive and rough painterly treatments, and designed to portray the existential image of mankind. On the other hand, based on the bright and warm natural quality of the local landscape, Uzbek Goryeoin often create brightly colored, decorative and elaborate works on canvas.

The third generation Goryeoin artists received their education after the turbulent times of the Perestroika-Glasnost era (1985) and the dissolution of the Soviet Union (1991). During this period local concerns with ethnicity within each republic became heightened after the collapse of the Soviet

5 Nikolai Sergeevich Shin, *Requiem, Candle of Farewell, Red Grave*, 1990,
Oil on canvas, 300×200 cm (two pieces out of a series of twenty-two)

6 Sergei Duhaevich Kim, *Cage*, 1999, Acrylic on canvas, 110.5×141 cm

7 Iskra Shin, *Two Apple Trees*, 1997,
Oil on canvas, 98×81 cm

Union, and the Goryeoin became more open-minded, pursuing cultural endeavors that respected the value of diversity. In other words, Goryeoin artists in their work attempted to exceed ideas of racial belonging and regionalism, and instead tended toward universalized notions of aesthetics, widening the visual and intellectual scope of Goryeoin diasporic art. Representative Kazakhstani artists from this generation are Natalya Dyu , who employs video to connect her personal narratives with the culture of the East and the West in ironic transcultural works, and Alexander Grigorievich Ugai, who portrays his journey in search of his identity through works of photography, video, and installation. In *Aral Project* (2002), Ugai presents a sailing manual that belonged to his grandfather who worked as a captain on the Aral Sea. It conveys an idea of a nation that no longer exists today (the Soviet Union) and a sea that no longer exists today (the Aral Sea). This project alluringly shifts between the past and the present as it metaphorically portrays the altered and vanished life of the Goryeoin in the Soviet Union. In this respect, whereas Kazakhstani Goryeoin artists pursue notions of contemporaneity through various media, it could be offered that Uzbek Goryeoin artists have developed a more classical interest in

the fine arts.[13] Exemplary Uzbek artists of this concern are Elena Lee and Evgeniy Pak. But it could be said that artists from this generation are each deeply invested in exploring their own unique methodological approaches within their artistic expressions. As such, the works of contemporary Goryeoin artists are highly significant in that they allow us to visually explore the present state and making of multilayered Korean identities far beyond the confines of the Korean Peninsula.

Through the unique Goryeoin experience of numerous historical ordeals and sociocultural environments, the art of the Korean diaspora in the (former) Soviet Union was developed almost in complete severance with the Korean Peninsula. Nonetheless it reflects the trajectory of the Goryeoin people as they have striven to endure, pioneer, and refigure their lives outside Korea. After the oppressive history of Stalinism in the 1930s and 1940s, and the recovery of full citizenship in 1956, the life of the Goryeoin within the CIS has not so much been that of a marginalized minority as an example of the creative potential of cultural hybridity, following the ongoing processes of their successful integration into the multicultural environment of the contemporary CIS.[14]

JOSEONJOK ART IN CHINA
Between the late nineteenth century and Korean independence in 1945, Koreans moved in substantial numbers to the Northeast Manchuria region of China. Initially this was a way for disenfranchised Korean farmers and peasants to escape financial poverty, and the seizure of land by the upper classes. In the early twentieth century, immediately after the Japanese colonization of Korea in 1910, the number of immigrants increased as many people sought political asylum from Japanese persecution. After Japan established the puppet state of Manchukuo in 1932, many Koreans were encouraged to settle in the area to displace the fractious native population and provide much needed agricultural and industrial labor, and the Korean population in Northern China increased again, through a mix of individual and group immigration. Following Korean independence in August 1945, many of these migrants moved back to Korea, however many also remained. Those who settled in China, referred to in Korean as Joseonjok, acquired legal status as Chinese citizens with the establishment of the People's Republic of China in 1949.

After the Sino-Soviet Treaty of Friendship, Alliance and Mutual Assistance was signed in 1950, the influence of Soviet socialist realism rapidly spread in China as reflected in the professional production of art and art education. The 1956 Chinese Hundred Flowers movement, inspired

8 Leran Han, *Tenran Railroad Construction I*, 1945,
Watercolor on paper, 32×47.3 cm

9 Lin Mao Xiong, *Water*, 1958, Oil on canvas

ART OF THE KOREAN DIASPORA

by Chairman Mao's poem "let a hundred flowers bloom, let a hundred schools of thought contend (百花齊放, 百家爭鳴)" was designed to promote progress in the arts and sciences. In this context of relative freedom, Joseonjok art was also enabled to gradually form its own style based on traditional Korean visual culture and art practices from various other cultural and historical sources.[15] In other words, Joseonjok artists employed subject matter relevant to their identity to convey, through artistic means, that they were proactively participating in the construction of China's socialist society as an ethnic minority within the larger nation state. As the influence of capitalist culture and pop culture of neighboring nations spread throughout China in the 1980s and 1990s propelled by national economic reform and a new global orientation for the communist state, the style of Joseonjok art diversified accordingly.

The first generation of professional recorded Joseonjok artists moved to China between the early twentieth century and 1949, by which time Koreans were officially recognized as one of China's ethnic minorities. The early painting style of Joseonjok art was informed by the work of artists who had studied overseas, prior to the establishment of Socialist realist painting in the 1930s. In terms of their political engagement, in the early twentieth century the Joseonjok people organized anti-Japanese movements in China, to protest the increase of Japanese influence in Northern China and fought for a new educational curriculum and anti-Japanese education. As a result of these efforts the Seojeon School was founded in Manchu in 1906. This was the Joseonjok people's very first independent educational institution.

In 1919, the progressive May Fourth Movement student protests in Beijing, within the wider New Culture Movement (1915–21), inspired people across China to take a greater interest in Western institutions of learning and culture. Intellects of this time believed that the way to salvage the nation, and save it from colonial takeover, lay in quickly embracing the modern scientific and technological approaches developed in of the West. This interest led some privileged Joseonjok artists to leave China to study the most up-to-date approaches in Western Europe and Japan. Representative artists of this period include Leran Han, who went to study in France in 1929 after graduating from the Shanghai College of Fine Arts, and produced work that was strongly imbued with political ideas $\boxed{8}$; Seok Heeman, who studied art in Japan during the 1930s and returned to Longjing in the 1940s where he served a significant role in the development of Joseonjok art education; and Shin Yonggum, who studied at the Musashino Art University in Japan and presented works based on

his remarkable draftsmanship and strong thematic ideas of the political autonomy of ethnic minorities. All these artists primarily worked in oil paint following their overseas studies. With the dominant work of these artists the influence of Western approaches became evident in Joseonjok art, and gradually came to dominate the art scene.

With the establishment of the People's Republic of China in 1949, the Joseonjok within the nation were acknowledged as Chinese citizens. The autonomy of ethnic Koreans in China was therefore secured at a governmental level, and Joseonjok art progressed to a new level of independent development. In this context, the recruiting of the first group of art students at the Yanbian Normal School in 1950 was the first step toward professional training of Joseonjok art educators in China. And following the recognition of Joseonjok autonomy, the Yanbian Koreans Autonomous Prefecture was established in 1952, and the first Yanbian Art Exhibition was organized to celebrate this event. This exhibition bears historical significance in that it served as prelude to the further institutional formation and development of Joseonjok culture in China.[16]

Joseonjok artists of this period largely produced ideological paintings within a Socialist realist manner. Here they selected subjects that were relevant to their cultural identity as Joseonjok, such as traditional Korean thatched houses, hanbok, or landscapes of Baekdu Mountain. Representative artists of this period include Ahn Gwangwoong, Lim Mao Xiong, Kim Yongho, Jeon Dongshik, and Lim Cheon. They were all born in the Yanbian region during the 1920s and 30s and received their art education before the sweeping reforms of the Cultural Revolution (1966–76). A significant Joseonjok artwork in the collection of the Beijing Cultural Palace of the Nationalities, and that was also awarded the grand prize at the first Northeast China Art Exhibition, is Lim Mao Xiong's *Water* (1958). This reflects a bright and healthy notion of Joseonjok society, in portraying a large-scale construction scene of irrigation facilities in a farming village. $\boxed{9}$

Many artworks were destroyed during the upheavals of the Cultural Revolution, and the development of Joseonjok art also waned as art schools halted education and the recruitment of students. It was only after Deng Xiaoping advocated pragmatism and proactively opened the nation to the world in the 1980s that Joseonjok art bloomed again. Publication of discourses and art critique emerged, while many solo exhibitions were also held. The main oil painters that emerged during this period include Jo Gyu-il, Kim Moonmoo, and Lee Bu-il, while those working in ink painting included Jeong Dongsoo and Jang Hongeul. Rather

than ideologically themed paintings, these artists focused on a diverse range of subjects, often portraying in detail the customs and everyday life of the Joseonjok. Such works were acclaimed in state-organized art exhibitions and collected by the National Art Museum of China, the Cultural Palace of the Nationalities, and the Military Museum of Chinese People's Revolution. As such, the artistry of these Joseonjok artists was widely recognized within Chinese society. In socialist countries such as China, the state traditionally assigned functional roles to artists within a national institutional system, while an organized large scale art market did not exist. Notwithstanding that this situation was rapidly shifting in China during the late 1980s toward a market based elite art world, during this period, state-affiliated Joseonjok artists still mostly showed their work through state-organized art exhibitions.[17]

From around 1990, the tradition of state sponsored ideological paintings and ethnic Korean subject matter gradually disappeared from Joseonjok art, and each artist's individual interests instead became the focal point of their work. Events such as the Tiananmen square protest in 1989, and the establishment of formal diplomatic relations between South Korea and China in 1992, increased the number of Joseonjok artists who gradually experienced capitalism and came to South Korea to study art. The artists that had pursued socialist realism in the 1980s also often changed their approaches and many produced a wider range of modernist works. Some Joseonjok artists attempted to express the inner essence of humans and the natural world through abstraction, while others portrayed everyday scenes and subject matter.

10 Piao Guangxie, *2007 No. 7*, 2007,
Oil on canvas, 200×200 cm

Moon Sungho, Lee Ho-Keun, Kim Bongsuck, Kim Gwangil, Cui Jun, Jin Rilong, Kang Jeong-ho, Lee Seungryong, Jo Gwangman, Lee Chulho, and Kim Youngshik are representative Joseonjok artists educated after the Cultural Revolution. They are of the generation in China that experienced social changes in the 1980s and 1990s through the state's reforms, and so were naturally interested in addressing new artistic thoughts and forms within their work. In some distinction to this group is Park Choonja, who took as his subject matter the life and identity of minority groups in China.

In the 2000s, China's economic growth and interface with Western capitalist culture affected all corners of national society. Also, with the spread of the Internet, the influence of pop culture greatly expanded. Under these conditions, the Chinese art market became the subject of capitalist investment interest, leading to the diversification of the Chinese art scene. In this new environment, some Joseonjok artists moved to Beijing to work. Representative artists from this contemporary context are Cui Xianji, who has presented avantgarde works of abstract calligraphy installations; Li Guinan, who portrays existential notions of human life through the use of red tones; Piao Guangxie, who conveys the suffocating nature of reality through the imagery of human figures drifting in water 10 ; and Jin Yu, who paints oppressed men repeating unconscious acts in the air. Looking at the subject matter addressed in the works of these artists, we can tell that the Joseonjok who created them focus more on universal ideas of human life and Chinese society than their own specific identity as a minority ethnic group. Through years of engagement, Joseonjok artists today understand the trends of China's mainstream art world and are finding their position in it by fully participating in the flow of the national contemporary art scene.

This chapter has examined how the work of ethnic Korean artists in Japan, the countries of CIS, and China has diversely formed and developed over the last 200 years. In every context the approaches used by Korean artists have varied in tune with the political and social circumstances of each country. Despite remaining closely associated with the divided political context of the Korean Peninsula, Jaeil artists successful conveyed their explorations of identity within Japanese society. In examining the history of Goryeoin art in the Soviet Union and the CIS, it is possibly to measure the process of how regional concerns were reflected in the foundation of Socialist realism and the state policy, and how ethnic Korean artists successfully transitioned into a contemporary multicultural environment. Through the lens of Joseonjok art, we can see how the Korean artists in China initially pursued their

prescribed roles as culturally productive members of a minority group within the socialist state, and the subsequent manner in which they gradually joined in the flow of contemporary art. Within their contributions to the development of each country's national culture, diasporic Korean artists have sought to create work that harmonizes with the mainstream art world while also actively portraying their individual concerns. This successful history of creative work is no more than the product of diasporic Korean artists fiercely striving to become independent subjects and overcome their positioning at the margin of society.

1 Yoon Injin, *Korian diaseupora: jaewoe haninui iju, jeokeung, jeongcheseong* [Korean Diaspora: Emigration, Adaptation, Identity of Koreans Overseas] (Seoul: Korea University Publications, 2004), 12, 14.

2 Ibid., 8–9.

3 Ahn Eunjoo, "Magsin hong kingseuteonui 'jungguk' gwa 'miguk' jaehyeon: damunhwajuui geukbokeul wihan diaseupora damronui ganeungseong" [Maxine Hong Kingston's Representation of China and the USA: Potential of Diaspora Discourses in Overcoming Multiculturalism] (PhD diss., Seoul National University of Korea, 2006), 3–6.

4 Yoon Injin, *Korian diaseupora: jaewoe haninui iju, jeokeung, jeongcheseong*, 4.

5 This text is partly based interview with Korean art researchers and artists in Japan, the CIS, China, and Korea, with local networks used to discover the artists. In Japan, the artists and educators Fungsok Ro, Lee Yonghoon and Park Ilnam greatly contributed through the AREUM Art Network. In Kazakhstan, the help of A. Kasteyev State Museum of Arts curator Elizaveta Kim and art critic Camilla Lee were crucial; in Uzbekistan, the artist Iskra Shin was consulted; and in China, Bo Ren, the vice-president of the China Yanbian Artists Association, facilitated meetings with artists and an examination of their works in Yanbian and Beijing between 2005–2008. This process was centered around the *Korean Diaspora Artists in Asia* exhibition held at the MMCA in 2009.

6 *Joseonjeok* is a Japanese foreign registration system granted to Koreans in Japan for administrative convenience. "Joseon" here refers to "Joseon" as an old place name before the division, not "Joseon minjujuui gonghwaguk" (meaning "the Democratic Republic of Korea"). It is a classification of nationality for the purpose of administrative affairs that is only held by some Koreans and their descendants who moved from the Korean Peninsula to Japan during the Japanese colonial period.

7 Mono-ha refers to a group of artists that had experimented with presenting raw and natural materials (mono) on the state of artistic expressions not as objects but the main subjects in the late 1960s Japan, seeking to draw out a certain artistic language from the movements and way of being of the mono. Minemura Doshiaki, "What was Mono-ha," in モノ派 *MONO-HA*, exh. cat. (Tokyo: Kamakura Gallery, 1986).

8 Kim Myungji, "Jaeil korian diaseupora misurui uiuiwa jeongcheseong yeongu" [A Study on the Significance and Identity of Diaspora Art of Korean Residents in Japan] (PhD diss., Chonnam National University, 2013), 84–87.

9 German Kim, "Koryo Saram—Koreans in the Imperial Russia, Soviet Union and Post-Soviet Space," *Korean Diaspora Artists in Asia*, exh. cat. (Gwacheon: MMCA, 2009), 154.

10 Yelizaveta Kim, "kajaheuseutangwa ujeubekiseutanui hanin jagkadeurui misul" [The Art of Korean Artists in Kazakhstan and Uzbekistan], *Korean Diaspora Artists in Asia*, exh. cat. (Gwacheon: MMCA, 2009), 172

11 Camilla V. Lee, "The Korean Artists of Central Asia," in *Korean Diaspora Artists in Asia*, exh. cat. (Gwacheon: MMCA, 2009), 255.

11 Ibid., 260.

12 Camilla Lee, *Korean Diaspora Artists in Asia*, 259.

13 Jeon Seonha, "Jungang asiaui goryeoin yesulga yeongu" [Study on Korean (Koryoin) Artists in Central Asia] (PhD diss., Hongik University, 2020), 27.

14 Lin Mao Xiong, *Jungguk joseon minjok misulsa* [Art History of Joseonjok People in China] (Seoul: Vision and Language, 1993), 94

15 Lee Taehyun, *Jungguk joseonjok misul gyoyuk yeongu* [Study of Chinese Joseonjok Art Education], *The Society for Korean Unification Culture and Arts Research Series* 2 (Seoul: Chaeryun, 2014), 59.

16 Mok Soohyun, "Gyeonggye-e seon jeongcheseong, gaehyeok gaebang ijeongwa ihuui jungguk joseonjok misul" [Multi-identities of Korean-Chinese Artists -Before and after Reform and Open Policy of China], *Journal of Korean Modern & Contemporary Art History* 23 (2012): 179.

The National Art Exhibition and the Development of the Art World After Korean Independence

Cho Eunjung

THE CHARACTERISTICS OF KOREAN CONTEMPORARY ART

While the Korean civil war deeply changed the nature of national society, the 'spirit' or ideological concerns of the 1950s art world remained remarkably unaffected by the conflict. Amid the unfamiliar and strange war, and even against a context in which numerous ideologically driven massacres were committed, the artists that dominated the Korean art world never discarded their belief in art's "supreme purity." This belief in art's purity was the same belief which sustained the young elites of colonized Joseon through the Japanese colonial era, and reversely also the result of Japan falling into its own trap of having forbid young elites from engaging in politics. As the "scholarship of the emperor," art allowed a master artisan to become an artist and served as a powerful means by which artists could gain honor and receive big awards. The Korean War did not change the dynamics of that power; such power was in fact reinforced through the new ideological concerns which were a byproduct of the cold war.

The professional structure of the art world during the Japanese colonial period was grounded upon the Joseon Art Exhibition, and following Korean independence this exhibition was directly succeeded by the National Art Exhibition. The Korean encounter with the international community beyond the yoke of the Japanese Empire changed the nation's perception of the world, and the proactive efforts of the U.S. government to foster a pro-American perspective within Korean society quickly extended to the art world. As the first painter officially appointed by the U.S. Army Military Government and a representative figure within the Korean art scene, Ko Huidong personally visited America.[1] Following his example, numerous Korean art students embarked on studies in the U.S.

Immediately after independence, Chang Louis Pal, who was one of the few Korean artists to study in the U.S. during the colonial period in the 1920s, was tasked with establishing and leading the art department in the newly established Seoul National University.

In contrast to artists who could afford to finance their own studies overseas, those artists who received financial aid from the U.S. government often studied practical art techniques. Such artists included sculptor and graduate of Hongik University, Kim Chungsook who studied the glass and welding, Min Chulhong, Pai Mansil, Kwon Soonhyung, Won Daichung, Kim Yik-yung, and the influential crafts designer Jeong Junghee, who studied in the U.S. through the Korea Handicraft Demonstration Center. Alongside Kim Chongyung winning the The Unknown Political Prisoner competition in 1953, sculptor Yun Hyojoong's participation in the UNESCO conference and exhibition of Korean artists at the Vatican, further fueled overseas interest in Korean artists' activities.

The desire to establish a strong notion of national art and the development of a keen interest in the international art scene are standard cultural phenomena in most post-colonial contexts. Like other countries that were liberated from colonialism following the Second World War, Korea recognized the need to establish its identity as a nation and gain representation within the global community, as represented by organisations such as the United Nations. However, the Korean process of independence was initially overseen by U.S. Military Government, and heavily influenced by the political conflict between communism and freemarket capitalism. Therefore, in the immediate aftermath of the Korean War the art scene was subject to very particular ideological pressures.

These were arguably internalized and naturalized within the Korean art world, and deeply affected the style of art and artists attitudes.

Within Korea communist artists had been subject to oppression since the colonial period, and this marginalization continued with the explicit anticommunist policies of the U.S. Military Government, which continued through the Korean War. Given this context of explicit, ideologically biased censorship and discrimination, Korean artists who desired success learned to deploy certain themes and styles in direct relation to their desire for professional survival. The strong competition between the younger generation and the older generation that had lived through Japanese rule was a further notable contextual circumstance in independent Korea. In this chapter we examine the foundation of this space of expression, which was grounded upon trauma, division and ideological polarity, and look at the effects of this on Korean art, the concerns expressed by Korean artists, and the long-term relationship between this situation and the emergent characteristics of Korean contemporary art in later periods.

IDEOLOGY, ART, AND WAR

The modern art scene relied heavily on juried exhibitions such as the Calligraphy and Painting Association Exhibition and the Joseon Art Exhibition. This was because in Korea ink painters mostly followed traditional training methods, based on private apprenticeship, while oil painting was mostly practiced by those who had studied abroad. Thus, the Korean Comprehensive Arts Exhibition during the U.S. Military Government era (1945–48) after independence was significant in that it took over the previous role of the Joseon Art Exhibition. In this respect, the *Art Exhibition in Celebration of National Independence* that took place immediately after independence was a landmark exhibition gathering the works of artists who came to prominence during the colonial period. This juried exhibition invited these older artists to compete for awards and was organized by the state as part of the Korean Comprehensive Arts Exhibition.

The purpose of the Korean Comprehensive Arts Exhibition was to "follow in the brilliance of Joseon art traditions and seek qualitative advancements and development." It was held in the Geunjeongjeon hall within Gyeongbokgung Palace in November 1947 to foster stability within the art world, following the U.S. Military government's anticommunist orientated approach to cultural development, and foster a firm "alliance [within] the right-wing nationalist [cultural] camp."[2] A fact attested to by the official refusal of the left-wing Korean Art Alliance to participate in the

exhibition. However, beyond the ideological conflict that existed between the U.S. Military Government and the socialist leaning Korean Art Alliance, this development was also driven by the ideas and desires of individual artists. In this respect it is worth noting the independent actions of Ko Huidong, the president of the Korean Art Association, who first broke the pledge of artists associations that artists will not side with any political line after independence. He participated in the Emergency National Conference chaired by Rhee Syngman, and sat as Administrative Director of the Korean Representative Democratic Council, the highest advisory body of the U.S. Military Government.[3]

After the government of South Korea was established in 1948, the first annual exhibition of the National Art Exhibition took place in 1949. The purpose of the exhibition was to seek "development of national art." This was an endeavor to recover national pride after the experience of colonization, and it was also a reflection of the post-war concern to advocate for the power of culture relative to the cold war. The pride of South Korea as a newly independent state was therefore proclaimed in direct relation to national politics, and statements regarding the pride that the new nation had for its cultural heritage were therefore significant.

> "This being the first sacred exhibition hosted by the state since the establishment of the Republic of Korea, all cultural professionals and artists shall do their best to illuminate the National Art Exhibition. As visual art is, more than any other genre of art, the most efficient in announcing the existence of Korea to the world, I solicit you artists for taking on this opportunity with new determination and pride."[4]

As the National Art Exhibition was a state-organized art event, right-wing artists were prioritized and mainly invited to the exhibition. The National Art Exhibition, in this context, was propaganda for those "artists who wonder around aimlessly," conveying the message that the state protects and supports those artists who believe in democracy.[5]

The first South Korean government, officially known as the government of the Republic of Korea after May 1948, that was established after the initial period of U.S. Military governance stuck to the anticommunist policies established by their liberators to usher in a period of liberal democracy. The peninsula was officially divided along the thirty-eighth parallel early in 1948, and the nation's upwardly mobile citizenry chose where to reside based on their ideological perspective. However, as can be seen in the case of an artist

like Lee Qoede, this was also a period where people often travelled back and forth between the South and the North to observe and confirm the reality of life in each context. Within the South Korean art world, the government was able to use the National Art Exhibition as a means to both deter artists from participating in leftwing activities and promote the production of anticommunist ideas in tacit support of the national capitalist agenda. By preventing artists from becoming engaged with socialist politics, and providing the sole point focus on national cultural policy during this foundational period of political and social turmoil in post-colonial Korea, the National Art Exhibition provided an official platform for artists who were sympathetic and openly embracing of their 'liberal' ideological perspective.

Just as anticommunist activity equated to the safety of the state, the promulgation of such ideology was inseparable from the national production of art. Clearing away the remnants of Japanese colonialism, which should have been the top priority after independence, thus became a secondary task. Thus, the first edition of the National Art Exhibition merely excluding those who had been classified as pro-Japanese from the jury.[6] Because fighting against communism was the top priority, pro-Japanese sympathizers like Yun Hyojoong, who had redeemed himself as the embodiment of anticommunist ideology through the Korean war, could subsequently work after the war on the commissioned production of statues for the presidential office. The orderly staging of the National Art Exhibition demonstrated that the art world within the newly independent country was properly functioning. A vast number of 840 works were presented at the first National Art Exhibition, excluding the works of the jury and recommended artists. This number of submissions was possible only because all professional artists, both left wing and right wing, who lived in South Korea applied. Since the second iteration of the show had to wait until 1953 due to the Korean War, the first National Art Exhibition was the first and last exhibition following the establishment of the South Korean government that was open to both left wing and right wing artists. By the time the second edition was held, most socialist-oriented artists had already chosen the North and the Korean art world shifted overwhelmingly to the ideological right.

The first National Art Exhibition was divided into five sections: ink painting; oil painting; sculpture; craft; and calligraphy. It was based on a system of jury selection and recommended artists and was held from November 21 to December 11 in 1949. Pai Un-soung, a jurist within the 'Western' oil painting section, claimed that as this was the first National Art Exhibition, "the national tradition could not help but be sufficiently considered" and that, for instance, Choi Gwangjin's work could not be awarded the Presidential Prize because while it was suitably classical and traditional, it lacked in originality. The Presidential Prize therefore went to Ryu Kyungchai's *Neighborhood of a Bare Mountain.* [1] In their analysis of this modernist reinterpretation of a natural landscape, Nam Kwan and Kang Changwon remarked that Ryu's painting was "dangerous" for not being academic, when the National Art Exhibition was in fact representative of the Korean academy. However, Lee Insung, also a jury member, commented that it was a good work, for its vibrant use of color and honest expression of ordinary senses in everyday life. [2] While apparently Chun Hyuklim's work was also discussed as a serious contender for the Presidential Prize, Ryu's was the final selection.[7] In making their decisions, the jurists had excluded all works that could potentially be subject to ideological controversy, and abstract works were also rejected by the conservative Korean academy as representative of new radical art.

At this moment in 1950, just as so many key figures in the Korean art world hoped to successfully establish a new 'national' art discourse through events like the National Art Exhibition, civil war broke out. The resulting Korean War was a regional conflict that reflected the new reality of global political division in the aftermath of World War Two. In this regard while it was ostensibly a conflict between communist North and capitalist South Korea, UN forces, and communist China and the Soviet Union also substantively participated as direct combatants. Studies of Korean art during this period therefore tend to focus on the issue of ideology. Academic evaluations of the 1950 Art Association (Osimnyeon misul hyeophoe), established before the war, for example, illustrate how ideology had become foregrounded within a retrospective revisionist history of the period. In 1950 the Association curated an exhibition, but with the outbreak of the Korean War and subsequent defect of some artists to the North, the Association disbanded and the exhibition never opened. Regarding the nature of this Association, Kim Byungki therefore noted that it was "an organization that blocked leftist artists in Seoul from defecting to the North,"[8] but also proposed that it was organized as an affiliated body of the Korean Cultural Studies Center as a way to gain financial support for its exhibitions. Of course, considering the fact that the Korean Cultural Studies Center hosted the National Spirit Lifting Art Festival (Minjok jeongsin yangyang jonghap yesulje) in December 1949, its main objective was to oppose North Korea.[9] However, taking into consideration the fact that there were no institutional grants for opening exhibitions,

1 Ryu Kyungchai, *Neighborhood of a Bare Mountain*, 1949, Oil on canvas, 94×129 cm

2 Lee Insung, *Portrait of a Lady*, early 1940s, Oil on canvas, 27.8×22.3 cm

ART IN A TIME OF WAR AND DIVISION

the support of the Korean Cultural Studies Center could be differently construed. What the Center sponsored was the exhibition and not the Association itself. The Association's members included Kim Whanki, Choi Jaiduck, Lee Qoede, Chang Ucchin, Yoo Youngkuk, Nam Kwan, Kim Man-hyeong, Kim Byungki, Kim Youngjoo, Song Hyesoo, Jin Hwan, Seo Kangheon, Son Eungsung, and Lee Bongsang who all sat on the organising committee, with Nam Kwan as its chair.[10] Along with them were 34 recommended members, including Park Sunghwan, Park Sunggyu, Kim Chanuk, Yim Jiksoon, Kim Hoon, Jo Gwanhyeong, Ryu Kyungchai, Jung Hyunwoong, Park Sangok, Moon Shin, Lee Jongmoo, Im Wangyu, Lee Insung, Yoon Wooseon, and Lee Gunpyo.

Park Kosuk explained that the 1950 Art Association was launched by a group of relatively well-known artists who had either been active in Tokyo or exhibited in the Joseon Art Exhibition, or came from North Korea, with the shared mission to break free of ideological bias and build a united coalition of artists.[11] Choi Soonwoo also commented that it was a group that hoped to assert itself as a primary force within the Korean art scene, and support the creation of 'pure' fine art practices removed from ideological sanction, largely composed of the most talented artists that had dropped out of the Korean Art and Culture Association.[12] In this respect, perhaps the only purpose of the 1950 Art Association was to build a notion of solidarity among the 'serious' artists within Korea, who were devoted to advancing the national art world through their proactive, independent creative approaches.[13] This group was therefore the product of several smaller dispersed art groups breaking up around this time, which lead the most important artists to unite in pursuing the development of national art.[14] The 1950 Art Association was also based on an inherent openness to all artists, in direct contrast to the restrictive gatekeeping that governed the National Art Exhibition . However, ultimately the Association was not able to organize an exhibition, both due to the war and because some of its members were classified as socialist sympathizers by the extreme conservative figures such as Chang Louis Pal.

Even after independence, the issue of anticommunism was deemed more urgent than addressing the substantive cultural and professional remnants of the Japanese occupation or establishing a new contemporary idea of 'national' art. The war greatly reinforced anticommunist zeal, and even though virtually all socialist ideologues had moved to the North during the war, ever greater emphasis was put on combating communism. For this reason, it arguably took 30 years for South Korean artists to be able to use realism in their depictions of the

Korean War. In this regard, while one could freely take a photo with a camera in the battlefield, the many war artists employed by the Republic of Korea were uniformly dissuaded from painting the brutal reality of the conflict in their work. The international war photographers that had gained rich experience through the Second World War had gathered in Korea, where their documentation of the war was disseminated via the international press. The local and national press in Korea also heavily depended on photography. As a rare example of a war painter who managed to join the front line, Lee Joon remarked that "most war documentation paintings did not so much portray the intensity of the war as merely passively express that war through portraying the back of a broken tank or the image of a few soldiers running forward, because they wanted to refrain from documenting the tragedy of national conflict."[15] However, works such as Lee Soo-auck's *Battlefront at Night* (1952), a bold visualization of the war's horrors, still managed to clearly document this tumultuous period.

In the provisional capital city of Busan, the National Art Exhibition could not take place, and so the largest art exhibition aside from the War Correspondent Painter Exhibition was the Great Korean Art Association Exhibition. During the hiatus of state-organized art exhibitions, a private artists organization put together this exhibition in commemoration of the March First Independence Movement. Upon seeing the show, Lee Kyungsung commented "that the presented works are of various styles from the avantgarde to the classic, that the fact that classicism, realism, surrealism, and avantgarde coexist within the same timeframe means that importation of Western painting to Korea is a recent event." During the war oil painters experimented with new styles. Increased experience of Western culture during the war led to artists pursuing new ideas, and so this period is associated with the emergence of Informel as the dominant art movement in Korea immediately after the conflict. In relation to the experimental impetus offered by contemporary Western painting, East Asian cultural traditions, as particularly represented by literati ink painting, were deemed outdated. This perspective is reflected in art critic Lee Kyungsung's statement that "it is not possible to praise, with our modern senses that everyday witness jets flying over our heads and streamlined cars . . . speeding down the streets, the East Asian concern with seeking to become a hermit and unscientifically rationalize the effects of coincidence."[16] In this respect, the continuous quest for novelty common to the western modernist tradition of oil painting now represented the mainstream of the South Korean art scene.

The most significant vestige of the Korean War left in the Korean art world would be the existence

of the Great Korean Art Association which was the product of reorganizing its members and privileging those who espoused anticommunist ideology. Additionally, several artists that were of notable standing within the Korean art world either moved to the North along with the retreating North Korean army and the partisans, or chose the North in prisoner-of-war exchanges. Noted figures in this group included Lee Qoede, Kim Yongjun and Pai Un-soung, moved to the North. Choi Jaiduck, Kim Man-hyeong, Chung Chong-yuo, Jung Hyunwoong, Im Gunhong, Ki Woong, Huh Namheun, Lim Jayeon, Ryu Sukyeon, Hyun Jaeduck, Han Sangjin, Lee Sung, Uhm Doman, Lee Soonjong, Lee Gookjeon, Hyun Choongsup, Lee Haesung, Yoo Jinmyung, Kim Gunjoong, Oh Jisam, Lee Sukju, Yoon Jaseon, Hwang Youngjoon, Park Seunggu, Ji Dalseung, Park Munwon, Hwang Dongyeon, Choi Changsik, Son Yeonggi, and Lee Palchan. On the other hand, several artists that had been in North Korea, including Lee Jungseop, Park Sookeun, Lee Soo-auck, Choi Youngrim, Chang Reesouk, and Hong Jongmyung moved to the South. These artists that had latterly suffered under the rule of the North Korean army were now condemned as communist collaborators by the artists that had early on fled from North to South.

Those who personally passed judgement on such 'collaborators', namely Ko Huidong, Lee Seduk, and Yun Hyojoong, emerged as major players within the post-war Korean art scene. This post-war concern with anticommunism, which became stronger than even during the period of U.S. Military Government rule, began to function as a standard orientation for determining the mere professional survival of artists in South Korea.

WAR AND INNOVATION
On August 15, 1953, the government announced the return of the capital to Seoul. Artists that had been scattered throughout Busan, Daegu, and Jeju returned to Seoul, their original site of activity.[17] Only a few, including Song Hyesoo, remained in Busan. The largest art event after this return was the second National Art Exhibition. After the purge of communist collaborators, the society and the art world realized the power of anticommunist ideology. With the Korean War, the Great Korean Art Association, with Ko Huidong as its head, became the pillar around which elite artists and art professionals gathered, overtly employing anticommunist ideology to secure their status as the main power brokers within the art world.

During this period, abstract works were produced in large numbers because of Korean artists' concern to follow the dominant art trends within the free world.[18] The influence of the war on the art scene lay in the propagation of the spirit to overthrow tradition and convention, eliminate any obstacles to social development,[19] and the desire to keep pace with international developments in the field. But there were also outliers, as some artists saw that their peaceful hometown villages as had remained isolated from the war and seemingly untouched by the havoc wrought by the conflict. In this respect, artists such as Chang Ucchin 3 'sought to find painterly inspiration in village life'[20] through his depictions of subject matter such as rural huts, trees, birds, and rock formations, while artists such as Park Sookeun and Lee Jungseop 4, painted domestic scenes of families and children.

The National Art Exhibition was a system in which artists collectively came together to network and exchange ideas, were awarded presidential prizes, and sold works. In short, it was a platform that provided them the opportunity to acclaim fame as painters. Within this framework, the struggle for professional power became more explicit after the war and ideology greatly affected the trends and styles favored by artists. The National Art Exhibition protocol that "submitted works shall be artistic productions of pure national sentiment, and the works that have been produced more than three years ago or presented in another public exhibition

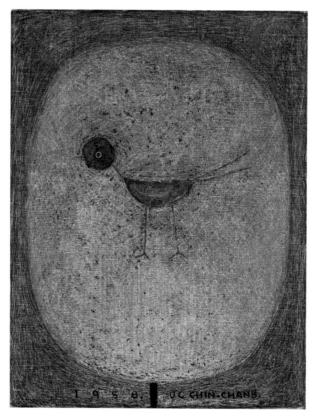

3 Chang Ucchin, *Magpie*, 1958, Oil on canvas, 40×31 cm

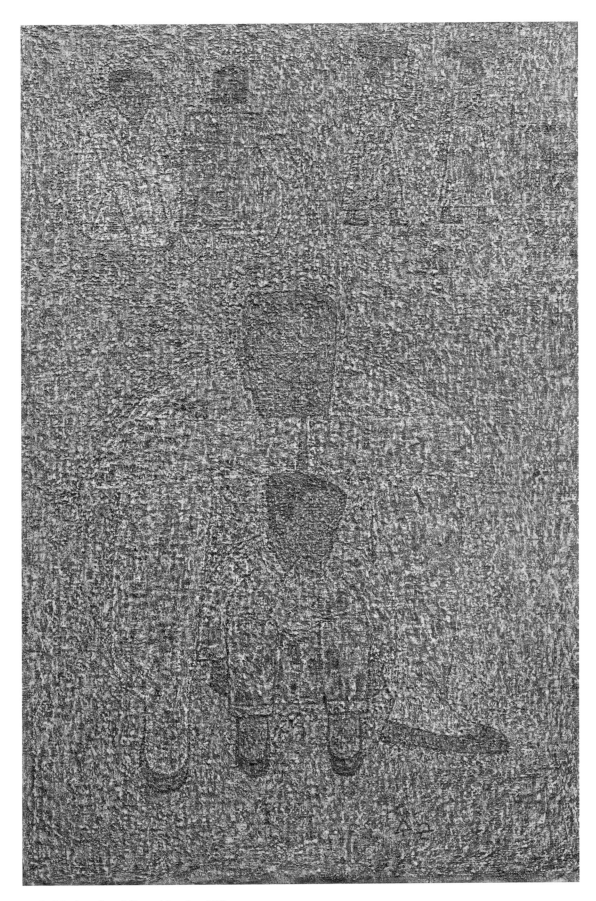

4 Park Sookeun, Grandfather and Grandson, 1960,
Oil on canvas, 146×98 cm

THE NATIONAL ART EXHIBITION AND THE DEVELOPMENT OF THE ART
WORLD AFTER KOREAN INDEPENDENCE

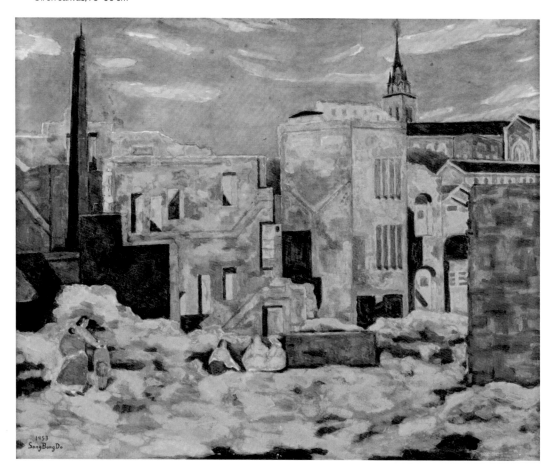

or have the potential to cause public disorder shall not be subject to entry" was reinforced after the war. Reflecting the division caused by the war, the number of works submitted to the second National Art Exhibition was 422, a half of that for the first edition.

The Presidential Prize went to Lee Joon, who was based in Busan. His winning work *Late Fall* (1953) was a portrayal of an old palace devoid of human figures. Also presented in the same exhibition was Kim Sou's *Invader* (1953), Lee Chongmoo's *Ruins Near Chungmu-ro*, To Sangbong's *The Ruins* 5 , Hwang Yeom-soo's *Remnants of a Defeated Enemy*, and Lee Sooduk's *Writing in Blood*, all works portraying the scars of war. Paintings reflecting the war experiences during this period can be categorized by theme, such as individual suffering, separation of families, and women's labor. But overall in this National Art Exhibition, immediately after the return of the capital to Seoul, not many works depicted the war. In this regard, the National Art Exhibition protocols that limited the submission of works relative to standards of "national sentiment" and "public disorder" served to

strengthen the National Art Exhibition's tendency to exclude realist works that focused on critical social and historical commentary. To Sangbong's proclamation that the Presidential Prize could not be awarded to *Gundong* unless Kim Sou voluntarily de-installed the other work that he also submitted, namely the non-juried abstract work titled *Invader*, attests to such circumstances.[21]

The anticommunist ideology that had been associated with nationalism before the war was of a fascist character due to the nature of the conflict and the need to rapidly mobilize the lumpen population of the South for the conflict. The relation between the nation and the experience of the war meant that the union of anticommunism and nationalism became a schematic which was also applied to art. In the early days of the National Art Exhibition, many significant artists refused to participate in the exhibition due to Ko Huidong's nationalist dogmatism. Ultimately, however, they could not help but voluntarily participate in the National Art Exhibition-oriented art system after the war, as there were very few alternative platforms for artists. In this context, the rise in the number of

artist groups after independence could be construed as an operation of this dynamics of power.

The third Presidential Prize in 1954 went to Park Sangok for his sentimental figurative painting *Leisure Day*, in which he portrayed children playing with a rabbit. In this exhibition, some artists withdrew their works in complaint against the composition of the jury, while others organized an exhibition for those who were excluded from exhibiting within the East Asian ink painting section.[22] Due to such resistance from the traditional ink painting community, the fourth Presidential Prize in 1955 went to the ink painter Pak Nosoo for his *Woman, Mystic Sound of Tungso*. Although the work was criticized for its poor drawing technique at the time of nomination, it also drew attention for its original usage and composition of dark ink as well as its lucidity based on the bold contrast between white and black, elements that were previously unknown in Korean painting.[23]

The issue surrounding jury selection arose because the Ministry of Education designated the National Academy of Arts as its advisory body. Elected as the president of the Academy, Ko Huidong asserted that "artists should not get involved in politics, and only focus on the noble act of art production,"[24] and he emphasized fine art that was free from politics. The Academy did not, in itself, grant artists a particular award, but its main task was to elect the influential National Art Exhibition jury. In this regard, the intent of the Academy to push the direction of the works exhibited toward the "pure," and exclude any reflection of social reality was extremely influential. The conflict surrounding the prize between the two camps intensified and as the division between the Great Korean Art Association and Korean Artists Association (Hanguk misulga hyeophoe) became more acute, there was an incident in the fifth National Art Exhibition where artists violated the rule of not withdrawing their works once submitted, and took their works out of the show. The fact that 836 works were submitted despite such disputes attests to the steadfast status of the National Art Exhibition.

The fifth Presidential Prize in 1956 went to Park Rehyun's *Open Stalls*. This was the second successive overall award for a work from within the East Asian ink painting division. As can be seen from the following recollection by Park, it was a work influenced by cubism: "After the return of the capital to Seoul in 1955, the fifth edition took place in Hwashin Department Store. The work completely moved onto three-dimensional expressions, departing from the realistic portrayals that I had for long continued as if copying and gradually shifting to a style centered around form and composition. . . as I repeatedly developed the

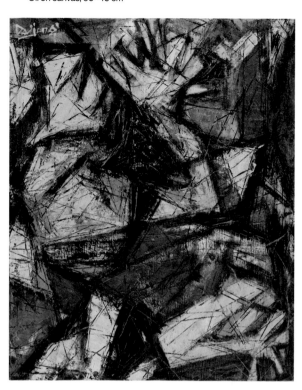

work, I came to attain a plurality of perspective, and as I pursued an expressive means of designating the perspective as multiangled, the work came to slowly obtain abstraction. The production continued with the joy of having found the expression of acute sentimentality, the joy of having found the world fitting for my physiology."[25] However, as evidenced by the following comment from Lee Bongsang, this approach was not what had been expected of an ink painting at this moment: "It is a bold endeavor stimulating the overall stagnant East Asian ink painting scene, but the modern sense of form in this work is [based on] the technique of oil painting while the form, placement of building and structure have completely exceeded the limitations of ink painting."[26]

For Park Rehyun, who employed color unlike most other artists who had sought creative renewal within the East Asian ink painting community as a means to capture the new character of the times, the use of a cubist composition was a brave choice; applying the visual language of modernist painting within the context of traditional East Asian ink painting. In fact, even simply acknowledging the possibility of cubism as a new visual system was something of an innovative triumph. In broader terms of the Korean art world, in wanting to follow the example of Picasso's *Guernica* (1937) as a means to depict the horrors of the Korean

7 Ha Indoo, *Self-Portrait*, 1957,
 Oil on canvas, 87.5×61 cm

8 Choi Youngrim, *Diary of Woman*, 1959,
 Oil on canvas, 105×145 cm

ART IN A TIME OF WAR AND DIVISION

War, for several artists the cubist approach was deployed as a strategically useful symbol of novelty. In this regard, what an artist like Ham Daejung presented in his solo show after returning from his studies in France was an entirely new approach to deconstructive drawing and cubist compositional perspective within Korea. 6 Having gained a knowledge of his craft in the birth place of cubism, his work represented a different take on cubist abstraction from that offered by the Korean artists who had earlier learnt about cubism 'at a distance' from the original avant-garde source material, through their studies in Japan.

A group of artists fresh out of college and selected for the National Art Exhibition of 1954 and 1955—Park Seobo, Moon Woosik, Kim Choongsun, and Kim Younghwan—opened a *Four Artists Exhibition* in 1956 and proclaimed their Anti-National Art Exhibition stance. While it is difficult to gauge the impact of them doing so, this group's action was significant as an official declaration of challenge against the National Art Exhibition. It was also around this time that a dispute between the Great Korean Art Association and Korean Artists Association erupted, and Informel, as a new art movement, gained great popularity among young artists.

The sixth Presidential Prize was awarded to Yim Jiksoon for his *A Sitting Figure*. A painting of a girl wearing a red top seated on a chair facing forward with an exterior landscape portrayed through the window behind. This work was a figurative oil painting close to classic academism, and could be construed as a response to the previous overall success of ink painting at the show. The fact that Yim's portrait was awarded the top prize in the oil painting section, whilst the majority of subjects being portrayed consisted of Buddhist statues, landscapes of temples and palaces, seated portraiture, and still-life, demonstrates that at this moment the National Art Exhibition opted to support a 'traditional,' academic Western work, rather than more nationalist fare.[27] This variety in itself was of course partly due to the fact that many artists pursuing modernist styles did not participate in the show. While some abstract art could still be witnessed among the nominated works, the classical academic manner had been selected to represent the mainstream position. The National Art Exhibition reacted even more adversely to the new wave of abstraction and modernism that emerged within the Korean art scene around 1957. In opposition, the Hyundae Fine Artists Association that was established (based on the Four Artists Exhibition in December 1956) now systematically challenged the National Art Exhibition. At this moment the Modern Art Association was also established under the motto of "taking on the issue of modern painting as the basic ideology and seeking an independent life as the avant-garde of that movement." This event inspired an unprecedented level of enthusiasm among the small groups of artists that made up the Korean modern art scene.[28] Ha Indoo, for instance, described this period in the following way: "Under the sweet name of abstract painting (Informel), we were ruminating the congested curse and sorrow, vomiting it out as a work of painting."[29] 7 Against this new wave of enthusiasm for contemporary modernist painting, the National Art Exhibition strived to maintain its dedication to tradition in the context of oil painting.

The seventh Presidential Prize in 1958 went to Chang Reesouk's figurative portrait *Old Man in the Shade*. However, the next year in 1959 at the eighth National Art Exhibition, Choi Youngrim's *Diary of Woman* was awarded the Ministry of Education Prize, the highest honor in the Western painting division. 8 The special prize was awarded to Lee Manik for his experimental work *Studio* and also to an emerging artist Youn Myeungro, and can be understood as evidence of the intent to embrace new trends and artists. The atmosphere of resisting against the National Art Exhibition was evident, with around thirty significant modernist oil painters from the Modern Art Association and the former Korean Artists Association refusing to submit their work to the show. Embracing new trends and artists was an effective strategy to nullify the potential unionization of contemporary artists against the National Art Exhibition. As an explosive wave of Informel had emerged through the Contemporary Art Exhibitions hosted annually by the *Chosun Ilbo* newspaper.

From October 1 to 15 in 1960, ten Seoul National University art students including Kim Jeonghyun and Kim Hyungdae organized the *Byeok Art Exhibition*, displaying around 40 works of art along the wall of the Deoksugung Palace.[30] Then, from October 5 to 15, twelve students and graduates of Seoul National University and Hongik University opened the *60 Fine Art Exhibition*, additionally hanging works on the northern wall of Deoksugung Palace. Hanging paintings on the outside wall of Deoksugung, with the National Art Exhibition taking place at the museum inside the Palace itself, was seemingly a proactive protest against the National Art Exhibition. As the organizers stated, "the endeavor was ventured to create a more essential statement of demands despite the limitations of a street exhibition."[31] Furthermore, Kim Hyungdae's work was also on display at the National Art Exhibition inside the Deoksugung Palace. The 1960s Artists Association encouraged the interest of organizations and public institutions proposing that they would distribute the works for free after the show,[32] something which makes it

9 Kwon Okyon, *Landscape*, 1957,
Oil on canvas, 53.5×64.8 cm. MMCA

10 Lee Jongsang, *Work*, 1962, Ink and
color on paper, 238×330 cm. MMCA

difficult to read the project as a proactive opposition to the National Art Exhibition. However, as Kim Whanki noted, the *Byeok Art Exhibition* was significant as an act of "resistance against society amid harsh ordeals."[33] Kim's words here also referred to the emerging political consciousness of the younger generation, responding to the student uprising and April Revolution of 1960, which briefly ushered in the possibility of democracy within South Korean society. Given that the ninth Presidential Prize of National Art Exhibition in 1960 was awarded to Lee Euyjoo's *Lady in a Greenhouse*, a portrait of a woman seated indoors, Kim Whanki's use of the term "resistance" was entirely accurate.

NEW ART AND TRADITION

The National Art Exhibition's positive acceptance of Informel, the dominant new modernist art manner within the Korean art world was influenced by this developing wider political context in the early 1960s. It was from the tenth edition in 1961 that abstract art and Informel, which until then had only been treated as peripheral concerns, emerged as the mainstream of the National Art Exhibition. But this was also due to the new military government's policy of advocating innovation within society. The veteran jury members were pushed back to the position of advisors, while Kim Youngjoo and Kim Byungki from the *Chosun Ilbo* nespaper's Contemporary Art Exhibit, Yoo Youngkuk from the fringe, and Kwon Okyon who had studied in Paris were included in the jury.[34] [9] The Presidential Prize of the year 1961 went to *Army Training Center Plan*, a collaboration between Kang Sukwon and Seol Youngjo in the architecture division, and the Chairman of the Supreme Council for National Reconstruction Prize went to Kim Hyungdae's *Restoration B*, a total work of abstraction. In this regard the momentous political incident of the May 16 military coup d'état, which signaled the start of almost 30 years of military rule, the rationale for which was the single-minded development of South Korea into a 'modern' industrial nation, and the continued influential growth of modernist art since 1957 had here coincided to affect the selection of awardees at the National Art Exhibition, with the new perspectives of the expanded jury also being a significant factor.

From the tenth edition in 1962, the winner of the highest prize was awarded a trip abroad to visit overseas art communities. This possibility, that one could now visit western museums and meet internationally renowned artists if triumphant, intensified Korean artists' coveting the National Art Exhibition award. However, at the climax of the eleventh iteration in 1962, the Presidential Prize was awarded to Kim Changrak's *The Reclining Sun*, while the Prime Minister's Prize went to Lee Jongsang's *Work*. [10] Here, the highest prize was awarded to a realist work, as Kim Changrak's *The Reclining Sun*, used the compositional approach of a traditional seated figure portrait, depicting an old man against the backdrop of a natural landscape, including trees and flowers in a highly realistic manner. This victory could be interpreted as a result of the change in jury composition affecting National Art Exhibition panels to embrace not just expressive figuration, but highly realist works. Alternatively, this award could also be construed as a reactionary response to the exhibitions of previous years, where abstract works were awarded the main prizes.

It was from the year 1962 that figuration was separated from abstraction as a category within the National Art Exhibition, but as Yoo Youngkuk was excluded from the jury while more than two thirds of the panel were Mokwoohoe members, there was concern that abstraction might lose its place entirely.[35] The Mokwoohoe was a group formed by leading figurative painters, including Kim Insoong, in 1958 amid the crisis of consciousness against western-inspired abstraction. The review results were as follows: Park Hanyoo's craftwork was awarded the Presidential Prize, the Chairman of the Supreme Council for National Reconstruction Prize went to Hong Chulsoo's architecture Memorial Hall for Patriotic Martyrs (Sunguk seonyeol ginyeomgwan), and the Prime Minister's prize went to Lee Dukchan's *Women Waiting for the Fishing Boat*. In the thirteenth National Art Exhibition in 1964, Kim Bongki's *Good Harvest* was awarded the Presidential Prize. This work was a portrait of a man sitting on a chair against a natural scenery in which a woman is holding a basket. In as much as this was an image of an orchard, or a background of fresh plants and trees, it was not much different from Lee Euyjoo's *Lady in a Greenhouse* or Yim Jiksoon's *A Sitting Figure*.

In 1965 at the fourteenth annual exhibition, the Presidential Prize went to a sculptural work for the first time. It was given to an abstract piece by Park Chongbae titled *Circle of History*. The Presidential Prize at the fifteenth edition in 1966 also went to the sculpture division, for a figurative portrait called *Rule of Sea* by Kang Taisung. In this regard, while *Circle of History* was an abstract work, its title clearly referenced a wider idea of history, while *Rule of Sea* employed more traditional iconographic forms to represent nature. Given the success of these works, the position of Informel in the National Art Exhibition, as the dominant new art movement in the wider elite Korean art world, was questionable at this moment.

11 Park Seobo, *Primordials No. 1-62*, 1962,
Oil on canvas, 163×131 cm

 ART IN A TIME OF WAR AND DIVISION

"In contrast to such international movements [like Informel], realist painting had been deemed the only absolute measure of value, and the National Art Exhibition represented this canonical authority. A few masters of realist painting were directly and indirectly threatening the new movements of frustrated generations. However, even with our underdeveloped feudal conditions, the martyr-like resolution of young generations toward establishing a new painting movement became increasingly stronger."[36]

In the quote above from 1966, Park Seobo described the struggle to establish 'new painting.' But by 1966, these ambitious revolutionary activities of Informel artists to reform the Korean art world were already considered outdated. Chung Kyu's comments on Informel that it is "noteworthy as today's new attempt to negate the established style and concept" was in 1958.[37] In this context, we should examine what happened between 1958 and 1966. At the second Paris Biennale for young artists in 1961, Kim Tschang-Yeul, Chung Changsup, Chang Seongsoun, and Cho Yongik participated. Kim Tschang-Yeul served as commissioner for the 1963 Paris Biennale, in which Park Seobo, Youn Myeungro, and Cho Yongik participated. As only younger artists from Korea participated in the Paris Biennale, it became the initial convention for the older generation to participate in the São Paulo Biennial and the younger artists to participate at Paris. However, as the artist group that was selected for international art events soon came to overlap among the different exhibitions, the leaders of the new, younger group gradually monopolized attendance at the international biennales.

In the meantime, Informel art was concentrated and exposed through the *Contemporary Art Exhibit*, and Park Seobo was already in 1962, from October 19 to 25, presenting 17 works from his Protoplasm series at the National Library of Korea's gallery. The *Protoplasm* works signified not a screen filled with black materials with the image of death and impoverishment, but rather the idea of life given form. By comparison, this could be considered a healthy form of life that had broken free of Informel's sarcastic and decadent approach.[38] 11 As a response to society, the new art of Informel was assigned the role of criticizing the concerns of past generations. It stressed a vitality in tune with the desire to rapidly support the legitimacy of the Third Republic of South Korea, which was established in 1961 under the 'presidential' rule of military leader Park Chung-hee, and after the mid-1960s, proceeded to focus on traditional subject matter, as dictated by state cultural policy. In this context, Kim Jinmyung's Pomegranate and Park Gilwoong's *Conversation* were awarded the Presidential Prize, and in 1970 at the nineteenth National Art Exhibition, Kim Hyung-geun's *Target* won the Presidential Prize. Notwithstanding the controversy of possible plagiarism,[39] it is notable that Kim Hyung-geun's hyperrealist painting won the highest prize in the National Art Exhibition. Neither figurative in a classical, academicist sense, nor realist in compositional concern, this hyperrealist painting succeeded in portraying the traditional culture of Korea by selecting traditional subject matter, and successfully manifested the motto of "state renaissance." Also, as a work of realism was awarded the Presidential Prize, the number of subsequently inspired works greatly increased among the nominated works of National Art Exhibition. However, as work associated with the so-called hyperrealism manner was accepted not in the figurative division but the non-figurative, or in other words the 'new' art division, we can say that it was embraced as an avant-gardist approach. Bai Donghwan's *Sidewalk*, portraying scattered newspaper and telephone pole's shadow on a paved road, Song Yong's *Staircase*, and Lee Hanwoo's still life of realistically painted traditional objects are all examples of such works, that demonstrate how this contemporary manner was different from that of traditional figurative painting.

From the late 1960s to the 1970s, Korean society was swept by modernization. In Korea, Hyperrealism became the art that emerged to reflect the new materialistic environment that developed during this period of intense social and industrial development in the 1970s. While the number of factories increased and urbanization accelerated exponentially in Korea, artists savored the possibilities offered by this new material world around them. Bereft of any meaningful critique of their subject matter, they produced canvases that seemingly sought to glorify materialism. Whereas hyperrealist painters in America portrayed the consumerist environment around them as an overwhelming materialistic world suffocating the artist's creative possibility, hyperrealism in Korea assumed a more duplicitous orientation, sharpening its critical edge through celebration of the modernizing national environment, at the same as engaging in a professionally expedient focus on objects associated with traditional Korean culture. The urban landscapes of Korean Hyperrealism were designed to induce a sense of contrast, filled with traffic lights and buildings in dissonance, but also embracing nature, a subject that western hyperrealist artists did not portray. On the other hand, the trend for hyperrealist still lifes, portraying traditional furniture and pots as steadfast symbols of Korean culture, could be construed as a cynical attempt to cater to the taste of state-organized exhibitions.

In this manner, the genres and styles of abstraction and figuration, or Informel and hyperrealism were constantly interpreted in relation to Korean national culture within the context of the National Art Exhibition. Here, specific local concerns were refigured in relation to modernist concerns within the international art world. The rapid deterioration of Informel as a fashionably novel manner and the rebound of realism (in the form of Hyperrealism) was the result of artists' desire to adopt new international art styles and adapt them to the military government's emphasis on Korean tradition. Thus, the development of Dansaekhwa monochrome abstraction was in a distinctly Korean mode, and was armed with the East Asian philosophy of meditative performance, and the traditions of Lao Tzu, and Zhuang Zhou, positioning itself in an aesthetic realm far removed from the Western materialist monochrome or minimalist post-war tradition.

MODERN ARTISTS AND NATIONAL ART EXHIBITION

The National Art Exhibition was an exhibitionary institution that functioned to realize the state's interests and political ideologies. The setting up of new divisions within, and the back-and-forth emphasis on styles and manners and cultural traditions that defines its history, emphasizes this nature. In the thirteenth National Art Exhibition held in 1964, a photography exhibition was included for the first time, with 2,190 works, excluding those from recommended artists, submitted. In 1968 with the seventeenth edition of National Art Exhibition, the organizing body was changed from the Ministry of Education to the Ministry of Culture and Public Information. This was because of a change in the Ministry's name, but it also served to shift the notion of the National Art Exhibition as an 'educational' event, to one designed to celebrate and promote 'culture.' The subsequent year at the eighteenth National Art Exhibition, figurative and non-figurative works were separately divided within the oil painting section, not as a means to systematically distinguish the two, but simply to proactively embrace abstraction as the more critically privileged genre. From the nineteenth edition in 1970, the East Asian ink painting, Western painting, and sculpture sections within the exhibition were divided simply into figurative and non-figurative paintings. Additionally, a fourth section was designated to calligraphy and a fifth to crafts. Photography and architecture, disciplines that had initially been incorporated into the National Art Exhibition system were again excluded. This reformation was the result of genres being selected for inclusion or reformatted in relation to the critical climate of the day.

The National Art Exhibition system attests to the process of embracing traditional figurative works and new abstract works. From the twenty-third edition in 1974, the National Art Exhibition was divided into a spring exhibition and a fall exhibition. The spring show was for abstract art, and the autumn for figurative art. Within the divided system, figurative art belonged to the fall exhibition, which implied that the National Art Exhibition committee acknowledges the traditional legitimacy of figurative art. Meanwhile, the abstract art was assigned to spring exhibition because it symbolized the vitality of the new art as spring revitalizes living creatures. However, it is worth noting that as early as 1970, when, with the nineteenth edition, there was great resistance from the photography and architecture communities for being excluded from National Art Exhibition, it had been disclosed that there may also be a further spring exhibition organized for these disciplines.[40] It was also around this time that the Seoul Contemporary Art Festival was organized, as the a non-government juried exhibition (*Minjeon*) came into being in direct reaction to the National Art Exhibition as young artists' desire for new modernist art surged and the National Art Exhibition was incapable of supporting such interests. It was only in 1974 that the National Art Exhibition Operations Committee was established and it was decided that the spring National Art Exhibition would exhibit abstract ink painting, abstract oil painting, and abstract sculpture along with crafts, architecture, and photography, while the fall National Art Exhibition would present figurative East Asian ink painting, oil painting, and sculpture along with calligraphy and ink paintings of 'The Four Gentlemen.' A Presidential Prize, Prime Minister's Prize, Minister of the Ministry of Culture and Public Information Prize were awarded within each division, and an Invited Artist Prize and a Recommended Artist Prize were given to one artist per season. At the twenty-third exhibition, 861 works were submitted to the spring National Art Exhibition and 1,070 to the autumn exhibition, signifying the continued popularity of representational art.

From the twenty-sixth exhibition in 1977 that figurative and non-figurative works were no longer divided into two seasonal shows. The spring exhibition now included calligraphy, crafts, architecture, and photography, while the autumn exhibition presented ink paintings and oil paintings in two divisions, and each included figurative and abstract works. Here the National Art Exhibition adopted a system of evaluating the works through the feedback of five critics to substantively distance the event from the notion that its judges were

biased. However, this reform did not lead to any actual effects because the jury members strongly refused to surrender their positions, which lead to the critics resigning in protest.

In 1979, the operation of the National Art Exhibition was transferred from the Ministry of Culture and Public Information, a bureaucratic body of the state, to the Korea Culture and Arts Education Service. At the twenty-ninth edition in 1980, the National Art Exhibition discarded its established awards system and opted to simply present a Grand Prize within each of the ten disciplinary divisions. In this context, separating figurative and non-figurative painting was not so much done to encourage the submission of various styles of art, to encourage the fair distribution of the prize among a diverse range of recipients. It was from here on that the term "abstract" was used in place of "non-figurative," and the National Art Exhibition institution was completely privatized. In 1981 at the thirty-ninth exhibition, it was announced that the exhibition would be divided into an invitational exhibition for the older generation of artists, and an open exhibition for the younger emerging generations. Thus, the system of recommended and invited artists, which was reflective of the power structure of the conventional art scene, was discarded. In this way the National Art Exhibition as a state-organized exhibition came to an end.

Initially condemned as both a restricted entry point for sycophantic emerging artists and an uncritical showcase for the conservative established figures of the Korean art world,[41] the original institution of the National Art Exhibition met a turning point with the fall of the first Republic of Korea, at which point its organizers sought to reform the system of recommended and invited artists. However, arguably until the exhibition was completely transferred to the private sector, it remained a platform dominated by the art scene's internal power struggles. The organizing structure of the National Art Exhibition directly reflected the ruling political system of the period. The genres subject to entry within the competition were also related to wider social, political, and economic conditions. For instance, the architecture section was added in 1955 and the photography section in 1964, then both were excluded in 1970, and ultimately re-included in 1974. The crafts section changed its name to Applied Arts in 1954 at the third exhibition, but was then re-introduced the next year under the title of 'Crafts.' The social importance of architecture was immeasurably strengthened after the war in relation to the need to rebuilding the nation, while the cultural currency of photography was heightened during the war, and the national importance of local craft work was emphasized in tune with the government's economic strategies before gradually being embraced as a concept that incorporated modern designers and their work.

After the May 16 military coup d'état in 1961, participating artists were divided into those invited and those recommended. The system was once again consolidated to primarily present recommended artists, but then from the eighteenth edition in 1969, the system of recommended and invited artists was re-instated. In relation to the context of recommended and invited artists at the National Art Exhibition, the official naming of the crafts division, and the issue of including photography and architecture, all these developments keenly reflected the relation between society and the utility of art as defined by the state. The rivalry between photography and architecture in seeking to become officially accepted by the National Art Exhibition, for instance, clearly demonstrates how state power could intervene in the operation of the National Art Exhibition. As such, the National Art Exhibition was a site of competition in relation to the establishment of Korean artists' social status within the art world and the beyond, and at the same time a site within which they might realize their wider artistic desires for fame and recognition. Whether accepted or not, it was a platform where all concerns prevalent within the Korean modern art world were manifested in relation to each other, whether that be in terms of form or discipline or stylistic concern. From the establishment of the government of South Korea until 1980, despite its negative elements, National Art Exhibition was, therefore, the primary institutional tool which supported the growth of new artists' careers, and, simply, the largest ongoing exhibition event devoted to displaying the concerns and interests of the elite Korean art world during the post war period. In this respect, examining the long history of the National Art Exhibition presents us with an important insight into the development of Korean modern art.

1 Cho Eunjung, *Chungok Ko Huidong: Gyeokbyeongi geundae hwadan, han misulgaui chosang* [Chungok Ko Huidong: A Portrait of a Modern Artist in a Period of Upheaval] (Paju: Culture books, 2015).

2 Lee Gu-yeol, "Gihoek teukjib/haebang gonggan (1945–50) ui uri munhwa yesul·misul" [Our Culture and Arts After Independence (1945–50)], *Munhwa Yesul*, September 1988.

3 Choi Youl, *Hanguk hyeondae misurui yeoksa* [History of Korean Modern Art] (Paju: Yeolhwadang, 2006), 118.

4 Statement of the Minister of the Ministry of Education, Ahn Hosang, "Misul jeollamhoe" [Art Exhibition], *Dong-A Ilbo*, October 19, 1949.

5 Lee Kyungsung, "Hanguk geundae misul 60nyeonui munjedeul" [Issues of the Six Decades of Korean Modern Art], *Shin Dong-A*, October 1968; Lee Kyungsung, *Eoneu misul gwanjangui hoesang: misuleun modeun saramui geosida* [Recollections of an Art Museum Director: All Art Belong to Humans] (Seoul: Sigongsa, 1998), 111–129.

6 Lee Kyungsung, "Gukjeon yeondaegi—jakpumgyeboreul jungsimhayeo" [Gukjeon Chronology—Around a Chronology of Works], *Sinsegae*, November 1962, 205.

7 Cho Eunjung, "Jeonhu hanguk hwadangwa jeonhyeoklim" [Chun Hyuklim and the Korean Art Scene After the War], *Jeonhyeokrimui salmgwa yesul* [Life and art of Jeon Hyuk Lim], exh. cat. (Changwon: Gyeongnam Art Museum, 2006), 9.

8 Youn Bummo, Testimony of Korean-American Painter Kim Byungki, "Bukjoseon misul dongmaengeseo jong-gun hwagadankkaji" [From North Korean Art Alliance to War Painters], *Gana Art*, January/February, 1990, 70–81.

9 At the National Spirit Lifting Art Festival, in each genre, there was a reading of letter to an artist colleague that defected to the North. Kim Man-hyeong wrote a letter to Gil Jinseop. "In the chaotic days after independence, I held hands with you to together work for the Korean art scene. But what did we get? Only the fury in realizing we were deceived. After you defected to the North, Korea developed even more into a democratic country, taking giant steps into the world. There is neither an iron curtain nor restraint in Korea, and all professionals of culture freely serve their needs in all liberated corners. You, the one that had so loved freedom! Do you not miss freedom? You surely by now have sufficiently realized all deceitful schemes of the North. I have already severed my ties with you. But you, there is no need for you to deceive even yourself and be a slave to the puppet state. I strongly urge you to return to your truth and come back to Korea, the country of freedom." "Minjok jeongsin yangyang jonghap yesulje gaechoe" [Hosting the National Spirit Lifting Art Festival], *Seoul Daily*, December 6, 1949.

10 "50nyeon mihyeop myeongil gyeolseongsik" [Organization of the 1950s Art Association Tomorrow], *Dong-A Ilbo*, January 4, 1950.

11 Park Kosuk, "8.15 eseo subok jeonhuui hwadan" [Art Scene Around Independence and Restoration], *Hwarang*, Fall 1975.

12 Choi Soonwoo, "Haebang isipnyeon—Misul" [Two Decades Since Independence—Art], *Daehan Ilbo*, May 28–June 19, 1965.

13 *Jayu Ilbo*, January 4, 1950.

14 "50nyeon misul hyeophoe gyeolseongsik geohaeng" [Inauguration of the 1950s Art Association], *Dong-A Ilbo*, January 1, 1950.

15 Lee Joon, "Busane unjibhan misulin" [Artists Gathered in Busan], *Gyegan Misul*, Winter 1985, 63.

16 Lee Kyungsung, "Miui wido (ha)" [The Latitude of Beauty], *Seoul Shinmun*, March 13, 1952.

17 Cho Eunjung, "Hangukjeonjaenggwa jibanghwadan" [The Korean War and the World of Rural Artists—The Artists World of Busan, Jeju, Honam], *Journal of Koreanology* 38 (2010): 35–64.

18 "Je 2 hoe gukjeon teukseon jakga daedanhoe" [The Second National Exhibition Special Artists Talk], *Munye* Spring Issue, January, 1954.

19 Bae Sungryong, "Dongyangjeok soetoesagwan gaeron" [Introduction to the History of Oriental Decline], *Sasang-gye*, March 1954, 18–30.

20 Chang Ucchin, *Ganggaui atteullie* [Atelier of the Riverside] (Seoul: Mineumsa, 1976), 43.

21 Kim Sou, *Yesulgaui salm, kim heungsu* [Life of an Artist, Kim Sou] (Seoul: Hyehwadang, 1993).

22 Lee Gyu-il, *Dwijibeo bon bangik misul* [Korean Art Upside Down] (Seoul: Sigongsa, 1994), 114.

23 Lee Bongsang, "Gukjeon (ha) seoye, dongyanghwa changjakjeongsin sallil geot" [Gukjeon will Revive the Creative Spirits of Calligraphy and Oriental Painting], *Dong-A Ilbo*, November 27, 1955.

24 "Haksulwon mich yesulwon gaewonsik" [Opening Ceremony of the Academy of Sciences and Academy of Art], *Seoul Daily*, July 17, 1954.

25 Park Rehyun, "Dongyanghwaui chusanghwa–jajeonjeok misullon" [Abstract Painting within Oriental Painting-Autobiographical Art Theory], *Sasanggye*, December 1965.

26 Lee Bongsang, "Gukjeoneul bogo (sang): gukjeon gaemak jejak jeongsinui bingon" [After seeing Gukjeon: Gukjeon Opens, Lack of Production Spirit], *Chosun Ilbo*, November 20, 1956.

27 Kim Byungki, "Yesul inyeomui sangsil" [Loss of Art Ideology], *Chosun Ilbo*, October 1, 1957.

28 Ki Hyekyung, "Modeon ateu hyeophoewa 1950nyeondae hwadan" [Modern Art Association and the 1950s Art Scene], *Modern Art Studies 2004* (Seoul: MMCA, 2004), 154–171.

29 Cho Eunjung, "Cheonghwa hainduui jakpumsegyewa misulsajeok wichi" [The Art World of Chunghwa(青華), Ha, In-doo and his Position as an Artist], *Inmul misul sahak* 6 (2010): 33–71.

30 After the first *Byeok Art Exhibition* outside of Deoksugung Palace, the Sketch Exhibition was held at Dong Hwa Gallery later that year from December 27 to 31. The members were Kim Iksoo, Kim Jinhyun, Kim Hyungdae, Park Sangeun, Park Hongdo, Park Byungwook, Yoo Byungsoo, Yoo Hwang, Lee Dongjin and Lee Dongsu. "Je 2 hoe byeokdonginhoejeon" [The Second Wall Art Group (Byeokdongin) Exhibition], *Kyunghyang Shinmun*, December 24, 1960.

31 *Hankook Ilbo*, October 6, 1960.

32 "Munhwa sosik" [Culture News], *Dong-A Ilbo*, October 13, 1960.

33 "Ihaeui hanmadi (8), misul yanghwaga kim hwanki ssi" [A Word of Understanding (8): An Artist of Western Painting, Kim Whanki], *Dong-A Ilbo*, October 23, 1960.

34 Kim Mijung, "Hanguk aengporeumelgwa daehanminguk misuljeollamhoe: 1960nyeondae choban jeongchijeok byeonhyeokgireul jungsimeuro" [Art Informel and The National Art Exhibition Focusing on the Political Changes of the Early Era of 1960's], *Journal of Korea Modern Art History* 12 (2004): 315–316.

35 "Gukjeon simsawiwoneul seonjeong" [Selected the Gukjeon Jury], *Dong-A Ilbo*, October 5, 1963.

36 Park Seobo, "Cheheomjeogin jeonwimisul" [Experiential Avantgarde Art], *Space*, November 1966, 83–88.

37 Chung Kyu, "Jeolmeun jeongyeolgwa uiyok: hyundae misulga hyeophoe samhoejeonpyeong" [Young Passion and Will: Modern Artists Association Third Exhibition], *Dong-A Ilbo*, May 24, 1958.

38 Kim Hyunwha, "Bakseoboui wonhyeongjil yeonjak yeongu: Jeolgyuhaneun inganui yeongsang, sareutereuui

sasanggwa jeommok gochal" [Park Seo-Bo's series of Protoplasm: 'the Image of a screaming human,' a reading by the philosophy of J-P. Sartre], *Art History and Visual Culture Volume* 14 (2014): 136–167.

39 "Gukjeon daetongryeongsang gwanhyeokeun dalmassda" [The Gukjeon Presidential Prize Awardee, Target, is Similar], *JoongAng Ilbo*, October 22, 1970.

40 "Gukjeon wolmalkkaji yeonjang" [Gukjeon Extended till End of Month], *Dong-A Ilbo*, November 17, 1970.

41 Lee Kyungsung, "Munjeuisikui bingon" [Lack of Critical Mind], *Sasanggye*, December 1959.

THE TRADITION/MODERNITY DYNAMIC
IN THE MODERNIZATION ERA

Kim Whanki, *16-IV-70 #166* (Where, in What Form, Shall We Meet Again series), 1970, Oil on cotton, 236×172 cm

Park Youngran

South Korean society from the 1950s to the 1970s can be divided into two periods. The Korean War and the subsequent recovery, followed by the government of the 1961–79 Park Chung-hee regime. This second period was ushered in by Park's May 16 coup d'état. It ended with his assassination on October 26, 1979 and was defined by the acceleration of national industrialization. The recovery from the Korean War was initially slow, hampered by rampant corruption in the Rhee Syngman administration. This government was established in 1948 following Korea's liberation from Japanese colonial rule in 1945. The situation in Korea came to a head in March 1960 when the people rose-up to protest fraudulent election results. The April 19 Revolution that year heralded the Chang Myon Government, which was supplanted the following year by Park's coup. The Park regime lasted eighteen years. From a political standpoint, it was a time of monolithic military dictatorship. Economically, however, those eighteen years saw unprecedented development and growth.

As Korea recovered from the poverty and suffering brought on by the war, long-standing social hierarchies dissolved rapidly. The old class system vanished, enhancing access to education in a nation that had long valued scholarship. As a result, the number of people who completed elementary and secondary education skyrocketed, which led to an immense rise in human capital and the beginning of Korea's meteoric economic development.

As industrialization progressed, the winds of change swept the nation. The urban population increased exponentially, while rural populations often kept their traditional ways. The unique circumstances surrounding the Korean Peninsula were a powerful influence on the lives of ordinary citizens. The military and ideological conflict in the country dovetailed with the global Cold War paradigm. Widespread anti-communist sentiments was dominant, bolstered by government censorship and media control. Popular culture was recognized as a useful means by which anti-communist and pro-US sentiments and their associated ideological perspectives could be proclaimed. At the same time, the pain of separation felt by family members divided across the Armistice Line following the peninsula's division was deeply rooted in the hearts of many ordinary citizens.

This period of Korean art history is largely dominated by modernism, based on the pursuit of a notion of the ideological independence of the arts. The origins of contemporary Korean art—encompassing Art Informel, geometric abstraction, experimental art, Dansaekhwa, and hyperrealism—come from the lyrical and performative abstract arts of Informel. This artistic trend, which emerged as a rebellion against the established authority of the art community, began in the late 1950s. The National Art Exhibition launched in the aftermath of liberation, had been at the center of artistic activity in the country at that point. However, its activities eventually veered from the original intention of the pure pursuit of art, to a forum for politicking in the art community. Young artists rose up to challenge this institution, establishing a number of communities of their own such as the Creative Art Association (Changjak misulga hyeophoe), the Hyundae Fine Artists Association, the Neoplastics (Sinjohyeongpa), and the Paek Yang Painting Association—with the Hyundae Fine Artists Association chief among them in their pursuit of Informel. Rooted in resentment against established artists and their existential experience of war, Korean abstract artists rose up furiously in parallel with the April 19 Revolution, even holding an ad hoc exhibit of large paintings—ranging from 500 to 1000 *ho* (about 22.7 x 15.8 centimeters) on the outer walls of Deoksugung Palace.

Unlike the modernist oil painting community, the ink painting community did not strongly oppose the National Art Exhibition. Even so, artists like Suh Seok received inspiration from the modernist oil painters and founded the Mook Lim-Hoe, an art group entirely composed of ink painters, in 1960. Others chose to break away from the bounds of tradition by experimenting with new kinds of paper, calligraphy brushes, and ink, and thereby extending the depth of the ink

painting tradition. They proposed a theory of abstract painting by merging the power of expressionism from Western painting with ink painting tradition of capturing the spirit (saui) and the unified nature of calligraphy and painting. In this manner it is possible to claim that contemporary abstract movements in the medium of ink, in both monochrome and polychromatic fields of production, inherited traditional practice of painting.

The field of sculpture, too, faced little conflict between abstraction and figuration, and conservatives and progressives. The judges serving at the National Art Exhibition—such as Kim Chongyung, Song Youngsu, and Kim Chungsook—were the pioneers of abstract sculpture in Korea and were favorably disposed to abstract art. As Informel Art came to prominence in Korea, young sculptors pivoted from traditional materials such as plaster, stone, and bronze, turning instead to iron as a symbol of modernity that allowed for new artistic effects through the utilizing of welding techniques, and which produced rough surfaces that lent themselves to emotional and aggressive new expressions.

It was after the 1950s that examples of contemporary printmaking from the West entered Korea, a country with a long history of woodcut printing. Artists Chung Kyu and Yoo Kangyul, who both studied the art in the U.S., returned to Korea and started to teach their successors in postsecondary education. Chung Kyu held his first solo woodcut print exhibit in 1956, while Yoo Kangyul held his first solo lithography show in 1958. The launch of the Korea Prints Association (Hanguk panhwa hyeophoe) in 1958 accelerated the development of contemporary Korean print art, with new techniques such as silkscreen quickly introduced and adopted, leading to a massive wave of Art Informel inspired work in the early 1960s. In 1962, Kim Sangyu held the first etching print exhibit in 1962, and Youn Myeungro and Bae Yoong held a joint silkscreen exhibit two years afterwards. Owing to the ease with which materials could be transported, print artists were able to easily participate in international exhibits and interact with artists from around the world.

When Park Chung-hee came to power in 1961 through coup d'état, the social norm spread across the country was to reject the traditional approaches of the past, and the National Art Exhibition was not an exception. Previous judges, such as Ko Huidong, Chang Louis Pal, and Lee Chongwoo resigned and took on advisory roles, new faces from the abstract art movement such as Kim Yeongju, Yoo Youngkuk, and Kwon Okyon became judges. This transformation refocused attention on the National Art Exhibition. More than a thousand works were submitted that year, with a significant number of works in the Informel style. The Korean art community made a rapid pivot towards abstraction, with the National Art Exhibition awarding the first prize to *Restoration B* by Kim Hyungdae in 1961 and to *Circle of History* by Park Chongbae in 1965—the first work of abstract sculpture in history to win this prize, considered the foremost of the National Art Exhibition's awards. It was in this period that young artists formed artist groups such as Origin Fine Arts Association, the Zero Group, the Sinjeon Group, and the Korean Avant Garde Association (AG) in their pursuit of unconventional experimentation.

The progress of urbanization and industrialization led to social changes, which in turn led to artists' budding interest in new media and forms such as op art, Neo-Dada, pop art, happenings, and event art. These artists embraced new techniques in their formal experimentation, establishing Korean experimental art in the 1960s and breaking down the boundaries of the field. However, some forms of performance art (such as happenings) were treated as unseemly by the government and censored and restricted. Following the dissolution of the AG, experimental art was passed down through the Space and Time Group (ST). But without a singular dominant formal style, the experimental art scene began to decline. It was around this time that artists began to follow the painterly trend of Dansaekhwa, meaning "monochrome painting."

If the decade of the 1960s can be defined by the April 19 Revolution and national economic development alongside artistic revolution and

experimentation, the following decade was a time of mounting social frustrations, as political oppression and increasing inequality exposed the limitations of the government's growth-focused policies. After the first two stages of Five-Year Economic Development Plan (1962–71) resulted in great success, the national economy seemed to have reached the goal of economic modernization. However, these developments were built on the light industry sector and the use of cheap labor. Problems resulting from this continued to fester across Korean society, leading to resentment against the Park administration and mounting social tension.

Circumstances were no less problematic on the political side, as the National Assembly passed an exceptional legislation that extended the number of re-election terms permitted to each president from one term to three consecutive terms. In the seventh presidential elections in April of 1971, Park defeated Kim Dae-jung of the New Democratic Party of Korea by a slim margin and secured his third consecutive term, but this result—which came from a direct election by the people—showed that Park did not enjoy a clear monopoly over the public's support. In December that year, the Park administration declared a state of national emergency to silence all opposing voices and declared the Yushin Constitution. In October 1979, things finally came to a climax as the citizens of Busan and Masan led a democratization protest against the military junta, which was quashed with military force. The involvement of the military, however, led to disagreements and divisions within the administration itself that culminated in the assassination of Park Chung-hee and the end of his regime.

The Nixon Doctrine (1969), proclaimed at a time when military tensions on the Korean Peninsula had continued to worsen, had a significant impact on inter-Korean relations. To avoid military clashes between the Koreas, the U.S. demanded an inter-Korea summit of the Park administration. In response, Park altered his North Korea policy and proposed official talks with the North and launched the North-South Red Cross Summit for the reunification of separated family members. These measures also served the purpose of mollifying national resentment against his repeated terms in power and addressing the national security issues that terrified the Koreans during this time of rapid political change.

The third stage of Five-Year Economic Development Plan involved the development of export-focused heavy industries, with the nation invested heavily in petrochemicals, shipbuilding, steel, non-ferrous metals, electronics, and automobile production, with these industries quickly outstripping export volumes of light industry products. However, the government-led growth policies and the nature of heavy industries—which require massive capital investments—meant that *chaebol* conglomerates were given preferential treatment, leading to their corporate influence in matters of governance. At the same time, factory and agricultural workers who were excluded from the rapid economic development of Korea began to put up fierce resistance and demand their rights. These events occurred concurrently with Korea's ongoing economic development, which was imperiled by the 1973 oil crisis, from which the government recovered by taking construction projects in the Middle East and generating a massive influx of foreign capital.

In the 1970s, the Park administration made national unity and nation-building its main priorities. National development was the keyword by which policies were adopted, all for the purpose of simultaneously reunifying the Koreas and revitalizing the economy by realizing a so-called Korean-style democracy. National development was the driving theme behind cultural policy as well, which were applied to the Korean art community. Such efforts indeed boosted interest in traditional Korean art among artists.

Park pursued a policy for the promotion of Korean national culture, believing that cultural identity stemmed from a nation's unique history and that the creation of a new national culture untainted by the West was necessary. To this extent, he published the National Chart of Education in 1968, the Five-Year

Plan for the Redevelopment of Culture in 1969 and the Project on Developing the Ancient City of Gyeongju in 1971, and also legislated the Culture and Arts Promotion Act in 1972. It was in these circumstances that the MMCA Gyeongbokgung was established in 1969 at Gyeongbokgung Palace, then moved to the Seokjojeon Hall at Deoksugung Palace in 1973, where it hosted the exhibitions *60 Years of Modern Korean Art* (1972) and *Korea: The Trend for the Past 20 Years of Contemporary Arts* (1978) in order to establish Korean art in the wider context of art history. At the same time, a budding commercial art market took root on the foundations of national economic development, as art galleries opened their doors one after another in Seoul. This trend started with the Hyundai Hwarang in 1970 and then continued with the Myeong-dong Gallery, the Chosun Art Gallery, Dongsanbang Gallery, the Sun Gallery, the Moon Hwa Art Gallery, the Songwon Gallery, and the Seoul Gallery, throughout the 1970s.

The field of Dansaekhwa was where the effort to create a uniquely Korean notion of cultural identity relative to contemporary art truly shined. In a social context where tradition and national uniqueness was heavily encouraged, artists in this genre combined traditional aesthetics and values to produce works that brought together ideas of past and present, and East and West.

In the field of ink painting, landscape paintings based on 'real' scenery were increasingly executed in monochrome ink wash rather than in polychrome. This genre of painting did not simply aim to replicate natural scenery, but reflected an idea of nature from a uniquely East Asian perspective and was seen as style deeply rooted in philosophy, that reflected the scholarly desire to enter and discover the true self, thereby attaining enlightenment.

In the 1970s, print art was widely acknowledged within the Korean art community as a new art form and joined the mainstream. As new techniques and skills were honed and developed, print art carved out an identity of its own. The Seoul International Print Biennale was launched in 1970, boosting participation and awareness about the art form further. Kim Sangyu's *No.Exit* (*Room without an Exit*), Song Burnsoo's *Pantomime*, and Hwang Kyubaik's *Turtle and Rabbit* are considered some of the masterworks of this period.

The 1970s also marked the advent of hyperrealism in the Korean art world. The National Art Exhibition undertook reforms in this period, and the figurative painting section too began to see works that moved beyond academic style. The President's Prize in 1970 at the nineteenth National Art Exhibition went to *Target* by Kim Hyung-geun, but it was only in the late 1970s that hyperrealist art gained popularity in the Korean art community as a backlash against the domination of Dansaekhwa and due to the influence from new figurative art from overseas.

In 1978, realist and hyperrealist painters Cho Deokho, Ju Taeseok, and Ji Seokcheol founded an artist group Fact and Reality (Sasilgwa hyeonsil), as they turned away from the dominant abstract art that they considered to be removed from reality and instead focused on daily life, common objects, and illusions. The hyperrealists of the 1970s also showed an interest in exhibiting at the National Art Exhibition, which was at the dawn of the decade the primary channel through which to make an official artistic debut in Korea. Multiple artists attempted to supersede the precedent of academic realism through their own unique brands of figurative art. In 1974, Ko Younghoon presented *This Is a Rock*, a hyperrealistic depiction of stone, at the *Independants* exhibition. In 1978, Kim Hongju was awarded the Frontier Gold Prize at the Korean Art Grand Award Exhibition. The same year, a group of hyperrealist artists held joint exhibitions like *Founding Exhibit for Realism and Reality* and *Figuration 78*.

Juried art exhibits run by newspaper corporations also emerged in the 1970s as a critical response to the authoritarian nature of the National Art Exhibition. In 1978, the *Dong-A Ilbo* newspaper launched the Dong-A Art Festival to offer a site for new figurative art, and the *JoongAng Ilbo* newspaper's JoongAng Fine Arts Prize matched this new interest in figuration. The *Hankook Ilbo* newspaper's Hankook Art Awards, the Dong-A Art Festival, and the JoongAng Fine Arts

Prize also all sought to challenge the status quo and made no effort to hide their critical and progressive attitudes, bringing about a new order in the art community. As more and more gallery spaces became available in the 1970s, and artists increasingly flocked overseas to showcase their work, the National Art Exhibition lost its purpose and finally closed down for good after its thirtieth iteration in 1981.

The Development of Korean Modern Art and International Exchange

Chung Moojeong

NEW TASKS IN THE ART WORLD

Many art organizations formed immediately after Korea's liberation from Japanese colonialism claimed that the liquidation of pro-Japanese vestiges and the creation of new "national art" (*minjok misul*) were important tasks for the art world to address. Various measures were proposed to carry out such tasks in the ideological chaos of the liberated country, but ultimately ideological conflicts were minimized due to the suppression of the United States Army Military Government in Korea. The South Korean government was established in 1948, and the tasks of the art world seemed to be unified. As far as the removal of pro-Japanese remnants from within the art world, the ideological aspects inherent in the task were eliminated, and the tasks were narrowed down to the issues of materials, expressive techniques, or terminology, while the creation of a new national art was promoted in the direction of actively accepting the influence of Western art. What revealed this change implicitly in 1950 was the formation of the 1950 Art Association, which advocated for a historically orientated mission to developmentally break up the dispersed art organizations and to create an "art that fights against communist ideology and that is rooted in national spirit by correcting conservative academism" so that "artists who stood at the center of world history [could] open a big gate to the twentieth century."[1] Although the association's activities were stymied due to the Korean War, its members, such as Kim Whanki, Nam Kwan, Kim Byungki, Kim Youngjoo, Yoo Youngkuk, Chang Ucchin, Lee Bongsang, Son Eungsung, and Cho Byungduk, soon became established as artists, educators, and theorists who would lead the Korean art scene in the years to come. In that sense, it is no exaggeration to say that the 1950 Art Association's sense of mission was a driving force behind the development of Korean art.

On the other hand, the "fight against communist art ideology" foregrounded in the 1950 Art Association's mission suggests that Cold War ideology may have strongly influenced Korean modern art from the 1950s onwards. In fact, the Cold War is an important internal and external factor that influenced the development of Korean art in the 1950s, and an element that partly defined the nature of such. From the late 1940s, the support for cultural exchange programs implemented by the Soviet Union and the United States to lure countries around the world into their divergent ideological spheres of influence are important to think about when considering the global development of national culture during the Cold War era. In Korea, especially, during the main stage of the Cold War in Asia, financial support and programs from the U.S. and the U.S.S.R had a great influence on the region from the 1950s forward. In terms of U.S. support within South Korea, the nature and types of support were diverse, with the funding sources including both government agencies and the private sector. However, from a macroscopic perspective, the goal was to enable people to directly experience the dynamic 'power' of American culture and civilization, and naturally embrace American hegemony in the liberal 'free' world. In order to effectively carry out such American interests, government and private funding agencies maintained complementary relationships.

During the Cold War era, the U.S. government administered enormous resources to cultural propaganda programs covertly conducted in Western Europe and Asia. These programs were led by the U.S. State Department, its affiliates, and the Central Intelligence Agency (CIA). In order to counter communism and effectively pursue the interest of U.S. foreign policy abroad, the

1

U.S. State Department and the CIA established a very influential network, stressing the need for a "Pax Americana" around the world. In particular, the international human network established by the CIA was a hidden weapon of the Cold War, exerting extensive influence on the world's cultural community. Whether they liked it or hated it, knew it or not, innumerable writers, poets, artists, historians, scientists, and critics around the world took part in the CIA's covert planning in some way.

One of the CIA's cultural propaganda programs was the Congress for Cultural Freedom (CCF), which was run by CIA agent Michael Josselson from 1950 to 1967. To help Western European and Asian intellectuals steer clear from the temptation of Marxism and Communism and embrace the American way, the CCF published through more than twenty magazines in thirty-five countries, held various exhibitions and international conferences that garnered critical attention around the world, and rewarded artists with prizes.

The financial support and exchange programs channeled through the private sector were centered around foundations such as the Asia Foundation, the American Korean Foundation, the Rockefeller Foundation, and the Ford Foundation. These private foundations contributed to the formation of pro-American networks in Korea along with the Fulbright Program as part of public diplomacy, and their beneficiaries became powerful elite that led the fields of politics, economy, and culture. They also played an important role in spreading American values and ideology to Korean society. The Asia Foundation and the Rockefeller Foundation played a prominent role in the art sector. I would like to examine to what extent the desire of Korean artists—those who wanted to create new national art through the acceptance of Western art—was fulfilled through the Cold War-accelerated cultural exchanges, and how it ultimately affected the development of postwar Korean art.

THE ACTIVE EMBRACE OF WESTERN ART AND YOUNGER GENERATIONS

After the Korean War, the Korean art world plunged into a deep slump. The leading critics of the liberation sphere such as Gil Jinseop, Kim Yongjun, Park Munwon, Yoon Hee-soon went to North Korea, resulting in a vacuum in art criticism in the South. Exhibitions were rarely held due to the aftermath of the war, and exchanges with the outside world were almost cut off. This cultural vacuum continued for several years, and by the time the post-war chaos subsided, new critics who were filling the gap in the art world diagnosed the psychological state of the field as one of lethargy and self-depreciation that dominated the isolated—both in terms of

time and space—seeing the Korean art world as "depressive," and suggested an active imitation of Western art as a prescription. As Lee Kyungsung wrote: "We must not forget that imitation is a path to creation . . . In the early days of cultural creation, bold imitation may be acceptable. [More than that], this imitation is what accelerates cultural development."[2] This argument was persuasive because it was a realistic way to revitalize the isolated Korean art world at the time. New critics put forward the idea that younger generations would be the agents of such imitation. Therefore, in 1954, the emerging artists who submitted their works to the Ink Painting Department of the third National Art Exhibition—including Kwon Youngwoo, Pak Nosoo, Suh Seok, and Chang Unsang—were praised as "promising avant-garde artists in the East Asian art community." When Kim Younghwan, Kim Choongsun, Park Seobo, and Moon Woosik participated in the *Four Artists Exhibition* under the banner of the anti-National Art Exhibition, they were encouraged to challenge established values or authority based on the privilege of youth, which featured innocence, cool-headedness, and intransigence.

To imitate Western art became considered as a way to create. In the 1950s, one of the ways Korean artists could engage with Western art was to go to the West themselves. Of course, there were exceptional cases of such travels even in the Japanese colonial era, as a few artists went abroad to study in Europe or the U.S. and to experience Western art instead of indirectly accepting the teaching of such via Japanese art colleges. For example, Lee Chongwoo moved to France in 1925 and studied at the ateliers of Charles-François-Prosper Guérin and Grégoire Schreiber before returning to Korea. Paik Namsoon studied at Scandinavian Academy (Académie Scandinave) in Paris in 1928, and her works were selected for Salon and Salon des Tuileries exhibitions. Gilbert Pha Yim graduated from Yale College Arts in 1930, and then went to Paris to submit his entry to the Salon d'Automne. Additionally, Pai Un-soung studied art in Germany in 1937 and moved to Paris to work as an artist in Europe. However, with the exception of Lee Chongwoo, these artist did not play any significant role in the development of South Korean art since they either defected to North Korea or were kidnapped by the North amid the turmoil of the Korean War.

But from the 1950s, Korean artists' travel to foreign countries was on a gradual rise. Artists who arrived in France, which had long been considered as the global center of modern art production, included Rhee Seundja 1 in 1951, Nam Kwan, Kim Sou, Na Hikyune, and Park Youngseun in 1955, Kim Whanki and Kim Chongha in 1956, Kim Seyong

1 Rhee Seundja, *House Thousand Years Old*, 1961,
Oil on canvas, 196×129.5 cm

THE DEVELOPMENT OF KOREAN MODERN ART AND INTERNATIONAL
EXCHANGE

2 Chung Kyu, *White Porcelain Jar with Under Glaze Iron-Brown Painting*, 1950s, H 21cm, diam. (mouth) 8.7 cm, (foot) 9.5 cm

3 Yoo Kangyul, *Work*, 1966, Woodcut on paper, 108×77 cm

in 1957, as well as Lee Ungno and Park Inkyung in 1958. Artists who went to the U.S. included Kim Choungza in 1952, Chun Sungwoo in 1954, Lee Soojai in 1955, and Chung Kyu $\overline{2}$ and Yoo Kangyul $\overline{3}$ in 1958. In general, these artists returned home after studying abroad for two to three years, and sometimes settled in small towns while continuing to interact with the art world within Korea, influencing the development of Korean modern art.

Another opportunity to refer to Western art was provided through international art exchanges. As mentioned earlier, these international exchanges were mostly part of cultural propaganda to maintain or expand the cultural influence of the U.S. in the Cold War, and they were often conducted in the form of American art being introduced to Korea rather than Korean art being introduced abroad. In the Korean art world, bold imitation was recommended as a means of creation, so these foreign art exhibitions held in Korea seemed to have been the target of great interest, especially for younger artists.

An early example of international exchanges was *Exposition d'Art Moderne Belge*, which was held in November 1952. Yet this exhibition had first been held in Japan and then travelled to Korea through the efforts of a military reporter in Korea, simply because the two countries were so geographically close, and its impact on the Korean art world seems to have been insignificant. Another example was a world-wide sculpture competition called "The Unknown Political Prisoner," which was held at the Tate Gallery in London in March 1953. Korea came to participate in the competition as a result of an official invitation from the Institute of Contemporary Arts in the UK. However, in general the Korean art community would not have cared little about the international competition at this moment, given the extreme turmoil of the Korean War, it is therefore assumed that the cooperation of an American government organization like the United States Information Service (USIS) or a private foundation was related to this exhibition's remit being extended to Korea. Judging from the fact that the competition was planned with funding from the CIA, the participation of a sculptor from Korea (while at war) is likely to have played a role in highlighting the political nature of the exhibition theme. Kim Chongyung, who participated in the competition as a representative of Korea, later became a pioneer of abstract sculpture in Korea after moving away from figurative sculpture.

It was in the mid-1950s that international exchanges between Korea and foreign countries began in earnest. This process started with the *American College Student Art Exhibition*, which was held at Seoul National University's College of Fine Arts from November 1-10, 1956. It was prepared by the

College Art Association in the U.S. at the request of the USIA with the intention being to introduce and spread their own education system and ideology. In the review of this exhibition, critics noted the decidedly liberal production and experimental methods used by artists. Kim Youngjoo, for example, claimed free thinking and production methods were the foundation for diverse and creative works. He praised American college art education for its focus "on discovering new personalities and [encouraging] creativity" unlike Korean college art education, which encouraged standardized art with no real personalities through the academic-style educational method. At the same time, the exhibition called for a reflective awakening on the part of university art educators and college students, and also called for established artists to seriously consider the meaning of the freedom of art.[3] In addition, Kim Byungki regarded free formal experimentation as the basis for the future promise of American art—which is "poor in tradition while at the same time unconstrained by tradition"—and praised American art education for supporting such free experimentation.[4]

On March 1 to 10, 1957, the *Exhibition of International Graphic Art* co-hosted by the Deoksugung Museum of Art (present-day MMCA Deoksugung) and the Art Society of Korea, consisted of seventeen prints donated by the International Association of Printmakers (Gukje panhwaga hyeophoe). Out of the seventeen pieces, all but three German and one Italian artist's works were by American artists. The International Association of Printmakers was a non-profit organization frequently mobilized for international printing exchanges by the U.S., so it can be assumed that the exhibition was a planned element of American cultural propaganda. In fact, prints were frequently mobilized for cultural exchange programs by the U.S. because of the ease in transporting and reproducing the works. Chung Kyu, who wrote the exhibition review, praised the exhibition for its "fresh vitality [and] free, creative attitude," adding that he expected that these foreign prints would stimulate the Korean art community. This opinion reflected a similar perspective as those offered in review of the *American College Student Art Exhibition*.

Eight American Artists, which was held at the Deoksugung Museum of Art from April 9 to 21, 1957, was sponsored by the USIA and organized by the Seattle Art Museum. This was the first exhibition of contemporary American art held in Korea based on a meaningful institutional exchange and also the first opportunity for Koreans to see actual paintings of abstract expressionism. Given that artists from the Hyundae Fine Artists Association began to showcase the Art Informel style a month later in May, it is believed to have

given younger Korean artists great confidence in assuming this new direction for their work. Commenting on this exhibition, Chung Kyu pointed out that American art was deviating from the traditional European tradition and discovering its own themes and styles. Based on this, it had begun to establish its own voice in world culture. Chung Kyu called for a change in our perception of American culture. Lee Kyungsung also urged Korean art circles to have a greater interest in American art, which had become an important part of Western art, and he fully accepted the USIA's intention to spread American institutions and values by insisting that American art—which (outside of Europe) had reached a point of influence within the canon of modern art through the shortest course in history—could be a role model for the Korean art world, given Korean artists strong desire to create modernist works.[5]

The critics who wrote reviews of the exhibitions delivered by the U.S. to Korea were those who had filled the intellectual gap in the art world caused by many critics having defected to North Korea after the country's liberation from Japan. Except for Lee Kyungsung from Incheon, these critics were all formerly from North Korea and had a strong anti-communist ideology. As a result, they benefited directly and indirectly from the U.S. cultural and foreign policies, as America wanted to inform the world of the negative reality of communism by fully supporting the activities of intellectuals and artists who defected to South Korea. For example, Kim Byungki and Kim Youngjoo held lectures on modern art with the support of the Asia Foundation, and explained how Chung Kyu studied at an American university with the support of the Rockefeller Foundation. [4] It is believed that this fact is not irrelevant to their urging a better understanding of American art and presenting modern American art as a model for the modernization of Korean art.

There were some instances when Korean modern art was introduced overseas in the 1950s. For example, the exhibition *Korean Art-Faculty and Students, Seoul National University* was held at the University of Minnesota in January 1957 as part of a series of exchange art exhibitions led by the University of Minnesota in agreement with Seoul National University. A total of 61 works by Seoul National University professors and students, including Noh Soohyun, Chang Woosoung, Park Deuksoon, and Chang Ucchin toured numerous universities and galleries in the U.S. after this exhibition. Thus, this exhibition was meaningful in presenting a cross-section of modern Korean art to various cities in the U.S., a year earlier than the *Contemporary Korean Painting* exhibit, which was held in New York in 1958. The University of Minnesota's

4 Kim Byungki, *Street Trees*,
1956, Oil on canvas,
125.5×96 cm

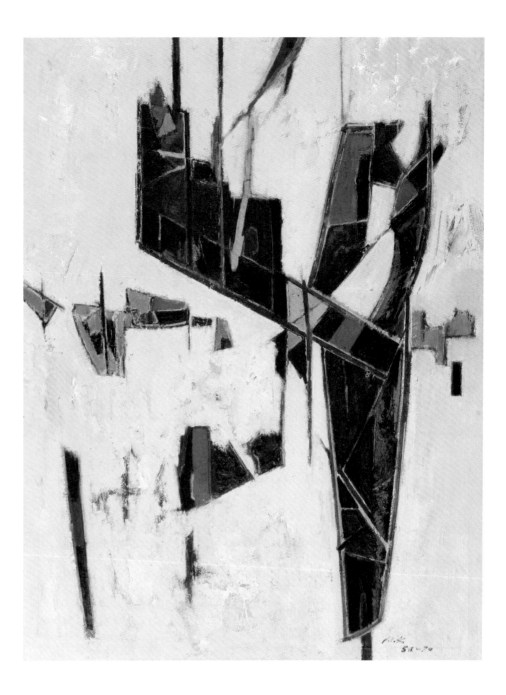

tour of *Korean Art-Faculty and Students, Seoul National University* to several universities and art galleries in the U.S. was part of an effort to raise interest in the U.S. about Korea's war-torn culture. Malcolm M. Willey, the University of Minnesota's Vice President of Academic Administration, wrote in a preface to the exhibition catalogue, "The exhibition demonstrates, however, that distance expressed as miles is really not the significant measure of the closeness of people. In things of the mind and the spirit there can be an identity of feeling and purpose that transcends physical separation. This exhibition of Korean art is proof positive of this, for it symbolizes perfectly the common aspirations, the common ideals, the common love of the beautiful that give men courage and faith, whether in Korea or in Minnesota."[6] This commentary revealed the organizer's willingness to actively meet the political demands U.S. government's cultural and foreign policy, which wanted to unite Korea in a free and democratic regime led by the U.S. Then, in May 1958, *American Art, Faculty & Students, University of Minnesota* was held at Seoul National University's auditorium to respond to the purpose of these exhibition exchanges.

In addition, from February 26 to March 26,

1958, the World House Galleries in New York hosted the exhibition *Contemporary Korean Painting* to introduce Korean contemporary art to the U.S. The exhibition was sponsored by the American Korean Foundation, and a total of sixty-two works by thirty-five artists were exhibited. They were selected by Professor Ellen D. Psaty from the University of Georgia, who had visited Korea for the selection process.

Selected artists included Ko Huidong, Kim Youngki, Kim Kichang, Kim Whanki, Kim Foon, Kim Sou, Nam Kwan, To Sangbong, Moon Hakjin, Pak Nosoo, Park Rehyun, Park Seobo, Park Sookeun, Byun Chongha, Sung Jaehyu, Ryu Kyungchai, Lee Jungseop, Lee Sukwoo, Kim Youngjoo, Kim Byungki, Ham Taejeong, Chung Changsup, Cheon Pyongkun, and Choi Youngrim. This selection made across generations was somewhat shocking to the Korean art community, which had traditionally valued an artist's experience and career over anything else. The press release for the preview held on February 25, stated that the exhibition was a result of impressive activities by the American Korean Foundation, which had supported Koreans' efforts to revive their own culture, in addition to contributing to the health, education and welfare sectors. The exhibition brochure also stated that it would help in the development of modern Korean art by providing Korean artists with opportunities to sell their works, as tourists at the time were rarely visiting the country. This suggested that the exhibition plan was conceived for a similar ideological purpose to that of the exhibition led by the University of Minnesota.

At the same time, foreign art exhibitions, which were frequently held in the late 1950s in Korea, also played a role in propagating the generation gap within the Korean art world regarding concerns about national and Asian traditions of cultural practice. In the 1950s, the younger generation of artists who had been assigned with the task of modernizing Korean art generally regarded this 'local' tradition as something that need to be resisted and overcome. And while this attitude continued into the 1960s, the older generation gradually began to see tradition as a positive force. For example, in an article titled "The Future of Koreanness: The Harmony of Tradition and Modernity" (Hangukjeogin geosui mirae: Jeontonggwa hyeondaeseongui johwa), published in the early 1960s, Kim Byungki argued that in Korea, East Asian qualities like "simplicity, purity, elegance, humbleness, and silence" were derived from Korea's natural environment, so the country had been able to maintain the idea of the nature of the East more purely than any other country in the region. Based on this conception, he presented an optimistic outlook that Korean art, which retained

the purest state of "Eastern quality," had the potential to contribute to the development of global art at a time when abstract expressionist painting characterized by "infinite space" and "non-geometric brushstrokes" was coming to increasingly greater critical prominence. Lee Hangsung's work at the fifth International Biennial of Contemporary Color Lithography, hosted by the Cincinnati Art Museum in Ohio in 1958, won a prize, and garnered praise for combining such Eastern traditions and Western styles. The painter Lee Ungno was also praised for the originality of his work, through solo exhibitions in Germany and France. News of such cases is also likely to have influenced the Korean art world's change in its attitude toward tradition.[7] This reconsideration of the possible value of national traditional culture spread further in the 1960s as international exchanges became more frequent, enabling people to view Korean art in terms of a relationship with Western art.

THE ARTISTS WHO EXPANDED THE GLOBAL REACH OF KOREAN MODERN ART

Korean artists who were active in foreign countries and began international exchange exhibitions—which started in the late 1950s—were one of the factors that led the younger generation of artists in Korea to actively adopt the styles of Art Informel and Abstract Expressionism. As a result, young artist groups such as the Hyundae Fine Artists Association, the 1960s Artists Association, the Wall Art Group (Byeokdongin), and Mook Lim-Hoe emerged as influential within the mainstream art world, leading to something of an oversaturation of gestural abstract artists practicing in Korean painting.

In the 1960s, individual artists continued to live and practice in foreign countries. In particular, the overseas travel reward program was implemented as a privilege for National Art Exhibition Presidential Award winners in 1962. This further increased the number of Korean artists entering the overseas art world. Well-known examples of artists who went to France include: Byun Chongha in 1960; Moon Shin $\overline{5}$, Park Seobo, Bang Hai Ja, Kim Guiline, and Han Mook in 1961; Kim Changrak and Seok Ranhui in 1963; Chung Sanghwa in 1967; and Kim Tschang-Yeul and Chun Kyungja in 1969. While those who entered the U.S. included: Kim Foon in 1960; Kim Whanki, Kim Kichang, and Park Rehyun in 1964; Kim Byungki and Kim Bongki in 1965; Kim Tschang-Yeul $\overline{6}$ and Park Chongbae in 1966; Youn Myeungro and Park Kiloung 1969. Overall, in the 1960s, the major overseas regional interest for Korean artists shifted from France to the U.S. due in part to the increased support from U.S. private foundations for Koreans to study in the U.S. and

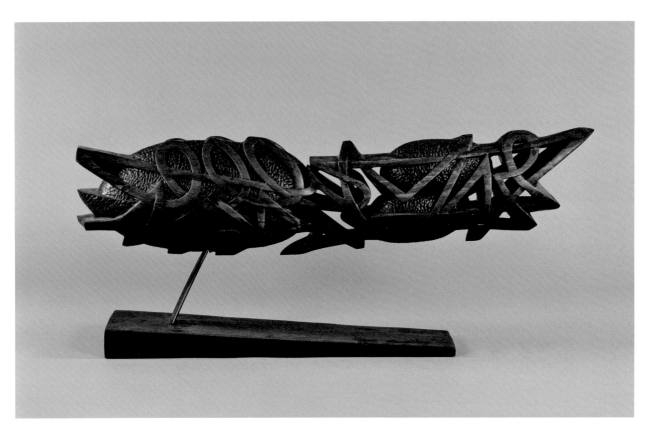

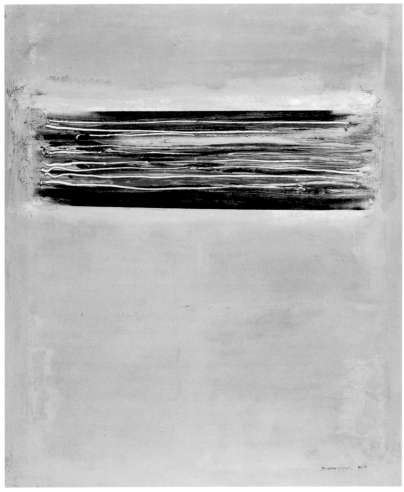

5 Moon Shin, *An Ant*, late 1960s,
Ebony, 130×30×50 cm

6 Kim Tschang-Yeul, *Rite*, 1966,
Oil on canvas, 162×137 cm

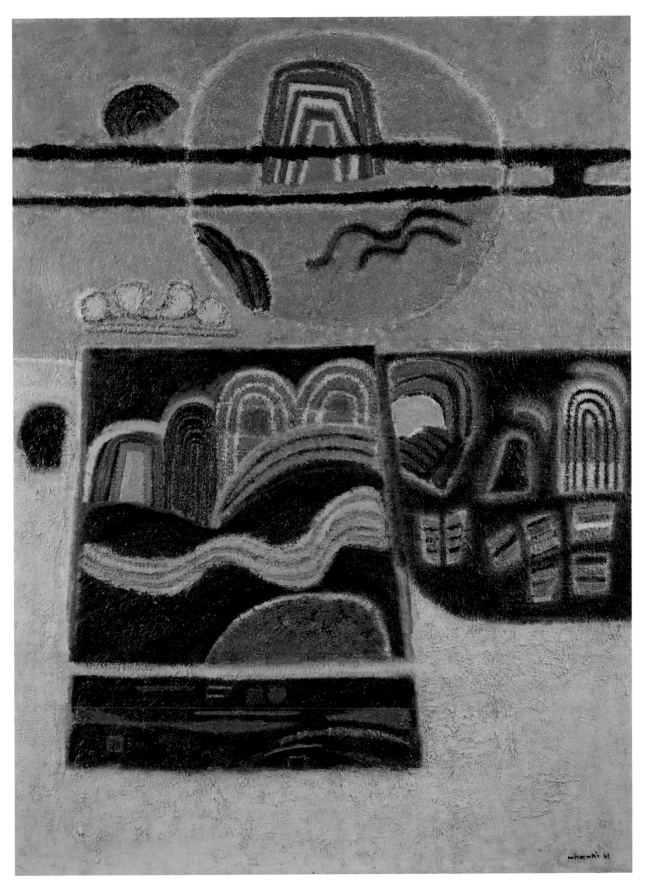

7 Kim Whanki, *Moonlight in Summer*, 1961,
Oil on canvas, 194×145.5 cm

THE DEVELOPMENT OF KOREAN MODERN ART AND INTERNATIONAL
EXCHANGE

8 Nam Kwan, *The Ruins in the Light of Sun*, 1965,
Oil on canvas, 160×130 cm

visit the American art world.

In the 1960s, the Korean art community broke away from how international exchanges were made through exhibitions planned mainly by the U.S. to be introduced in Korea. Instead, Korean art circles began to take the initiative in introducing Korean art to Europe, the U.S., and Asia. For example, Park Seobo participated in the Young Painters of the World competition, sponsored by UNESCO and hosted by the International Association of Arts' National Committee of France. Park then arranged for the participation of Korean painters in the second Paris Biennale, enabling Kim Tschang-Yeul, Chang Seongsoun, Chung Changsup, and Cho Yongik to present their entries. In 1962, the Ministry of Culture & Education (now Ministry of Education) started to provide its policy-level support for raising Korean artists' morale and promoting Korean art internationally. As a result, Chung Changsup's *Questioning (G)* won a bronze medal in the First Saigon International Biennale, which was held in Saigon, Vietnam. In 1963, Korean artists first participated in the seventh São Paulo Art Biennial and Kim Whanki won the honorary award. [7] The international status of Korean art was gradually enhanced, for example, with Lee Ungno winning the honorary award at the Eighth São Paulo Art Biennial in 1965, and Nam Kwan winning the first prize at the Sixth Biennial of Painting, Menton in 1966. [8]

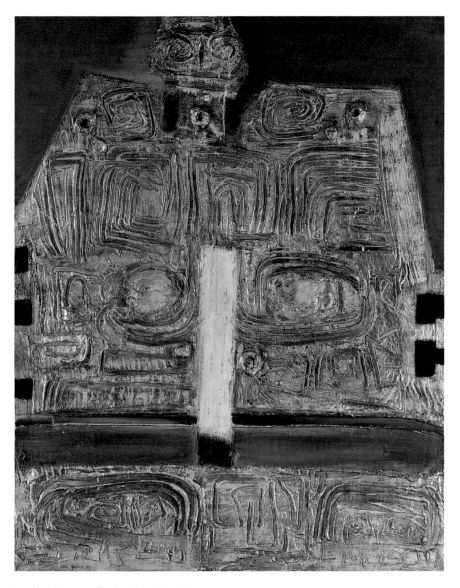

9 Youn Myeungro, *Painting M10-1963*, 1963,
Mixed media on canvas, 162×130 cm

In the 1960s, when the Korean art world was overcoming its developmental impasse of the 1950s, the aggressive activities of the CCF, established in the 1960s to carry out American cultural propaganda programs, cannot be ignored. The activities of the CCF, were carried out through its Korean headquarters at the Choon Choo Fine Arts Association which had been launched on April 11, 1961. The Choon Choo Fine Arts Association held friendly discussions on Asian tradition and religion, and supported research on the relevance of modernization and tradition as an alternative to attract Asian intellectuals who considered the Soviet Union as a role model. The association hosted seminars on issues such as economic growth,

the future of democracy and the relationship between tradition and modernization by gathering intellectuals from various fields of Korean society. In particular, seminars were held under themes such as "Eastern and Western Art," "Revolution and Artistic Freedom," "The Directions of Modern Art and Korean Art," "The Reality of Korean Art," and "The Development of Korean Art," all designed to awaken the importance of freedom of expression and the tradition of national culture. In addition, the Choon Choo Fine Arts Association held a contemporary art exhibition every year from 1962 to 1966 to provide Korean artists with opportunity to show their works. International art exchanges were also a major project of the CCF. In 1963,

THE DEVELOPMENT OF KOREAN MODERN ART AND INTERNATIONAL EXCHANGE

Young Korean Artists (Les Jeunes Peintres Coréens) was held at Galerie Lambert in Paris, France, and this was sponsored by the CCF. In the spring of 1969, *11 Korean Young Artists* was held at Solidaridad Gallery in Manila, Philippines, and Kim Kulim, Kim Tchahsup, Park Seobo, Suh Seungwon, Youn Myeungro, Chun Sungwoo, Chung Chanseung, Cho Yongik, Ha Indoo, and Ha Chonghyun participated in it. Also in 1969, Park Seobo, Youn Myeungro, Kim Tchahsup, Suh Seungwon, Lee Ufan, and Kwak Duckjun participated in the International Young Artists Exhibition hosted by the Japan Culture Forum. This event was again suggested by and carried out under the auspices of the CCF, which sought to promote anti-communist awareness through encouraging solidarity among young artists from all over Asia.

However, in the 1960s, as Korean artists took the lead in participating in various international art exhibitions, including the Paris Biennale and the São Paulo Art Biennial, subtle changes began to emerge in Korean artists' views about Western art. For example, in his article about participation in the third Paris Biennale, Lee Yil insisted that the young artists turn to abstract art was very natural because the spirit of abstract art had been long latent in Korean culture, and that the reason why Korean art was different from Western art lay in this very point. In doing so, he cited almost ancestral ideas of national tradition, and offered that the foundation of abstraction lay within Korea's traditional formative awareness.[8][9] Following this argument, a general perspective emerged that over time the type of self-consciousness about tradition that young Korean artists could come to realize in the West would helped them in developing their own original artistic practice, and return their gaze back to their own culture. Furthermore, the resumption of regular cultural and social exchange with Japan following a diplomatic thawing in relations in the 1960s provided an opportunity to highlight a common interest in the East Asian worldview held by both nations, in resistance to the notions of Western culture that dominated modernist discourse.

One particularly noteworthy development in relation to the resumption of cultural exchange with Japan was the creation of the Federation of Artistic & Cultural Organization of Korea (FACO). This was founded in January 1962 and planned to establish its Tokyo branch in 1963. Chairman Yoon Bongchun and public relations chairman Cho Taekwon visited Japan in 1963 and the establishment of this FACO Tokyo branch was pursued in order to build "normal cultural exchanges between Korea and Japan as well as cultural policies related to Korean residents in Japan and relations between the two countries."[9] It was conducted as part of behind-the-scenes work to normalize cultural exchanges with Korea and Japan in preparation for the 1965 normalization of diplomatic and economic relations between the two countries. FACO's branch in Japan has earned attention in relation to Korea-Japan art exchanges of the period because the head of the Tokyo branch was Quac Insik, a Korean artist residing in Japan. Quac was an artist who had clearly established himself in the Japanese art world throughout his career: He participated in the first Coalition Exhibition held at Muramatsu Gallery, *Tokyo in 1961*; the eighth Japan International Art Exhibition (Tokyo Biennale) at the Tokyo Metropolitan Art Museum, which was jointly organized by the *Mainichi Shimbun* newspaper and the Japan International Art Promotion Association in 1965; and *5 Contemporary Artists* which was held at Gallery Shinjuku in 1967. After the Treaty on Basic Relations between Japan and the Republic of Korea was signed in 1965, Korea's diplomatic relations with Japan were normalized. From that point, Korean artists had frequent exhibitions in Japan, suggesting the possibility that one of the FACO Tokyo branch's major interests was in art. Those exhibitions included the eighth Japan International Art Exhibition, where Quac Insik, Yun Hyojoong, Choi Kiwon, Park Hangsup, Kwon Youngwoo, Ryu Kyungchai, Choi Youngrim, and Pak Nosoo presented their work; solo exhibitions by Kwon Okyon, Chun Kyungja, Pak Nosoo, and Kim Seyong at different galleries in Japan; and the *Paek Yang Fine Art Exhibition* which was held to celebrate the opening of the Public Information Office of Korea inside the New Japan Hotel.

However, it was the fifth International Biennial Exhibition of Prints in Tokyo, with the participation of Kim Chonghak, Yoo Kangyul, and Youn Myeungro in 1966, which fully opened the door for the resumption of Korea-Japan art exchanges in the post war period. At this biennial, Kim Chonghak was selected for an honorable mention with his work titled *History*.[10] Unlike the contrasting method of woodblock print used in the past, his work was evaluated as one that demonstrated the modern possibilities of the medium through a harmonic use of delicate symbolic shapes in various colors and with margins. In 1969, Chung Changsup, Park Seobo, Kwak Duckjun, Suh Seungwon, and Youn Myeungro participated in the International Young Artists Exhibition held at Seibu Museum of Art in Tokyo and further expanded the scope of the new Korea-Japan art exchange. The event that provided the major critical turning point in the context of creative intercourse between Korea and Japan was the exhibition *Contemporary Korean Painting*, which was held at the National Museum of Modern Art, Tokyo as part of a wider raft of Korea-

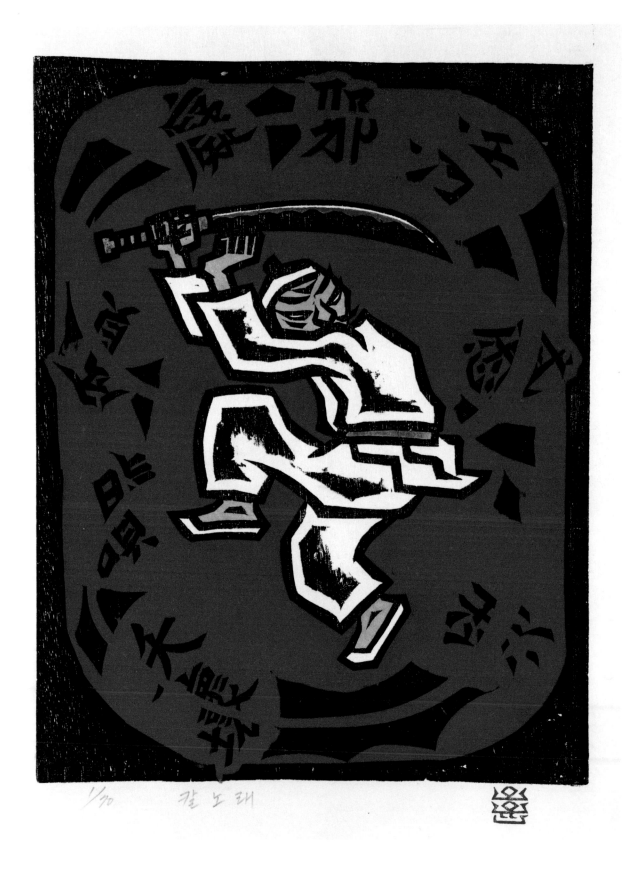

1/70 칼 노 래

10 Oh Yoon, *The Song of Sword*, 1985,
Woodblock print, 30×25 cm

THE EXPANSION OF CONTEMPORARY KOREAN PRINTMAKING IN THE
POSTWAR PERIOD

Japan is geographically close to Korea doubtless played a part in this decision, but domestic artists' interaction with Korean artists in Japan—such as Lee Ufan and Kwak Duckjun (and perhaps Quac Insik, too) who established the aesthetic foundation of Japan's Mono-ha movement—may have also played a role to some extent. The connection forged through printmaking may have contributed to developing the relationship between Japan's Mono-ha and Korea's Dansaekhwa that would have lasting impacts on both parties involved.[13]

In later years, printmaking advanced as part of the larger field of contemporary art—either as its sub-field or one of many modes of expression style—but it also gained in the 1980s a notable momentum relative to the minjung woodblock print movement. ⎯10⎯ While there exist many definitions of 'art,' art is essentially a technology of communication. And when it comes to communication, few mediums or genres are more appropriate and effective than printmaking. Given the minjung woodblock print movement's advocacy of art's engagement with reality,[14] in this respect it is understandable that the revival of the woodblock printmaking movement occurred in the 1980s. In addition, if printed materials are considered as prints in the broadest sense—although the conceptual distinction between art prints and prints for communication should be made—printmaking is not unrelated to media art, at its most broadly defined, and it can similarly employ the tactics of collage by incorporating a range of mass media. As such, the minjung woodblock print movement and media art compose the two pillars on which the influential concern with realist art in Korea was established upon in the 1980s. The crucial role played by printmaking here cannot be understated. To this extent, we may also consider the 1970s, the arguably heyday of contemporary printmaking in Korea, as the moment when Korean artists first started taking their artworks to other countries to show in collective transnational group exhibition, and come to conclude that printmaking has been, from the beginning, an important driver of the development of contemporary art in Korea.

1 Youn Myeungro, "Panhwaui gicho gaenyeom" [Basic Concepts of Printmaking], *Space*, May 1975, 29.

2 Here, contemporary printmaking is an idiomatic expression like contemporary art. Both contemporary printmaking and contemporary art are closely related to the concept of contemporaneity. Therefore, separate discussions about the concept of contemporaneity are required in order to obtain its objective definition.

3 What is interesting about the illustration of *Sakyamuni's Teaching on Parental Love* (1796) is that the original drawing was created by Kim Hongdo during the reign of King Jeongjo (1752–1800). The illustration from Yongjusa Temple has both a Korean edition and a Chinese character edition, just like the sutra, and its template and original drawing have been handed down through the years. Along with *Illustrated Stories Exemplifying the Five Confucian Virtues* (Oryunhaengsildo, 1797 edition), in which an original drawing was also created by Kim Hongdo, this print shows aspects of "true view" landscapes, which can be compared to Jeongseon's style in painting.

4 For example, there was ornamental paper on which Kim Kyujin depicted orchids using lithography in 1905.

5 For example, Lee Sangchoon's illustration *Nitrogenous Fertilizer Factory* produced in the woodblock printing technique for the *Chosun Ilbo* newspaper in 1932.

6 In addition, a bookplate that is attached to the inside of the book cover to identify its owner can be classified as a print in daily life. On the other hand, if those prints also involve certain aesthetic or individual expressions in the production process, the distinction between prints in daily life and art prints tends to be practicable.

7 The primitive method here refers to printing, but strictly speaking, there is no difference in the process between printing and printmaking. However, it is possible to distinguish printing from printmaking in terms of intended commercial use through mass reproduction from the case of producing a work while being conscious of its status as an artwork from the beginning.

8 When Choi Youngrim was studying at the Pacific Art School in Japan, he learned printmaking under Shikō Munakata, who won the grand prize for his print at the Venice Biennale in 1956. Choi exemplified idyllic rural landscapes with a boy piper and a naked woman as subjects. With works following this manner, he received awards at the *Exhibition of Japan Print Association* in 1934 and 1940.

9 He held Korea's first solo exhibition of woodblock prints in 1958.

10 The Art Informel practice of artists such as Tàpies and Pierre Soulages are known to have had a significant influence on Korean artists for some time, as in the early 1960s. This is a different aspect from the relationship between Japan's Mono-ha and Korea's Dansaekhwa.

11 Kang Aeran presented a three-dimensional print work by life-casting cloth bundle (*bottari*).

12 Mezzotint is the most traditional printmaking technique, and is excellent for a realistic, precise description, so it had been widely used for producing portraits before photography emerged. In contemporary printmaking, it is mainly used for presenting a meditative atmosphere or a static, contemplative depth. The reality is that there is not a large group of artists who use the technique in Korea because of its labor-intensive process.

13 The two painting styles probably share the artists' attitude to abandon (or present) a phenomenon so that it reveals itself and to minimize artificial intervention as much as possible in the process. In that sense, it is also in line with the philosophy of Korean Seon Buddhism.

14 In terms of advocating art's participation in reality, there

was the Korean Proletarian Artist Federation (KAPF) movement in the 1920s and 1930s, earlier than Minjung art of the 1980s. Printmaking is known to have played a role as a major medium for practicing and promoting propaganda art in the early twentieth century as well.

THE EXPANSION OF CONTEMPORARY KOREAN PRINTMAKING IN THE POSTWAR PERIOD

The Development of Korean Sculpture from the 1950s to the 1970s

Kim Yisoon

THE HISTORICAL DEVELOPMENT OF KOREA'S SCULPTURE

When the concept of sculpture as a fine art genre was introduced to Korea in the twentieth century, this provided a significant change in the history of Korean art. Up until the nineteenth century, most Korean sculptures were Buddhist statues and stone tablets installed around ancestral tombs and the producers of these artworks were considered craftsmen rather than sculptors. Sculpture first became meaningful as a category of modern art in Korea when Kim Bokjin learned Western sculptural concepts and techniques at the Tokyo School of Fine Arts in Japan. Starting from 1925, he submitted statues of heads or whole bodies that expressed the human figure in a realistic way to the Joseon Art Exhibition, and produced statues.[1] Following his example, about ten Koreans majored in sculpture in Japan during this period, and subsequently the so-called "sculpture community" was formed in Korea.

Immediately after Korea's liberation from Japan in 1945—and as some sculptors went up to North Korea—the South Korean sculpture community became immediately smaller, but soon became revitalized again as sculptors were trained in the colleges of fine arts established after the country's liberation. Seoul National University's College of Fine Arts was established in 1946 and Hongik University's College of Fine Arts was launched in 1949. Sculpture majors from the two schools, such as Kim Chungsook, Youn Young-ja, Kim Se-choong, Jeun Loijin, Song Youngsu, Kim Chanshik, Choi Euisoon, Choi Manlin, and Choi Kiwon became active as sculptors in the mid-1950s. These artists led the Korean sculpture community from the 1950s to the 1970s. They taught the younger generation at universities together with Kim Chongyung, Kim Kyongseung, and Yun Hyojoong, who were some of the older generation of artists active since the colonial period, and had participated in statue and monument-building projects while serving as judges or recommended artists at the National Art Exhibition. Under these circumstances, when Kwon Jinkyu returned to Korea after majoring in sculpture at Musashino Art School in Japan, the sculpture community grew to include even more artists. The number of sculptors was still small compared to that of painters, but they were as influential as the painters and formed an important pillar of contemporary art practice in Korea. Thanks to the fact that the sculpture scene lacked senior sculptors who insisted on academic type styles for government-led exhibitions, it was possible for abstract sculpture featuring certain avant-garde qualities to be immediately accepted as the mainstream form of sculpture at the National Art Exhibition.

The first sculpture organization in Korea, the Won-hyung Club, was not formed until 1963. This was partly because sculpture divisions in government-led exhibitions were not conservative and artists did not feel any urgency to launch oppositional, alternative artist groups. In bold gestural advances during the period, Korean sculptors utilized various new objects and materials like plastics available at the time, while also introducing within their sculptural practice materials such as water, fire, smoke, and wind (which could not be used as materials in the past) as they expanded the realm of sculpture into installation and land art.

To further delimitate the context outlined above, this section will now examine the development of Korean sculpture from the 1950s to the 1970s by dividing the period into figurative sculpture, abstract sculpture, and "trans-sculpture" which overcame the traditional concept of sculpture. In addition, this was the period when

Korea's national identity was being established, and sculptors built many statues and public monuments that the government requisitioned, works that are also relevant to a discussion of the development of postwar Korean sculpture.

FIGURATIVE SCULPTURE: EXPRESSING THE SPIRITUAL WORLD THROUGH THE HUMAN BODY

In the South Korean art world, the term "figuration" (*gusang*) is often used without much distinction from "fact" or "reality" (*sasil*), yet "figurative sculpture" (*gusang jogak*) is clearly different from "realist sculpture" (*sasil jogak*). The term "realist sculpture," considered to objectively depict visible objects, reflects the general representational tendency of early twentieth-century sculpture. By contrast, an interest in "figurative sculpture" emerged in the postwar period and subjective expressiveness was more important to artists than objective reality. In other words, "figuration" refers to a range of new expressions that went beyond the poles of academic realistic description or abstraction and sought to express the violence of war and human brutality in the postwar period. This interest in "figurative sculpture" was a concern that emerged after the Korean War. Aspects of such sculpture in Korea can be found in work from the 1950s by Kim Kyongseung and Yun Hyojoong, the sculptures of the human body created by Oh Jong-uk and Choi Manlin in the 1950s and 1960s, and Kwon Jinkyu's works in the 1960s and 1970s.[2]

After the Korean War, Kim Kyongseung and Yun Hyojoong who had studied the creation of realist human body sculpture at the Tokyo School of Fine Arts in the colonial period and showcased their works through the Joseon Art Exhibition were leading sculptors. In their work, there was a tendency to distort or transform the objects depicted. For example, Kim Kyongseung's 1950s and 1960s nude statues displayed simplified or transformed shapes instead of offering a straightforward realistic rendering of the human body, and many of these works were nude statues based on a slanted, lying position of the figure in their composition. Kim Kyongseung mentioned that he produced nude statues to express "freedom and justice."[3] The resemblance of these nude statues to Venus-like goddesses from Western art history is undeniable; so is the implication of eroticism. These female images are in contrast with the war heroes he captured in public monuments or other sculptures for political or didactic purposes.

In the 1950s, Yun Hyojoong more actively pursued a new type of sculpture. He replicated the form of statues publicly made during the Japanese colonial era, in new works such as *Statue of Horace*

G. Underwood and *Statue of Choe Songseoldang* (1950). He made a Rhee Syngman statue and also produced a 'pure' art sculpture titled *Gabo* in 1954. *Gabo*, which has been lost, and is only recorded within a black-and-white photograph, was apparently a statue depicting a person riding a horse. The rider was relatively small for the horse and the horse's legs were made longer and thinner for its body. This indicated that the artist deviated from the realistic expression seen in his 1942 work, *Wise*. What made Yun Hyojoong explore new expressions was probably his attendance at the International Conference of Artists held in Venice in July 1952, where he met with several figurative sculptors, including then world-renowned sculptor Marino Marini as well as Emilio Greco and Pericle Fazzini. In *Gabo*, the rider's posture is reminiscent of a mounted archer depicted in a Goguryeo hunting scene mural from the fifth century A.D., but the expression of the horse's legs shows the formative characteristics of Marino Marini's *Cavallo e Cavaliere* (1951). After that, Yun Hyojoong sought to create figurative sculptures that combined traditional Korean elements, but it is difficult to say if he developed such works through his own original formative language.

Figurative sculpture began to develop in earnest through a generation of artists who were educated after liberation. In particular, artists such as Choi Manlin and Oh Jong-uk, who had experienced war at a young age, produced sculptures of distorted human bodies from the late 1950s to early 1960s. Choi Manlin's *Eve 58-1* (1958) not only has a small face and thin (or weak) limbs compared to her body, evoking a sense of instability, but also has thorn branches, not flowers, in her hands, indicating a completely different context from traditional female nude statues that tried to express human beauty. **1** The title "Eve" can be seen as a symbol of original sin in a Western context, but in on a more comprehensive sense, the work could be taken to represent humanity itself.

In the West, unstable proportions and distorted figures of the human body are a type of expression that became particularly prevalent in post-World War II society and can be considered as reflecting the pain inherent in the consciousness of the post-war generation. Oh Jong-uk's 1960 work *The Heretic* can be seen in the same context. *The Heretic* also arouses a sense of anxiety because the figure's limbs are expressed as much thinner than is to be expected considering the body size. In addition, the body is disfigured, and the skin is expressed roughly, making it almost painful to look at. Oh Jong-uk suffered from the trauma of war all his life after he fought in the Korean War at an early age and witnessed many deaths, and in his work he often depicted 'out-of-the ordinary' human figures.

His 1960 work, *Perjurer No. 2*, which is housed at the MMCA, is in the same context. 2 As part of the surface is smooth, it appears to be a bronze casting work at first glance, but it is actually a welded steel sculpture made to form a human figure by welding thick wire pieces together. Right after the Korean War, when these artists suffered from a lack of so many materials, young sculptors produced sculptures using waste steel, and these were welded steel sculptures called cheoljo in Korean. Many of those who pursued abstract sculpture after the war pursued welded steel sculpture. Among them, Oh

Jong-uk produced expressive, figurative sculptures by highlighting the rough texture of steel. *Perjurer No. 2* can be called "torso," in which the head and legs are not expressed. In its expressive method, it is in contrast to the elegant appearance of the 1962 wood sculpture *Torso* by his contemporary Kim Chungsook. 3 Cruelty and violence are felt in the posture, as if the person were stopped while taking an oath with her raised hand because her head was cut off. The violence of the image reinforced by the bony fingers, asymmetrically sunken breasts, and irregular skin of the torso. Choi Manlin and Oh

Jong-uk did not adhere to just making figurative sculpture, but freely crossed between abstract and figurative art, expressing the frustration and existential consciousness that prevailed after the Korean War, especially through distorted human figures. Beginning in the mid-1960s, Choi Manlin and Oh Jong-uk immersed themselves in abstract sculpture, which allowed them a freer range of expression than figuration.

An artist who consistently pursued figurative sculpture in the 1960s and 1970s was Kwon Jinkyu. He studied sculpture at Musashino Art School in Japan and returned to Korea in 1959. At the time, there was a growing awareness in the Korean art world that abstraction was avant-garde and modern. After learning sculpture from Takashi Shimizu, who had learned from Antoine

3 Kim Chungsook, *Torso*, 1962, Wood, 97.8×32×24 cm

Bourdelle and led Musashino Art School, Kwon Jinkyu delved into figurative sculpture upon his return to Korea. He himself mentioned that he wanted to pursue Korean "realism," but his art can be classified as figurative sculpture rather than realistic sculpture. Kwon sculpted many terracotta female figures, including Bust "Z" (1967), with real models in the 1960s, but the works consistently showed frontal views without any implication of movements, creating a feeling of contemplation. 4 This is a unique quality of Kwon Jinkyu—one which is completely different from many other artists' ordinary portrait sculptures—and instead embodies the artist's notion of the spiritual world. In the second half of his career, Kwon developed the traditional "dry lacquer technique" to better express this inner world. For example, in his 1970 work *Christ on the Cross*. The image of Christ was expressed in a primitive art style of the Romanesque period but with an application of the dry lacquer technique, one of the methods used to produce Buddhist statues in East Asia. Taking advantage of the dry lacquer technique, he made the statue of the crucified Christ without support so that it could be hung on a wall. The distorted face, the expression of stretched arms, and the rough gray skin texture reflect ideas of antiquity and eternity, almost making it look like as if the figure could exist forever. In his later years, Kwon Jinkyu produced several female portraits produced in the dry lacquer technique. Instead of producing original molds, Kwon reused plaster molds from earlier terracotta sculptures of female figures.[4] Portraits such as *May Queen, Gyeongja (Bust Choi)*, and *Suna* are interesting examples through which to compare his terracotta works and dry lacquered works. In the dry lacquered works created in his late years, there is not the gracefulness or elegance found in the terracotta works. For the most part the solid structure of the torso disappears, and the skin is treated very roughly, making these works reminiscent of ancient mummified figures at first glance. This reflects the psychological state of the artist at the time, as he hopelessly focused on the existential certainty of death.

After Kwon Jinkyu passed away the human figure ceased to be a major focus in Korean sculpture during the 1970s. The incorporation of everyday objects in contemporary art-making emerged as a forceful tendency early in the decade with a variety of experimental works in performance and installation. In contrast to this new tendency rooted in the everyday reality of Korea at the time, "figurative sculpture" was seen as merely pursuing lyrical atmosphere and aestheticism detached from the specificities of time and space. However, the situation changed in the late 1970s. Voices against abstract art and

4 Kwon Jinkyu, *Bust "Z"*, 1967,
Terra-cotta, 50×32×23 cm

THE DEVELOPMENT OF KOREAN SCULPTURE FROM THE 1950S TO THE 1970S

6 Kim Chongyung, *Work 70-3*,
1970, Marble, 22×19×7 cm

 THE TRADITION/MODERNITY DYNAMIC IN THE MODERNIZATION ERA

experimental conceptual art emerged in earnest. The desire for return to figurative realism became palpable in the art world, and was reflected in the newly devised terms such as "new figuration" (*sin gusang*) and "figurative form" (*hyeongsang*). Such a shift became critically overt in 1978 when the first Dong-A Art Festival, hosted by the *Dong-A Ilbo* newspaper, set its operational direction under the main theme of "The Figurative Form." There was also a discussion between critics (Yu Jun-sang, Lee Gu-yeol, Lee Yil, Oh Kwang-su). Held in 1978, these intellectuals argued for making a distinction between the newly formulated term "figurative form" and the earlier term "figuration." They considered that the idea of "figurative form" was not just in reference to the reproduction of forms that exist in nature but rather an expression of "the artist's inner images."[5] Thus, a new generation of sculptors started to produce works of "figurative form," which were considered different from mere "figuration." That is, they were designed as sculptures of the human body that expressively embodied questions of human existence and the zeitgeist of the time, rather than as mere aestheticized depictions of the human body. While it was only from the 1980s that this idea "figurative form" began to become critically prevalent, and influence the production of such works in substantive quantity, this new idea of "figurative form" already existed in Kim Youngwon's human body sculptures produced in the late 1970s.

Kim Youngwon's *Gravity Nongravity* (1978) shows a young man hanging from a horizontal bar. [5] Male nude figures were rarely depicted in Korean sculpture, even in the postwar period, and Kim Youngwon's youthful nude was influenced by depictions of the idealized human body such as the kuros statuary of ancient Greece. However, it is not a figure standing proudly, but rather hanging from a horizontal bar with his head down and his body drooping and floating in the air. This person depicted could be described as one who has an elegant, ideal figure, and is yet lethargic. Here, the representation of the human body, which looks perfect with its smooth surface, is reminiscent of a mechanized human, devoid of mind and soul, a representation that perhaps implies a metaphorical, critical view of modern human existence. This sense of alienation, conflict, futility, and an existential consciousness can also be found in Ryu In's sculptures of the human body, created in the late 1980s. In the 1990s, there began a trend of formative sculpture by artists including Ku Bonju, who was known for more actively expressing ideas of social anxiety, alienation, and political conflict through his human body sculpture.[6]

ABSTRACT SCULPTURE: THE EMERGENCE OF NEW MATERIALS AND PLASTIC LANGUAGE AFTER THE WAR

In the conventional understanding of the history of Korean sculpture, abstract sculpture first appeared in the entries to the 1953 National Art Exhibition held right after the Korean War. Although it is difficult to officially confirm the facts (because no exhibition catalogue was published at that time), it is known that Kim Chongyung submitted a bat-shaped work in wood titled *Bird* (early 1950s) to the National Art Exhibition as a judge, and Kim's pupil Jang Gieun submitted an abstract work called *Contemplation*, a painted plaster piece. As such, abstract sculpture in Korea did not begin relative to the teaching of such in higher education, but was the result of artists exploring new directions by gathering information about Western trends right after the Korean War. Jang Gieun is said to have also created abstract inspired by images of Western works, seen in photographs from magazines, and Kim Chongyung began to produce abstract works as he was directly exposed to the Western art world through his travels.

Kim Chongyung, in particular, came to understand that abstraction was a substantive international trend when he participated in The Unknown Political Prisoner, an international sculpture competition in 1953. However, he was not merely following international trends. The following text he wrote in the 1950s tells us what he considered to be unique about abstract sculpture:

> From an earlier time, I have been very skeptical about the motifs of sculptures that are mainly limited to the human body. I have believed that art should be able to freely express our experiences in everyday life. After a long time of exploring and wandering, I became interested in abstract art, and many of my problems seemed to be solved to some degree. My interest in and understanding of things grew, and the issue of harmonizing regional specificity and global universality— which is very difficult to realize—seemed to have some possibilities [in abstraction, rather than figuration].[7]

Kim Chongyung studied realism based on academicist human body sculpture as he had no other choices at the Tokyo School of Fine Arts. Later, however, he came to focus on abstract sculpture. It is difficult to say that the reason was simply his desire to catch up with international trends or to his hope to become recognized as an avant-garde artist. Because he decided that realistic human sculpture could neither fit his creative interests, nor could it capture the spiritual world that he was pursuing in his practice, he sustained

his investment in abstract sculpture until his death. Kim Chongyung's sculptures are often discussed relative to the expression "the beauty of non-sculpting." In this regard, *Work 70-3* (1970), is a well-known piece by Kim that illustrates this phrase, offering a work of an abstraction that avoided excessive decorative and artificial elements. **6**

Kim Chungsook, who learned sculpture from Yun Hyojoong after 1945, also pursued abstract sculpture all her life. Although she started studying sculpture at a relatively late age, she was the first Korean to study sculpture in the U.S. through an arrangement with the American-Korean Foundation in 1955. In 1957, she became a professor at Hongik University and taught abstract sculpture, thereby playing a leading role in spreading abstract sculptural practice in Korea. In particular, she greatly contributed to the spread of welded sculpture in the 1960s by teaching Korean students about the welded sculpture techniques she had learned herself in the U.S. However, in her own practice Kim Chungsook preferred a reductive method of abstraction that simplified forms by cutting stones and wood rather than irregular and improvised pieces of welded sculpture. As seen in *Kiss* (1957), *Reclining Woman* (1959), and *Torso* (1962), she produced reductive abstract sculptures by simplifying the human body and focusing on its reductive essence in the 1950s and 1960s. Then, in the 1970s, Kim chose natural or cosmic subject matter, and created forms such as *Sun, Moon and Star* (1974), *Mountain and River* (1976), and *Half Moon* (late 1970s). In the example of *Half Moon*, made with obsidian, the flow of atypical lines and surface texture of the half-moon shapes are highlighted. In the 1980s and 1990s, such as in her *Flying Form* series, Kim continued to create abstract forms inspired by avian imagery. However, much earlier in her career, she first took an interest in the form of bird wings in the work *Flying Form*, which was submitted to the 1968 National Art Exhibition, and in 1971's subsequent work *Flying Form* she developed her formal technique by further simplifying bird wings. As a result, by the 1980s and 1990s, she was able to complete refined, purely abstract sculpture based on incredibly simple and symmetrical formal ideas.

On the other hand, many of the post-war generation of sculptors produced abstract sculptures featuring irregular and rough textures by welding waste steel or steel objects, sharing an affinity with the aesthetic of Art Informel painting that had emerged in the late 1950s. Welded sculpture was a type of assemblage that was considered as particularly effective for producing abstract sculptures in the postwar era, when Korea suffered from a shortage of many essential materials. Like Kim Chongyung and Kim Chungsook, both of whom were mentioned earlier, they were able to produce abstract works through by wood or stone carving, but most of these young sculptors were more fascinated with steel—which symbolized modernity—rather than traditional materials. Furthermore, improvised expressions were made more possible through the medium of welded steel because artists could more freely attach or detach steel pieces as the composition progressed. Most of all, however, scrap metal was considered a perfect material to express feelings of postwar pain and anxiety. As mentioned earlier, welded steel sculpture was encouraged by Kim Chungsook, who had just returned from her studies in the U.S. The technique became so popular that most sculptors from art colleges in the 1960s produced abstract sculptures using metal welding techniques.

One particularly celebrated sculptor who adopted the welding technique was Song Youngsu. In 1957, when most young Korean sculptors produced human body sculptures using plaster, Song Youngsu submitted abstract welded sculptures such as *Dawn and Tree of Absence* to the National Art Exhibition. He continued to create welded sculptures throughout the next several years, and *Horror of Atomic Bomb*, which was submitted to the National Art Exhibition in 1959, is an abstract work that combined an image of a nuclear explosion with a hook-like figure on a nuclear warhead-shaped pedestal. Later, this was also developed into a work that maximized the horror of the situation by removing the explanatory, framing image of a nuclear explosion, and leaving sharp hooks only.[8] **7**

In the 1960s, sculptors rushed to submit welded sculptures to the National Art Exhibition. In his *Crack of Dream*, Choi Byeongsang rolled up iron plates to conjure a group of up-side-down conical shapes whose bottom halves are substantially smaller than the top halve, and thereby dramatically expressed the psychological state of anxiety. **8** In 1965, Park Chongbae's welded sculpture *Circle of History* won the Presidential Prize at the National Art Exhibition. The work, a distorted round shape symbolizing the Earth in which an irregular and rough texture reminiscent of an Art Informel painting dominates, asks questions about the origin or source of history in postwar society. In 1968, Park Suk-won's *Scorched Earth*, another welded steel sculpture, won the first prize at the National Art Exhibition. **9** The work basically takes the form of an oval egg, but presents an image in which the egg has apparently been cut and torn, destroying whatever incipient life was inside. As the title suggests, the traces of desolation or a scorched earth expresses the desperation and misery of war and the futility of a postwar world.

In the Korean art world, the movement of Art Informel gradually became oversaturated with similar, repetitive works, and lost its avant-garde quality in the late 1960s. Geometric

abstract sculpture with neat surfaces emerged as an alternative trend. To the 1970 National Art Exhibition, Lee Sangkap submitted *3:4:5*, consisting of three geometrical cubes all connected, and Lee Woonsik submitted *Traces of a Light-Reflecting Thing*, a geometrical piece made of stainless steel, to the 1972 National Art Exhibition. In addition, Shim Moon-seup submitted *Point 77* to the 1969 National Art Exhibition, and *Relation 77*, an abstract sculpture that connected geometrical cubes to the 1970 National Art Exhibition. **10** New materials more suited to contemporary industrial age, such as stainless steel and acrylic sheets, started to be actively introduced to artworks.

Yet, in the 1970s, sculptures created in expressive solid materials—such as bronze, granite, and wood—became popular, especially among members of the Esprit group, who included Chun Kook-kwang, Noh Jaeseung, and Kim Kwangwoo. Chun Kook-kwang's *Accumulation-Variation V* (1978) renders a solid wood with the lifelike quality of an internal energy. **11** Noh Jaeseung, transformed a piece of granite into a flowing, liquid composition in *Leak of Power* (1977), while Kim Kwangwoo also embodied the notion of natural energy through his work *Nature + Human + Chance* (1976). These works could arguably be classified as hyper-realistic in that they accurately depicted and truthfully featured the surfaces of the materials used, but they can also be called abstract sculpture or "non-figurative" sculpture in a broad sense because they tried to depict invisible elements inherent in nature, such as energy, not visible objects visible in the natural world.

8 Choi Byeongsang, *Crack of Dream*, 1963, Steel, 130×80×110 cm

9 Park Suk-won, *Scorched Earth*, 1968, Steel, welding, 112×133×30 cm

THE TRADITION/MODERNITY DYNAMIC IN THE MODERNIZATION ERA

THE EXPANSION OF THE TRADITIONAL CONCEPT OF SCULPTURE: FROM EVERYDAY OBJECTS TO OUTDOOR INSTALLATIONS

Contemporary sculptors actively adopted non-traditional sculptural materials and abandoned traditional sculptural materials such as stone, wood, or bronze. As a result, the idea that sculptures are based on solid pieces of matter, or the creation of objects that seem to naturally occupy space according to the law of gravity was no longer valid. Furthermore, everyday objects and videos were introduced into works, and fluid materials such as water, fire, and smoke were used as the main medium of expression for works. As such, many things that could not be considered as suitable materials for sculpture relative to the traditional concept of the art form were newly introduced, so the realm of sculptural possibility was vastly expanded. Consequently, as the boundaries between genres were blurred, the term "artist" came to be used more frequently than "painter" or "sculptor."[9]

Lee Seung-taek was an artist who broke away from the mainstream and sought to create "non-sculpture." Lee, a graduate of Hongik University's Sculpture Department, called himself a "maverick" and strived to challenge established conceptual approaches all his life. *History and Time*, which he submitted to his college graduate exhibition in 1958, is a large chunk of plaster shaped like a crescent painted with red and blue, and then wrapped in barbed wire. **12** At the time, when most college graduate works were representational sculptures of the human body, Lee Seung-taek's activities were unique from the start of his career. From the early 1960s, he tried to create works with elements that had been considered impossible to be incorporated within artworks from a conventional perspective—such as water, fire, wind, and smoke. He continued to ask fundamental questions about sculpture while labelling his works as "non-sculptures," and therefore granting himself the freedom to work

10 Shim Moon-seup, *Relation 77*, 1970,
Stainless steel, 204×100×60 cm

11 Chun Kook-kwang, *Accumulation-Variation V*, 1978,
Color on wood, 183×69×25.5 cm

12 Lee Seung-taek, *History and Time*, 1958, Wire, painted plaster, 153×144×23 cm

13 Park Hyunki, *Untitled*, 1979, Video installation; single-channel video, color, silent; 14 stones, one monitor, 120×260×260 cm

outside the traditional genre of "sculpture."[10] In his 1974 work *Untitled (Burning Canvases Floating on the River)*, he put into practice an idea to use that had dominated his hypothetical conceptual experiments since the 1960s. His interest in fire continued throughout his career, and with *Performance Art of Burning*, which was presented at the Total Museum in Jangheung in 1989, he burned numerous human body-shaped objects, notably including a *Self-Portrait*.[11] One of Lee Seung-taek's most well-known works, the *Wind* series, was created in 1970, when he installed pieces of cloth from a straw rope between buildings at the Korea Contemporary Sculpture Society. This piece was a leading example of the contrarian idea to express the invisible and immaterial phenomenon of wind through visual art. The idea to visualize the wind with the fluttering of cloth or paper was derived from Korea's traditional customs exemplified, for instance, in *seonghwangdang* (a shrine for a village guardian deity) and *pungeoje* (rituals to pray for the safety of fishermen and their successful catch).[12] As Lee mentioned, "It is no exaggeration to say that contemporary art is [based on] experimentation with materials, and my non-sculpture is also an experiment with materials,"[13] Lee Seung-taek resisted the established concept of sculpture by constantly introducing non-sculptural elements, deconstructing them, and continuing to expand the idea of what sculpture really is.

In the 1970s, Korean sculptors conducted a variety of experimental works. At the second Korean Avant Garde Association (AG) group exhibition, *Réaliser et la Réalité*, which was held in December 1971, artists such as Park Suk-won, Shim Moon-seup, Kim Kulim, and Lee Kun-Yong presented installations that spread soil, pieces of wood, canvases, and cloth on the floor of the exhibition venue. Their works were not considered traditional sculptures per se, and it was difficult to explain them through the theoretical concept that sculptures can occupy spaces in a fragmentary fashion. At the *Three-dimensional Exhibition* in 1977, Shim Moon-seup scrubbed the surface of an empty canvas with sandpaper and hung it on the wall, while Park Suk-won laid pieces of granite—with their surfaces roughly trimmed—on the floor. Through such activities these artists deconstructed the boundaries of artistic genres by exploring materiality.

In the 1970s, as Paik Nam June's video art was introduced throughout Korea, and there emerged a series of movements to introduce video media into sculpture. Park Hyunki, who majored in architecture, introduced video to his work *Untitled* in 1979.[14] [13] After piling natural stones, a TV monitor was placed among them, and a video about natural stones was played on the TV monitor. This

work was made in a very modest, simple form, but it is noteworthy that it brought forth moving imagery into Korean sculpture in an era when video media was not yet commonplace, raising issues of reality and virtuality, and reality or fiction. Park Hyunki participated in the fifteenth São Paulo Art Biennial in 1979 and the eleventh Paris Biennale in 1980, and then continued to produce works using videos after that.

In the 1970s, Korean sculptors started to install their works in outdoor places. Members of the Korean Young Artists' Association (Hanguk misul cheongnyeon jagkahoe), such as Kim Kwangwoo, Noh Jaeseung, and Chung Kwanmo, presented installations in outdoor places that included Kkotji Beach on Anmyeondo Island, Chungcheongnam-do and the Gwangneung Forest (where the Korea National Arboretum is located) in 1976. Writing about these outdoor projects, critic Kim Inhwan wrote, "[They are] an announcement and acceptance of humans and materials, humans and nature, humans and the environment, humans and elements, as well as the finite and infinite, moment and eternity, everyday things and unusual things, the body and perception, and traces of action." These artists' works—which revealed the sea and mountains, the sky above the Earth, the sun, the moon, stars, darkness, light, air, water, the horizon, sandy fields, trees, forests, fallen leaves, soil, and land as they were—laid the foundation for future generations to work on outdoor installation projects seen in exhibitions like *Winter*, *Open-Air Art Show at Daesung-ri*, *Baggat Art Exhibition*, and the Geumgang Nature Biennale organized by YATOO.

PUBLIC SCULPTURES: THE EMBODIMENT OF PUBLIC IDEOLOGY

In the modern era, public monuments were built throughout cities in Korea, starting with the construction of King Gojong's fortieth anniversary memorial monument in 1902 on the government building street in front of Gwanghwamun Gate in Seoul. The designs and scales of public monuments such as this were unprecedented in traditional Korean society, and public sculptures before 1945 were mostly established for the purpose of furthering Imperial Japanese colonial ideology.[15] Public sculptures from this period have almost all been torn down now, but the tradition of building statues and other monuments in public spaces continued even after Korea's liberation. In fact, from the 1950s to 1970s, public sculptures with the aim of promoting particular figures or events to the general public were created in a large quantity. On rare occasions, artist-led relief sculptures were also commissioned for the exterior walls of buildings. Sculptures designed for public appreciation, which

14 Kim Se-choong, *Statue of Admiral Yi Sun-shin*, 1968,
Bronze, granite, overall height 17 m (statue 6.5 m) in Gwanghwamun Square

were called "environmental sculptures" or "public sculptures" and notably visible in many parts of Korean cities, are deeply connected to the urbanist concern of the 'Arts Decorations for Buildings' policy (Geon-chungmul misuljangsik jedo), which was instituted in the 1980s. In order to examine the forms taken by public sculpture and statuary over the postwar period, we will briefly examine many statues and public monuments produced in the period from the 1950s to the 1970s.[16]

STATUES

Aside from statues of the Buddhist deities, it was extremely rare to make statues out of bronze, a long-lasting material, in Korean traditional society. Although there a bronze statue of the Goryeo Dynasty's King Taejo remaining today, the concept of making bronze statues of living people were rare in traditional Korean visual and material culture.

In this regard it was only in the early 1900s that the word "statue" first appeared in the mass media. Over the colonial period, the production of statues spread rapidly, and in March 1927, the magazine *Byeolgeongon* even featured an illustration satirizing the popular trend of statue production. During the colonial period, statues were built of not only Koreans but also of Japanese people and Westerners. Most of them were made of founders of schools, except when it came to celebrated Japanese figures. Because most of such statues were dismantled by the Japanese government during World War II to reuse the metal, it is now hard to find any remaining statues produced during the early modern period.[17]

As Korean society gradually regained stability after the establishment of the Korean government in 1948, some statues that had been taken by the Japanese government were reconstructed and new statues were made for memorable people. Well-known examples of reconstruction are the Statue

of Horace G. Underwood at Yonsei University and the Statue of Choe Songseoldang at Gimcheon High School. The Statue of Horace G. Underwood was destroyed again during the Korean War, and the statue currently standing at Yonsei University is a replacement created after the Korean War. The Statue of Choe Songseoldang was rebuilt just before the Korean War broke out in 1950, and fortunately remains intact today. This statue is the oldest life-size statue in Korea and is currently designated as a government-registered cultural property.

After the Korean War public statuary began to be created in earnest. Statues of school founders such as the Eom Gyeik Statue (1956), the Statue of Kim Seong-su, (the founder of Korea University, 1959), the statue of Yim Young-shin, 1959), continued to be built. And there were also controversial statues such as the Rhee Syngman's statue, 1955).[18] However, most of statues erected after the Korean War were war heroes—people who historically defeated foreign invasion and contributed to overcoming national crises—and figures related to the Korean War. The Douglas MacArthur statue (1957) at Freedom Park, the statue of James Van Fleet, the commander of the Eighth United States Army (1959), and the Lieutenant General John B. Coulter statue (1959) are well-known cases. Right after the Korean War, it was not usually Koreans but representatives of the United Nations military force who were selected as war heroes deserving of statuary. In terms of Korean figures suitable for statues after the Korean War, these were mainly historical figures who had contributed to overcoming earlier national crises rather than people who were directly related to the Korean War. Admiral Yi Sunsin was the most favored figure, and his statues were built in areas including Chungmu and Jinhae, even during the Korean War. The *Statue of Admiral Yi Sun-shin*, which is currently in Bukwon Rotary, Jinhae, was built in 1952 with donations from Masan, Changwon, Dongyeong, and Gimhae, to inspire people to overcome the national crisis. It was produced by Yun Hyojoong, one of the most celebrated sculptor at that time, a choice appositely local to Jinhae. After that, statues of Admiral Yi Sunsin were built throughout the country, the best known of which was created in 1968 by Kim Se-choong at Gwanghwamun Square, Seoul. 14 From 1968 to 1972, the Committee for Patriotic Ancestors' Statue was organized by the government to carry out statue production. At the time, the government also erected statues of King Sejong, The Buddhist Monk Samyeong, Yulgok, The Buddhist Monk Wonhyo, Kim Yusin, Eulji Mundeok, Yu Gwansun, Shin Saimdang, Jeong Mongju, Jeong Yakyong, Yi Hwang, Gang Gamchan, Andrew Kim Taegon, and Yun Bong-gil, as well as Admiral Yi Sunsin. The committee effectively visualized Korea's national ideology by comprehensively selecting eminent people from Korean history, including not only war heroes but also people who practiced patriotism such as anti-colonial resistance fighters, scholars, famous mothers, and religious men.[19]

In addition, the committee continued to build statues by selecting a line of greatly admired individuals who had worked hard to stabilize the country and establish its modern identity. Statues erected during this period included those of Ahn Joonggeun (1959), General Gwon Yul (1963), Gyebaek (1965), Choe Je-u (1964), Son Byonghi (1966), Kim Gu (1969), and Bang Jeong-Hwan (1971). Monuments for military people who symbolized comradeship such as Major Kang Jae-Gu (1966), Master Sergeant Lee Wondeung (1966), composer Hyun Jae-Myung (1961) and scholar Choe Hyeonbae (1971) were also created over this period.

MEMORIAL SCULPTURES

Public memorial sculpture started to be built when figures whose lives and achievements directly reflected the ideals of national policies or the ideology of ruling class were celebrated as Korea set out to reestablish national systems and policies after the Korean War. In relation to the war, there at first memorial facilities such as towers and commemorative stone plaques and monoliths for war dead. One well-known example is the memorial tower built in 1967 at the Seoul National Cemetery in Dongjak-dong. This memorial facility, based around a tall tower is aesthetically similar to the war memorials erected in the Japanese colonial era, but the precise function is somewhat different. The structure and purpose of the war memorials built in the Japanese colonial era is completely different from that of the memorial towers built after the country's liberation, because the war memorials basically had facilities to house the remains of the deceased inside the tower. In this regard, there is a space for memorial tablets in the memorial towers, but it is a primarily a facility to commemorate the war dead, rather than inter their remains.[20]

After the Korean War, sculptures commemorating war victims were erected in the forms of towers and stone memorials across the country. For example, the Memorial Tower for Patriotic Martyrs in Udu-dong, Chuncheon, was created in 1955 with the central tower standing tall in the middle and flanked by two human figures. In 1957, a Korean War Veterans Memorial was built at Yongdusan Park in Busan, while other sculptures to commemorate war victims such as the Korea National Police Memorial Tower, the British Commonwealth Forces Korea Memorial, and the Memorial Tower for Fallen Students were also

constructed. In the late 1970s, war monuments were also erected in different regions. Up until the early 1980s, fourteen war monuments were constructed across the country, including the War Monument for the Chuncheon District, the War Monument for the Waegwan District, and the War Monument for Yeongsan District. Koreans commemorated war victims and turned their history into monuments by continuously creating sculptures honoring Korean War veterans, especially victims and battle sites.

In the first half of the 1960s, many April 19 Revolution memorial stones were established along with other memorials to commemorate victims of the 1960 revolution. One of the best-known examples is the April 19 National Cemetery Memorial, which Kim Kyongseung established in Suyu-ri, Seoul in collaboration with Kim Youngjung, Lee Seungtaek, and Lee Jong-gak.[21] Other sculptures to commemorate the April 19 Revolution include the Dongwoo Tower established at Dongguk University by Song Youngsu and Choi Kiwon and the April 19 Tower constructed at Kyung Hee University by Kim Chanshik, both of which were completed in 1960. In 1961, the Tower of April 19 was built at Seoul National University and the April 19 Revolution Monument was constructed at Korea University. Even after these two major works, public sculptures to commemorate the April 19 Revolution were continuously built across the country. In the 1960s, in addition to the April 19 Revolution monuments, sculptures commemorating events that celebrated the people's spirit of resistance were regularly produced. A leading example is The Monument in Commemoration of the March First Independence Movement, which Kim Chongyung established at Tapgol Park in 1962. In addition to the March 15 Monument (1962) in Masan and the Donghak Peasant Uprising Monument (1963) in Jeongeup, in 1967, the March First Independence Movement Memorial Relief was created at Tapgol Park. A tower to commemorate the student movement in Sinuiju against communism was constructed at the Asian People's Anti-Communist League Center on the slopes of Namsan, and a sculpture celebrating the independence movement at the Byeongcheon Market in Cheonan was also produced in this period. What is interesting is that there were no noteworthy sculptures established in relation to the May 16 military coup d'état, except the May 16 Military Revolution Monument and the May 16 Birthplace Statue built in 1961.

On the other hand, there were also sculptures that celebrated the development of Korean society, for overcoming the ruins of war and taking up the path toward industrialization.[22] The number was not large, but such sculptures are noteworthy in that they are more 'future-oriented', in contrast to the memorial facilities to celebrate the past and

commemorate deceased national heroes. Well-known cases include the tower to commemorate Busan's becoming a city under the direct control of the central government in 1962, the Industrial Tower (1967) in Ulsan, Daejeon Tower (1972), and Incheon Civil Progress Tower (1976), all of which are common in that they are gigantic structures in geometric forms designed by Park Chilseong. In addition to these monumental works, there is Oh Yoon's Wall Painting in The Commercial Bank of Korea (1974), Song Youngsu's Seoul-Busan Expressway Completion Tower (1970), and Family (1978), which was built in a fountain in front of the Bank of Korea's head office.

In the 1960s, prior to the institution of the 'Arts Decorations for Buildings' policy, murals were usually designed by the famous architects Kim Chung-up and Kim Swoogeun, both of whom had studied architecture abroad. Their murals are different from the aforementioned works, but they also belong to the category of public sculpture in a broad sense. In 1961, Kim Chonghak and Youn Myeungro produced murals on the walls of the French embassy in Seoul, which was designed by Kim Chung-up. Then, in 1963, Chung Kyu produced porcelain murals on the exterior walls of the Asian People's Anti-Communist League Center in Namsan, the Oyang Building in Myeong-dong, and Woosuk University Medical Center, which was designed by Kim Swoogeun. These murals, which primarily consisted of pure geometric patterns in bold colors, were intended to help revitalize urban areas, and were an early form of public art that would become increasingly popular in the future.[23]

This article has examined the major sculptural works produced from the 1950s to the 1970s. Over this period, Sculptors produced works suitable for the new era, while also seeking to adhere to the established conventions of modern sculpture. While public monuments are still being produced today, most sculptors have tended to consider such as exceptional works, relative to their studio-based art world concerns. One exception might be Lee Seung-taek, who continued to work on experimental "non-sculpture" projects as he made living by receiving commissions for public statues. However, many sculptors in the 1950s and 1960s did not think of public sculptures separately from artistic projects. Sculptors such as Kim Kyongseung, Yun Hyojoong, and Kim Se-choong seem to have recognized the notion that sculptors are specialist designers and artists who can play a certain social role. In fact, this kind of awareness was also seen in Kim Bokjin's plaster mold for a statue submitted to the Joseon Art Exhibition. It was with the awareness that abstraction was the language of the avant-garde that artists began to consider realist sculptures as disconnected from their artistic world or art

historical value. Given the avant-gardist spirit and individual creativity increasingly required of artists in the postwar era, sculptors active from the 1950s to 1970s constantly sought new creative paths. This resulted in sculptures that were completely different from those created in the colonial period in terms of styles, techniques, and materials. In the 1980s, with the emergence of Minjung art, the traditional concept of figurative sculptures reappeared, but overall, the notion of what sculpture is, is infinitely expanding as it merges with the contemporary practices of installation and public art.

1 Youn Bummo, *Kimbokjin yeongu: Ilje gangjeongha joso yesulgwa munye undong* [A Study on Kim Bokjin: Plastic Arts and Literary Movements under the Japanese Colonial Rule] (Seoul: Dongguk University Press, 2010).

2 Kim Yisoon, "Hankug gusangjogakgwa oeyeongwa naepo" [Denotation and Connotation of Korean Figurative Sculpture], *Journal of Korean Modern Art History* 15 (2005): 89–116.

3 Kim Kyongseung, "Yeoninsang: 'Eonronui jayuwa jeonguiui seonyang'" [Female Statues: Enhancing the Freedom of Press and Justice], *JoongAng Ilbo*, September 22, 1965.

4 Kim Yisoon, "Jonjaeui naemyeon pyohyeoneul wihan silheomgwa mosaek: Gwongyujinui geonchil jogak" [Searching for Ways to Express the Inner World of Existence: The Dry Lacquer Sculptures of Kwon Jinkyu], *Journal of Art History*, no. 34 & 35 (2018): 213–242.

5 "Saeroun hyeongsangseongui chugu—Donga misuljereul malhanda" [Pursuit of New Formative Properties: About the Dong-A Art Festival], *Dong-A Ilbo*, February 1, 1978.

6 For more details about the trend of figurative form in sculpture making, see the following: Ryu Dawoom, "1980nyeondae hanguk hyeongsangjogak yeongu: Inganjogageul jungsimeuro" [A Study of Figurative Sculpture of Korea in the 1980s: Focusing on Human Figure Sculpture], *Korean Bulletin of Art History* 51 (2018): 267–290.

7 Kim Chongyung, "Naui jageopgwaneul balkim" [About My View of Work], *Chowolgwa changjoreul hyanghayeo* [Towards Transcendence and Creation] (Paju: Yeolhwadang, 2005), 29.

8 For more details on Song Youngsu's art world, see the following. Kim Yisoon, "Song yeongsuui yongjeop jogak" [Song Youngsu's Welded Sculpture], *Journal of Korean Modern Art History* 8 (2000): 97–122.

9 About deconstructing and expanding the concept of sculpture, see the following. Kim Yisoon, "Hanguk geunhyeondae misureseo jogak gaenyeomgwa geu jeongae" [The Concept and Development of Sculpture in Korean Modern and Contemporary Art], *Journal of Korean Modern & Contemporary Art History* 22 (2011): 36–52.

10 Kwanhoon Gallery ed., *Bangaenyeomui jeongsingwa bijogak* [Anti-Concept Sprit and Non-Sculpture], Lee Seung-taek solo exh. cat. (Seoul: Kwanhoon Gallery, 1988).

11 Lee Ihnbum, "Yiseungtaek jakpum yeongu: Bijogak gaenyeomeul jungsimeuro" [A Study of Lee Seung-taek's Art Works: Focusing on the Concept of Non-sculpture], *Korean Bulletin of Art History* 49 (2017): 263–264.

12 Lee Seung-taek, "Nae jogagui geunwon" [The Root of My Non-sculpture], *Space*, May 1980, 38–39.

13 See Kwanhoon Gallery ed., *Anti-Concept Sprit and Non-Sculpture.*

14 Kim Hong-hee, "Bakhyeongiui hangukjeok minimeolijeum bidio: Saiteu teukjeongseonggwa jeongsinseong" [Park Hyunki's Korean-style Minimalism Video: Site Specificity and Spirituality], *Korean Contemporary Art 197080* (Seoul: Hakyoun, 2004), 236–239.

15 Kim Yisoon, "Jeguk ilbonui singmin jibaewa gonggongginyeommul" [The Japanese Colonialism and Public Monuments in Korea], *Journal of Korean Modern & Contemporary Art History* 34 (2017): 7–34.

16 For discussions about the overall development of public art from the period when outdoor statue construction started in Korea to the present day, see the following: Kim Yisoon, Moon Hyeyoung, "Inyeomeul wihan gonggongmisureseo gongjoneul wihan gonggongmisullo: Hanguk gonggongmisurui paereodaim byeonhwa" [From Public Art for Ideology to Public Art for Coexistence: The Paradigm Shift of Public Art in Korea], *Korean Journal of Art and Media* 13, no. 1 (2014): 33–60.

17 The bronze relief of Alfred Irving Ludlow produced by Kim Bokjin in 1938 was not taken by the Japanese government and is currently housed at the Dongeun Medical Museum under Yonsei University's medical school.

18 For more details about Rhee Syngman's statues, see the following: Cho Eunjung, "Yiseungman dongsang yeongu" [Figures and Monuments Built to Commemorate Lee Syng-man], *Journal of Korean Modern & Contemporary Art History* 14 (2005): 75–113.

19 Jung Hogi, "Bakjeonghui sidaeui dongsanggeollibundonggwa aegukjuui: Aeguk seonyeol josang geollibwiwonhoeui hwaldongeul jungsimeuro" [Park Chung-hee Government Statue Movement: National Heroes Statue Committee], *Review of Korean Studies*, no. 106 (2007): 335–363.

20 Kim Yisoon, "Hyeonchungtabui giwongwa hyeongseong" [The Origins and Formation of Memorial Tower (Hyeonchung-tap)], *Korean Bulletin of Art*, no. 48 (2017): 93–121.

21 For more details on the April 19 National Cemetery Memorial in Suyu-ri, see the following: Chung Moojeong, "Gungnim 4.19 minju myoji johyeongmurui byeoncheongwa geu uimi" [Transformation of Public Monuments for the April 19 National Cemetery and Its Significance], *Journal of the Association of Western Art History*, no. 38 (2013): 165–186.

22 Kim Mijung, "Hanguk saneopwa sidaeui yutopiajeok bijeon" [The Utopian Vision of Industrialization in 1970s Korea], *Journal of Korean Modern & Contemporary Art History* 20 (2009): 206–227.

23 Cho Hyunjung, "1960nyeondae modeonijeum geonchukgwa dojagi byeokwa, yesurui jonghapgwa geonchugui jeontongnon" [Ceramic Murals in the 1960s: An Intersection between the Synthesis of the Arts and Tradition Debates in Architecture], *Korean Bulletin of Art History*, no. 53 (2019): 103–122.

Experimental Art: The Beginning of Moving Beyond Conventional Genres

Cho Soojin

The April 19 Revolution in 1960 was the first anti-dictatorship, pro-democracy movement in South Korean history since the emergence of the South Korean government. Students and citizens enraged by the Liberty Party's rigged election staged protests to nullify the result and demanded a re-election. As a result, the twelve years of long-term rule by Rhee Syngman and the Liberty Party administration ended. However, the April 19 Revolution was followed by a military coup on May 16 the following year. Through this incident, those who supported industrialization under developmentalism and dictatorship gained power, and from then on Korean society began to strive for the modernization of the country under the auspices of the Park Chung-hee government and its Yushin ('revitalization') policy. At the time of the April 19 Revolution, some Art Informel artists held the *60 Fine Art Exhibition* and the *Byeok Art Exhibition* on the eastern and western walls of Deoksugung Palace, respectively, in protest against the established art community that defended the National Art Exhibition. However, even the most vocal Art Informel artists stopped their direct action against the government soon after the military coup. The reason was that the demands for modernization at the time felt too urgent and powerful for these artists to be mired in nihilism driven by the aversion towards the regime.

For the artists, the development of the nation-state was understood as equaling the development of the art world, even though not all of the artists devoted to the modernization of art were united in their aims. Among those avant-garde artists, some sympathized with the regime's notion of an notion of an ethno-national democracy, which emphasized tradition, the state and people, and others showed a critical attitude toward state power as it suppressed individuals while claiming to support the realization of a liberal democracy. Despite this distinction, the two avant-garde groups were not that different in that they agreed to maintain the postwar national division of Korea and that they maintained their prioritization of art over all else. As a result, the avant-gardes of the Korean art world in the 1960s and 1970s were equipped with a type of depoliticized modern intellectual subjecthood. Gradually, the idea of the avant-garde in the Korean art world came to refer to artists primarily dedicated to building a new regime rather than resisting the old regime, and fully focused on their artistic practice. These avant-garde artists sought to modernize Korean art and take over the hegemony of the new national art world by forming groups that vehemently opposed the institution of the National Art Exhibition, desired to advance into the international art world, experimented with new media, and sought to develop logical and natively Korean methods of art-making.

ORGANIZING INDEPENDENT GROUPS AND RECEIVING CONTEMPORARY FOREIGN ART

In the Korean art world, the backwardness of the National Art Exhibition was first raised as an issue in the 1950s, but in the mid-1960s, as power in art circles intensified around certain connections, calls for the reform of the National Art Exhibition rose throughout Korean society. Furthermore, when Art Informel, once a self-proclaimed avant-garde movement, was absorbed into the National Art Exhibition and lost its force of resistance, members of the art community longed for new avant-gardes and paid attention to contemporary trends in the West and in Japan, including Neo-Dada, happenings, pop art, minimalism, kinetic art, conceptual art, land art, Arte Povera, Gutai, and Mono-ha. These trends inherited the innovative techniques of the

European avant-garde art of the early twentieth century, and desired to challenge the formalist aesthetics and institutionalization of modernist abstract art. The interest Korean artists had in overseas art led them to passionately read foreign art magazines, and often even migrate to Paris or the U.S., as well as participate in international exhibitions such as the Paris Biennale and the São Paulo Art Biennial.

Leading critics at this moment in time, including Lee Kyungsung, dismissed academicist art that inherited the Japanese colonial era's legacy as a specter of modern times, and argued that the true contemporaneousness of Korean art could only be established through a radical break from the past. By defining the modern era as a time of emptiness and denying the history of colonial experience as a whole, artists found a sense of legitimacy in their attempts to discover a Korean-style avant-garde movement in contemporary art after Art Informel. In particular, these young Korean artists—those who were dismayed by the older generation of artists—were stimulated by the type of practices in these contemporary art trends that could not be explained through conventional genres like painting and sculpture. At that time, the National Art Exhibition was operated with divisions of painting (ink painting and oil painting), calligraphy, crafts, architecture, and photography. It was not a system that could accommodate art with characteristics such as the use of ready-mades, site-specificity, improvisation, or performance. As a result, young artists working against the National Art Exhibition formed various non-governmental, independent groups in the mid-1960s, and began to showcase experimental works that crossed the boundaries of established genres.

This new direction began with the Zero Group, which was formed in 1962. The members of the Zero Group—Kim Youngnam, Kim Youngja, Moon Bokcheol, Seok Ranhui, Lee Taehyun, Choi Boonghyun, Hwang Ilji, and Lee Dongbok, Seol Yeongjo (From Hongik University's Department of Architecture), and Kim Sangyeong (from Seoul National University's Department of Painting)— presented pieces of "object art" (obeuje misul), which were art composed with ready-mades, influenced by Neo Dada's anti-art practice.[1] They held the group's first exhibition in June 1962, and the second exhibition in June 1967. At this exhibition, which introduced assemblage art for the first time in Korea, various ready-made objects were attached to canvas or combined with one another and were installed on the floor. At that time, these works that presented three-dimensional sculptures in a three-dimensional space were also called "environmental arts" (hwangyeong yesul or hwangyeong misul). In 1967, some other artists who

graduated from Hongik University's Department of Western Art (oil painting)—Kang Kukjin, Chung Chanseung, Jung Kangja, Shim Sunhee, Yang Deoksu, and Kim Inwhan—organized the Sinjeon Group.[2] In addition to "object art," they were also interested in happening, which was actively being created in the West and Japan at the time.

In December 1967, the artists of the Zero Group and the Sinjeon Group united with another group called Origin Fine Arts Association,[3] which presented geometric, abstract paintings, and held the Union Exhibition of Korean Young Artists with the aim of creating a new plastic morale from the innovation of awareness, away from the idleness and habitual routine of the current art community. On the opening day of the Union Exhibition of Korean Young Artists, 12 artists from the Zero Group and Sinjeon Group staged a protest on the streets of Seoul, calling themselves "acting painters" and holding pickets that stated: "Joint statement by young artists on behalf of the Korean art community." They showed their criticism of both the academicist art of the National Art Exhibition and Art Informel through their choice of picket phrases such as "Stagnant National Art Exhibition," "Korea without any view of contemporary art," "Works after abstract art," and "Contemporary painting is close to the public."

Artists of the Zero Group and Sinjeon Group mainly showed "object art" and happening at the Union Exhibition of Korean Young Artists. They formed a group named the Korean Young Artists Coalition, while holding academic events and lectures across the country, focusing on the promotion of new art trends. They held their first seminar on November 15, 1967; started a lecture tour on February 10, 1968; and had an event titled A Night of Contemporary Art and Happening on May 2, 1968. At this evening event, artist Chung Chanseung gave a presentation on the styles of the entries to the Paris Biennale and São Paulo Art Biennial held in 1967, while art critic Oh Kwang-su explained Allan Kaprow's happening and John Cage's art world in detail.

If the 1967 Union Exhibition of Korean Young Artists was the first case of genre deconstruction in art that emerged based on contemporaneity in Korea, the activities of the Korean Avant Garde Association (AG), an avant-garde art organization that emerged in 1969 after a preliminary meeting in 1968, constituted an attempt to introduce new art practices to Korea more systematically through exhibition planning and the publication of periodicals. Participating artists in the AG were Kwak Hoon, Kim Kulim, Kim Tchahsup, Kim Han, Park Suk-won, Park Chongbae, Suh Seungwon, Lee Seungjio, Choi Myoungyoung, Ha Chonghyun, Lee Seung-taek, Cho Sungmook, Lee Kun-Yong, Shim Moon-seup, Shin Hakchul, Song Burnsoo, and Kim

Dongkyu, alongside critics Lee Yil, Oh Kwang-su, and Kim Inwhan. These group gathered with the aim to explore and create a new plastic order in the visionless Korean art world by being grounded in the strong consciousness towards avant-garde art and contribute to the progress of Korean art and culture.[4]

In the circumstances where little information on contemporary international art was available, the association published a total of four volumes of the *AG* journal (1969-71). In addition, the AG strove to find the identity of contemporary Korean art as it focused on the research and introduction of avant-garde art to Korea by holding three themed exhibitions. These were: the *1970 AG Exhibition: The Dynamics of Expansion and Reduction* in May 1970; the *1971 AG Exhibition: Réaliser et la Réalité* in December 1971; and the *1972 AG Exhibition: The World of Post-Abstraction* in December 1972; and they were supplemented by their submission to the first Seoul Biennial in December 1974. In Lee Yil's essay "A Theory of Avant-garde Art" which he contributed to *AG* volume 1, the critic cited Pierre Restany's statement: "Today's avant-garde is not an art of resistance, but an art of participation," and emphasized that Korean artists should positively embrace the reality of modern civilization and create a new art appropriate for the times according to international trends.

Many artists, including Park Chongbae, Choi Myoungyoung, Ha Chonghyun, Kim Tchahsup, Kim Han, Park Suk-won, Shin Hakchul, and Shim Moon-seup contributed to the *AG* journal to express their theories of art and their views on the direction of Korean art in the 1970s. On top of that, *AG* included "In Search of Encounter: At the Dawn of a New Art"[5] written by Lee Ufan, a Korean artist residing in Japan, and "Naissance d'un art nouveau" by Michel Ragon. The journal also introduced the art worlds of Marcel Duchamp, Lucio Fontana, and Nicolas Schöffer, as well as the latest trends in art, such as conceptual art and land art by using terms like "works of concepts" and "the art of impossibility."

If the AG artists' activities were focused on installations using the ready-made and things from nature, happening offered another possibility for the members of the Fourth Group, which was formed in 1970 based on the experience of the *Union Exhibition of Korean Young Artists*. Earlier in Korea, on December 14, 1967, when the *Union Exhibition of Korean Young Artists* was held, ten artists from the Sinjeon Group and Zero Group staged *Happening with Vinyl Umbrella and Candle*, which critic Oh Kwang-su wrote about. This work was designed to show Dadaist notions of chance. After this, many happenings were introduced to the general public up until 1970, and finally in June 1970 the Fourth

Group, a full-fledged performance art group, began its activities. The members of the Fourth Group—Kim Kulim, Chung Chanseung, Kang Kukjin, Bang Taesu, Son Ilgwang, Koh Ho, Jeon Yuseong, Lee Iktae, Im Jungung, Tak Yeong, Seok Yajeong, Li Jagyong, Kim Beolrae—covered a wide variety of fields that included all of fine art, theater, fashion, music, cinema, publishing, popular arts, and religion. It was arguably a full-range cultural group. Furthermore, it was a young community of individuals, all of whom were in their 20s or 30s and already emerging leaders in their respective fields at the time.

The Fourth Group called their happenings "intangible art" (*muche yesul*), based on the philosophy of intangibility, which was the group's perspective on art. Said to be taken from the core idea of the Chinese philosopher Lao Tzu—the political philosophy of abandoning the will to rule and to govern through non-action—the philosophy of intangibility was appropriate to explain art like happenings which do not create any end products. In addition, intangibility also signified avoiding the mindset that had separated the mind from the body and helped to integrate everything from politics, economics, society, culture and science into an artistic dimension. To this end, the driving idea here was that all existing independent fields must return to a state of nothing, and the boundaries of each field inevitably disintegrated, and that happening was the art that could best follow this logic. This concern followed the notion that because performance restored the body's subjectivity and organically integrated different genres of art, in contrast to how the body had long remained in the position of an object in visual art. In this way, the Fourth Group artists achieved a particular Korean transformation of the art form of happening.

As such, Korean artists' will to logically create distinctly Korean art forms and practice had already started with the AG and the Fourth Group, and was further accelerated with the Space and Time Group (ST), which was formed in 1970 and held its first group exhibition in 1971.[6] Artists, including Lee Kun-Yong, Sung Neungkyung, Chang Sukwon, Kim Yongmin, Yoon Jinsup, Kim Hongjoo, Nam Sanggyun, Lee Jaegeon, Chang Hwajin, Cho Yeonghui, Choi Wongun, Song Jeonggi, Yeo Un, Kim Munja, Park Wonjun, Han Jeongmun, Kim Yongchul, Kang Yongdae, Kang Changryul, Kang Hoeun, Kim Sun, Kim Yong-Ik, Kim Jangsup, Shin Hakchul, Jang Gyeongho, Choi Hyojoo, Jung Hyeran, and Kim Yongjin, along with the critic Kim Bokyoung, held a total of seven group exhibitions from the first ST Exhibition in April 1971 to the last in 1980. However, they also held many seminars and discussions, and published materials in the form of newsletters. Major exhibitions by

EXPERIMENTAL ART: THE BEGINNING OF MOVING BEYOND CONVENTIONAL GENRES

the ST members included the second ST Exhibition in June 1973, the third in June 1974, the fourth in October 1975, *Three People's Event* in December 1975, *Four People's Event* in April 1976, *Event Logical* in July 1976, *The Fifth ST Exhibition: Things and Events* in November 1976, the sixth group exhibition in October 1977, and *The Seventh ST Exhibition: The Whole and Aspects* in June 1980. Art critic Kim Bokyoung theoretically supported the group's activities by publishing articles such as "Historicity and Anti-Historism of Contemporary Art" (1974) and "The World as Things and Events" (1976). ST's artists held research meetings for more than a decade to find their own ideas, namely the main methodology of creating works, which would distinguish them from the rest of the Korean art world, the previous generation, and contemporary international art. These intellectual activities set ST apart from other groups.

In those research meetings, they intensively discussed Ludwig Wittgenstein's theory of language, alongside the ideas of Clement Greenberg, Harold Rosenberg, Joseph Kosuth, Brian O'Doherty's theory of art, Lee Ufan's theory of criticism, Martin Heidegger's ontology, Maurice Merleau-Ponty's *Phenomenology* and Japanese philosopher Kitaro Nishida's world view. Through Wittgenstein's idea of considering language as a measure of all things and seeking clarity through language criticism, the theory of Kosuth, an American conceptual artist who explored the philosophical concept of art, and the criticism of Lee Ufan, who insisted that art completely reveals the world by presenting raw physical materials, and the notion that the place where we meet the world is none other than the body, the ST artists were led to pay attention to the materiality of artistic media and contemplate the meaning and role of art itself. Throughout the 1970s, the ST pursued conceptual installation art, which was called "three-dimensional art" (*ipche misul*) in those days along with "event" art, and thereby intended to distinguish their practice of performance from that of the 1960s' happening. In this way, ST laid the conceptual foundation for Korean art.

The 1970s witnessed, as seen above, the emergence of numerous non-governmental, independent artist groups and the vibrant activities of those artists and art critics involved with such.[7] This meant that artists were able to present their works without resorting to the stage of the National Art Exhibition, and as such, these independent exhibitions were held more frequently and gradually grew bigger in size. Representative exhibition platforms organized by individuals and groups as private citizens included an art award exhibition by the *Hankook Ilbo* newspaper, the Korean Fine Arts Association Exhibition, *Independants*,

Ecole de Séoul, the Daegu Contemporary Art Festival, the Seoul Contemporary Art Festival, the Busan Contemporary Art Festival, the Gwangju Contemporary Art Festival, the Jeonbuk Contemporary Art Festival, the Dong-A Art Festival, and the JoongAng Art Festival. Among all these, the Daegu Contemporary Art Festival was a large-scale avant-garde exhibition and one of the major examples that showed the spread of installation and performance art across the country.[8]

At the Daegu Festival, which was held five times from 1974 to 1979, three-dimensional art and events were presented at outdoor venues. At the fourth Daegu Contemporary Art Festival in September 1978, Kim Deoknyeon, Kim Youngjin, Park Hyunki, Yoo Geunjun, Lee Kangso, Lee Sangnam, Lee Hyangmi, Choi Byungso, and Lee Hyeonjae presented works using image media through an auxiliary exhibition called *VIDEO & FILM*. First introduced in the Korean art world in the mid-1960s, the type of avant-garde art that moved beyond conventional genres expanded not only to Seoul but also to the surrounding provinces, and not only to museums and galleries but also into the world outside of the art system in the 1970s. Until 1981, when the National Art Exhibition discontinued, these art practices remained unabsorbed by the National Art Exhibition, but nonetheless became the driving force behind the innovation that shaped the Korean art world during this period.

THE INFLUENCE OF INDUSTRIALIZATION, URBANIZATION, AND POPULAR CULTURE

In 1967, the Zero Group and Sinjeon Group presented innovative ready-made works and artists' performances at the *Union Exhibition of Korean Young Artists*. That year was also significant in the modern history of Korea. When incumbent President Park Chung-hee was re-elected in the sixth presidential election in May of that year, there were a series of incidents such as the arrest of Chang Chun-ha, a leading member of the opposition party, the corrupt election of the National Assembly on June 8 and the East-Berlin Affair that involved artist Lee Ungno and composer Yun Isang. Korean society then entered into a politically volatile situation in which individual freedom was limited in the name of anti-communism and national security. However, the government's strong economic development policy continued dramatically and unabated, and continued to change the lifestyle and value system of the Korean people. Due to full-fledged urbanization, a massive exodus from small towns to big cities was taking place, thereby concentrating the population in large cities such as Seoul and

rapidly changing the spatial structure of local communities. A national project to aesthetically transform the urban environment not only resulted in a collaboration between art and architecture, but also reflected the aesthetic interest in mechanical civilization in various art practices during this period. Furthermore, as mass media such as television and radio began to spread throughout the country with rapid economic development, notions of Western individualism and popular culture, especially youth culture symbolized by acoustic guitars, jeans, draft beer, long hair and miniskirts spread throughout Korean society. Under these circumstances, many artists were noted for presenting genre-shattering avant-garde work as fine art practice that approached such populist tastes, but many of these figures were dismissed at the time as decadent artists by the government.

In 1967, Zero Group members such as Choi Boonghyun, Lee Taehyun, Kim Youngja, Kang Kukjin, Jung Kangja, and Shim Sunhee presented

1 Lee Taehyun, *Command 1*, 1967 (Reproduced in 2001), Gas mask, knapsack, 140×70×14 cm

a variety of object art using the ready-made or representing everyday items in a realistic way. Choi Boonghyun displayed empty beer bottles, paper cups, and plastic bags in an iron cabinet in *Human Being 2* (1967), and in *Cylindrical Pipes* (1967), he covered tin cylindrical pipes, which were commonly used for heating at the time, with primary colored foil and installed them on the inside floor of the exhibition venue. Lee Taehyun tried assemblage works by attaching a military gas mask and a backpack reminiscent of military culture to the canvas in *Command 1* (1967), and by lining up black industrial rubber gloves in *Command 2* (1967). 1 Kim Youngja presented three-dimensional woodworks, such as *Coal—Briquettes 000* (1967) and *Matches 111* (1967), which featured matches and briquettes, objects closely related to Korean people's lives. In addition, Jung Kangja expressed women's independent sexual desire with *Kiss Me* (1967), a combination of plastic and glass bottles in a lip-shaped plaster sculpture, while Shim Sunhee turned a new generational approach to women's daily life into art in *Mini 2* (1967), a mixed media work with fashion as its subject.

Artists considered that art could participate in society by capturing the sense of life of the general public in the city; but in fact the visual environment of Korean society in the late 1960s was changing day by day. The new aesthetic sensibility created by urban life and popular culture influenced both the fields of pure art and applied art. In particular, as the full-fledged development of industrial design began in accordance with the export-driven economic strategy of the Park Chung-hee administration, society's interest in goods and environmental design rose under the slogan of "art exports." During this period, when the differentiation of art and design began, some artists worked in and out of the two areas of art and design. In this regard, Kang Kukjin's installation work *Display—Amusement of Visual Sense* (1967) and *Visual, Sense I, II* (*Amusement of Visual Sense*, 1968) reflected his unique career as an interior designer. 2

The connection between avant-garde contemporary art and cities, machines, and popular culture was also apparent in work by Kim Kulim, who had various experience in applied art and popular art, including textile design, film, advertising, and theater. His electric art series, *Space Construction* (1968-69), was designed like an industrial product using raw materials commonly found in textile factories such as plastic, vinyl, water, and electricity. Such work represented the full-fledged emergence of new media and formative aesthetics based on mechanical images created by industrial society. In addition, the short avant-garde film *The Meaning of 1/24 Second* (1969) directed by Kim Kulim and starring Chung Chanseung and

EXPERIMENTAL ART: THE BEGINNING OF MOVING BEYOND CONVENTIONAL GENRES

2 Kang Kukjin, *Display—Amusement of Visual Sense*, 1967 (partly reproduced in 2001), 151 penicillin bottles, table, mirror, artist photo, Aramis scent bottle, other assorted personal items, 165×155 cm

Jung Kangja reflected the psychology of Koreans who faced the unacceptable speed of modernization through the rapid change in modern landscapes of the capital Seoul, and citizens' seemingly dull and indifferent facial expressions, which were in contrast to the rapidly changing nature of the urban landscape. In Korean cinematic history, the industry's heyday was from 1965 to 1970. In this period, just before the TV era began in Korea, more than 150 Korean films were produced every year and more than 100 million viewers visited the theaters. The year 1969, when *The Meaning of 1/24 Second* was created, 233 other Korean films were also created. In this regard, the work signifies the discovery of film as a new artistic medium and avant-garde artists' critical statement about the Korean mass culture industry on the rise.

As capitalism took hold, topics such as the construction and collapse of the city as well as production and disposal of utilitarian products were frequently dealt with in artworks. Well-known cases included Kim Kulim's *Art of Incomprehensibility* (1970), a collage of photos of garbage, buildings and bridges cut from the U.S. magazine *Life*, and AG member Shin Hakchul's *Naught No. 3* (1974), which decorated a photo of a female model from a magazine with a string. Yeo Un, a member of ST, presented a satirical piece, *Work 74* (1974), by attaching cut-out political articles and sensational photographs from newspapers and magazines to a window; Nam Sanggyun presented *Matter I* (1973), which featured cigarette butts in a transparent acrylic box, and Choi Wongun presented *Assemblage A* (1973), in which old dolls were tied to a chair with wire, suggesting the surplus nature of artistic objects.

Another style of art adopted by avant-garde artists starting from the 1960s, as they struggled to create popular and accessible art, was the happening. Members of the Sinjeon Group, Kang Kukjin, Chung Chanseung, and Jung Kangja staged a happening called *Transparent Balloon and Nude* on May 30, 1968. The incident, in which female artist Jung Kangja became a living nude in a populist cultural space Music Hall C'est SI BON, and stood in front of more than 300 people, provided a decisive opportunity to help the general public recognize happenings as an avant-garde art practice. This happening was designed to satirize the removal of Kim Sou's painting *A Group of Nude Women* (1949) from the exhibition hall at the first National Art Exhibition in 1949, as the painting was considered as demoralizing. In 1968, the three artists sought to popularize academic art and challenge authorities of the National Art Exhibition by replacing the notion of a nude painting as art with what would

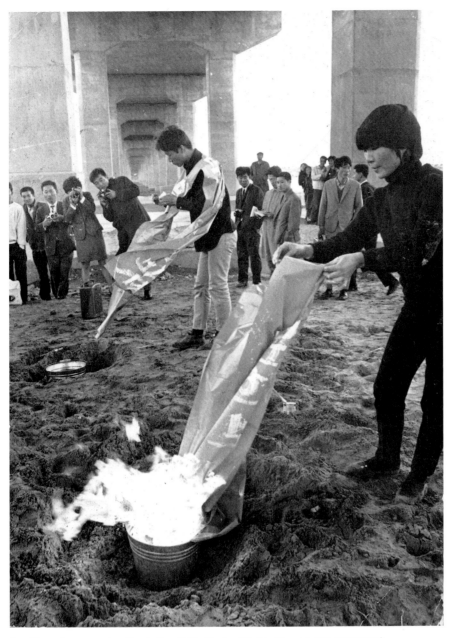

3 Chung Chanseung, Jung Kangja, Kang Kukjin, *Murder at the Han Riverside* (October 17, 1968),
Still from the original performance

have been widely considered as an obscene public performance.

After the three artists became famous as "happening show" artists with *Transparent Balloon and Nude*, they unveiled *Murder at the Han Riverside* (1968) on October 17 of the same year, which surprised the art world again. ⸾3⸿ At this happening, these artists took over a part of the bank of the Han River to make a hole under the Second Han River Bridge (now the Yanghwa Bridge) with over fifty people watching them. The artists got themselves into the hole and some spectators poured water

on the artists' heads. Having dragged themselves out of the holes, they wrote critical phrases on vinyl clothes, such as "illicit fortune maker (a pretend great master)," "cultural swindler (pseudo-artist)," and "cultural acrobat (artist jumping on the bandwagon)." Then they burned the clothes, shouting "We want to kill all of them!" This work, which symbolized the act of punishing the cultural swindlers of elite society and holding their funerals, expanded the scope of their criticism to the cultural establishment, and expressed the artists' desire for reform more straightforwardly.

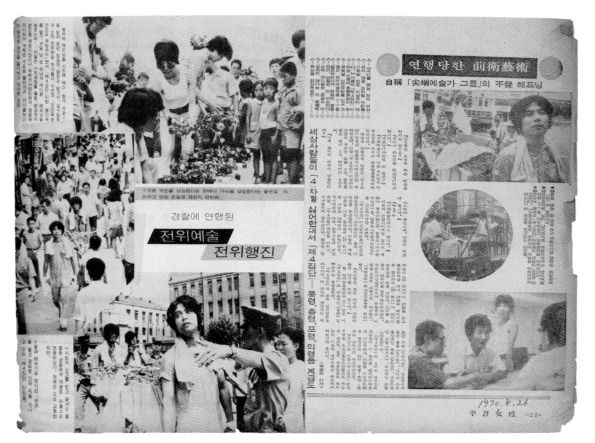

4 The Fourth Group, *Funeral Ceremony of the Established Art and Culture* (August 15, 1970),
 Jugan Yeoseong, August 1970

In those days, Koreans were suffering from the repressive government of the military dictatorship and its coercive modernization projects. Happening artists shared typical concerns with much of the April 19 Revolution generation, who expressed their resistance to the older generation in the field of culture, which had become increasingly stagnant due to the country's oppressive political revolution. The desire for democracy created while going through the April 19 Revolution instilled in these young artists a willingness to become the subject of a new culture, encouraged by the foregrounding of their individualistic attitude as a way of life. In July and August 1970, the artists of the Fourth Group, a performance art group formed around this time, conducted two street events, which were then suspended by the government. In *Street Theatre*, staged on July 1, a pantomime-style happening was unveiled in Myeong-dong, Seoul, criticizing human alienation because of money. Up to 100 people witnessed the scene, but the artists were eventually arrested by police for violating the Road Traffic Act.

Later, on August 15, to commemorate the twenty-fifth anniversary of Korea's liberation from Japan, *Funeral Ceremony of the Established Art and Culture*

(1970) was staged to criticize the fact that society was still dominated by pro-Japanese groups and to symbolically bury those cultural practitioners unable to escape from the outdated ideologies. 4 On the same day, the Fourth Group artists marched from Sajik Park, carrying a coffin and holding a Korean flag to an area under the First Han River Bridge, a burial site, before they were arrested and handed over to authorities for immediate trial and judgement in court. *The Funeral Ceremony of the Established Art and Culture* eventually became the funeral of the Korean happenings scene because the government crackdown on social degenerates had just begun, and the members of the Fourth Group were subject to virtual exclusion from Korean society. Happenings, which disappeared after only a short period of activity from 1967 to 1970, were conducted by young artists who sought to restore the meaning of individual identity, and reform society through the self-assertion of the desiring body. Most notably, these happenings were characterized in the 1960s by ideas of Western liberalism, pop culture, individualist resistance, and femininity, and rendered such an important artistic indicator of the modern, contemporary nature

of Korean society at the time. However, because of this very nature, happenings were rejected by the governing forces that pursued rationalism, production and growth, as well as collectivity and masculinity.

NEW CONCEPTS OF ART AND MEDIA EMERGE

In 1972, the Park Chung-hee administration implemented emergency measures to dissolve the National Assembly, suspend some of the provisions of the Constitution, and on December 27 proclaimed the Yushin Constitution, under which all power of the state was vested in the president alone. Up until the end of the Park regime in October 1979, the Ministry of Culture and Public Information monitored all media and used cultural censorship as a governing technique. Under such a circumstance, artists' competence was directed not outward but inward. To add to the traditional art concept of reproducing the real world, what emerged in the Korean art world was a new concept of art, as a means with which to explore art itself. Following such concerns about "what art is," artists soon began to ask the question, "What is Korean art really like?" For Korean avant-garde artists, the contemporaneity of foreign art trends was only experienced remotely through printed images, and so it was difficult to understand the production principles behind the work. Moreover, Korean art at that time lost much of its historical continuity with tradition due to the colonial experience and the Korean War, and so it was considered not easy for artists to portray something truly Korean in their works. Despite these difficulties, the avant-garde artists worked hard to discover their own art media and tried to create specifically Korean contemporary art by experimenting with materiality and expression under the conditions of the times.

For example, Lee Seung-taek wanted to establish the independence of Korean contemporary sculpture, and paid attention to traditional objects such as earthenware pottery; the stones used in weaving traditional mats; the roof tiles of *hanok*; ropes and flags found in *seonangdang* (a shrine for a village guardian) or *pungeoje* (a fishermen's ritual for a big catch); or kites seen in folk games. He attempted to change the concept of materiality through his *Godret Stone* series for which he had hard stones tied together with strings and expressed

5 Lee Seung-taek, *Wind*, 1970 (reproduced in 2020),
 Cloth, rope, dimensions variable

6 Lee Ufan, *Relatum—Perception and Phenomenon*, 1969,
Glass, natural rock, 230×270×1.8 cm, 80×80×75 cm

7 Kim Tchahsup, *Triangle, Circle, Square*, 1969,
Wood, 80×300×240 cm

like soft stones. He then introduced atypical natural objects such as smoke, wind, fire and fog as materials within his art to pursue the idea of "non-sculpture as formless art." Lee Seung-taek conceived of the idea of *Untitled (Burning Canvases Floating on the River)* (1964-88) in 1964, and left photographs of the results of the work's implementation in 1988. After presenting *Wind* (1970), in which pieces of cloth were tightly hung from a rope between two buildings, he developed a follow-up series in which the activities of wind are made visible by pieces of cloth tied to a tree branch or a large cloth shaken by human hands. 5 Through this act of converting old Korean things into unfamiliar objects and the most contemporary art practice, the artist surpassed the blind faith in foreign art common to his contemporaries and secured a distinctly Korean character for his art world.

Meanwhile, those working in the AG and the ST adhered to Lee Ufan's East Asian philosophical ideas and thereby developed a concept of art that explored the nature of objects, and the characteristics of time and space as embodying the basic forms of objects' existence. Lee Ufan himself is a Korean artist and art critic who has resided in Japan for most of his career, and he led the theory and practice of the Japanese art group "Mono-ha" that emerged in the late 1960s. Lee had long criticized the notions commonly associated with Western modernity, which he considered destroyed the continuity of humans and nature, and separated the mind and body. Lee therefore advocated for the creation of a specifically East

Asian contemporary art approach that distinguishes itself from art trends such as minimalism, Arte Povera, and conceptual art. For Lee Ufan, it was objects and the human body, with its physicality, that would provide the basis for going beyond the limits of Western modernist aesthetic concerns. He articulated that when presenting an object as it is, its structure, not the illusion of the world, is revealed, and the body is the place that enables this relationship between the object and the world. Korean artists longed for a more independently-led adaptation of contemporary Western art, and Lee's theory influenced the development of Korean art in relation to the development of so-called "three-dimensional art," "events" and the monochrome abstract painting movement now widely referred to as "Dansaekhwa."

When Lee Ufan began presenting the *Relatum* series in the early 1970s, it was designed to create encounters between objects and objects; between objects and exhibition space; and objects and viewers. In this approach Lee used objects such as glass, natural stones, iron plates, cotton, wood, and rope. 6 Prefiguring this approach, in the early 1960s, Quac Insik, a Korean artist residing in Japan, dropped iron beads on a glass plate in *Work* (1962), then scratched a copper plate in *Work 65-6-3* (1965) to show physical changes to the nature of objects. Lee Ufan then expanded the artistic discussion into how objects and viewers relate to each other in certain places and situations. As artists began experimenting with mediums such as those mentioned above, there emerged many works

8 Kim Yong-Ik, *Plane-Object*, 1977,
Airbrush on fabric, 175×99, 174.5×98, 175×100 cm

In *Triangle, Circle, Square* (1969), Kim Tchahsup presented the geometric form of a three-dimensional work, which was a mixture of natural and processed wood. This was a reflection on abstraction in art as seen across East Asian and Western European cultural contexts. And the initial idea for this work came from the morphological similarities of ancient tombs in Gyeongju and Scythian tombs. [7] Shim Moon-seup also created art using the energy of raw materials and changes in their properties due to human involvement. In *Relation* (1972), Shim suggested an architectural environment by piling cement powder on the four iron plates laid on the floor, whereas in *Relation-Union* (1972) several pieces of wood were cut and parts of them were dug up and then the traces of those actions were arranged on the floor. Choi Myoungyoung also explored the materiality of the media in a series of works entitled *Deterioration*. For example, in *Deterioration-70-B* (1970), he placed artificial concrete conduits in the exhibition hall or showed how the amount of soil on the panel gradually changed in *Deterioration-Extreme* (1971). These artists' works, based on the simultaneous use of industrial and natural materials, revealed Koreans' desire for industrialization and urban civilization as well as their nostalgia for nature and a more primitive mode of existence.

Artists' questions about art, and what objects they could use as media, led to the exploration of canvas, the medium of painting itself. In *Cloth-Ultramarine A, B, C* (1974) Lee Kun-Yong made wrinkles from canvas, sprayed paint on it, and drew a straight cross on it, suggesting the relationship between illusion and reality. Kim Yong-Ik's *Plane-Object* (1977) was also a two-dimensional object, an image seen from a distance, but a material when seen from a close distance. [8] Their works, which integrated the illusion of wrinkles on the canvas, as well as the wrinkles themselves, exemplify how the response to the three-dimensional art practice at the time was expressed in material-oriented, two-dimensional, planar art. They made objects out of paintings that were previously considered only as images.

On the other hand, the physical changes in the media, a phenomenon caused by each artist's artistic intervention, inevitably led to the creation of works that rendered time as constitutive of form. In such works, more meaningful was the production process itself instead of the immutable results, and such works often require the creative agents' physical actions in creation. In this regard, Kim Kulim presented *From Phenomenon to Traces* (1970), which burned the grass near the Salgoti Bridge in Ttukseom, Seoul, leaving a temporary trace of a triangle on the earth. [9] Lee Kangso tied a chicken to a stake within an exhibition hall, then sprinkled

in Korea in which various objects were temporarily installed with minimal human touch. For instance, with *Counter-Phase* (1971), Ha Chonghyun stacked up pieces of paper cut to mimic the size of newspapers, thereby transforming a two-dimensional material to a three-dimensional work. Such a method allowed the artist to compare the properties of the same materials manifested in different circumstances. Similarly, Suh Seungwon developed the idea of *Simultaneity* (1971) from the window of a *hanok* (traditional Korean architecture). He attached dozens of white traditional Korean paper pieces to fourteen wooden boards, each in a different way, thereby creating individual sculptures that simultaneously embody two and three-dimensional qualities.

9 Kim Kulim, *From Phenomenon to Traces*, 1970,
Chromogenic print on paper, 99×148 cm

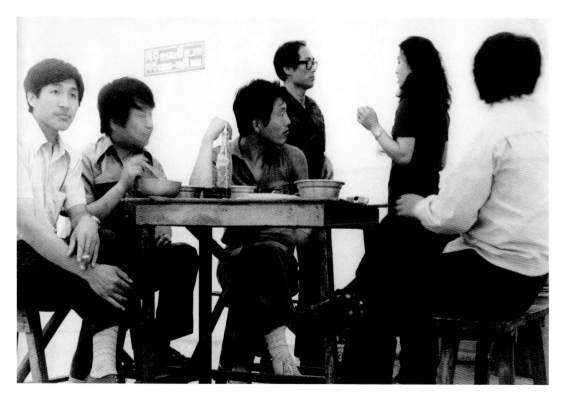

10 Lee Kangso, *Disappearance—Bar in the Gallery*, 1973,
Digital print, 78.7×108.8 cm (10)

EXPERIMENTAL ART: THE BEGINNING OF MOVING BEYOND CONVENTIONAL
GENRES

plaster powder on the floor under the bird, leaving traces of the chicken's movement in *Untitled-75031* (1975). In *Disappearance—Bar in the Gallery* (1973), Lee moved the tables and chairs of an actual bar to an exhibition hall. **10** As a result, viewers experienced a situation in which their act of drinking *makgeolli* and talking instead of appreciating the work became the artwork itself. The title, Disappearance, revealed the nature of the work as "process art," symbolizing the actual time of a fleeting everyday life, not the eternal present pursued in conventional art.

The discussion of the body as an activated art medium during this period prompted some artists of the ST to re-introduce the performance art of the "event" into the Korean art world. Unlike happenings in the 1960s, these events were only held within the art system to overcome the prejudices that occurred, when the happening was widely dismissed as non-art. Among the artists involved in this, Lee Kun-Yong embodied the concept of considering nature as a body through *Corporal Term-71* (1971), which displayed an uprooted tree as it was, and then began creating further events, to turn all daily activities into art in the mid-1970s. For Lee Kun-Yong, performance art was a logical act of art, and that is how his practice of event became named "Event Logical." The acts of Event Logical were both ordinary and never ordinary at the same time, as they were pure acts that served an artistic purpose in themselves, and an event made art driven by the logic of art alone. In *Logic of Place* (1975), Lee Kun-Yong visualized the relative meaning of demonstrative pronouns by drawing a circle on the ground and pointing his fingers to various places. For *Snail's Gallop* (1979), Lee did something very different from the established approach to creating art by drawing chalk lines on the floor in a sitting position and then moving forward to erase them at the same time. The two performances were leading examples of Event Logical. **11**

At this time, many artists thought that the logic of events was linguistic logic that makes you think reasonably and that this logic stems from a body that thinks about the world like a structure of language. For example in *Diction* (1977), Yoon Jinsup placed twelve pictures of his face, pronouncing Korean vowels such as "a," "ae," "i," "o," and "yi" on the upper part of the wall and below, arranged scenes of the characters, written with a mop on the floor, as they evaporated with the water. This activity was designed to reveal a phenomenal world that is recognized only at the moment of linguistic action. **12** In addition, during the event *Yellow Shoes* (1977), the artist put a yellow chrysanthemum, yellow-painted stone and yellow paper in the same-colored envelope and wrote "The shoe color of a woman passing through Sinchon." He wanted to

emphasize that the meaning of the word "yellow" is not necessarily connected to the object it refers to. In other words, he wanted to say that language does not acquire meaning by referring to things. Demonstrating an influence of Wittgenstein's linguistic philosophy and the Korean Zen Buddhism's teaching of the intuitive discernment of Buddhahood, this work represents the main characteristic of "events" in the 1970s.

In contrast, for Chang Sukwon, the event had a tautological meaning that action is action and it had to represent life itself before it made sense. According to him, what doesn't make sense refers to something that remains what doesn't make sense, while embracing what makes sense. As he argued, this is because what makes sense is clearly defined and loses profundity, and all art is formed out of the nonsensical. The event was also used by Kim Yongmin, who was inspired by the Eastern view of nature, as a means of emphasizing the non-purposefulness of repetitive objects and human life. Kim Yongmin squeezed a wet mop several times and finally mopped the floor before he left the stage in *Damp Cloth* (1976). In *Match* (1976), Chang Sukwon burnt matches from a matchbox, one after another, eventually setting fire to the whole box. These were artistic events that did not make sense, through which the artists objectified everyday activities as if they held the activities up to a mirror. Chang Sukwon also claimed, Just as theatrical performances are extremely similar to everyday life and become more theatrical, art and life are one in the same because "event" cannot be disconnected from everyday activities although they belong to art. He then proved this through his own wedding as an artistic performance titled *Marriage Event* (1977). **13** This event was reported in several media outlets at the time, allowing the artist to convey to the mass public an exemplary avant-garde method of thinking that rejected social conventions about marriage.

Photography, meanwhile, was actively used as a conceptual tool for art beyond its function to simply record actions in various "events." Sung Neungkyung had earlier noted the informative attributes of photography and newspapers and the political status of everyday life and incorporated them into the creation of his events. In his photographic installation *Location* (1976), he used various parts of his body to hold a copy of *Space* magazine and realized the concept of tautology with certain acts using photographs, while raising questions about the status of *Space* as the intellectual and cultural powerbroker of the day. Sung Neungkyung also independently attempted to reflect the times using newspapers from 1974, before "event" as art practice started to be staged in earnest. In *Newspapers: From June 1, 1974, On*

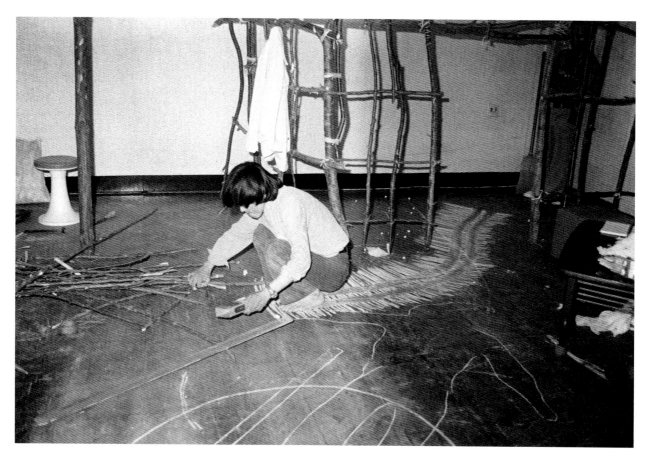

11 Lee Kun-Yong, *Snail's Gallop*, Performed at the *Lee Kun-Yong's Drawing·Event*
(June 10–16, 1979, Namgye Gallery)

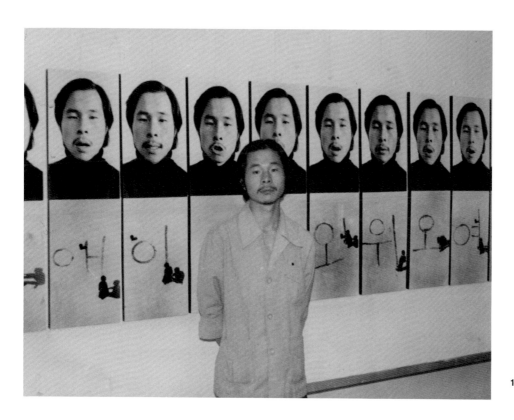

12 Yoon Jinsup, *Diction*, 1977,
Photograph, 90.4×28.2×2 cm

EXPERIMENTAL ART: THE BEGINNING OF MOVING BEYOND CONVENTIONAL
GENRES

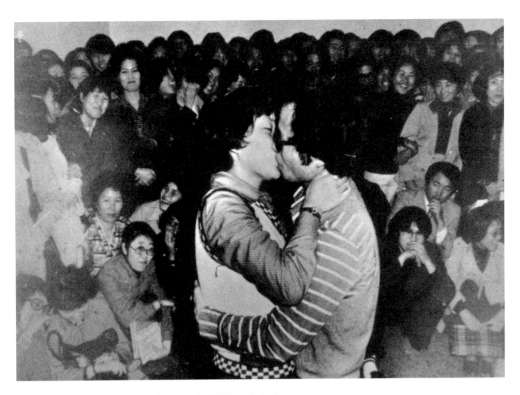

13 Chang Sukwon, *Marriage Event* (February 4, 1977, Seoul Gallery),
Still from the original performance

14 Sung Neungkyung, *Newspapers: From June 1, 1974, On*, 1974,
Acrylic box, newspaper panel, acrylic box: 90×70×65 cm (2), newspaper panel: 87×63×5 cm (4)

(1974), Sung brought each day's newspaper to the exhibition hall for a week and attached them to four white panels. He then clipped articles with a razor blade to throw them into a blue acrylic container, which was reminiscent of the regime's suppression of the press and political power in the 1970s that permeated people's everyday lives. 14 Later, his *Reading Newspapers* (1976) was also an "event" in which the artist read the newspaper article aloud and then cut parts of it out with a razor blade in a direct reenactment of the government's censorship. These works were artistic utterances related to social issues, produced in a way that converted public messages into a private art act.

The ST officially disbanded in 1981, but in November of the same year the first Geumgang Contemporary Art Festival was held (at the white sand beach of the Geumgang River) in Gongju by YATOO (later re-named Korean Nature Artists' Association),9 a collective formed in June 1981. In the Seoul metropolitan area, the first *Winter, Open-Air Art Show at Daesung-ri by 31 Artists* (Gapyeong, Gyeonggi-do)10 was held, and the event continued up until the 1990s. This was the result of artists' new recognition of nature as potential stage for avant-garde artists opposed to perspectives and practices that dominated the urban centers of art production, as "outdoor" (*baggat*) art practices outside the city took place in various parts of the country in the late 1970s. Attempts of genre-shattering in art to overcome the limitations of institutional art led to the emergence of another avant-garde attitude from the 1980s, one that foregrounded the environmental and ecological issues referenced above.

KOREAN EXPERIMENTAL ART AS ALTERNATIVE MODERNISM

Genre-shattering avant-garde art, which emerged in the Korean art world in the late 1960s, gradually developed throughout the 1970s. It was recognized as the origin of installation and performance art, which were major trends in contemporary art. Since then, installation art and performance art continued to be called "experimental art" (*silheom misul*) throughout the 1980s, and their characteristics started to be identified in earnest through related exhibitions and research from the 1990s.11 Leading exhibitions included *Rebellion of Space: Korean Avant-garde Art Since 1967–1995* in August 1995; *Korean Contemporary Art from the mid-1960s to mid-1970s: A Decade of Transition and Dynamics* in June 2001; *Another Aspect: The Contemporaneity of Korean Contemporary Art, Part 2, Part 3* in November 2001; *You Are My Sunshine: Korean Contemporary Art 1960–2004* in October 2004; *Performance Art of Korea 1967–2007* in August 2007; *Korean Historical Conceptual Art 1970–80s: Jack-of-all-trades* in December 2010; and *Renegades in*

Resistance and Challenge in January 2018. Underlying the more recent exhibitions, besides revisiting historical significance of the experimental art, was the intention to discover Korea's alternative modern art movement, one distinguished from monochrome abstract painting, and one that can counteract the dominance of realist art, so that it becomes possible to associate the avant-garde characteristics of postmodern art with the art of an earlier era.

The rise of experimental art (that is, object art, three-dimensional art, happening, and event) in the 1960s and 1970s marked the first full-fledged instance in which genre-shattering artistic practices and related discourses were introduced into the history of Korean contemporary art. This introduction of conceptual production processes and non-material and linguistic features into the Korean art world for the first time gave way to the trend of conceptual art that emerged later. Along with the advent of this art, a new consideration was required to be granted toward the artist's subjectivity, changes in the perception of art, the diversification of forms, the exploration of the relationship between the media's materiality and spatio-temporality, and institutional issues in the Korean art community. In particular, monochrome abstract painting's dominance of the Korean art world as a representative of the new establishment and its preoccupation with Korean tradition—a tendency apparent by the mid-1970s—was without doubt motivated by the rise of experimental art in the previous decade. The terrain of the Korean contemporary art world at the time was formed as a result of the dynamics formed between the two approaches of art. The specificity of Korean modernism in the 1970s is found in the phenomena in which experimental art—which newly emerged as avant-garde art—collided sharply with the existing, established avant-garde practice, as represented by abstraction.

1 The Zero Group's other members included Jin Iksang, who presented electronic music, and Im Dan (Im Myeongjin), who was working as a diplomat. They participated in *Union Exhibition of Korean Young Artists* only.

2 The Sinjeon Group was formed by some members of the Non Col in 1967. Prior to this, the Non Col was formed by students at Hongik University's Department of Western Painting—Kim Inwhan, Han Youngsup, Choi Taeshin, Chung Chanseung, Yang Cheolmo, Nam Yeonghui, Kang Kukjin—in 1964. The Non Col published the journal *Non Col Art* in 1965, and held the first *Non Col Exhibition* that same year. They held the second *Non Col Exhibition* in 1966.

3 The Origin Fine Arts Association was formed by students at Hongik University's Department of Western Painting in 1962. The members were Suh Seungwon, Choi Myoungyoung, Lee Seungjio, Kwon Youngwoo, Lee Sangrak, Kim Suik, Kim Taekhwa, Shin Giok, Choi Changhong, and they held their first exhibition in 1963.

4 When Kwak Hoon, Kim Kulim, and Kim Tchahsup joined the AG, they were members of a group called Painting '68, which was centered around artists from Seoul National University. Painting '68 consisted of Kwak Hoon, Kim Kulim, Kim Tchahsup, Park Heeja, Li Jagyong, Cha Myeonghui, Ha Dongchul, and Han Gisu. They held a *Painting '68 Exhibition* at the Press Center of Korea in Seoul from March 21 to 27, 1968.

5 Lee Ufan was attending the College of Fine Arts at Seoul National University in 1956 before he moved to Japan, where he studied philosophy at Nihon University. While communicating with Quac Insik, a Korean artist residing in Japan, Lee started his artistic activities with an interest in contemporary art, and explored the nature of objects. He held his first solo exhibition at Sato Gallery in Japan in 1967. Starting with his criticism of Nobuo Sekine's *Phase—Mother Earth* in 1968, Lee began to became famous as the critical voice of the Mono-ha group in 1969. That same year, he released critical essays such as "From Object to Being," "Beyond Being and Nothingness: On Sekine Nobuo," "Is Conceptual Art Possible? The Character and Direction of Ideas on the Object." In 1971, he published a book of critical essays called *In Search of Encounter*. Lee's essays started to be introduced to the Korean art world in 1969. "Trends in Contemporary Art Exhibitions" was included in the magazine *Space* in that same year. "In Search of Encounter: At the Dawn of a New Art" was printed in *AG* in 1971, and "The Identity and Place of Object Ideology" was printed in *Hongik Misul* in 1972.

6 When established, the group's official name was "Space and Time Group," and it was referred to as "S.T" in publications, including exhibition brochures. However, the name of the group was mentioned in different ways such as "S.T Society" or "S.T Group" and the art community and the press often marked the same group in different ways, such as "ST" and "S.T." As a result, "ST" has been used more often than the original "S.T" In this essay, the official name of the group is "ST" by accepting surviving members' opinion that they accept the change in the name as a historical phenomenon.

7 In addition to these, genre-shattering, avant-garde art groups formed in the 1960s and 1970s around Seoul, Daejoen, Busan and Gwangju that included WHAT (Seoul, 1967), Ihujakgahoe (Busan, 1968), Esprit (Seoul, 1972), Muhandae (Seoul, 1973), Korean Young Artists' Association (Seoul, 1974), Daegu Contemporary Artists Association (Daegu hyeondae jakga hyeophoe; Daegu, 1975), the 1975 1225 Group (Daejeon, 1975), and Daejeon 78 Generation (Daejeon, 1978).

8 The Daegu Contemporary Art Festival was led by Lee Kangso, an artist who belonged to the AG. Lee was also one of the founding members of Sincheje (New System), an artist group consisting of graduates from Seoul National University's Department of Painting: Kim Changjin, Yoon Geoncheol, Lee Kangso, and Jeon Changun. The Sincheje Group held discussion meetings on modern art from 1968, and had a total of eleven exhibitions. Starting with the first exhibition held at Shinsegae Gallery in June 1970, they had two exhibitions every year until the last, eleventh exhibition, in 1976.

9 Artists who were based in Gongju and the area along the Geumgang River, including Rim Dongsik, Ko Seunghyun, Kang Huijung, Lee Eungu, Hong Obong, Moon Jeonggyu, Koh Hyeonhui, Kim Haesim, Jung Jangjig, Lee Jonghyup, formed this group in 1981 with the idea of projecting the artists' thoughts into nature. They conducted four nature-orientated field trips and research under the name of the Four Seasons Research Society (Sagyejeol yeonguhoe) every year, and since 1983, they have introduced the concept of "nature art" in their works and have explored the path of "ecological art."

10 The members of the *Winter, Open-Air Art Show at Daesung-ri by 31 Artists* mainly consisted of artists from the DAMU Group (Chung-Ang University graduates). They formed the Baggat Art Group in 1985, and Baggat Art Research Society in 1986 before establishing the Baggat Art Association in 1992, and then changed the title of the exhibition into the Baggat Art Exhibition. The Baggat Art Association's activities have continued to date.

11 In the early 1970s, the terms, such as "experiment" or "experimental" were often used in essays or articles introducing Korean contemporary artists beyond the boundaries of the existing art field. Then, from the mid-1970s, some people began to refer to this term to differentiate this new art genre from sculpture and painting (artwork based on the picture plane). On the other hand, others regarded the term as a synonym for avant-garde art and named all avant-garde art trends "experimental art" after the rise of Informel in late 1950s. The term "experimental art" appeared occasionally in art reviews and exhibition titles until the 1990s, and in the 2000s, the term was finally defined by art historian Kim Mikyung and other art officials relative to "Korean object art, three-dimensional art, happening, event, and film in the 1960s and 1970s."

Ink Painting from 1945 to the 1970s: To Inherit or Confront Tradition

Kim Keongyeon

INK PAINTING IN THE LATE 1940S: THE EXPLORATION OF NATIONAL ART AND DEMOCRACY

After the liberation of Korea, ideological confrontations and organizational reshuffling continued in relation to the process of how to establish art in a new independent state. Amid the chaos, the Dangu Art Academy (Dangu misulwon) was formed in September 1945 for the first time as an organization dedicated to ink painters. Except for those considered as pro-Japanese artists, such as Kim Eunho, Lee Sangbeom, and Kim Kichang, there were twenty artists, including Chang Woosoung, Lee Seokho, Chung Chong-yuo, Heo Geon, Lee Geonyeong, and Choi Keunbae, who established the group to straddle the political spectrum, regardless of factions that had existed in the colonial era.[1]

The Dangu Art Academy's first exhibition was held in 1946 to commemorate the 1919 March First Independence Movement. Displayed at the exhibition were Lee Ungno's *Fight*, which features a large-scale protest march, and Chang Woosoung's *Study*, which reminded viewers of the March First Independence Movement by offering the image of a beacon on a mountain. Every member that was part of this movement displayed an effort to establish a 'purely Korean-style painting.' However, the Academy dispersed after its third exhibition. After that, ink painters carried out different activities depending on their position relative to the establishment of a national art (*minjok misul*), which was considered an immediate task in the Korean art world.

As with the general trend in the art world, the establishment of a national art and the eradication of colonial remnants were considered as urgent tasks most people within the various left-wing, right-wing, and non-political groups. However, they had conflicts stemming from their different positions on what remnants of colonial rule should be eradicated and how such an eradication would work alongside the development of ink painting as the national art. In particular, under the framework of 'Eastern' ink painting versus 'Western' oil painting that had developed during the colonial era, modern ink painting had been defined as the genre that naturally inherited the creative mantle of traditional calligraphy and painting. As a result, it is only natural that the discourse surrounding ink painting was sensitive to the renewed focus on tradition, and that which type and nature of traditions should be inherited.

Kim Chukeung, a member of the Korean Artist Federation argued that the tradition of East Asian ink painting was formed under the conceptual influence of feudal period Chinese art, so Korean artists needed to separate themselves from that as soon as possible and switch to a more realistic direction. On the contrary, Kim Yongjun, a member of the preparatory committee of the Association of Joseon Writers (Jeon joseon munpilga hyeophoe), a right-wing cultural organization, cautioned against such dismissals of pre-modern art that might result in the eradication of tradition. Kim Yongjun argued that a nation's tradition has independent and immutable characteristics that transcend social systems, classes, and historical contexts such as feudalism and capitalism, and that these characteristics should be discovered through the history of
Korean art.

This confrontation over the nature of tradition was more evident in the evaluation of literati painting from the Joseon Dynasty. While Kim Chukeung treated literati painting as an amateur activity of the *yangban* class during the Joseon Dynasty, Kim Yongjun said literati painting was a traditional art with the characteristics truest to

Joseon Korea and must be inherited. Originally, the basic principle of literati painting was that the painting is an extension of the art from of calligraphy, carried out by skilled calligraphers and poets. Therefore, Kim Yongjun's argument that literati paintings of the Joseon Dynasty should be hailed as a formative pillar of national art was based on the value of calligraphic brushstrokes in paintings while emphasizing the essential quality of ink rather than qualities such as the daring use of color. Specifically, when discussing the influence of colonial period art practices still found in ink painting after 1945, the use of opaque colors using oyster shell white, or detailed descriptive lines were problematically cited as common elements of Japanese paintings. Therefore, the use of the clear color and concise yet free-spirited brushstrokes that Kim Yongjun cherished quickly emerged as key plastic elements that ink painting was considered to ideally have as a national painting. Kim Yongjun's argument could be called a "new literati painting theory" (*sinmuninhwaron*), which adopted a method of reviving the tradition of East Asian ink painting by selectively choosing or excluding specific materials and techniques. And this theory directly inspired the production of actual works.

Of course, literati painting was not the only traditional art discussed in the process of establishing a national art. Yoon Hee-soon, the chairperson of the Korean Plastic Arts Federation cited portraits and everyday documentary paintings from the Joseon Dynasty as traditions to inherit because these genres were considered as based on realism. For Yoon, the tradition to be inherited had to be art that could achieve the "democratization of art."

Another important axis considered in the process of seeking the development of ink painting, besides "tradition," was the attainment of "contemporaneity." In the art theory of this period that is also referred to as the "liberation sphere," attaining contemporaneity was understood synonymously with the destruction of premodernity, the fight against feudalist traditions, and the establishment of democratic art; it was also connected to Korean art's prospects for global relevance. Artists who remained neutral in the ideologically divided landscape and who focused instead on overcoming the outdated history of ink painting often belonged to the Korean Plastic Arts Federation chaired by Yoon Hee-soon. Representative of such artists were Kim Kichang and Chung Chong-yuo. While looking back at a year in the art world in 1948, Kim Kichang identified the division of the art world as a confrontation between the "antiquated remnants" and the "democratic camp," the latter of which was struggling to construct national art. As such, the goal of realizing democratic art was as important a principle in the creation of national painting as the inheritance of tradition.

People paid great attention to Kim Kichang after he submitted to the Seven Ink Painters exhibition in 1948 a work titled *Blue Sky* (1948) that reflected his stance towards democratic art.[2] Portraying a large group of sparrows attacking an owl in the sky, it has been read as an active embodiment of the reality and struggle of the people. At the same exhibition, Chung Chong-yuo's two paintings of Jirisan Mountain received attention along with Kim Kichang's *Blue Sky*. Of Chung Chong-yuo's two paintings that he submitted, *Sangbongunhae*, which depicted an endless sea of clouds and overlapping mountain peaks rising above them, was praised for attracting viewers to the movement of real society under the clouds. (There is a high probability that Chung Chong-yuo's eight-panel folding screen currently known as *Jirisanjeondo* is in fact the work *Sangbongunhae* that was submitted to this exhibition.) In premodern ink painting, clouds imply poetic elegance and transcendental utopia, while Chung Chung-yuo instead used them as a medium to reflect a moment of huge transformation. The painting is therefore mentioned as an example that overcame the antiquated characteristics of the ink painting tradition.

Kim Kichang and Chung Chong-yuo also received favorable reviews for creating masterpieces corresponding to some of these grand themes, particularly given the great difficulties in securing materials. This is in part because the artists who emphasized democratic art at the time were active in their pursuit of improving the aesthetic life of the public through art education, public exhibitions, art magazines, and mural productions for public buildings. *Eagles* (1948), which Chung Chong-yuo presented at his solo exhibition in 1948, was also a large-scale work in the form of a six-panel folding screen. It leaves viewers with a strong impression of a golden background reminiscent of Japanese screen paintings with its vivid colors and delicate description. **1** Unlike the atmosphere of the art world in Korea, where selecting specific materials and techniques was synonymous with the pursuit of national art, Chung Chung-yuo took the liberty to incorporate various formal tactics and sought a wide range of formal pathways for the contemporary development of ink painting.

The demand for more democratically framed art also allowed Korean artists to gain a new perspective on their relationship with international art. For Yoon Hee-soon, the construction of national art had to be carried out within the context of international democratic culture and it meant that national art should be connected to

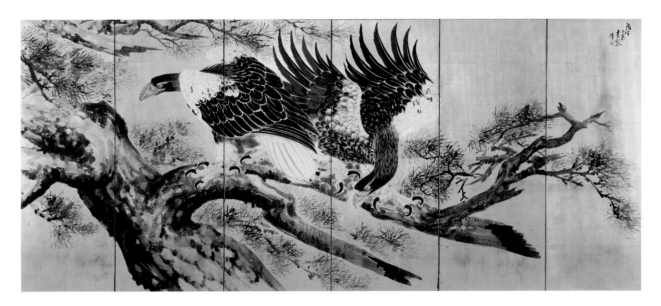

1 Chung Chong-yuo, *Eagles*, 1948,
 Ink, color, and gold on gilt paper, 155×356 cm

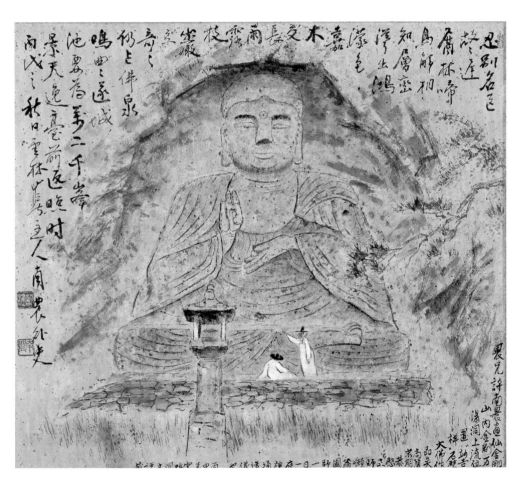

2 Heo Geon, *Appreciation of Mt. Geumgang*, 1946,
 Ink and color on paper, 43×50 cm

ideas of globality without being buried in regional specificity. Chung Chong-yuo also emphasized a method of expression suitable for "a modern citizen breathing a modern breath."[3] Kim Kichang also said that classic art from the East and the West should be studied together to encourage the development of ink painting. Like Yoon Hee-soon, they aimed to create ink painting based on both notions of national specificity and global 'universality.' The proposition of ink painting participating in the development of world art was paused for a while due to the immediate problem of national division, and many artists' going up to North Korea, and then civil war in 1950. After the ceasefire in 1953, however, the ideas of globalism reappeared through the work of Kim Kichang and other established artists who actively accepted ideas from Western modernism.

After 1945, new movements arose not only in the country's central art community but also in the ink painting community outside Seoul. The Honam region, which is centered around Gwangju and Mokpo, was particularly active. In fact, artists in Mokpo, including Heo Geon [2] and Kim Junghyun, actively pursued the development of new approaches to ink painting, for example, by organizing the Mokpo Art Federation together with local oil painters.

The specific use of the term "Eastern painting" (*dongyanghwa*) to stand for "ink painting" was also related to the establishment of national art. As this term was created in relation to Japanese ideas of a common East Asian cultural sphere, propagated during the Japanese colonial period, it was argued that a new term should be used after liberation, and Chung Chong-yuo predicted that the simple term "painting" would soon replace "Eastern painting." In fact, the School of Fine Arts at Seoul National University's College of Art, founded in 1949, used the name "painting," without the specific designations as Eastern painting or Western painting, although this was only for a short period of time. In addition, terms such as "joseonhwa" and "hanwha" appeared, both meaning, essentially, "Korean art." But the National Art Exhibition, when founded in 1949, officially adopted the term "Eastern painting" for ink painting, despite it originating in the colonial period. Furthermore, the Department of Calligraphy, which had been ultimately abolished within the Joseon Art Exhibition during the colonial period, was reestablished within the National Art Exhibition.[4]

The continued existence and practice of calligraphic art under the term "calligraphy" meant that among the various traditional theories that competed in those days, the ink painting and Eastern painting community favored Kim Yongjun's literati painting theory, which progressively re-examined the traditional theory that ink painting was an extension of calligraphy. Chang Woosoung became a professor of art at Seoul National University's College of Art in 1946 along with Kim Yongjun, and sympathized with Kim's literati painting theory, while Kim Yongjun also considered the ink wash portraits that Chang newly attempted as a good model of ink painting. Kim Yongjun's literati painting theory provided the formative ideology of Seoul National University's Eastern Painting Department after the Korean War, and it continuously influenced Korea's modern ink painting community.

INK PAINTING IN THE 1950S-60S: AN ENCOUNTER WITH ABSTRACTION AND MODERNIZATION

Founded in 1949, the National Art Exhibition was the first institution of art and culture created by the Korean government to foster arts and culture in the newly independent country. In other words, this specific institutional platform was deployed for the government to take the lead in solving the issue of establishing and developing national art, an issue that had been raised within the liberation sphere.

The "national traditional style" most cherished in the National Art Exhibition's Ink Painting Department was ink and wash painting with an emphasis on the emotive, subjective use of brushstrokes and ink. From the beginning of the National Art Exhibition paintings with strong colors and meticulous brushstrokes had already been rejected as a form of Japanese-style art, while ink wash paintings had been accepted as the legitimate approach to traditional Korean painting.

Chang Woosoung, who was a judge for the first National Art Exhibition submitted his work *Retrospection* to the exhibition. The painting depicted a portrait of an old man blowing a large bamboo flute with a porcelain vessel in front of him. Chang's student at Seoul National University, Suh Seok in his work *Flower Seller* (1949) portrayed a young man carrying a traditional Korean A-frame carrier filled with flowers to sell to women. Both works were painted in thick, elastic lines and light colors that had not been seen during the colonial period, clearly showing the changes in the ink painting community after liberation. At the fourth National Art Exhibition in 1955, two years after the Korean War, Pak Nosoo's *Woman, Mystic Sound of Tungso*—which sophisticatedly depicted the side of a woman in hanbok in dark monochrome, revealing the contrast of black and white—won the Presidential Award and Chang Unsang's *Cello and Woman* won a Special Selection Award. [3] As these elegant portraits of women continued to win successive awards, ink wash portraits became the

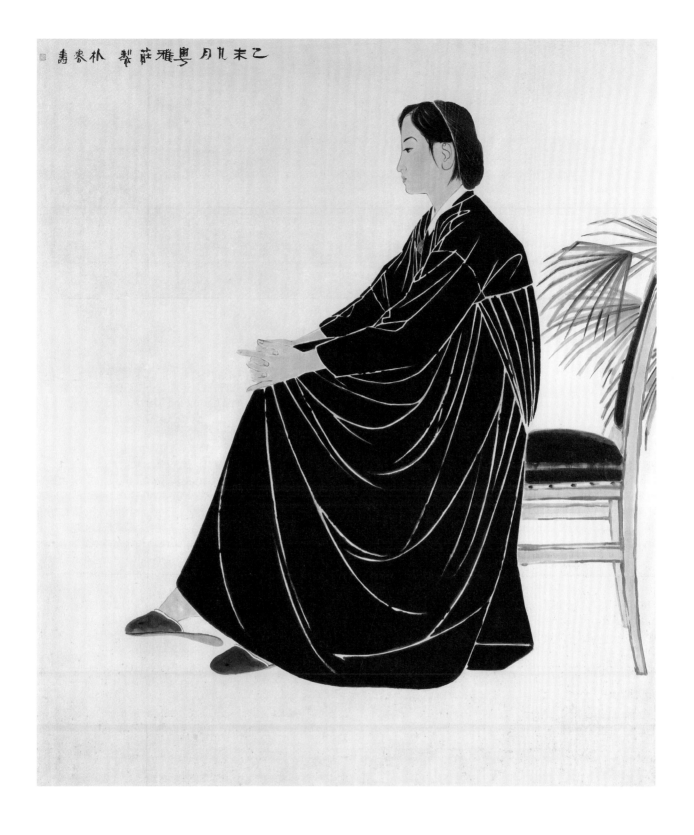

3 Pak Nosoo, *Woman*, Mystic Sound of Tungso, 1955,
Color on paper, 187×158 cm

INK PAINTING FROM 1945 TO THE 1970S: TO INHERIT OR CONFRONT
TRADITION

mainstream of the National Art Exhibition.

Along with ink wash portraits, landscape paintings by artists such as Lee Sangbeom, Heo Geon, Noh Soohyun, Byeon Gwansik, Huh Baeklyun, and Pae Ryom also played an important role in ink wash paintings emerging as the main trend in the National Art Exhibition's Ink Painting Department. In particular, Lee Sangbeom's style which featured landscapes of hills—a sight disappearing because of rapid industrialization—offered a welcome primordial notion of Korea 4 and Byeon Gwansik's style that recreated Geumgangsan Mountain as a dynamic and refined utopia became model approaches, demonstrating a very modern inheriting of national tradition. 5 Other influential approaches within the ink wash genre include Noh Soohyun's landscape paintings, which embodied classical ideas of utopia with a unique formal aesthetic, and works by Huh Baeklyun and Heo Geon, who creatively pursued the traditional Chinese painting manner of the Southern School, centering around the Honam region of Korea. Influenced by these artists, even more ink wash landscape painters emerged, and such artists won a large proportion of the prizes at the National Art Exhibition. Because judges and recommended artists for the ink painting division of the National Art Exhibition were also involved in tertiary education, at different colleges of fine arts, the trends at the Exhibition and within Korean art schools were closely related. As a result, ink wash painting became a dominating trend in the contemporary ink painting community.

Such a way of inheriting tradition, by choosing ink wash painting and excluding color painting, was a response from the Korean art world to the request to preserve an ideal national identity amid the reality of industrialization and Westernization faced by Korean society since the 1950s. After the Korean War, the influence of the United States as a supporter of anti-communism and economic revival was growing day by day in South Korea. Yet, the rapidly introduced American culture also threatened Korea's national identity in cultural terms. Ink painting visually embodied a unique notion of national art to stand against that of modernist Western art, that symbolized the United States. Ink painting as the appropriate form for national art was therefore constantly demanded, so that elite national culture could continue to reflect Korean tradition in its contemporary production.

Chang Woosoung emphasized the inheritance of traditional literati painting and said that the ink painting community in the 1950s tended to be unhelpfully swept up with foreign trends. For Chang Woosoung, modern abstract painting was an art that tried to approach the subjective, transcendent, and spiritual world, in contrast to the rational-centered mechanical civilization of the West that had already exposed its limitations. The world approached by this uniquely Korean approach to modern art was none other than the world of the East Asian traditional art. He reprimanded the ink painting community because it did not recognize the quality of traditional literati painting relative to ideas such as "transcendent spirit" or the "Seon Buddhist worldview," while Western modern art was actually inspired by the philosophical concerns common to traditional East Asian ink painting.[5] He ultimately reached the conclusion that what modern ink painting needed was to return to its essential concerns.

Chang Woosoung's argument, which can be defined as a "new literati painting theory,"

INK PAINTING FROM 1945 TO THE 1970S: TO INHERIT OR CONFRONT TRADITION

offered that modernity was already inherent in the tradition of ink painting, so a return to this tradition would lead to the most modern art. In his 1961 work, *A Shower*, a crane that does not stop beating its wings even in the midst of a driving shower seems to symbolize the idea that traditional painting should continue unwavering even during the deluge of foreign artistic trends. 6 The background of water and the straight and hard legs of the crane strongly contrasted, revealing the beauty of the artist's ink brushstrokes, and this style demonstrated a leading method of inheriting tradition in the 1950s and 1960s.

The trends that Chang Woosoung criticized as the blind pursuit of Western art were precisely the experimental works that established artists such

as Kim Kichang, Kim Youngki, Park Rehyun, and Lee Ungno sought to create. These experimental artists criticized that the limited material of ink wash, and subject motifs such as portraiture and landscape standardized ink painting and caused the tradition to lose its possible quality of freshness and originality. In addition, they argued that ink painting also needed to forge a response to modernity. Or to put it another way, ink painting required a more adventurous approach, in order to "make progress as soon as possible in line with the world's prevalent abstract painting styles."[6] Their efforts to modernize ink painting had a strong tendency to include a wide range of materials and forms, as can be seen from the examples of Chung Chong-yuo and Kim Kichang

6 Chang Woosoung, *A Shower*, 1961,
 Ink on paper, 134.5x117 cm

before the Korean War. However, in the 1950s, as they faced the situation of a Korean art world dominated by the idea that modern art should be abstract, they converted to active experiments with Western modernism that encompassed Cubism, Art Informel, and Abstract Expressionism.

In 1954, the married couple Kim Kichang and Park Rehyun held their fourth couple exhibition in Seoul, where there were still traces of the ruins after the Korean War. The pair's works at this exhibition showed clearly different styles from before the war. Kim Kichang's *Small Store* (1953–55) and *Real Estate Agency* (1953) along with Park Rehyun's works including *Brother and Sister* were created by simplifying people and buildings into geometric shapes such as squares and circles and then dividing them into colored planes for compositions. This approach signaled the start of the pair's abstract experiments. These experiments revealed interest in Cubism, particularly the brown-skinned women in Park Rehyun's 1956 *Open Stalls*, which are reminiscent of the images of women in Picasso's works. 7̄ This work won the Presidential Award at the fifth National Art Exhibition. At the time, it established a rare precedent of an experimental work winning such a prize. Kim Youngki also played a leading role with his experimental ink painting after presenting his 1958 work *March at Dawn*, which depicted herds of cattle walking in a market at dawn in a Futurist style.

Efforts to connect with trends in the international art world were also embodied through the overseas exhibitions of the Paek Yang Painting Association, which was organized by the above artists. The Paek Yang Painting Association was the only organization of ink painters in the 1950s, with nine members including Kim Kichang, Park Rehyun, Kim Youngki, Chun Kyungja, Lee Yootae, and Kim Junghyun. In addition, Paek Yang Fine Art exhibitions held in Taiwan, Hong Kong, Tokyo, and Osaka were the first overseas exhibitions held by a Korean private art organization, and the experience gained from contact with overseas art communities led to an argument among Korean artists about whether to use the term *hangukhwa* ("Korean painting") instead of the existing term, *dongyanghwa* ("Eastern painting"), as means to refer to ink painting.⁷

The Paek Yang Painting Association members' new attempts were made in various ways regardless of genre. One member, Sung Jaehyu, developed a characteristic style in landscape painting, which featured bold composition, relentless brushstrokes, and the intense use of different shades of ink. 8̄ Although not a member of Paek Yang Painting Association, Lee Ungno also sympathized with their ink painting experiments. In his 1955 solo exhibition, Lee presented works that he personally termed "semi-abstraction." Those works captured subjects in bold brushstrokes, and were interpreted as a style that resonated with Fauvism or Expressionism within European art.

Regarding these artists' experimental works, suspicions arose within the ink painting community that they had deviated from the tradition of ink painting, as in the example of Chang Woosoung. However, critics outside this community, such as Kim Byungki and Kim Youngjoo, concluded that they showed admirable effort to reduce the distance between the tradition of ink painting and the art concerns of the present day. Those artists were considered as pioneers, competing with dominant historical precedent in order to modernize ink painting, following a spirit of resistance to tradition.

Interestingly, most of the articles urging ink painting to participate in the more universal concerns of international art declared that it needed to "confront tradition" rather than "inherit tradition," but demanded, in a full circle, the art form also "breath with tradition." In other words, they created a confrontation between two different traditions: "past tradition" that became formalized through meaningless repetition and "today's tradition" that interacted with modern plastic principles.⁸ Those arguments stated that the globalization and modernization of ink painting were based on the logic that a new tradition should be selectively established in Korean art history. That is to say, since the 1950s, the pursuit of modernity in Korea's ink painting community was all about forging a relationship with tradition, regardless of whether to inherit it or confront it. The very origin of this characteristic of ink painting— that it is constantly required to face the difficult problem of "tradition"—can be located in the early twentieth century colonial period, when the realm of painterly art previously considered as simply calligraphy and painting within Korean culture was divided into "Eastern" painting and "Western" painting.

Kim Youngki wanted to suggest a more active connection between Western abstract painting and the traditions of East Asian painting. He said that Art Informel and Abstract Expressionism were "Western painting styles that were being Easternized" because they studied and imitated the calligraphy of traditional literati painting. He mentioned well-known artists such as Mark Tobey, Hans Hartung, and Jackson Pollock, and explained that their works reached the world where "lines themselves became the subject of the composition of the canvas."⁹ In the 1950s, Western abstract artists interacted with Japanese calligraphers, and attempted to create works reminiscent of the cursive writing of literati calligraphy, a tradition

7 Park Rehyun, *Open Stalls*, 1956,
 Ink and color on paper, 267×210 cm

THE TRADITION/MODERNITY DYNAMIC IN THE MODERNIZATION ERA

8 Sung Jaehyu, *Songgye Valley*, 1978,
Ink and color on paper, 33.5×65.5 cm

9 Lee Ungno, *Composition*,
1974, Color on fabric,
220×167 cm

INK PAINTING FROM 1945 TO THE 1970S: TO INHERIT OR CONFRONT
TRADITION

10 Chun Kyungja, *Gate of the Springtime of Life*, 1968,
Ink and color on paper, 145×89 cm

possessing a shared affinity with the cursive script of traditional calligraphy or the bold brushstrokes common to ceramic decoration. After settling in France, Lee Ungno developed a new approach toward the creation of abstract lettering based on the reinterpretation of the literati notion that painting is part of calligraphy. **9**

To select the specific practice of literati painting, characterized by quality of brushstroke and use of ink, out of the many kinds of art historically produced in East Asia, and make it the representative traditional genre of Korean elite visual culture, had the consequence of further continuing the exclusion of vivid and dynamic "color painting" from this self-conscious process of modernization. In this respect, from 1945 up until the 1970s, Korean ink and color painting was pejoratively considered a style influenced by Japanese painting (*nihonga* more specifically) and was excluded from the idea of traditional painting that was deserving of contemporary continuation. In addition, the controversy surrounding ideas of "tradition" and "modernity" was another important rationale that caused color painting to remain in the non-mainstream of the ink painting community until the 1970s. This is because it was considered that the realistic and detailed description and decorative effect of color painting was distant from the aesthetic and conceptual concerns of abstract art. Rare cases in which ink and color paintings received attention were those such as Chun Kyungja's paintings, which expressed the artist's autobiographical world through a figurative surrealist manner, and Park Rehyun's color abstraction, which was produced through experiments with various materials and techniques. The modernist sensibility clearly displayed in their works likely also played an important role in such positive evaluations of their work. **10**

In the 1960s, particularly among the young artists who had received professional university education in the post-liberation period, the movement to pursue the modernization of ink painting took center stage. While there were works created earlier in the 1950s, which showed the influence of Matisse and Surrealism, such as Kwon Youngwoo's *Glance of Atelier* (1956) and *The Fantasy of the Beach* (1959). The difference between the 1950s and the 1960s, however, is that by the 1960s such exploration was carried out en masse.

Suh Seok and Kwon Youngwoo were part of the first class that entered Seoul National University's College of Fine Arts. When new postwar abstract art represented by Art Informel spread in the Korean art world in the late 1950s, Suh organized the Mook Lim-Hoe collective together with other artists such as Min Kyoung-Kap, Chung Takyoung, and Chun Youngwha in 1960, claiming to be the

which had a great influence on the development of Abstract Expressionism and Japanese avant-garde calligraphy, respectively. Kim Youngki's argument shows that the Korean ink painting community was also carefully observing this trend within the international art world.

Lee Ungno held an exhibition to commemorate his departure for Europe in 1958. The critical evaluation of this exhibition in the Korean art world also shows how Korean artists and critics were trying to understand the Western abstract art by linking it to traditional Korean art. Critics viewed Lee Ungno's works, which were filled with improvised and rough brushstrokes, such as *Pulse*, *Seabed* (1950s), *Growth*, and *Secret Garden*, all produced in the late 1950s, as similar to Art Informel, while at the same time explained these works as

"first avant-garde group" in the Korean ink painting community.

Mook Lim-Hoe held the first Mook Lim Art Exhibition in March 1960. Within were presented works full of rhythmical lines and symbolic images, including Suh Seok's *Twilight on Address No. 0* and Min Kyoungkap's *Yeongeoui Yeo*. The collection of Mook Lim-Hoe members' works on paper was considered as critically impressive, particularly in relation to the artists' use of ink-spreading effects and their free-spirited ink brushstrokes. This trend emerged as an important change within the National Art Exhibition's Ink Painting Department, particularly as reform of the Exhibition was underway at this moment. [11] Furthermore, in 1962, at the eleventh National Art Exhibition Ahn Sangchul's *Spirit-62-2* was displayed. This work created a critical sensation relative to its experimental use of abstraction in a different way to that pioneered within the Mook Lim-Hoe. [12] Ahn's work, which featured stones attached to a three-dimensional canvas, incorporated real-life objects, and further developed an approach he had worked with an entry for the previous National Art Exhibition, *Dream of Spring* (1961), in which small stones were attached to a canvas composed of expressive brushstrokes.

The type of abstract ink painting that emerged through the National Art Exhibition in the early 1960s led to further experiments within the genre. Up until the 1950s, such innovations had only been attempted by few established artists, but now they spread more widely and amongst the younger generation of ink painters. Following the idea of 'the modernization of ink painting,' young artist groups such as Chongto-hoe and Shin Soo-hoe were organized in 1963. In 1967, the Korean Painting Group (Hanguk hwahoe) was launched, consisting of graduates from Seoul National University's Ink Painting Department. They succeeded Mook Lim-Hoe. In their group exhibitions, abstract works using various materials and techniques such as ink, color, and assemblage and collage were displayed together.

In addition to such group exhibitions, other important venues for abstract ink painters in the 1960s to present their works were international and overseas exhibitions. This started with *Paek Yang Fine Art Exhibition* in Taiwan, and there were more opportunities for going abroad than before through events such as the São Paulo Biennale, the Tokyo Biennale, and the *International Festival of Painting at Cagnes-sur-Mer* in the 1960s. Among ink painters, mainly abstract artists—such as Suh Seok, Kim Kichang, Park Rehyun, Lee Kyusun, Lee Ungno, and Chung Takyoung—gained opportunities to participate at such events. For instance, Ahn Dongsook's submission to the tenth São Paulo Biennale in 1969 was an experimental work using a straw mat collage, and it drew critical attention for its original use of material and technique. [13]

Such experiments by the ink painting community were generally positively received as an encouraging phenomenon, and an appropriate response to the demands of the period. However, many critics held the position that these attempts were mere experiments with the introduction of new materials and their effects, and that they deviated "from the limits of expressions that could be considered as ink painting at the minimum level."[10] As such, the formal experiments aimed at creating "modern" ink painting led to serious questions about the limits of ink painting, and when such work could no longer be accepted as such, as well as questions about the identity of ink painting in general.

INK PAINTING IN THE 1970S: THE EXPLORATION OF HANGUKHWA AND THE DISCOVERY OF NEW TRADITION

In the 1970s, the tradition of Korean art was more actively reexamined. The Yushin Constitution declared in 1972 conducted a policy to protect and foster traditional art as a way to promote the legitimacy of the presidential administration. Furthermore, regardless of whether ink or oil painting, contemporary art was increasingly required to visually demonstrate its links to the tradition of national culture, which was now officially framed as the spiritual driving force for national modernization.

The successful implementation of the Five-Year Economic Development Plans, which started in 1962, also affected the ink painting community. Although there were limitations to the high growth, which was mostly centered on large companies, rapid national economic growth laid the foundation for a surge in the consumer demand for art that led to the formation of a full-fledged national art market. In fact, the boom of the art market in the 1970s was characterized by a focus on antiques and ink painting, as indicated by the expression "ink painting boom." One important reason that antiques drew attention was that Japanese visitors to Korea rapidly increased after the establishment of diplomatic relations between Korea and Japan in 1965. It was also during this period that new light was shed upon folk craftwork and folk painting. Among ink painting, traditional landscape compositions, Taoist and Buddhist figure paintings, and decorative color paintings were favored in the art market. This new situation also significantly influenced the ink painting community of the period. Combined with such social and economic factors, the ink painting community was strongly encouraged to "inherit

11 Suh Seok, *Work*, 1962,
Ink and color on paper, 176×106 cm

13 Ahn Dongsook, *Affection of Immemorial Antiquity I*, 1969,
Woven rush mat, color on fabric, 168.5×122.5 cm

12 Ahn Sangchul, *Spirit-62-2*, 1962,
Stone, ink and color on paper, 40×135×20 cm

THE TRADITION/MODERNITY DYNAMIC IN THE MODERNIZATION ERA

tradition" in the 1970s perhaps more than ever.

Shim Kyungja and Lee Youngchan won a Special Selection Award in the non-figurative category of ink painting, and the Presidential Award in the figurative category at the twentieth and twenty-first National Art Exhibitions in 1971 and 1973, respectively. Despite their different styles, one abstract and the other figurative, the two artists were commonly evaluated as pursuing Korean aesthetics in their work. Aside from genre, material, technique, and a new diversity of subjects, a link to tradition was considered an essential element for ink painting in the 1970s.

Lee Youngchan's *Autumn Wind and Mountain Peaks* (1973) shows the overwhelming power of precise brushstrokes, revealing a modern sensibility while following a traditional landscape painting style. 14 Furthermore, he reimagined Seoraksan Mountain as a space that represented the beauty and strength of the country, while successfully inheriting the plein-air landscape manner of Lee Sangbeom and Byeon Gwansik. Lee Youngchan's way of continuing established painterly tradition was to develop new and characteristic brushstrokes unique to the artist in the portrayal of "real" national landscapes. This method illustrates that due to the influence of abstract oil painting, there emerged a tendency to emphasize the expressiveness of brush and ink in ink wash landscape painting. In this respect, young landscape painters in the 1970s, such as Ha Taejin, Kim Dongsoo, and Cho Phyunghwi sought to create ink wash landscape paintings featuring grand brushstrokes based on their experience of practicing abstract painting in the 1960s.

Shim Kyungja's *Annual Ring* (1971) received the Minister of Culture and Information's Award at the twentieth National Art Exhibition in 1971. This work was a collage of rubbings made from objects like wooden rice cake patterns from the Joseon Dynasty and the annual rings of a dead tree 15 The rubbed copies of old things and natural objects all served to remind viewers of the traces of time, and they were naturally connected to traditional imagery. Among those artists who attempted an

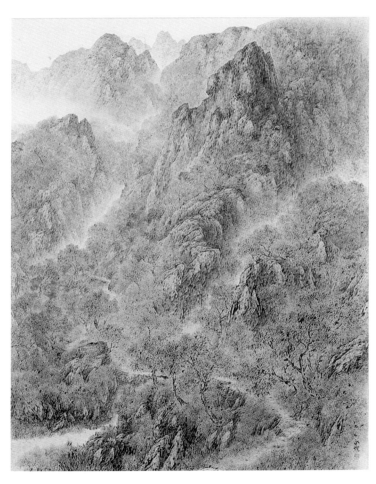

14 Lee Youngchan, *Autumn Wind and Mountain Peaks*, 1973,
Ink and color on paper, 162.8×132.4 cm

INK PAINTING FROM 1945 TO THE 1970S: TO INHERIT OR CONFRONT
TRADITION

15 Shim Kyungja, *Annual Ring*, 1971, Rubbing, collage,
Ink and color on paper, 213×152 cm

abstract approach to ink painting in the 1970s, there was a preference for the method of applying the images of natural objects like dead trees and rocks and different folk goods such as earthenware, wooden rice cake patterns, earthen wall, lattices, and corroded bronze ware. In addition, there were also cases of artists creating works based on historical mural images, just as Oh Taehagk and Lee Jongsang did.

Shim Kyungja won the newly established non-figurative ink painting award in 1970 at the National Art Exhibition. As the number of artists experimenting with abstraction in Korean art gradually increased, they came to ask the National Art Exhibition to provide a separate venue for abstract artists around the late 1960s. Then, finally in 1970, the National Art Exhibition's Ink Painting Department was divided into figurative and non-figurative (abstract) categories, and from that year on abstract ink paintings started to win awards, drawing attention this manner of work. One such award-winning painting was *Tathagata* (1970) by Lee Kyusun. He also won a Special Selection Award

by submitting in 1971 *Afterimage*, painted that year, in which the vivid red and geometrically divided surface of the pictorial space was considered unique. When the non-figurative category was newly established, abstract-style paintings that had not been found in the existing ink painting community appeared to have been submitted due to the expectations for the newly launched category. This reflected the influence of geometric abstract art from within the Korean oil painting community.

Official approval for abstract ink painting from the national art salon in turn caused disputes about the identity of ink painting. In particular, such disputes were connected to the term "Hangukhwa" in the 1970s, something which led to even bigger issues. Abstract artists, who advanced onto the international art scene with more regularity and confidence than figurative artists, nonetheless faced the challenge of demonstrating "modernity" and a "properly Korean identity" simultaneously to audiences abroad. In an ironic twist, while experimental, anti-traditional works were considered to show little differentiation from Western painting, traditional and ink works were considered more novel and innovative.[11] Therefore, there emerged an initiative to label ink painting simply "Hangukhwa" in order to solve the dilemma presented within international contexts of exhibition.

From the 1960s Oh Kwang-su had been concerned that the formal experiments within ink painting were beyond the framework of what be considered acceptable within the genre, and therefore noted that while abstract ink paintings might be considered universal "paintings" influenced by Western abstraction, they could not be considered as examples of "Hangukhwa" that inherited a Korean tradition.[12] Amid the widespread social atmosphere emphasizing the identity and independence of national culture, it was difficult to avoid the criticism that insistence on the contemporary idea of the universality of painting in the end offered only an imitation of modernist Western art.

Apart from the question of whether it is reasonable to consider abstract works of ink painting as "Hangukhwa," the voices demanding that ink painting should be Korean painting, that is to say a painting with the proper characteristics of Korean art or a unique Korean identity, gradually became stronger. When there were terms like "Japanese painting" and "Chinese painting," the imperativeness that the term "Hangukhwa (Korean painting)" should also be used was continuously raised. Then, in 1982, "Hangukhwa" finally came to be officially used. As such, in the process of starting with the idea of "Eastern painting" and ultimately finding "Hangukhwa," folk painting and "true view" landscape painting were critically

reevaluated, and added to the existing ideas of literati painting as worthy examples of the nation's traditional painting.

In the late 1960s, academic studies focused on the Practical Studies (*silhak*) and the growth of common people's consciousness in the late Joseon Dynasty emerged in the disciplines of history and Korean literature. As a response to this, the field of art history also experienced a slew of research on the "true view" landscape painting of the late Joseon Dynasty. "True view" landscape painting was reexamined as a painting style that adhered to a strong national spirit against an influx of Chinese culture in the late Joseon Dynasty. Posthumous exhibitions of artists such as Lee Sangbeom, Byeon Gwansik, and Noh Soohyun held in the 1970s also played a role in raising the consciousness of reevaluating traditional landscape paintings. In those days, established artists in the Eastern art community, mostly in their 40s, tried to express their surroundings and real-life impressions, just as Jeong Seon and Kim Hongdo had done so in the late Joseon Dynasty. Their works showed not only a famous mountains like Seoraksan, and quiet, old Buddhist temples, but also a high-rise observatory and cable car as in Lee Jongsang's *Namsan* (1977) and lyrical descriptions of modern urban landscapes as in Kim Hoseok's *Time and Space 79* (1979). And these new landscapes were soon labelled as the "true view" landscape painting of the contemporary age.

Folk painting, which was often in the spotlight in the art market throughout the 1970s, was also presented as a traditional art that retained the identity of national culture. As discussed earlier, traditional folk crafts were notably collected by foreigners, including Japanese tourists in the late 1960s. It is also around this time that the term "folk painting" (*minhwa*), first used by Yanagi Muneyoshi in the late 1920s, reappeared. Later, folk painting collectors and researchers such as Cho Jayong, Kim Hoyeon, and Kim Cheolsun became prominent, and many folk painting exhibitions and related books emerged. Those collectors imposed the notion that folk painting was an art form that contained the original aesthetic consciousness of the Korean people, and that these works were unlike works by court painters and aristocrats influenced by Chinese painting, and as they offered, this type of art represented the "origin of Hangukhwa." There were also some artists who collected folk paintings. Among ink painters in particular, Kim Kichang showed a notable interest in folk crafts and folk painting from 1945 onward. In the 1970s, he actively introduced folk painting elements in his works. For instance, *Dawn Bell* (1975) follows the free composition and simple expressive method of folk painting. **16** Kim Kichang's works in the

folk painting style influenced other ink painters including his students, and a number of artists adopted folk painting elements regardless of whether they were figurative or abstract artists. The new awareness of folk painting also served as an opportunity for the reevaluation of the use of color within the ink painting community. Various traditional color paintings, including shamanic painting and Buddhist painting, also began to be newly included in the category of traditional art to be inherited.

The 1970s was a period when the "inheritance of tradition" and reexamination of traditional painting were more important than ever in the ink painting community. At the same time, however, ink painters began to address and include various subjects, materials, and techniques that were not previously seen, as can be seen in the reevaluation of traditional color painting and the subject matter of new urban scenery appearing within their work. Demands for painting with a Korean identity, or "Hangukhwa," flourished, and the pursuit of tradition was emphasized. This situation served as an opportunity to instill greater diversity into the ink painting genre. Moving on toward the specific framework of Korean painting in the 1980s, formative experiments with ink painting expanded further, leading to new thoughts on the concepts of what constituted authentic East Asian and Korean painting.

16 Kim Kichang, *The Sound of Dawn Bell (Yard of Mountain Temple)*, 1975, Ink and color on silk, 51×55 cm

1 "Dangumisurwon seolchi" [Establishment of Dangu Art Academy], *Maeil Sinbo*, September 26, 1945. Generally, the founding members of the Dangu Art Academy are widely known to be nine people including Kim Youngki, Chang Woosoung, Lee Ungno, Lee Yootae, Chung Chincheol, Jeong Honggeo, Cho Yongseung, Cho Joonghyun, and Pae Ryom. However, these artists seem to show the list reorganized centering around those who had presented their works at the Academy's first group exhibition to commemorate the March First Independence Movement in 1946 (Kim Youngki, Pae Ryom, Lee Yootae, Lee Ungno, Chang Woosoung, and Jeong Honggeo). When it was formed right after liberation, in addition to the previously known artists, many more artists, such as Lee Geonyeong, Jeoung Unmyoun, Chung Maljo, Chung Chong-yuo, Lee Seokho, Lee Palchan, Park Wonsu, Shim Euntaek, Shim Hyeongpil, Oh Juhwan, Choi Keunbae, and Heo Geon joined, which shows that these artists wanted to make a group that truly represented the ink painting community. As for the first group exhibition of the Dangu Art Academy held in 1946 to commemorate the March First Independence Movement, see An Seok-ju, "Dangumijeonpyeong" [Review of Dangu Art Exhibition], *JoongAng Ilbo*, March 10, 1946.

2 *Seven Ink Painters* was an exhibition held at Dong Hwa Gallery from September 25 to October 1, 1948. Kim Kichang and Chung Chong-yuo as well as some other members of the Korean Plastic Arts Federation such as Lee Seokho, Lee Palchan, and Park Rehyun, and non-members Cho Joonghyun and Lee Geonyeong, exhibited their works. The artists who participated in this exhibition opened the Eastern Painting Research Institute (Dongyanghwa yeonguso) near Namsan Mountain, Seoul, in December 1948. Today, there are surviving works that show the friendship of ink painters within the newly liberated land. One of these is Chung Chong-yuo's *First-birthday Party of Baby Kyoung-in* (1949), which depicted the first birthday party scene of Lee Ungno's granddaughter. Materials related to the *Seven Ink Painters* also allow us to guess about the exchanges between established ink painters in those days. Works exhibited at *Seven Ink Painters* are mentioned relatively in detail in Heo Gung's "Dongyanghwawa sidaeuisik: Dongyanghwa 7injeon pyeong (sangha)" [Eastern Painting and Zeitgeist—Review of Seven Eastern Painters Exhibition (1 & 2)], *Kukje Sinmun*, October 3 and 5, 1948.

3 Chung Chong-yuo's suggestion that they replace "Eastern painting" (*dongyanghwa*) with "painting" was well revealed in his review of Kim Youngki's work in 1949. Chung Chong-yuo's "Gimyeonggissi gaejeonpyeong" [Review of Kim Youngki's Exhibition], *Kyunghyang Shinmun*, March 16, 1945. Kim Hwakyung is the best-known artist who proposed the term "hanhwa." Kim Hwakyung, "Dongyanghwaroseoui hanhwa" [Hanhwa as Eastern Painting], *Kyunghyang Shinmun*, January 14, 1950.

4 Chang Woosoung, "Dongyangmunhwaui hyeondaeseong" [Modernity of Eastern Culture], *Hyundai Munhak*, February 1955, 32–35.

5 A leading artist who insisted on the use of "Korean painting" was Kim Youngki. Kim played an important role in spreading this term by continuously contributing articles featuring this argument to newspapers from the 1950s.
Kim Youngki, "Hyeondae dongyanghwaui seonggyeok: Sigeupan hanguk gukhwaui surip" [Characteristics of Modern Eastern Painting—Urgent Need to Establish Korea's National Painting Style], *Seoul Shinmun*, August 5, 1954; "Gaecheokdoeneun hyeondae hangukwa: Unbo gimgichang bubujeoneul bogo" [Modern Korean Painting

That Are Being Pioneered—Reviewing the Couple Exhibition of Kim Kichang and His Wife], *JoongAng Ilbo*, May 16, 1956. "Hoehwaui myeongchinge daehayeo" [About the Names of Painting Styles], *Seoul Shinmun*, December 11, 1958. "Dongyanghwaboda hangukwareul" [Korean Painting Rather Than Eastern Painting], *Kyunghyang Shinmun*, February 21, 1959.

6 For example, sixty-one works by three deceased artists (Lee Sangbeom, Byeon Gwansik, Noh Soohyun) and three practicing artists at that time (Kim Kichang, Chun Kyungja, Suh Seok) were introduced within four European countries—Sweden, the Netherlands, West Germany, and France—over nine months (from October 1977 to July 1978) through the *Traveling Exhibition of Contemporary Korean Ink Painting*. Regarding this exhibition, European reviewers felt that traditional ink wash works were noteworthy, but offered a more reserved evaluation in relation to the works that showed a style similar to Western modernism. In addition, it can be understood in the same context that Song Soonam—who had attempted colored landscape paintings using intense primary colors such as blue and red—returned to ink wash landscape paintings after an invitational solo exhibition held at the Museum of Far Eastern Antiquities in Sweden in 1975.

Monochrome or Dansaekhwa: The Making of Contemporary Abstraction in Combination with Korean Tradition

Kwon Young-jin

NATIONAL MODERNIZATION AND THE ESTABLISHMENT OF NATIONALIST TRADITIONS

In the 1970s Korea witnessed remarkable changes brought by the success of the Five-Year Economic Development Plan, which had been under way since the 1960s at rapid pace. Taking power after the May 16 military coup d'état in 1961, the Park Chung-hee regime declared the urgent intention to promote exports for the reconstruction of the country, and launched the Five-year Economic Development Plan in 1962. This first, and then subsequent second Five-year Economic Development Plans resulted in average annual growth of an extensive 9 percent. In the 1970s, the country's dream to engage in both export and import markets came true relative to the so-called "miracle on the Han River." New cities were constructed and people from rural areas flooded into these urban zones. In the late 1960s, Western popular and mass culture and sites of consumption began to flourish across major cities, and the growing urban middle class was positioned to benefit from high economic growth. On the other hand, risk factors for social conflict and anxiety caused by rapid industrialization and Westernization—such as the soaring urban population, the gap between the urban rich and the rural poor, dire labor situations and insufficient housing—also increased.

The Park Chung-hee regime, which had successfully led economic development in the 1960s under the banner of "national modernization," pushed ahead with a constitutional amendment allowing the incumbent president—Park himself— to run for three consecutive terms in 1969, continuing his tyrannical dictatorship into the second half of his eighteen-year rule. In April 1971, Park retained power in the seventh presidential election, then declared a state of national emergency at the end of the year and announced the unveiling of the Yushin Constitution on October 17, 1972. The Yushin Constitution used the slogan "Korean-style democracy" to embrace Western 'liberal' democracy with a flexibility that accommodated Korea's unique situation of de-facto dictatorship. It granted sweeping executive and legislative powers to the president beyond the constitution, relative to the declaration of a state of emergency, and thereby effectively allowed the president to stay in power for life. The Park Chung-hee administration, which had sought long-term power based on the principle of economic development, then lost public support with the declaration of the Yushin Constitution and moved quickly to force an extension of power and totalitarian control of long-term dictatorship. Throughout the 1970s, the garrison act, martial law, and emergency measures were repeatedly introduced, and resistance from protesting citizens continued.

Export-oriented industrialization policies in the 1970s, which had relied on foreign capital and cheap labor, also started to reveal their limitations. Labor disputes took place in many places and the marginalization of the urban poor emerged as a serious social problem while many export-dependent companies went bankrupt due to the oil crisis and the decline in free trade. On top of that, the dispatch of Korean troops to Vietnam and the continued military standoff between the two Koreas functioned to keep the Cold War as a central issue within national politics, and one which dominated the organization of Korean society in the 1970s through a rigid security system.

In the 1960s, as the country entered into mass industrialization in earnest, many of the "outdated old things" which had been dismissed as bygone conventions to be dispelled as soon as possible, often reemerged as beautiful "traditions"

1 Park Seobo, *Ship Export*, 1973,
Oil on canvas, 195×303.3 cm

that should be carefully preserved. In the 1970s, the regime established a strong nationalist system centered on the president, reorganizing various arts and cultural institutions and implementing various policies privileging traditional Korean culture. In 1968, the Ministry of Culture and Public Information (hereinafter Ministry of Culture) was newly formed and was dedicated to the preservation and propagation of traditional culture.[1] Led by the Ministry of Culture, the Five-year Cultural Property Development Plan (1969–74) and the first Five-year Literary Revival Plan (1974–78)—similar to the Five-year Economic Development Plan—were established to implement long-term, systematic policies in support of traditional culture to emphasize the greatness of Korea.[2] Accordingly, cultural heritage sites and relics nationwide, including the Hyeonchungsa Temple, were restored and refurbished, and a total of 15 statues of patriotic ancestors were built in Seoul, Suwon, and Daejeon. The National Documentary Painting project, which had been partially implemented under themes such as "Participation in the Vietnam War" and "The *Saemaul* (New Village) Movement" since 1967, started to operate as a massive "Five-year National Documentary Painting" project in 1973. This functioned to support work in five areas, including the economy, historical legacies, great achievements in saving the country, and culture, until 1978. As a result of this initiative, ninety-fine large-scale paintings (290.9×218.2 cm) were produced and shown to the public. ⬛1

The regime's policies on traditional culture in the 1970s were driven by ideas of self-defense,

national security, and national consensus. They were based on an ideology of militarism, nationalism, and anti-communism, as well as offering a means of cultural governance that would emphasize the legitimacy of Park's prolonged rule and control unfavorable public sentiment in the 1970s. However, even everyday citizens recognized the pressing need for new cultural forms based on the reality that everything had changed due to rapid industrialization, and this concern led to widespread efforts to re-examine and discover national culture across all social strata. Amid the rapid spread of Western popular and mass culture, traditional landscape paintings depicting Korean mountains and streams were reevaluated, and new attention was paid to folk painting and "true view" landscape painting. Efforts to revive traditional forms of performance, like agricultural rituals (*madanggut*) and mask theater (*gamyeongeuk*) were actively under way.

In the 1960s and 1970s, when the regime's policies on traditional culture were strongly implemented, paintings of traditional themes and subjects were common at the National Art Exhibition, while the collection and appreciation of folk crafts such as white porcelain and wooden furniture was booming through sites such as the antique markets of Insa-dong in Seoul. In short, a renewed interest in national culture in the 1970s meant that the idea of "tradition" was now defined in relation to the mainstream issues of contemporary existence. It was identified as the "spirit" that would help revive the life of Koreans—a life that was considered to be quickly changing

and lost due to Western industrialization and urbanization. It was also recognized as a valuable domain of cultural heritage that required collection and preservation, or to be highly-priced then bought or sold, and the essence of a distinctly Korean national culture that need to be constantly reenacted through historical genres such as folk paintings, open-air performance, mask dance, and folk music.

MODERNIZATION OF KOREAN ART: THE EMERGENCE OF MONOCHROME PAINTING

Abstraction once again emerged as the task of the moment for Korean artists in the 1970s. In the immediate context of the postwar liberal polity, abstraction was seen as a synonym of contemporaneity, and the establishment of Korean contemporary art was considered an urgent task in the art world—as unquestionable as the modernization of the country. The postwar Korean history of abstract art began with Art Informel in the late 1950s, moved onto geometric abstract art in the late 1960s, and arrived at the third wave, one largely composed of white, fully abstract painting in the mid-1970s. The abstract art of the 1970s, commonly referred to as "monochrome painting," insisted on two coexisting aims: participation in the contemporary international art world and the exploration of what is distinctly Korean. In monochrome painting, white and restrained achromatic colors were proposed to represent national identity, while repeated acts of inaction served to universally confirm the flatness of the painting genre. Ultimately, this focus on action (or inaction) served to consolidate the idea of painting as the most suitable site for an individual artist's expression of their internal discipline.

3 Lee Ufan, *From Line*, 1974,
Stone pigment on canvas, 194×259 cm

In the late 1960s, the enthusiasm in Art Informel (or so-called "hot abstraction") dissipated, while bold initiatives like geometric abstract art 2 and post-painterly, anti-art activities were unfolding in earnest, but with not much clarity for their future directions. As information about the Western art world began to directly arrive in Korea, rather than through the intermediary of Japan, Korean artists and critics began exploring more a diverse range of art criticism and theory. In particular, the theories of modernism, introduced through the U.S., deepened the understanding of the practice of abstract art after Art Informel. From the 1960s Korean artists also continued to participate in international exhibitions such as the Paris Biennale,[3] and the São Paulo Biennial,[4] allowing them to access information from the international art community more directly. However, numerous critiques that Korean contemporary art was superficially imitating and following Western art persisted. This was especially

true in the 1970s, with the growing reflection that Korean art was losing its presumed unique identity due to rapid Westernization. Thus, returning to tradition and the particular need to rediscover Korean traditions were considered as an important task of the moment.

Meanwhile, the 1965 signing of the Normalization Treaty with Japan saw resumed exchanges between Korea and Japan, which had been cut off from each other for 20 years. As a result, it became more frequent for Japanese art world participants to visit Korea and a lot more exhibitions of Korean artists were held in Japan. Japan had rapidly developed in the 1960s after overcoming the chaos that followed defeat in World War II, and it served as a useful local bridgehead for Korean artists eager to internationalize Korean art and to test Korean art's international credentials. Lee Ufan, who moved to Japan in 1956 and encountered post-war contemporary art there earlier than many other Koreans, produced works

and writings from Japan that would be introduced to Korea in the late 1960s, making a significant impact on both the Korean and Japanese art worlds. Lee Ufan, had majored in philosophy in Japan, and criticized modern Western civilization's base in phenomenology and structuralism, paying particular attention to Kitaro Nishida's "The Logic of the Place of Nothingness and the Religious Worldview" as an East Asian idea with which to overcome the international hegemony of modern Western cultural and social ideas.

> For human beings to perceive the world may mean that the body is a "corporal term" of the world, a term through which a person feels empathy, reality, and unity. Therefore, it would be self-evident that the body perceives the world through the intuition of seeing and feeling one another. In this case, intuition is about seeing faster than the eyes, and grasping deeper than the hands; it is an awareness of simultaneity between the world and human beings, and the encounter between the body and the world in absolute unity. Put another way, it's an encounter where the body is completely united with the world. Nishida's idea, "Intuition is not about quietly reflecting on things as if looking at them with the eyes, but rather about the subject and the object becoming one singular pure movement," infers an encounter based on physical perception as a medium.[5]

Introduced in Korean, within the publication *AG* in November 1971, Lee Ufan's essay "In Search of Encounter" became the origin of the Korean art world's deep interest in the ideas and work of Lee Ufan, reinforcing the theoretical foundation of contemporary art and reminding people of the need to rediscover Korean traditions and specific East Asian aesthetic concerns. Lee Ufan's "art of encounter" was an interpretation of Nishida's "The Logic of the Place of Nothingness and the Religious Worldview" that offered a new way of putting contemporary art into practice. In this essay, Lee Ufan felt that Western art was facing a crisis caused by the failures of modern materialistic civilization and believed that artists should find an alternative way to rescue cultural production through the spirit and cultural traditions of East Asia. Lee Ufan's criticism was well received in Korea and played a major role in the formation of the art theory that attended to white monochrome painting in the 1970s. [3]

In 1978, when white monochrome painting was expanding as a collective trend in Korea, the artist Park Seobo contributed an essay to the art magazine *Misulgwa Saenghwal*. In it, he wrote that Western art since the late 1960s had reached the point of bankruptcy caused by a human-centered modern society, making it impossible to find any relevant ideology. Furthermore, he evaluated that Korea's white monochrome painting entered the international art world in this midst of this crisis and overcame the limitations of Western art through the use of abstract aesthetics that combined traditional East Asian ideas with a traditional Korean view of nature. Park Seobo claimed that the core of this approach to monochrome painting lied in an "intrinsic, simple view of nature, structural expression without images, and the stance of hating unnaturalness, of living in obscurity with nature, trying not to make or dream of another world other than reality."[6] In this respect he claimed that it was entirely different from Western abstract art. Park's ideas shared the criticism about Western modernity which was the base of Lee Ufan's theory of encounter. Most white monochrome artists, including Park Seobo himself, developed their abstract aesthetics based on critical ideas about Western modernity, as they corresponded to the societal trend, developed since the late 1960s, of revisiting national tradition, while at the same time expressing sympathy with Lee Ufan's theory of encounter.

In the 1970s Korea witnessed mass industrialization under the banner of national modernization, art faced the task of overcoming modernity and realizing contemporaneity in the face of the crisis within Western modernist art. In this process, modernity as a new form of art and contemporaneity as an alternative to overcoming modernity were compressed in their simultaneous realization. Western formalism was accepted, but supplementing it with traditions and a view of nature offered a starting point of achieving contemporary Korean art. Replacing Western abstract art's metaphysical sense of aesthetics with the tradition of white and the intuitive enlightenment reached through repetitive acts was agreed upon by the participants as a way to render modernist abstraction from a uniquely Korean perspective. Art Informel of the late 1950s, which demanded a breakaway from the established art of the day and expressed a passion for newness, was a bold avant-garde initiative in Korean art. Geometric abstract art in the late 1960s, which revealed an urban sensibility based on primary colors with a presumed connection with nationalist folklore or shamanism, offered another way for Korean artists to reexamine their painting styles.[7] Then in the 1970s, the emergence of white monochrome painting confirmed the arrival of a style equipped with traditional aesthetics, that achieved the realization of fully-fledged, nationally specific, modernist manner, a process partly achieved earlier by Art Informel and geometric abstract art. Korean artists' solution was to flexibly accept

"abstraction"—as standing for the idea of modernist "contemporaneity"—through Korean traditions, and this third-wave of abstraction in the postwar period was finally able to achieve its own dialectical synthesis after going through an examination of the processes of the national development of avant-garde art. The white monochrome of the 1970s, immediately garnered the moniker of "Korean modernism," and provided a type of art that was recognizable as such both in Korea and overseas, for it combined a local spirit of tradition with a modern style on the premise that abstraction was inevitable in contemporary art.

ADVANCING INTO INTERNATIONAL EXHIBITIONS: THE FORMATION OF WHITE AESTHETICS

It was at the exhibition *Korea. Five Artists, Five Hinsek ‹White›* held at the Tokyo Gallery, Japan in May 1975, that the type of white abstract paintings emerging from the early 1970s became the representative style. The show was planned as a Korea-Japan exchange exhibition between the Myeong-dong Gallery in Korea and the Tokyo Gallery. At the exhibition, the white paintings by five artists were brought together, including Lee Dongyoub and Hur Hwang who were both the winners of the 1972 *Independants* exhibition, Kwon Youngwoo, Park Seobo, and Suh Seungwon. The *Independants* was founded by the Korean Fine Arts Association in 1972. It was an annual exhibition event designed to showcase newly emerging artists and was open to anyone aged between 19 and 34. The young artists set to participate in the eighth Paris Biennale in 1973 as leading Korean artists were selected for this event relative to the *Independants*. Previously, Lee Ufan, a Korean artist residing in Japan, participated in the seventh Paris Biennale in 1971, was appointed as the sole judge of the first *Independants* in 1972, and selected white paintings by Lee Dongyoub and Hur Hwang, two artists in their 20s, as winners. **4** **5** Takashi Yamamoto, director of the Tokyo Gallery and critic Usuke Nakahara came to Korea together with Lee Ufan. After viewing the *Independants* held at the MMCA Gyeongbokung in August 1972, they praised the prize-winning works—white paintings by Lee Dongyoub and Hur Hwang—by saying, "They remind us of the Joseon Dynasty's white porcelain."[8]

Korea. Five Artists, Five Hinsek ‹White› held at the Tokyo Gallery in 1975 started with the impetus of Takashi Yamamoto, who gave his specific attention to the white paintings by Lee Dongyoub and Hur Hwang at the 1972 *Independants*. His high opinion provided the grounds for a special exhibition that combined five Korean artists between their 20s and 40s under the theme of "white." The foreword

4 Lee Dongyoub, *Situation*, 1972,
 Offset ink on canvas, 161.5×131 cm

5 Hur Hwang, *Flexible Consciousness*, 1973,
 Oil on canvas, 162×130 cm

to the exhibition catalog was jointly written by Japanese critic Yusuke Nakahara and Korean critic Lee Yil, and was akin to a manifesto on Korean monochrome painting that would eventually develop into a more widely and collectively-practiced method. Nakahara found in the color white a commonality binding the five artists, noting that their white was not an element of color on the canvas, but "something fundamental" that established painting, and that it was the "matrix of vision,"[9] in which forms and colors can be born and disappear. Following Nakahara's views, Lee described white in the following passage:

> In fact, white is a color that has traditionally been closely associated with Korean people. And for us, this color is not only a representation of our own aesthetic sense, but also a symbol of our people's spirituality. Furthermore, it is the most essential language that defines our thinking.... In short, for Koreans, white is, so to speak, a spirit before it is a color. Before it becomes a color called white, it is a universe called white.[10]

Nakahara and Lee focused on white as something that is abstract but unique to Koreans. Their comments appropriated the theory of Joseon folk crafts (民藝) by Yanagi Muneyoshi—at Japanese art historian who considered that colonial Korea's authentic aesthetic essence resided within things such as white clothes and white porcelain—and transformed it into a treatise on Korean abstract art. Their approach gained a sympathetic reception from Korean artists and viewers who yearned for the establishment of an authentic Korean identity within contemporary art practice. As large-scale special exhibitions and many solo exhibitions focusing on white abstract paintings were held in Japan and Korea, being driven by the Korean government and the Korean Fine Arts Association, as well as some private sector groups, white monochrome painting became considered the major achievement of the Korean art world in the 1970s and the realization of a most distinctively Korean art.

Two years later, in 1977, *Korea. Five Artists, Five Hinsek ‹White›* was held, *Korea: Facet of Contemporary Art* was held at the Tokyo Central Museum. This exhibition introduced white abstract painting as a collective aspect of Korean painting. Nineteen artists including Quac Insik, Kwon Youngwoo, Kim Kulim, Kim Guiline, Kim Yong-Ik, Kim Jinsuk, Kim Tschang-Yeul, Park Seobo, Park Jangnyun, Suh Seungwon, Shim Moon-seup, Yun Hyong-keun, Lee Kangso, Lee Dongyoub, Lee Sangnam, Lee Seungjio, Lee Ufan, Chin Ohcsun, and Choi Byungso presented their works at this exhibition. As with *Korea. Five Artists, Five Hinsek ‹White›*, Yusuke Nakahara wrote the foreword to this exhibition

catalogue. He commented that participating artists commonly showed anti-colorism—that they were more interested in viewing something aside from colors—and confirmed the requirement for the existence of painting as an "expressed plane," not a background, for representing images by revealing white or black backgrounds that excluded colors.[11]

In 1978, Lee Yil discussed the achievements of *Korea: Facet of Contemporary Art*, and said that the entries demonstrated the unique characteristics of Korean art, a collective aspect of Korean art in the late 1970s and a cross-generational set of concerns. He said the Korean artists who participated in the exhibition "represented Korea in the 1970s, and went back to basics." He thought if the intrinsic, primordial Western critical approach to painting reached its apex in the formalism of abstraction, a parallel East Asian primordial interest can be found in spiritualism, and linked the style and content of white monochrome to this idea using the concept of the primordial.[12]

The white aesthetics of monochrome paintings in the 1970s aimed to make Korean art contemporary and international, and was refined into a collective identity representing Korea through exchanges between Korea and Japan. International exhibitions, which Korean artists began to participate in steadily from the 1960s onwards, operated as an expanded situation that also increased the desire to establish Korean identity relative to contemporary art and culture. Korean artists offered up white monochrome works with success at international exhibitions and overseas exhibitions in their mind. In this regard, focusing on the white aesthetic and the exclusion of color was an aesthetic device suitable for export, as it allowed Korean artists to signify the uniqueness of their abstract art, rather than engage in a unilateral acceptance or pursuit of Western style aesthetics. In addition, Japan's approval of the white aesthetic meant Korean paintings received a successful foreign evaluation in this preliminary round of overseas evaluation, before advancing into the international arena of exhibitions.

After Korean artists began participating in the second Paris Biennale in 1961 and the seventh São Paulo Biennial in 1963 through the efforts made by young, independent artists in the early 1960s, Korean artists in the 1970s were participating in an increasing number of international exhibitions and large international exhibitions organized according to national division—the latter of which came to be more prized by the artists than participation or recognition within the National Art Exhibition. In the 1970s, the National Art Exhibition was still considered the most prestigious stage for Korean art, but international exhibitions provided an expanded horizon for world art beyond this arena,

and participation in international exhibitions offered a parallel opportunity for artists to establish their status as leading figures in Korea, and so every artist hoped to participate in such international events. The Ministry of Culture and Public Information, which organized contributions to international exhibitions along with the National Art Exhibition, also supported and operated various internationalist projects in the art sector as there was a need to introduce and promote Korean arts and culture abroad. At the time, they had the unstated belief that Korean modern art needed to be "abstract" in order to be shown overseas.

After Korean artists first participated in an international exhibition in 1961, a tacit structure of staging academic realism for the National Art Exhibition, and abstraction for international art exhibitions was established. However, in the 1970s, this approach changed. In 1969, the Ministry of Culture founded MMCA Gyeongbokgung with the establishment of a new venue for the National Art Exhibition in mind. On the other hand, this new museum meant there was a rising need to newly establish and describe the modern art and history of Korea, which had changed due to industrialization and urbanization in the 1970s. It was apparent that abstract art—whose development had been considered independent from governmental infrastructure—was beginning to be accepted within the National Art Exhibition.[13] 6 In 1969 the eighteenth National Art Exhibition divided the oil painting section (i.e. the "Western

painting section") into figurative and non-figurative categories.[14] officially establishing abstract art as one of the two styles promoted in the National Art Exhibition. The following year, the "Eastern painting section" and "Sculpture section" were also divided into figurative and non-figurative categories respectively, making abstract art a general trend regardless of genre. In the 1970s, abstract art therefore dominated not only international exhibitions that featured Korean artists, but also the National Art Exhibition. It became clear now that abstract art was designated as representing Korean modern art.

In an era of state campaigns for national modernization, the white monochrome painting reified the modernization of Korean art in the name of abstract art. An implied agreement on the signification of the monochrome painting led to its spread within discourses about national painting both in Korea and abroad. Although this paradigm of meaning-making via the authentication of foreign expertise summoned up memories of colonialization, the establishment of Korean identity represented by white was a distinctly locally decided solution for the task of accepting modernist abstraction, the conceptual foundations of which were not Korean. And importantly, the solution was found in traditional aesthetics. The formation of a critically deconstructive and radical avant-gardist approach was not suitable for a country so overtly under reconstruction, and Koreans had no time to properly interrogate what exactly abstract art was, and why they needed it. Abstract art was simply recognized as representative of a national "modernity" that had to be obtained quickly. In order to accept these formal aesthetic approaches, which had emerged relative to a transcendental sense of aesthetics based upon the purity of the visual plane, as something that was unique to Korea, it was necessary to envision a path to aesthetic autonomy. Monochrome art's solution that juxtaposed a distinctly modernist style with the local tradition of white gained support from many artists and critics in Korea, and soon became a collectively shared aesthetic practice. As a result, white monochrome painting was established as Korean modern art, differentially informed by East Asian aesthetic concerns, and not created as a simple recycling of Western styles and concerns.

THE NON-MATERIALIZATION OF PAINTING AND THE METHODOLOGY OF REPETITIVE ACTION

While white monochrome painting was manifest as collective distinction in the 1970s, important factors that determined whether an artist belonged to this collective effort featured the characteristics of the materials chosen by said artist and their unique methodological approach to their practice. Painters selected materials with outstanding objectivity, such as white pigment, *banji* handmade paper, cotton cloth, and hemp cloth, and paid close attention to the properties of the materials themselves, before then seeking to confirm the flatness of the canvas through the infinite repetition of their manual practice. While Western minimalists confirmed the physical reality of the work through an extremely reductive, self-referential approach to painting, Korean monochrome artists unfolded a field of intuitive enlightenment in which the world and the self, objectivity and subjectivity, and the material and immaterial world were united through repeated physical actions on the surface of the canvas. In monochrome painting, the main idea is that the material is dematerialized by the artist's repetitive actions. In addition, the unity of the self and the outside world through repetitive actions was suggested as the ultimate goal of painterly practice.

Officially released in 1973, Park Seobo's *Écriture* consists of diagonal pencil lines drawn on a white canvas with consistent intervals. 7 On the canvas, painting, drawing lines, erasing, and drawing again unfold as traces of countless actions. The painting seems to extend endlessly from side to side beyond the boundaries of the canvas. From a distance, the painting looks like a single white plane, but if you look closely, you can see countless repetitive pencil lines, and viewers come to experience a phenomenological work, traveling between infinity and the bare minimum. Regarding his practice, Park Seobo said: "The act of repeating something endlessly as if it were chanting a spell or meditating is the repeated act of self-effacement or emptying myself, not just a repetition of a style."[15]

In his work, Lee Ufan repeated the moment of painting with a single brush stroke. As he described it: "[It's like] touching a brush somewhere on the canvas while catching my breath and feeling the rhythm with my body."[16] While intermittently repeating the first brush stroke, or repeatedly drawing a line until the color pigments were completely gone, leaving only a transparent trace, the artist left the only barest indication of his actions on the canvas. The implication being that a person had been transformed into a state of nothing. This moment of painting with a single brush stroke was compared to the moment of enlightenment when the artist faced the "absolute time-space."[17] In order to render the "one-time" of such a moment continuous, "repetition" was a crucial requirement. Lee Ufan described this repetition as aesthetically representing the principle of identity in the East Asian sense, corresponding to the visual ideas of perspective or the golden ratio that had historically informed the development of

7 Park Seobo, *Écriture No. 60-73*, 1973,
 Oil and pencil on canvas, 130x162 cm

8 Yun Hyong-keun, *Umber-Blue*, 1975,
 Oil on linen, 130×97 cm

9 Ha Chonghyun, *Conjunction 74-98*,
 1974, Oil on hemp cloth, 225×97 cm

10 Chung Sanghwa, *Untitled 74-F6-B*,
 1974, Oil on canvas, 226×181.5 cm

Western painting.[18]

Yun Hyong-keun repeatedly applied blue and umber paints in his *Umber-Blue* series, but unlike the general oil painting technique of stacking paints on the canvas, he applied paint several times and let it permeate the canvas fabric, creating a notion of the unity of the background material and applied pigment. <u>8</u> In his *Conjunction* series, Ha Chonghyun experimented with the physical properties of the painting medium as a trajectory of repetitive actions that vertically penetrated the flat plane of a canvas. Ha pushed white oil paint down from the back of the coarse canvas fabric, or re-swept the paint pushed out to the front of the coarse fabric, and gently pushed the viscous paint through the hemp-coated structure. He repeated this method over and over. <u>9</u> Chung Sanghwa repeated the process of painting zinc paint on a canvas, folding the canvas horizontally and vertically after drying it to create cracks in checkerboard patterns, and filling the acrylic paint in layers in the small square-shaped spaces created when the zinc paint was removed. <u>10</u> In Chung Sanghwa's white monochrome, was therefore based on this process of "taking off and filling," small squares in the grid structure created irregular and natural cracks, which were often compared to cracks on the surface of white porcelain.

In each case above, the repetitive application of white or achromatic paint on the canvas is a key process of dematerializing the materiality of the painted work. The artist's body is the main channel that continuously mediates the meeting between the world and the self, and the painted surface is the place where the meeting between the self and the world takes place. The subject, object, ego, and world are considered to be united by these repetitive actions unfolding on canvas. This practice is considered to supplant the dominant notion of the Western dualism of the subject and object, a process based on the claims the superiority of the subject within a mutually opposed relationship between subject and the object, the self and the world.

If Western abstract painting was considered at this time to have been an effort to reach the immediate substance of the painting, that is, an empty canvas, at the end of a modernist process of reduction that continuously sought to remove elements other than the painting itself from the context of the canvas, Korean monochrome painting is instead a process of filling the artist's intuitive realization with infinitely repetitive physical actions on a white canvas. This paradoxical filling process becomes a trademark of monochrome painting, wherein the "emptied self" that abolishes the artist's authority becomes the distinctive characteristic connected to the artistic identity, beyond the artist's signature itself. This foregrounding of intuitive realization to replace Western metaphysical concerns, allowed artists to achieve immaterial sublimation beyond the material limitations of painting. The immateriality of the painted surface formed by repetitive physical actions becomes an indicator that guarantees the noble aesthetic sense of the white monochrome. If the Western formal modernist aesthetic has been about confirming the material substance of the work by reduction, culminating in the dematerialization of art works within conceptual art, and ultimately abandoning the practice of painting, Korean monochrome painting is about opening the transcendental realm by dematerializing painting through traces of countless actions added to the painted surface. What is found in the Korean monochrome painting is, therefore, a powerful affirmation of painting as a practice.

In the 1970s, when the white monochrome painting style was established as the Korean abstract art, various art institutions were expanded: many arts and cultural events were organized by the government; international exhibitions were launched; and various private sector exhibitions were held by newspaper companies.[19] In addition, commercial galleries appeared, forming a contemporary commercial art world that helped to further introduce and establish the works of the leading artists of the time. White monochrome painting was what the postwar Korean art community—with abstract art as its urgent concern—achieved through domestic and international exchanges, and was a full-fledged contemporary art movement, serially presented through international exhibitions and galleries. This tradition of monochrome painting in the 1970s successfully refined a culturally elite aesthetic discourse in which artists reached intuitive enlightenment through repetitive actions. The critical approval afforded to monochrome painting was the basis for pricing works in the newly formed commercial art world, and almost forty years later Korean monochrome paintings have been ultimately further evaluated in the globalized art market of the 2010s. The emergence of white monochrome painting resulted from Korean artists' response to the challenges of modern art and the task to find Korean identity in the industrial era. It was a full-fledged postwar Korean modern art movement that measured the value of paintings relative to traditional aesthetic concerns and one that was commercially and critically translated with great success into the wider realms of the Korean art world, particularly relative to the newly emerging capitalist art market.

THE CRITICISM AND CHALLENGE OFFERED TO KOREAN MODERNISM, AND THE DANSAEKHWA BOOM

White monochrome was recorded as a leading art form of the 1970s along with the evaluation that it produced the most Korean form of art. However, criticism of white monochrome painting was also raised from the very beginning of its emergence. When Kim Yoon-Soo, an art critic who attempted to evaluate the social contribution of the arts and its relation to the perception of reality, discussed postwar Korean art in 1975, he argued that abstract art, the dominant phenomenon of postwar Korean art, follows the principle of art-for-art's sake and is engaged in an act of escapism from reality. For Kim, the significance of this movement in the postwar period can be located in its challenge to the establishment realist painting style, enshrined within the National Art Exhibition, in the name of eradicating colonial remnants. But it was just a nominal "avant-garde" and failed to avoid rapid academicization due to its basis in empty individualism and the false autonomy of art.[20]

Bang Geun-taek is a critic who, starting in the late 1950s, critically supported the Korean Art Informel movement. In the mid-1970s he harshly criticized Park Seobo's pencil work Écriture. For Bang, Park's works abandoned the avant-garde spirit in the name of Korean tradition and East Asian spirit, showed a false consciousness that reflected escapism from reality, and commercially colluded with the art market in responding to Japanese neo-colonial tastes.[21] Bang pointed out that monochrome was different from Art Informel, even though both were conducted under the name of abstraction. In the late 1970s, Won Dongseok stated that offering up monochrome aesthetics relative the slogan of a nationalist modernity was merely a play with ideas. He pointed out the role of Lee Ufan as a key figure and refuted Lee's ideas in detail.[22] Above all, Won did not accept Lee Ufan's claim that Korean monochrome paintings served as a modern representation of the spiritual value of East Asia, and functioned to deny the Westernization of material civilization. According to Won, Lee Ufan's argument that Western modernity should be overcome with Eastern ideas only further demonstrates the void in the modern spirit. For him such an argument exposes a compromise made by the bourgeoisie, which had been established as the new ruling class of Korea, only to hypocritically follow foreign trends. Instead, Won Dongseok advocated for the recovery of a national aesthetic sentiment that the people could relate to. His position demonstrates that Korean intellectuals' understanding of modernity and the ethno-nationalism was far from uniform. Their positions differed, especially depending on their individual awareness and

concerns with issues such as class inequality and colonialism. Ironically, the national establishment of monochrome painting in the 1970s soon became the starting point for heralding the emergence of a new strain of figurative, realist Minjung art in the 1980s, as the nationalist achievements of monochrome painting in the industrialization era informed the new challenge for such nationalist art to also be socially relevant in the democratization era. The Korean art scene was reshaped into a world in which monochrome painting, the key elite cultural achievement of the industrialization era, came face-to-face with those who challenged its cultural hegemony by demanding greater social participation in the democratization era.

Between the 1970s monochrome abstract paintings and the 1980s interest in the socially relevant, there existed a third camp, composed of realist artists who defied Minjung art in terms of their individualistic choice of subject matter while confronting the stylistic basis of abstraction. 11 12 This painting style, which appeared in the late 1970s and was termed "hyperrealist painting," elaborately developed representative realism by accurately describing everyday objects as if the paintings were like photographs. Hyperrealists mainly released their works in the non-governmental exhibitions newly established by newspaper companies,[23] and were critically evaluated to have further expanded the horizon of realism beyond the customary figurative painting of the National Art Exhibition as they sought to describe contemporary urban reality with photograph-like precision.[24] These artists refused to join the earlier generation's monochrome practice that flourished with collectively shared distinctive characteristics. But because their hyperrealist paintings focused on the pictorial techniques to represent objects rather than considering painterly elements as objects themselves, their style was also understood as a painterly extension of the practice of monochrome painting.

Monochrome painting has since developed steadily despite various mixed evaluations and criticisms, and the meaning of the style was re-examined in the 2000s. In the 2010s, the prices of those works soared in the overseas art market. It received newly surged attention as a leading achievement of contemporary Korean art. Namely, the internationalization of Korean art, aspired by the 1970s monochrome artists, finally came true.

It was around this period when a suggestion to replace the English term "monochrome" with the Korean "Dansaekhwa," was made by Korean artists. If white monochrome painting in the 1970s reflects the nationalist ideology of Korean art in the industrial era, Dansaekhwa, which revived with high-price sales records in the 2010s, was reborn as

11 Kim Kangyong, *Reality + Place 79*, 1979, Oil, soil on canvas, 116×244 cm

12 Ju Taeseok, *Railroad*, 1978, Oil on canvas, 145×112 cm

THE TRADITION/MODERNITY DYNAMIC IN THE MODERNIZATION ERA

an attractive cultural product in the globalized art market. Dansaekhwa in the 2010s included many works with various colors, rather than emphasizing the meaning of "white," which was conceived as referring to Korean identity. Instead, the abstract painting methodology of working without intention emerged as carrying more significance than the discussion of colors. As demonstrated by the commercial success of Dansaekhwa in the global art market after the short prosperity of contemporary art with rising post-media theories, the concept of fine art whose apex is abstract painting remains strong—even after the deconstruction of fine art in post-modernism. Formalist aesthetics that supports fine art has transformed into far more powerful exchange value.

Art Informel in the late 1950s further advance abstraction into Korean art by considering abstraction such as "capturing the spirit" (*saui*) and the concept of "cheerfulness and vividness" (*giunsaengdong*) as the true nature of East Asian quality. Geometric abstract art in the late 1960s further advanced the general public's understanding of painting styles with an urban sensibility. Their use of primary colors was an attempt to connect with folklore or shamanism. The white monochrome that emerged in the 1970s completed Korean abstract art through the dialectical synthesization of a Western style and Eastern spirit, gaining support and empathy both inside and outside art circles. Monochrome aesthetics replaced the metaphysical aesthetic sensibility of Western modernity with the intuitive enlightenment of the East. It is modern abstract art, but elaborately distinguished by painting methodologies that inherited Korean traditions, showing the possibility of the development of formalism outside the West.

Most of all, contemporaneity of Korean art was realized with white monochrome in the 1970s, and it was meaningful in that white monochrome established the new order of postwar Korean art through the pure aesthetics of modernism equipped with traditional aesthetics rather than an avant-garde method of denial and deconstruction of the existing art. This meant not only the exit of a prewar generation and the generational transition by the postwar generation in the art world, but also the fact that a new tradition of contemporary art was established to succeed the previous generation while challenging it in a newly organized postwar art world. In a way, this resulted in the incapacitation of the tradition of calligraphy and painting because the white monochrome painting combined oil painting with the 'capturing of spirit' mentality taken from the traditional art world, one in which artists had been sticking to the realm of Eastern-style or Korean painting with the media of paper, brushes, and ink as well as spirituality unique to Eastern painting. In a postwar Korea reshaped with overall industrialization and urbanization, new light was shed on Korean history and tradition. This is when contemporary art was newly institutionalized, and the white monochrome—as a modern abstract art that combined Korean traditions—became the final achievement of Korean modernism. Later, the white monochrome became a new origin for the history of contemporary art in Korea equipped with its own development process, one that would spawn the description of actuality against abstraction, engagement with reality against art for art's sake, and participation in reality against self-discipline.

1 The Ministry of Culture and Public Information was formerly the Bureau of Public Information, a central administrative body established in 1948 with the establishment of the government of the Republic of Korea. The Bureau was in charge of promoting the nation's ideologies and policies and was in charge of domestic and foreign public relations, public opinion polls, tasks related to the press, and reporting. In 1956, the Bureau of Public Information was changed to the Department of Public Information, which was promoted to the Ministry of Public Information in 1961. It was expanded to the Ministry of Culture and Public Information in 1968. The function of "public information" was to inform people of the state's policies in a simplistic way, but it was widely aimed at ensuring that the people had a sense of unity about situations occurring in everyday life and state affairs. The Ministry of Culture and Public Information was responsible for these "public information" tasks as well as policies for promoting traditional culture and the National Art Exhibition. The Ministry of Culture and Public Information, *Munhwagongbo 30nyeon* [30 Years of Culture and Public Information] (1979).

2 Oh Myungseok, "1960, 70nyeondaeui munhwajeongchaekgwa minjokmunhwa damnon" [Public Discourse on National Culture and Cultural Policy in the 1960s and 1970s], *Cross-Cultural Studies*, no. 4 (1998).

3 The Paris Biennale is a biennial international art exhibition founded by the French Fifth Republic's Ministry of Culture in 1959. It was also called the Youth Biennale because the age of participants was limited to 20–35. It was considered one of the most important international art festivals in contemporary art in the 1960s and 1970s, along with the Venice Biennale and the São Paulo Biennial. However, it has not been operated properly since the late 1970s due to financial difficulties. Korea started participating in the event from the second biennale in 1961, which was the first international exhibition participated in by Korean artists.

4 The São Paulo Biennial is a biennial international art exhibition held in São Paulo, Brazil. The biennial was founded by the Italian-Brazilian industrialist and art collector Francisco Matarazzo Sobrinho in 1951, and has been held thirty-four times as of 2020. It is considered one of the world's top three biennales, along with the Venice Biennale in Europe and the Whitney Biennale in the U.S. Korea started to participate in the São Paulo Biennial from the seventh event in 1963, and it was one of the major international exhibitions for Korean artists until the opening of the Korean Pavilion at the Venice Biennale in 1995.

5 Lee Ufan, "Mannamui hyeonsanghakjeok seoseol: Saeroun yesullonui junbireul wihayeo" [In Search of Encounter: At the Dawn of a New Art], *AG*, November 1971; *Space*, September 1975, 50–57.

6 Park Seobo, "Hyeondaemisureun eodikkaji wanna?" [How Far Has Contemporary Art Come?], *Misulgwa saenghwal*, July 1978, 32–41.

7 There is an analysis of geometric abstract art in the 1960s in relation to the motifs of folklore and shamanism. Kim Mijung, "1960nyeondae hanguk misure natanan minsokgwa musok motibeu: Hanguk hyeondae misureseoui gukjeseonggwa jiyeokseongui munjee gwanhayeo" [Folklore and Shamanic Motif at the 1960s Korean Modern Art Concerning on the Globalism and Localism of the Korean Modern Art], *Journal of Korean Modern Art History* 16 (2006): 189–223.

8 Oh Sang-Ghil, "Yidongyeop daedam" [A Talk with Lee Dongyoub], *Hanguk hyeondae misul dasi ikgi III* [Rereading Korean Modern Art III] (Seoul: ICAS, 2003), 299–314,

379-408. Tokyo Gallery's director Takashi Yamamoto ran an antique shop in colonial Korea from 1941 to 1943. According to the recollection of Lee Dongyoub, who stayed at the Yamamoto's for an exhibition in Japan, a lot of antiques had been collected in his house. According to Park Seobo, some figures from the Japanese art circles, including Yamamoto, visited Korea three to four times a year starting from 1972, and intensively bought antique art such as folk paintings, wooden furniture, and portraits from the Joseon Dynasty as well as works by Korea's modern-time Eastern-style painters such as Lee Sangbeom and Byeon Gwansik. Interview with Park Seobo and Kwon Young-jin, Seobo Art Foundation, November 8, 2012.

9 Yusuke Nakahara, "Baek" [White], *Korea. Five Artists, Five Hinsek ‹White›*, exh. cat. (Tokyo: Tokyo Gallery, 1975).

10 Lee Yil, "Baeksaegeun saenggakanda" [White Thinks], *Korea. Five Artists, Five Hinsek ‹White›*, exh. cat. (Tokyo: Tokyo Gallery, 1975).

11 Yusuke Nakahara, "Korea: Facet of Contemporary Art," *Korea: Facet of Contemporary Art*, exh. cat. (Tokyo: Tokyo Central Museum, 1977).

12 Lee Yil, "Hanguk 70nyeondaeui jakgadeul: Wonchojeogin geoseuroui hoegwireul jungsimeuro" [Korean Artists in the 1970s: Focusing on Retuning to the Basics], *Space*, March 1978, 15–21.

13 In 1961, at the tenth National Art Exhibition, Kim Hyungdae, a student from Seoul National University's College of Fine Arts won the first prize for his Art Informel painting. In 1968 and 1970, Lee Seungjio's geometric abstract painting won the Minister's Award from the Ministry of Culture and Public Information. As such, approval of abstract art inside the National Art Exhibition continued.

14 In 1969, the Western Painting Department was divided into figuration and non-figuration categories for screening, so the term "non-figuration" came to be used inside the National Art Exhibition. This term was used until 1980, when the twenty-nineth National Art Exhibition changed its categories into "figuration" and "abstraction."

15 Park Seobo, "Dansang noteueseo" [From My Idea Notes], *Space*, November 1977, 46–47.

16 Lee Ufan, "Tumyeonghan sigageul chajaseo, noteueseo (1960–77)" [Looking for a Transparent View: From My Notes (1960–77)], *Space*, May 1978, 44.

17 Oh Kwang-su, "Hwaga iuhwan ssiwaui daehwa, jeomgwa seoni haengwihaneun segyeseong" [A Conversation with Artist Lee Ufan: Globality Performed by Dots and Lines], *Space*, May 1978, 41.

18 Kim Youngsoon, "Daedam: Segyewa segyeui saieseo gaesihaneun sinsegye" [Talk: A New World That Begins between a World and Another World], *Hyundae Misul* (Summer 1990): 30.

19 In comparison to exhibitions hosted by the government, exhibition events operated by the private sector are generally called non-governmental juried exhibitions. Mostly operated by newspaper companies, those exhibitions were managed by non-governmental authorities contrary to the National Art Exhibition. In 1957, *Chosun Ilbo* newspaper launched the *Contemporary Art Exhibit* to provide independent artists with a venue to present their Art Informel works; in 1970, Hankook Ilbo newspaper established The Korean Art Grand Award Exhibition (Hanguk misul daesangjeon); in 1978, *The Dong-A Ilbo* newspaper and *JoongAng Ilbo* newspaper competitively launched the Dong-A Art Festival and JoongAng Fine Arts Prize, respectively. The Korean Art Grand Award Exhibition was held five times, up to 1978, and mostly

280 THE TRADITION/MODERNITY DYNAMIC IN THE MODERNIZATION ERA

works affiliated with modernism received prizes there. However, the Dong-A Art Festival and JoongAng Fine Arts Prize, both of which were founded in 1978, put forward operational policies such as "new formativeness" and "balanced acceptance of figurativeness and non-figurativeness" respectively.

20 Kim Yoon-Soo, "Gwangbok 30nyeonui hanguk misul" [Korean Art during 30 Years after Liberation], *Changjak-gwa bipyeong*, June 1975, 207–231.

21 Bang Geun-taek, "Bakseoboui myobeobiran" [What Park Seobo's Ecriture Is!], *Simunbak*, December 1976, 114-116.

22 Won Dongseok, "Hanguk modeonijeumui heosanggwa maengjeom: Iuhwan hoehwairon gujoui bunseok" [The Illusion and Blind Spot of Korean Modernism: Analysis of Lee Ufan's Painting Theory Structure], *Space*, October 1984, 44–52.

23 Many hyperrealist paintings received prizes at the Dong-A Art Festival and the JoongAng Fine Arts Prize ceremony.

24 Lee Yil, "70nyeondae hubane isseoseoui hangugui haipeorieollijeum" [Korean Hyperrealism in the Late 1970s], *Space*, September 1979, 106–108.

DEMOCRATIZATION AND THE PLURALIZATION OF ART

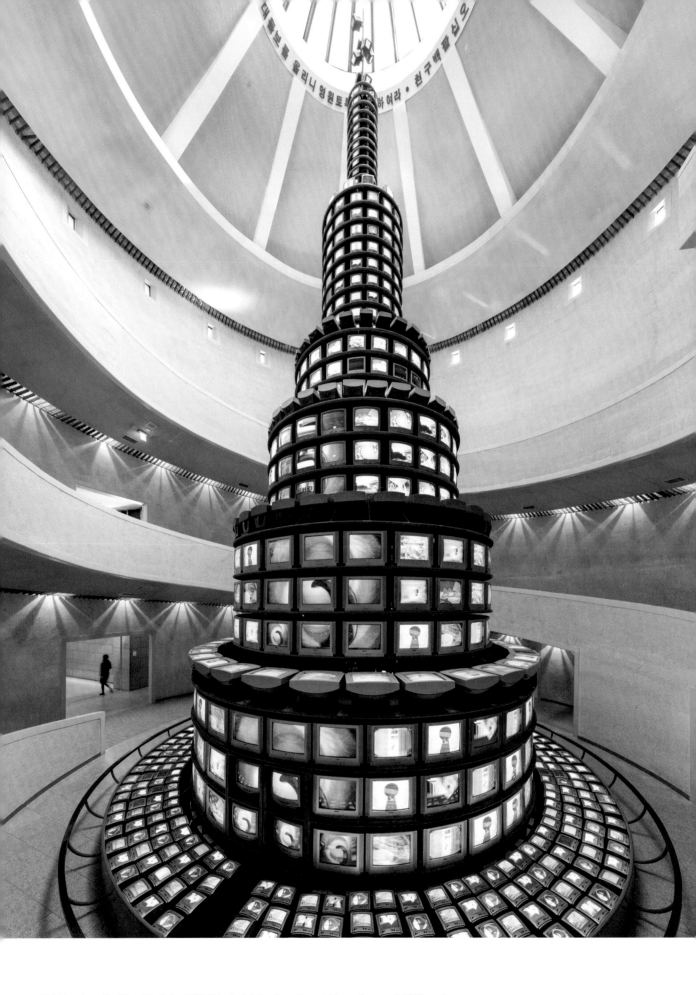

Paik Nam June, *The More, The Better*, 1988, Video installation; four-channel video, color, sound; 1,003 monitors
(6", 10", 14", 20", 25"), steel structure; laser disc, 1,850×1,100×1,100 cm

Kang Soojung

The history of the 1980s could be said to have begun with the 1980 Gwangju democratic uprising. Citizens of Gwangju protested the new military dictatorship that had just taken control of the South Korean government, and they were violently suppressed by the police and army. The pro-democracy resistance movement of the period took on the responsibility of achieving democracy, and this movement therefore heavily influenced the political realm, the social environment, and not least of all cultural production. The ultimate June Democratic Struggle of 1987 finally led to the establishment of the direct presidential election system, taking Korean society a step forward. However, with the subsequent electoral defeat that led to the election of the dictator's handpick successor, citizens had to confront unresolved issues before the final establishment of a real civilian government in 1993. Meanwhile, the economy was flourishing, particularly due to the so-called "three lows": the low price of oil; interest rates; and the relative value of the Korean won. The economy also benefitted from the success of the nation's condensed period of modernization and economic development experienced under the military regimes of the preceding decades. Based on the relative stability of the economy and national prosperity, the government won its bid to host the 1988 Seoul Olympics, which enabled the nation to demonstrate to the rest of the world the economic "Miracle on the Han River." The Seoul Olympics was the turning point for South Korean society and culture, as it dispelled memories of the Korean War and international economic aid. Also, throughout the 1980s, rapid economic development brought about the growth of consumer culture, the far-reaching spread of the media, especially television, and the widespread construction of modern apartments to house the ever-expanding urban population, a development which indelibly influenced everyday life and urban space across Korea. In the 1980s, all these changes massively effected the living environment in general, and a diverse range of social and cultural phenomena and interlinked conflicts emerged relative to this expansion.

Minjung art ("people's art") emerged as an art movement that ran counter to the dominant practice of monochromatic abstract painting that had foregrounded the idea of "art for art's sake" during the 1970s military regime. In contrast, Minjung artists established the new type of realist aesthetics and styles of art required for social renovation, by reclaiming art as, primarily, a "communicative language" and engaging the minjung ("people") as the subject of this "communication." On the one hand, works that represented the human figure and objects in a realistic manner offered a critique of the established abstract art practices of the time, and many such works were submitted to the non-governmental juried exhibitions organized since the end of the 1970s mainly by newspaper corporations. On the other hand, Minjung art is also radically differentiated from the art of the previous era in that it mainly pursued the idea of art as a social practice based on a critical view of the real world. Especially, visual artists engaged in critiques of the social, historical and economic fields through collaborations with diverse genres and disciplines of cultural production such as literature, theater, film and stage performance, and thereby forming new potential for visual art.

The artist group Reality and Utterance (Hyeonsilgwa bareon) considered art in direct relation to society, politics and urban society, and defined art as a reflection of human life as a whole. This focus provided the subjects or themes, and forms for Minjung art. Other artist groups, including Imsulnyeon, Dureong and Gwangju Free Artists Association (Gwangju jayu misurin hyeobuihoe) followed the development of this new art movement. Minjung art extended in diverse directions and expanded to various fields. In common, these groups criticized the established art world's excessive admiration for western modernism, and instead focused on socio-political subject matter. In particular, they conceived that the division of the Korean Peninsula caused by the Korean war, the influx and influence of American culture and the intervention of foreign military forces were social devices that bolstered the strength of the

domestic dictatorship, so they expressed their resistance toward these factors using diverse methods. In their works, they re-wrote the history of Korea and its culture with the Korean 'people' at the center of the story. They also sought to identify the essential spirit of Korean culture in the nation's "traditions," which had been repressed by the external powers of Japanese colonial rule and American military rule and intervention. Therefore, they often incorporated traditional patterns, attire, and folklore in their contemporary art practice, and used traditional mediums such as *hanji* paper, and monochrome and color ink. Their art often represented anti-American and anti-colonial perspectives, through the portrayal of historical incidents of oppression, including the 1894 Donghak Peasant Uprising, the 1948 Jeju April 3 Uprising, the Korean War (1950-53), the 1960 April 19 Revolution and the 1961 May 16 Coup. Moreover, their works attempted to reveal that the Cold War ideology and the national division were the driving forces that prolonged the rule of the military dictatorship and prevented democratization.

During this period, the National Security Office frequently subjected works of certain themes and dispositions to censorship. For instance, officers confiscated Shin Hakchul's work *History of Modern Korea—Rice Planting* (1987) for violating National Security Law, charging it with displaying an admiration of North Korean ideology, despite the artist's claims that the work simply depicted an agricultural landscape, a judicial decision that has still not been overturned. Some artists also criticized the capitalist system as driving force behind the destructive pace of rapid industrialization and modernization that caused the dismantlement of traditional agricultural communities, a dramatic increase in poverty, proliferation of underpaid urban laborers and the growth of various labor-related issues across the nation. Many artists compared such poverty to the apparent material abundance within the city, or simply presented honorific portraits of working people, such as elderly farmers. In the work *Lucky Linoleum and the Abundant Life* (1981), Kim Jungheun divided the picture plane into two and depicted the contrasting scenes of commercials as shown in the mass media in the upper half with images of farmers' lives in the bottom half. Another Minjung artist, Oh Yoon, made satirical versions of commercial advertisements and critiqued the capitalist system by comparing it to the judgment of the masses in hell, through a composition and painting technique that reflected the Korean tradition of Buddhist painting. He not only successfully made iconographic imagery by portraying ordinary women, but also articulated the pain and anxieties of reality in the works *Dad* (1981) and *Land* (1983), through the contrast between his knife-edged woodcutting and razor-sharp lines. Oh deeply contributed to the development of woodcuts as the major medium of Minjung art. Woodcuts were often used to make flyers in public protests, and Oh's works conveyed the messages of reality without facing the limitations of printed editions. Woodcuts were an especially useful medium for the artists of the time, as woodcut prints enabled them to reproduce massive quantities of copies even during economically dire situations. Likewise, the artists of Reality and Utterance criticized the social reality of the time within a more elite, gallery setting, while communicating or demonstrating their messages through diverse experimental mediums and methods.

However, when the police confiscated works from the exhibition *The Power of the Art by the Twenties* (Hanguk misul, 20daeui himjeon) and arrested the artists involved in July 1985, the situation within the art world changed. Confronting this oppression of artistic freedom, the artists associated with Minjung art established the National Art Association (Minjok misul hyeobuihoe, 1985) in order to systematically resist such oppression as a unified group. In particular, just before the onset of the June Democratic Struggle in 1987, as all protesting forces concentrated as one, artists focused on art production more as a collective movement than as a form of individual expression. These artists emphasized such concepts as the nation (*minjok*) and the people (*minjung*) and tended to join in solidarity with other social groups, including students, factory workers, farmers

and the urban poor. From this moment, the artists represented their messages more clearly and presented works outside the exhibition space in diverse protest sites. They also created works in various forms, such as banner paintings, flag paintings, woodcuts, posters, and book cover art, which efficiently functioned to help gather masses of people at sites of political engagement. In addition, artists generated the "citizen woodcut movement" to further engage with the lives of real people and practice a more politically orientated socio-cultural art engagement.

Amongst the forms of art mentioned above, banner painting (*geolgae geurim*) refers to the massive-scale paintings hung in protest sites, and it is regarded as a significant form of Minjung art. Choi Byungsoo, thirty-five students, citizens and artists co-created the monumental banner paintings *Save Han-yeol!* (1987) and *Labor Liberation* (1989), which were displayed at protest sites for visual impact during the June Democratic Struggle and the Great Workers' Struggles in 1987, and called on the people to overthrow the dictatorial government for the development of Korean democracy. Artists who created the banner paintings generally took on anti-Americanism and the unification of the Korean Peninsula as their themes. Works for the liberation of the Korean working people were also created at their production venues. Artist collectives that produced mostly such large paintings for protest sites were especially active in this period, and also became the targets of state censorship.

Meanwhile, it was a crucial period for the rise of what was called "women's art" (*yeoseong misul*), as feminist movements also experienced a moment of acute solidarity. October Gathering (Siwol moim) composed of three artists first promoted the concept "women artists" (*yeosong jakga*) instead of "female artists" (*yeoryu jakga*), a derogatory term that had its origins in the early twentieth century. This artist group joined the Women's Art Subcommittee, which was established within the National Art Association and which explored the issues of women and their labor in the patriarchal society. *Twenty-Two Daughters Died in Green Hill Fire* (1988) by Kim Insoon depicted the young factory workers who lost their lives because a door in their dormitory was locked from the outside at night to prevent their possible escape from their servitude. Lee Kiyeon of the Dureong collective represented the reality and alternative future of women who were living as mothers and laborers in the style of Buddhist paintings in her work *On the Verge of Life or Death* (1984). In this narrative painting, which shows the details of women's pains and hopes, the artist depicted different incidents taking place at different times in one pictorial composition. These developments represented an important change in the Korean art world because for the first time women started to appear regularly within the art scene as producers, in addition to the fact these artists jointly insisted on recognizing the immense national contribution and sacrifices suffered by women laborers in their work.

During this period, Minjung art primarily aimed to encourage social reform and effect changes in the reality of everyday life, and thus, it was considered as more important than ever for art to function as a practical part of life. "Living art" (*saenghwal misul*) especially played a significant role in this aim. In the early 1980s, craft artists, designers and sculptors produced various items necessary for protests. After the June Democratic Struggle of 1987, as these artists and designers participated in the so-called "open markets" held in public spaces, their practices expanded to form the so-called "everyday culture movement" (*saenghwal munhwa undong*). Gaining popularity amongst the general public, they often used traditional symbols such as the "Jangsangot Hawk" or the mythical animal "Ishimi" in their patterns, and produced handkerchiefs, rings and wallets which were distributed nationwide. In the 1990s and afterwards, these creative practices focused on communication with everyday Korean people developed into the participatory practice of so-called "post-Minjung art."

To understand the 1980s, apart from looking at the immense populist movement of Minjung art, it is worth examining the practices of small groups of artists who likewise rejected the uniform style of 'monochromatic' painting in more individualistic ways, differing greatly in their separate approaches. The

attempt of these artists to change the structure of the art world was realized through their creative focus on new artistic sensibilities and perceptions of reality. They were more concerned with individuality than with engaging with social issues and presented new figurative paintings or large-scale installations collectively, all of which can be encapsulated within the idea of "exiting modern" (*tal modeon*) artistic practice. Beginning with TARA (formed in 1981), this trend was followed by other collective exhibitions held as Meta-Vox (1985), Nanjido (1985), Logos & Pathos (1986), Museum (1987) and Golden Apple (1990). In this context, many artists actively participated in different groups for short periods of time. For the artists involved in such group activities, the contexts of site, material and concept were extremely important concerns. While criticizing the absurdities of contemporary society, they engaged in highly spatialized installation art, and considered everyday objects, natural and artificial, in relation to society, contemporary reality and history. Meta-Vox, in particular, broke away from two-dimensional art-making and pursued three-dimensional, and object-oriented installations. By doing so, the group presented ways of re-acknowledging materiality through subjective experience and revealing the everyday objects themselves based on the artists' own personal perceptions and character. The activities of Nanjido can be described as in terms of an "anti-art protest" in a relatively direct way. The artists of this group criticized contemporary reality in which mass production, consumption and waste proliferated, by reviving industrial waste as works of art. These two groups, among others, actively demonstrated their critical opinions on the authoritarian nature and hegemony of 'modernism' In Korea.

Meanwhile, there also existed alternative art movements in which the participating artists completely abandoned the institutional system centered around Seoul. Some considered the rhythm of nature to be of the utmost importance, and desired to accept art as a wider part of human experience. Pursuing the so-called practice of "nature art" (*jayeon misul*), they separated themselves from artificial, built exhibition spaces and mainstream art activities, and attempted to realize the unity of art and life. In exhibitions including Geumgang Contemporary Art Festival (1980) and *Winter, Open-Air Art Show at Daesung-ri by 31 Artists* (1981), many artists presented installations, performances, plays and poetry readings to combine the experience of art and nature at a fundamental level. Later, they continued the practices of ecological art in exhibitions, such as *Winter, Open-Air Art Show at Daesung-ri* or through organizations, such as Korean Nature Artists' Association·YATOO.

In contrast to the sociopolitical situation, the economy was booming and it was this expansion of the economy that changed the people's lifestyles and cultural interests. In particular, hosting the 1988 Seoul Olympics and the lifting of the ban on international travel for Korean citizens led to rapid internationalization. It became possible to receive information from around the world in real time and more freely communicate their individual thoughts and feelings. All these factors contributed to accelerating the change in cultural environment. Accordingly, traditional Korean painting also faced change. In the early 1980s, artists focused on the aesthetics of ink painting, but during the mid-1980s, they accepted a wider range of formal approaches and dealt with diverse subjects more diversely embracing abstraction, figurative compositions and landscape painting. Also, while maintaining the traditional symbolic materials of ink painting (paper, brush and ink), artists additionally imported various materials and mediums to experiment with materiality and alternative techniques. For instance, in the field of traditional color painting, the solo exhibition for Park Saengkwang (1984) initiated a new phase that definitively broke away from the influence of Japanese ink color painting and had a major influence on the establishment of a new contemporary color-ink-painting style.

But perhaps even more than art, it was architecture and design that underwent the most significant changes. These fields in particular grew because of the national government's expansion of cultural policies and wider

institutional support. During this period, the government and experts in the field planned, and built, many foundations for urban design. In this respect Seoul is a now an urban space in which the remains of the Olympics have been fully integrated into the contemporary surroundings. But at the time, the government engaged in numerous innovative cultural building projects to coincide with the Olympics, such as the construction of the MMCA Gwacheon, which featured the installation of Paik Nam June's *The More, The Better*, at the museum's center. Such projects represented the close relationship between national cultural policies and the field of the visual arts. In an attempt to definitively visualize Korean culture, Lee Manik directed the comprehensive performance and staging of the 1988 Seoul Olympics opening and closing ceremonies. The stage design, costume design for the performing artists and so forth reflected the overall idea, and the art programs were distributed internationally. Designed based on an overarching visual concept, the Olympic emblem, mascot, and posters helped to construct a new global image of Korea. Around the time of the Olympics, the development of such large corporations as Geumsung (currently LG), Samsung electronics, KBS and Junglim Architecture also offered an opportunity for designers and architects to grow in the corporate setting. These professionals contributed to expanding the scale of architectural design in the everyday living environment, and to the realizing new designs and technological developments through things such as corporate identity manuals, Hangul (Korean alphabet) typography, publishing and graphic design. Just as the new plans for urban development served to standardize the housing systems, design and architecture plans further constructed standardized modern visual approaches in the globalized world.

The computerized data processing system also saw an unprecedented growth, as Korea transmitted extensive information about the Olympic games around the world, and this resulted in the advance of the information and communication industry. As the personal computer and network systems enjoyed wider distribution, a new era of computer communication opened. These technological shifts provided the ground upon which new forms of art that integrated computers, art, design, electronic music and other elements emerged. In this respect, the Electronic Café (1988), established by Gum Nuri and Ahn Sang-Soo, has historical significance in that it functioned as a virtual café where engineers, programmers and artists communicated with one another. In this space, the performance titled *Communication Art* (1990) connected Seoul to Los Angeles through a real-time network. It meant that Koreans could share experiences with others around the globe without spatiotemporal constraints, and it indicated the beginning of a new world where artists could practice artistic activities interactively and simultaneously. On the social level, the introduction of this technology indicated the Korean economy's shift from the secondary sector to the tertiary sector of industry, and from the analog to the digital era, heading toward the 1990s, as a decade of national liberalization and diversification. Internationally, with the collapse of the Berlin Wall (1989) and the Tiananmen Square Protest (1989), a new global era leaving behind the international pervasiveness of Cold War division was approaching.

As such, in the 1980s, the democratization movements within Korean society and the nation's experience as the host of the Olympics brought about notable changes in the socio-cultural structure; subsequently, the art of this era responded to social phenomena more actively than before. In the field of visual art, artists shared an awareness of the changing reality and contested the authority of the established art of past generations, while exploring a wide range of new discourses and artistic languages. As a result of these diverse new efforts, new art practices, led by Minjung artists, successfully changed the structure of the existing system. In addition, the expansion in the use of time-based media introduced various new approaches within contemporary artistic practice, and thus, expanded the boundaries of art production and prepared audiences for the new contemporary era of the 1990s.

Minjung Art Movement

Gim Jonggil

THE HISTORY OF MINJUNG ART MOVEMENT

The 1980s Minjung art movement (lit. the "people's art movement") and the activism associated with it transpired in the same context as the democratic movements shaping Korean society at that time. At first, what is now known as Minjung art appeared as an art movement based on the activities of small groups of artists that challenged the critical pre-eminence of monochrome painting during the 1970s. However, as the previously concealed information about the violent tragedy of the 1980 Gwangju Democratic Uprising was disseminated throughout society and the government explicitly started to oppress political inclinations in cultural production, these artists started to more actively engage with politics. Such a trajectory demonstrates that the Minjung movement cannot be viewed in isolation from the coinciding social movements. In addition, this art movement can be understood more clearly, when examined in relation to activist literature, minjung theology, youth culture, nationalist aesthetics, and labor movements that all diversely reflected the major social concerns of the period.

One precursor to the aesthetic concerns of the Minjung art movement can be found in the The Reality Group (Hyeonsil dongin)'s First Manifesto, which declared that "art is a reflection of reality," an assertion that widely influenced many small Minjung art-oriented groups, which had come to be established since 1979.[1] In general, scholars have organized the history of Minjung art into several categories based on each groups' characteristics and activities, including: critical realism, minjung realism, and autonomous realism among others. Before scholars had categorized these generic concerns, each group claimed and expressed its own unique aesthetic inclination, such as figurative art,

new figuration, neo-expressionism, (subjective) hyperrealism and communal joy. Such multiplicity is related to the multi-faceted social circumstances in Korea during the late 1970s and early 1980s, and each group's position in relation to such.

Although discussions on establishing a united art community had taken place since 1983 and out of which an aligned Seoul Art Coalition (Seoul misul gongdongche) was created, Korean artists were unable to organize a nation-wide art community at first. Then, in November 1985, several small Minjung art-oriented groups established the National Art Association and created the "Nation-Minjung art" discourse, which embraced a diverse range of critical discussions. However, in the late 1980s, these artists began to divide the discourse into the separate categories of national and Minjung art, a division which was based on political perspectives and different approaches to social reform. This division occurred as a result of the enduring debates amongst small groups in the association known as the "social composition debate." Finally, in December 1988, when the Preparation Committee for the Nationwide Alliance of National Minjung Art Movement (Minjok minjung misul undong jeonguk yeonhap) was established, the National Art Association experienced a decline in its activities, and the Research Society for Art Criticism (Misul bipyeong yeonguhoe) launched in 1989, led the Minjung art discourse to its critical apex.[2]

In 1989, the Tiananmen Square Protest arose in China, the Berlin Wall fell and socialism collapsed in the Eastern Bloc. In South Korea, after the Great Workers' Struggle for democracy had taken place from July to September 1987, followed by the socially progressive True Education Movement and the Korean Reunification Movement, a concern with activist art permeated many aspects of these

social movements. As the early 1990s witnessed the development of numerous new discourses and practices in the art world, the political concerns of the 1980s faded very rapidly. An inward turn, or "localization," served as an effective strategy for the new art movement that sought to counter the art establishment. We can refer to the movements in the first half of the 1980s as the first generation of Minjung artists, those in the latter half of the 1980s as the second generation, and those in the early 1990s as the third generation. Following this timeline, the third generation's practices, in particular, resonated most closely with the wider critical discourses on postmodernism, globalization, localization and feminism.

In 1994, *The 15 Years of Korean Minjoong Art: 1980–1994* exhibition was held at the MMCA. Although some small collectives refused to participate in the show and some criticized the event as the institutional cooptation of the movement's protest art against the establishment, this exhibition officially positioned the Minjung art movement as an immense and crucial part of Korean contemporary art. Taking this institutionalization of the movement as a historical terminus, this section overviews the fifteen year history of Minjung art movement from 1979 to 1994.

THE MULTI-FACETED NATURE OF KOREAN SOCIETY IN THE LATE 1970S

In the late 1970s, considerably diverse range of cultural and religious discourses and activities emerged in Korean society. Prominent among these were the emergence of a rebellious youth culture that challenged the militaristic establishment, the publication of books on the humanities and social sciences by a publishing organization created by journalists dismissed from *Dong-A Ilbo* newspaper, the emergence of religious activists who championed a progressive practice-centered minjung theology that operated outside the institutionalized church, and scholars' unearthing of the cultural value of traditional Korean literature. In the arts, the younger generation of artists made efforts to depart from the abstract monochromatic painting (paradigmatically represented by Dansaekhwa) that had dominated the 1970s art world, by exploring alternative approaches more grounded in everyday reality, such as figuration and expressionism, and they quickly embraced hyperrealism.

Prior to the Korean publication of Gustavo Gutiérrez's *A Theology of Liberation* (1972) in 1977, religious scholars in Korea, including Hyun Younghak, Seo Namdong, Ahn Byungmoo and Yoo Dongsik, had already explored new interpretations of practice-oriented theology in relation to socially progressive 'minjung' activity, and gained a populist

foothold for this new theological approach. Then, in the 1979 International Theology Symposium, the expression "minjung theology" became an official academic term.[3] The liberation theology of Latin America and minjung theology of Korea both emerged under military dictatorial regimes and social circumstances in which economic disparities led to deep-seated class stratification, severe social inequity and prevalent bureaucratic corruption. Gutiérrez interpreted the traditional theological concept of liberation as human liberation within an extant social structure and placed this idea at the center of his theology, thereby establishing the originality of his scholarship. In parallel, in Korea minjung theologists interpreted the marginalized, impoverished or politically oppressed social groups in relation to the biblical idea of oklos (χλος), a term mentioned in the Gospel of Mark, as somewhat analogous to the idea of "people" (see Ahn Byungmoo). They additionally integrated Biblical history into Korean history, and further interpreted the idea of minjung in relation to the nationalist concept of *han* (恨, an intrinsically Korean spiritual quality of grief or regret) (see Seo Namdong), and in contrast, found spiritual levity in the traditional ideas of minjung and minjung culture (see Hyun Younghak, Yoo Dongsik). Furthermore, in his philosophizing Ahn Byungmoo explored the notion of a Minjung Messiah. This minjung theology directly influenced the artist group Dureong and the Gwangju Free Artists Association, an artist group in which the Minjung artists Kim Bong-Jun and Hong Sungdam participated.

In the field of literature, the discourse on national writing had emerged in the early 1970s and had since been further developed. In the art world, the art critics Park Yongsook and Won Dongseok published "The National Realism" (1974) and "The Theory of Minjung Art and Minjung National Art" (1975) respectively. As studies on national aesthetics and the aesthetic consciousness of minjung developed, new light was shed on Korean traditional philosophies and religions, including Shamanism, the practices of sightseeing and play, Maitreya faith, the East Asian Studies, and pre-colonial national arts and culture such as folk painting, Buddhist painting, Goguryeo-dynasty murals, everyday documentary painting, shamanic ritual picture-making, and mask dancing. Then, in the 1980s when Minjung art began to blossom in earnest, this background of traditional philosophies, religion and national culture provided many artists with creative inspiration.

By the late 1970s, images of hyperrealist and photorealist painting from the Western art world had arrived in Korea. Here, artists experimented with creating a localized form of hyperrealism by using the technique to express their critical views

on Korean society, and their work can be divided into two categories, "subjective hyperrealism" and "fantastic hyperrealism." "Subjective hyperrealism" actively embraced the formal characteristics of neo-expressionism and new figuration. Small artist groups that pursued subjective hyperrealism include Hoengdan, Imsulnyeon, Silcheon and Namu. Along with the many other artists who participated in exhibitions at the Hangang Museum, these groups significantly demonstrated tendencies typical of "subjective hyperrealism." This type of artwork could also simply be called "figurative art." On the other hand, the artworks of "hyperrealist surrealism" exhibit qualities closer to surrealism. Artists of this disposition created their works individually without forming any types of groups.

In April 1978, the first Dong-A Art Festival was held under the title "Toward a New Form." The first prize went to Byun Chong-gon. In his winning work, he painted an empty airfield that the American Army Forces had evacuated. In response to this work, the dictatorial military government persecuted the artist. Here, his hyperrealist style was used to reflect his social views. In this context, ironically, the Dong-A Art Festival catalyzed the far-reaching spread of "subjective hyperrealism."

The extreme dedication of college students to the labor activism at the time was manifested in a phenomenon unseen elsewhere in the world. Often called *hakchul* (student-turned-laborer) or *hakppiri* (a derogative term for student), these elite students in the thousands willingly entered into the heart of the industrial labor force like the Guro factory complex, and abandoned their other interests and guaranteed social mobility. The media called them undercover activists, while the labor market called them intellectuals and the government called them socially harmful groups or left-oriented dissidents. In a similar way, Minjung art movement is also regarded as a social movement because some young artists participated in the lives of the factory workers, while other artists tried to revolutionize society by revealing the reality of the laborers' lives through their artworks. Small groups of Minjung artists emerged in response to this social context since these artists were so concerned and engaged with real-world issues.

THE ESTABLISHMENT AND ACTIVITIES OF SMALL GROUPS AND INDIVIDUAL MINJUNG ARTISTS

We can regard the emergence of these small groups as the prelude to the full-fledged Minjung art movement. In August 1979, the Gwangju Free Artists Association wrote the draft of their first manifesto "For the Restoration of Healthy Art." The artists gathered in Hong Sungdam's studio to plan future activities and in September that year officially organized the Gwangju Free Artists Association during their discussions after visiting coal mines. Originally, they planned to hold the inaugural exhibition in May 1980, but the 1980 Gwangju Democratic Uprising functioned to prevent its launch, as the new military regime executed a brutal massacre of protestors, and the subsequent civil uprising took center stage. In response to the tragedy, on July 20, the artists presented a performance piece in the form of *gut*, a shaman ritual for cleansing a dead person's soul, on the Nampyeong Deudeul riverside in Naju. In the first manifesto, they claimed: "Artists must be discoverers. They must gaze upon the reality of this land and the events of the era. They must be concerned with and focus on reprehensible and corrupt social phenomena. All these actions must come from their conscience."[4] After publishing their second manifesto, the Gwangju Free Artists Association disbanded in 1983 and expanded the association into a larger organization called the Gwangju Visual Media Research Society (Gwangju sigak maeche yeonguhoe), a unit within the Gwangju Minjung Culture Research Institute (Gwangju minjung munhwa yeonguso). In this process, they initiated a printmaking course for citizens at the Gwangju Catholic Center in order to help to spread the truth about the events of May 1980. ⎯1⎯ Hong Sungdam, Kim Sanha, Kang Daekyu, Choi Ikkyun (Choi Youl), Lee Youngchae, Hong Sungmin and Park Gwangsoo joined this educational program.

Reality and Utterance was founded in December 1979 in Seoul. When the members first gathered to prepare for the twentieth anniversary of the April 19 Revolution, they created a small artist group, and Youn Bummo, Choi Min and Sung Wan-kyung finalized the inaugural announcement in January 1980. In October of that same year, they prepared to open their inaugural exhibition at the Korea Culture and Arts Foundation Art Center, but the gallery cancelled the show without notice on the scheduled opening day. Instead, the group reassembled the inaugural exhibition and held it at Dongsanbang Gallery a month later. In relation to this show, the members offered the following critique of the Korean art world: "The existing art is too conservative. Whether the works are rooted in tradition or avant-gardism or experimental concerns, all these approaches either serve middle-class pretensions or stubbornly limit themselves to reactionary ideas. As a result, those in the art world have disregarded our inner realities and isolated themselves from other people. Moreover, they have not been able to discover their own inner truths."[5] Since this exhibition, the group has continued to publish an annual anthology titled *Art and Words*

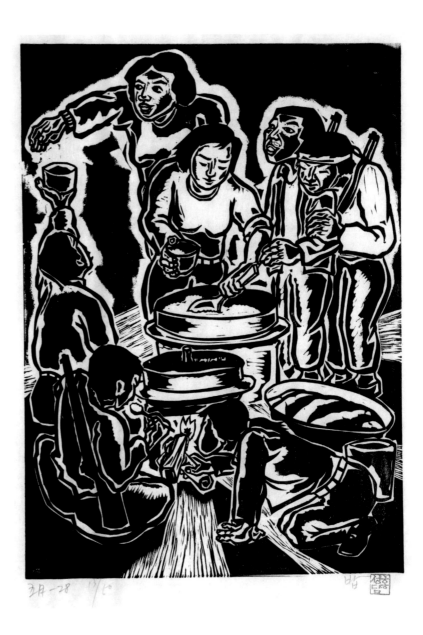

(Geurimgwa mal) and hosted workshops and themed exhibitions every year.

While the Gwangju Free Artists Association was established in Gwangju and Reality and Utterance in Seoul, POINT opened its inaugural exhibition in December 1979. In May 1984, they changed the group's name from POINT to Locus and Focus (sijeom sijeom). They reflected on the social role of art, expressing, "Contemporary art seems to have ended. It just requires us to follow in its wake. We have no choice but to convince ourselves to seek potential alternatives to the real human conditions of our times, starting from the most ordinary matters."[6] Later, some of the members led the woodcut movement and the activities of the Artist Group Dawn (Misul dongin saebyeok, established in 1988). The founding members of POINT included

Baek Jonggwang, Chang Younggook, and Choi Choonil. With Park Chaneung, Lee Ukbae, Kang Moonsoo and Moon Seokbae joining later. Choi Choonil and Park Chaneung also led related artist collectives in Suwon and Anyang, respectively.

By the early 1980s, the tendency of artists coming together to establish small artist groups was a movement in full scale. For instance, the group Hoengdan held their first exhibition in 1980. However, it was not until 1982 that they clearly expressed their support for the socially oppressed through figurative art. DAMU Group was significant for its "emphasis on the best use of a medium's potential and site specificity in the context of the artwork's position and spatial existence."[7] The group held a co-exhibition with another group called TARA, and Hoengdan titled

The Innocence of Conscience: That Sound in August, 1982.

On October 29 1982, Imsulnyeon held an inaugural exhibition. The group members' early pieces had been regarded as works of subjective hyperrealism but following their inaugural exhibition, they started to present socially engaged works. In the exhibition, they proclaimed the purpose of the group: "[In this exhibition titled] *From 98992*, we attempted to convey the symbolic meaning of the temporality of 1982 (Imsulnyeon) and the spatiality of 98992, which indicates the territorial size of South Korea. The word *from* also implies a *departure*. In other words, it was the simple directive that [we depart] 'from the here and now. We endeavor to cultivate an eye to see not the revealed reality but the uncovered truth, which includes human beings, things, the pain that we all tolerate, a reflection of the [chronological] historical awareness and the [synchronic] formation of the foundation for symbiosis. We accept the multiple forms of productions of this era, but our priority is to express the cultural problems in specific and clear language and truthfully formalize the uncertain and transitional reality."[8]

Dureong was established in October 1982, when Imsulnyeon held its inaugural exhibition. In July 1983, the group members planned the exhibition *Rehearsal for the inauguration* at Aeogae Little Theater and opened their first show at Kyung-in Museum of Fine Art in Insa-dong in April 1984. They also made woodcut calendars at the end of that year and stated the purpose of their practices in that format. Their statement proclaims, "The Korean word 'Dureong' refers to the small mounds around rice paddies. Such spaces provide farmers with a place to stack their produce and take a rest during break times, as well as engage in activities such as singing and dancing. The term 'Dureong' therefore refers to the ground on which people both work and play in the quotidian world. We named our group Dureong because we want to assert that a work of painting or sculpture is not a commodity but the result of hard work, and we want to engage with the heart of everyday life."[9] They also edited publications titled *Live Pictures* (1983) and *Live Art* (1984). In the section on methodology for making art that is alive, they suggest the ideal of their art practices: "We use Nectar Ritual Painting as a model and the compression of three worlds, three skies and three spaces as a profound framework. We attempt to integrate cartoons, folk art, Buddhist painting, genre painting, and paintings of nature to form a union. We also suggest that heaven is not simply a world full of pleasure but rather a world overflowing with love and amusement that follows the sense of pride that coincides with hard work."[10] Many of the Minjung artists in the early 1980s shared objectives based on the national

aesthetics that were found in Dureong's statement and their conception of art is most closely akin to the aesthetic theory espoused by the Gwangju Free Artists Association.

In March 1983, a small artist group named Silcheon was organized. In general the participants in the group discussed the problems in the 1970s art scene, contemplating and debating to find a new artistic language for the 1980s. They summarized their deliberation of such problems in three categories: first, the negligence of the issues of reality; second, the confinement to the idea of "art for art's sake"; and third, "the indifference to Korean aesthetics due to a fixation on Western aesthetics or an erroneous approach toward the traditional sense of art."[11] Besides the group exhibitions and themed exhibitions, the members curated the show called *The Cartoon Spirit* and published *The Harmony of Picture and Poetry* and the first edition of *The Cartoon Spirit*.

In October 1983, young artists gathered in Daeseong-ri, Gapyeong-gun, Gyeonggi-do and held a gathering now known as the "discussion over three days and nights," where debated their ideas about establishing an art community. Ok Bonghwan hosted the gathering and Kim Bong-jun, Chang Jinyoung, Hong Sungdam, Choi Youl, Hong Seonwung, Moon Youngtae and Choi Minhwa participated in the discussion. As a result, they established the community's mission and vision relative to the following concerns: First, to eradicate the remnants of colonial art, rediscover Korean traditional art and refigure this inheritance in a creative way; second, shift toward the minjung-oriented national art, which is based on reality; third, create the conditions for more individuals to become attached to art movements; fourth, producing and distribute artworks for the public; fifth, deliberate on the development of in-depth art education for the public; and sixth, reach an agreement on collaborative practice with activist organizations on the ground and set the stage for the establishment of nation-wide solidarity. They also agreed to expand the Youth Art School, Citizens' Art School and the woodblock printing courses at colleges across the nation. In the spring of 1984, discussions on healthy art culture continued at the Contemporary Art Research Institute. In September of that year, the Institute officially held an inauguration ceremony and the Seoul Art Coalition printed *Poems and Woodcut Calendars* in the following month. The Seoul Art Coalition consisted of several small artist groups, including Silcheon, Hoengdan, Namu, Espa, the Committee of Time Spirit (Sidae jeongsin gihoek wiwonhoe), Sipjangsaeng, and Uksae. The first directorship of the Seoul Art Coalition was held by Choi Minhwa, followed by Park Jinhwa, Son Kihwan and Yoo

Yeonbok. One of their goals was "to make a fair trade and proper distribution structure in the art market by lowering the artwork's sales price to one that the general public could afford, and to find new distribution channels."[12] With this purpose in mind, they organized the Eulchuknyeon Group Art Festival in February 1985 and opened the inaugural exhibition of the Gangnam Art Market in March. They also published five issues of the journal *Misul Gongdongche* and held the exhibition *Art and Politics at Great Transition*.

The first project-oriented collective called the Committee of Time Spirit was established in 1983 by Moon Youngtae and Park Geon. Curating exhibitions and publishing were the main activities of the collective. The two group leaders curated the exhibition *Time Spirit*, which was held five times until 1987, and they published three issues of the themed journal *Sidae Jeongsin*. The concept of "time spirit," or zeitgeist, was created based on Park Geon's aphorism that said, "'life' to run toward from all directions; touch, pinch and embrace."[13] They also stated that for them 'time spirit' referred to "the indescribable after effects of and people's sacrifices during and after the cruel Japanese colonial administration, the forced division of the nation, ideological clashes, savage warfare (the Korean War), industrialization dependent on foreign powers, corruption, environmental degradation and nuclear deployment that all persist in our society, evoking constant pains and insecurities. Moreover, the desperation of anti-minjung groups further provokes mistrust of the impotent government and bizarre tension within both individual lives and the overall culture . . . The exhibition *Time Spirit* endeavors to unfold the individual or minjung's lives and unravel all the thoughts and perceptions on and historical awareness of today's social structure to be shared collectively on one table."[14]

The first feminist artist group October Gathering was created from the *11-person Group Exhibition Drawing* held in 1982. Amongst participating artists, Kim Jongrye, Kim Insoon and Yun Suknam prepared to organize a group based on an awareness of feminist issues. The group's inaugural exhibition *October Gathering Exhibition* was held in October 1985 at Kwanhoon Gallery, and Kim Insoon, Kim Djin-suk (replacing Kim Jongrye) and Yun Suknam took part in it. In 1986, they held the second group exhibition *From Half to Whole*. In Claudie Broyelle's *Women's Liberation in China*, translated to Korean in 1985, the author quoted Mao Zedong launched a campaign called "Women hold up half the sky on their shoulders." and claimed "Women cannot not attain half of the sky."[15] Meanwhile, *From Half to Whole*, proposed by Kim Insoon, asserts that women are not a half but a dignified one in their own right. That year,

the artists joined the National Art Association. Afterwards, they integrated their group into Teo (Teo dongin) and Women's Art Subcommittee, and later expanded and reorganized the group into the Women's Art Research Society (Yeoseong misul yeonguhoe). Within the institute, artist group Dungji (Geurimpae dungji) practiced art movements for female workers. They criticized the problematic contradictions against women in the real world in an aesthetic way through the exhibition *Women and Reality*, which was planned since 1987.

One of the most significant activities in the early 1980s was the second Contemporary Art Workshop, organized in 1981 by curator Park Yongsook. Three invited artist groups were ST, Seoul 80 and Reality and Utterance. ST was an avant-garde experimental artist group founded in the 1970s. In the 1980s, Seoul 80 had presented various experimental concepts, standing in opposition to the unoriginal, repetitive artworks that dominated the critical milieu at the time, through exhibitions like *36-3 Art Studio Display I, II* and *Seoul 80–Work with Screen*. As the final addition to the trio, Reality and Utterance attracted attention for introducing their critical realist aesthetic ideas in the mainstream art world. This exhibition was held at Dongduk Women's University in June and July of 1981, and representatives of each group delivered lectures in the hall of the school throughout the duration of the exhibition. They also hosted a workshop titled "Artist Groups' Methods of Presentation and Ideology" for two days at the Academy House. In this workshop, artists with different ideas clashed with each other; these confrontations offered guidelines for distinguishing the aesthetics of the 1980s from those of the 1970s.

In January 1981, the exhibition *Winter, Open-Air Art Show at Daesung-ri by 31 Artists* was held. It was a multi-genre art event during which poets, actors and musicians participated alongside visual artists. Regarding this exhibition, art critic Kim Kyungseo mentioned, "In the harsh winter of 1981, even though the relentless Chun Doo-hwan military regime has stolen power after brutally crushing the Gwangju Democratization Movement of May that year, thirty-one young artists stood up against their oppressors in Hwarangpo, Daesong-ri of Bukhangang."[16]

The Seoul Museum opened in December 1981 under the directorship of Kim Yoon-Soo. It immediately held the exhibition *Artists in Focus of 1981* in January 1982. This show would become an annual event that led to the emergence of many established artists and small groups. Another exhibition called *Young Minds*, which was held at Duksoo Museum in 1982, is also important. In the exhibition's opening statement, the curators said, "We are illegitimate children born in the midst of

issues that pack the streets, and encompassed by a clamor that fills the sky with fragmented names."[17] This exhibition series was held eight times until 1988. In the same museum, the Maru Sculpture Group held its inaugural exhibition. A group of young sculptors had organized this collective and here presented socio-politically inspired works under the theme "the Division of Korea and Reunification."

Hangang Museum opened in June 1984, and held its inaugural exhibition *The Grandiose Root*. In August, they curated the touring exhibition *40 Years of History Since Liberation*, which toured to Gwangju, Daegu, Busan, Masan and Seoul. Among others events, the most important exhibition of that year was *Life Portrayed by 105 Artists* held at the Kwanhoon Gallery, the Third Museum and the Arab Art Museum. This show affirmed that diverse branches of Minjung art were converging to create a larger pool of related activities. In the catalog, the curator firmly stated, "Art is to explore the truth of life, and so, it should not be limited to [the creation of] decorative forms or works for pleasure that avoid reality. Therefore, we attempt to critique and overcome such forms of art, and advocate for healthy, vital and communicative art based on our everyday lives."[18]

In July 1985, Park Buldong, Son Kihwan and Park Jinhwa co-curated the exhibition *Power of the Art by the Twenties* at the Arab Art Museum. This show intended to examine the Minjung art of the early 1980s as well as the activities, aesthetics and soul of different generations, by extending the concept to include the additional exhibitions of *Power of the Art by the Thirties* and *Power of the Art by the Forties*. However, two days before the closing of this exhibition, police seized the artworks and took the artists to the police station, which was the first shocking instance of the political oppression within the art world itself. Art critic Choi Youl defined this incident as the "oppression of art by the political power" and, with Chung Heeseop, recounted the details of this injustice in the publication *A White Book on the Oppression of Art* published by the Minjung Culture Movement Association that year. The publication details the background, descriptions of the artworks in *Power of the Art by the Twenties*, the processes behind, and reflections on the exhibition (in relation to its cultural effects) and the related context of political oppression. Here, Choi Youl deemed that political oppression had originated from the regime's self-contradictory and erroneous understanding of art. On July 20, the then Minister of Culture and Information Lee Wonhong delivered a speech in Gyeongju, which included a comment on art that engages with social issues. Here, Lee said, "There is a growing number of people who regard small inadvertent accidents as major social

phenomena and even distort and manipulate the facts based on their negative views on society."[19] Only a few hours after this speech, the Jongro police suddenly invaded the exhibition space and committed a staggeringly violent dismantling of the event. Following this incident, the Minjung artist groups immediately rose in defiance, issuing a statement of dissent and collectively protesting against the authorities.

THE ESTABLISHMENT OF THE NATIONAL ART ASSOCIATION AND THE DIVISION OF THE NATIONWIDE ALLIANCE OF NATIONAL MINJUNG ART MOVEMENT

The Grand Conference of Debate on National Art was held in August of 1985. But its can be traced to July 1984, when student-led art activist clubs at several universities held a training retreat. Soon afterwards, the activities of university student-led art clubs expanded. In April 1985, there was an attempt to organize a nation-wide umbrella organization for these art movements. As recalled by Choi Youl, this sequence of events stimulated other artists who had been scattered across different areas to request that the first meeting on the matter of forming such an umbrella organization be held in early May of 1985.[20] Twenty-eight participants were present at this meeting, including Kim Yoon-Soo, Won Dongseok, Sung Wan-kyung and so forth. Won Dongseok, Sung Wan-kyung, Kim Yongtae, You Hongjune, Kang Yobae, Hong Seonwung, Jeon Joonyeop, Kim Bong-Jun, Park Geon, Kim Woosun and Choi Youl came to take part as the preparatory group members. They stipulated for the following provisions of their profound mission and vision for the organization: 1) to create a consultative unit of individuals and collectives, 2) the creation of a national art, and 3) solidarity with allies in the developing world.

The preparatory committee, as its first iteration congregated on May 22, 1985, had initially planned to hold an inauguration ceremony during the first half of 1985. However, in light of the cancellation of *Power of the Art by the Twenties*, some members thought this ceremony would be too soon. Incidents such as those concerning the Council of the National Unification, Democratization and the Liberation of Minjung as well as the Law of Educational System Stabilization continued to worsen the external political and social situation. Therefore, the inauguration was delayed. During this period, 13 artists, including Kim Joohyeong, Ra Wonsik and Choi Youl, organized the Task Force against the Oppression of Minjung art (formerly, the Task Force for *Power of the Art by the Twenties*) and protested against the authorities through sit-ins and demonstrations to publically broadcast

their statements. On August 17, the preparatory group hosted the Grand Conference of Debate on National Art—here, members who thought the inauguration was too early clashed with those who thought it was imperative. After the debate, the majority of the members agreed to act immediately, so they delivered the address on "the Declaration to Establish the National Art Association."[21] Like-minded artists and the artist groups of the early 1980s, including the Gwangju Free Artists Association, Reality and Utterance, Imsulnyeon, Seoul Art Coalition, Dureong and October Gathering, participated in the inauguration. The declaration included the following key passage:

Today's Minjung art is in desperate need of creative efforts that truly contribute to the development of art and culture while confronting the reality of the nation and engaging with the practices of community life. We gather here with a collective will and the knowledge of what is required of national art at this transitional moment of our history. Therefore, we affirm our will to establish a national art by practicing creative activities and spreading our shared vision. We, as an organization that supports and promotes all the rights and welfare related to art and culture by strengthening bonds through cooperation with the people, earnestly declare the establishment of the National Art Association.

FROM "THE DECLARATION TO ESTABLISH THE NATIONAL ART ASSOCIATION"

Upon the establishment of the National Art Association, the art movements of the 1980s shifted toward more organized operations and entered a new stage. Since the police had destroyed the murals in Sinchon and Jeongneung and often cancelled the exhibitions scheduled at museums and galleries, the most urgent issue at that time was dealing with the authority's oppression of art collectively. Within the National Art Association, the direction of the movement's activities was divided into two broad factions. The older generation challenged the established art institutions while attempting to change the ways of communication related to artistic practice and formally pursuing realism. Meanwhile, the younger-generation artists were more interested in political confrontation and explored different approaches to integrating art within social movements through innovative alternative methods of practice.

In the late 1980s, small groups of the younger generation were quickly reconstituted to reflect the urgency of the wider field of political and social movements in Korea. In each administrative region, new small groups and collectives emerged. Gwangju's Work and Play was reorganized into

Gwangju Visual Media Research Society, and Dureong divided into two groups: Batdureong (the field group based in Incheon) and Nondureong (the supporting group located in Seoul). New artist collectives also surfaced and practiced significant activities: Teo, Hwalhwasan, Ganeunpae, Unggungkwi and Dungji in Seoul, Nakdonggang in Busan, Seomajigi in Masan, Teo in Daejeon, Ddang and Gyeorye Art Research in Iri, Tomal in Gwangju, Gaetkkot in Incheon, Baramkoji in Jeju, The Association of Suwon Cultural Movement—The Visual Art Council and The Artist Group Dawn in Suwon, and Woorigeurim in Anyang. The Young Artist Coalition, made up of art college students, also emerged during this period.

These young artists immersed themselves in a diverse spectrum of real-life situations, through which they put to practice their ideas about realist aesthetics. They found appropriate methods that accommodate the circumstances of each region and each site of activism. Through these art practices, which together roughly constituted a national cultural movement, these young artists literally became the avant-garde activists of Minjung art. They criticized the older generation's approach of presenting artworks in gallery settings for offering merely a conservative, establishment approach to upholding the aims movement. They were not interested in exhibition spaces but championed for their practice the sites of struggle and the democracy movement as the very sites that corresponded to the reality of people's lives. Art criticism also shifted to encompass discussions about the proper direction apposite for a "true" Minjung art and the spirit of the times. The writings of Choi Youl, Ra Wonsik, Chang Haesol and Kwak Daewon published around this time suggested various ways to initiate public organizations, gain public attention, embody the sensibility of minjung and theorize archetypes.

In 1987, the June Democratic Uprising and the Great Workers' Struggle from July to September ignited a widespread social debate about how to move Korean society progressively forward. After the June Democratic Uprising, artist groups and art associations in every regional province began to discuss explicitly with one another the various lines of discourse in relation to their creative practice, which had previously only been discussed internally within those groups. In other words, because of the emergence of a wider debate about social transformation, artists had to clarify their positions within the debate. Moreover, tacit pressure from the wider field of groups engaged with progressive cultural and social movements in Korea, which encompassed the Minjung art movement, pushed artists to concretely determine their ideological outlook. This debate resulted in a conflict within the National Art Association. That is, the hard-

liners criticized more moderate members, and their disagreements ultimately led to the establishment of a separate organization, the Preparation Committee for the Nationwide Alliance of National Minjung Art Movement. Eventually, the clash between the National Art Association and the Nationwide Alliance of National Minjung Art Movement resulted in a split. Art critic You Hongjune recorded that, during this confrontational situation, the different sides resorted to rather emotionally charged criticisms that employed dismissive terms like culturalism, reformism, theoretical heroism, partisanism, separatism, minjung fascism, minjung minimalism and petit bourgeois concerns.

Art critic Choi Youl explained the process and justification for the establishment of the Nationwide Alliance of National Minjung Art Movement as follows: "[It] discussed the vision and direction of the May Art Exhibition [after the 1980 May Gwangju democracy movement], determined its principle direction as "reinforcing the organizational power of the *Minmin* art,"[22] laid the foundation for a "nation-wide organization of unified ideological aesthetics," and inherit the spirit of the 1980 Gwangju democracy movement. This is how they collectively decided on their proposal for Minjung art's direction for the 1990s. Then, at a meeting on September 17 of 1988, they decided to ratify the proposed document, the "Theory of Constructing the Nationwide Alliance of National Minjung Art Movement."

The document determined the future direction for the Nationwide Alliance of National Minjung Art Movement. Based on an analysis that the art movement of this moment was divided it into two categories—the activist practices based in Seoul and Gyeonggi-do and the more conservative traditional art practices scattered across the nation—the National Art Association was considered a means to help to reform the latter category. It designated as its first task the establishment of networks of activist practices within regional coalitions, whilst absorbing those artists orientated toward more conservative art practices into a unified, singular entity that is the Nationwide Alliance of National Minjung Art Movement. In addition, the document summarized the elements that were worth preserving from previous Minjung art practice: The continuation of protests against imperialist toadyism; continuing to organize regional art movements; and continuing to explore ways of using various mediums of art and forms of national art. It also made a list of areas that required necessary reform: the reformation of progressive artist's practice; the unstable reproductive structure of art movements; and the Seoul-centered nature of the National Art Association.[23]

At the end of the 1980s and into the early 1990s, new artist groups affiliated with neither of the National Art Association nor the Nationwide Alliance of National Minjung Art Movement began to emerge. For instance, both Geurimnuri in Seoul and Saemulgyul in Busan were organized in 1993, but they did not join either the National Art Association or the Nationwide Alliance of National Minjung Art Movement. There were also new groups which focused primarily on art criticism. In 1989, the Research Society for Art Criticism was organized under the leadership of Sung Wan-kyung. The Research Society for Art Criticism criticized the existing range of art writing that had been rooted in formalism, while experimenting with other alternative discourses. Above all, this group suggested the theoretical utility of a critique of mass consumer society and its associated cultural production and consumption. On this issue, the members declared, "We aim to explore the aesthetics of each practice and use a scientific critique appropriate to our situation through comprehensive and scientific research on the interrelations between art culture and socio-historical reality."[24] In 1993, the National Art Association closed their exhibition space Min Art Gallery (Geurim Madang Min), and in 1994, MMCA held the exhibition *The 15 Years of Korean Minjoong Art: 1980–94*, bringing fifteen years of alternative Minjung art movement, beyond the scope of nationally established institutions, to its end.

THE THIRD ZONE OF DISCOURSE AND EXPERIMENTATION IN VISUAL MEDIA

Minjung art of the 1980s explored diverse aesthetic subjects. The first prize of the Dong-A Art Contest 'Toward a New Form' went to Byun Chong-gon's *January 28, 1978*.[25] This work was created in the hyperrealist style but differed from Western hyperrealism, which excluded any 'subjective' senses.

In 1981, art critic Kim Yoon-Soo established a new keyword with "reality," and paid more attention to emerging artists and artworks that were grounded in figurative art, considering such as "new pictures that approach the truth of life." He stated, "We chose figurative painting as a way to rediscover our lost reality through art." In making this claim Kim sought to stake out a new political notion of the importance of figurative art in the context of Korea. Since 1987, the Hangang Museum designated "figurative art"[26] as their main conceptual focus and held the notable exhibitions, *The Represented Figurative Art in the 1980s* (1987) and *The Status of Korean Art in the 1980s* (1988). In 1989, Lee Joon curated a show called *Figurative Art in the 1980s* at the Kumho Museum of Art. In his writing for the exhibition titled *The Exploration of the Figure*,

he particularly emphasized, "A true art form is not based on an independent, self-satisfactory and abstract perspective but it can emerge only when an in-depth awareness of reality leads to capturing the process in which the visible and the invisible are in a co-dependent circulation."[27]

In his essay "The Expansion of Sculpture or an Uncollapsed Myth" (1989), art critic Choi Tae-man attempted to elaborate on the concept of figurative art relative to sculpture in the context of Korean art. He proposed five main attributes. First, before the 1980s, Korean sculptors, including minimalist artists, were primarily interested in creating complete singular sculptural objects composed of one single material, but sculptors after the 1980s were increasingly open to integrating different materials. Second, while the sculptural forms of the previous generations abided by traditional rules and created a consistent body of work, the artists of the 1980s installed their works in theatrical or artificial sets, and even tended to regard the installation itself as a work of art. Third, artists and critics began to consider new subjects and messages as suitable for the medium of sculpture. Fourth, the scope of the subjects widened. Fifth, artists started to express interest in traditional Korean visual culture.

Figurative art can be considered as a 'third' major concern within Minjung art production,[28] and relative to this was a substansive interest in labor art. The early history of labor movement art commenced with several publications that were published following Jeon Tae-il's self-immolation in 1970. These publications include *The Guidebook for Laborers*, written by Father Michael Bransfield, and produced by Park Yongbok, and *What Would We Do with These Guys?* and *The Working Children* edited by Lee Ohdeok in 1977 and 1978 respectively. In 1978, Kim Bong-Jun drew the illustrations for *What is a Labor Union?*, edited and published by the Alliance of Textile Labor Union. In 1979, Chang Jinyoung created educational slides for Daehan Electric Company Labor Union. Soon after the establishment of Dureong, the everyday culture research group called Research Institute of National Culture (Minjok saenghwal munhwa yeonguso) branched out from Dureong. From the late 1980s to the early 1990s, many small groups and artists practiced labor art. Representative groups include Hwalhwasan and The Labor Art Promotion Group, Ganeunpae and Saedduki in the Guro factory complex, Urigeurim, Ggamakgomusin, Unggungkwi in Anyang, Gaeggot in Incheon, Nanum in Suwon, Jakhwa Workshop in Guro-dong, Heukson Workshop, Dungji, Somssi Workshop, the Alliance of the Integrated Art Research Labor Inc., Labor Art Committee (Nodong misul wiwonhoe) and the Association of Labor Culture and Art Movement. The idea of labor art was originated within the

Dureong group, and the group's aesthetics deeply influenced other groups practicing the art. Dureong called themselves "tteunpae" (a group of professional artists) and sought to engage in what they called "*durepae*" (art practice embedded in sites of productive labor). On the outskirts of Seoul, where many factories are concentrated, the artists held the touring exhibition *Sunshine of Labor*.

The most prominent points of discussion when it comes to the aesthetics of activist art can be made in relation to shaman ritual painting, flag painting, story-telling picture, mural, and banner-format painting (*geolgae geurim*). Banner painting originated from the Sino-Korean word 'gwaehwa,' which comes from the Buddhist term *gwaebulhwa* and means the colossal paintings of Buddhas. Dureong introduced the use of this term in activist art. Although in 1979 a large painting was produced as a backdrop for the theater performance *The Lights of Factories* held outdoors, it was not until 1983 that a flood of banner painting began to appear in various sites. Ra Wonsik claimed that Kim Bong-Jun's *Painting of the Patriotic Martyr: Kim Sangjin*, which was hung at the main gate of Seoul National University in 1982, was the first banner painting, but *The People of Land and the Son of the People* in 1983 was the first painting to be introduced properly as a banner painting, following on from the Buddhist tradition of gwaehwa, when hung at the Presbyterian Church Conference. *The Battle of Minjung* created by Gwangju Visual Media Research Society in 1984 also has an important meaning with regards to the history of banner painting. After Dureong's inaugural exhibition, people naturally accepted the use of banner paintings as a major visual presence demarcating and signifying public gatherings or cultural rallies. Throughout the mid- and late 1980s when the number of small groups rapidly increased, several art activist collectives emerged, folk art and wood cut groups appeared on university campuses, and banner painting became the symbol of the activist art movement. Choi Byungsoo is recognized as a representative producer of banner painting in the 1980s because of the work *Save Han-yeol!* (co-produced with Kim Kyunggo, Kim Taekyung, Moon Youngmi and Lee Soyeon). [2] With his death at the hands of the police, Lee Han-yeol, a student protestor and patriotic martyr of the June Democratic Movement of 1987, became a celebrated figurehead of the democracy movement. In this context, Choi Byungsoo gathered the members of the wall painting division of the National Art Association and representatives of the cartoon club of Yonsei University to create a large-scale banner portrait painting of Lee, which would become emblematic of the democracy struggle and key feature at many rallies.

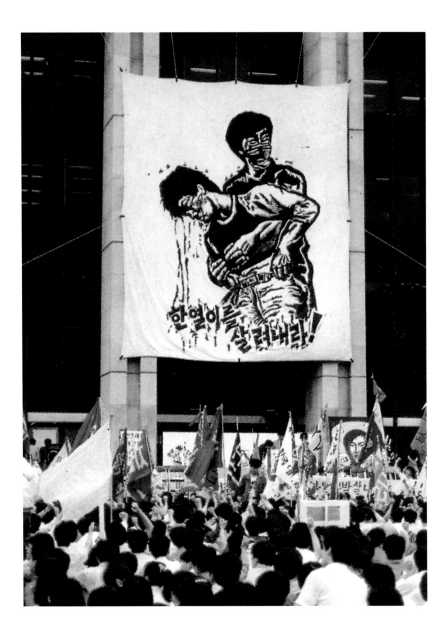

2 Choi Byungsoo, Kim Gyeonggo, Kim Taegyeong, Moon Yeongmi, Lee Soyeon, *Save Han-yeol!*, 1987, Water-based paint, acrylic on nonwoven fabric; hanging painting, 1,000×750 cm

FIGURATION AND CREATIVE EXPRESSION IN MINJUNG ART

While the period between 1980 and 1985 represents an era of 'aesthetic battles' amongst small groups—the so-called Saving Private Avant-garde (in political art)—the years between 1985 and 1990 mark the era of revolution, during which the National Art Association raised high the theory of national Minjung art and dived into the ideology of social reform. Then a symbolic battle based on this mature notion of Minjung art theory and aesthetics took place between 1990 and 1994.

As mentioned above, the period of Minjung art was not dominated by individual artists but the activities of small artist groups. The reason for the historical emergence of such groups is because they took the initiative to declare their missions and visions and pioneered an innovative activist art movement. Their declarations guided the direction of future art movements and they developed methods for collaborative production while still enabling their members' to focus on their individual concerns. Either through exhibitions or through site-based protests, these small groups used 'art' as a creative political medium. Also, in every group there were some artists who assumed leadership positions. Those whose names are mentioned here are, therefore, but a few of the many artists who contributed to this development.

Hong Sungdam of the Gwangju Free Artists Association continued his activities at both protest sites and art galleries, focusing on disseminating information about the brutal massacre and the desperate protests of the 1980 Gwangju Democracy

3 Kang Yobae, *Justice*, 1981,
Watercolor and pastel on paper, 182×384 cm

Movement. His efforts successfully informed the nationwide public about this incident through the Citizens' Art School. In addition, he described the historical details of the incident through a series of prints titled the *Gwangju Democratic Uprising in May Series*, a work which can be considered as the epitome of minjung woodcut print practice. Kim Bong-Jun recognized traditional Korean art as offering many prototype models for the minjung aesthetics of the new era. The Gwangju Free Artists Association and Dureong had become more radical after the June Democratic Uprising of 1987. In the National Art Association, these changes in direction provoked intergenerational conflicts over the wider direction of the Minjung movement. While the younger generation wanted to engage with the real lives of everyday people outside of exhibition spaces, the older generation preferred to shape the direction of the art movement through exhibitions.

The artists of Reality and Utterance were adamant about continuing exhibition-based practices because they believed that the creation of traditional artworks served as the foundation of the minjung aesthetic and the wider movement. From the onset, they created and presented critical realist artworks, which they called "new art," through workshops and themed exhibitions. Sung Wan-kyung, Shim Jungsoo, Oh Yoon, Won Dongseok, Youn Bummo and Choi Min explored critical discourses, whereas Kang Yobae, Kim Kunhee, Kim Jungheun, Noh Wonhee, Min Joungki, Park Buldong, Son Jangsup, Ahn Kyuchul, Ahn Changhong, Lim Oksang, Lee Taeho and Chung Dongsuk displayed their awareness of social issues through artworks. [3] [4] [5] [6]
In the early period, these artists strongly renounced the monochromatic style of the 1970s and, thus, worked with paintings, photographs, and sculptures to reveal "the specific truth of our lives." And, in this endeavor they were successful at garnering attention from the media and the public. Experiments with kitsch styles (Min Joungki), critical landscapes of capitalist society (Kim Jungheun), the dark and shadowy nature of reality (Noh Wonhee), reality as a historical landscape (Son Jangsup), melancholic reality on the other side of reality (Ahn Changhong), [7] the shadow scenery of the North and South division situation (Chung Dongsuk, Ahn Kyuchul), Gamheung spirit and the spiritual community (Oh Yoon), [8] and dynamic works reflecting the circumstances of real people (Kang Yobae) embody the major aesthetic concerns of Reality and Utterance. However, they refused to engage in more concrete social and activist terms with the turbulent political upheaval of the late 1980s.

The seven founding members of Imsulnyeon are all worth mentioning in this regard. The core

4 Kim Jungheun, *The Land I Should
 Plough*, 1987, Oil on canvas,
 94×134.3 cm

5 Min Joungki, *Washing Face*, 1980,
 Oil on canvas, 97×130.3 cm

6 Lim Oksang, *For Oneness*,
1989, Acrylic, ink, paper bas-
relief on paper, 236×266×3 cm

7 Ahn Changhong, *Dangerous
Play*, 1985, Color pencil on
paper, 77×108 cm

DEMOCRATIZATION AND THE PLURALIZATION OF ART

MINJUNG ART MOVEMENT

8 Oh Yoon, *Dokkabi in a Broad Daylight*, 1985, Woodcut on paper, 54.5×36 cm

9 Hwang Jaihyoung, *Coal Town*, 1989, Oil on canvas, 52×71 cm

10 Lee Jonggu, *Earth—At Ojiri (Ojiri People)*, 1988, Acrylic, paper collage on paper, 200×170 cm

11 Song Chang, *Pleasure Ground in Sagimakgol Village*, 1984, Oil on canvas, 130×162 cm

12 Choi Minhwa, *Your Wakeful Eyes*,
1987, Acrylic, paint on canvas,
250×830 cm

of their aesthetic subject was the "here and now"
in which they were situated. Hwang Jaihyoung
painted the reality of coal mines and miners lives
in Sabuk, Gangwon-do. ‾9‾ And his paintings
generated from his raw experience living at this
site convey a direct aesthetic truthfulness. In his
work, Lee Jonggu focused only on his hometown
of Ojiri. ‾10‾ Although Ojiri was one of the smallest
towns in Korea, the artist insightfully envisioned
the changing world through his images of this
microcosmic social milieu. Song Chang initially
painted the Nanjido landfill mounds, but he shifted
the focus of his subject to the DMZ (demilitarized
zone) after realizing the presence of this divided
national territory as a driving force behind
urbanization and social and material waste. ‾11‾ In
his paintings, the artist expressed a vision of the
divided territory in the form of a mandala. Also
worth mention are the works of Moon Youngtae,
Park Geon, Park Heungsoon, Lee Incheol, Son
Kihwan, Lee Myungbok and Choi Minhwa ‾12‾ who
all pursued both artistic practice and engagement
with the real world. These artists all acknowledged
the political possibility of their art and delved
deeply into the reality of Korean society. They
mainly expressed the reality of the oppressed,
highlighting the division within the nation and
the reality of Korea as a post-colonial country.
They did not adhere to the idea of exhibition-based
practice, nor did they seek to portray any idea of
social reality that they had not directly experienced

for themselves. For them, reality referred only to
that which was experienced; therefore, they had to
engage with the real world in their lives and their
art. In this sense, of all the competing sentiments
of the era the concepts embedded into their practice
were the most influential.

As mentioned above, we cannot discuss
Dureong without acknowledging Kim Bong-Jun and
Lee Kiyeon because they created banner paintings
and pioneered the early Minjung art theory based
on the national aesthetics found in folk art.
Unwinding Resentment of Suffering Minjung of Joseon by
Kim Bong-Jun et al, and *Guardians for Labor* by Lee
Kiyeon and their woodcut prints and other banner
paintings constituted the epitome of the Dureong's
aesthetic. ‾13‾ Sung Hyosook, Jung Jungyeob and Lee
Ukbae who committed themselves to the reality
of their labor established a focus on the aesthetics
of the 'labor' movement as paramount of all their
concerns.

The October Gathering represented the
emergence of the feminist art movement in Korea,
and Kim Insoon and Yun Suknam led the way. Kim
Insoon focused more on portraying the direct and
realistic labor of women than abstract concepts.
She curated the exhibition *Women and Reality*,
which opened the door for women's liberation, and
organized Dungji, an artist collective that formed
alliance with women who worked at factories. Yun
Suknam critiqued the patriarchal Korean worldview
through her works on the theme of 'mother.' These

13 Dureong (led by Kim Bong-Jun), *Appeasing Joseon People from Sufferings*, 1983, Color on silk, 208×171 cm

14 Kwun Suncheol, *Face*, 1990, Oil on canvas, 160×130 cm

sculptures and images represented an honest and expanding language of artistic protest. Her works also reflected directly on the ways in which women autonomously reveal their own power within society, paralleling her own emergence as an artist within the patriarchical Korean art world.

From early on, Son Kihwan and Chang Jinyoung were interested in the aesthetics of cartoons and presented graphic comic imagery that reflected the spirit of the times. Son Kihwan incorporated cartoon forms and experimented with new styles of Korean pop-painting. As a member of the painting group Silcheon, he curated the exhibition *Cartoon Spirit*. In parallel, Chang Jinyoung used comic strip style imagery to tell the stories of laborers, thereby presenting the cartoon as another form of Minjung art.

The June Democratic Uprising of 1987 was a

crucial event that accelerated the growth of the spirit of challenge across Korean society. With regards to the woodcut movement, it can be said that the inspiring work of Oh Yoon was further developed through that of Kim Bong-Jun, I Cheolsu, and Hong Sungdam, and the woodcut-focused group Namu nurtured deepened the concepts of form and existence. At first, many artists only worked on woodcut out of curiosity about this new medium, but after June 1987, mainstream printmaking developed in a completely different direction due to this influence. Kim Joonkwon, Namgung San, Yoo Yeonbok, Choi Byungsoo and Hong Seonwung inscribed ideas of the political into their woodcut art practice and demonstrated the spirit of this medium in relation to national and minjung aesthetics. The expansive production of minjung woodcuts in the late 1980s is not unrelated to the

circumstances of the time. During this period, artists also produced a great number of banner paintings that became symbolic of the propagandist protest aesthetic. Artists, such as Choi Byungsoo and Choi Minhwa, and small artist collectives, such as Ganeunpae, Hwalhwasan and Dungji, produced some of the most significant banner paintings in Minjung art history. A late arriving group in this genre, Ganeunpae, developed into the Nationwide Alliance of National Minjung Art Movement's Seoul branch, led by Park Younggyun. This group showed outstanding potential during this late period in the history of banner painting.

In his work Kim Jinyeol portrayed the real circumstances of the time, and his expressionist figurative works captured a unique notion of Korean society. Kim Joonkwon, Yoo Yeonbok and Hong Seonwung revived woodcut printmaking (initiated by Oh Yoon), using new forms and visual approaches. On the one hand, they examined the traditional Korean woodcut aesthetics; on the other hand, they studied the Chinese New Woodcut Movement led by Lu Xun, and used woodcut as an art form to inspire social reform that significantly contributed to the power of Minjung art in the 1980s. Moreover, they expanded a practice of realist landscape woodcuts that specifically sought to inscribe and represent Korean aesthetics.

The representative sculptors of the time include Choi Byungmin, Shim Jungsoo, Kim Gwangjin, Park Heesun and Ku Bonju. All of them, except Park Heesun, utilized the human body as a medium to reflect the reality of the contemporary era. Choi Byungmin expressed the spirit of the time in a reflective way through featuring mythical figures found in history. Shim Jungsoo presented his analysis of the reality through the intense image of a deconstructed human body. Kim Gwangjin portrayed notions of minjung aesthetics using an extremely realistic manner. Ku Bonju was a young artist active during the transitional period from the 1980s to the 1990s. As can be seen in his work *The Donghak Peasant Revolution*, Ku was consistently interested in the reformative possibility of Minjung art relative to Korean culture and history. Park Heesun reflected on the division of the Korean Peninsula through his wooden sculptures, works that occupied an innovative border space between non-figurative and abstract styles.

The following three artists were not active in small groups but made an outstanding impression as individual Minjung artists: Kwun Suncheol, Shin Hakchul and Choi Byungsoo. Kwun Suncheol was creatively invested in exploring the form of the *Face*. **14** In fact, his work is more akin to landscape imagery representing time than a depiction of a human face. Shin Hakchul made a big impact in the art scene with the presentation of his *Korean*

Modern History series, based on a photomontage technique. **15** The historicity and the meaning of the Korean 'minjung' people, as represented through his painterly forms show the artist's capacity for effortless aesthetic expression. Choi Byungsoo started his artistic practice while he was working primarily as a carpenter, as he was not a trained artist. However, his banner painting *Save Han-yeol!* at Yonsei University deeply impressed the other artists and critics who saw it, due the skill of his execution. In this respect one could state that though Dureong initiated the minjung practice of banner painting, Choi Byungsoo perfected the form. And, finally, Ganeunpae's piece Worker offered the epitomic iteration of this art. **16**

Throughout the 1990s, a period of symbolic, rather than actual social protest, most small groups were dissolved. Therefore, this period is also referred to as marking the end of the history of the "fifteen years" of Minjung art. The political avant-garde of the next generation was in this context labeled "post-Minjung art" or the "new political art." Even though Minjung art was never sufficiently examined by art historians in this decade, artists, critics and the media could not but regard all the new trends as part of the extended history of Minjung art, even through the practice of Minjung art movement was scattered and essentially dismantled primarily in 1994. Minjung art as a movement had ended at that point. Nonetheless, it would be reasonable to say that the Minjung artists continued to maintain their stance, and their works consistently remained political. This fact notwithstanding, it is perhaps going too far to insist that all political art in Korea is reducible to ideas of Minjung art or post-Minjung art.

It is from the Great Workers' Struggle that the trajectory of Minjung art came to be folded into the broader picture of the immense social changes that occurred in 1987 which ushered in the gradual onset of democracy in Korea. The motivation driving 'National Democratic Reformism'—which developed to reflect the new solidarity that existed between working-class laborers, farmers, the urban poor, progressive intellectuals and college students, and their affiliations with the urban middle-class, petit bourgeois and liberalists—was not unlike the concept of minjung (as in the "Korean people") that Minjung artists had considered and pursued. While observing the Great Workers' Struggle, the Minjung artists carried out the unprecedented task of integrating the political nature of art with the social reform movements. This endeavor was reflected in two projects that became key to the Minjung movement in 1987, the liberation and democratization of art, and the creation of an aesthetic entirely open to realizing the "outside spirit," or that which had traditionally resided

beyond the concerns and scope of elite Korean art and culture. From then on, art no longer limited itself to conventional forms, but celebrated hybrid forms of production, including labor art, publication art, feminist art, everyday art, art education, prints, cartoons, banners and mural art.[29]

Minjung art took on this "spirit of the outside" that was not embraced by the institutional establishment and mainstream art. And, in turn, Minjung artists converged on the establishment from the outside. They innovatively integrated various types of marginalized art in such categories and subject matters as folk art, Buddhist painting, Buddhist banner painting, Western art, East Asian art, notions of tradition and contemporaneity,

capitalism and consumer culture, and high culture and popular culture. They also constituted a revolutionary community by blending the labor revolution, with the minjung revolution and the 1987 democracy movement. In this context, they produced art that was not intended for a limited few but for anyone in Korea who identified with the minjung struggle and desire for freedom and democracy.

Artists experimented with community art and art practices in the realms of the everyday, and a new genre of Korean public art emerged. If one may say that Korean art has today reached contemporaneity in parallel with other global art traditions and become 'avant-garde' independently

15 Shin Hakchul, *History of Modern Korea — Rice Planting*, 1987
(remade in 1993), Oil on canvas, 160×130 cm

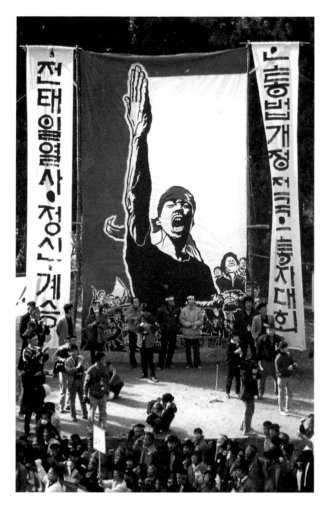

16 Ganeunpae, *Worker*, 1987–88,
Acrylic, paint and mixed media on fabric, 800×400 cm

Three Barbarians and Hong Sungdam's print *Grand Union World*, oppression of *Power of the Art by the Twenties*, removal of Shin Hakchul's work in the exhibition *Artists in Focus*, arrest of Lee Eunhong (whose penname is Ggangsuni), destruction of the wall painting *Reunification and Working People* in Sinchon and *Coexistence* in Jeongneung, oppression of the exhibition Anti-torture, seizure of Choi Minhwa's *The Resurrection of Lee Han-yeol*, application of the National Security Act to the participating artists in the *Exhibition for Reunification* exhibition, seizure of the work *Towards Equality*, arrest of Son Kihwan, the curator of the exhibition *Cartoon Spirit*, confiscation of Song Mankyu's banner painting, confiscation of *Banjjoki Cartoon*, destruction of the banner painting *The History of National Liberation Movements* and arrest of Hong Sungdam and Cha Ilhwan for violating the National Security Act regarding the 1989 History of National Liberation Movements.[30] Later, a number of additional artists, including Baek Eunil, Jung Hasu, Jeon Seungil, Choi Youl and Ganeunpae, who took part in the establishment of Minjung art and the creation of its theoretical and practical underpinnings, all served time in prison.

The early 1990s was the post-arrest and censorship period. In 1993, the Nationwide Alliance of National Minjung Art Movement, which led Minjung art movement along with the National Art Association, announced the dismantlement of the organization. Since the Nationwide Alliance of National Minjung Art Movement represented the radical wing of the art movement, the symbolic meaning of its dissolution was profound. But in fact, a few years prior, at the time of the June Democratic Uprising of 1987, many small groups first began to be dismantled or scattered to different regions. Therefore, in the early 1990s, they were re-organized as councils or associations based on each region, as in the case of the Council of Suwon Artists and the Tamra Artists Association. In this context, many artists who were exhausted by the group activities turned to individual art practice. Meanwhile, diverse approaches to forming new art movements emerged in the 1990s. However, in the long term these could neither adapt to an art environment influenced by postmodernism nor suggest an appropriate alternative discourse.

The exhibition *The 15 Years of Korean Minjoong Art: 1980–1994* provided the institutional foothold upon which to historicize the minjung activist art movements. However, Korean art history at this time could not properly examine the detailed facts on or the dynamics of the movement. During the mid- and late 1990s, post-Minjung art (which can be considered as the third-generation Minjung art) and its discourse emerged. Unlike the art and discourse of the 1980s, these artists explored a more

of any foreign concerns, then it is during this period that such a process began. The unfolding of this process can only be seen from a historical perspective. If we turn that critical historical lens toward the current local conditions in Korea, we can find Minjung art on the one side and post-conceptualist art and experimental art on the other, and arguably the new generation of Korean contemporary art has been born out of the hybridization of these two streams of practice.

THE REMAINING ISSUES FOR MINJUNG ART MOVEMENT

Throughout the course of Minjung art movement, there were many instances of oppression and censorship. The cancellation of the Reality and Utterance inaugural exhibition, dismantling of Choi Minhwa's work *The Citizen 1* in the Seoul Contemporary Art Festival, confiscations of Kim Bong-Jun's cartoon series, Choi Minhwa's cartoon

integrated, post-genre, conceptual notion of minjung aesthetics. Nevertheless, they had not been able to capture the essence of the original movement properly enough to "historicize" an idea of Minjung art. In this respect, only since Korean Art history has been able to describe the multi-layered details of the minjung activist art movement, has it been able to properly outline and fully address the development of Korean contemporary art in the twenty-first century.

1 The members of the Reality Group are Oh Yoon, Oh Kyunghwan and Lim Setaek. Kim Jiha wrote "Hyeon-sildongin je 1(il) seoneon" [The Reality Group's First Manifesto].

2 This group was organized to support Minjung art through theories and explore new methodologies. They studied modern and contemporary art of Korea, critical theories, cultural theories and mass media theories from the perspective of social sciences. The group was disbanded in July 1993.

3 The National Council of Churches in Korea hosted and the Christian Conference of Asia endorsed the International Theology Symposium.

4 Choi Youl, Hanguk hyeondae misul undongsa [The History of Korean Contemporary Art Movements] (Paju: Dolbegae, 1991), 169. Refer to Gwangju Freedom Artists Association's first manifesto.

5 For the inaugural manifesto of Reality and Utterance, see Minjung misureul hyanghayeo [Toward Minjung Art] (Seoul: Gwahakgwa Sasang, 1990), 594–595.

6 Gyeonggi Museum of Modern Art, 2010 Gyeonggi misul peurojekteu: Gyeonggidoui him jeonsi jaryojip [2010 Gyeonggi Art Project: Him of Gyeonggi-do Exhibition Source Book] (Ansan: Gyeonggi Museum of Art, 2010), 86–87.

7 Hanguk misul jeonsi jalyojib III 1980–89 [Korean Art Exhibition Information Booklet III 1980–89] (2017), 14.

8 Manifesto that was published on the back of the Imsul-nyeon inaugural exhibition poster (Deoksu Art Museum, 1982).

9 Gwangju Work and Play, Misul dongin 'dureong' panhwa dally-eok 1984 gapjanyeon [Printed Calendar of 1984 by Dureong] (Namyangju: Silcheon, 1983), backcover.

10 San geurim: Misul dongin "dureong" geurim chaek 1jib [Live Paintings: Dureong's First Color Book], ed. Dureong (1983), 6.

11 "Silcheon geurup, tteusinneun 'silcheon'eul hyanghayeo" [Silcheon, Toward a Meaningful 'Silcheon'], Gyegan Misul, Winter 1984, 187.

12 This phrase was written on the poster of Eulchuknyeon Group Art Festival (1985) hosted by Seoul Art Coalition and organized by Eulchuknyeon Group Art Festival.

13 This text comes from the cover page of Sidae jeongsin (je 1gwon–je 3gwon) [Time Spirit (First to Third Issue)] (Gwangju: Work and Play, 1984–86).

14 Sidae jeongsin je 1gwon [Time Spirit First Issue] (Gwangju: Work and Play, 1984), 30–31.

15 Claudie Broyelle, La Moitié du Ciel: Le Movement de Liberation des Femmes Aujourd'hui en Chine [1985], trans. Kim Juyoung (Paju: Dongnyok Publishing, [1985] 1990), 3.

16 Kim Kyungseo, 26nyeonsa, gamchugi deureonaegi itge hagi 1981–2006: Hanguk jayeon seolchimisurui sae jangeul yeon bakkanmisul [26 Years—Hide, Reveal and Leave It as It Is 1981–2006: The Outside Art Opened a New Chapter of the Nature Installation Art of Korea] (Seoul: Da Vinci, 2006) 16.

17 Hanguk misul jeonsi jaryojip III 1980–89 (Seoul: Korea Arts Management and Kimdaljin Art Archives & Museum 2017), 28.

18 Ibid., 47.

19 "'Ilbu munhwa yesul tujaeng doguhwa insang' imun-gong, yechong hoeiseo gangjo" ['The Impression of Using Art and Culture as Tools for a Fight' Lee Mungong, Voices at the FACO Meeting], JoongAng Ilbo, July 21, 1985.

20 Choi Youl, Minjok misurui irongwa silcheon [Theory and Practice of National Art] (Paju: Dolbegae, 1991), 52–53.

21 Ibid., 53.

22 It refers to the National Minjung art.

23 See Choi Youl, "Minjok minjung misurundong-jeongugyeonhapgwa hangmiryeonui chulbeom" [The

Establishments of Nationwide Alliance of National Minjung Art Movement Activism and the Association of Student Art], *Hanguk hyeondae misurundongsa* [The History of Korean Contemporary Art Movements] (Paju: Dolbegae, 1994).

24 Shim Kwanghyun, "1990nyeonui donghyanggwa jeonmang" [The Direction and Vision of the 1990s], *1990nyeonui donghyanggwa jeonmang: Saebyeogui sumgyeol* [The Direction and Vision of the 1990s: The Breath of Dawn], exh. cat. (Seoul: SeMA, 1990).

25 The work titled *January 28, 1978* (1978), Oil on canvas, 130×324 cm.

26 Kim Yoon-Soo, "Salmui jinsire dagaseoneun sae gusang" [New Figurative Art to Engage with the Truth of Life], *Gyegan Misul*, Summer 1981, 109.

27 Lee Joon, "Hyeongsangeui jinjak" [Vigor of Figuration], *80nyeondae hanguk misurui wisangjeon* [Exhibition of the Stature of 1980s Korean Art], exh. cat. 34. The homonymous exhibition was held from August 8 to 28, 1988.

28 Art critic Lee Joon and Chang Sukwon acknowledged the importance of 1980s figurative art. Often using the phrase "the third territory," they considered it the "third way" of [new] art that escapes from the dichotomy of Modernism and Minjung art.

29 Refer to Ra Wonsik's serial article "Hanguk hyeondae misurui jeongae" [The Development of Korean Contemporary Art], *Misul Segye*, January–December 1992.

30 Banner painting *The History of National Liberation Movements* created as a collaborative project of the Busan Art Movement Research Center, Gwangju Visual Media Research Institute, Jeonju Gyeorye Art Research, Daegu Association of Minjung Culture Movement Art Department, Ganeunpae (artist group in Seoul), Bonghwa (artist group in Masan), Seoul Youth Artist Coalition, the Association of College Artist Groups in Gwangju and Jeollanam-do, Jeollabuk-do Youth Artist Coalition, Daegu Group of College Art Students and the Preparation Group for the Student Association of Pusan National University of Arts.

The Polyphony of Feminist Art in Korea

Kim Hyeonjoo

The modern history of Korea, both in art and in general, witnessed the sequential appearance of "the first women" in many fields. Among many others, there were the "first woman oil painter" (Rha Hyeseok), the "first woman poet in 'the new poetry' movement" (Kim Ilyeop), and the "first woman pilot" (Kwon Kiok). The words "first" and "woman" (*yeoryu*) seemed to go hand in hand as these breakthroughs were being made due to the historical lack of female figures in the cultural and professional arenas in Korea. In this respect, *yeoryu* is a modern term commonly used to refer to the "new women" who managed to rise to prominence in their respective professional fields during the twentieth century. It may sound like a complementary term applied to praise these women, but it also carries a negative connotation in Korean society, denoting a "strange breed of females" who will always be considered something secondary to their male counterparts. Another term, *yeoin* ("woman"), which was commonly used in the modern period across the broader cultural sphere, likewise does not refer neutrally to a woman. Instead, it exercises a romantic objectification of women. It is possible to locate in the word *yeoryu* a projection of the uncomfortable realization that men now have no choice but to accept women as cultural producers and historical agents, while in *yeoin* we find a projection of the eternal male desire to objectify and control women. These words are evidence that the Confucian patriarchal system, which has long dominated Korean society, has been maintained, albeit on an unstable foundation. However, they have not been discarded and continue to be used as conventional terms in the Korean art world.

Employing the mirroring strategy practiced by the so-called "young young feminist" generation in South Korea today, one may reciprocate by coining terms like *namnyu* ("talented men"), and *namin*

("men"). They sound awkward and implausible, however. Language as such not only reflects thoughts and social customs, but it also limits the imagination. Women artists of the twentieth century at times cooperated and compromised, but at other times they made bold artistic statements without hesitating over sparking conflict in the institutionally male-dominated art community. They pressed on, carving out their own place in the world by criticizing existing art concepts and institutions and provoking or otherwise forcing change within the system.

However, the endeavors of all women artists cannot be subsumed simply as feminism since feminist art specifically refers to artistic practices that are carried out with a feminist and gender-consciousness. Feminist art bases itself on the women's experience and reject the conventional thinking that art is unrelated to gender while it intends to abolish the prejudices against and suppression of all social minorities. It consists of re-imagining, renovating, and offering alternatives to the male-oriented structure of the art world. It concerns the construction of multi-tiered artistic practices and activities. Feminist art in this sense came to the fore in South Korea in the mid-1980s and thus has a history of a little over thirty-five years. It is not a simple history formed by discrete individual voices, but a dynamic one characterized by a polyphony of countless female agents whose voices are woven together. This essay outlines the works of women artists who were active in the 1980s with a focus on the feminist art of the era, and aims to broadly cover the diverse trajectory of South Korean women's art in the twentieth century.

WOMEN'S ART IN THE AGE OF MODERNISM

Let us first look at the definition of what is referred

to as "Women's art" (*yeoseong misul*). Literally, it refers to all art created by female humans. In other words, it is a broad term that refers to the art created by people who are biologically or socially categorized as women. However, Women's art does not only refer to artworks by women, but includes art that hints at femininity or the experiences and sensibilities of women. In this regard, female artists whose work reflects their experiences as women but does not claim to be 'feminist' art would still correspond to this definition.

Women's art of the modern period was driven by a handful of pioneers such as the oil painters Rha Hyeseok and Paik Namsoon and the ink painters Park Rehyun and Chun Kyungja. The conventional route to becoming an artist during the Japanese colonial period was to receive a modern education by studying abroad in Japan or France. Most of the women artists of the time were "new women" from middle-to-upper class educationally and socially 'enlightened' families. They were modern people, often having studied abroad and having been exposed to the modern culture. Even when marrying following a romantic rather than an arranged courtship, their passion for working as professional artists never wavered despite the social prejudices they faced. However, neither did the

prejudice they were forced to endure end, leaving them forever caught between their contradictory identities of being a "woman" and an "artist." Even as they worked on their art, they were burdened with domestic responsibilities such as maintaining a household, undergoing childbirth, and providing childcare, and they remained marginalized in the conservative, male-centric art world. However, driven by a desire to be recognized as artists, most of these women nonetheless regularly submitted works to state-run juried exhibitions like the Joseon Art Exhibition and the National Art Exhibition to build their professional reputations.

There are ambivalent opinions regarding these women artists. One is the criticism that they did not join in professing the people's independence, socialist, or feminist ideas of the time, and instead simply received influences from Western and Japanese culture and focused solely on the production of 'art for art's sake.' The other is that their mere existence as women artists is meaningful at a time when women were severely oppressed under a Confucian patriarchy.[1] Rha Hyeseok and Chun Kyungja in particular, whose life courses considerably deviated from the life trajectory of so-called 'normal women' in Korea, were constantly suffering from being considered 'morally corrupt

1 Bang Hai Ja, *In the Heart of the Earth*, 1961, Oil on canvas, 100×81 cm

2 Youn Young-ja, *Work*, 1976, Bronze, 66×40×21 cm

women' and bore outright public condemnation. Their lives were rife with scandal and, as objects of public curiosity, they were constantly in the limelight. This prevented people from objectively evaluating their professional activities, including their art. However, there have been significant strides made since the 2000s in rediscovering and reevaluating Women's art from the modern era. Some prime examples of this phenomenon are the reevaluations of Rha Hyeseok as the first Korean feminist artist, and the discovery and showcasing of previously unseen works by Jung Chanyoung at the special exhibition *When Brushes Are Abandoned* (2019) held at the Museum of Modern and Contemporary Art, Korea (MMCA). For the sake of understanding modern Korean society and culture, rediscovering and reevaluating the artworks of once-forgotten women artists is an important task that we can no longer delay. Rhee Seundja, Lee Soojai, Bang Hai Ja, Shim Chookcha, Lee Insil, Kim Chungsook, Youn Young-ja, Jung Kangja, and Kim Youngja were among some of the women who followed in the footsteps of the first wave of modern female artists. The above-named women graduated from art schools that were established after Korean independence and began their careers as modern artists in the 1950s and 60s. During this era, modernist art made substantive inroads into the Korean art world, and a heroic masculine conception of the artist further reinforced the idea that the realm of art belonged to men. The South Korean art world became ever-more vigilant against the perceived amateurism to which many of women artists were supposed to belong. The success of a woman artist was all but impossible without the acceptance and support of the male artists around her. Most women artists armored themselves through conformity to society's moral standards so as to avoid following in the tragic footsteps of their predecessors, and proactively took on the roles of both "women" and "artists," thereby accommodating the concept of a gender-neutral artist in an attempt to remove is issue from consideration.[2] Even under these circumstances, some of these women were able to proudly seize opportunities to participate in international exhibitions alongside men, while others became professors at universities in order to train upcoming generations after studying in France or the United States. These artists worked mainly in abstract painting, like Rhee Seundja, Lee Soojai, and Bang Hai Ja **1**; modernist sculpture, like Kim Chungsook and Youn Young-ja **2**; or new avant-garde art such as the bold happenings and incorporation of everyday objects found in the works of Jung Kangja, Sim Sunhee and Kim Youngja.

Jung Kangja, who was especially self-aware of her identity as an artist and woman, was a part of the avant-garde collectives the Sinjeon Group

3 Chung Chanseung, Jung Kangja, Kang Kukjin, *Transparent Balloon and Nude* (May 30, 1968, Music Hall C'est Si Bon), Still from the original performance

and Fourth Group. She stood at the forefront of the avant-garde art by leading early happenings and performances, provoking shock waves within South Korea's conservative society and art scene. In *Transparent Balloon and Nude* (1968) Jung Kangja stood daringly on stage clad in her underwear while the audience blew up balloons and stuck them to her body. **3** Jung's performance can rightfully be

called the first feminist performance in Korea, and is no less worthy of respect than Yoko Ono's *Cut Piece* (1964) in which the line between subject and object was resolutely and powerfully blurred.[3] However, in wider South Korean society, Jung's unconventional work was considered more a sexualized object of voyeurism than art practice. This public reception traumatized the artist. She left the Seoul art community but continued to create unique paintings, even while suffering from sociophobia and being gradually forgotten in the art world, right up until her death in 2017.

The 1970s and 1980s saw an increase in the number of practicing women artists, as well as more group activities, and this full-fledged emergence of women gallerists became a new phenomenon in the art world. This change was not unrelated to the fact that economic development and advancements in civic awareness had opened up more opportunities for education and social participation among women. The number of female students in art schools eventually surpassed that of males, and female students also started to study for degrees in art theory and history. However, the number of professional women artists and theorists in the field still fell grossly short of the number of men. In the 1970s, woman-owned and -operated galleries with a modernist orientation, such as Park Myung-ja's Hyundai Hwarang (1970),

Cho Heeyoung's Growrich gallery (1975), and Kim Changsil's Sun Gallery (1977) opened one after another, marking the beginning of a wave of Women gallerists. These gallerists played an important role in expanding the field of modern art and in exploring the South Korean art market, as well as in opening a road to the international stage that allowed the next generation of women followers to reach out to global audiences. In the early 1970s, the Korea Woman Artists Association (1973) and the Korean Sculptress Association (1974), both being pan-women's groups of artists, were established and held periodic exhibitions promoting works by women artists. However, as their names suggest, the two groups were far from maintaining a defined purpose, nor did they base their activities on any clear gender awareness. Instead, they concentrated their efforts on fostering exchanges and encouraging the creative aspirations of their members as they worked to overcome the gender-based disadvantages they faced in the art world.

The most prominent women artists of this period were the oil painters Suk Ranhi, Choi Wook-kyung 4, Lee Chungji, Hong Junghee, Chin Ohcsun, Noh Jungran 5, Yoo Yeunhee, and Hwang Julie; the ink and color painters Lee Sookja, Shim Kyungja, Won Moonja 6, and Song Sooryun; the sculptors Kang Eunyup, Lim Songja, and Kim Hyewon; the U.S.-based painter Kim Wonsook 7;

4 Choi Wook-kyung, *Unfinished Story*, 1977,
 Color pencil, crayon on paper, 147×266 cm

5 Noh Jungran, *Colors Play Sweeping #48*, 2006,
 Acrylic on canvas, 190×190 cm

6 Won Moonja, *Tranquil Garden*, 1976,
 Color on paper, 166×120 cm

7 Kim Wonsook, *Gymnastics in the Moonlight*, 1979,
 Ink on paper, 104×117.5 cm

and the object-based installation artist Chung Kyoungyeon. Despite an increasing number of women artists, the paradoxical clash between the conception of a woman and that of artist continued to be an issue in South Korea, and their views on and position in art also varied. On the one hand, there were those who believed that their art practices were unrelated to their gender identity and focused instead on general aesthetic ideas. Such artists were (arguably) indifferent to the issues women faced and surrendered to the mainstream ideas within the male-centered art world. They embraced their femininity and their experiences as a woman artist, or at least a 'feminine sensitivity' unconsciously played an important role in their work. It was, however, not easy to distinguish such differences in their works, and most artists assumed a flexible attitude depending on the situation. In this regard, they were all compelled to make compromises between the circumstances in which they found themselves and the dominant language of art at the time as they continued their struggle for recognition.

Worth noting in this environment was the work of the Pyohyun Group, which was established in 1971 by graduates from Seoul National University and Ewha Womans University. This collective associated femininity with positive values, sought out alternative expressive methods such as craftwork, and made early strides similar to those of essentialist feminist artists. However, after feminist art came to the fore in South Korea in the late 1980s, the Pyohyun Group did not take on the role of a leading alternative feminist art group by overtly recognizing gender issues and seeking new directions for their practice. Instead, the members pursued a more personal form of aesthetic fulfillment through their art before finally disbanding in the 1990s.

THE FORMATION AND DIVISION OF "YEOSEONG MISUL" AND "FEMINIST" ART IN THE 1980S

General Chun Doo-hwan's assumption of power in 1979 marked the initiation of a military regime that ruled from 1980–88. The popular desire for democracy and social change erupted across the country and ushered in a new era of social and political resistance movements. Minjung art and feminist art both emerged in the 1980s out of the local responses to the social realities of the period. Feminist art formed an important pillar of the new art of the 1980s, and it was in solidarity with Minjung art as both movements sought the restoration of art's relevance and role in social communication. Both movements also pursued participatory art and realism in order to bring

about social change in the world around them. At the same time, they formed an axis opposite to the Dansaekhwa abstract modernist movement that pursued the modernist tendency of advocating art for art's sake. The women artists who drove feminist art recognized that the problems women experienced did not arise from personal issues, but from wider social structures. They strengthened their feminist consciousness as social subjects after encountering the wider scholarly manifestations of realism in the literature of the 1970s, women's studies, social theory, and the overall women's right movement. They also advanced feminist art as participants in the Minjung art movement, which was a congregation of small groups and collectives, and they were actively engaged with women's rights organizations in the 1980s.

The feminist art of the 1980s can be largely grouped into three categories. The first is the activities led by women artists beginning with the October Gathering (Siwol moim) and followed by the establishment of the Women's Art Division within the National Art Association (which later became the Women's Art Research Society), the women's art group Dungji, and the Labor Art Committee. The second is the work of the Women's Art Research Society members who interacted with members of the group Alternative Culture (Tto hanaui munhwa),[4] who focused on bolstering their feminist consciousness and developing alternative feminist aesthetics. The exhibition *Let's Burst Out: The Collaboration of Women's Liberation Poems and Paintings* is one example of the fruit of this cooperation. The third is the individual works of women artists who were members of various Minjung art groups. Of the three categories, the first covers the majority of feminist art of the 1980s. However, in reviewing even this relatively recent historical context there are many more tasks yet to be completed in terms of rediscovering the forgotten voices and artists whose legacy has been excluded from South Korean art history. Such tasks include a reevaluation of the works of Noh Wonhee [8] and Kim Kunhee, who were members of Reality and Utterance, and research on women artists who were a part of other Minjung groups, such as Sung Hyosook and Lee Kiyeon [9] (one of the founding members of the Dureong group).

The October Gathering

The October Gathering was a group that was formed in 1985 by the mid-career artists Kim Insoon, Kim Djin-suk, and Yun Suknam, who shared similar ideas about their lived experience as women in South Korea. Although the group disbanded after only two group shows, the October Gathering was responsible for laying a foundation

8 Noh Wonhee, *A Main Street*, 1980,
Oil on canvas, 130.3×162.1 cm

for feminist art in South Korea.⁵ Kim Insoon and Yun Suknam in particular played key roles in the rise and development of feminist art in the country. The inaugural exhibition of October Gathering showcased large-scale drawings portraying the everyday lives and labor of women, but was unable to garner much attention. This critical lack of interest seems to have stemmed from the exhibition's lack of an overall conceptual theme, the fact that the art world of the time had yet to accept drawings as complete works of art, and the disparities in the quality of the works featured in the show. However, this inaugural exhibition (which is in itself deserving of greater historical attention) was soon overshadowed by their more successful second show.

The second exhibition by the October Gathering, *From Half to Whole* was considered an improvement on the group's first show and delved deeper into the theme of the lived experiences of women. The title itself was a symbolic declaration of their will to become new artistic and social subjects. The exhibition sent shockwaves around the country after being introduced in the media as the first Women's art exhibition to take up the

issues of women's emancipation. It was also severely criticized by a few feminist activists and scholars who deemed it no more than an expression of rage or self-ridicule and seriously questioned whether such art could truly change the realities faced by women in everyday life. However, as the first show to explore women's issues, the exhibition marked the emergence of feminist art in South Korea. It provided an impetus for artists to form an affinity with women in various fields and expand their feminist consciousness.

At a point when existing references to feminist art were close to nonexistent, the artworks showcased in the exhibition realistically expressed the lived experiences of married women in South Korea at the time. *Good Wife and Wise Mother* (1986) **10** by Kim Insoon, *Towards Tomorrow* (1986) by Kim Djin-suk, *Even I Had Ten Hands* (1984) by Yun Suknam **11** , and other pieces are now considered defining works of 1980s' feminist art. The humiliating sight of a wife in her university graduation cap washing the feet of her husband as he brazenly looks through his papers in the nude, as portrayed in *Good Wife and Wise Mother*, was truly shocking to behold. Kim Insoon created

a newspaper collage with varied textures and an unstable color palette, thereby evoking feelings of apprehension from the tension fueled by this image of the rigid hierarchy between this married couple and the prevalent threat of violence within the home—a reality that contrasted with the rapid changes taking place in society and the opportunities for higher education opening up for women at the time. Yun Suknam's *Even I Had Ten Hands* evokes the Korean proverb, "not even ten hands would be enough," meaning a workload beyond what one person could bear. This painting was modeled after the artist's mother, who became the family breadwinner after the death of her husband. The mother's need to take on any arduous task that came her way on top of her regular household chores is clearly expressed through Yun's

bold line drawings. The book in the foreground shows the artist's deep admiration for her mother, who, despite the harsh realities she faced, never lost her dignity. In short, this work is Yun's homage to her mother.

The October Gathering was instituted in the mid-1980s, a time when the Korean art world was re-consolidating into several factions according to the affinities based on aspects such as the art schools attended, personal connections, or aesthetic orientation. The October Gathering decided to form a coalition with the National Art Association, an umbrella association for the Minjung art movement that was composed mostly of male artists who were galvanized in response to the government censorship of art. The affiliation with the National Art Association was possible due

9 Lee Kiyeon, *On the Verge of Life or Death*, 1984, Color, paper collage and ink on paper; hanging scroll, image: 120.5×93 cm, scroll: 194.5×104.7 cm

10 Kim Insoon, *Good Wife and Wise
Mother*, 1986, Acrylic on canvas,
91×110 cm

11 Yun Suknam, *Even I Had Ten Hands*,
1984, Acrylic on canvas, 105×75 cm

to their shared interest in applying art as a means of public communication through realism rather than pursuing art for art's sake. While the October Gathering members sympathized with the National Art Association's goal of social reform through art, they soon became aware of the patriarchal structures and indifference towards gender issues that pervaded the National Art Association and felt a need to pursue independent collective action. Thus was born the Women's Art Division within the Association, with Kim Insoon as its head. By late 1986 the October Gathering had disbanded as its members began to focus on their activities within the Women's Art Division.

Women's Art Research Society and Dungji
Before detailing the activities of the Women's Art Division, it would be useful to outline the precise definition of "women's art" as it appeared in the title of the group. When the Division was established at the end of 1986, the term "*yeoseong misul*," or "feminist art," was still in an early phase of its application. The term "*yeoryu misul*" was more commonly used in the art world—even among women artists themselves—to differentiate artworks created by women from those by men. The members of the Women's Art Division defined "*yeoryu misul*" as art created by women who sought to keep hold of their privileges as they relied on the power of men to achieve success in a patriarchal society. They further defined it to be lacking women's self-consciousness and awareness of their issues. By calling their own work *yeoseong misul*, they differentiated their practices from *yeoryu misul*. Even after feminist art from the West was introduced to the South Korean art scene through articles published in art magazines in 1988, they deliberately avoided using the term feminist art as a means to convey their commitment to exploring women's issues within a Korean context rather than blindly adopting what they were learning about Western feminist theories and art. Given this context, *yeoseong misul* can be understood as a 1980s term that reflected a uniquely Korean historical and regional background. In its content, however, *yeoseong misul* paralleled various other forms of feminist art being created in the West at the time.

The Women's Art Division changed its name to the Women's Art Research Society in January 1988 and recruited 26 members, expanding both the scale and the activities of the group. By renaming themselves, they clarified their identity and aim to explore women's issues while staying grounded in reality and pursuing activist art. One of their practices included a semimonthly study group that began in 1987 in Kim Djin-suk's studio. They also held seminars where they read and discussed social and feminist theory.[6] The society remained active from 1987 to 1994 and held eight annual exhibitions under the title *Women and Reality*. When Korea Women's Associations United was inaugurated on February 18, 1987, the society joined as a member organization, cementing their identity as a group within the women's art movement.

The annual exhibitions of *Women and Reality* were organized around special themes with the exceptions of the second and sixth iterations. These annual exhibitions regularly raised concerns such as the concept, categories, and issues of women's art; variations in media; social roles of art; and gender discrimination. After the shows, a number of the displayed works went on tour upon requests from universities and workplaces. The first *Women and Reality* exhibition began with the ambitious aim of bringing together women artists dispersed around the country. Despite the efforts of the organizers, only a small number of artists participated and the quality of the works varied. However, the groundbreaking curatorial intent was clear and influential.[7] Park Youngsook's photograph of a female peddler leading her difficult life was used as the poster for the inaugural exhibition and its tour through seven universities in Seoul, Jeollabuk-do Province, Chungcheongbuk-do Province, and Busan. At the time, the *JoongAng Ilbo* newspaper covered the aims and process of the exhibition in detail. Under the subtitle "A report on the hardships of women in the workplace," the article described the show as "the first ever large-scale special exhibition on the theme of women's issues" that encompassed oil painting, ink painting, sculpture, and ceramics.[8]

The curatorial orientation of the second *Women and Reality* exhibition (1988), which also focused on women's issues, was well received and was chosen by the Seoul Museum for its *Artists in Focus for 1988*. During a week-long exhibition that included a rich lineup of related events every day, including pansori performances, a traditional ritual for women's liberation (*yeolrim gut* or "shamanic ritual performance"), lectures on *yeosung misul*, screenings of slides and films that illustrated the realities of women in South Korea, and review sessions. These events contributed to boosting interest in traditional cultural elements that had been suppressed or devalued during the process of modernization. They also helped participants and visitors critically reflect on the content and formal aesthetic achievements of the individual and group works and strengthen their solidarity. There were changes in the *Women and Reality* exhibition themes around 1990. Unlike in the 1980s, when they largely focused on social and structural issues that directly impacted the labor and lives of working-class women, the shows of the 1990s reflected the participating artists' interests in the expansion of popular culture and

media amid the rapid ongoing transition to the postmodern era. With the final *Women and Reality* as their last exhibition, the Women's Art Research Society disbanded in 1994 in response to changes in the times, leaving a source book that outlined and reviewed their eight exhibitions.

In late 1987, the Women's Art Division formed the group Dungji to co-produce large banner paintings. This was done after Kim Insoon was forced to live in hiding from the police for several months due to the overtly political content of her work. Kim became the leader of both the Women's Art Research Society and Dungji, and further encouraged creative collaboration with women laborers at worksites. Starting in 1988, Dungji served as the main driver of the *yeoseong misul* movement. Many members had been working on banner paintings even before Dungji was formed. The three most notable banner paintings created by the members were: *Onwards Until the First Dawn of Independence Rises*, *Towards Equality* (1987), and *Women of the Land Living Together* (1987). *Onwards Until the First Dawn of Independence Rises* was created during the Democratic Citizen's Festival held at Myeong-dong Cathedral from July 8 to 11, 1987. The festival was organized by Korean Women's Associations United to help rally the democratization movement. It was the first large-scale banner painting by the Women's Art Division, with some of the members creating an outline and sketch and citizen volunteers completing the painting. *Towards Equality* (1987) was commissioned for the inaugural meeting of Womenlink, but it was confiscated by the Seoul Metropolitan Police on the grounds of being an "tainted painting that agitates turmoil of democratic struggle." It was eventually returned after a protest by National Art Association members.[9] Such exhibitions and events were always under strict police surveillance, and the works produced under the auspices of the National Art Association underwent a repeated cycle of being confiscated by the government and then returned after official complaints were lodged. Dungji was formed as a means to evade the continued government surveillance, censorship, confiscation, and oppression of Minjung art by working anonymously and surreptitiously in rigorous support of the production of activist art for women's rights group events or labor meetings.[10]

Nine banner paintings by Dungji have been identified to date, but it is assumed that the group produced more works. One of the most notable banners is made up of a series of ten paintings known as the *Pico* series (1989), but also referred to as the *Mother Laborer* series. This series took its inspiration from the poem *Mother Laborer* by Hong Seongae, who was the head of the Pico Labor Union. The American branch manager of Pico Korea Inc.

returned to the United States without paying the Korean employees their salaries, so the workers banded together and struggled for 200 days to reach a legal resolution to the situation. The series illustrated this process and celebrated their victory. The work received considerable attention at the time because its public debut was accompanied by a meeting of workers on Labor Day and a play by female workers. It was also included in the third *Women and Reality* exhibition. Dungji produced a wide range of activist art in addition to banner paintings, including a funerary portrait of Kim Kyungsook who had died during the government suppression of the YH labor union.

Dungji's banner paintings, most of which were initially created for events by women's organizations or women laborers, went on tours of the country requested by women's rights groups, universities, and farmers' organizations. The painting *At the Foot of the Mountain that was Clawed at by the Empire* (1988) was included in the *Exhibition for Reunification* (c. 1988) organized by the National Art Association. Most of these paintings are lost or missing due to their frequent transportation without proper record-keeping, except for *Towards Equality*, *Max Tech Democratic Labor Union* (1988) 12 , *At the Foot of the Mountain that Was Clawed at by the Empire*, and *Mother Laborer*. The critical evaluation of Dungji's activist art remains polarized. Some celebrate them as "works comprising a completely new genre of painting." For others, they are simply examples of Minjung art by women that are no different from Minjung art by men, leading to their critical dismissal.[11] The Women's Art Research Society's activities also include manga (*manhwa*) by the Miyal collective that was established in 1988. Miyal published manhwa newspapers and participated in annual exhibitions.

LET'S BURST OUT: THE COLLABORATION OF WOMEN'S LIBERATION POEMS AND PAINTING

Serving as the leader of the Women's Art Research Society, Dungji, and the Labor Art Committee, Kim Insoon was intimately associated with the Minjung art movement. She spearheaded the women's art movement by focusing on activist art and collaborative production. Unlike Kim Insoon, other October Gathering members such as Kim Djin-suk and Yun Suknam continued to look for ways to expand upon their individual works even when participating in collective activities within the Women's Art Research Society. The two achieved a breakthrough when they were introduced to the Alternative Culture collective through their involvement with the *From Half to Whole* show. Alternative Culture pursued feminist

12 Dungji, *Max Tech Democratic Labor Union*, 1988,
acrylic on fabric, 108.5×154.3 cm

cultural production in direct resistance to
Confucian patriarchal culture. It fostered a
sense of sisterhood among its members while
still encountering their individual art practices.
Within the group, Kim Djin-suk and Yun Suknam
experienced a sense of liberation as they began to
study feminism from a more theoretical direction
and sought new ways to develop their individual
art practices in earnest through intellectual and
cultural exchanges with Alternative Culture
members. Feminist poets like Goh Junghee and
Kim Hyesoon of Alternative Culture and four
visual artists met together to read and discuss
their poems. Women's Art Research Society
members Jung Jungyeob and photographer Park
Youngsook also joined the group meetings.
These poets and artists first gathered for about
a year under the loose aim of seeking to jointly
undertake research and dialogue. The fruits of
their exchanges were presented at the exhibition
*Let's Burst Out: The Collaboration of Women's Liberation
Poems and Painting* in November 1988.

Organized by Alternative Culture, the show

13 Park Youngsook, *The Witch*, 1988,
B/W gelatin silver print, 26.5 x 217.2 cm

featured more than thirty artworks by the four artists Yun Suknam, Kim Djin-suk, Park Youngsook, and Jung Jungyeob. Over ten women poets were involved in the show, including Goh Junghee, Kim Hyesoon, and Cheon Yanghee. The exhibition was held in the Min Art Gallery (Geurim Madang Min) space run by the National Art Association. The event was held in low regard and criticized by the male artists and critics of the Minjung art movement, and hence failed to garner widespread recognition.[12] The artists conducted extensive research into women's poetry as preparation since part of the concept for the event was to translate the meanings underlying these poems into visual images. As a means to shift away from the age-old format of a poetry-and-painting exhibition, the artists drew inspiration from the American artist Barbara Kruger's direct use of texts and images in her work. They chose to either illustrate the feel of a poem's message without its text or to directly employ the text itself as the image.

Notable works presented in the show include *Let's Form a Deep and Distant River*, *588, Cheongnyangni*, and *Rha Hyeseok Complex* by Yun Suknam; *Life of a Shell*, *The Moon that Shines a Hundred Rivers*, and *Memory of Giving Birth to a Daughter* by Kim Djin-suk; *The Witch* (1988) 13 and *The Rose* by Park Youngsook; and *While Sewing Bedclothes* and *Potato Flower* (1988) 14 by Jung Jungyeob. *The Witch* by Park Youngsook is a particularly powerful work. It was inspired by a poem by Kim Hyesoon, but does not confine its focus to the original verse and is instead based on an imaginative interpretation of the text. In a series of six photographs, Park aimed to summon the souls and heal their scars of women who were killed after being falsely accused of being witches. The artist presented the discovery of this forgotten women's history and the foregrounding of contemporary women's self-awareness as two prongs in the key to women's liberation through this story of witches brought forth from a grim past.

No catalog was published for the exhibition at the time. However, the contents can be surmised from its poster and from a related book of women's liberation poems entitled *The Face of a Hundred that Is Better than One* (1988) written by twelve women poets. Just like the poems, the artworks were centered on three major themes: the oppressive realities faced by women; women's consciousness and self-awareness; and their experience of motherhood and the sisterhood supporting women's liberation. These themes were the key agenda items for women's issues as proposed by Alternative Culture at the time. Through these three themes, the four artists presented not only the reality of middle-class women, but also the reality and history of women of various classes and the prospect for an egalitarian society.

THE POLYPHONY OF FEMINIST ART IN KOREA

14 Jung Jungyeob, *Potato Flower*, 1988, Woodcut on paper, 40×60 cm

Feminist Art in the 1990s and 2000s

The first generation of artists who contributed to shaping feminist art in the 1980s began to create unique artworks in the 1990s, thereby providing grounds and support for a second generation of feminist artists who emerged in the 1990s. Feminist art in the 1990s was largely driven by emerging artists influenced by 1990s consumerist postmodern culture, including Lee Bul, IUM, and Ahn Pilyun. These artists broke away from painterly practices and embraced diverse media such as photography, installation, and performance. This period is defined by both individual practices and group activities, such as those of the group 30 Carat. While groups composed of women artists with an awareness of women's issues did form in the 1990s, they typically disbanded unfortunately quickly.

In addressing the development of South Korean feminist art in the 1990s, this section offers just a general outline that includes a number of key themed exhibitions and notable second- and third-generation feminist artists before finally examining the influential group Ipgim and their works. Kim Hong-hee, art administrator and curator, set the course for feminist art in the early 1990s and discovered new young artists while undertaking her activities as a curator, researcher, and critic. Kim Hong-hee organized *Woman, the Difference and the Power* from 1994 which was the most influential

feminist exhibition of its day. As suggested in the subtitle of the show, *Feminine Art and Feminist Art*, Kim Hong-hee did not clearly distinguish feminist art from Women's art, but rather took an inclusive approach to providing a model for a Korean feminist art exhibition in the 1990s. For Kim, the works by Yoo Yeunhee of the Pyohyeon Group and the exploration of feminine sensibilities in Kim Wonsook and Kimsooja can be referred to as feminine art, but works of new feminist artists of the 1990s such as Lee Bul and Ahn Pilyun should be classified as feminist art.

The first Women's Art Festival *Patjis on Parade* held in 1999 was organized by the Feminist Artist Network in 1997. A meaningful exhibition that shed light on the then-current state of feminist art in South Korea, the show comprehensively included both Women's art and feminist art. The title was a clear reflection of women artists who were unafraid of becoming *patji*, a benchmark for a 'bad' woman within the Korean patriarchal order. The show employed a myriad of devices—subversion, parody, humor, and play—to undermine the seriousness of the male-centric art concept. The exhibition was made up of Historical and Themed sections, and the five themes were Women's Sensibilities, Women and the Ecosystem, Sex and Gender, Rituals and Play, and Media in the Home. Together, these sections showcased the great breadth of contemporary Women's and feminist art and demonstrated the

broad range of similarities and differences between the individual women artists involved.[13] Compared to the first Women's Art Festival, the second and third exhibitions—*East Asian Women and Herstories* and *FANTASTIC ASIA: New Relations within the Invisible Borders*—conveyed clearer concepts and topics in terms of feminism and catalyzed exchanges and dialog among a wide range of women artists across Asia. The significance of the two exhibitions can be found in their successful identification of a shared intersection related to women's experience of neocolonialism in many Asian countries in a climate of accelerating globalization. The shows helped to unveil the wide spectrum of such experiences while exploring the similarities and differences found in the individual approaches and national contexts. Following these precedents, there were many more exhibitions, both large and small, which led to a considerable expansion of feminist art production in South Korea.

The three most distinguished Korean feminist artists of the 1990s are Yun Suknam, Park Youngsook, and Lee Bul. As observed in her work from the 1980s, Yun Suknam had long been expressing an interest in the concrete concept of maternity rooted both specifically in her own experience and in women's history more generally. In the early 1990s, she developed this concern into a unique approach to installation. Yun continues to experiment with various media today as she explores themes related women, serving as a stable figurehead within South Korean feminist art. Lee Bul's feminist perspective was nurtured by the contexts of popular culture and postmodernism that arose in 1990s South Korea. Her major early works include, among others: The performance titled *Abortion* (1989) in which she provided a clear illustration of the pain of abortion using her own body; *Sorry for Suffering—You Think I'm a Puppy on a Picnic?* (1990) **15** that subverts the voyeuristic nature of the male gaze by taking a performative walk through Gimpo Airport, Narita Airport, and downtown Tokyo over twelve days clad in a monster-like soft sculpture created by quilting artificial rubber over cloth; *Hydra* (1998), a twelve-meter-tall balloon tower that revises the passive

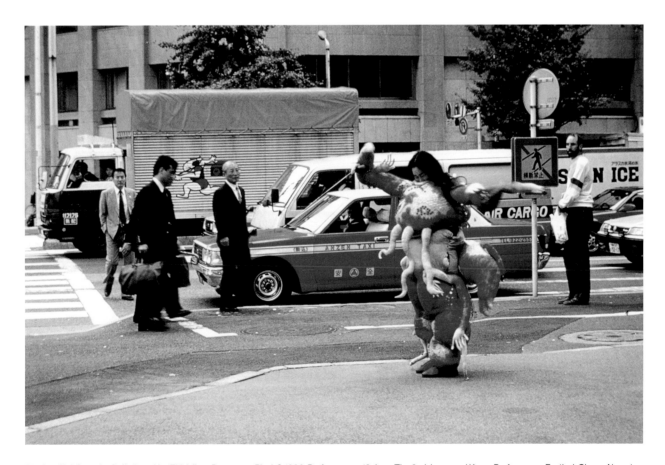

15 Lee Bul, *Sorry for Suffering—You Think I'm a Puppy on a Picnic?*, 1990, Performance, 12 days, The 2nd Japan and Korea Performance Festival, Gimpo Airport, Korea; Narita Airport, Meiji Shrine, Harajuku, Otemachi Station, Koganji Temple, Asakusa, Shibuya, University of Tokyo and Tokiwaza Theater, Tokyo, Japan

16 Chang Jia, *Standing up Peeing*, 2006,
Digital inkjet print, glass frame, 154×124 cm

DEMOCRATIZATION AND THE PLURALIZATION OF ART

image of Asian women constructed within the perspective of orientalism; and *Majestic Splendor* (1991–) which Lee created by sewing sequins onto a raw yellow corvina that was then sealed in plastic bags to symbolize the oppression of women's bodies. Lee Bul's early works are mainly about deconstructing the visual and material idea of a woman's body, particularly in relation to how it is idealized within patriarchal society, using visual tropes such as female nudity. Lee has been breaking up the idealized female body in the patriarchal society, moving from a nude performance to creating a female body sculpture drawing on human and bestial forms, and then to a cyborg body.

After receiving initial recognition as a fearless feminist artist, Lee declared in the early twenty-first century that she no longer wished to have her work pigeonholed through the idea of feminism. Despite this disavowal, and even though her recent practice has moved on to deconstructing the modernist grand narrative of utopia, her latest works can still be constructively interpreted from a feminist point of view.

After the 2000s, feminist art was developed further both in volume and quality by artists like Song Sanghee, Yang Haegue, Chang Jia **16**, and siren eun young jung. These artists were politically baptized in the wave of feminism that swept South Korea in the 1990s along with the feminist culture movement. This generation of artists were exposed to Korean and Western feminist art and were armed with contemporary feminist theories that spanned multiculturalism, postcolonialism, and queer theory, not to mention their familiarity with the digital technology that they fully exploited while carrying out their endeavors online. These artists were thus more confident in breaking down traditional gender roles and embracing ideas such as Judith Butler's concept of gender performativity, as well as proving themselves unafraid to subvert pre-existing institutions and norms. They used media such as photography, video, performance, and installation in their works in order to expand the boundaries of feminist art and transcend the limits of the artistic imagination. Their art practices have been received with ease across national borders as they navigate the global stage within various networks.

Ipgim (literally meaning "breath") is a feminist artist collective, the only one of its kind in South Korea at the turn of the twenty-first century. It is particularly notable for its focus on activist art. They organized seven projects over six years from 2000 to 2006. The group was first established in 1997 by eight women in their thirties who were looking for means to thaw a cold world through the "gentle and warm breath" of women.[14] However, Ipgim's *A-Bang-Gung: Jongmyo Seized*

Project (2000), the winner of the New Millennia Art Festival, was canceled under the guise of an incident with the royal Jeonju Lee Clan. This led to a four-year lawsuit, and the project consequently became Ipgim's best-known artwork. The *A-Bang-Gung: Jongmyo Seized Project* greatly contributed to kickstarting activist art practices in South Korea and influenced female artists who had been more focused on individual artwork in the 1990s toward feminist art. This is well reflected in the positive criticism of the project: "A symbolic event in the history of Korean feminist art history," and "The event that awakened an art movement that had kept silent since Minjung art."[15]

Ipgim was invited to the Busan Biennale in 2004 and collaborated with the US feminist group Guerrilla Girls on Tour. Together they showcased a project, *Island-Survivor*, that addressed the issue of sex trafficking.[16] [17] They also raised awareness of not simply the forgotten women excluded from the male-centric grand historical discourse, but also the many everyday women who had been physically disappearing inside South Korean society, through online and in-person exhibitions within the *Disappearing Woman* project in 2005 and the *Disappearing Woman -Stories of Eumsa* co-organized with the Feminist Artist Network in 2006. They continued to maintain their connection with 1980s feminist art, which they recognized as the precursor to their work, but also flexibly managed the collective by employing various media to illustrate the real problems that women face in South Korea and embracing the changing cultural sensibilities of the period. At times the members joined together in creative actions furthering feminist art by combining movement and art. The activities of Ipgim as an art collective effectively ended after 2006. A number of its members continued to frequently collaborate, but the group officially disbanded in 2018. An archive including a number of Ipgim's works along with artworks by the "young young feminist" collective artists Kwon Seajung, Chung Soyoung and Woo Jian were showcased in the exhibition *Between the Lines* that was held in the non-profit art space Hapjungjigu in the winter of 2019. Here, *Vagina Cushion*, which had been created for the *A-Bang-Gung: Jongmyo Seized Project* was displayed for the first time in nineteen years. The exhibition shed light on Ipgim as a model contemporary feminist activist collective and showed the works of feminist artists who are inspired by Ipgim, particularly in the wake of the #MeToo movement in South Korea. The show was meaningful in that it found clues to connection and communication among seemingly disconnected feminist generations.

The feminist art scene since 2015 has grown more complex with groups such as the "young

young feminists" working on social media platforms, and the "net femi" (short for internet feminist) generation of artists. This group includes Shin Min, Lee Eunsae, Jang Pa, Black Jaguar, and Chi-Myung-ta. Many are looking forward to further works from these artists as they apply a number of different media to make powerful statements with new sensibilities on women's issues and express their desire for social change in areas such as the labor market, gender stereotypes in relation to the expansion of the beauty industry, and violence against women in contemporary visual culture. Furthermore, an unprecedented number of visual art collectives who self-define as feminists have been gaining recognition over the past few years, and these artists are becoming new agents expanding the discourse of feminist art. This change was the result of a number of contemporary events and social struggles. There was also the "#Iamafeminist" hashtag movement that began online in early 2015; the sense of outrage and solidarity triggered by the misogynistic murder of a women at the Gangnam subway station in 2016; and the explosion of feminist activism and the "feminism reboot" (not only in South Korea but across the world), alongside and in connection with the #MeToo movement, as women in the cultural industries shared their stories of being

sexually harassed and assaulted. Most of the newly formed collectives have a strong activist tendency to raise women's issues via art and emphasize in-situ activities. Just as feminism in Korea does not attempt to present itself as a single united voice, most contemporary feminist collectives have unique characteristics and take action in different ways and on different scales. No New Work, founded in 2016 is a prominent feminist visual art collective that held notable and well-received events encouraging understanding and communication among women artists across many different generations. They have continued producing works that aim to reconceptualize feminist art and reconstruct contemporary issues and mainstream discourse. On the other hand, there are also voices of caution and concern about some collectives misinterpreting feminism and lacking introspection, sometimes dividing women artists into groups and attempting to seize power by using feminism.

Feminist art in South Korea has been formed over multiple generations of artists across its thirty-five years of history—from the bellwethers of the 1980s who broke the ground to the emerging young feminists of today. It is a history overflowing the voices of women artists who have passed through different historical, social, and spatial experiences as they transited contemporary discourses and

17 Ipgim·Guerrilla Girls on Tour, *Island-Survivor*, 2004,
Performance and poster of *Disappearing Women*

DEMOCRATIZATION AND THE PLURALIZATION OF ART

aesthetic practices. This chapter has attempted to offer a summary of this history by focusing on a number of the most notable artists and collectives. All the artists mentioned here have criticized male-centered art concepts and systems, challenged or traversed mainstream art, and aimed to bring about positive changes, both intellectually and practically, by intervening in women's issues through art. Various contemporary art forms and media—final works, their working processes, and archives—have been galvanized to carry out equally diverse practices of aesthetically subverting, alternatively imagining, and taking powerful action toward this end. Now, in the twenty-first century, South Korean feminist art is becoming more complex and multifaceted as it interacts with global feminist discourses and communicates with artists around the world while remaining closely connected to the key issues faced by women in the local society.

1 Kim Hong-hee, "Geundae yeoseong hwadan 30nyeon: 1920–1950" [30 Years of Modern Women's Art World: From 1920 to 1950], *Yeseongwa Misul* [Women and Art] (Seoul: Noonbit, 2003), 289–290.

2 Lim Jeonghee, "Yeoseong misulgwa modeonijeum" [Women's Art and Modernism], *Patjis on Parade: 99 Women's Art Festival*, exh. cat. (Seoul: Feminist Artist Network, 1999), 71–72.

3 While this performance was the collective effort of Kang Kukjin, Jung Kangja and Chung Chanseung, its execution would have been impossible without Jung as the principal actor. Unlike Yoko Ono's *Cut Piece* that was recorded on video, Jung's performance can only be reconstructed through a handful of reporting featured in magazines and daily newspapers for entertainment, and the memories of the participants. After the late 1960s, when the Park Chung-hee administration enforced strict censorship and conservatism in the arts field, the avant-garde artists were no longer able to continue with their work. This was when Jung Kangja turned to the medium of painting.

4 Alternative Culture is a women's movement organization created in 1984 to form an alternative culture based on feminism against the patriarchy. Professors such as Cho Hyung (Sociology at Ewha Woman's University), Cho Uhn (Sociology at Dongguk University), Jo-han Hye Jeong (Sociology at Yonsei University), Cho Oakla (Sociology at Sogang University), and Cheong Jin-Gyeong (Sociology at Chungbuk University) were founding members. Alternative Culture Publishing, a sister organization, published a magazine entitled Housewife, the Limitation and Possibility. In addition, members collaborated with female artists in the National Art Association and held a feminist exhibition, *Let's Burst Out: The Collaboration of Women's Liberation Poems and Painting*, which combined art and literary genres at the Min Art Gallery in 1988.

5 Yun Suknam testified that Kim Insoon came up with the name October Gathering from the Russian "October Revolution." This idea was readily received by the members who were prepared to cause a stir in the outdated art world dominated by the earlier generation. Conversation with artist Yun Suknam, Studio in Hwaseong, December 9, 2016. However, Kim Insoon said in a recent interview that the name did not have such a grandiose meaning behind it. Kim Insoon. "Yeoseongui hyeonsile majseoda" [Facing the Reality of Women!], in *Minjung misul, yeoksareul deutneunda* [Minjung Art, Listening to History 1], eds. Park Woongju, Park Jinhwa and Lee Youngwook (Seoul: Hyunsil Publishing, 2017), 327. The exact date is unclear, but Kim Insoon and Yun Suknam would have returned from the U.S. and met around October. It can be deduced that the idea of the October Revolution might have come up just as they shared the impetus that more senior women artists could also do something bold.

6 The Women's Art Subcommittee was established by 11 yeoseong artists in their 20s to 40s in December 1986, with the members of October Gathering at the core and joined by members of Teo (Teo dongin), which included Ewha Womans University Department of Fine Art 1985 graduates Koo Seonhwe, Kim Minhee, Shin Gayoung, Lee Kyungmi, Jung Jungyeob, and Choi Kyungsook, Kim Jongrye and Moon Saem. The department created a study group with art critic Min Hyesook who ran the Min Art Gallery, and remained active for quite some time.

7 The exhibition organization committee was established on April 3 for the first exhibition. It compiled a list of female art school graduates, and sent out approximately 1,700 invitation letters. As a result, the participating artists to the first *Women and Reality* exhibition included

a total of 38 artists in their 20s and 30s, who were in their third to fifth year out of university, in addition to 11 founding members of the Women's Art Subcommittee.

8 *JoongAng Ilbo*, August 31, 1987.

9 For references on banner paintings, see Oh Hyejoo, "Yeoseong, nodong, misul" [Women, Labor, Art], in *Yeoseong·ingan·yesul jeongsin* [Women, People, Art Spirit], ed. Kim Insoon (Gwahakgwasasang, 1995) and an information booklet published by the Women Art Research Society, *Yeoseong, misul, hyeonsil: 1980–94 'yeoseonggwa hyeonsil'eul jungsimeuro bon yeoseong misul* [Women, Art, Reality: A Study on Women's Art from 1987 to 1994 with a Focus on *Women and Reality*], Year unknown, 7.

10 Members of Dungji in its early stages included Kim Insoon, Koo Seonhwe and Choi Kyungsook, and in its later stages included Kim Insoon, Kim Youngmi, Koh Seonah, Seo Sookjin and Lee Junghee.

11 Oh Hyejoo, *Yeoseong·ingan·yesul jeongsin*, 96; Kim Hong-hee, "Hanguk yeoseongjuui misurui banghyang mosaegeul wihan peminijeum yeongu" [A Study on Feminism to Seek the Direction for Korean Feminist Art], *Misul Segye*, September, 1992, 35.

12 Feminist artists in the 1980s crossed paths with two women's movement groups with slightly different agendas. One is the so-called "Progressive Women's Movement," which operated in solidarity with the broader democratization movement and which designated activities of the Korea Women's Associations United founded in 1987. The Korea Women's Associations United spearheaded the 1980s women's movement with the goal of making radical change through the class struggle by female workers and farmers. At the end of the 1980s, the Women Art Research Society and Dungji strongly supported the activities of these groups through their protest art. Another is the so-called "Independent Feminist Movement" led by Alternative Culture, a collective formed in 1984 by intellectuals including women's studies professors, lecturers, and social theorists. Alternative Culture sought to make changes in the feminine consciousness and develop a unique and open alternative women's culture movement against the patriarchy. The two types of women's movements were carried out in two separate places, but were at odds with one another. Alternative Culture was strongly criticized by the progressive women's movement groups and the Minjung art camp for being Western-oriented, and inclined towards intellectual bourgeois women. Lee Hyaekyung. "Hanguk sahoeui jinbojeok yeoseong undonggwa yeoseong munhwa yesul undong" [Progressive Feminist Movement, Women's Culture and Art Movement in Korea], Yeoseong·ingan·yesul jeongsin 100–109; Cho Joohyun, "Yeoseong jeongcheseongui jeongchihak: 80–90nyeondae hangugui yeoseong undongeul jungsimeuro" [Gender Identity Politics: The Case of Women's Liberation Movement in Korea in 80s and 90s], Gender Identity Politics (Seoul: Alternative Culture, 2000), 230–243; Cho Hae Joang, "The 'Woman Question' in the Minjok-Minju Movement: A Discourse Analysis of A New Women's Movement in 1980s' Korea," in *Gender Division of Labor in Korea*, eds. Cho Hyoung & Chang Pil-Wha (Seoul: Ewha Womans University Press, 1994), 324–353.

13 Kim Hong-hee, "Introduction to the Exhibition," *Patjis on Parade: 99 Women's Art Festival*, exh. cat. (Seoul: Hong Design, 1999), 12.

14 Ipgim was established in October, 1997 by eight women artists: Kwak Eunsook, Kim Myungjin, Ryu Junhwa, Woo Shinhee, Yoon Heesu, Jung Jungyeob, Je Miran and Ha Insun. These artists born from 1959 to 1966 were all in their thirties except for Ha, and were specialized in different media such as painting, video and design, all with different backgrounds.

15 Cho Soonryeong, "Hanguk peminijeumui misurui eojewa oneul" [The Past and Future of Korean Feminist Art: On the Link with 1980s Feminist Art], *Munhwa Gwahak*, no. 49, December 2007, 188; Kim Jungi, "Gimjungiui sahoe yesul bipyung (11) haengdong yesul 1: Jeomgeo" [Kim Jungi's Social Art Review (11) Art as Action 1: Occupation], *Kyunghyang Shinmun*, May 8, 2015.

16 Guerrilla Girls on Tour separated in 2001 from the American activist feminist art group Guerrilla Girls that formed in 1985, and focused their activities on performance and satirical theater.

Hangukhwa: Late Twentieth Century Korean Ink Painting

Song Heekyung

HANGUKHWA (KOREAN PAINTING) IN THE 1980S ONWARD

From the 1980s onward, the term *hangukhwa* (Korean painting) was generally applied to all paintings on paper expressed with traditional brush and ink. The issue of applying this term had been put forth as early as the 1950s by some artists and theorists, but major universities and the National Art Exhibition—one of the foremost channels for exhibiting the medium of *jipilmuk* (lit. paper, brush, and ink) at the time—had used the term *dongyanghwa* (lit. Eastern painting, referring to the ink painting tradition of East Asia) to demarcate the medium and entrenched its common use in the art community. However, the overhaul of national public education in 1981 led to the publication of new art textbooks in 1983, which used the term *hangukhwa* to describe traditional Korean painting. The Grand Art Exhibition of Korea, the successor to the National Art Exhibition that was launched in 1982, also used the term *hangukhwa* and successfully established its place as the common terminology for this field of art.

Galvanized by the new categorization, Korean *jipilmuk* artists sought new creative methods and forms, which are apparent in the tendencies of works that were recognized by organizations such as the Grand Art Exhibition of Korea. The National Art Exhibition had been plagued with managerial issues and controversies, with all attempts at reform failing to address systemic injustice and established customs—hence its dissolution in 1981 and the launch of its successor the following year. This was around the time that news corporations also launched juried art exhibitions, such as the JoongAng Fine Arts Prize and the Dong-A Art Festival (both started in 1978), which served as new channels offering official recognition to young artists.

In the early 1980s, the Grand Art Exhibition of Korea tended to award landscape paintings more than other genres within the *hangukhwa* category, but this tendency gave way to awards for increasingly abstract works, portraits, and cityscapes. Once considered the surefire winners of these competitions, the production of landscape compositions went into decline, and portraits—where the watery nature of ink wash and realism were prominent—became the mainstream.[1] However, the majority of artists who submitted portraits to these competitions, once they were officially recognized, branched out into other genres, showing that for many artists, portraits were simply a means to winning competitions and establishing themselves as artists in the public realm.

In the late 1980s, *hangukhwa* reached a turning point with the 1988 Seoul Olympics. As part of the art festivities, the Olympic Committee organized a large-scale art exhibition to display the beauty of Korean art to tourists from other parts of the world. Other massive exhibitions that brought together artists from home and abroad were also planned, but works in the *hangukhwa* genre were curiously absent from all these events. The *Olympiad of Art*, for example, excluded the category for being "unsuited to Western modernist sensibilities," and the *International Contemporary Painting Exhibition* only selected three artists in the *hangukhwa* category.[2] It was a frustrating situation for ink painters, who had been confident that *hangukhwa* constituted the mainstream of contemporary art practice in Korea. The moment served to convince these artists that a new creative direction and overhaul would be needed, with "a pivot away from generic, traditional themes and forms, and expressions of Eastern sensibilities in a way that do not mimic the imagery and form of Western art."[3]

This tectonic shift in the field of post-Olympics *hangukhwa* is most noticeable in the 1992 conference "A Tomorrow for *Hangukhwa*" hosted by *Wolgan Misul*. Panelist Oh Kwang-su noted that the biggest reason for the crisis facing the field was the expansion of the ink as a medium, which led to the relative dismissal of traditional brushwork. On the other hand, Park Yeong-taek argued that the restrictions of the *jipilmuk* medium had driven away young artists and advocated for the inclusion of more postmodern elements within the genre.[4] Amidst this flurry of opposing opinions, young artists continued to join competitions to establish their names while participating in art shows and residencies in Korea and overseas. They also brought in new materials and media to the genre of *hangukhwa* and held small group exhibits to distance themselves from traditional methods. In this process, the once-unshakable belief that *jipilmuk* was the standard form of *dongyanghwa* began to

falter. This was the beginning of the clash between the conservation of tradition and the acceptance of contemporary techniques.

Hangukhwa in the 2000s pushed the horizons of creativity further. Although many artists continued to carry on the traditions of *dongyanghwa*, a significant group of younger artists no longer anchored themselves to the traditional theories and techniques dealt with in *hangukhwa* discourse. For these artists, paintings from the past were simply relics of history or of mildly curious interest. Tradition was no longer a heavy burden to bear, improve upon, and pass on, but a new and interesting experience from which to draw upon; a sort of repository of knowledge, not unlike an encyclopedia.[5] With this perspective, they brought acrylics and other new materials into the world of *jipilmuk*, broke down the borders between genres, and produced works of art that embraced the new concepts discussed in other contemporary art communities.

At this point, the suitability of the term *hangukhwa* once more came into debate, as well as the underlying question: "what makes something 'Korean,' and how must 'Korean-ness' be expressed?" Artists who wished to straddle the worlds of tradition and modernity were faced with a dilemma. Some called for the term *hangukhwa*, which was simply a combination of the Hangul words for "Korea" and "painting," to be used as a proper noun, or for the usage of a traditional term such as *hoehwa* (lit. picture, painting, or drawing)—to place the existing category of *hangukhwa* in the greater category of painting, and at the same time employ specific terms such as "ink wash painting" or "polychromatic painting" depending on the medium utilized for the work.

VARIATIONS ON INK WASH AND POLYCHROMATIC PAINTINGS: AN OVERVIEW OF THE INK WASH PAINTING MOVEMENT AND ABSTRACT INK WASH ART

Ink wash paintings were without doubt the most prominent genre in early 1980s *hangukhwa* works. Artists with Seoul National University pedigree such as Shin Youngsang, Chung Takyoung, Lee Kyusun, and Hwang Changbae had inherited the creative attitudes of the Mook Lim-Hoe, the ink painters' association active from 1960 to 1964, and carried on making abstract ink wash art within the manner of what could be called the "post-Mook Lim-Hoe" generation. **1** This group focused on the delicate balance between black and white produced in the blending of ink and hide glue, and in effects where ink lines of identical thickness were painted in repetition. Some artists forewent traditional Korean *hanji* paper altogether and attempted to

1 Chung Takyoung, *Work 83-82*, 1983, Ink and color on paper, 141×71.5 cm

2 Lee Ungno, *Crowd*, 1986,
 Ink on paper, 211×270 cm

paint ink on linen or canvas.

Artist Lee Ungno, who had experimented with a variety of mediums following his move to France, also returned to the *jipilmuk* tradition with *Crowd* 2, in which his dynamic and powerful brushwork rendered people in a manner reminiscent of calligraphy. Although the forms of the people in this series of works have been deconstructed, Lee's brush painted strict anchors through the center of each stroke to express the dynamism within each figure, making the simplified human figures resemble written characters. The hieroglyphic characters composed of human bodies spread evenly across a wide canvas produced a work of all-over painting. The artist Suh Seok, head of the Mook Lim-Hoe, also composed a similar series of works in the 1990s titled *Dancing People.* 3 The human figures, composed of quick brushstrokes, resemble symbols that have been schematized. The bodies connected only by lines and circles are gender-neutral, condensed, and featureless, created through a marriage between traditional ink painting brushstrokes that form the foundation of this series and Western abstract expressionist aesthetics.[6]

A significant new movement in the field of ink wash paintings in the early 1980s was the Ink Wash Painting Movement led by Song Soonam 4 alongside alumni of Hongik University, who set out to experiment with new methods of expression. Song was a staunch critic of the encroachment of commercialism into the art community and proposed ink wash paintings as an alternative. The term "ink wash painting movement" was first used by art critic You Hongjune in the preface to the exhibition, *Today's Ink Wash Painting* held at the Songwon Gallery in 1982.[7] Song, alongside Hongik alumni Hong Seokchang, Rhee Chulryang, and Shin Sanok, held a large exhibition to showcase the endless potential of the ink wash medium. Unlike their forebears, these artists proudly acknowledged

3 Suh Seok, *Dancing People*, 1990s,
Ink on paper, 77×64.6 cm

DEMOCRATIZATION AND THE PLURALIZATION OF ART

4 Song Soonam, *Tree*, 1985,
Ink on paper, 94×138 cm

the influence of abstract expressionism and proved
the importance of applying the techniques of a
given medium through a diverse array of methods.[8]

Some critics, however, voiced concerns about
this movement. Namely, that the ink wash medium
was so steeped in tradition that there was no
novelty in its range of techniques, and that the
new movement was merely a biased experiment
conducted by a group of people tied together by
academic affiliation.[9] As though proving the
criticism correct, the movement came to a sudden
decline in the mid-1980s, largely due to the
meteoric fashionable emergence of polychromatic
work. Park Saengkwang's solo exhibition at the
Korea Culture and Arts Foundation Art Center
in 1984 turned those in the traditional *hangukhwa*
community on its head, bringing polychromatic
paintings to the forefront of the scene. Until Park,
polychromatic paintings were often labelled as
stylistic remnants of the colonial period practice,
as ink coloring was often considered a major
expression of Japanese aesthetics. This resulted in
the relative spurning of the genre at exhibitions, but

the success of Park's new work in the genre opened
countless possibilities for Korean polychromatic
painting.

The biggest names of the Ink Wash Painting
Movement began to distance themselves from
the depiction of realistic landscapes, radically
altering the forms of the mountains and water that
constituted their subject matter, and even adding
color to their work. As such, the polychromatic
wave of the mid-1980s swept up even these
established supporters of the ink wash medium,
including Song Soonam—widely considered the
leading figure in the movement—who would now
start a work with strong ink brushstrokes for his
mountains, fields, and rivers, then add primary
colors to parts of the landscape. Rhee Chulryang
also added primary colors to depict the landscape
after applying ink seeping technique (*balmuk*) and
split brush technique (*papil*). [5] Another factor that
led to the weakening of the movement was the
double standard artists had concerning the medium.
Although their emphasis was always on the visual
art theory of *dongyanghwa* literati painting, they

5 Rhee Chulryang, *Mountain in the Spring*, 1988,
Ink and color on paper, 183×122 cm

6 Oh Sook-hwan, *Repose*, 1981,
Ink on paper, 146×112 cm

7 Kim Hodeuk, *Untitled*, 1996,
Ink on linen, 122×188 cm

were captivated by the beauty of the ink wash medium. Song Soonam in particular had repeatedly stated that the movement was "an endeavor to go beyond the technical and expressive aspects of the medium and unearth its spiritual elements and uniquely Korean cultural roots." Yet he was so obsessed with the medium itself that he focused primarily on research into the material aspect of his work.[10] Hong Sukchang, too, called his works "contemporary literati art" while also confessing that his works were more so "an expression of the spiritual nature of the literati poetry and painting in contemporary colors, finished with contemporary aesthetics."[11]

Thus, the 1980s Ink Wash Painting Movement gave way to independent pursuits that reflected the subjective perspectives of the participating artists. Following in the footsteps of Song and Hong, Oh Sook-hwan, Kim Hodeuk, Cho Soonho, Lee Jongmok, and Park Soon-Chul delved into the materials of ink wash paintings and left powerful legacies in the world of *hangukhwa*. Painting on large backdrops, they refused the fetters of the discourse concerning 'Eastern-ness' and focused on conveying the ephemeral essence of nature and the gentle changes within such. These artists who continued the pursuit of abstract ink wash paintings conversely proved that the issues facing *hangukhwa* could not be solved simply through the exploration of contemporary techniques or an obsession with traditional East Asian philosophy and aesthetics. It was made abundantly clear that traditional materials constituted the best paints, and the calligraphy-like brushstrokes unique to the genre were the most powerful and dynamic technique. Abstract ink wash artists in the 1990s, therefore, did not set an attainment of the mythical "soul of *dongyanghwa*" or literati painting as their starting point. Rather, they focused on the creation of the abstract and conceptual based on depicting the concrete world around them, prioritizing their practice as means to first fully understand the nature of their subjects before transitioning to explore the abstract possibility of their work.

Oh Sook-hwan depicted the ever-changing world of light through abstract ink wash 6 , starting with a painting of lights on an impoverished hillside neighborhood—a slum district in the daylight, but just as radiant as the rest of the city at night, no different from wealthier counterparts. The painting was a representation of Oh's realization that in spite of financial difficulties, the people in these neighborhoods and their lives were no less beautiful and valuable than those of anyone else. The artist Kim Hodeuk took on a completely different style by drawing, scattering and shaking rough lines across the picture plane. 7 Asserting that there was no meaning in a binary divide

between East Asian and Western art, Kim boldly applied new materials to the *jipilmuk* medium. Cho Soonho chose to display the power of ink wash paintings with dramatic brushstrokes and bold composition, branching out into self-reflective portraits and ink wash and polychromatic paintings of subjects easily found in daily life, such as birds, flowers, animals, and weeds. Heavily influenced by Taoism, Park Soon-Chul focused on the coincidental discovery of the unusual effect produced by mixing adhesive and ink, and used the effect to express the emotion and movement of human characters on paper. Park is one of the most well-known artists to research the myriad types of lines produced by brush and uses ink wash drawings not as sketches for finished works but as a genre of art in their own right.

Abstract ink wash painters in the 1990s were well aware of the importance of the void, or the area on the painterly surface left untouched, which is a critical element of ink painting. These spaces may lend the appearance of incompleteness, but are in themselves a compositional element with form of their own. They can be considered as a space where nothing exists, but possible harbors of a new universe within, where something is born from nothing. As such, the blank space is not simply "white," but a decolorized, empty space which is in opposition not to "black," but color itself, and which contains the constituent elements of the universe. It was with this important idea as the focus that abstract ink wash art from the 1990s started to break down the fundamental boundaries of form and composition to write a new chapter in *hangukhwa* history. By fully understanding the form of a subject, these artists were able to overcome boundaries and condense their shapes in a new kind of expressive formativeness.

MULTILAYERED EXPLORATIONS OF POLYCHROME

The genre of polychromatic painting was largely ignored by the *hangukhwa* artists in the ink painting discipline following Korean liberation from Japanese colonial rule, due to the significance of coloring in modern Japanese ink painting. Constantly made the subject of comparison against ink wash painting, such works with polychromatic ink were labeled "unprincipled," "uncultured," and "vulgar," and the manner was either treated as taboo or spurned for its apparent incompatibility with Korean sensibilities. That did not, however, change the possibility that color could add to a work of art. The use of the natural colors of the subject, for instance, altered by the addition of light, could deliver delicate textures and emotions different to the sensibility of ink wash art—hence

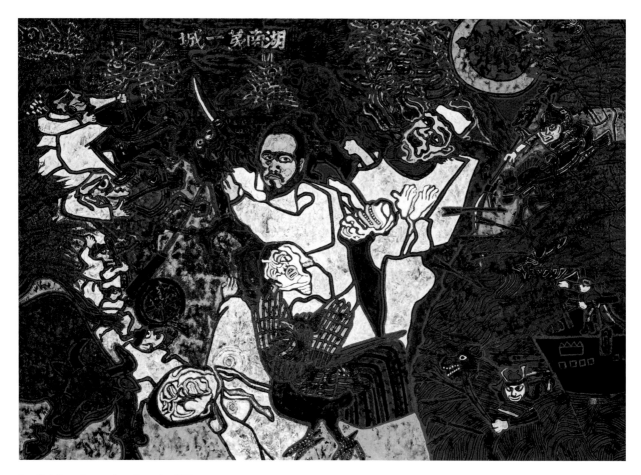

8 Park Saengkwang, *Jeon, Bong-Jun*, 1985,
Color on paper, 360×510 cm

why polychromatic paintings continued to be produced despite such strictures, and Korean artists continued to push at the boundaries of expression with their use of color.

As discussed earlier, Park Saengkwang was the artist responsible for bringing polychromatic paintings into the critical spotlight within the *hangukhwa* genre. 8 It was Park who presented a large Korean shamanistic and Buddhist-themed polychromatic painting, over 500 *ho*, in the early 1980s at the peak of the Ink Wash Painting Movement. The subjects of Park's work—Korean traditions such as shamanism and mask dancing—showed how the use of color could be distinctly Korean. He utilized generous amounts of traditional Korean *obangsaek* (five cardinal colors)—blue, red, yellow, white, and black—in his work, and outlined all objects in red to create the effect of both spiritual mystique and dynamism. The thick, dramatic lines, heavy use of primary colors, and the straightforward subject matter tied together his works, which straddled the boundaries between the spiritual and secular and tradition and innovation

9 Oh Taehagk, *Figure*, 1988,
Color on paper, 162×130 cm

while breaking down the borders between Korean, Japanese, and Western art to redefine the term "Korean polychromatic art."

Min Kyoung-Kap, who led the Mook Lim-Hoe alongside Suh Seok in the 1960s, began to explore wash paintings—the marriage of ink wash and polychromatic paintings—in the 1980s, and went on to present the *Mountain* series of works, which were colored landscapes. The bright primary colors and the geometric shapes of the mountains reached a new high point in the 2000s with the series of work titled *Into the Nature*. Meanwhile, Lee Jongsang analyzed the paints used in a famous Goguryeo-era tomb mural and utilized motifs from the ancient work to create a polychromatic painting that occupied a border space between form and abstraction. Drawing upon on Swiss scholar Josef Gantner's prefiguration theory, Lee judged that the East Asian concept of *qi* was the foundation of all existing things and the source of life and spirituality. This perspective was expressed in his large-scale mural works, where the forms of subjects were rendered into symbols and colored.

Artists practicing polychromatic painting dedicated themselves to researching the compatibilities between paints and the material that served as the background. As a student at Hongik University, Oh Taehagk was so passionate about this matter that he would make requests of his teacher Chun Kyungja for paint purchases. He would later go on to develop the *jangji* (thick, high-quality paper) technique of polychromatic painting to open a completely new path in the discipline. 9 The *jangji* technique involved multiple light applications of paint on *jangji* paper so that the colors in the background would faintly radiate like an aura. In this experimental technique, light paints would seep into the paper, and the repeated additions of color would evoke a heavy yet cheerful atmosphere. Oh also employed pigments made of crushed stone, putting a thick layer of paper over the *jangji* and spreading the stone powder over it, then using a fur brush or a hammered bamboo brush, or another tool for creating sharp lines, to draw acute lines across the surface and express a variety of forms. Another artist who researched the connection between *hanji* paper and paints is Song Sooryun, who is known for coloring on the back of the paper, and rather than start out with strong colors, slowly dyes the back of the paper with multiple brushstrokes so that the colors seep onto the front of the paper. The color and aura of the countless layers applied over time defines Song's work. This difficult labor blends together the paper

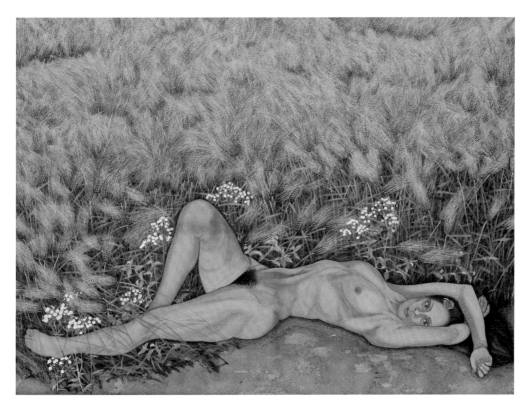

10 Lee Sookja, *Eve's Barley Field 89*, 1989,
Mineral pigment on paper, 148×198.8 cm

11 Kim Bohie, *Towards*, 2011, Oriental color on canvas, 200×200 cm (3)

12 Jung Jongmee, *Queen Myungsung*, 2008, Paper, ramie, pigment, dye, bean essence, gold powder

and colors through the creation of an understated and subtle surface evoking comfort and subtlety.

Artist Lee Sookja has been painting polychromatic works since the 1970s. Her works are characterized by several sheets of *hanji* paper pressed into five or more layers, and colorful combinations of stone powder paints. Lee's series of works *Eve's Barley Field* **10** , a shockingly realistic depiction of nude female figures, is a depiction of Korean sensibilities and a historical lament that likens Koreans to the persistent nature of barley, which only grows when it is heavily pressed. The provocative forms of the subject matter, the bold contrasts of primary colors in the figures and background, and the barley fields that fill the space offer a highly sensual expression. Kim Bohie is another female polychromatic artist who has worked within the discipline since her time as a student. Starting in the 1990s, Kim has focused

on sentimental landscapes, setting up a studio on Jeju Island in 2005 where she worked on paintings related to the theme of "healing," depicting natural environments such as the sea, mountains and land, and plants and animals. Her colors are defined by ink and blue hues that fill the colors of the island's surrounding seas, and by lush greens that depict the vitality of wildlife. Her series of works titled *Towards*, **11** which focuses on the sea, the island, and green plants, are landscapes concerned with showcasing the vivid imagery of plants, animals, and the power and atmosphere of nature.

Artist Jung Jongmee, who researched natural paints, devised a new technique where the *jangji* paper would be first refined, then applied with countless layers of glue between thin layers of paint, and finally finished with crushed beans dyed to form the background, on which paint could be applied. **12** The addition of natural colors to *jangji*

paper showed that polychromatic painting was far from inferior to monochromatic ink work as a form of creative expression, allowing for completely new forms to be depicted that ink wash paintings could not replicate. This disciplinary practice breathed new life into the *jipilmuk* medium, drawing out further potential that had been long hidden.

RECORDS OF LANDSCAPES AND CITYSCAPES

In the latter half of the twentieth century, a new school of landscape painting was born in the world of *hangukhwa*.[12] This new discipline, founded by young artists trained at universities rather than privately, drew on the techniques of traditional ink painting while adding their own personal touches to the established conventions of landscape painting. The Shinmook Group, an association of artists from Hongik University, was formed to explore this trend. Led by Ha Taejin, the group sought to "visualize landscapes conjured in artists' inner minds with the everlasting infinity of the *jipilmuk* medium, through the lens of personal philosophy and emotion." Although the term landscape was not explicitly mentioned, all the over one hundred works presented by this association were in the landscape genre.[13]

With this trend of artists in their twenties and thirties reimagining landscape paintings through their own distinctive styles, commercial galleries jumped on the opportunity to hold group exhibitions of *hangukhwa* for such works. These exhibitions, intended to display new forms of ink painting included polychromatic landscape in addition to ink wash paintings. This marked the birth of 'emotional landscape' as a new genre, a term used to describe works where the depiction of landscape was refigured through the artist's imagination and perspective.[14] Oh Yongkil, awarded multiple times for his rural portraits and depictions of animals, adopted a combination of traditional East Asian ink brushwork and Western aerial perspective in the 1980s to express landscapes that depict mountains, trees, and farms with the understated use of ink and bright but soft colors. In the 2000s, Oh presented a new masterpiece that brought together city and nature, *Seoul-Inwang Mountain* (2005). **13** Within this majestic work the peaks of Inwangsan Mountain are spread like a folding screen, with the vast grounds of Gyeongbokgung Palace below, indicating the coexistence of modernity and history in the city beyond.

The artist Park Daesung, who was not formally trained, was officially recognized at a competition for his landscape. His debut was followed in 1988 with a solo exhibition at the Ho-Am Art Gallery with a gargantuan work of art with a canvas size of 1,000 *ho*, created for the stated purpose of "capturing Korean sentiments through a depiction of the vast nature."[15] In the early 2000s, when

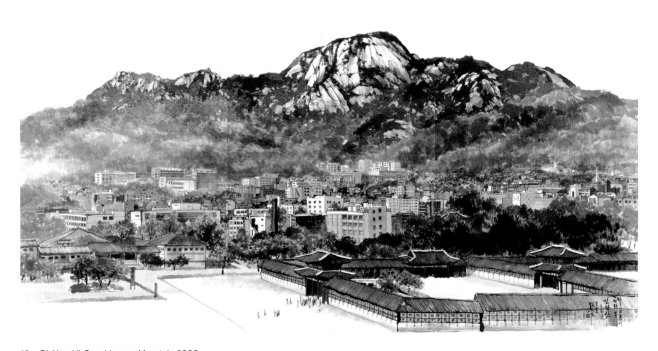

13 Oh Yongkil, *Seoul-Inwang Mountain*, 2005,
Ink and color on paper, 196.5×408 cm

14 Park Daesung, *Total Scene of Kumkang Mountain I*, 2000,
Ink and color on paper, 134×169 cm

15 Kim Hyunchul, *Islands*, 2016,
Ink and color on fabric

16 Lee Cheoljoo, *About Time*, 1981,
Ink and color on paper, 130×130 cm

17 Cho Hwan, *Idle Talk in a City*, 1986,
Ink and color on paper, 163.5×204.5 cm

HANGUKHWA: LATE TWENTIETH CENTURY KOREAN INK PAINTING

South Korean tourist access to Mountain Geumgang in North Korea was not yet been possible, he visited North Korea through Japan in order to recreate the Outer and Inner Geumgang mountains and the vistas of Pyeongyang and Myohyangsan Mountain on canvas. 14 Artist Kang Kyungkoo is the mastermind behind *Seoul Byeolgok*, a series of landscape paintings begun in the 1990s that visualize elements of Seoul as the center of finance, politics, society, and culture within the Korean Peninsula for 700 years, since its designation as the capital of the Joseon Dynasty. Without relying on rough sketches, Kang's work featured an array of vibrant colors to express the famous mountains, valleys, and sights of the Seoul area. His rough and unrestrained brushwork, as well as the eye-catching combination of ink and color added a new layer of life and dynamism to the genre.

Kim Hyunchul is considered as a successor to the legacy of Joseon Dynasty's true-view landscape painting, thanks to his ink-splashing technique that allows him to uniquely visualize natural space. Kim works on hemp canvases, which combine the absorbent nature of rice paper and the clear-cut texture of silk. Kim also utilizes a skilled combination of indigo, azurite, and acrylics to depict the precise shades of blue that best suit the Korean landscape. His 2016 landscape series *Islands* captures both the blindingly blue seas and the islands on the horizon in one frame for each image. 15 Three lengths of hemp were connected lengthwise for each painting, with the frame bisected horizontally—the bottom half a sea of clear blue, and the upper half islands of ink, faint azurite and blank skies.

Alongside these landscapes based on real scenery, works that depicted urban vistas were also a consistent mainstay of the second half of the twentieth century. Cities are a symbol of modernity as well as a place of contradiction, where development, prosperity, and consumption coexist with pollution, conflict, and inequality.[16] For the working people who called cities home, the development and material prosperity of cities were a boon—but industrial development also inflicted numerous negative side-effects heavily on the working classes. These injustices of reality and the passive acceptance of these injustices weighed heavily on the lives of everyday people. The urban spaces depicted in ink painting during this period are places of "civilization" that have achieved industrial development, as well as places of hope where people could express their deepest desires.

The 1980s marked the notable acceleration of urbanization in Korea, and the cities that grew and sprouted led to a change in perception and new interest. It was at this point that the experiences and memories of urban spaces were depicted in

picture form. Artists first focused on the slum neighborhoods of cities, where homes were largely built out of plywood. These neighborhoods were often located on the tops and sides of mountains and hills, areas which were left out of the unusually rapid development of Seoul in the 1960s. Unplanned, rampant development led to the unequal distribution of administrative zones, and the result was the stratification of city residents. The biggest side-effect of this period of urban development was the polarization of space, where areas in the cities were either highly developed, cultured areas that guaranteed prosperous living conditions or destitute slums. Scenes of the latter were captured perfectly in the 1980s paintings of Suk Chuljoo and Kwack Jungmyung.

The physical appearances of cities were not the only subjects to receive attention. Artists found inspiration in the daily lives, desires, and thoughts of working people. Cityscapes now took on the roles of both the *pungsokhwa* (everyday documentary painting) that depicted the everyday scenes and the *girokhwa* (documentary painting) that served to record commemorative scenes and gatherings. Lee Cheoljoo is the first major *hangukhwa* artist to focus on cityscapes, having submitted portraits of fishermen, farmers, and artisans to establish himself in the art community, he then began to paint abstract ink wash paintings in the 1990s. Not content to confine himself to these fields, however, Lee also painted landscapes of urban settings and the lives of the working class. His 1980 series of works titled *About Time* features portraits of city-dwellers, such as an elementary school student walking home with a handcart standing vertically in the background; a laborer squatting for rest; and a couple who have closed their roadside stand and are looking at a newspaper together. 16 Works in the *Today's Expressions* (1983) exhibition, which was a collaborative effort with artist Hwang Changbae, also depict serious and humorous moments from city life.

Cho Hwan, Kim Sundoo, and Suh Jungtae are some of the foremost painters of daily life and urban living. In the 1986 series *Idle Talk in a City*, Cho painted the hustle and bustle of a subway station and the lively atmosphere of a bar in something resembling a snapshot format. 17 Kim Sundoo used the *jangji* technique to recreate the familiar yet strange lives of city dwellers and the lives of the marginalized working class. 18 Suh painted expressionless human figures devoid of life in order to depict the twisted side of city life and the circumstances of the urban downtrodden. Ink wash painter Kim Hosuk also captured the faces of working class people in his paintings of the city, focusing on depicting the human form to convey an idea of reality, using a brush technique

18 Kim Sundoo, *Line 2*, 1985, Ink and powder color on paper, 117×150 cm

19 Jung Jaeho, *Ecstatic Architecture— Cheonggye Tower, Modern Arcade, Jongno Building, Yongsan Hospital*, 2006–2007, Ink and color on paper, 194×13 cm (3), 191×130 cm

which produces clean lines to lend strength to the contours, elements which were then covered with thin veneer of watercolor. His depiction of people based on his experience through the medium of ink wash painting, carries a tone of unembellished rawness that is rare in polychromatic portraits.

Another artist who focused on cities in the 2000s is Jung Jaeho, who utilized the traditional *jipilmuk* medium to capture the underside of contemporary life, combining the aesthetic sensibilities of modern art with an awareness of social issues. **19** Jung's works depict unplanned public spaces such as the Sibeom Apartment Complex—once the dream of the working class—

to bring to light the side-effects of nationally-driven modernization and the working people who were forced to bear the brunt of these effects. Artist Na Hyoungmin composes fictional utopic spaces thought to exist beyond the world of city life using the contrasting colors of ocher and blue. Domesticated by the rewards of living in the city, people continued to dwell within urban space without addressing the manmade problems that were generated in the wake of industrialization. As a response, Na pictures beautiful, imagined spaces to reveal the double conscious of city people who wish to dwell in such places. Lee Yuwoon employs immaculate perspective and the principle of the

vanishing point in her depictions of the cities in which we live, visualizing dreamlike spaces where the individual does not exist. Using thin brushes, Lee draws an endless series of vertical and horizontal lines to paint geometric and monumental blueprints of city buildings. Her recent series of artworks titled *Monument* display symbolic Seoul structures such as Gwanghwamun Gate and the Seoul city hall in symmetrical positions.

Some artists chose to combine nature with the city in their works. For instance, Yoo Geuntaek brings together contemporary perspectives on nature with the urban spaces of the working class. **20** Yoo explains that he focuses on the sense of place within urban spaces where daily life, sentimentality, and the act of communing intersect, visualizing scenes that draw the eye from the interior to the exterior, and vice-versa. The latter half of the twentieth century in Korea was marked by rampant development and urbanization, which came with benefits but also created unwanted effects such as marginalization and inequality. This is why such cityscapes serve as an alternative record of the scenes of ruin and development that filled Korean cities as well as being symbolic of urban life throughout the ages, representing history and the passage of time.

THE INTRODUCTION OF NEW MEDIA AND MATERIALS

A slew of unprecedented creative methodologies and forms were introduced to the field of Korean ink painting in the 1990s. The boundaries between works in two and three dimensions collapsed, Western paints were brought into the fold, and experimental new media and materials were utilized. Artists had experimented with non-*jipilmuk* materials since the 1960s—artist Ahn Dongsook, for instance, used watercolors and oil paints to paint geometric abstract art on rush mats, and Shim Kyungja used tree rings and coins as stamps in her work—however, this massive introduction of new objects and materials greatly expanded the boundaries of *jipilmuk*.

The most prominent of the artists who broke down longstanding norms of ink painting practice in expression and materials is Hwang Changbae. As a student he painted on the traditional laminated paper normally used as flooring, rather than *hanji* paper, and following graduation, he developed a new blurring technique utilizing boiled hemp and was awarded the President's Prize at the National Art Exhibition. In his second solo exhibition to celebrate his 1987 Seon Art Prize win, Hwang presented a series of works titled *Untitled*, also known as *Find the Hidden Pictures*, garnering attention from the art community by breaking from tradition

21 Hwang Changbae, *Untitled*, 1990, Mixed media on paper, 145.4×101 cm

and forgoing the base sketch, instead staining the horizontal *hanji* paper with ink and paint, then adding details onto the stains to create form.

Hwang's work was not limited to *jipilmuk*—he also made use of materials such as canvas, lye, acrylic, and coal briquette ashes to paint social parodies. The acrylic work *Untitled* (1990) features a grotesque chicken with its wings spread proudly and a comic speech bubble coming from its mouth. **21** The text on the right is the onomatopoeia of a chicken's clucking written in hangul. The text on the left presents three Chinese characters each meaning "cry," "high," and "home"

20 Yoo Geuntaek, *Long Fence*, 2000,
Ink and color on paper, 162×130 cm (6)

22 Won Moonja, *Untitled*, 2001,
Ink on paper, 178×358 cm

that when put together are pronounced similarly to the clucking onomatopoeia. The Korean text, however, is crossed out. The artist statement has been composed in hangul, and the year in traditional Korean count has been written in Arabic numerals. Whereas the Chinese characters are painted in pink on a black backdrop, the hangul inscription is painted in white. The year, which has been connected like a spring, is gilded. The strong, unwavering brushstrokes, simple coloring, and bold use of negative space is an accusation of greed and avarice against the uncultured upstarts who live in "high homes" while "crying" like chickens. By

borrowing from the traditional forms of East Asian ink painting, Hwang here offered a social critique of contemporary life.

Won Moonja is known for using the characteristics of *jipilmuk* to create a three-dimensional effect. Having sought to master all *jipilmuk* techniques in the 1960s, Won reached a new peak in miniature flower-and-bird painting with a masterful level of realistic depiction. In the mid-1980s, Won began to work with *hanji* engraving, making use of a dak paper frame and staining and blending techniques. The technique of applying different materials onto *hanji* paper

23 Lee Jongmok, *Excitement with Natural Flow*, 2010,
 Ink and color on paper, 55.5×97 cm

24 Yoo Seungho, *Shooo*, 2000,
 Ink on paper, 129.6×72.3 cm

had been practiced since the 1950s; however, Won was the first to practice engraving onto the paper without altering the nature of the paper itself, while only using traditional *jipilmuk* tools. In her series of works, *Untitled* (late 1980s–), Won featured shapes of birds, animals, and flowers made with mulberry paper by blending characteristics of *hanji*, vibrant colors, and the shapes of objects seamlessly. Won would go on to drift away from coloring and experiment with inking dak paper, exploring the formal boundaries between the conceptual and the abstract. **22**

Other works readily adopted the themes and forms of *dongyanghwa*. Lee Jongmok began working with abstract ink wash paintings in the 1990s, producing works such as *Entrance of Mountain* (2002), *Just Like Water* (1997), and *Inner Landscape* (2002) as he explored ink wash techniques that were compatible with elements of nature. He went on to attempt a new technique where he would paste a mimicked version of an existing painting onto his backdrop, or engrave shapes onto stone, to stamp onto *hanji* paper. *Excitement with Natural Flow* (2010), *Aue darongdiri*, and *That is What* are prints derived from the same motifs. **23** The fish, tiger, bird, phoenix, and clouds are motifs common to classical East Asian art and painting. The rabbit and toad, for instance, are featured in the picture scrolls *Chōjū jinbutsu giga* from Japan's Heian era, and *That is What* is a line from a song from Korea's Baekje era about a woman waiting for her husband, a traveling merchant. Lee made full use of these classic motifs in his works.

Park Yoonyoung combines folding screens, the styles of traditional scrolls, pictograms combining calligraphy and depictions of objects with narratives in mixed media, and theater formats. Seo Eunae is

25 Son Donghyun, *Logotype-CocaCola*, 2006,
Ink and color on paper, 130×324 cm

26 Lee Jinju, *The Lowland*, 2017, Powdered pigment, animal skin
and water on unbleached cotton, 222×550 cm

another artist adopting the techniques of classical East Asian art and painting. In her series of solo exhibitions in the 2010s, including *Cheerful Solitude* (2010), *Junzi's Garden* (2011), and *Boundaries of Dreams* (2012), she summoned the concepts and discourses discussed in past paintings into the twenty-first century, reshaping them in her own style. Seo's vivid use of green in particular is reminiscent of the colors of blue-and-green landscape, and her snapshots based on moments from literature and daily narrative hearken back to the historical East Asian tradition of narrative portraiture.

Many other artists have attempted to recombine the content and form of ink painting to make it more accessible to mainstream audiences. For example, Hong Jiyoon takes the literati genre's fundamental philosophical importance of the trinity of "poetry, calligraphy, and painting," and

interprets it for contemporary times by combining hangul, classical Chinese, and English, blurring the boundaries between calligraphy and drawing, and applying ink with neon colors to create a new style called "pop literati painting." Artist Yoo Seungho developed the style of "text art," or "text landscape painting," in which characters are written in repetition or dots are drawn to form images. From afar, his works appear to be ordinary landscape painting, but from up close it becomes clear that the images are made of vast arrays of tiny Hangul characters. His work, *Shooo* (2000) 24 , mimics Song dynasty artist Fan Kuan's *Travelers among Mountains and Streams*. Whereas Fan Kuan utilized an array of techniques to depict the breathtaking vista, Yoo expressed the textures of the mountains and streams solely with repeated expressions of the Korean character that reads as "shooo." Artist Son Donghyun combines pop culture imagery with the styles of Eastern art, painting characters from Hollywood movies or Disney animated features on *jangji* paper with ink and paint, transliterating the names of the characters into Chinese characters and a traditional artist's seal in place of a signature. Son also made use of the brilliant patterns of late-Joseon era ideography (*munjado*), a genre in which large textual compositions are filled in or decorated, and here the design offers a variation on the Coca-Cola logo. 25

Finally, Lee Jinju depicts deconstructed narratives and unstable egos with striking visuals, expressing the many individual perspectives of different people, as they remember given incidents differently. 26 Although the people in Lee's works are detailed and realistic, the objects in the images have been deconstructed, divided, and cut off to give a dreamlike yet strange and unsettling atmosphere. Lee's intention in these works is to reconstruct these scattered memories and facts to indicate an uncertain answer to the uncertain questions of life.

In the mixed torrent of perspectives and discourses that define the contemporary art community, *hangukhwa* today is at a crossroads between tradition and innovation. Artists continue to hold on to the traditions that distinguish *hangukhwa* from other genres, but are always drawn to new artistic trends. It is now the mainstream opinion that even the relatively new term *hangukhwa* is no longer suitable in the influx of combinations of materials and media, and should be rather replaced with simply "painting" or "art." This ongoing discourse of syntactic uncertainty indicates the imperative perspective that drives artists and scholars as they continue their explorations into the subject and practice of "Korean" painting.

1 Kim Yoon-Soo, Oh Kwang-su, and Chung Kwanmo, "Minjeon 10nyeonui seonggwawa sae jakkasang" [10 Years of Minjeon and the Portrait of the New Artist], *Gyegan Misul*, Fall 1987, 195.

2 For more on exhibits connected to the 1988 Seoul Olympics and the attitude of the Korean ink painting community following its snub, see Lee Minsoo, "1980nyeondae hangukwaui sanghwanggwa galdeung: Misurui segyehwa maengnageseo hangukhwaui hyeondaeseong nonuireul jungsimeuro" [Situation and Conflicts of Korean Painting in the 1980s: Focusing on the Discussion about Contemporaneity of Korean Painting in the Context of Globalization of Art], *Art History Forum* 39 (2014): 125–130.

3 "Saeroun johyeongseong chugu, hangukhwa jeonhwan-gie" [A Transition Period for Korean Art, the Pursuit of New Form], *Dong-A Ilbo*, May 17, 1988. 7.

4 Oh Kwang-su, Kang Seonhak, and Park Yeongtaek, "Hangukhwaui naeireul mosaekanda" [Searching for Korean Art's Tomorrow], *Wolgan Misul*, February 1992, 57–61.

5 Park Jeong-gu, "Oneul, 'hangukhwa'neun mueosinga" [What is "Korean Art" Today?], *Wolgan Misul*, June 2007, 109.

6 Yun Nanjie, "Sigakjeok sinche gihoui jendeo gujo: Willem deu kuninggwa seoseogui geurim" [Gender Construction in the Visual Signs of Body: The Paintings of Willem de Kooning and Suh Seok], *Art History Forum* 12 (1998): 141. In this article, it is stated that the modernist term "avant-garde" used in Suh Seok's declaration of the Mook Lim-Hoe was imported alongside ideas of abstract expressionism and informalism.

7 Lee Minsoo, "Hangukwaui hyeongsang pyohyeongwa hyeonsil insigui jaejomyeong: 1930nyeondae ihu gungnae hwadanui gusang·chusang nonjaengeul jungsimeuro" [A Study on the Figural Representation and Consciousness of Reality in Hangukhwa (Korean Painting): Focusing on the Debates between Figurative and Abstract Arts in Korea since 1930] (PhD diss., Hongik University, 2019), 83.

8 Kwon Yeong-pil, "'Dongyanghwa'ui yeoksaeseo bon 'hangukhwa'ui gwaje" [Remaining Issues for "Hangukhwa" in the History of "Dongyanghwa"], *Johyeong* 18 (1995): 15.

9 "Hangukhwa 'taljeontong' momburim" [Korean Art's Struggle to Throw off Tradition], *Dong-A Ilbo*, November 9, 1984.

10 Song Soonam, *Hangukhwaui gil* [The Path of Korean Art] (Paju: Mijin, 1995), 124–155.

11 "10nyeon mane 'hyeondaejeok muninhwajeon' ganneun hongseokchang gyosu 'hyeongsigi daesureonga'—hanbatang heudeureojin butchum" ["What Does Form Matter?" Hong Sukchang's Enthusiastic Brushwork at the First Contemporary *Muninhwa* Exhibition in 10 Years], *Dong-A Ilbo*, November 23, 1998; "Hyeondaejeok muninhwa 'meogui rhapsody' Seonhwalang, Hong Sukchang 10nyeon gyeolsan jakpumjeon" ["The Rhapsody of Ink" with Contemporary *Muninhwa* at Seonhwalang, Featuring Hong Sukchang Ten-Year Showcase], *Kyunghyang Shinmun*, November 20, 1998.

12 In this essay, landscape paintings are defined as paintings of real natural landscapes utilizing the traditional *jipilmuk* medium that implement new poetic forms from modern Western art to imbue the work with the artist's personal sentiment.

13 Ha Taejin, "Sinmukhoe changnipjeone bucheo" [Adding to the Shinmook Group Launch Exhibition], *Shinmook Group Launch Exhibition* (Seoul: Korea Culture and Arts Foundation Art Center, 1984).

14 On the concept of landscape art from a sociocultural

perspective, see Kim Hong-jung, "Munhwasahoehakgwa punggyeongui munje—Punggyeong gaenyeomui gu-seonggwa geu ganeungseonge daehan ironjeok tamsaek" [The Problem of Sociocultural Landscapes: The Compo-sition of the Concept of the Landscape and a Theoretical Exploration of the Possibilities Thereof], *Society and Theory* 6 (2005): 129–167. In this essay, landscapes are referred to not as Euclidian, homogenous, and quantitative spac-es, but qualitative places that exist as a possibility, which allow the instinctual airing of senses and emotions.

15 "Interview ilcheon ho daejakjeon ganneun hangukhwaga Bakdaeseong ssi areumdaun uri sanha hwapoge" [Inter-view with Korean Art Painter Park Daesung Celebrating 1,000 *ho*: "Committing Korea's Beautiful Mountains and Rivers to Paper"], *Kyunghyang Shinmun*, February 26, 1988.

16 Lee Mu-yong, *Gongganui munhwa jeongchihak* [The Cultural Politics of Spaces] (Seoul: Nonhyeong, 2005), 75–76.

National Mega-Events and the Formation of Korean Design

Choi Bum

A large-scale banner, ninety meters in height, designed in a traditional Korean style for the *National Wave '81* (Gukpung '81) event was vertically hung over a building under construction. The image of a Korean traditional mask called a *tal* filled the center of the banner and the event logo covered the bottom of it. The height of one letter in the Gulim font almost reached 10m. The work of the graphic designer Chung Yeonjong, this symbolic banner was hung at the main site of the 1981 *National Wave '81* Festival. **1** Having majored in craft at Hongik University, Chung focused on reinterpreting traditional Korean patterns and applying them to modern commodities. As he said in an interview: "Redesigning Korean motifs for commodification is my lifetime vocation and the only aim of my work."[1]

The new military government, which had seized power after the assassination of president Park Chung-hee on October 26, 1979, hosted the grand national festival *National Wave '81* in an attempt to improve public sentiment and unify Korean society. Huh Mundo, the first senior secretary of the State Affairs Committee of the Blue House, primarily planned the event, which was held at the Yeoui-do Square for five days from May 28 to June 1, 1981. Approximately 6,000 students from 198 colleges and universities, and 7,000 citizens took part in the event, presenting a diverse range of performances, competitions, festivities and markets primarily with themes based on traditional Korean culture. 160,000 people in total were mobilized as organizers and staff members, and almost 6 million spectators visited Yeoui-do to participate in this event. *National Wave '81* was held at the same time as the first anniversary of the May 18 democratic uprising in 1980—and several months before Seoul's bid as the host city for the twenty-fourth Summer Olympic Games to be held in 1988. For this reason, with this event the new military government attempted to divert public attention from the May 18 uprising, and positively turn their attention to the future possibility of the Olympics through this immense national festival.

In this event, the most representative visual images were the symbol and poster designed by Chung Yeonjong. As in his own words, his works were specifically "Korean designs,"[2] or the results of "reinterpretations of Korean motifs with a modern sensibility." Here he had selected a common item of national material culture, more precisely the traditional Korean mask called *tal*, and recreated it as a modern visual symbol by adding simple shapes and vivid colors to the standard design. While many other designers had taken this approach in the 1970s, Chung here demonstrated the most complete and stylized version thus far.

The eclectic approach to Korean design was formed on the combination of decorative art and the ideas of modernism. In the history of Western design, the term eclecticism is often used to refer to the fusion of different styles of the past, which in modern design often emerged through the appropriations and combinations of different styles of different historical eras, including the gothic, Renaissance or Baroque. Eclecticism in Korean design is differentiated from that of the West in that it is the combination of traditional motifs and modern forms. It is meaningful as it clearly signifies the visual representation of the characteristics of modernization or modernity in Korean society. That is, in the forms of Korean design, traditional motifs serve to reflect Korean-ness, and these motifs are dealt with by means of modern design methods. This is comparable to the idea of Korean modernity as created through the hybridization of pre-modernity ('inner nature') and modernity ('outward appearance'). In this sense, we can say that Korean

design is a visual form that aptly represented the hybridized nature of Korean modernity.

With regards to the emergence of modern Korean design, the design researcher Kim Jongkyun has commented: "From the late 1970s to the 1980s, in the field of visual communication, designers began to present their works as works of 'Korean design.' Also, several exhibitions focused on the portrayal of Korean traditions, including *The Image of Korea* (1979), *The Korean Beauty* (1981), *The Color of Korea* (1981), *The Patterns of Korean Design* (1985) and *The Korean Style*. As in other fields, the Korean nature of the design was also discussed in the context of government-led nationalism. Designers at that time examined ideas of Korean-ness or the Korean style while mainly focusing on formal elements like traditional patterns or colors. They often used

traditional terms and images like *arirang, hwarang, chungmugong,* 'the golden crown from the *Silla* Kingdom' and *Namdaemun Gate* as the major motifs in their graphic design."[3]

Kim Kyoman, a former professor of Seoul National University, was one of the pioneers of Korean design. In particular, he often used unique characters and patterns as signature visual devices. After his 1976 solo exhibition curated under the theme "Korea," he produced numerous, diverse graphic works (e.g., the cultural poster for the Seoul 1986 Asian Games and the symbol for the "Visit Korea Year") and published a book of his graphic works. Following Kim Kyoman, many designers, such as Na Jae-oh, Bang Jaeki, Kim Sangrak, Koo Dongjo and Cho Jonghyun, immersed themselves in this style of visual works throughout the 1970s

and 1980s. This Korean style was rooted in the historical dynamics of modern Korea—from "local" color which emerged during the Japanese colonial era to the various "traditional" art practices which were encouraged during the Park Chung-hee regime in the 1960s. In this sense, we can say that "many of the traditions that are regarded as [representative] of the 'identity of Korea,' or 'Koreanness' in Korean society, were the results of repetitive selections and reproductions throughout the nation's shifting political situations. Thus, the perspectives of the governing power were embedded within them."[4]

We can find a similar case in the history of Japanese design. The graphic designer Ikko Tanaka recreated the traditional images of Japan by transforming them into extremely simple and modern forms. Although he heavily influenced the works of Korean graphic designers, his designs arguably featured more minimalist and sophisticated forms than those created by Korean designers. Nevertheless, Tanaka's designs do not deviate from the normative visual framework of stereotypical Japanese traditional culture. In a similar vein, the production of modern design in post-colonial Korea showed a hybrid, eclectic approach, and thus it is difficult to label it modernist in the true sense. In this regard, the monochrome tendency in Korean painting, which is often termed simply 'Korean modernism,' and graphic design shared the same historical and formal foundation despite the differences in the genres.

INTERNATIONAL EVENTS AND DESIGN: THE 1986 ASIAN GAMES AND 1988 SEOUL OLYMPICS

The intense period of state-driven modernization in the 1960s and economic development in the 1970s under the Park Chung-hee regime lay the foundation for the prosperity and expansion of Korean society in the 1980s. Contrary to the political oppression that historically defined the decade, the 1980s witnessed a considerable degree of economic growth. Due to the industrial accomplishments of the 1960s-70s, the new decade of the 1980s demanded greater internationalization. On a social level, there was a strong desire to escape the image of Korea as an impoverished country, that followed in the wake of Korean War, so that Korea could establish a new image on the international stage. The two large-scale international sporting events, the Seoul 1986 Asian Games and 1988 Seoul Olympics, provided the Korean government with the opportunity to meet these new demands.

For these international events, the government turned to design and established related organizations on a large scale. The national design committee was organized, and several design experts were mobilized to serve the event.[5] They developed or selected the event mascots, emblems, official posters, information pictograms, sports pictograms, cultural posters, and athletics posters. Besides that, they designed the cover and editorial designs of the Olympic games-related book, various writing templates, badges, medals, symbols, souvenirs, stickers, vehicle registration plates and colors, exhibitions, interior designs for various facilities, brochures, banners, event posters and assorted PR materials. Due to this occasion, the expression 'total design' grew within the popular public imagination.

The most representative visual designs include the official poster (Hwang Buyong and others) and event-related cultural posters (Kim Kyoman and others) for the Seoul 1986 Asian Games, the official poster of the Seoul 1988 Summer Olympics (Cho Youngjae) 2 , the Olympic emblem (Yang Seung-Choon) 3 and the Olympic mascot called "Hodol" (Kim Hyun) 4 Designated designers created the emblem and mascot designs, and a nation-wide competition determined the mascot's name. In every sense, the design for the 1988 Seoul Olympics was the result of the combined efforts and interest of Korean society and Korean designers at the time. From a stylistic point of view, however, the designs were an extension of the formal approaches taken during the 1970s, albeit that they represented those approaches in a more refined and sophisticated fashion through computer graphic technologies. Likewise, although the design of the 1980s drew the public's attention on a national level as opposed to the "design for export" of the 1970s,[6] both were ultimately the same, as they were grounded on a tradition created by authoritative governments.

FROM HANGUL TO BOOK DESIGN: CULTURAL NATIONALISM AND MODERNISM

On the one hand, the 1980s was a time when Korean design, which had been cultivated by successive authoritarian administrations, was coming to the climax of its stylistic journey. On the other hand, it was also an era when people paid more attention to Hangul from a cultural and nationalist standpoint than they had before. Amongst the many traditions that had been cultivated during the postwar period through careful selection and invention, Korean people valued Hangul with more esteem than they attributed to any other cultural asset. Hangul was deemed to reflect the unique character of Korean national identity. Thus, the design of Hangul typefaces served to heighten national pride. During this era of political struggle for democratization in the 1980s, intellectuals and artists attempted progressive practices through social movements and

2 Olympic Games Seoul 1988 Official Poster, 1985,
Design: Cho Youngjae

4 Olympic Games Seoul 1988 Official Mascot, 1983,
Design: Kim Hyun

3 Olympic Games Seoul 1988 Official Emblem,
1983, Design: Yang Seung-Choon

5 *bogoseo\bogoseo* (Seoul: Ahn Graphics, 1988), Book design: Ahn Sang-Soo

cultural politics. It would not be an exaggeration to assert that, for designers under the same historical circumstances, designing new and populist Hangul typefaces represented their way of engagement in many ways equal to the actions of socio-political movements.

Under these circumstances, the emergence of the Hangul font designer Ahn Sang-Soo and the typeface called Ahnsangsoo (1985) was perhaps the most significant incident in Korean design to occur during the period. Ahnsangsoo is the representative de-squared typeface of Hangul and was installed as the default font in the Hangul Office word processing software popular within Korea. Ahn

Sang-Soo created an innovative way of typing Hangul by using only 67 characters, so in this sense, the design principle of Ahnsangsoo rightfully met the original minimalist spirit of the Hangul writing system. In addition, Ahnsangsoo was not only used as a font itself, but also as a reference for other formal design elements—examples include the poster titled *Hangeul Mandala* (1988) and the experimental periodical *bogoseo\bogoseo* (1988). 5 Ahn Sang-Soo, in this sense, is venerated not only for designing an innovative typeface for Hangul script but also for developing it from an artistic perspective.

Ahn Sang-Soo's design demonstrated an unprecedented formal aspect in Korean design by

6 Sung Wan-kyung, Choi Min eds., *Visual and Language 1:*
 Industrial Society and Art (Seoul: Youlhwadang
 Publishers, 1982), Book design: Chung Byoungkyoo

7 Sung Wan-kyung ed., *Visual and Language 2: Korean*
 Contemporary Art and Criticism (Seoul: Youlhwadang
 Publishers, 1985), Book design: Chung Byoungkyoo

relinquishing the lingering traces of decorative art
and attempting to realize a completely modernist
aesthetic with respect to form. An unusual designer
in the Korean design scene, Ahn perfectly mastered
the formal language of modern design. In fact, the
ideology that supported his form was rooted in
the historical ideas of Korean cultural nationalism
inherited from the era of King Sejong (1397–1450)
and the Korean Linguists Ju Sigyeong (1876–1914)
and Choi Hyeonbae (1894–1970). Nevertheless,
Ahn's typeface designs and other experimental
practices are emblematic of the pinnacle of modern/
contemporary Korean design. In addition to Ahn
Sang-soo, the designs of Hangul typography of Lee
Sangcheul, the art director of *Ppurigipeunnamu*, and
Han Jaejoon, a professor of visual design at Seoul
Women's University, also drew public attention.

During the 1980s, the overall approach to
editorial design, beyond the Hangul typeface, was
defined by innovation. One of the representative
designers in this field is Chung Byoungkyoo, who
was an editor-turned-designer. He pushed the
boundaries of book cover design and introduced
and established a new concept of 'book design' that
encompassed the whole process of designing the
publication. ‾6‾ ‾7‾ He presented a series of designs
from the early 1980s, after completing his studies

in France, and those book designs constituted a
pioneering total project that served to open up a new
horizon in Korean publishing. Since then, Chung
has continued to create experimental design works
in the fields of typography and publication design.
Likewise, Ahn Sang-soo and Chung Byoungkyoo's
attempts at creating 'alternative' design approaches
played a vital role in counterbalancing the
popularity of Korean graphic design that was
inclined toward nationalism in the 1980s.

THE TRANSFORMATION AND DEVIATION OF MODERN CRAFT

In practical formal contexts of production,
modernization indicates the transformation of craft
into a true design activity. It refers to a shift from
the hand-made, cottage industry production of
traditional handicrafts to that within the modern
and industrial system. Such a transformation is
never simple nor linear. Arguably this process
demands the immediate creation of a new plastic
language. Yet at the same time, historians should
also pay attention to the way in which the position
of traditional craft production and consumption
changes in the new industrial and socio-cultural
context.

In the process of modernization, the fate of traditional craftwork is generally twofold; the status of such works is obliterated, to some degree, while being culturally elevated. If a craft process cannot be absorbed into the process of modernization through the mechanical production system, such are often annihilated completely. However, if such practices survive, they can continue to exist on a different level of consumption and reception, such as that of the art-craft. The notion of an 'art-craft,' in the historical context, this idea can be used to refer to the transformation of handicrafts that occurred when the independent concept of art appeared during the Renaissance. As art took the central position of prestige within visual culture, it 'alienated' the traditional sense of craftwork, which was then absorbed into the boundaries of fine art. As a result, the form and function of crafts were transformed in the new context. Most traditional forms of craftwork met their demise, as they were unable to adapt to the modernization processes; however, some found new paths through their transformation into fine art, or rebirth as art-craft. Art-craft pertains to the transition of an object into a work of art, and correspondingly the conversion of craftsmen into artists. In other words, a new system of art production and reception serves to co-opt craftwork relative to the processes of cultural and industrial 'modernization,' which entail the loss of practicality.[7] According to Choi Gongho, In Korea, this transition first began at the Hanseong Craft Workshop (1908), and the categorization and critical practices that occurred relative to the foundation of the Craft Department and exhibition within the colonial period national showcase of the Joseon Art Exhibition completed the process (1932).[8]

The transformation of craftwork into artwork had a more in-depth meaning. First, in relation to the idea of a public consciousness, Korean people began to recognize crafts not as daily objects of use but as artworks, as was implied by the name of the Hanseong Craft Workshop. Accordingly, the usage and context of craftwork extended beyond the realm of daily life and grew close to receiving the reverential appreciation reserved for 'art' within Korean society. Second, the social status of craftsmen was no longer restricted to the lower working class but potentially levelled up with that of other cultural producers, such as artists, among the social elite of Korean society. As such, the transformation of their craft into art brought about fundamental and overarching changes to the social understanding and experience of craftwork as well as to its cultural positioning. Of course, this changed the morphology and usage of craftworks. Even though such works maintained their traditional forms, these were no longer the same items as those produced in the past. Moreover, the more prosaic aesthetic quality and utilitarian functionality that craftwork historically possessed was replaced with a new appreciation for the genre as a form of modern art.[9]

This was a major threshold and revolutionary change in the history of Korean craftsmanship in the past thousand years, and was not different from the meaning of the modern in Korean history. Various interpretations are possible regarding this historical transformation of craftwork. On the one hand, it represents deviation and demise for the loss of its traditional function. On the other hand, it signifies progressive development in that craftwork gained a new status and function for a new era.

This modern transformation of Korean craft eventually reached a deadlock in the 1980s. Namely, the art-craft that developed throughout the colonial era and proliferated after Korea's national liberation finally abandoned its minimal focus on "function" and became something beyond craft. I call this process "de-craft" in that craft work at this point completely exceeded the traditional ideas of function and use. Such "de-craft" production came to dominate the policies and discourses on craft in the 1980s. Largely referred to as "de-functional craft," "*objet* craft" or "plasticist craft," this new genre of "de-craft" served to deny craft itself in the name of craft. This phenomenon thus demonstrated the crucial point at which Korean culture had failed to modernize in its own terms. While Korean design demonstrated the hybridity of Korean modernity in the blended form of pre-modern content (motif) and modern form, "de-craft" production revealed the sterility of Korean modernity in the form of its self-denial of traditional material culture.

Choi Gongho refers to this situation as an "irreconcilable division between form and function."[10] Another craft researcher Huh Boyoon states, "The most significant point in Korean craft during the 1980s and 1990s is that modern craft turned into fine art, and the discussion on modernity and tradition was replaced by one on practicality and impracticality. As the number of students majoring in craft increased, the number of modern craft producers also multiplied. They were susceptible to the external influence of the West, especially in the U.S. where art-craftsmen explored the potential of more deeply art-oriented craft production during the 1960s."[11] These comments all allude to the final destination of Korean craft during this period. However, there were also major groups of craftsmen who maintained the original concerns of Korean craftwork and attempted to preserve the characteristics of both traditional and modern practices and aesthetics—for instance, Kim Seunghee [8] and Hong Kyunghee in metal work, Gwak Daewoong and Park Hyungchulin lacquer work Park Soochul [9] and Shin Youngok in

8　Kim Seunghee, *Fall Letter (Harvest)*, 1987, Copper, 33×160×54 cm

9　Park Soochul, *Wall-81*, 1981, Tapestry, 235×135 cm

10　Chung Yountaeg, *Decorative Plate*, 1988, White porcelain, diam. 32 cm

textiles, and Kim Ikyoung and Chung Yountaeg in ceramics. **10**

As time passed, art-crafts, and furthermore, the "de-craft" trend gradually declined without creating any momentum for their continuation. Then, in the twenty-first century, artisans within the Korean craftwork scene attempted to reflect on such past deviations and re-balance their approaches. Belatedly, the revitalization of diverse craft fairs and other movements inspired the cautious hope that such art workers would open the door to a new progressive path for Korean craft. Looking back at the long history of national modernization, from the opening of Korean ports in the late nineteenth century, Korean craft was unable to fulfill its traditional role throughout the twentieth century. Now, after this long detour, this genre must begin to explore and find its rightful position in Korean culture.

THE LIVING ART MOVEMENT

Various art genres joined in with the Minjung art activist movements of the 1980s. Among them, the Living Art Movement (Saenghwal misul undong) was engaged with diverse fields of craft and design. While the mainstream of Minjung art focused on critiques of reality, political messages and propaganda, the Living Art Movement can be understood as the practical application of minjung principles. Ra Wonsik outlines the character of the movement, mentioning the importance of specific areas of production, such as "publication art, reproduction art, everyday craftwork, clothing, murals in our living environment, banner painting, photography, video and so forth, the works displayed at Jeongmyonyeon Grand Art Festival (February 1987), *National Art—Pretty Art Exhibition* (February 1988), *Small Art Exhibition* (March 1988), *Healthy Life, Energetic Art Exhibition* (March 1988), and *Sunrise Art Festival* (December 1991)." For Ra: "We can call these works living art, [or] art that permeates into and applies to people's daily lives."[12]

The Living Art Movement began by producing objects required for the diverse types of Minjung art activism prominent throughout the 1980s, including items used in demonstrations and protests, and daily items such as calendars, postcards, season's greeting cards, bags, cups, necklaces, shirts and *hanbok* (traditional Korean clothes) for daily use. The sculpture, craft and design specialists Kim Namsoo from Sotdae Workshop, Lee Choonho from Somssi Workshop, Kim Bong-Jun from Heukson Gongbang, and Lee Kiyeon from Research Institute of National Culture, among others, all took part in this movement.

According to Ahn Youngjoo's research, the Living Art Movement revolved around three different periods: first, the early and mid-1980s; second, from 1987 to the early 1990s; and third, after the mid-1990s. The two most significant years are 1987 when the National Art Association established a Sculpture Department, craft and design, which led more organized activities, and 1995 when the Min Art Gallery, an exhibition space for Minjung art (led by the Korean People's Artists Association) closed, which reduced the magnitude of the field for these movements as a result.[13]

During the first period (1980–86), the Living Art Movement focused on making propagandist items including the flags or flyers used in political protests. With regards to formal characteristics, the practitioners applied the woodcut method common to Minjung art to create diverse printed materials or textiles.[14] Since this period took place before the establishment of National Art Association, most works were created individually rather than collectively.

The second period (1987–95) was significantly different from that of the previous era due to the heavy influence of the increasingly active democratization movements. Then, as the demand for political protests decreased in the 1990s, the Living Art Movement turned its focus from social engagement to daily lives, and made more efforts to engage with people's lives than to facilitate organized political action. Thus, the activities of this period include popular exhibitions such as the *Living Art Open Market* held mainly by the Min Art Gallery. In addition, a distribution network was established across the country. In Seoul alone, there were approximately 10 marketplaces mainly located in university areas, including Jikimi (Yonsei University), Duggeoba Duggeoba (Seoul National University), Gaegujaeng-i (Hanyang University) and Sora Sora Pururun Sora (Hankuk University of Foreign Studies). Also, specialized distribution companies such as Chamgyoyuksa and Cultural Trade Halla appeared.

The third period after 1995 witnessed the demise of the movement, as it failed to compete with increasingly refined capitalist consumer culture. The closing of the Min Art Gallery also had a direct impact on the downfall of the movement.

Likewise, as a part of the overarching Minjung art movement, Living Art Movement evolved actively throughout the 1980s and 1990s. As mentioned, a diverse range of progressive minjung cultural movements in the 1980s constituted its background, and this inspiration particularly contributed to the production and distribution of various propaganda and household items. We can also view the Living Art Movement as a form of advertisement and promotion for the wider Minjung cultural movement. The products of this movement showed a formal language entirely

different from those within other forms of modern craft or design. Like Minjung art, the Living Art Movement took the elements of traditional visual culture as its predominant components, while rejecting any modern idioms. Critics thus ascribed it with the label "minjung kitsch," as it restricted minjung ideas to the context of decorative art, by essentially applying traditional elements to propagandist items and daily necessities.[15]

As a subculture of the minjung cultural movement, Living Art Movement opposed mainstream capitalist culture, but also simultaneously affected and changed the direction of such. One of the most significant examples was that traditional Korean characters gained popularity in the designs of various products. Lee Choonho, who ran Somssi Workshop, found the predominance of Westernized characters in illustrative books or postcards problematic and started to create characters of Korean figures.[16] Such an attempt directly influenced the development of new characters such as "Geumdarae Sanmeoru" by the Barunson Card Co., which led to an upsurge in the production of fancy products and stationary designed in a Korean style in the early 1990s. It is therefore clear that the Living Art Movement made a great contribution to elaborating vernacular expressions in the realm of stationary and fancy products.

The popularization of daily Hanbok, which continued to receive significant attention after the 1990s, was another impact of Living Art Movement. Called il-ot (clothing for work), nori-ot (clothing for playing) or nadeuri-ot (clothing for outing), daily Hanbok began as an outfit designed for student protesters at that time and evolved into a nationalist cultural commodity under the name uri-ot (our clothes). Representative brands include 'Nurungso' and 'Saenae' as well as Jilkyungee uri-ot by Lee Kiyeon. A former member of Dureong and Hanbok designer, Lee explained when and why the movement emerged, stating: "From the beginning of the Living Art Movement in the early 1980s, our aim was to change every aspect of our daily lives including food, clothing and housing that had been negatively inundated by Western idioms."[17]

However, the minjung cultural ethos was fundamentally based on a limited binary approach, dividing the idea of a traditional-national-good from that of the foreign-modern-vice, and Living Art Movement largely adhered to this ideological frame. For them, serving the people (the minjung) was understood as affirming pre-colonial period lifestyle and culture. In this way, the Living Art Movement ran the risk of a 'pre-modern' regression in the name of the Minjung movement, which differed from the direction taken within the field of institutionalized craft. As mentioned above,

in contrast, the institutionalized craft movement within Korea took another deviated path that kept it from making a positive social impact. This demonstrates the reason for the absence of such movements in Korea as the Arts and Crafts Movement in Britain, or the Japanese Folk Crafts Movement, and one reason for the inability of Korean modern craft to evolve into a truly modern design practice.

THE MEANING OF MODERNITY IN KOREA, THROUGH THE FORMS OF THE 1980S

Design form can be considered as the outcome of a specific historical period, and as a reflection of the spirit of that time. The forms used in the 1980s represent the zeitgeist of Korea at his moment perhaps more clearly than in any other era of modern Korean history. The modern/contemporary design of Korea can be divided into two branches: Corporate design as a product of industrialization and national design as an outcome of national policies; both of which grew significantly in the 1980s. During the early industrial eras, Korean design relied on the transplantation and imitation of foreign idioms. A significant moment in Korean industrial design occurred when Hyundai Motor Company developed a unique car design for the Hyundai Pony in 1974. It is not an exaggeration to say that with this development began the true age of industrial design in Korea. In this respect the 1980s were an extension of the previous eras.

Just as national government policies had driven the industrialization of Korea, design began as it was co-opted by the process of industrialization, something which is evidenced by the design promotion policies of the 1970s. However, since the 1970s, as the non-government civil arena advanced, the role of the national government in public society weakened relatively. Nevertheless, the government still took the charge of preparing for events such as international fairs and expositions, and specifically the biggest two international events in the modern history of Korea— the Asian Games and the Olympic Games in the 1980s. In this context, how the nation understood its own cultural identity and represented it was a matter beyond the professional dimensions of the visual arts. That is why we must pay attention to the fact that the formal language used in these international events came to historically represent the idea of Korean design.

The discursive structure of Korean contemporary design, which involves a complex set of embedded cultural and historical connotations, reflects and reveals the structure of Korean modernity as created through integration of mental-cultural pre-modernity and material-technological

modernity. Since the nineteenth century, Korean society has undergone the process of modernization and technological industrialization, reaching a state of high capitalist development and establishing itself on the international stage. Despite this socio-economic transformation, Korean design culture remained arguably limited by its fixed concern with 'pre-modern' visual forms and cultural ideas. It could, therefore, be said that the 1980s was an era when Korean society progressively constructed an idea of Korean modernity both in terms of its economy (through the advancements of 'industrialization' extending from the previous two decades) and its politics (through the 'democratization' of the late 1980s), but not convincingly in the arena of design.

Korean visual culture has profound significance in that it allows us to investigate how various ideas of Korean modernity are constructed in relation to design. As mentioned before, Korean design culture could be considered to be a heterogeneous combination, or a hybrid form, of the visual culture of pre-modernity and the material technology of modernity, as represented through diverse forms of design and craft. In design, this dynamic was described as "Korean design" or a hybrid form created by the integration of pre-modern motifs and modern techniques; in institutional craft, this led to the establishment of a new "post-craft" practice that completely deviated from the processes of modernization, as such traditional approaches were not able to survive within the changing environment. Meanwhile, the Living Art Movement, a non-institutional craft/design concern, resulted in something of a cultural regression, denying ideas of modernity in both content (motif) and form (technique). As such, in the modern visual design culture of late twentieth century Korea, we cannot find a formal practice that served to conceptually reflect the modern, contemporary condition of society in its totality, inclusive of both content and form. Furthermore, this circumstance arguably extended beyond the characteristics of Korea's modern design culture but encompassed the essence of Korea's encounter with 'modernity' at the end of the twentieth century. In this sense, paradoxically, the modern design of Korea aptly reflects the Korean experience of modernity.

Based on this conception, we could draw a conclusion that the process of modernization in Korea since the late nineteenth century has been concentrated on its material and technological aspects, and marginalized the intellectual or cultural aspects. Regardless of the field or discipline, this assertion is arguably proved by the fact that the recognition of cultural identity in Korea has remained fixated on visual forms and stereotypes from the pre-modern era. For Koreans,

the idea of tradition still refers to the 'pre-modern,' while the chaos of modernity cannot be channeled within contemporary visual culture. This limited notion of historical tradition only includes what has been filtered and invented through the history of colonization and authoritative governments in Korea. As such, this fixation is itself an entirely modern invention that has remained largely invisible to most Koreans.

Koreans acknowledge the modern primarily as a materialistic construct, while regarding their national spirit and culture as a remainder of the pre-modern era. This might be partially due to the compressed history of industrialization as well as the nation's tragic history as a heavy burden. In this context, questions on how to contextualize the experiences of modernization and transform them into a new 'tradition' are challenges that remain to be addressed. Therefore, the conceptualizing of modernity as a combined form between spirit and material is a task for future designers to take on in their work. Therefore, in terms of the art history of Korea, it could be said that the 1980s was the era that most vividly demonstrated the conficting ideas of modernity and tradition.

1 Sung Wooje, "30nyeon oegil, dijain dongnip undongga jeongyeonjongssi" [30 Dedicated Years: Mr. Chung Yeonjong, Design Independence Activist], *Sisa Journal*, April 1997.

2 "Korean design" as a proper noun is a particular term that indicates particularly the graphic design that used Korean motifs, rather than the expression of Korean style in general across genres.

3 Kim Jongkyun, *Hangugui dijain: Orientallijeumeseo dijain seoulkkaji dijainui jeongchisahoesa* [Design of Korea: Design Politico-sociology: From Orientalism to Design Seoul] (Paju: AHN Graphics, 2013), 211.

4 Ibid., 192.

5 On June 1982, 1988 Seoul Olympic Games organization established the Design Specialist Committee. The chair of the committee was Cho Youngjae and design experts included Kim Youngki, Min Chulhong, Park Daesoon, Ahn Jeongun, Yang Seung-Choon, Yoon Hoseop, Chung Shihwa, and Han Doryong.

6 This was the era when the national government accelerated the Saemaul (New Village) Movement and national design promotion policies. The establishment of the Korea Institute of Packaging Design Promotion (1970) demonstrated that the government employed design to accomplish the export-import based economy and promoted "design for export" services. (Choi Bum, "Hanguk dijainui sinhwa bipan" [A Critique on the Myth of Korean Design] *Hanguk dijain sinhwareul neomeoseo: Choebeom dijain pyeongnonjip 3* [Beyond the Myth of Korean Design: Choi Bum Design Critiques 3] (Paju: AHN Graphics, 2013).

7 Choi Gongho, "We can summarize that the modern craft of Korea was a process of shifting the purpose of making from practicality to craft for art (art-craft)" (Choi Gongho, *Hanguk hyeondae gongyesaui ihae* [On the History of Korean Modern Craft] (Seoul: Jaewon, 1996), 12.

8 Ibid., 19.

9 The meanings of appreciation for traditional craft and modern craft are similar yet must be distinguished from each other. They have a commonality in that they function based on the act of viewing. However, while the traditional sense of appreciation mainly refers to individual experiences, the modern sense of appreciation pertains to spectatorship in a collective sense. Also, the traditional sense is limited to the boundaries of daily lives, while the modern sense implies a collective act within the modern cultural institution. Overall, the appreciation for modern craft must be interpreted in a context different from the pre-modern era when traditional craft was experienced within high-class society only.

10 Choi Gongho, *Hanguk hyeondae gongyesaui ihae*, 133.

11 Korea Craft & Design Foundation, 2011 *Gongyebaekseo seonhaengyeongu* [A Preliminary Research for 2011 Craft White Paper] (Seoul: Korea Craft & Design Foundation, 2012), 19.

12 Ra Wonsik, "Salmui teo gotgoseseo gongsaenghaneun misul" [Coexistence of Art inside Daily Lives], *Misul Segye*, July 1993, 99.

13 Ahn Youngjoo, "1980–90nyeondae hanguk saenghwalmisurundong yeongu" [A Study on the Living Art Movement of Korea in the 1980s and 1990s], *The Journal of Korean Society of Design Culture*, no. 21 (2015): 369–379.

14 Choi Bum, "80nyeondaeui mokpanhwa yangsikgwa illeoseuteureisyeoneuroseoui seonggyeong" [The Style of Korean Woodcut (1980s) and Its Illustrative Characteristics], *Wolgan Design*, February 1989, 52.

15 Kim Namsoo, Lee Choonho, Choi Bum and Eom Hyeok, "Minjung gongyeneun 'geudeul'manui geosimnikka?" [A Discussion: Is Minjung Craft 'Theirs'?], *Art & Crafts*, June, 2004.

16 Choi Bum, An Interview with Lee Choonho (December 10, 2020).

17 Kim Kyungae, "Uri uisikjue saram sallineun jihye gitdeureo . . . 'jinjja hallyu' allyeoyajyo" [Life-saving wisdom in our food, clothing and housing . . . [The] 'need to promote the true Hallyu'], *Hankyoreh*, April 7, 2013.

Writing Architecture in Prose: Korean Urban Architecture in the Late Twentieth Century

Chung Dahyoung

Time has changed a lot. We need to send out stronger signs and we have to say more. To say it metaphorically, architects who once wrote poetry must now tell bigger stories.[1]

THE GENERATIONAL SHIFT IN KOREAN CONTEMPORARY ARCHITECTURE

Kim Chung-up, who was celebrated as "the poet of architecture," revealed a different mindset in an interview with Kim Won for *Space* (in March 1979). He said to this architect of the younger generation "Poetry gives us a great impression in its full implications," and he added "(but) I now want to tell a bigger story." This statement made by one of the most representative Korean architects has provoked us to examine the general circumstances of the shift.[2] As Kim Chung-up witnessed, Korean architecture faced a new chapter of its history. His remark that architecture needed to tell a bigger story was definitely related to the turbulence within Korean society during the 1980s. In 1979, Chong Sangchon, the mayor of Seoul, announced plans to host the twenty-fourth Summer Olympics, and two years later, Seoul was designated as both the host city of the 1986 Asian Games and the 1988 Olympics, which fueled great excitement at the time. Unfortunately, however, Kim Chung-up could not continue to tell bigger architectural stories in the way he desired. In May 1988 just before the opening of the event, Kim passed away and left the *World Peace Gate* as his last work. 1

Another representative of Korean contemporary architecture, Kim Swoogeun also died in 1986 immediately after the completion of his Main Olympic Stadium design. 2 The death of these two architects in the late 1980s was strongly felt within the world of Korean architecture. Prior to the 1988 Seoul Olympic Games, Korean architecture could hardly create its own territory independent of national governmental influence, as the private market for architecture was not developed enough. The state was the primary client for most architects. Building industrial facilities, including highways, power plants and factories, under such national authority made it difficult to establish architecture as an academic discipline or independent practice. Under such circumstances, positioning themselves as auteurs, somehow Kim Chung-up and Kim Swoogeun managed to conduct their architectural practice as a form of 'art,' protecting their authorship from external influences.

After Korean liberation from Japanese colonial administration, very few people understood the professional function of architecture. In 1955, the fourth National Art Exhibition decided to include architecture as a separate genre for the first time. But generally, in the post-Korean war period "architecture lacked sufficient power to establish itself" and therefore "exhibitions served [to] define the field of architecture as distinct from external powers and points of view."[3] The National Art Exhibition was the only path through which architecture could be approved as an art form. Kim Chung-up' status an 'artist' within the field therefore "served to elevate the social status of Korean architects overall." However, he considered his architectural art practice as "not the pursuit of a [an idea of] universal beauty, but a strategic concept to confront the tough post-colonial situation where architects were moving forward in the realm of modern architecture markedly behind" their peers in the West.[4]

In the same context, Kim Swoogeun solidified his status as an auteur through solidarity and exchange with artists from diverse fields. In 1966, he published *Space*, one of the earliest periodicals

1 Seoul 1988 World Peace Gate, 1988

2 Seoul Sports Complex construction site, 1983

specializing in art and culture. Covering many visual and performing arts-related issues before it began to focus on architecture in the new millennium, *Space* led the discussion on the artistic and cultural world in general. And the journal also fostered the small theater, Space Sarang in 1977 in the basement of the Space group building. In Space Sarang, which staged over 4,000 works of performing art, Gong Okjin first presented *Changmugeuk* (an theatrical performance featuring an integrated program of traditional song, *pansori*, contemporary dance, and comical commentary), and jazz mime and contemporary classical music were first introduced to the public.[5] In Korean architecture, which mainly operated relative to the driving logic of capital and technology, Kim Chung-up and Kim Swoogeun held key positions in the world of art and culture through their involvement in diverse activities, including exhibitions, publications and performances. Therefore, the death of these two architects marked a defining moment, representing a generational shift in Korean contemporary architecture.

THE AFTERMATH OF THE OLYMPIC GAMES AND THE REMAINS OF THE CITY

The generational shift owed much to the material abundance that defined Korean society in the 1980s. For the 1986 Asian Games in Seoul and the 1988 Seoul Olympic Games, Seoul prepared to become a "shop window for the world."[6] The city government conducted construction or reconstruction projects in various areas, including the neighborhood of the main Olympic stadium in the Jamsil area, the road for the sacred torch relay, the marathon course and the roadside landscape downtown and around major highways. Urban projects such as the Comprehensive Development Plan for the Han River, the opening of the subway and the expansion of the Olympic Expressway created a highly complex network connecting each region in Seoul. The international event particularly drove forward many of the construction projects that had been decelerated or postponed in previous years, getting them back on track and completed. As the city's infrastructure expanded, many large-scale projects began. These included urban regeneration and housing redevelopment for impoverished areas, which entailed re-formulating major aspects of the city's development plan. 3 Before and after the Olympic Games, the number of downtown projects increased from 21 to 93, while the total ground area of development expanded fourfold from 94,314 to 424,893 square meters. Moreover, the number of regions designated for housing redevelopment increased from 56 to 128, apartment buildings from 176 to 285 and building permits from 11,946 to 30,860, almost three times the previous number.[7] This tendency continued and even strengthened in the early 1990s. The construction plans for 2 million houses and new satellite cities were announced, massively expanding the architecture market in scale and quantity. Architects also started to employ new planning methods such as urban design. In this respect, organizing and beautifying the urban environment, while conscious of the foreign gaze, was Seoul's most important project throughout the mid and late 1980s.

A new type of architecture appeared based on the material abundance that arose around the time of the Olympic Games. A plethora of construction projects, including districts of large-scale apartments, high-rise office buildings, large cultural facilities, luxury hotels and theme parks, were conducted, changing the everyday environment of Korea immensely. As society demanded architectural works defined by new functional and technological programming, the field of architecture also shifted by engaging with innovative construction methods and building techniques that hinged on new forms of organization and skills to respond to new market demands. Large architecture companies were at the forefront of this transformation. Although apartments had dotted the city landscape in the past, the apartment buildings constructed in new districts, including the Asia Athletes' Village, Olympic Athletes' Village and Mokdong New Town, were much taller and larger than previous types. The design for these apartment districts required a thoughtful and detailed planning approach. Therefore, the city selected design firms through architectural competitions, resulting in a new level of apartment design, easily distinguishable from those built urgently during the early modernization period of the 1960s. With the integrated designs featuring a master plan, elevation drawings, and landscape/environmental and graphic design, Korean architects created new residential spaces suitable for the new urban environment of the period. The architects Joh Sung-Yong, Woo Kyu-sung and Kimm Jongsoung were in charge of the three primary undertakings mentioned above respectively, and over thirty years later, these apartments are still known as pleasant residential environments.

As Korea's industrial structure shifted from secondary industry to tertiary industry and the demand for business-oriented districts in the city increased, a large number of skyscrapers were built in downtown Seoul. Nothing was considered more adequate to represent the modernized image of the city than such sleek, soaring constructions. Korean architects were able to build such towering buildings for the first time at this moment, as

3 Kim Chung-up, et al., Urban Redevelopment of Euljiro 2-ga
(photographed 2020, built 1987)

they had not been possible before the 1980s because of the scarcity of such materials as steel and glass. Large urban redevelopment projects triggered the construction of downtown office districts, which provided opportunities for mid- to large-scale architecture firms like Wondoshi Architecture Group and Junglim Architecture to grow significantly. However, this meant that relatively small and medium sized studios led by artist-architects like Kim Chung-up and Kim Swoogeun, had reduced the number of works with which they were involved because of the scale of the new projects. Moreover, in the 1990s, many architectural competitions were opened-up to the global market, and some corporations also invited renowned foreign architects, or so-called starchitects, to tackle local projects. Shifting professional conditions like these brought a sense of crisis to the Korean architecture market.

The few established artist-architects mainly engaged with prestigious government projects. Reaching their peak at the end of the 1980s, these national projects were mostly public cultural facilities, including the MMCA (designed by Kim

Taisoo), the Seoul Arts Center (Kim Seokchul), and the Independence Hall of Korea (Kim Kiwoong). MMCA opened in 1986 along with the outdoor sculpture park of 30,000 square meters, following the Chun Doo-hwan administration's order to establish a modern museum before the 1988 Seoul Olympics. In the same manner, the Seoul Arts Center was also established as international performing arts center on the occasion of the Olympic Games. Other provincial or city governments also constructed cultural facilities under the title of "Culture Center." The proliferation of office buildings and nationwide public culture centers—the two main types of substantive architectural projects—resulted in a division between the mid and large-scale architecture firms and individual architects.[8]

Though Seoul has not ceased to develop since the end of the Korean War, there is a difference in the quality of the rapid city development throughout the 1960s and 1970s and that of the architectural projects and urban transformations undertaken from the late 1980s until the IMF financial crisis in the late 1990s. The latter had

taken place after the fundamental establishment of more secure domestic economic conditions. The city was subjected to a thorough reorganization, which was generated by an awareness of international standards, this awareness provoked widespread changes in the urban environment through new architectural works, product development and visual design. While it might be too far-fetched to subsume all these new socio-environmental phenomena under the label of the 'Olympic effect,' it is hard to deny that the development of Korean urban culture occurred in directly concurrence with this international event. Also, all the images of this transformation immediately spread throughout the urban-socio-environment via mass media including TV broadcasts and electronic billboards. In the 1990s, this new urban environment served as a "source of the imagination" for many Korean visual artists.[9] The city was no longer deemed as a negative space of exploitation or oppression, but a new visual environment to explore and embrace. This new generation of artists, alongside new forms of popular and middle-class culture came to constitute the narrative of this new, materialistic, era of relative abundance. For architects and city planners, however, these new phenomena were arguably not as simple a matter as they were for the people who consumed this new image of the city. In this regard, in design terms, the city was an ambivalent space that simultaneously attracted and frustrated Korean architects.

THE KOREAN CONTEMPORARY ARCHITECTURE MOVEMENT AND ARCHITECTS' GROUPS

Democratization and globalization, keywords of the late 80s and the early 90s, introduced two contradictory structure of feeling into the field of Korean architecture – anticipation and crisis. As the number of building projects increased in the 1990s, the importance of "architecture" was supplanted by that of "construction." Just as the cultural realm, which had been under the governmental sphere of national planning, was absorbed into the private market, the expansion of the construction industry affected the essence of architecture and weakened the role of architects. Unlike the previous generation, which had conducted large-scale national projects, the new generation could hardly partake in any projects without involvement from the construction corporations that now dominated the field of architecture. For such individualists, it was necessary to find an alternative market. In this context, the only alternative was to design small houses and neighborhood-scale local community amenities (*geullin saenghwal siseoul*), and such designers often self-mockingly called

themselves "*geun-saeng* architects."[10] For these young newcomers—mostly born in the 1940s— the situation was completely different from that of the previous generation's architects, including Kim Chung-up (born in 1922) and Kim Swoogeun (born in 1931). In short, these "young architects accepted the reality of the 'invasion of external forces.' [Such as] the internationally renowned foreign architects and large corporations that entered the scene in preparation for the 1988 Seoul Olympics, and recognized that they could no longer work in the way that the previous generation had."[11] While "the ebb of the first generation, in a sense, meant that the second generation had lost its protection,"[12] it also provided an opportunity for the second generation architects to assume another position— the architect as writer.

At this time, designers including city planners, industrial designers, book designers and typographers as well as architects began to enlarge and systemize their own organizations. The fundamental question "what is the role of a designer?" was widely discussed, especially in design magazines. Designers sought to elevate their social and professional status and promote the public's understanding of them as the "avant-garde of contemporary industrial society."[13] What distinguished this question from similar concerns raised in the past is that, in the new era, architects and designers explored these issues not individually but collectively. With regards to architecture, architects started to examine who would and should lead Korean architecture in the midst of this radical socio-political transition, particularly after the death of two nationally senior architects. In response to that period of transition, the architects of the new generation began to unfold their stories through architectural ideas. This concern to 'write prose' through architecture was reflected within Kim Chung-up's argument. They also gathered and organized themselves to find a way to overcome the crisis and confront unforeseen historical changes. Several architecture magazines, including *Architecture and Culture* and *Korean Architects*, were published, and more architects took field trips abroad following the government's decision to lift the longstanding ban on unsanctioned international travel. People also gained access easily to foreign publications including books on architectural history, which provided these architectural groups with new theoretical contexts for their own ideas. Travel abroad especially helped individual architects to expand "their experience and awareness of new contemporary situations."[14] Through all these changes, architects were able to explore the identity of Korean architecture. Under such shifting circumstances, architects organized collectives, including The Young Architects

Association (Cheongnyeon geonchugin hyeobuihoe) which, influenced by the 1987 June democratic struggle, focused on the social role of architecture, and The 4.3 Group, established in the early 1990s, which emphasized the artistic and cultural value of architecture, among other issues.

The research carried out within these collectives helped architects to confirm where they as individuals and Korean architecture more holistically stood in the context of global architecture. They emerged during Korea's greatest ever economic boom, which had been achieved as a result of the 'three lows' (low interest, low oil prices and low dollar exchange rate) and managed to successfully maintain their activities until the mid-1990s. In reviewing this moment, Park Kilyong has offered that "with the dawn of national prosperity in the 1980s, Korean architecture was propelled into postmodernism." Within this moment of transition, these collectives of young architects "were creatively the beneficiaries of the material abundance in the history of South Korea."[15]

The Young Architects Association was the first progressive architecture group which called for "social and institutional reformation," and The 4.3 Group "marked a cardinal point in the history of Korea's architectural discourse" by giving "specific examples of architectural practice."[16] Besides these groups, there were others whose roles are worth examination. The Architects Association for the Future (Geonchugui miraereul junbihaneun moim) strived to reform architecture-related regulations, serving as a "measure of the changing times."[17] In addition, The Research Group for Architectural Movements (Geonchuk undong yeonguhoe), The Union of Architecture Students in the Metropolitan Area (Sudogwon geonchukakdo hyeobuihoe) and The Architects Association for the People (Minjok geonchugin hyeobuihoe) were also important components of the wider architecture movement of the period.

The progressive architecture groups, including The Young Architects Association and The Research Group for Architectural Movements, understood that the architect was "not as a simple technician or pseudo-artist but an intellectual engaged with reality."[18] In the early 1990s, as the wider public fever for sweeping social movements abated, these progressive architecture groups and the wider architectural movement also disintegrated. Instead, young architects focused on developing theories to create a foothold for new movements by re-examining the successes and failures of historical architecture movements in the twentieth century, including the Bauhaus, Russian Constructivism and Korean modern architecture before and after the Korean War. Their new theoretical approaches were related to the innovative architectural practices

4 4.3 Group, Exhibition poster of *Echoes of an Era*, 1992, Poster design: Ahn Sang-Soo, offset print, 109×78.8 cm

of the early 2000s, such as Chung Guyon's Muju project and Miracle Libraries and Lee Ilhoon's A Community Care Center for Children Next to the Railroad. In a broader sense, these activities also provided a foundation upon which new institutional roles such as "public architects" or "master architects" came to be implemented in local governments. In other words, progressive architecture movements claimed that architecture should be used not as an instrument for an architects' personal accomplishments but as a domain for reflections on, and resolutions of urban problems. They also researched and exchanged ideas with progressive intellectuals in art and culture. In particular, they hosted lectures by inviting Minjung oriented critics from the National Art Association (such as Park Sinui and Shim Kwanghyun). These scholarly exchanges served to convey the minjung theories of art to the field of architecture.

Meanwhile, The 4.3 Group, which stressed the artistic and cultural value of architecture, sought to bring the architects' "their own stories" into their practices.[19] Rather than voicing an ideological agenda, they focused on the autonomy

5　Seung H-Sang, *Sujoldang*, Slides
(Photograph: unknown date, built 1993)

6　Joh Sung-Yong, *Yangjae 287.3*, Slides
(Photographed 1993, built 1992)

of architecture by establishing a firm conceptual basis for their practice. The 4.3 Group was organized by the representative Korean architects of the contemporary era, including Kim Incheurl, Min Hyun-sik, Seung H-Sang and Joh Sung-Yong who were in their 30s and 40s. Within their work, while "it was a strenuous process to weave architectural practices and other mediums such as language together," they employed "language as a source of creative energy" and were "highly active in the production of textual materials."[20] The most significant outcome of their practices includes the exhibition titled *Echoes of an Era* (Ingong Gallery, 1992) and the publication of a collection of works under the same name. ‾4‾ Throughout the 1990s, the architects of The 4.3 Group "opened up a new mode of architectural practice by focusing on specific objects, such as courtyards, walls and roads, and establishing specific design language for them."[21] It is not an exaggeration to say that major concepts of contemporary Korean architecture e.g., 'Emptiness' (Min Hyun-sik) and the 'Beauty of Poverty' (Seung H-Sang) were cultivated from that groundwork. In particular, Seung H-Sang, the first and only architect to receive the MMCA 'Artist of the Year' award, held a solo exhibition entitled *Urban Void* at the MMCA in 2002 and has further extended his conceptual theme to the idea of *teo-moo-nui* (patterns inscribed on a site). As Park Kilyong commented, the practices of The 4.3 Group "were not a meeting of ideologies, but a generator of rich concepts" in Korean architecture.[22]

Of the architectural practices of the 4.3. Group significant projects included the two built works of *Sujoldang* (by Seung H-Sang, 1993) ‾5‾ and *Yangjae 287.3* (by Joh Sung-Yong, 1993) ‾6‾ , which both caused a great sensation. As a residence and a community center respectively, both buildings demonstrated key aspects of the Korean architecture of the 1990s. Located in the new Seoul district of Gangnam, outside downtown, the buildings needed a link to the fabric of the region. Although both were small structures about 300m² in size, their architectural concepts and significance were much greater than their physical scale. As many people know, *Sujoldang* was the house of art critic You Hongjune. This offered an ascetic space that emphasized the concept of the "courtyard" alongside other ideas. *Yangjae 287.3*, whose design engaged with the concept of "road," articulates that the building is adjoined to the city by creating a long stairway that starts from the front of the building and continues to the third floor. Both constructions establish a connection between the structure and the city, which defines the context of the work. Although the two architects remained largely negative about the contemporary city in their subsequent practice, which, in their minds had become increasingly

glamorous and hypertrophic, they continued to emphasize the spatial and historical relationship between architecture and its urban context in their designs.

ESTABLISHING THE GRAMMAR OF ARCHITECTURE

In the mid-1990s, the intellectual dimensions of architectural practice, such as seminars, site visits, discussions and exhibitions organized and performed by the architecture groups during the late 1980s and the early 1990s, turned to face a new direction in response to the new situation. The two aforementioned branches in the architectural movement contributed to establishing the institutional foundation for Korean architecture. The ultimate goal of the movement was to encourage a new generation of twenty-first century architects through new educational approaches. As Kim Sunghong pointed out accurately, "the transition of the topic of architecture to education in the mid-1990s [was] a highly meaningful sign."[23] The diverse practices of the previous era were employed to develop an intellectual foundation in architecture and provided source material upon which to institutionalize key parts of the architectural education. Various new intellectual forms and practices were also generated in the

surge of exchange that professional occurred in this context. These new approaches blurred ideological borders, and additionally, social changes in the 1990s, which served to transform the era of minjung activism and social movements into one of the "masses" and "consumption," deeply affected this new discursive shift in architecture.

As alternative academic institutions, the Seoul School of Architecture (SA, established in the mid-1990s), Kyonggi University Graduate School of Architecture, the Architects Association for the People and others provided architects with the opportunities to delve into the cross-disciplinary context of urban design. The experimental programs of these organizations influenced the wider existing institutions of architecture in the nation. As a result, the college architecture program was officially extended to five years (2002), and this became a model for a design studio system, with a greater number of tutors and critics being introduced in colleges, and regular architectural site visit programs being established. These new initiatives were acknowledged as paths to cultivate the intellectual dimension of the field. The Architects Association for the People, created mainly by the architecture committee members of The Federation of Korean Artists for the People (Minjok yesurin chong yeonhap) held lectures on architecture, and the SA—which became a part of

7 Paju Book City, 2004

the graduate program of the Korea University of Arts—hosted various special seminars or talks. The SA invited key figures from art and culture at that time, including You Hongjune, Lee Kun-Yong, So Hong-ryeol, Lim Oksang, Ahn Sang-soo, Gum Nuri and Sung Wan-kyung. As they represented different genres and fields, the exchange of discourse with them broadened the boundaries of architecture.

The SA led the development of the national architectural discourse and practice within the context of surging globalization in the 1990s, focusing on such issues as the opening of the global market, globalization and the city, and critical regionalism with regards to Korea's urban environment. Initially, the SA began as a preliminary course for higher education in architecture; it was based in *Yangjae 287.3* (designed by Joh Sung-Yong) and functioned as a special platform for visits from world-class architects, including Rem Koolhaas, SANAA and Ito Toyo, who communicated with the school members in person. Also, first-generation architects who had studied abroad e.g., Kim Jong-kyu and Choi Wook as well as architects from The 4.3 Group and The Architects Association for the Future participated in the school as the teaching faculty. An annual summer workshop began in the mid-1990s. During the workshop, participants stayed in small or mid-sized local cities such as Muju, Ganggyeong and Yanggu. Above all, their research and practice consistently began and ended with the theme of "the city." After the workshops on "the city," they published their proceedings and mounted exhibitions. These activities were of particular significance as they provided architects with an opportunity to turn their attention to provinces other than Seoul. As a result of a series of investigations into the identities of individual cities across Korea, new concepts, such as "reading cities," emerged as major keywords of the time.

The practices of architecture groups in the 1990s usefully positioned Korean architecture at that time, although its overall institutional stature was weak and insignificant. However, with the beginning of the 2000s, these groups notably expanded the architectural context of practice, crisscrossing the conflicting concepts of 'modernism and postmodernism' and 'globalization and localization,' which enabled the professional field to calibrate a spatial and temporal point where Korean contemporary architecture could manifest itself. Once it strove to identify itself through creative practice, Korean architecture could rediscover its identity and potential as a contemporary visual medium and develop its own process of delineation. Today, Korean architecture is armored with its own narrative and conceptual concerns, which it uses to communicate with other artistic disciplines on equal ground.

FROM 1988 TO 1998: THE JOURNEY TO URBAN ARCHITECTURE

I thought that we had reached a transition into a new phase in which we could not gain recognition as architects without declaring our own stories.[24]

Kim Incheurl, one of the three architects featured in the exhibition *Kim Ki Seok, Joh Sung Yong, Kim In Cheurl: Notion of Madang* (Gallery Ma, Tokyo, May 28–June 17, 1989), talked about his participation in The 4.3 Group and the aforementioned exhibition thusly above. This exhibition marked a crucial introspective moment with national architecture, as the Japanese architecture critic Miyake Riichi and Kim Jeong-dong, then chief editor of *Ggumim*, invited Kim Kiseok, Joh Sung-Yong and Kim Incheurl to participate in the exhibition, based on the primary curatorial plan to invite "architects who write."[25] As the first well-arranged international exchange exhibition to promote a meaningful collaboration, this show was originally planned as the two-person exhibition of Kim Chung-up and Kim Swoogeun in commemoration of the 1988 Seoul Olympics; however, due to the deaths of the two masters, it was replanned as a show.

The curators asked the architects not for floor plans or photographs of completed architectural structures, but for drawings, models or videos that would show their "concepts." For the architects, this "conceptualizing" of their projects was a new challenge – that is, it meant that architects needed to deal with architecture as a text. Two seminars related to this exhibition were held in Tokyo and Osaka on the subject of the "Architectural Vision of East Asia 1989—Departing from Seoul," which must have provided the architects with an opportunity to become versed in the 'writing' of architecture and building architecture within a 'textual' language of forms and ideas.

Kim Chung-up's desire to "write prose as another form of architecture" was, therefore taken up by the next generation of architects a decade later.[26] Those who experienced the transition throughout the late 1980s and early 1990s became established as representative Korean architects in the mid-1990s. Key members of The 4.3 Group, The Architects Association for the Future and the SA, in particular, led the development of Paju Book City and Heyri Art Village, the most important architectural projects of the late 1990s and the 2000s. In 1988 Kim Chung-up passed away, and throughout the following decade Florian Beigel, Seung H-Sang, Min Hyun-sik, Kim Jong-kyu and Kim Youngjoon led the completion of the core planning guidelines and principles for Paju Book City. **7** Over those next ten years, the key figures and types of projects in Korean architecture

immensely changed. With this project, which was a plan to build a city based on the architectural idea of utopia, a group of architects and publishers made the so-called "great deal" (2000). Calling for commonness and cooperation, this project seemed to convey that Korean architects had overcome the issue of the internal or external urban circumstances that they had considered such a crisis at the turn of the 1990s.

This idea of 'architects' prose' is now inscribed not only on individual buildings but also on the overall embodiment of urban architecture. This change represents the most transitional point during the late 1980s and 1990s. Along with Paju Book City, Heyri Art Village was also planned around the same period with a similar purpose. It became one of the most notable projects from the early 2000s to the 2010s, and so most architecture magazines have consistently covered Heyri Art Village throughout the years, and it was almost guaranteed that the architects who presented works within the Village would become prospective key figures in the field of art and culture. Architects of the new era tended to transcend the limits of the city's existing reality and found a middle zone or "architectural city" where they could realize their vision. That is, the younger generation of architects started to gain independence at the end of the 1980s, and, since then, they have created their own conceptual language and attempted to reflect such language through projects that go beyond the idea of architecture as a single structure. Even in small-scale projects, architects have positioned their language within the wider idea of the city rather than in the limited sense of building a work of architecture. The journey toward urban architecture is still in progress. But, as evidenced by the names of institutions or institutional events, including the National Museum of Architecture and Urbanism (to be built in 2025) and the Seoul Biennale of Architecture and Urbanism, the two forms of city and architecture have continued to maintain a symbiotic relationship within contemporary Korean culture.

1 Kim Won, "Geonchukgaui peuraideu, sahoejeong uimi" [The Pride of Architects: The Social Meaning], *Space*, March 1979.

2 "Inteobyu: Sireul sseuneun nangmanpa geonchukga, hangukgeonchugui hyeolmaeng gimjungeop" [Interview with Kim Chung-up: The Architect of Romanticism and the Bloodline of Korean Architecture], *Wolgan Design*, April 1979.

3 Park Junghyun, "Baljeon gukga sigi hanguk hyeondae geonchugui saengsangwa jaehyeon" [The Production and the Representation of Modern Architecture in the Development State of Korea] (PhD diss., University of Seoul, 2018), 39.

4 Cho Hyunjung, "Yesulloseoui geonchuk, jakgaroseoui geonchukga: Gimjungeopgwa 1950nyeondae hangukgeonchuk" [Architecture as Art, Architect as Artist: Kim Chung-up and Korean Architecture of the 1950s], *A Dialog with Kim Chung-up* (Paju: Youlhwadang, 2018), 336.

5 Kim Haeju, "Sarajin gongganui jaejomyeong" [Re-illuminating Disappeared Spaces], *Gyeoljeong jeok sungandeul: Gonggansarang, akaibeu, peopomeonseu* [Defining Moments: Gonggangsarang, Archive, and Performance], exh. cat. (Seoul: Korea National Contemporary Dance Company, 2014), 10–11.

6 "Ollimpikgwa hanguk" [The Olympic Games and Korea], *Dong-A Ilbo*, October 2, 1981.

7 Kim Jungbin, *Seoul gihoek yeongu 2: 88seourollimpik, seoureul eotteoke byeonhwa sikyeonneunga* [How Did the 1988 Seoul Olympics Transform Seoul?] (Seoul: Seoul Museum of History, 2017), 78.

8 Park Junghyun, 224.

9 Shin Chunghoon, "Korean Art and the City after Minjung Art," in *What Do Museums Change?*, ed. Jang Sunhee (Seoul: MMCA, 2020), 254.

10 Mokchon Architecture Archive, "Gimincheol gusul chaerok" [Kim Incheurl: The Oral History Recordings], *4.3 Geurum gusuljip* [The 4.3 Group Oral History Recordings] (Seoul: Matibooks, 2014), 84.

11 Jeon Bonghee, "4.3 Geurupgwa geonchukgyoyung" [The 4.3. Group and Architectural Education], *Jeonhwangiui hangukgeonchukgwa 4.3geurup* [The Korean Architecture and The 4.3. Group in Transition] (Seoul: Jib Books, 2014), 69.

12 Kim Sunghong, "Movements in Modern Korean Architecture 1987–97," *Papers and Concrete: Modern Architecture in Korea 1987–1997*, exh. cat. (Seoul: MMCA, 2017), 18.

13 "Dijaineoui sahoejeok wichi" [The Social Status of Designers], *Wolgan Design*, November 1982, 93–106.

14 Pai Hyungmin, "Papyeon, cheheom, gaenyeom: 4.3geurubui damnon gudoe gwanhayeo" [Fragments, Experiences and Concepts: On Discursive Structures of The 4.3. Group], *Jeonhwangiui hanguk geonchukgwa 4.3geurup* [The Korean Architecture and The 4.3. Group in Transition] (Seoul: Jib Books, 2014) 83.

15 Park Kilyong, Hanguk hyeondae geonchuk pyeongjeon [The History of Korean Contemporary Architecture] (Seoul: Space Books, 2015), 256.

16 Pai Hyungmin, 81.

17 Ibid.

18 Lee Jong-woo, "Toward Architecture for the Real World: Realism in Architecture by Progressive Groups (1987–199X)," *Papers and Concrete: Modern Architecture in Korea 1987–1997*, exh. cat. (Seoul: MMCA, 2017), 49.

19 Park Junghyun, "From Square to Boudoir: The Turning Point of the Early 1990s," *Papers and Concrete: Modern Architecture in Korea 1987–1997*, exh. cat. (Seoul: MMCA, 2017), 38.

20 Pai Hyungmin, 89–90.

21 Ibid., 90.

22 Park Kilyong, 253.
23 Kim Sunghong, "Hangugui geonchugundong, eotteoke
 bol geosinga" [The History of Korean Contemporary Ar-
 chitecture], *Architecture & Society* (December 2013): 10–27.
24 Mokchon Architecture Archive, 83.
25 Ibid., 111
26 "Inteobyu: Sireul sseuneun nangmanpa geonchukga,
 hangukgeonchugui hyeolmaeng gimjungeop."

1980s Korean Art Beyond Modernism

Lim Shan

Marked by critical events such as the May 18 Democratic Uprising in 1980, the Great Labor Struggle in 1987, the Seoul Asian Games in 1986, and Seoul Olympic Games in 1988, the 1980s witnessed strengthening of the national popular culture and commercialism, an expanded media environment, and structural shifts in the realms of the economy, politics, and society. It was also a turbulent age of creative diversification. Various forms of art practice emerged to overhaul the art scene. Many artists took to experimenting with deconstructing the conventional forms of 1970s Korean modernism, while those artists in the Minjung art camp called for the reinstatement of realism. Creative experiments in nature, media, installation, and performance art revealed Korean artists' commitment to addressing the crises of reality that defined the changing cultural landscape. This drove young artists—who were poised to take critical action against the consolidating process of modernism and who were armed with new theoretical ideas and concerns—to form small groups in order to advance their ideas. They rejected the path of uniformity and aggressively sparked disputes with more established figures in an attempt to seek alternative paths. They voiced their opinions based on their individual ideas about philosophical and artistic practice. The fruits of their efforts are currently still being realized, which is why the alternatives and outlooks of this period are still so significant in today's Korean art discourse. This section therefore delves into the complicated context of 1980s Korean art, and the particular concern with overcoming the dominance and critical legacy of 1970s modernism and the desire to seek an alternative to such, along with the parallel rise of numerous diversified artistic forms of experimentation that were driven by an intrinsically defiant quality.

THE UNITY OF ART AND NATURE: THE BIRTH OF NATURE ART

The inaugural outdoors in-situ exhibition of the Geumgang Contemporary Art Festival was held on the white sandy banks of the Geumgang River in Gongju from November 16 to 22, 1980. Young artists who were born and raised in the Chungcheong region banded together to showcase "outdoors in-situ art." Led by Baek Junekee, Yoo Keunyoung, Rim Dongsik, and Hong Myung-seop, this outdoor exhibition displayed various works, through which artists attempted to surrender themselves to the natural order by incorporating nature as their material. Largely marginalized from the institutional mainstream, these artists based in regions outside Seoul pursued a spontaneous aesthetic course in their work. They sought to overcome the notion of purity that had been reinforced within Korean monochromatic modernist art but at the same time deliberately kept their distance from the partisan social approach of Minjung art activism. Through taking this path, they strove to realize the ideal of unity between art and life. The free spirit that they considered had been suppressed under the stern discipline of academic art was now set loose in nature. The artists came up with a method of producing art which emphasized the idea of personal experience and giving in to nature, instead of seeing nature as an object of expression or employing the serendipitous disposition of nature for making abstract art, as in the case of Dansaekhwa painting. Therefore, it could be said that these artists were not simply transforming their exhibition venues but also attemped to work in union with nature to create a new example of ecological art. This 'nature art' (*jayeon misul*) spirit of the Geumgang Contemporary Art Festival was reorganized into the Outdoors Field Art Research Association · YATOO

DEMOCRATIZATION AND THE PLURALIZATION OF ART

in 1981, which in turn changed to the Nature Art Research Association · YATOO in 1983, and finally the Korean Nature Artists' Association · YATOO in 1995. Ko Seunghyun [1], Yoo Dongjo, Rim Dongsik [2], Ji Seokcheol, and Hur Jinkwon were the founding members of the YATOO group. The literal meaning of the Korean term "Yatoo" is "to throw from the meadow." Here the idea of "meadow" symbolizes that of nature as a place of potential that is outside the direction of mainstream art, while "to throw" signifies the experimental nature of a new aesthetic practice.[1]

Apart from the YATOO group, another noteworthy practice was demonstrated within the exhibition *Winter, Open-Air Art Show at Daesung-ri by 31 Artists* held on the banks of Bukhangang River in Daeseong-ri, Gapyeong-gun, Gyeonggi-do in January, 1981.[2] The show was led by the DAMU Group that was made up of seven Chung-Ang University alumni, from the Oil Painting Department—Kim Jeongsik, Kim Hakyeon, Lee Heungduk, Im Chungjae, Jeong Jinseok, Choi Hyunsoo, and Hong Seonwung.[3] The 31 artists in the exhibition, who were active various in the field of cultural production, including in fine art, theater, and music, freely became at one with nature on the river banks without limiting themselves to any certain artistic genre.[4] The holistic, artistic bodily action made here was not aimed at conveying a clear message, nor did it have a qualified formal aesthetic. Rather than complying with the dictates of institutional art, it revealed a set of gestures that were in harmony with the natural environment, underscoring the presence of a new youthful consciousness on the cultural landscape of the period. In this sense, this event informs the division and fusion of genres "after" modernism that characterizes 1980s Korean art. In other words, it was not a simple formal experiment involving genre "crossovers." The artists here realized that the forms of modernism that had dominated 1970s Korean art were incapable of inspiring new vitality into the art community, because they were isolated from society and turned a blind eye to crucial contemporary contexts such as political repression and cultural poverty. The exhibition demonstrated a new aesthetic paradigm of seeking new functions for artists and art, based on ideas of social coexistence and symbiosis instead of isolation.

YATOO refined their formal language by further developing the concept of "nature" from the mid-1980s. They relied on the natural environment to procure the material for their work and often looked for ways to return altered forms of nature to their natural state. In this context, the traditional system of artwork ownership and storage soon became obsolete, and the artists engaged in a mutual relationship with nature while affirming and expressing their aesthetic perspective relative to the natural environment. As such, combining the totality of sensory experiences with their intuitive encounter in nature, YATOO artists were able to sublimate the creative energy they found in nature into a process of inspiration and discovery. This concern quells any attempt to simply prescribe an idea of YATOO's "nature art" within the limited spatial frame of 'the outdoors.' Furthermore, their work is historically meaningful because it reconsidered rational thinking concerning the exploitation and objectification of nature and explored the existential potential of the artist and artwork through bodily movement in the natural environment.

The exhibition, *Winter, Open-Air Art Show at Daesung-ri* featured a seminar as part of the exhibition in 1986, along with the establishment of the influential Baggat Art Research Society. In the seminar, artist Kim Jeongsik suggested that "You must first soul search for what the freedom embedded deep within yourself is, and know how the providence of nature is placed within the human disposition and practiced, and in what form it is alive in yourself." This was a statement that reflected on the past of *Winter, Open-Air Art Show at Daesung-ri* and reaffirmed the importance of nature for future cultural development.[5] As such, the *Winter, Open-Air Art Show at Daesung-ri* served as a continuous exploration of the aesthetic consciousness these artists aspired to. In 1992, Baggat Art Research Society officially changed their name to Baggat Art Association, and with this, the *Winter, Open-Air Art Show at Daesung-ri* exhibition was dissolved. However, the group continued their practice, emphasizing "the relationship between the environment, nature and art," and not limiting their activities to Daeseong-ri, but expanding to Namhangang River in Yeoju, Taejosan Mountain in Cheonan, and Yangjae and Sinchon in Seoul.[6] In retrospect, *Winter, Open-Air Art Show at Daesung-ri*, along with the activities of the YATOO collective, exemplify the most representative practices of those artists who experimented the unique Korean perspective of nature. Their nature art offered a form of resistance against the obstinate authority of mainstream Korean art, while keeping a distance from any ideological or social movement such as Minjung art. It rather mobilized a practice of strategic introspection in order to survive independently.

THE RIVAL BRANCHES IN THE ADOPTION AND CRITICISM OF POSTMODERNISM

From the mid-late 1980s to early 1990s, the Korean community of art critics became unprecedentedly

fractious over the debate on postmodernism carried out between the modernist camp and the emergent Minjung art camp. Critics examined postmodernist theory that was being imported from the West and clashed over various issues regarding its interpretation. However, the debate at the time was centered around ideological positions rather than accurate interpretations or constructive discussions on the context at hand. In this respect, while it is natural that art criticism strengthens its own discursive potential in relation to the rapid expansion of Korean capitalism, but capital remains largely immune to any critique, particularly as the culture industry becomes institutionalized in relation to the rapid expansion of consumption culture. In this context, the critical debate failed to stay focused on the theory of postmodernism itself, and rather set off on a course of being either for or against Korean modernist art of the 1970s. It thus descended into invective. In this regard, "the dispute over postmodernist art," a phrase widely used to describe the debates that shaped the period hardly seem to describe the situation accurately.

The meaning and use of the term "postmodernism" changed depending on how it was translated in Korea. Three different terms appear in academic texts: "postmodernism," "ex (*tal*)-modernism" and "late (*hugi*)-modernism." For instance, the architecture journal *Korean Architects* featured a series of articles entitled "Precursors of Postmodernism" over three issues in 1983. It was a translation of an article written by architecture historian Suzanne Stephens under the same title that introduced the characteristics of postmodernist architecture centered on several prominent architects.[7] Also, *The Culture of Postmodernism* by American literary theorist Ihab Hassan was translated and introduced to the Korean public. In art circles, Kim Bokyoung delivered a lecture titled "The Task of Art Regarding Late-modernism: For the Great Conquest" (Hugimodeonijeume isseoseo misurui gwaje: widaehan chogeugeul wihayeo) in the twelfth floor auditorium of the The Korea Times building on August 7, 1985. In his lecture, Kim provided the historical and theoretical background behind postmodernism and emphasized that maintaining independence in embracing the concept was a key requirement for the Korean art scene.[8] Here, Kim translated postmodernism as "late-modernism."

The framework of postmodernism was mostly adopted by mainstream modernist art critics. Following Kim Bokyoung, Seo Seong-rok sought to find the root of postmodernism in modernism in his article "Two Aspects of Modern Art Rooted in Modernism" (Geundaejuuie ppuribageun hyeondaemisurui du gungmyeon) in 1986. He argued that artistic tendencies concerned withof

"new lyricism" as an "expansion of expression" and of "atonal structure" as "internalization of expression" constituted the key elements of postmodernist art. Then, In 1987, Lee Yil published "On 'Expansion' and 'Reduction' Again," in which he observed the transition from modernism to postmodernism (as either "late-modernism" or "ex-modernism") and described modernism as "reduction-oriented art," and postmodernism as "expansion-oriented art." Lee seemed to accept the innovative approach of postmodernism, and yet he did not offer a persuasive explanation of its "anti-traditional and anti-authoritative" nature. In other words, he took postmodernism as an updated framework to explain American modernism rather than an analytical framework to explain the actual changes in the contemporary art scene. As a result, it was rendered as merely a discursive means to reconsider self-identity.

The generation of critics at the time failed to sufficiently understand the context behind the changes that occurred in the art world during the early stages of the adoption of postmodernism. Even the debates within the critics' community by using the concepts of modernism and postmodernism were carried out without a shared notion of what these concepts actually were. And this situation was no different when further discussions were sparked after the democratic breakthroughs of 1987. However, as Western postmodernist theory was directly studied by artists towards the end of the 1980s. These artists turned to a different range of texts to strengthen the aesthetic and conceptual potentials of their artistic expression, as the mass media images became the principal tool for sensory stimulation and information consumption for the general public. Amidst these wider social and cultural changes, the young critics began to gain recognition at the time through exhibition reviews and talks, and thereby contributed to the debate over postmodernism being a shaping power in the field of art criticism.

Seo Seong-rok, who authored several influential texts that introduced postmodernist theory and its critical application, highlighted that the small groups Meta-Vox and Nanjido had usefully raised the issue of "ex-modernism" within the art world. The logic behind this statement was that the two groups had moved away from the uniformity of 1970s modernist art. However, although the groups' installation art addressed the subjective experience of materiality and thus emerged as a criticism of the limits of Korean modernism, they were far from departing from the formal logic of modernism and abstraction. Their "ex-modernism" criticized modernism but at the same time bore the limits of being confined to the artistic forms of modernism. Artists like Kim Yong-Ik, Moon Beom [3], and

Lee Kyojun of the Logos & Pathos and Kim Chandong and Hong Seungil 4 of Meta-Vox dealt with found objects in relation to personal ideas of myth and symbolism, Shin Youngseong 5 and Choi Jeonghwa, who used industrial waste to voice a critical commentary on contemporary society, or Ko Younghoon and Lee Sukju who created hyper-realistic paintings all used this transitional concept of ex-modernism during this time. For Minjung art critics, however, these works were pluralistic and neutral in value, and only served to produce a false utopia that nullified the possible recognition of the concrete historical reality of the period.[9]

Ultimately, it is indisputable that the debate on postmodernism in the mid to late 1980s was heavily mediated by the issue of modernism and realism. There was a shared awareness that Korean art at the time should depart from 1970s modernist art, and yet at the same time there was an irreconcilable gap between the differing perceptions of how the paradigms of modernism and postmodernism—that arose in the west to become an international meta-discourse—could be re-interpreted within Korea and coexist with existing discourses of Korean art.

BETWEEN DISCORD AND ASSIMILATION: THE GOLDEN AGE OF THE SMALL GROUP MOVEMENT

The political situation in 1980s Korea led to the formation of small groups in various arts fields, including art, literature, theater, and film that were determined to add depth and breadth to their thinking on the function and value of arts in society. Breaking away from 1970s purism and emphasizing their artworks leaning towards cultural movements, a number of small collective artists had to look for new ways to express their political resistance. In literature, Silcheon Munhak, Magazine Changbi, Nodong Munhak, and the likes published literary coterie magazines and books, resisting the literary community, democratizing literature, while also systematizing non-fiction and other new genres. Also, in theater, professional troupes like the Yeonhee Entertainer Group and Minjok Theater Research Association developed a realist play that called for the theatrical engagement with social reality in multifaceted ways and, in so doing, developed a theater format that addressed workers and farmers to raise social consciousness among them. While in the context of film, small collectives like the Seoul Film Collective, Dongseo Film Research Association, and Yeonghwamadang Woori published books and held screening events, developing new methodologies for producing and distributing art film that could overcome the capitalist limitations of the film industry. In the field of visual art, however, there were also small

3 Moon Beom, *Four Apples*, 1986,
Graphite, conte, paraffin on canvas, 291×182 cm

4 Hong Seungil, *North*, 1989,
Mixed media, 750x360x48 cm

5 Shin Youngseong, *Korean Dream*, 1986–2002,
65 electric fans, 40×31×10 cm (65)

6 Kim Kwansoo, *Black Box*, 1981,
Object, 60×145×43 cm

7 Kim Jangsup, *Materialized Painting*, 1986,
Ink on paper, object, 18×90 cm (12)

art groups that did not participate in the Minjung art movement in favor of their own aesthetic freedom. These groups formed a separate pillar within the art world that stood alongside Minjung art, generating a wealth of critical discourse in the 1980s Korean art community.[10] These groups invented new aesthetic concepts and expressive language and, as such, gave voice to the wide array of artists whose goal was to surpass the aesthetic and conceptual limitations of 1970s modernist art. The backdrop to the emergence of these small collectives is much more complex than that of the Minjung art groups that had their roots in political causes and the democratization movement. Indeed, the concept of "new figuration" (*saeroun byeongsang*) was promoted as a means to replace "abstraction" within the Dong-A Art Festival, an art competition, and "neo-expressionism" became a major trend within the international art world in the early 1980s. The Korean art discourse, however, seemed lethargic to generate any new issues that could replace the formalist conception of abstraction as the primary critical position of the art world. However, against this, and largely inspired by the cultural influence of industrialization and the

expansion of global capitalism, young artists sought to overcome the limitations of Korean modernism and expand upon their expressive repertoire by passionately seeking out new materials for art as well as new messages to underpin their formative explorations.

The history of such small groups in the 1980s began with TARA. This collective held an inaugural exhibition at the Dongduk Art Gallery from May 7 to 13, 1981, and the members were Kim Kwansoo [6], Oh Jaewon, and Lee Hoon. Later, Kang Youngsoon, Kim Jangsup [7], Park Geon, Park Dooyoung, Park Eunsoo, Ah Heesun, Ye Yougeun, Yook Keunbyung [8], Lee Kanghee, Lee Kyojun, Lee Jangha, Lee Jinhyu, Lee Hyeok, and Choi. As is well indicated in the fact that its name TARA is an amalgamation of the first two letters of the words in "Tabula Rasa," the self-stated aim of the collective was "to break free from the issues and problems that ran rampant in the 1970s and 80s."[11] They mainly worked with installations that evoked a mythical and archaeological interest in everyday images, objects, and actions. While most TARA members had studied art at university in the 1970s, both Nanjido and Meta-Vox were

8 Yook Keunbyung, *The Sound of Landscape+Eye for Field*, 1988 (remade in 2019),
 Mixed media, dimensions variable

composed of young artists, who went to Hongik University in the 1980s. Organizing their inaugural exhibitions in 1985, these artist groups delivered their personal experiences and firsthand accounts of various social injustices, raising issues through formal experimentation using three-dimensional works and installations. For Instance, Nanjido used discarded materials and objects in order to invite critical reflections on contemporary society,[12] [9] and Meta-Vox explored the narrative potential and linguistic dimension of everyday objects.[13] [10]

The year after Nanjido and Meta-Vox's inaugural exhibitions, Logos & Pathos held theirs in 1986.[14] [11] [12] [13] Consisting of Seoul National University alumni, the group experimented with the idea of non-figurative abstraction by working on three-dimensional structures and installations. Despite their group exhibitions being held for more than 10 years until 1995, however, some have pointed out that the group's main aesthetic statements were somewhat vague. As such, Logos & Pathos were more open to free individual experimentation than strict collective doctrine. Then, in 1987, more small groups were formed including Museum,[15] Golden Apple, Sub Club, Coffee-Coke, and Off & On.[16]

These groups intuitively accepted contemporary visual culture and created exhibition formats that

9 Bak Bangyoung, *Voice-Mythology*, 1985, Straw and wooden box glued with adhesive, 250×380×210 cm

10 Kim Chan-dong, *Myth-Ritual for Sacrifice*, 1987, Oriental paper, objet, 200×300 cm

11 Shin Okjoo, *On the Horizon*, 1981,
 Steel, dimensions variable

12 Chang Hwajin, *Untitled*, 1985,
 Lithograph on paper, drawing,
 56×77 cm

13 Hyung Jinsik, *Untitled*, 1987,
 Charcoal, conte, crayon on
 canvas, 122×200 cm (2)

were easily distinguished from those favored by the previous generation. In other words, their work served to immediately deny the modernist aesthetic of their predecessors without being confined to the ideologies of meta-discourse and the limits of narrative. In this regard, these artists freely navigated through various themes such as the kitsch urban aesthetic of the city, the fleeting and floating nature of mass consumption, and the spectacle of technology media. These trends received more attention within what was called 1990s "new generation art."

The aim of "overcoming modernism" has become something of a cliché when discussing 1980s Korean art. However, this concern was more than a concept that was fabricated by the critics. These aforementioned small groups dominated an entire era of Korean art thanks to their affirmative sense of self-identity and their assertive manner of self-expression.[17] Equally, each group was active at different times and the expressive methods they employed were different from one another. They garnered different amounts of critical attention, and therefore any attempt to make sweeping evaluations of all these small groups amounts to something of a risky generalization. However, these small groups made an effort to bring about change in relation to the idea of 'post' modernism and received subsequent credit within the discourse of Korean art history, coming to be known as the 'small group movement' of the 1980s. This collective recognition was not necessarily attributed to actual networking processes undertaken by artists of a similar age but rather to their collective efforts to move on from the hopelessness and trauma they shared in the 1980s. In this respect, a different look into Korean art history in the 1980s might be possible by re-examining the art practices and the social and cultural contexts that informed their practice.

THE LANDSCAPE OF NEW MEDIA ART
The 1980s made a number of noteworthy strides in aesthetic form using video media and the computer.[18] Of course, there was also the key backdrop of a sudden surge in video image consumption along with the development of mass media technology in Korea at the time. Color television broadcasting was launched in 1980 under the new military dictatorship, the merger and abolition policy of the press led to the dissolution of private broadcasting companies, which were merged with national broadcasters. Though television programs were exploited as a means to promote the government administration, new sources of sensory stimulation such as video began to appear in domestic contexts, in particular after 1987, when the process of democratization led to an increase

in broadcasting media and television channels. The general public developed an interest in kinetic and video art after they viewed the live broadcast of Paik Nam June's *Good Morning, Mr. Orwell* (1984), *Bye Bye Kipling* (1986) and *Wrap Around the World* (1988), and the exhibitions *Kinetic Sculpture, Japan* (1986), *Video Art of the World* (1987), and *Poetry through Material Light and Movement* (1987). Young artists, who sought to move away from the traditional modernist approaches that had been dominant in the 1970s increasingly engaged with the medium of video.[19]

The aforementioned small group members led the use of media such as television and the video camera in their practices.[20] Yi Wonkon, who was a member of Logos & Pathos, showcased *System & Structure Block Diagram* and *Communication* in 1986. In his first one person show entitled *Yi Wonkon Video Installation Show* held in June, 1987 he exhibited an installation that consisted of a television as an art object, electronic signals, and performative body movement. Kim Deoknyeon, another member of Logos & Pathos, experimented with the video feedback effect in his 1988 work *Untitled*. Yook Keunbyung of TARA had a solo show entitled *The Sound of Landscape + Eye for Field* in 1988 in which he inserted a 14-inch television monitor in a large burial mound from which a video of a blinking human eye played, compelling viewers to make eye contact with the image on the screen. This work was featured in the São Paulo Biennale 1989, and Kassel documenta 1992, garnering international attention. Kim Youngjin, who was mainly based in Daegu alongside the noted video artist Park Hyunki from the late 1970s, participated in the exhibition *Seoul, March of 1987, 23 Artists* along with Yi Wonkon and Yook Keunbyung[21] and presented his video work *Work-86*. Oh Kyung-hwa's first solo show that opened in April 1988 was about the artist's personal narrative. However, in *Video Reunification Gut* video installations and performance served to awaken the public's political awareness to the reality of their divided country.

These early Korean video artists began to showcase their experimental installations in the mid to late 1980s when the aforementioned various small groups formed. However, they were unable to use advanced technological equipment to radically transform their video imagery. Instead, they used basic editing techniques to produce abstract, fragmented, repetitive effects on a television monitor, replacing the perspective system used in painting. Also, while they made the sound and film images seem as if they were transient, they were imbued with sculpture-like characteristics to occupy their own area within the exhibition space. Here, the television gains a key function as an art 'objet' and forms a sculptural narrative as it replicates the relationship between people and

the object seen in everyday life. The use of the television as a neutral image conveyor or mediator is different from that in early Western video art that saw it as a tool for criticizing and raising the issue of its cultural domination and unilateral communication. However, one should take into consideration the distribution history of television, the development of media criticism, and the technical context that allowed only the monitor to become the medium for image display in the South Korean art world.[22]

Computer art is another noteworthy form of media art that emerged in the 1980s. In the early 1980s, the government implemented a policy to foster the information and communications industries, and researchers developed the Hangul word processor and printer. However, there was no noticeable rise in the demand for PCs until the late 1980s, when the PC became popularized in business, for education, or for gaming purposes. The art field at the moment began to show interest in "computer art" as a new genre.[23] Manipulating sound and images, the computer was largely understood as a highly specialized technology for industrial design. Also, it was not a popular idea at the time to use an expensive tool that was imported from abroad to create artwork. This was the case until SAS (science art·art science) made their appearance. Pioneering artistic expression using the computer, the small group opened the exhibition *Computer Art Slide Project—Good Morning 1985* in January 1985. The thirteen member artists who were trained in various disciplines including computer engineering, fine art, graphic design, and electronic music created more than 1000 cartoons, twenty minutes' worth of graphic animation using home PCs, IBM's JUN 4D STATION and a synthesizer that were screened on two slide projectors and by using a video tape recorder.[24] As the first computer art exhibition in Korea, *Computer Art Slide Project* was close to electronic total art including musical improvisation and performance art. For this exhibition, Shin Jinsik, who gave up on Minjung art, showcased a printout of computer processed images, and he held a performance of computer art along with composers, performance artists, and movie critics in October the same year.

Computer-based artworks are predicated on the interaction between human and machine. The aesthetic potential of this interaction was explored by Kim Yoon. In his one person show Art Now, Kim showcased works that portrayed people's lives instead of the cold "sensibilities" of a machine by focusing on the extension of humanity and our coexistence with media technology. Such an attempt became completed via through semantic form and substantial interaction. Kim Hae-Sook, who had worked with computer graphics from

1984, displayed images that were made up of an infinite number of colors using the computer in her third one person show *Computer Graphic Artworks* held in December 1986. She continued to explore contemporary sensibilities using the computer, video and the automated mechanisms of other electronic machines in exhibitions like the computer graphics exhibition *MYSTERIOUS* that opened in the MMCA in November 1987; *High Tension Line* in March 1988[25]; *220V* in March 1989[26]; and *Light and Movement* in July 1989.[27]

Looking back to 1980s technology-oriented Korean art now evokes a sense of nostalgia. That sense seems to be ironical because the media formats used by these pioneers are still prevalent in contemporary art. In this respect it is possible to assert that we have little knowledge of the history of new media art in Korea. The mainstream critics were so reliant on the conventional norms of fine art that they failed to appreciate this new type of art. They either wrote sentimental articles after briefly looking at them with superficial curiosity or deemed it inhuman art that relied on machines. As such, there is insufficient analysis of the new media practices beyond the modernist art narrative. The art-historical research into media art is intrinsically complex and multi-tiered. This is because this type of art can adapt to and from traditional formats of art practice as well as become completely detached from such. The world of media art that is both cultural and technological remains suggestive and mysterious. However, if we are going to be able to accept its future potential for contribution to art discourse, then perhaps we need to overcome the boundaries of the different disciplines while embracing the different layers to the discourse and reviewing the works with affection and responsiveness.

ART LANGUAGE BEYOND THE BOUNDARIES: INSTALLATION AND PERFORMANCE

Understanding the installation art trend in the 1980s requires extensive research. This especially rings true because installation art dealt with the core issues of the Korean modernist art. Also, installation art is the only example of art that transcends the boundaries of different genres which is why it is particularly difficult to define, and at the same time it also has a long genealogy. Above all, it forms an ambiguous boundary with other traditional art formats. Therefore, 1980s installation art could be considered as a unique and meaningful framework to understand Korean art history. However, just as the core differences between modernism and postmodernism are often blurred, the "crossover" nature of installation

art is not exclusive to the genre. It would also be risky to consider it a unique genre that defines the art and style of an entire era. It might have to be interpreted as one of the Korean art practices that advanced the principles of the modernist avant-garde spirit. In this sense, Chang Sukwon's idea that during the 1980s installation artists became "of the limits of art itself, and began to incorporate the diversified tokens of life," in their work, warrants attention.[28]

Installation artworks in Korea can be traced back to the late 1960s, when the *Union Exhibition of Korean Young Artists* took place in 1967, Lee Seung-taek presented his wood and rope works in 1969 and a series of *Wind* in 1970; and Kim Kulim also showed his outdoor work *From Phenomenon to Traces* in 1970. Later, Lee Kangso, Lee Kun-Yong, and Shim Moon-seup of AG; and Kim Yongmin, Kim Jangsup, Sung Neungkyung, and Song Jeonggi of ST became responsible for the installation art trend in the 1970s. As mentioned above, Park Hyunki combined installation art and video images to create an "environment" that encompassed the issues of temporality and spatiality from the late 1970s to early 1980s. 14 More than a three-dimensional composite of the visual elements, his installation work allows for the coexistence between the past and present, change and continuity. Furthermore, it constitutes an environment where bodily movements take place and semantic events emerge. As such, Park's installation provides the viewer with the opportunity to experience both the aesthetic themes and the movements of the artist, experimenting with the reciprocal relationships between an object and a person.

The *Winter, Open-Air Art Show at Daesung-ri* exhibition and YATOO's outdoor in-situ installations employed the distinct spatial characteristics of the outside environment as the identity and core strategy for their notion of nature art. They also foregrounded the artists' actions of moving the body as a medium of expression, granting performance an equally important role as the installation. This context must be read in a different dimension from that of Park Hyunki's work, or the activities of the 1980s small groups. The "aesthetics of the *objet*" that were advocated for Nanjido, Meta-Vox and Logos & Pathos (although uniting the three groups under one single banner entails the risk of over-simplification) may be the key to interpreting their installation artworks. To them, the idea of the "*objet*" paved the way for three-dimensional work that allows the "democratization of expression" that had been suppressed by the authoritative formalism of Korean modernist art. But at the same time, it remained conceptual in its examination of the "world of things," an ideological exercise focused on abstract

stylization that maintained an aesthetic dialogues with the objects rather than exploring a structural relationship among object, audience, and space.[29]

Within the great wave of installation art that gained prominence as a key method of artistic practice in the 1980s, performance art emerged from 1986 as a concerted attempt to address history, reality, and the issue of communication while bringing the purported purity of Korean modernism into question. A number of performance art events occurred in the late 1980s, including *This is Korea 1986*, *Seoul '86 Performance Installation Festival*, *Daejeon Performance Art Festival 87*, and *Performance in the 80s: A Stage for Transition Art & Performance* and *Human Being and Life and Thinking and Communication*. Along with avant-garde artists in different fields including dance, theater, and music, Korean artists such as Kang Yongdae, Kang Jeongheon, Koh Sangjoon, Kim Younghwa, Kim Yongmoon, Kim Joonsoo, Kim Jaegwon, Nam Soonchoo, Moon Jeonggyu, Park Changsoo, Bang Hyoseong, Sung Neungkyung, Shin Youngseong, Shim Cheoljong, Shim Hongjae, An Chiin, Yoon Jinsup, Lee Kanghee, Lee Duhan, Lee Bul, and Cho Chungyeon participated these events in order to share the energy and aesthetic commitment that required to move in line with the contemporary. They rejected becoming a "product" that corresponded to the consumerist capitalist characteristics of art and were therefore largely

14 Park Hyunki, *Drawing Book, 1980*, 1978–80, Pencil, pen on paper, 35.5×26 cm (22)

ignored by art critics and the market. Instead, their bodies became a mediator for the community's ritualistic expression and were a signifier of the times in embodying the call for communication and cooperation.

As such, the artists' endeavors that were manifested as installation and performance art erupted in many forms as a means to resist the uniform style and formal flatness that were the legacy of Korean modernism of the 1970s. Media art, which can be seen as an aesthetic reaction to the asset of the times, namely the evolution of industry and technology; installation art of the small "ex(tal)-modern" groups that was based on the need for a new formal language and a collective awareness of the need to call for transformation; and performance art that built the paradigm of Korean performance by slipping in and out of the boundaries of the traditional art system made the aesthetic possibilities of their sensory media tangible and filled the 1980s with events that creatively disturbed the status quo. These formats that later became separate genres failed to receive the support of in-depth research, but it can be agreed that they were the results of passionately thinking about and reflecting on how the cultural phenomenon of art should form a relationship with society, and how it could consciously express such reflections.

The 1980s was an age of aesthetic achievements carried out by endless reflection and searching for alternatives. It was a form of "experimentation" for overcoming the 1970s. It is also evidence of symbolic communication that was carried out in order to keep up with the changing times. What these specific art practices demonstrate, particularly in relation to the work of later generations, was the process of an active debate over the Korean art world which had fallen into a rut of uniformity. Some characterize 1980s Korean art relative to the rise of postmodernism, while others, the era reflects the difficult clash between modernism and realism, while others still call it, the world that broke free from the logic of genre that deviated from the great narrative. We know that one dimensional evaluation of any of these forms of art is inadequate which is why we must confront the grounds for such judgments and question them again. There was a lack of discussion of this subject, which is why we must re-explore the historical forms of 1980s Korean art as the theme of art history research and criticism.

1 Rim Dongsik outlined the concept and practices of nature art in the founding declaration upon the establishment of YATOO: "YATOO is a group that researches outdoors art through making novel contact with nature, and admires natural change, its infinite breadth and depth, and all life forces within it based on our powerful love of nature. YATOO, a group dedicated to the research of transparent art that moves with nature . . . has become a research society dedicated to the fervent desire and explosive passion of people who are profoundly eager to remain in nature." Rim Dongsik. "YATOO changnip seoneonmun" [Declaration of the Establishment of Yatoo], *YATOO Inaugural Exhibition*, exh. cat. (Daejeon: Outdoors Field Art Research Association · YATOO, 1981)

2 The following text that describes this exhibition from the period clearly conveys the freedom the artists felt: "January 15. It's funny. We began our foolhardy writhing, 'flinging' ourselves on the river banks in Daeseongri, with the intention of throwing ourselves into nature in winter. The tree trunks are wrapped with white paper and each tree is tied with rope made from straw. And beneath the rope, the members, with either a shovel or broom in hand, scoop up the snow and cover the transparent plastic as if they are about to make incredible history. / January 20. Twenty-three participants and a few outsiders. More than 200 viewers. It is a collective work made with the body. A meadow with nothing but snow, young people charged forth like predators. But, what should we do? And how? Our bodies are all that we have . . ." This is an excerpt from the exhibition journal of Seo Youngseon, one of the participating artists. Kim Kyungseo, "Gamchugi deureonaegi itge hagi 1981-2006: Hanguk jayeonseolchimisurui sae jangeul yeon bakkanmisul 26nyeonsa" [Hiding Unveiling Making It Be 1981-2006: 26 Years of Baggat Art that Opened a New Chapter to Korean Nature Installation Art] (Seoul: Davinci Publishing, 2006), 21–22.

3 *2019 Gyeonggi ateu peurojekteu sijeom·sijeom—1980nyeondae sojipdan misul undong akaibeu* [Locus and Focus: Into the 1980s through Art Group Archives], exh. cat. (Ansan: Gyeonggi Museum of Modern Art, 2019)

4 There were thirty-three artists who participated in the exhibition by genre according to the catalog that was published at the time. Among these artists, poets Choi Younghae and Kim Hongseong each included their poems in the catalog. [Art] Kang Yongdae, Kwak Jeongil, Kim Kwansoo, Kim Bojoong, Ghim Eonbae, Kim Wonmyeong, Kim Jung-soo, Kim Jeongsik, Kim Hakyeon, Moon Youngtae, Park Jinah, Seo Youngseon, Yoo Gilyoung, Lee Joon, Lee Heungduk, Im Chungjae, Jang Ikhwa, Jeon Younghee, Jeong Jinseok, Jeong Jinyun, Choi Woonyoung, Choi Hyunsoo, Hong Seonwung. [Theater] Kim Seonggu, Yoo Jingyu, Ki Gukseo, Lee Jeonggap. [Music] Han Daehoon, Park Yongsoo, Hur Younghan, Park Yongsil. [Poem] Choi Younghae, Kim Hongseong.

5 A seminar was also held with the 1981 exhibition in which art critics Yu Jun-sang and Kim Bokyoung gave talks that primed the ideological path for the nature art that they pursued.

6 Jeon Hyesook. "Bakkat misulhoewa yatu geurubui jayeon misure natanan saengtaejuuijeok teukseong" [Ecological Aspects in the Nature Art of Baggat Art and YATOO], *The Korean Society of Art History*, no. 51 (2018): 298.

7 This text was originally published in the following: Stern, Robert A. M. *American Architecture after Modernism*, A+U Publishing, ed. Robert A. M. Stern, 1981.

8 The lecture was a part of the Frontier Festival that opened from August 7 to 27, 1985. Exhibitions were held in twelve venues around Seoul during the festival includ-

ing Dongduk Art Gallery, Gallery YEH, Gallery Yoon, and Alliance Française.

9 Refer to the following reviews: Park Sinui, "Misulpyeo-ngnoneuroseoui poseuteumodeonijeum: Geu bipanjeok suyong mit geukbok" [Critical Acceptance of and Victory over Postmodernism as Art Criticism], *Misul Segye*, July 1989, 29–35; Shim Kwanghyun, "Hugijabonjuui sahoewa poseuteumodeonijeum ideollogi" [Postcapitalist Society and Postmodernist Ideology], *Misul Segye*, July 1989, 36–41; Lee Youngchul, "Talmodeonui binnagan daean: Hugimisuljakgahyeopoe changnibe daehae" [The Divergent Alternative of Ex-modernism: On the Inaugural Exhibition of the Late Artists Association], *Wolgan Misul*, August 1989, 174.

10 The literal meaning of both "small collective" and "small group" are ostensibly the same in that they are both small-scale interpersonal unions. In Minjung art discourse, however, "small collective" refers to a group of artists who believed that art had to have a role in bringing about change in society and formed a uniform ideology across the whole community by means of debate and discussion. This article uses a "small group" to refer to a group of non-Minjung art artists who shared similar sense of aesthetics, but rejected political ideologies in favor of free individual artistic creation and self-reflection, though this distinction may be arbitrary.

11 Interview with Kim Kwansoo in Oh Sang-Ghil, *Hanguk hyeondaemisul dasi ikgi il 80nyeondae sogeurubundongui bipyeongjeonk jaejomyeong* [Another Look at Korean Modern Art I. A Critical Re-examination of the Small Group Movement in the 80s] (Seoul: Cheongeumsa, 2000), 15–16.

12 The inaugural exhibition that included the works of Kim Hongnyun, Bak Bangyoung, Yoon Myeongjae, and Lee Sangseok was held at the Kwanhoon Gallery from February 20 to 25, 1985. Ha Youngsok and Cho Min joined later in 1985 and 1988 respectively.

13 Meta-Vox's inaugural exhibition was held in Hu Gallery from September 17 to 23, 1985. Artists who participated included Kim Chan-dong, An Wonchan, Oh Sang-Ghil, Ha Minsu, and Hong Seungil. Jang Kibeom joined the group later in 1987. In 1986, Meta-Vox planned and opened the exhibition *EXODUS*. The group was joined by non-member artists Kang Sangjung, Kim Sungbae, Seo Jungkug, Jang Kibeom, and Cho Sungmu. In 1988, the group was invited to become a part of the *9 Artists & Groups Exhibition of 1987* exhibition hosted by the Seoul Museum in which six members participated, and the group dissolved after the show *Meta-Vox Disbanding Exhibition: A Condition of 80s Art* at the Noksaek Gallery in August 1989.

14 Invited members include Kwon Hoonchill, Kim Deoknyeon, Kim Jooho, Kim Hodeuk, Kim Heesook, Noh Sangkyoon, Doh Heungrok, Moon Beom, Park Jungwhan, Shin Okjoo, Shin Hyunjung, Yang Heetae, Yoo Insoo, Yoon Sungchin, Lee Gwihoon, Rhee Kibong, Yi Wonkon, Lee Yoonku, Yi Insoo, Chang Hwajin, Cho Duckhyun, Choi Gwangcheon, Choi Byeongmin, Choi Insu, Choi Hyogeun, Hyung Jinsik, Hong Myung-seop, and Hong Hyeonsoo.

15 "Museum" held their inaugural exhibition at the Kwanhoon Gallery in February, 1987. Invited members included Koh Nakbeom, Noh Gyeongae, Myeong Hyegyeong, Lee Bul, Jung Seung, Choi Jeonghwa, and Hong Sungmin.

16 Refer to the following for a brief introduction to new generation art: Yoon Jinsup, "Sinsedae misul, geu banhangui sangsangnyeok" [New Generation Art, Their Rebellious Imagination], *Wolgan Misul*, August 1994, 149–160.

17 This article does not touch upon the small collectives that participated in the Minjung art movement. Reality and Utterance, Imsulnyeon, Gwangju Free Artists Association, Dureong, Ttang and other small collectives did have slightly different ideologies but they formed the core body of Minjung art in terms of aesthetics, method, organization, strategy and other causes of Minjung art.

18 Park Hyunki, who created video art from 1977, and is known as a pioneer of video art in practice in the Korean art field, began to employ video as his primary medium after watching Paik Nam June's *Global Groove* at the Daegu American Cultural Center. Yi Wonkon. "Bakhyeongiui 'bidio doltap'e daehan jaego: Jakgaui yugoreul jungsimeuro" [Reconsideration about Park Hyunki's Video Totem Pole—Focused on the Posthumous Papers of the Artist], *Journal of Basic Design & Art* 12, no. 1 (2011): 453.

19 Kim Kulim, Kim Deoknyeon, Kim Soun-Gui, Kim Youngjin, Park Hyunki, Lee Kangso, Chang Hwajin, and Choi Byungso began to use video and movie cameras in their works in Korea and abroad, and eventually the term "video art" started to appear on the pages of artists' catalogs and daily papers. However, there were little to no critical reviews of their media works in the Korean art world. The works of these artists at the time appropriated the visual grammar typical to films and art into unique video imagery to express lyricism or address cognitive changes caused by the development of media technology. Refer to the following for more related information: Lim Shan. "Maengnakgwa gwangyeui gallae: 1970–80nyeondae, baengnamjungwa hangugui bidio ateu" [Strands of Context and Relation: Paik Nam June and Korean Video Art of the 1970s and 1980s], *Korean Video Art From 1970s to 1990s*, exh. cat. (Gwacheon: MMCA, 2019), 231–254.

20 Tracy Min, "Hanguk midieo ateuui chogi damnon yeongu: 1960nyeondae buteo 1990nyeondae kkaji yongeoui byeonhwareul jungsimeuro" [A Study on Initial Discourse in Korean Media Art—Focused on the Change of Terms from the 1960's to 1990's] (master's thesis, Kookmin University, 2014), Chapter 4 was referenced on the media art practices of small group member artists in the 1980s.

21 Artists who participated include Kim Youngjin, Kim Kwansoo, Kim Jangsup, Kim Yong-Ik, Kim Heeseung, Noh Sangkyoon, Moon Beom, Park Dooyoung, Park Jungwhan, Park Eunsoo, Park Hyunki, Byeon Jongsoon, Shin Okjoo, Oh Hyeongtae, Yook Keunbyung, Lee Kyojun, Rhee Kibong, Yi Wonkon, Lee Hoon, Chun Kwangyoung, Jeong Deokyoung, Hyung Jinsik, and Hong Myung-seop.

22 Among the 1980s Minjung artists, Sung Wan-kyung, Lee Taeho among others used images from popular magazines or advertisements to critically analyze and challenge the commercial visual culture of industrial society, and the authoritative artistic norms.

23 "Computer Art," *Misul Segye*, August 1988, 34–48; Bang Geun-taek, "Computer Art and Computer Graphics," *Misul Segye*, August 1989, 88–96

24 "Composite Group of Artists Staging Computer Art Show," *Korea Times*, January 16, 1985, 6.

25 Featured artists include Kang Sangjung, Park Hoonseong, Lee Kanghee, Yi Wonkon, and Ha Youngsok.

26 Featured artists include Kang Sangjung, Kim Jaedeok, Kim Hyeongtae, and Song Joohwan.

27 Featured artists include Kang Sangjung, Ghim Eonbae, Gum Nuri, Seo Donghwa, Shin Mingyu, Shin Jinsik, Oh Inseok, Lee Gwangyeol, Lee Taeyeon, and Ha Dongchul.

28 Chang Sukwon, "Seolchimisurui sae gungmyeongwa wigi" [New Developments and Crises of Installation Art],

Misul Segye, June 1987, 51–55.

29 This is not an evaluation of their installation works, but
 a comment about whether the term "installation art"—
 that has been used to account for the small "ex-modern"
 groups—is used properly after closely examining its
 conceptual roots and artistic value or misled as a simple
 rhetoric that only described the external features of the
 artworks.

The Development of Contemporary Photography: Media Experiments and Diverse Perspectives

Song Sujong

The beginning or the turning point that marked the inception of what could be called contemporary Korean photography remains debatable. However, the key is when significant internal or external forces emerged to trigger a break with the past. In this sense, the post-Korean War era can be said to be the most decisive moment of transition in the history of Korean photography. Practitioners moved away from the past and sought new approaches to rethink the specificity of photography. "Everydaylife realism" (saegnwhaljuui), a concept mainly developed by Limb Eungsik, refers to a type of realist concern that advocated for a new age of photographic art, emphasizing that photography is specifically suited to the task of capturing the detail of everyday life. Calling the pictorial photography that was taken during the Japanese colonial period 'Salon Photography,' the artists of this group ignored it as a legacy of the old era.

Although the everydaylife realism made a valuable attempt to depart from the pictorial mode of the photography of the past, it stopped short of formal elaboration. The practices of the Modern Photography Society throughout the 1960s are meaningful, particularly with regards to the efforts of the collective to overcome the narrow scope of photographic realism, produced under the heavy influence of the realist concern. Sponsored by the collective called Salon Ars, the Modern Photography Society supported realism but simultaneously attempted to develop the artistic nature of photography. While the members of Salon Ars— mostly older and more experienced artists—trained and led a group of thirty young photographers in the Modern Photography Society as an independent branch of Salon Ars, they co-hosted exhibitions and symposiums, and both groups influenced each other fraternally. As its name suggests, the Modern Photogrpahy Society studied and critiqued contemporary works in its journal titled Sa-an (alternative views) to forge new directions for contemporary photography, and hosted regular exhibitions as a part of its collective practice.

Several young artists established their careers through the practices of this group. Joo Myungduk held his first solo exhibition in 1965, a year after he joined the group. In 1966, Park Youngsook started her professional career by holding her first solo exhibition, which was recorded as the first female photographer's show in Korea. Jeon Mong-gak developed a theory on radical realist photography while he was in the Modern Photography Society and Salon Ars. Based on his philosophy, Jeon published the photography art book Yunmi's Album, narrating the photographic history of his eldest daughter from her birth to her wedding. This ultimately brought Jeon widespread recognition.[1]

Hwang Gyutae participated in the activities of the Modern Photography Society before moving to the United States in 1965. Here he began to undertake progressive formal experiments, as the consumerist capitalism and speedy development of science and technology in American culture particularly stimulated him. He pushed the boundaries of the photographic form with the question 'Should photography only be photography?' The results of his rebellious experiments were shocking and replete with uncommon imaginative detail, staying deliberately free of melancholy or negative content. In the work Untitled (1970) 1 , Hwang portrays a surreal scene in which an owl appears to be driving a red sports car. His was an entirely new form of photographic expression and gained such wide recognition that it was published in the American magazine Popular Photography (February 1974). In his practice Hwang used multiple exposures in a darkroom to represent the world of fantasy through the medium

1 Hwang Gyutae, *Untitled*, 1970,
Digital chromogenic print on paper, 100×80 cm

of photography. His work sought to mediate between the unstoppable progression of American automobile culture and the society's anxiety over such unruly technological development.

Hwang also broke away from the tendency to treat film itself as precious. Instead, he experimented with the materiality or physical properties of film; for example, he scorched the film before printing on it. He perceived the aesthetic value of color photographs and used them in his artwork in an experimental manner, testing the limits of photography. In this sense, he can be unhesitatingly labelled as a "pioneer of Korean avant-garde photography."[2]

There is no doubt that many photographers were overtly biased toward the idea of life-ism realism, and realist concerns clearly continued to impact the history of Korean photography. "Since the 1970s, the idea of realism has directly or indirectly affected the practice of photographers whose top priority was documentary and archival work. As a result, such concerns constituted a substantial part of the subsequent development of Korean photography."[3] This is the most fundamental and, thus, most important contribution of realism to the history of Korean photography, as it

established the new cultural context of Korean photography. In this new context, we can applaud Joo Myungduk and Kang Woongu for their refusal to apply for institutional competitions and their success in overcoming the stereotyped forms of realism throughout the 1950s and 1960s. While Chu and Kang demonstrated different styles in their works, they both escaped the dramatic visual elements of the past, and suggested a new style of realism established on a refined perspective and visual form.[4]

The 1970s witnessed a peak moment for governmentally driven, nationally planned, economic development of Korea. This new era demanded more from photography, which had been confined to a role of recording and documentation. In offering his interpretation of the 1970s, Yook Myoungshim, a photographer and first-generation educator of photography, remarked: "The previous decades' photography movement toward realism was a transition from pictorial visuals to the perspective of the camera's eye, which restored the quality of photography. [But] the recent images have has further investigated the potential of optical vision and developed the mechanical diversity of photography."[5]

FROM THE EMERGENCE OF A NEW GENERATION TO THE ADVENT OF DIGITAL TECHNOLOGY

The mechanical diversity of photographic practice came to be explored even further and combined with other forms of visual art in evermore varied ways in the 1980s. These changes developed rapidly. An issue of *Gyegan Misul* (Spring, 1983) focused on the relationship between photography and art. In one of the four articles, Kang Woongu examined the new trend in which photography deviated from its prescribed role in documenting the real world and increasingly experimented with diverse forms. He predicted that this trend would tear down the barrier between photography and art, creating an entirely new genre. However, Kang's analysis was limited to cases in the West where the history of photography was long enough to allow for radical formal experiment, whereas the temporal history of Korean photographers' formal experimentation was arguably not long enough to engender the new genre of which he spoke at that time.[6]

Five years after Kang Woongu wrote that article, however, the photographic experiments that had been observed in the West began to occur locally within Korea. Globalization and the opening of international trade not only transformed the landscape of Korean art but also caused seismic changes in the role of photography as a medium of representation. Especially in 1988, when the Seoul

Olympics took place, many important transitional moments in the history of contemporary photography transpired. Among them, the exhibition *The New Wave of the Photography*, curated by Koo Bohnchang at Walker Hill Art Center, signaled a dramatic shift in the era.[7] Trained in photography in Germany, Koo recognized distinct cultural differences when he returned to Korea in 1985. For instance, European photographers focused on the idea of the artists' subjectivity, and the formal diversity of their work, whereas many Korean photographers still regarded photography's documentary quality as the essence of the medium. In addition, this period coincided with the homecoming of a new generation of photographers who had studied in the West due to the new national policy of issuing travel visas for overseas studies in the 1980s. Eight such artists participating in this exhibition therefore attempted to broaden the boundary of photography by experimenting with the diverse qualities of the medium. For instance, Lee Kyuchul rendered three dimensional works using photography, and Kim Daesoo incorporated a drawing technique on photographic paper.

The New Wave of the Photography provided the involved artists with an opportunity to apply their international experiences to the notion of the contemporaneity of art. However, this show could not fully demonstrate to the wider Korean art world why it was essential that contemporary art turn its attention to photography. Instead, this breakthrough occurred when another exhibition called *Contemporary Art From New York* held at Ho-Am Art Gallery and Gallery Hyundai in the same year, illuminated the role of photography in contemporary art. This was the first large-scale contemporary art exhibition to showcase the works of preeminent American artists, including Roy Lichtenstein, Andy Warhol and Robert Rauschenberg, in one place in Korea. It also embraced the works of visual artists who actively used photography as a medium, such as Lucas Samaras, Nan Goldin and Cindy Sherman, thereby presenting photographic works under the title of 'contemporary art' to the Korean public. This exhibition constituted a critical moment in which the traditional sense of genre categorization was being deconstructed, and some artists realized that it was difficult to represent the complex social issues of that time, including gender, race and cultural identity, by only using a single medium. Thus, they started to use photography as a preferred medium, due to its great potential for expressive flexibility.

The exhibitions *Mixed Media* (Kumho Gallery, 1990) and *Art and Photography* (Hangaram Art Museum, 1991) focused on the post-media tendency in contemporary art, and actively embraced photography within the field of visual art. In particular, *Mixed Media* was composed of three parts: photography, 3-dimensional work and installation. The first part included photographers, such as Koo Bohnchang and Kim Daesoo, and artists who had used photography in their artwork, such as Sung Neungkyung, Choi Jeonghwa and Park Buldong. By doing so, the exhibition explored the potential of breaking down the borders between genres and using diverse media appropriate to the artists' subject matter.

In addition, museums or galleries hosted large-scale exhibitions that presented the power of contemporary photography. Among others, the *Horizon of Korean Photography* exhibition held crucial significance. The curatorial idea of this exhibition was to deconstruct the hierarchy between senior and junior artists and thus open a "horizontal" platform upon which any artist could participate and diversely showcase the utilization of the media. *Horizon of Korean Photography: November* opened the first chapter of the exhibition at Total Museum (Jangheung, 1991), and two more shows including the one at Gongpyeong Art Center (1994) followed. These three exhibitions introduced a total of 150 local and international artists, constituting a "critical point in contemporary photography." Indeed, this new attention within Korea was inclusive of both the local and international scenes of contemporary photography, and it expanded the idea of the genre to include painting, sculpture and installation that used photography as a medium.[8]

In the 1990s, the expansion and growth of visual and pop culture naturally provoked the further revitalization of photography. The new generation, which had grown up during the emergent height of television in the 1980s, amid a rapidly changing visual environment, used the instantaneous and replicative quality of photography to express the questionable and quotidian sensibilities of popular culture. Photography entered into the depths of our daily lives, not as an instrument for the creation of completed images or the expression of serious subjects, but as a media orientated toward visual playfulness, based on its capacity for image reproduction and synthesis.[9] Of course, the flood of images did not influence subcultures alone. The public, which had become familiar with such images of popular culture, simultaneously developed a taste for higher qualities of images and subsequently began to desire much more sophisticated visual forms, such as high-resolution large-format print images. In this context, photographers needed to apply high-quality technology to every process to create superior and sophisticated imagery. Correspondingly, the new high-quality images also meant high-priced images as artists required greater financial capital for

production. Due to Korea's rapid economic growth and the emergence of digital technology, the social environment speedily transformed into a spectacle, which accordingly, prompted a flood of large-format prints and color images.

In this changing socio-cultural atmosphere, the '93 Whitney Biennial in Seoul (MMCA) and the first Gwangju Biennale in 1995 both allotted large portions of their exhibitions to new media art including photography, which consequently provided a further opportunity to reconsider the position of photography in contemporary art. And, just as the IMF crisis in 1997 caused a violent shock to the Korean economy and greatly increased social problems like the unemployment rate and the homeless population, a new cultural situation—an opportunity for photography—was created. Due to the economic recession, the art market that had usually dealt with expensive artworks turned its eyes to the relatively underrated genre of photography, which instantly became a blue-chip commodity. During the economic boom of the 1980s, Korean photographers had mainly worked toward outcomes in print. However, as the publishing market grew stagnant, they shifted the axis of their work activities to center around museum or gallery exhibitions.

As more researchers examined the potential and value of technology and its application to art, experts in photography explored an increasingly heated range of debates on the vision and future direction of photography. During the formation of the contemporary photography of Korea, some had maintained that realism (the mainstream of contemporary Korean photography) was the essence of photography, while others had pursued new formal possibilities for photography based on the artist's thematic consciousness. The exhibition *The New Wave of the Photography* renewed this conflict into a new form of debate on the idea of the created photograph versus the captured one, ensuing a need to extend the critique and discourse on photography.[10] The quarterly journal *Sajin Bipyung*, published by the first-generation photo critic Kim Seung-gon, has been widely understood as a practical attempt to overcome the poverty of philosophy in Korean photography. It was the first theoretical quarterly on Korean photography, and a total of fourteen issues were released. It contributed to opening the door to deeper discussions on key subjects in the Korean history of photography, extending new theoretical approaches that viewed concerns from innovative socio-political and aesthetic perspectives, and discovering new photo artists and critics through events like the Photo Critics Award.

By the end of the 1990s, there were photography departments in about forty universities and junior colleges across Korea. It was the era of a renaissance in photography. During this period, theorists and critics who specialized in photography emerged to wider cultural significance. Lee Youngjune, who majored in Aesthetics and Art History, argued that photography is, primarily, a mechanical method of recording the world. Breaking the conventional idea that had confined photography within the framework of documentation and aestheticism, Lee dismantled the various walls within the genre of photography to that had divided photographic practice into categories for optical, medical or documentary purpose.

Around the time of the 2002 FIFA World Cup in Korea and Japan, Korea witnessed the accelerated importation of high-performance digital cameras. This generated skepticism about the traditional value of photography, the idea of 'truth' endangered in the era of digital processing. On the other hand, the emergence of digital technology along with the spread of the internet contributed to the increase of an interest in photography within the general populace. Around this time galleries experienced huge success with photographic exhibitions of internationally renowned artists, including Magnum Photographers, which proved that photography could serve as the basis for blockbuster exhibitions that were as popular as those of Impressionist painting. These cultural shifts encouraged experts to host large-scale photo festivals. The DongGang International Photo Festival was launched as the first of these in 2002 and the Daegu Photo Biennale followed in 2006. Moreover, the establishment of photography museums also ensued. In 2004, the first such institution, The Museum of Photography, Seoul and the first publicly funded photography museums, Dong Gang Museum of Photography was established in 2007.

From the mid-1980s, when the contemporaneity of Korean photography came into focus, to the 2000s, the era of digital cameras, artists of the time pursued a variety of possibilities for their works. These were as diverse as the internal and external factors that operated behind the scenes to drive the general changes in photography. Nevertheless, despite the individual artists' wealth of approaches to their styles, we can subsume the variations that emerged during this period into two branches: the investigation of the essence of the medium and the question of how to capture the reality of Korean society through the camera lens.

FORMAL EXPERIMENTATIONS: TAKING PHOTOGRAPHS AND MAKING PHOTOGRAPHS

Koo Bohnchang is one of the most regularly referenced Korean artists in contemporary

photography. In Germany, where Koo studied during the 1980s, a new method of subjective expression called "New German Photography" was preeminent. Under this circumstance, he presented works that reveal his unique sensibilities, representing his dreams, fantasies, feelings of solitude and emotional void within a neat and simple formal frame. When his mother passed away in 1985, he created a series titled *One Minute Monologue.* In this work, he included a total of twenty-five photo works of four collaged color photographs that visually reflect the past or evoke death, thereby addressing his thoughts on existence, memory and evanescence in a concentrated way. Having immediately returned to Korea in 1985, Koo focused on the rapidly changing cityscape of Seoul, the altered living environment of his own home, and the sense of loss, especially in relation to the death of his parents, as the main subjects of his work. Moreover, in *One Minute Monologue,* he also delved into the internal world of individuals based on his own experiences. Likewise, *Clandestine Pursuit in the Long Afternoon,* a black and white series created between 1985 and 1990, reflected his inner world by projecting it through the lens of the other side of the city and other people. He combined visual ideas of time and space with the objects situated inside of such chronotopic contexts, provoking both notions of harmony and tension relative to his subject matter. In this manner, Koo used photography as an instrument to represent his own feelings and ideas, instead of to reproduce the sheer façade of reality.[11]

Around 1990 when Koo was finishing *Clandestine Pursuit in the Long Afternoon,* he began a new project on the human body. Among the works in that project, *In the Beginning* (1991–98) was the most quintessential series. Whereas his previous works were rather metaphorical and symbolic, the subjects of this project and those that followed were directly portrayed in a blatant fashion and accordingly the series conveyed far a more intense body of messages.[12] For this work, he created large-scale photographic paper by stitching small sheets together and used this to represent the male or female body. The end result engaged with instinctual anxiety and the essential meaning of existence. For his 1996 piece titled *In the Beginning 10-1,* he took pictures of his own hands and feet, printed those images on four separate sheets of papers, and then stitched them together to create one larger piece of work. [2] He explored his own existence as a human being through these layered patches of paper, joined by long threads stiches that remained exposed at the edge of the photographic paper, creating an object that serving as a metaphor for the scars of life that are inflicted from the beginning of time.

Grounding their studies on the idea that

the camera lens functions as an extension of the human eye, some artists such as Lee Kyuchul researched the subject of visual perception through photography. Trained in sculpture, Lee Kyuchul investigated the profound concept of "seeing" itself, through converging experiments on sculpture and photography. For his first solo exhibition *Space and Visual Perception* (Kwanhoon Gallery, 1988), he constructed a three-dimensional space by using two-dimensional photographs to speculate on new visual-perceptual experiences and the meaning of the spatial representation within two-dimensional images. Lee's untimely accidental death in 1994 prevented the further development of his experiments, yet it is undeniable that he approached and dealt with photography as a unique medium and influentially explored the philosophical possibility of the medium.

Coincidentally, Gwon Osang, is the alumnus of Lee Kyuchul, also merged his practice in sculpture and photography, albeit in a somewhat different way from Lee. Since his college years, Gwon had sought a light material to handle with ease and eventually came across isopink, a compressed form of Styrofoam insulation. He first photographed every single part of the human body from head to toe, 360 degrees, and then attached the printed photos to life-size human forms made of isopink. This extraordinary method was received as most remarkable in his early series titled *Statement,* as he had created each piece by collaging hundreds of photographs. For example, for the work *A Statement of 420 Pieces on Twins* (1999), he produced a life-size twin-headed figure by wrapping it with a total of 420 photographs. By doing so, he tried to overcome the limited viewpoints common to both photography and sculpture and suggested the potential of new material properties relative to both disciplines. [3] During the processes of transforming the three-dimensional body into a two-dimensional print and then converting it into a life-size three-dimensional sculptural form again, he called the gap between real and fabricated imagery into question. He named this method of his work *Deodorant Type,* which is a compound phrase of that pertains to the categorization of photographic techniques based on chemical processes. In choosing this title for his work, Gwon suggested the dilution of the static traditional ideas of genre practice, while clearly denoting that his work was an extension of (the chemical process of) photography.

In the same year that Koo Bohnchang curated *The New Wave of the Photography,* Lee Gapchul established himself as a creative documentary photographer through his solo exhibition *Land of the Others* (1988). Under the social circumstances of Korea at that time, he was frustrated with local politics the illusion of economic progress. Though

2 Koo Bohnchang, *In the Beginning 10-1*, 1996,
 Gelatin silver print on paper, cotton, thread, 177×480 cm

he did not disregard the reality of the social situation, Lee attempted to move beyond the idea of documentary as a record or archive. Instead, he aimed to maintain a certain distance from the existing realist tendency of photography, which fixated on sensational subjects or events. In his alternative style, the photo scenes that he captured while traveling across the country look random, out of context, unfamiliar and fragmented, yet in combination they possess a breathtaking flow like a diorama, which fleetingly reveals this precise historical period of Korea.

In the work *Conflict and Reaction*, one of his most representative series of work, undertaken from 1990 to 2001, Lee reveals that he did not persist with documentary work for 'documentary's sake.' In his photo of the two old men with somebody else's hands captured within the frame— presented in the 1990 Youngdeok Big Haul Ritual Festival—he strove to represent the psychological state or vitality that extended beyond the immediate indicative meaning of the image. ⎯4⎯ In this uncanny work, the old men seem to face the beckoning sign of a spirit, or the waving hands of the deceased. We cannot determine the identity of the person whose hands are out of focus, so this uncertainty brings about a sense of anxiety or a feeling that something ominous may occur. Even though no determinedly clear event is taking place in this image, the off-kilter diagonal line of the ocean horizon accelerates the precipitous sensation.[13]

Lee dealt with a variety of subjects including

3 Gwon Osang, *A Statement of 420 Pieces on Twins*, 1999,
 Chromogenic print on paper, mixed media, 190×70×50 cm

4 Lee Gapchul, *Good Haul Ritual, Yeongdeok*, 1990, Gelatin silver print on paper, 50.8×40.6 cm

landscape, found objects, people and animals, always representing them within the frame in his own manner. He publicly exhibited his works in this style for the first time in the *Conflict and Reaction* show at the Kumho Museum of Art in 2002. The early 2000s witnessed the rapid spread of digital cameras. In this new phase, photographers held high expectations for the creative possibility of digital photography's diverse editing techniques such as collage and montage. On the contrary, however, Lee persisted with the traditional mechanical operation of cameras, pursuing subjective documentary aesthetics through black and white photography.

IDEOLOGICAL VISUAL DEVICES AND THE WAYS OF SEEING

Photographers at the turn of the century studied the ways in which the meaning of objects (as referents) changes in different contexts. They were keenly aware that photographs are not actually the most objective documentary mediums for capturing reality. Both as photography only captures what is seen through the camera lens, and because there are more conceptual limits to its representation, as it can convey only the meanings of objects or situations dependent on the different socio-political contexts of its display and creation. For such

critically orientated artists, photographic practices offer a way to reveal the medium's limitations and incite the viewers to doubt the visual world that we experience.

Chung Dongsuk had intensely examined the relationship between visuality and photography before contemporary artists actively used this medium in their art. He was the only photographer amongst the founding members of Reality and Utterance, which was established in 1980 to call for the social role of art and artists' direct engagement with issues of real life. From 1983 to 1989, he captured landscapes on both the east and west coasts of the Korean Peninsula and at the DMZ (dematerialized zone). What he captured in these photos were not mere documentary images of the landscape. ⁵ Not least as his images were not the typical outcome of capturing a landscape within the frame in a traditional manner, nor overly concerned with creating a 'beautiful' aesthetic effect. Instead, they bring into question the ways in which the military facilities and boundaries create our visual environment and intervene in our visual systems of social understanding.

He took those scenes inside a driving car from a distance. Such a nonchalant attitude toward his subject matter served to expose the oppressive nature of the situation secretly, as the military facilities did not permit the photography of the area around their installation. The images that he created are scenes that are so familiar and banal that they even leave an impression of boredom on the viewer. In one way, the viewer cannot sense any ideological tension in the bland photos; rather, these ostensibly neutral scenes, full of mere traces of the division of the peninsula, invoke an uncanny and strange feeling in the viewer, which provokes a new

perception of the ideological reality more strongly than any more sensational methods could arguably achieve. Ultimately, for Chung Dongsuk, the Korean landscape itself is 'nature' or a natural 'object,' that is under surveillance, dominated and demarcated by military facilities—facilities essentially related to the destruction of nature and human civilization— and therefore something that "culture" tames and objectifies in the name of "nature."¹⁴

In 1983 (the year when Chung Dongsuk began the *Anti Landscape* series), a senior college student Kang Yongsuk entered a night club exclusive to soldiers in the American Army base in Dongducheon while disguised as a souvenir photographer. During his year-long stay in the region, he took photos of American soldiers and Korean women couples in a pop or even kitsch style, creating the images of *Dongducheon Commemorative Photograph* (1984). ⁶ At first glance, they are all typical commemorative photos of couples gazing at the camera lens. However, the highly saturated color photos emphasize the stark contrast between the different skin colors of the sitters; furthermore, the flamboyant look of the women and extra-ordinary interiors create an indelible imagery of awkwardness, reminding us of the darker aspects of the period when the American dream was a destitute woman's last hope. Afterwards, Kang continued his works on the division of Korea in *Scenes from Maehyang-ri* (1999) a work that was acclaimed for its new formal style, which was completely different from the traditional style of documentary photography used in *Dongducheon Commemorative Photograph*. This new project shows the topographies and landscapes of the small village of Maehyang-ri on the west coast of Korea and a nearby farming island. In these black and white

5 Chung Dongsuk, *Anti Landscape 839-39*, 1983–89, Digital pigment print on paper, 100×150 cm

images, he significantly decreased the brightness and the degree of contrast in an attempt to maintain an objective view on the ideological traces and tensions of war that still remained in place.

Noh Suntag has been especially sensitive to the malfunction of the divided nation. For him, the lunacy of the North Korean regime, and South Korea in turn, internalizing rabid anti-communism, militarism and state sanctioned neoliberal violence merely serves to render each state a reflection of the other relative to wider malfunctioning national order of the peninsula. He conceived that the problem was the invisibility (or intangibility) of that mal-functionality, and in this respect, his work attracts attention for its visual completeness and the manner of humorous distortion he presents while addressing socio-political issues. *StrAnge Ball* (2004–2007) is one of his signature pieces, that served to put him in the critical spotlight. ⁊ This work began when he attempted to discover the mysterious purpose of a large-scale radar dome placed in the American army base in Daechu-ri, Pyeongtaek—as even the residents did not acknowledge the dome's presence. In this work, he follows the stream of visual pleasure elicited from the varying images of the dome, which looks like either a moon or a golf ball, depending on the distance or perspective from which it is viewed. However, by combining his visual humor with the peaceful farm-scape and the nervous scenes of those protesting against the building of an American military base in the region, he prompted the audience to recognize the ball (or dome) as an ominous entity, provocative of curiosity and tension. Here, the value of Noh Suntag's work lies in its power to explore the serious issues of our society, including politics, labor and Korean national division, by merging them with everyday matters so that viewers can identify with such issues more closely.

Another quality of Noh's practice is that he has never stopped delving into the social role of photographers through ceaseless self-reflection over the process of "capturing" or "shooting" photos, as an act that involves unavoidable elements of voyeurism and irresponsible hypocrisy. In 2014, the MMCA awarded him the Korean Artist Prize for the work titled *Sneaky Snakes in Scenes of Incompetence*, which dealt with the photographers who hunt down various social incidents and events as the subjects of their work. The title, "Scenes of Incompetence" refers to the cruel yet inevitable situation of our reality, while the "Sneaky Snake" indicates the sly characteristics of photography, which has a shorter history than other artistic mediums but wields perhaps the most sensational social power. Noh, who began his career as a photojournalist, has continued to focus on field-oriented work throughout his practice. However,

6 Kang Yongsuk, *Dongducheon Commemorative Photograph-1*, 1984, Chromogenic print on paper, 50.9×32.8 cm

by blurring the border between archival or documentary and artistic photography, the artist has kept questioning the role and meaning of the very act of taking a photograph, thereby expanding the creative boundaries of photo aesthetics into the matter of ethics.

THE REDISCOVERY OF LANDSCAPE AND SOCIAL LANDSCAPE

As conveyed in the title of Noh Suntag's work "Scenes of Incompetence," landscape is a subject that photographers address in their work most widely. Here, the idea of 'landscape' encompasses all possible visual phenomena taking place within the 'real' world. Ironically, people rarely use this term to indicate the natural landscape, which is the most fundamental meaning of the word. This is perhaps because the pictorial photography of the past, which mainly sought to represent somewhat bucolic natural scenery, has become a stereotypically problematic genre that contemporary photography must serially overcome. Kim Jangsup, who had been a member of the art group Space and Time Group (ST), has dedicated himself to photographic practice since the 1990s and thereafter, he has established a unique form of his own by combining photographic

7 Noh Suntag, *StrAnge Ball*, 2004–2007,
Pigment print on paper, 50.6×76.6 cm (10)

techniques with the traditional literati ink painting of the Joseon Dynasty.

His photographic landscape does not merely seek to frame the beauty of nature but rather explores the conventional ways of dealing with the landscape. **8** In familiar rectangular or square compositions, he juxtaposes continuous shots of the same scenes vertically or horizontally to present the subtle changes of the landscape—the mobility of the landscape—in temporal and spatial dimensions. This process is also a self-reflection on his own work. Indeed, he exposes the materiality of photography by including details such as the film manufacturer, type and number visually on his prints. These "contradictory elements" function as the determining factors or codes of his own style. Through this approach, Kim attempts to objectify his own practice, while maintaining a certain distance from the subject or the work. That is, he subscribes to the specificity of the photographic medium but recontextualizes his work through formal apparatuses and, as a result, detaches the idea of photography from the practice

of photography itself.[15]

Kim Jangsup did not limit his engagement with the issue of landscape to his own work but expanded it into a collective concern by establishing a photographers' group named DaeDongSanSu, which aimed to visualize Korean geography not in the form of paintings or maps but in the form of photography. Based on his early experiences as a member of an artists' group, he believed that a group activity could offer a productive approach supporting a new photographic movement. DaeDongSanSu inherited the empirical and pragmatic ideas and attitudes of Kim Jeong-ho (a Joseon-era cartographer who created the map of Korea called "Daedongyeojido") and Jeong Seon (a "true-view" landscape painter of the Joseon Dynasty). The group members here attempted to realize their ideas in the contemporary context, and they presented their ideas within nine exhibitions held over ten years. Through the group's activities, although many members joined and left, the main members, including Bae Bien-u, Park Hongchun and Lee Joohyeong, provoked a radical change to Korean

8 Kim Jangsup, *Beyond the Landscape—Anmyundo II*, 1997,
Cibachrome print on paper, 101×145 cm

landscape photography and also critically addressed the changing landscape of the nation throughout the decade.

Since the 2000s, artists have attempted further diverse new ways of observing and interpreting urban spaces. Artists have integrated explorations of spatial issues as a socio-cultural concern and developed new perspectives on urban space not from a humanist (or realist) viewpoint but from a neutral depiction of 'living conditions.' In this context, an interest in the city itself as a rapidly shifting visual apparatus further gave rise to new approaches to recording and creating images of the cityscape.

In particular, Kang Hong-goo paid attention to the physical transformation of the cityscape brought about by the urban redevelopment boom at the turn of the century. He began this project with *Greenbelt* (2001), which represented the scene of a greenbelt area that remained on the periphery of urban space, but was on the verge of destruction due to reckless development policies. Since then, he has captured further bizarre situations in the

suburban areas or outskirts of the city, where the logic of development combines with the brute force of capital. In these images, Kang incorporated his own unique cynicism and humor to a kitsch style. His subjects are sloppy, trivial and insignificant. He dubs himself a 'B-level' photographer. This self labelling is not just a mere expression of his humility but a manifestation of his disinterest with formal completion. The simple mechanical operations of the camera help him to observe the black comedy so apparent in everyday life.

For the *Mickey's House* series, Kang took pictures of a discarded toy house found on a redevelopment site, placing it in several different locations on the site. In creating the final images, he employed a form of panorama by splicing digital photographs together horizontally, leading the viewers' eyes not the major subject 'events' within the image, but to the small objects and trivial elements that were affected by such events. In this regard, the toy house placed upon a fence or in an empty room just before its demolition speaks to people's essential hope for shelter, which is often left unfulfilled. The

demolished wall of an old house lies in the midst of the development site of the large apartment complex. In *Mickey's House—Clouds*, a small toy house sits in front of a panoramic view of Bukhansan Mountain, and one cloud floats in the sky as if it were the symbol of a utopian landscape. 9 On that site, which was due to give way to a grandiose apartment complex 'with a splendid view,' Kang depicts the unwavering or increasing development of the city as a surreal urban landscape, or a clichéd visual joke.

REALITY AND FICTION:
AN EXAMINATION ON IDENTITY

Majoring in film and photography, Oh Heinkuhn has concentrated on portraiture throughout his career. In his work, we can sense certain ideas of ambiguity and anxiety, particularly about identity. Oh Heinkuhn grew up in Itaewon, a town containing many complex cultural elements, with an immense American military base at its center. The biographical background of his younger years spent in this unique area influenced the markedly peculiar atmosphere permeating his images. For instance, *Cosmetic Girls* shows the face of a teenager; with a touch of makeup, the face appears to be dreaming about achieving the freedom of adult life,

but simultaneously is clearly that of a youth 'under eighteen.' *Middleman* touches upon the identity of a soldier, who, though an adult, is alienated from the general social boundaries of everyday life. In this respect, Oh's works often deal with groups of individuals isolated from the general public, or outsiders standing on the periphery. For these reasons, in his portraits, the outfits or bodily attributes of the people depicted seem to signify their socio-cultural positions accurately, but, in fact, they cause the viewers confusion, something that provokes them to question the stereotypes associated with these figures.

The *Ajumma* series is the representative work that served to inscribe Oh's artistic style in the minds of his audience. Here, he drew public attention by visualizing a group or a class of "*ajumma*." This term was originally a noun that pertains to the general collective idea and fact of middle-aged married women in Korea. However, in Korean society, the idea of ajumma often refers to a practical social subject who, with no specific title, actually leads an active social and professional life within various fields from real estate to education, and, as such engages highly productively with the national economy. These works are also related to the social atmosphere of the 1990s when people started to pay attention to cultural diversity.

9 Kang Hong-goo, *Mickey's House—Clouds*, 2005–2006 (printed 2014), Digital pigment print on paper, 90×259.4 cm

DEMOCRATIZATION AND THE PLURALIZATION OF ART

However, Oh Heinkuhn took one step beyond this general cultural trend, as he not only captured the visual commonalities and almost stereotyped images of ajumma, but also distorted the common conventions of this group by drawing out the individuals' unique characters while simultaneously cloaking them with the garb of anonymity. For this effect, he shot fake candid scenes that appeared as if he had randomly casted the person on the street; while in fact, he had carefully selected the time and space and carefully orchestrated every detail of the shoot. For example, *Ajumma Wearing a Pearl Necklace* shows the typical image of a middle-aged woman wearing a luxurious necklace. However, the artist does not provide the viewer with any objective clues about the real individual, such as the name of the person. **10** Likewise, "Their outlook demonstrates their wealth or social class, but their gaze unfulfilled aspiration and desire, [something which] ultimately reveals the 'lack' of everything."¹⁵ These anonymous figures, suddenly exposed in streets, detached from the residential areas and families by which they are mainly identified, portray the conventional and grotesque images of society holds up of individuals.

In her work, Yoon Jeongmee addresses the issue of gender identity from a socio-cultural perspective through the use of color codes. For instance, one

of her significant works is a piece entitled *The Pink & Blue Project* (2005–) in which she photographed rooms filled with items of children's favorite colors in the U.S. and Korea. **11** As the work progresses, it clearly reveals the female children's preference for pink and the male for blue. By re-shooting the same children at regular intervals, she examines the ways in which individual tastes are shaped over time by cultural stereotypes, social norms, and material culture.

Through his photographic practice Choi Kwangho dismantles the conventional form of the family photograph, deconstructing the notion of how these items are believed to document special moments of emotional intimacy, through an honest and radical approach to the genre. **12** For Choi, his family members are doubtless the object of his love, just as they are for most people. However, his way of representing the lives of his own family through the camera lens is far from concerned with the happy moments that we often expect and find in photo albums. For instance, in creating images of his parents, he focuses on the body of his mother, and her experience of the physicality of life, including through processes such as delivering children and aging. Through the photos of his grandparents' deaths and his father's funeral, he reveals the patterns of relationship that exist between families and family members as though they are the subjects of sociological research. He takes full advantage of the essence of photography as an archival tool, and aide-mémoire by appropriating his brother's photo to memorialize his sudden, untimely death and by revealing his daughter's physical changes through the process of her growth. In this way, he completed a visual chronology of his own family over a long period of time from the mid-1970s to the 1990s through various diverse forms of portraiture and document.

Kim Oksun deals with the issue of relationships starting from her own experiences and expands the boundary of her exploration by further addressing the experiences of others. Her work shares certain commonalities with the work of Choi Kwangho in terms that both artists attempted to dismantle the secrecy of private lives, when confined to private spaces. However, her work is distinct from Choi's with regards to its strict 'neutral' perspective as regards is subject matter. Her first work released in 1996, was titled *Woman in a Room*, and dealt with the subjectivity of life through presenting a series of images of nude women, gazing at the camera while situated in distinct individual rooms. This work attracted great attention due to its representation of sexuality, women's social positioning and the increased interest in the human body that critically dominated at the time. While her early works began from the question of her own identity as a woman,

10 Oh Heinkuhn, *Ajumma Wearing a Pearl Necklace*,
 1997 (printed 2000), Gelatin silver print on paper,
 45.5×45.5 cm

11 Yoon Jeongmee, *The Pink Project I—SeoWoo and
 Her Pink Things*, 2005, Digital chromogenic print on
 paper, 120.8×120.8 cm

12 Choi Kwangho, *My Family*, 1976, Gelatin silver print on paper, 20×20 cm

13 Kim Oksun, *Happy Together—Oksun and Ralf*, 2002, Digital chromogenic print on paper, 96×114 cm

THE DEVELOPMENT OF CONTEMPORARY PHOTOGRAPHY: MEDIA
EXPERIMENTS AND DIVERSE PERSPECTIVES

a later notable project entitled *Happy Together*, which was first presented at Art Space Pool, dealt with her identity as an outsider in Korean society, due to her international marriage. By investigating the lives of, for instance, international couples or homosexual couples, Kim raises the question of whether their "different" experiences stem from the gaze and perception of 'others,' wider cultural causes or their own individual characteristics. Through the artist's own concern with featuring specific conditions in her imagery, such the singular unique spaces common to her subjects, and their individualistic poses, her works reveal the individual tastes of the subjects and their cultural proclivities, which are rendered as entirely visual and typological information. Even in her self-portrait *Happy Together—Oksun and Ralf*, she objectifies herself, minimizing the subject's scoop for intervention in the work to maximize the power of the camera's gaze in photography. 13

Through this concern, it could be argued that Kim's works are "based on that old and powerful quality of photography, namely the 'composition of facts' as well as the awakening of people who come into contact with it. And the power of such photography is the driving force that enables the medium to acquire a contemporaneity that moves in parallel with the changes in the world."[17]

It has been over thirty years since contemporary photography significantly emerged in the Korean art world of the 1980s. Now, the twenty-first century has witnessed a proliferation of snapshot-based de-narrative photographs that are centered around social networking services. In this respect, the value and use of photography has become so widely open to interpretation that all the past decades' debates on the aesthetics and documentary value of photography seem meaningless. This contemporary circumstance of extreme and dynamic rapid image production, manipulation, and distribution in the digital age seems to render the silver print an obsolete medium. How will such changes in photographic practice continue to shape ideas of contemporaneity? As photography gains and maintains its contemporary value by reflecting the world's changes, there is no doubt that photography will continue to develop in response to numerous unpredictable creative experiments and the globally relevant questions they engender, as much as in response to the social and historical dynamics of Korean society.

1 Choi Bonglim, "Hyeondae sajin yeonguhoe gigwanji saanui modeonijeum sajindamnon bunseok" [A Study on Modernism Photography Discourses of *Sa-an*, a Journal of Modern Photography Society], *Hanguk sajin munhwa yeonguso jaryojip: Hanguk hyeondae sajingwa 'hyeondae sajin yeonguhoe'* [Korea Institute of Photography and Culture: Korean Contemporary Photography and 'Modern Photography Society'], no. 12 (2016), 29–30.

2 Park Sang-woo, "Hwanggyutaeui 1960–70nyeondae chogi sajin yeongu" [Study on Hwang Kyu Tae's Early Photographs in 1960–70], *AURA*, no. 37 (Seoul: AURA, 2016), 15.

3 Park Pyungjong, "Sallong sajingwa rieollijeum" [Salon Photography and Realism], *Hanguksajinui jasaengnyeok* [The Autonomy of Korean Photography] (Seoul: Noonbit, 2010), 41.

4 "Hanguksajingwa hyeondaeseong" [Korean Photography and Modernity], Ibid., 57.

5 Yook Myoungshim and Choi In-jin et al., *Hanguk hyeondae misulsa: Sajin* [The History of Korean Contemporary Art: Photography] (Seoul: MMCA, 1978), 176.

6 Kang Woongu, "Hyeondae sajin yesurui byeonmo" [Transformations of Contemporary Photography Art], *Gyegan Misul*, Spring 1983, 52–57.

7 Koo Bohnchang and Kim Seung-gon (discussion), "Sajin·sae sijwajeon ihuui hyeondaesajin 10nyeon" [Ten Years of Contemporary Photography since *The New Wave of the Photography* Exhibition], *Sajin Bipyung*, no. 1, 1998, 20–51.

8 Jin Dong-sun, "Hanguk sajinui bunsuryeong, Hanguk sajinui supyeongjeon" [The Watershed of Korean Photography: 'The Horizon of Korean Photography (November, 1991)'], *Hanguk hyeondaesajinui heureum* [The Contemporary Photography of Korea] (Seoul: Archive Books, 2005), 60–68.

9 Kim Hyeondo, Eom Hyeok, Lee Youngwook and Chung Youngmok, "Sigak hwangyeongui byeonhwawa saeroun sotongbangsigui mosaekdeul" [A Conversation on Visual Environmental Changes and New Ways of Communication], *Gana Art*, January/February, 1993, 82–95.

10 Lee Kyungmin, "Hanguk sajinjedoui jihyeonggwa geu gyebo" [The Topography and Genealogy of Korean Photographic Policies], *Peureim ihuui peureim hanguk hyeondae sajin undong 1988-1999* [Frames after Frames: Modern Photography Movement of Korea from 1988 to 1999], exh. cat. (Daegu: Daegu Art Museum, 2004), 21–25. Kim Gyewon, "Mandeuneun sajin, jjingneun sajin: 1990nyeondae hanguk sajineseoui maeche teuksuseong nonui" ['Making Photos' or 'Taking Photos': Rethinking the Debates on the Medium-Specificity of Photography in 1990s Korean Art], *Journal of Korean Modern & Contemporary Art History*, no. 36 (2018): 255–284.

11 Kim Seung-gon, "Sigagui badage chimjeondoen gieogui anggeum" [The Remnants of Memories at the Bottom of Time], *Koo Bohnchang* (Seoul: Yeolhwadang, 2004), 3–10.

12 Ibid., 10.

13 Song Sujong, "Jusulsaeseo gudojaro" [From Shaman to Truth-seeker], in *Lee Gapchul*, Lee Gapchul et al. (Bologna: Damiani/The Museum of Photography Seoul, 2019), 11.

14 Park Chan-kyong, "Jeongdongseogui banpunggyeong bangwanggyeong" [Anti-Landscape and Anti-View of Chung Dongsuk], in *Anti Landscape*, (Seoul: Noonbit, 1999), 7.

15 Kang Hong-goo, "Gamgagui modeonijeum: Gimjangseobui chogi jageopgwa sajin" [The Modernism of Sensibility: Early Works and Photography of Kim Jangsup], *Gimjangseop punggyeong neomeoui punggyeong* [Kim Jangsup, a Scenery beyond a Scenery], Kim Jangsup and Kang Hong-goo et al. (Seoul: Culture Books, 2012), 21.

16 Karen Sinsheimer, "Identity, Family, Memory," *Chaotic*

Harmony: Contemporary Korean Photography, exh. cat. (The Museum of Fine Arts, Houston, and the Santa Barbara Museum of Art, 2009), 67.

17 Beck Jee-sook, "Sasirui him" [The Power of Reality], *Happy Together*, Kim Oksun et al. (Seoul: The Works, 2006), 1–2.

THE DEVELOPMENT OF CONTEMPORARY PHOTOGRAPHY: MEDIA EXPERIMENTS AND DIVERSE PERSPECTIVES

GLOBALISM AND CONTEMPORARY KOREAN ART

Lee Bul, *Cyborg W5*, 1999, Hand-cut EVA panels on FRP, polyurethane coating, 150×55×90 cm

After the Seoul Asian Games in 1986 and Seoul Olympic Games in 1988
Korea had established its national presence on the international stage. This
was when the structure of the Korean art world as well as its surrounding
environment underwent transformative changes as the country opened its gates
to the world against the backdrop of globalization. Korea relaxed its overseas
travel restrictions in 1989 following the Olympics, which brought greater
opportunities for people to experience other cultures firsthand. That same
year the Cold War came to an end as symbolized by the fall of the Berlin Wall,
and a number of other walls, both tangible and intangible, fell with it. Korea
formed diplomatic ties with Hungary and Poland in 1989, the Soviet Union in
1990, and China in 1992. Cultural exchange with the likes of socialist Eastern
European countries that had been thus far severed due to differences in ideology
began once more. In an environment now free from the global cold war logic of
competitive dichotomy between communism and capitalism, things that were
once ideologically taboo began to be accepted as Korea began to achieve full
economic development and democratization. A key example of this shift was
the lifting of the ban on the artists who had defected to North Korea, which
represented a great leap forward in the liberation of ideological expression
within the nation. Korea also opened up to Japanese pop culture progressively
over three rounds in 1998, 1999, and 2000, legalizing under-the-table Japanese
pop culture imports, and through this Koreans were further able to enjoy the
benefits of greater cultural diversity.

The establishment of biennale institutions contributed significantly to
artists developing their international sensibilities. This began when the MMCA
hosted the '93 Whitney Biennial in Seoul, the opening of the Korean Pavilion
at the Venice Biennale in 1995, and the Gwangju Biennale launched the same
year. Local assembly and city council regional elections were held in 1991 for the
first time since 1960, and the four regional elections were held together in 1995,
finally opening an era of local self-government within Korea. Globalization
coupled with more autonomy given to the regional governments led to biennales
mushrooming all over the country: Cheongju Craft Biennale (1999–), Seoul
Mediacity Biennale (2000–), Korean International Ceramic Biennale (2001–),
Typojanchi: International Typography Biennale (2001–), Busan Biennale (2002–),
Geumgang Nature Art Biennale in Gongju (2004–), Incheon Women Artists'
Biennale (2004–2011), Daegu Photo Biennale (2006–), Changwon Sculpture
Biennale (2010–), Seoul Biennale of Architecture and Urbanism (2017–), Daejeon
Biennale (2018–), and Jeonnam International SUMUK Biennale (2018–). This
prompted some to call for critical reflection over this rapidly expanding state
of affairs. The regional governments also took initiative to build national art
museums, quickly establishing the publicly funded nationwide infrastructure
for art institutions across the country. From when the city operated Gwangju
Museum of Art opened in 1992 to when the provincially run Jeonnam Museum
of Art opened in 2021, almost one art museum per year had opened over this
thirty year stretch. These were accompanied by a number of new private
museums created by prominent companies including those in media, a trend
which culminated in the formation of the Leeum, Samsung Museum of Art in
2004, a collection of buildings designed by the star architects Mario Botta, Jean
Nouvel, and Rem Koolhaas, now established as a national cultural landmark.

The Korean art world infrastructure became more diverse in the hands
of regional governments and under the influence of globalization. Korea also
participated in the reorganizing of the world economic order with the founding
of the WTO in 1995, joined the OECD in 1996, and received a relief loan from
the IMF due to the foreign currency crisis in 1997. This series of events led
the Korean economy to become irrevocably woven into the fabric of the global
market. In this context by the twenty first century Korea had further opened
its economy to the world and international capital mobility steadily increased
amidst the wave of neoliberalism. In the cultural field, postcolonial and
multicultural discourses gained traction relative to the spread of globalization

and liberalization. A number of artists gained experience of the global art world by living and studying abroad, and through international exchange were able to grasp the opportunity to move freely across institutions around the world.

The Michael Schultz Gallery that has its flagship space in Berlin was the first foreign gallery to open on Korean soil in 2006. This was followed by Opera Gallery in 2007, Galerie Perrotin and Barakat in 2016, Pace and Lehmann Maupin Galleries in 2017, and König Galerie in 2021. In the process of the Korean art market making inroads onto the international stage, along with the many biennales, new auction houses and international art fairs also became a part of the institutional scene of a Korean art world that had formerly only consisted of art museums and galleries. Sotheby's opened its Korean branch in 1990, and Christie's followed suit in 1995. This period also saw the foundation of the first Korean owned auction houses, Seoul Auction in 1998 and K Auction in 2005. The MANIF Seoul International Art Fair launched in 1995; the Seoul Print Art Fair that started in 1995 became the Seoul International Print, Photo Art Fair, and finally settled on ART EDITION in 2010; and the Korea International Art Fair or KIAF began in 2002. As such, the art market became more systematized, and the art ecosystem rapidly adapted itself to the contemporary environment, keeping beat with the rhythm of the international contemporary art market.

Public support for artists also diversified. Korea Culture and Arts Foundation, an entity that was originally founded in 1973, was newly launched as the Arts Council Korea, a private autonomous organization following the 2005 Culture and Arts Promotion Act. The Korea Arts Management Service was also established in 2006 to systemically support artwork distribution and artists' autonomy. Creative studios that provided workspaces and supported artists' creative endeavors were also established and later developed organized residency programs. The Gwangju Museum of Art formed the Palgakjeong Art Studio in 1995, and the MMCA began the Changdong and Goyang Residencies in 2002 and 2004 respectively which were followed by many more public and private residencies peppered across the country. Around the turn of the millennium, alternative spaces also emerged to support up-and-coming artists. These provided exhibition spaces and support for young artists who had been unable to find a foothold in the mainstream after the chaos caused to the art market by the IMF crisis in 1997. Coincidentally, many artists again started to establish new exhibition spaces after the global financial crisis in 2008. With ever more new practices emerging, the regular establishment of new art spaces that are completely different from their conventional counterparts has become an established part of the Korean art world. As such, a diverse and concrete foundation of art world infrastructure has successfully formed across Korea amidst the ups and downs of the contemporary era.

The regularly implemented Five-Year Economic Development Plan that started in 1962 to drive Korean economic development changed its name to the Five-Year Economic and Social Development Plan following its fourth round in 1982, and finally came to completion in 1996 after its sixth round. In the 1980s, Korea saw ultra-rapid development in the high-tech industries centered around semi-conductor production as the national economy flourished as a result of the three lows—low oil prices, low interest rates, and the weak Korean won— and subsequently welcomed an economic boom in the 1990s. Korea's per capita annual income that had been ten thousand dollars in 1994 jumped to twenty thousand dollars in 2006, and thirty thousand dollars by 2018. This persistent economic growth raised the average household income which in turn boosted purchasing power. This led to an increase in demand for various cultural products. Overall, Korea was beginning to acquire all the hallmark features of a consumer society. As the economy grew, civic awareness also improved as the country underwent democratization, and more people began to seek a better quality of life. And for the first time since the democratic national government was established, the budget allocated for the cultural sector exceeded 1% of the entire national budget in 1999.[1] The purchasing power of teenagers increased,

and pop-cultural expression rapidly expanded and commercialized as a result. In this regard, a number of entertainment agencies were founded such as SM Entertainment in 1995, JYP Entertainment in 1996, and YG Entertainment in 1998, systemically leading the industrialization of the popular arts. Furthermore, various popular subcultural interests and genres flourished within major cities which led to an age of unprecedentedly rich cultural production. Visual culture also became more sophisticated as more and more products were introduced relative to the expansion of consumer culture. Many clubs, bars, cafes and other leisure spaces were born in relation to the diverse popular subcultural interests that emerged after the late 1980s, and artists and those who enjoyed such cultural expressions came together, further fueling each other's activities. The development of different media, and the assorted cultural formats intermingling and combining with one another gave rise to even more diverse approaches to creative and artistic activity. Also, the growing interest in the cultural significance of public urban space manifested in the form of the Arts Decorations for Buildings policy after the revision of the Culture and Arts Promotion Act in 1995, which became the Artworks for Buildings Policy in 2011, further driving forward critical discourse on public art.

While there was some respite in the public desire for social change after achieving procedural democracy, critical art practices strove to further expose the ever more sophisticated and ongoing contexts of social oppression. And more emphasis was also placed on individual freedom of expression during this time. A number of controversial works brought to light the limits to the freedom of expression that an individual was allowed to have in Korea. These were: Ma Kwangsoo's novel *Happy Sara* (1992); Jang Jeongil's novel *Lie to Me* (1996); Jang Sunwoo's cinematic version of this book entitled *Lies* (1999); and Lee Hyunse's comic book *Mythology of the Heavens* (1999). A number of these works were even taken to court, which sent shock waves throughout the liberally minded sectors of the national population. Controversy over the freedom of expression and the events that transpired following the release of these works significantly contributed to the abolition of the system for suspending film rating classifications through the Film Promotion Act revision. This act, which was enacted in 1995, systematized the support provided to the film industry by adapting to the changes in Korean film policies. Originally, the Korean Motion Picture Promotion Corporation was founded in 1973 and later changed its name to the Korean Film Council after the second revised Film Promotion Act in 1999. Various devices were put in place to foster the film industry such as the Busan International Film Festival that began in 1996, and the Bucheon International Fantastic Film Festival that began in 1997. This was when the very first seeds were planted that would later bear fruit through what is often labelled in Korea as "*hallyu*," or the globally influential 'Korean wave' in popular music, film, drama and more. Through this global popularization of Korean culture, Korea as a nation has come to enjoy increasing soft power internationally.

The spread of personal computing from the late 1980s gave rise to a social communications network that blossomed into a myriad of online communities and societies. Namely, this shaped the national cultural landscape in the 1990s. Korea was the first country to finish building a nationwide information superhighway in 2000, a project that the country had begun in 1995 and which was crucial to the unprecedented national spread of the internet.[2] The speed of transferring to a knowledge and information based society accelerated with establishment of the internet, a tool which also indelibly changed how information on art was shared. The *Gallery & Art Museum Exhibition Guide*, a bimonthly booklet that carries information on exhibitions was launched in 1996, and this led to the launch of the *Seoul Art Guide*, a monthly periodical, in 2002, and a comprehensive internet-based art portal began operation the same year. Meanwhile, Neolook.com, an online archive that documents information on art, also began its services in 1999. As such, substantive new art information distribution platforms were created in addition to the traditional forms of

media. And now, due to the internet the entire world is evolving into a global community the likes of which have never been seen before, a realm which encompasses the emergence of different social networking platforms and online markets to virtual reality experiences and NFTs. In this context the art world steadily becomes ever more based on digital practices, opening up myriad possibilities for the creation of new sites of experience and contact that far exceed the physical construction of gallery spaces for art exhibition.

1 "Munhwayesan 1% uimiwa bijeon: Sae cheonnyeon jisikgibangyeongje balpan maryeon" [The Significance and Vision of the 1% Culture Budget, Forming a Foundation for the New Millennium Knowledge Based Economy], *Kukjung Sinmun*, October 4, 1999, accessed on April 23, 2021, https://www.korea.kr/news/policyNewsView.do?newsId=148745394.
2 Lee Hunchang, *Hanguk gyeongje tongsa* [Economic History of Korea] (Seoul: Haenam Books, 2018), 674.

The Globalization of Contemporary Korean Art in the Era of Biennales

Yang Eunhee

THE WAVES OF GLOBALIZATION

With the end of the Cold War as marked by the fall of the Berlin Wall in 1989, globalization became an increasingly palpable force across the Korean Peninsula. This phenomenon that was interconnecting the world's cultures failed to link the divided Koreas, however. The demilitarized zone created at the end of the Korean War remained rigidly in place and continued to forbid the border crossings that had become more common worldwide. In this respect, the concept of globalization on the Korean Peninsula found itself caught somewhere between the ideal and a more limited reality. It is hard to deny that waves of globalization reached South Korea, however, which will be the focus of this essay.

Globalization in South Korea was largely led by the democratic government established in 1993. Keenly noting the changes taking place in the post–Cold War global landscape and international relations outside the Korean Peninsula, President Kim Young-sam (in office from 1993 to 1998) strategically announced his Globalization Declaration in 1994, and in 1995 the Globalization Promotion Committee was launched. At the time, a new world order was being forged based on free-market economics. Under the leadership of the United States, the Uruguay Round of global trade negotiations was ratified in 1994 and the World Trade Organization (WTO) was resultingly formed in 1995. South Korea could not stand against the reformed world order as it demanded the elimination of trade barriers. As an ally of the United States, South Korea adopted such globalization as a policy. For a nation dependent on imports and exports, the pressure to open the national economy to trade was intense. It became an issue that needed to be managed politically.

South Korea was in fact unprepared to meet the fast-approaching requirements for the full opening of its economy to multinational interests. In common with many other countries where rice is the staple food, the government encountered growing domestic resistance to the opening of the domestic rice market since it was considered an essential foodstuff and any tampering with the market could cause a collapse of the supply structure. Facing firm resistance to free-market globalisation under the auspices of the WTO, for political reasons the South Korean government could not translate the Korean term *segyehwa* as "globalization" in English. Instead, it initially used the Korean romanization *segyehwa*.[1] As an excuse for this translation choice, the government explained that the English term *globalization* conveyed a limited conception by an international economy that saw the world as a single market. At that time, the government was attempting to sell the concept of globalization as an extension of a less controversial 'internationalization' process, which meant strengthening national competitiveness and exchanges with the international community. The president, however, failed to keep his promise not to open the rice market and deregulated national markets in line with global demands. The underprepared Korean economy soon faced an immense debt crisis, exposing its vulnerability and eventually requiring a request for an International Monetary Fund (IMF) bailout in 1997. This encounter between the national economy and the forces of global capital became a traumatic memory and proved an expensive lesson that a new era had arrived.

THE GLOBALIZATION OF ART THROUGH EXHIBITIONS

It may be futile to attempt to specify the starting point of the *segyehwa*, or globalization, of Korean

art, as every culture has been in a process of transformation over history via exchanges and contacts with others. Korean art is no exception. Instead, it would be more fruitful to approach the concept of globalization more narrowly and in relation to the historical framework outlined above.

Some say that the South Korean contemporary art community entered an era of full-fledged globalization following the 1988 Seoul Olympics.[2] Others claim that it is more useful to consider the starting point to be around 1994 when the Kim Young-sam administration began to concretely pursue the issue of globalization through its cultural policies. Looking at these two views together, it is safe to say that the rapidly changing international environment in the years between the 1988 Seoul Olympics and the globalization policy launched by the Kim administration in 1994 generated considerable momentum for the globalization of the South Korean art world.

This general trend toward increasing globalization within South Korean art encountered some minor resistance, but it in general developed without much difficulty. It accelerated as an extension of the "internationalization" movement that was perceived as necessary to remain in step with the contemporary Western world since the 1960s. In the 1960s, the Korean contemporary art community first began to participate at an organized national level in post-war international art events such as at the São Paulo and Paris Biennales. The spread of international art dominated by abstraction, which was intertwined with the cultural politics of the Cold War world order, also played a role in Korean enthusiasm for this engagement. As part of this process, there emerged a dominant view that artists who worked in western styles and in genres more attuned to international modernism and who could communicate well in the international art world should be the ones to go to overseas exhibitions where artists from various countries were officially competing for recognition. For artists working in more traditional media, modernizing their style remained a primary goal before attempting to reach outside Korea.

With this view providing the standard for selecting artists to participate in overseas exhibitions, it is not surprising that abstract artists such as Park Seobo and Kim Whanki were given chances to show their work abroad in the 1960s. The effect of participating in western biennales was immediate: Artists became keener to following Western art trends and art students came to favor western-style painting. Abstract art subsequently dominated South Korean art and culture in the 1970s and 80s and laid a foundation for the globalization process of Korean art in the 1990s.

There are two possible explanations for the lack of major resistance to globalization in the South Korean art scene in the 1990s. The first is that the influx of international art in the 1980s eased the tensions felt when encountering foreign art. At that time, museums and galleries were being established or moving to new homes, including the National Museum of Modern and Contemporary Art, Korea (MMCA), and they served as outposts for globalism by showcasing overseas contemporary art. As an example, the Walker Hill Art Center and the Ho-Am Art Gallery, which opened respectively in 1984 and 1985, both introduced a range of international art. Unlike exhibitions held in the 1970s that introduced modernist masters such as Pablo Picasso and Jean-François Millet, museums in the 1980s curated such exhibitions as *Nouvelle Figuration en France* at the Seoul Museum in 1981; *Contemporary Prints: London-New York* at the Walker Hill Art Center in 1984; *Contemporary Prints of Eastern Europe* at the Walker Hill Art Center in 1985; *Contemporary Art of New York* at the Ho-Am Art Gallery in 1988, and others. These exhibitions offered South Korean audiences an opportunity to view overseas art trends in the final years of the Cold War.

The removal of an import ban on artworks in 1991 led to a further increase in the number of galleries, and, subsequently, the number of exhibitions from overseas. The increase in shows featuring international artists was prominent, rising from thirteen in the 1960s to eighty in the 1970s. It reached 383 in the 1980s and nearly tripled to 973 in the 1990s. In the 2000s, 2,430 exhibitions were held centering on international art.[3] This influx of modern and contemporary art from outside Korea cultivated a number of art lovers and collectors, prefiguring a blockbuster exhibition boom in the 2000s that introduced the Western masters of Impressionism and the collections of many renowned overseas art galleries.

The second reason is that resiliency was developed after an incident that revealed conflicts between the artists and critics affiliated with the "Modernist" group and the "Minjung art" group that had bifurcated Korean art in the 1980s and early 1990s. The incident was sparked by the open opposition from members of the Minjung art movement to the selection of artists from the Modernist group during preparations for the *Olympiad of Art* being held as an auxiliary event to the 1988 Seoul Olympics. The festival was organized with the aspiration of moving beyond differences in nationality, race, and culture and forming a harmonious field with art and creativity as its common denominators. However, the process of selecting artists to represent South Korea exposed the psychological gap and ideological differences inherent in the local art scene, leading

1 Exhibition view of the *Olympiad of Art*, 1988, Art Research Center

to further heated debates that exposed the extreme antagonism among the various cliques within the Korean art world.

THE 1988 OLYMPIAD OF ART

Despite economic success and the introduction of international cultural elements, South Korea was still under a military dictatorship in the 1980s just as it had been in the 1970s. The successive regimes of Chun Doo-hwan (in office 1980–88) and Roh Tae-woo (in office 1988–93) sponsored large-scale events aimed at creating images of a prosperous society in order to gain domestic and international support for their governments. The most notable events were the 1986 Asian Games and the 1988 Summer Olympics, both held in Seoul. These events were outcomes of these regimes' strategies to enhance the country's status through exchanges in sports and the arts and, in doing so, establishing supportive international relationships.

The Olympiad of Art was the largest event among the regimes' international cultural exchange projects. **1** Costing over nine billion Korean won, the exhibition was touted as a cultural Olympics that could showcase various international and South Korean artists at the same time. However, selecting artists to represent South Korean contemporary art became a thorny issue. When the organizing committee for the Olympiad of Art

was formed in 1987, a group of artists and critics who had been left out from the selection process— most of whom were associated with the Minjung art movement, traditional Korean painting, or figurative painting—questioned the fairness of the selection and operation processes. They criticized the organizing committee's attempt to determine who should represent Korean art in an outdated manner. It was unacceptable to them to allow a select few curators invited from overseas and certain mainstream Korean artists to dominate the operation of the event. Among the organizing committee were five international curators and critics (Gérard Xuriguera, Thomas Messer, Yusuke Nakahara, Ante Glibota, and Pierre Restany) and eighteen domestic artists and critics (the artists included Chung Kwanmo, Choi Manlin, Ha Chonghyun, Lee Daewon, Moon Shin, and Park Seobo; the critics included Kim Bokyoung, Lee Yil, Lee Kyungsung, Oh Kwang-su, and Yu Jun-sang). In particular, artists associated with Minjung art protested against the formation of these operational committees, issuing statements signed by numerous artists and sending the temporary organizing committees open letters and questions, claiming that they could not trust the choices of just a small number of experts.

Their demand was that the operating committees be evenly recruited from across the entire Korean art world in order to fairly select a

representative body of artists rather than favoring just a limited number of established artists and critics. They also asked for a change in the selection: The selected artists for the *Olympiad of Art* should be equally based on a range of ages, styles, and genres. This demand inevitably clashed with the concerns of the operating committees, who insisted that they could not allocate artists according to the political landscape of the domestic art scene simply in order to be seen as 'democratic.' During this process, members of the South Korean art community took conflicting positions based on certain binaries that had been sources of latent conflict in the domestic scene, such as insiders vs. outsiders, the colonized vs. colonialists, locality vs. globality, and tradition vs. contemporaneity. Contradictory concepts also played a part, such as East Asian painting vs. Western painting, abstract art vs. figurative art, and Minjung art vs. Modernist art. Although the protests did not result in the replacement of committee members or artists, the conflict continued until the end of the event, presenting one of the most divided landscapes in the South Korean contemporary art world in the 20th century.

Despite this heated antagonism, the *Olympiad of Art* provided an opportunity for the art community to confront the challenges of the era as direct exchanges and communication with the global art world became inevitable. Unlike in the past, when South Korean art was immersed in the overarching topics of "Koreanness" and "modernism," the *Olympiad of Art* incident provoked an awareness that the relationship between Korean art and the international art world should be re-examined. It also highlighted the inevitability in the process of integrating Korean art with global culture and showed how artists in Korea were coming to terms with the historical trauma of ideological division and political bias that had riven the post-war art world. At the same time, the incident provided momentum for reflecting on the position of contemporary South Korean art and on the necessity of fostering difference and diversity.

GLOBALISM IN THE POST-OLYMPIC ERA
The events surrounding the 1988 Olympics were roughly concurrent with the end of the Cold War. In the wake of this large-scale international political transformation, South Korean society embraced foreign cultures more openly and came to envision the country as integrated with the outside world. The country's art scene steadily diversified as new concepts such as postmodernism, consumerism, and media culture advanced. The emergence of a new generation reinforced the growing sensitivity to contemporary ideas of individualism and consumerism. Young artists began to develop a considerable population as the universities were allowed to increase student enrollment in the 1980s. The new graduates preferred small-scale artist collectives aiming at innovative practices distinct from those of the previous generations. This new generation of artists fueled the rapid globalization of Korean art in the 1990s. Artists such as Choi Jeonghwa and Lee Bul formed collectives, including Museum (1987), Golden Apple (1990), and Sub Club (1990). Freely adopting various forms such as installation, video art, and performance and exploring such topics as popular culture and gender, their practices overtly challenged the status quo in a Korean culture where artistic form and themes had traditionally been conservative due to patriarchal conventions and rigorous political censorship.

In addition, many artists also studied abroad in the 1980s and early 1990s and traveled regularly between Korea and their places of residence. These artists were often at to the forefront of the globalization movement within the South Korean art world, participating in major exhibitions at home and abroad. In this respect, 'globalization' was not merely a new phase of modernist internationalization; it turned out to be an opportunity to politically and intellectually unite with other 'non-western' and historically marginalised artists in Southeast Asia, Africa, and Latin America. In a 1994 exhibition preface, art critic Lee Yil argued that considering the Asia-Pacific art landscape in the 1990s, Korean art needed to overcome both traditional and contemporary problems and boldly escape from its heritage without severing with the past. Borrowing Hans Belting's concepts, Lee argued that we needed to acknowledge "art as one of the various systems [useful for] interpreting and expressing the world."[4] This concern pointed to the fact that South Korea needed to embrace the concepts circulating in the global field of contemporary art practice, but without abandoning its own unique cultural assets. As a prominent critic who had been active in the mainstream of the South Korean art scene for almost three decades, Lee predicted the arrival of a new era in which different cultures could usefully communicate through contemporary art and helped to explain the potential of the landscape of Korean art world in the 1990s.

A decade later, art historian Jung Hun-Yee described the 1990s as "the time of greatest change and growth in Korean art history."[5] According to Jung, the era was marked by the following changes: a paradigm shift in artists' international awareness; modernist-era values being dismantled under the banner of cultural pluralism; the collapse of distinctions between genres; and artists' active use of new media in their work. Jung's observation

2 Inauguration of the Korean Pavilion at the Venice Biennale, 1995

and Korean Americans in one place, expanding the scope of Korean art to include migrant artists from Korea practicing in New York.

The exhibition also addressed the question of how best to combine two different contexts: one being the introduction of Korean-orientated Minjung art to the New York art world, and the other being how to embrace Korean-born artists living in the U.S. As the artists in New York were often conscious being members of a minority in a multicultural Western society, their stance was slightly different from that of Minjung artists who criticized Modernist art in Korea and western influence on Korean culture and art. The two contexts required a change in focus depending on the location of the exhibition, so the exhibition in New York highlighted Korean-American artists and the current artistic trends in the U.S. based on multicultural politics. In contrast, the exhibition in Seoul was promoted as an international event that had successfully attracted "the attention of the global art community," by introducing Korean art, which had been considered peripheral to Western contemporary art, in New York.[6] The exhibition triggered an awareness that a more intellectual analysis and approach were required to the topic of the framing of contemporary South Korean art in the global era.

THE KOREAN PAVILION AT THE VENICE BIENNALE

The globalization of South Korean art was stimulated by the proliferation of state-led biennials and international exhibitions incepted under the Kim Young-sam government. Hosted with support from Paik Nam June, the 1993 Whitney Biennial in Seoul widely promoted the concept of the biennale among the Korean public and introduced contemporary art that engaged with postmodernism and a US-centered cultural identity. The opening of the Korean Pavilion at the Venice Biennale in June 1995 and the launch of the Gwangju Biennale in September 1995 were the direct outcomes of the *segyehwa* policy. These biennials funded by the government served as platforms for artists to gradually escape from the bifurcated confrontation of Western vs. Korean art and to envision the globalization of Korean art as a local form of international contemporary art.

The Korean Pavilion at the Venice Biennale became a notable point of departure for the globalization process. 2 The Venice Biennale had long been considered a prized but unobtainable stage for Korean artists. Since the 1960s, South Korean artists had aspired to be included in international biennales, which they viewed as hubs of information and cultural contact with

indicates that an awareness of South Korean art's potential to communicate with the wider world of contemporary art, which Lee Yil had emphasized, had been established to some extent by this point. The spread of the internet in the second half of the 1990s further accelerated the opening of the art world, as did the broader cultural globalization that began in the aftermath of the Olympics. In this respect, South Korean art embraced globalization by reflecting on both postmodern and postcolonial circumstances.

Within the post-Olympic and postmodern context, *Across the Pacific: Contemporary Korean and Korean American Art* (1993) presented Korean artists practicing in South Korea and in the United States within a single exhibition. Initially led by the artists of the Seoro Korean Cultural Network in New York, the exhibition was overseen by Jane Farver of the Queens Museum of Art and curated by Lee Youngchul. It premiered in New York and then traveled to the Kumho Museum of Art in Seoul. The exhibition introduced Minjung artists

the international art world. In fact, the biennials would provide opportunities to confirm the talent and creativity of the participating artists, so the South Korean art community had striven to secure national pavilions. Led by the Contemporary Artists Association (in which Park Seobo and Kim Tschang-Yeul served as leading figures), a fundraising exhibition for the construction of a Korean Pavilion was held at the Gyeongbokgung Palace Museum, December 4 to 12, 1960.[7] Such initiatives did not come to immediate fruition, however. In fact, Korean artists were unable to participate in the Venice Biennale until they were officially invited 1986. It took ten years from this first participation that a Korean Pavilion was finally constructed at the Venice Biennale.

The Korean Pavilion at the Venice Biennale was an outcome of two sides effectively coinciding. The Venice Biennale aimed to re-establish the relationship between local and global culture within its purview and expand its range to the global art community amid the launch of the European Union after the Cold War. At the same time, the South Korean art community aspired to shift beyond the geographical limits of East Asia. In this process, Paik Nam June served as an important mediator by using "globalization" and "peace" as rhetoric for persuasion. Paik had already been serving as a bridge between Korean and international art since the 1980s. Having worked on the front lines of experimental contemporary art in Europe and the United States since the 1960s, Paik became well-known to the Korean public in the 1980s when he experimented with a series of transnational works that included South Korea, such as the satellite broadcast project *Good Morning Mr. Orwell* (1984). He held a retrospective exhibition at the MMCA in 1992 and organized a symposium "The Turn of the Century, 91/92" to which he invited world-famous figures such as Achille Bonito Oliva, Pierre Restany, David Ross, and Irving Sandler, all at his own expense. He also worked to host the 1993 Whitney Biennial in Seoul.

Having locally emphasized the importance of the Venice Biennale and the construction of the Korean Pavilion, Paik worked to persuade the Venice Biennale to open a Korean Pavilion after he won the Golden Lion Award at the 1993 Venice Biennale as one of the two artists from the German Pavilion. At a meeting with the mayor of Venice and other officials, Paik coaxed the biennale organizers by arguing that the city of Venice could be in line for the Nobel Peace Prize if a Korean Pavilion were to be built, following the logic that "South and North Korea can resolve political tensions through art."[8] He further argued that 1995 was both the one hundredth anniversary of the Venice Biennale and the fiftieth anniversary of

Korea's liberation from Japanese colonization, and such a gesture would demonstrate that world peace can be achieved through art.

The Korean Pavilion became a new channel for narrowing the distance between Korean and global art. The history and authority of the Venice Biennale increased the persuasiveness of its framing as a global art hub within Western Europe during the 1990s, and enabled many South Korean artists to rise to international and national prominence through the event. Among the Korean artists, Jheon Soocheon, Kang Ik-Joong, and Lee Bul won three consecutive honorable mentions from 1995 to 1999, confirming the potential of South Korean art on the international art scene. These artists largely eschewed directly confronting the heavy issues of "identity," and "Koreanness," something that South Korean artists had been unable to avoid in the past. Instead, their work was dominated by contemporary themes, such as discourses on Asia, gender, and multiculturalism, which enabled them to further influence the wider discourses of contemporary art in South Korea.

The creation of the Korean Pavilion at the Venice Biennale also marked the starting point of a domestic "biennale boom" inside South Korea, including the popular Gwangju Biennale. When the establishment of the Korean Pavilion was confirmed in 1994, the South Korean government began to consider creating an international biennale of its own. It initially discussed founding a "Pacific Biennale" in which Asian nations, Australia, the United States, Russia, and other nations in the Pacific area would participate. It the end, however, the Gwangju Biennale was established as a political gift to Gwangju, a city which had suffered greatly under government oppression and military violence during the Gwangju Democratization Movement in the early 1980s. Since then, several other biennales have been established in cities like Seoul, Busan, Incheon, and Daegu. These biennales stimulated further openness in the country's art by integrating the local and the global. In the meantime, they narrowed the distance between contemporary South Korean and global art.

THE GWANGJU BIENNALE

Thanks to the unprecedented scale of its budget, the Gwangju Biennale has grown from its inauguration in 1995 into a global art event where curators, artists, and critics from South Korea and abroad gather to create exhibition concepts, discuss related topics, and exchange information through mutual networking. Its value and roles are well-recognized: In a survey conducted in 2015 domestic experts cited the first and second exhibitions of the Gwangju Biennale as the most influential

exhibitions in the history of Korean art in the 20th century.[9] The Gwangju Biennale has also received international critical acclaim. Along with the Johannesburg Biennale and the Istanbul Biennial, the Gwangju Biennale is considered one of the fundamental events that expanded the horizons of global art by cementing the de-Westernization of the international art world in the 1990s. It has become one of Asia's leading art exhibitions and is considered comparable to events such as the Venice Biennale, documenta in Kassel, and Manifesta, the European Biennial of Contemporary Art.[10]

The Gwangju Biennale's global renown was not easily achieved. Since its foundation, conflicts have arisen regarding many aspects of its organization, including exhibition planning, the structure, and human resources management. However, it was able to grow by establishing the Gwangju Biennial Foundation and adopting Western curatorial practices. In particular, the foreign curators invited to the Gwangju Biennale in the early period played an important mediatory role in the exchange of conceptual approaches common to contemporary art and in introducing European and U.S. art customs to South Korea, thus helping to integrate the distinct exhibition cultures of Korea and the West.

So far, the curators who worked for the Gwangju Biennale have included diverse figures, such as Korean curators active in international contexts (Min Yongsoon and Kim Yooyeon) and major figures from the global art world (René Block, Charles Esche, Hou Hanru, Okwui Enwezor, Massimiliano Gioni, Chika Okeke-Agulu, Wu Hung, and Maria Lind). Their influence in the 2000s provided themes for the Gwangju Biennale that included more contemporaneous issues that could resonate with both the global art scene and the Korean art world.

Among the invited curators, Harald Szeemann contributed significantly to the early development of the Gwangju Biennale. First selected as one of the five international commissioners to the second Gwangju Biennale (a time when Lee Youngchul, a Szeemann admirer, was the director of exhibition planning), Szeemann displayed curatorial methods fundamentally different from those of his Korean counterparts. Already famous as a pioneer of "creative curating" in Europe, Szeemann introduced intellectually-oriented, discourse–based curating approaches to Gwangju. His themed exhibition *Speed* was, according to him, inspired by the flowing water in the stream at Soswaewon, a renowned traditional garden in Damyang created in the sixteenth century by a classical scholar in seclusion. Szeemann's show provided a model of imaginative curatorial methods, presenting a wide range of artists such as Wolfgang Laib and Lim

Choong-sup in a single place. Full of confidence and aware of local expectations of him, Szeemann said in an interview: "If the Gwangju Biennale wants to strengthen its international positioning, use me for publicity."[11] His role did not end with the 1997 biennale. While in South Korea he discovered Lee Bul and included her works in his exhibition at the 1997 Lyon Biennale.

KOREAN CURATORS AND ARTISTS IN THE ERA OF GLOBALIZATION AND THE BIENNALE

The biennale era brought about two notable changes in South Korea. The first was the development of professional curators as a group distinct from other art administrators. Prior to the biennial age, the term "curator" in Korea mainly referred to a small number of people in charge of art administration, and the title of curator was used inconsistently along with such terms as "commissioner" or "director." With the establishment of the Gwangju Biennale, however, figures such as Lee Youngchul and Kim Hong-hee emerged as professional curators with intelligent and creative perspectives, contributing to the emergence of the concept of independent curator. These curators often clashed and negotiated with the bureaucracy at government-led events, but they succeeded in securing their independence and autonomy since there were not many with the ability to identify themes and curate large-scale international exhibitions. They established curation as a professional field.

Their numbers remained small, however. Lee Youngchul, for instance, gained recognition on the global stage after he left Gwangju. He was invited to curate exhibitions in Europe and the United States. Kim Hong-hee and Song Misook were female pioneers who eagerly employed new subjects such as gender and feminism, postmodernism and urbanity, and more. It is noteworthy that both of them had an art history background and were educated in English-speaking countries. However small in number, the new generation of independent curators forged new ways to implement curating as an intellectual practice. Their activities inspired the next generation of curators in the 2000s.

The second change was that the transcultural shift seen in the practices of global artists attracted South Korean artists to imagine a world beyond the boundaries of Korea. There had been older Korean artists who transcended these boundaries. Although there were just a few, some artists such as Lee Ufan and Paik Nam June worked in diverse countries like Japan, Germany, and the United States. Since the 1990s, however, Korean artists have had increasing opportunities to work in the field of global contemporary art. Through studying abroad

3 Jheon Soocheon, *Clay Icon in Wandering Planets—Korean's Spirit*, 1995,
TV monitor, VCR, glass, clay figures, mixed media, 380×1,800×800 cm

4 Kang Ik-Joong, *Buddha Singing Italian Opera*, 1997,
Mixed media on canvas, 7.6 × 7.6 cm each

and long-term migration, the expansion of these artists' creative activities across national borders has led to an era in which artists have been freed from the obsession that their art convey some form of "Koreanness."

One example of this new global orientation can be found in Jheon Soocheon, who received an honorable mention at the 46th Venice Biennale for his work at the inaugural exhibition of the Korean Pavilion in 1995. Having studied outside Korea, Jheon was relatively far from the major thrust of Korean art compared with the other artists who participated in the Korean Pavilion. However, he proved to be the only one to win an award in Venice. His award was understood as confirmation of the direction that Korean contemporary art should take in order to be recognised within the biennale. The Korean art community, which had focused on the conventional mediums of painting and sculpture, began to pay greater attention to installation and media art. Along with Yook Keunbyung, whose media art was invited to documenta 9 in 1992, the example of Jheon's success soothed the Korean art community's unease about installation and media art, both of which had been considered outside the mainstream of the domestic art world.

Inspired by clay figurines from the Silla Kingdom (57 BCE to 935 CE), Jheon's *Clay Icon in Wandering Planets-Korean Spirit* (1995) was a large-scale work for which he produced more than 1,000 figurines that were installed along with industrial waste and TV monitors on glass plates on the floor. 3 Fragmented images from contemporary civilization emanating from the TV monitors against a dark background caused the clay figurines to appear like guardians of civilization, somewhat as if they embodied the nobility of human life. Not bound to particular formal or cultural concerns regarding his education, Jheon studied the art and aesthetics of the East and West in Japan and the United States before returning to South Korea in 1989. By winning an honorable mention at the Venice Biennale, he was thrust into the forefront of the contemporary Korean art scene. He came to help popularize postmodernist discourse in South Korea through his diverse conceptual and formal practices.

In a later project entitled *The Moving Drawing of Jheon Soocheon* (2005), Jheon further promulgated ideas such as "post-conceptualism" and "relational aesthetics." Created following thirteen years of preparation, *The Moving Drawing of Jheon Soocheon* involved the artist's travel from New York to Los Angeles via Washington and Chicago on Amtrak trains over seven nights and eight days. Jheon led a symposium while traversing 5,500 kilometers in the fifteen cars of a train that had been wrapped in white polyester cloth. During this process, he conversed with more than one hundred professionals from Korea and abroad, including the art historian Song Misook and architect Hwang Doojin. The progress of the work was broadcast over the Internet and recorded on video. He explained that he used the white cloth because the color is considered a symbol of the Korean people and because it provides the fundamental background of painting and drawing. The Amtrak train referred, as he explained, to a brush moving across the North American continent, which provided both the country where he studied and "a factory that has produced cultural discourses, such as daily communication and information exchange." [12] Jheon demonstrated his cosmopolitan orientation by freely applying the vast continent of North America as a backdrop and not being confined to the geographical boundaries of Asia while not giving up his own cultural concerns. He later hoped to continue the effort through his *Global Village Drawing Project* that would travel from Busan, the southernmost port in South Korea, to Germany via North Korea. However, he abruptly died before achieving this dream.

A recipient of an honorable mention at the 47th Venice Biennale (1997), Kang Ik-Joong developed his work while living in the culturally diverse city of New York. He reflected notions of multiculturalism by drawing colorful symbols, letters, and pictures on 3-by-3-inch wooden boards. His *Buddha Singing Italian Opera* (1997) 4 and *I Have to Learn English* (1991–96) were exhibited at the Korean Pavilion at the time. Both were installations consisting of thousands of small wooden plates set in a grid-shaped arrangement on the wall. Representing inspiration from his daily life as a foreigner and member of a minority, each plate showed his openness and flexibility in the use of themes and materials.

It is noteworthy that Jheon and Kang were both influenced by Paik Nam June. Jheon interacted with Paik in New York in the 1980s, and in an interview conducted after winning the award in Venice, he gave credit to Paik in the following statement: "I constantly recall Paik's advice that an artist should not lose his or her freedom and imagination. His words lingered in my head throughout the process, making me feel confident in my decision." [13] Paik is also known to have expressed his pleasure with Jheon winning the award, proudly noting how quickly Koreans started winning awards after a Korean Pavilion was opened. [14]

Kang was also inspired by Paik, who had appeared on South Korean television in the 1980s while Kang was a college student in South Korea. Kang was impressed by the way that Paik compared his work to bibimbap, a Korean dish of rice,

5 Lee Bul, *Majestic Splendor*, 1997,
Fish, sequins, potassium permanganate, mylar bags, 360×410 cm

6 Im Heung-soon, *Things That Do Us Part*, 2019,
HD video, 5.1 channel sound, 100 min.

vegetables, and meat mixed together in a bowl. Paik often said he liked blending elements together like bibimbap. This metaphor for cultural mixing became a lesson for Kang on how to approach contemporary art practice. When Kang first came to New York to study, he began to paint on small wooden plates in the subway on his way to work at a grocery store. The plates were sized to fit his pockets so that he could carry them easily. One day he encountered Paik when he visited Kang's show and had a chance to interact with him. Despite the fact that Kang was much younger than himself, Paik

even arranged a joint exhibition entitled *Multiple/ Dialogue: Nam June Paik & Ik-Joong Kang* (1994) at the Whitney Museum of American Art. Paik's support helped Kang become active as an international performance/conceptual artist in New York.

Among the South Korean artists who have attracted significant attention within the global art world, Lee Bul stands out. One of the *shinsedae* (new generation) artists who emerged in the late 1980s, Lee gained recognition by sharply presenting gender issues and was discovered by Szeemann while he was in Korea. Lee won an honorable mention at the 1999 Venice Biennale as part of the Korean Pavilion. In the series *Majestic Splendor* (1991–), an installation of raw fish decorated with sequined ornaments, she presented a contrast between the mortality of the fish and the artificial beauty of the kitschy embellishment. 5 Due to the stink of rotten fish, the work was withdrawn from the Museum of Modern Art in New York in 1997, which only amplified its subsequent fame. Since then, through the series *Cyborg* (1997–), which focuses on hybridized women's bodies, Lee Bul has highlighted the weakness and fundamental anxiety regarding the body while reimagining and empowering women's bodies through mechanical forms and moving beyond the conventional ideas of feminine form common within patriarchal history and society. Recently, she introduced a three-dimensional installation series that seems be foreseeing an unstable future in the wake of technological development.

Most recently, Im Heung-soon took home the Silver Lion Award at the 2015 Venice Biennale. His award-winning *Factory Complex* (2014) featured scenes of workers at a Samsung semiconductor manufacturing center, factories operated by Korean corporations in Cambodia, and migrant workers' rallies in Seoul. The film poignantly demonstrated how the working conditions of female laborers in industrial complexes across South Korea and in other parts of Asia overlap and are repeated over time. His works often shed light on the marginal histories of disenfranchised people in South Korea and across the wider world.

Im seeks to create "art documentaries" that obscure the boundaries between objective facts and subjective imagination. In his practice, Im hires performers to act out scenes and links fragmented passages that show both fact and fiction, discontinuously mixing up the timeline of the past and present.

His film *Things That Do Us Part* (2019), which was recently selected for the MMCA Hyundai Motor Series in South Korea, presents the tragedies and survival stories of three real women: Kim Dongil, Ko Gyeyeon, and Jeong Jeunghwa. The film shows their lives and activities in Gwangju and other parts of Korea, Shanghai, Osaka, and elsewhere, based on their involvement in the anti-Japanese movement during the colonial period, the Jeju April 3 uprising, and the Jirisan Mountain-North Korean partisan resistance. The film repeatedly explores the tragic lives of each individual that has been neglected in the official historical record and memorializes their personal survival and pain across geographical boundaries. 6 Most recently, Im introduced *Good Light, Good Air* (2020), a work linking the Gwangju Uprising under the dictatorship in South Korea in 1980 with the atrocities committed by the Argentinian military junta during the 1970s.

The idea of a cosmopolitan artist as exemplified by predecessors such as Paik Nam June and Lee Ufan came to encompass both these aforementioned artists and others such as Kimsooja, Suh Doho, and Yang Haegue. Breaking away from entrenched cultural identities, they came to favor ideas of individual identity and artistic freedom. Maintaining a flexible attitude and extending their practice beyond the cultural boundaries of Korea and into cultures from other regions, they demonstrate a broad range of works that are not confined to their native culture.

Kimsooja has drawn attention from the global art community for her nomadic projects documenting people and cities around the world, including New York, Delhi, Shanghai, London, and Paris. She first entered the New York art scene through a residency program at MoMA PS1 in 1992, and ever since has been working primarily with installation and video work. Inspired by her experience of sewing with her mother, her work has often embraced fabric and sewing, most famously *bottari* (fabric bundle[s]) and quilting, which she uses to represent women's labor. Referring to the custom of wrapping important items in a piece of a small or large cloth, *bottari* was historically widespread in Asia as a method for women to carry goods, but has slowly disappeared with modernisation. Colorful cloth remains a material that causes people to recall pre-industrialization traditional society and contrasts with the present day where plastic containers are common. The act of wrapping things with *bottari* also symbolizes the careful touch of women who cherish the item they are wrapping.

Connecting the *bottari* culture with a nomadic ascetic, Kimsooja performed *Cities on the Move* (1997) by carrying *bottari* on a truck. The title was borrowed from an exhibition of the same name curated by Hou Hanru and Hans Ulrich Obrist. For this work Kimsooja loaded a truck with *bottari* and then sat meditatively on top of the pile as it was driven around various parts of South Korea, on rural roads and urban boulevards, over the course of eleven days. While the concept of migration allowed her to enact a fluid cultural identity in this work,

7 Kimsooja, *A Needle Woman*, 1999–2001,
Eight-channel performance video, color, silent, each channel 6 min. 33 sec.

it was further developed in a video work entitled
A Needle Woman (1999–2001) in which she moved
to various cities, such as Tokyo, Shanghai, Delhi,
London, and New York, calling herself "the needle
woman." Here, Kimsooja used fabric as a medium
to reveal women's lives and labors immersed in
materials. **7** This concern also appeared in her more
recent work, *Mumbai: A Laundry Field*, from 2007–08.
In it, she captures the lives of economically and
socially disenfranchised women in Mumbai as they
work in laundry sites, alleyways, and streets. The
work documents the collision of heterogeneous
values of global society through the lens of the
impoverished lives of women.

The artist Suh Doho has lived a nomadic life
since completing a period of study in Seoul. This
self-imposed geographical and cultural distance has
enabled him to critically revisit his experience of
his school days in South Korea, his ideas about the
Korean people, and the cultural identity of Koreans.
In his work *Who Am We?* (2000), Suh reconstructed
portraits of students in school uniforms from South
Korean high school albums, downscaling the faces
of countless people to a minuscule size and then
printing them out as wallpaper.

For Suh, the idea of home has been a consistent
key theme. Starting with reproducing his dormitory
in fabric in 1994, Suh built semi-transparent fabric
'houses,' or structures that resemble houses he
has occupied in the past and present. They range
from a traditional tiled-roof house in Seoul to
apartments in New York and London. Through
the question 'What is home?' Suh reflects his own
transcultural circuits of migration. These large-scale
productions embody notions of home, memory, and
displacement that many people today experience.

In his piece, *Home within Home within Home within
Home within Home* (2013), displayed at the MMCA,
Suh recreated a life-sized fabric version of the
building where he stayed while living abroad. Inside
it, he installed a fabric *hanok* (traditional Korean
house) that resembles his father's house in which he
had lived in Seoul. Creating a house within a house,
he presented a multilayered structure that combined
houses of the past and the present in an intersection
of corporeal reality and virtual reality. **8**

Another notable South Korean artist living a
transnational life is Kim Soun-Gui, who has been

8 Suh Doho, *Home within Home within Home within Home within Home*, 2013,
 Polyester fabric, metal frame, 1,530×1,283×1,297 cm.

435 THE GLOBALIZATION OF CONTEMPORARY KOREAN ART IN THE ERA
 OF BIENNALES

9 Kim Soun-Gui, *Interview with Jacques Derrida*, 2002,
Single-channel video, 48 min. 2 sec.

10 Nikki S. Lee, *The Hispanic Project 25*, 1998,
Digital chromogenic print on paper, 74.8×100.2 cm

active in France since the 1970s. Using various forms of photography, video, and installation, Kim asks contemplative questions crossing Eastern and Western philosophical contexts. She turns interviews with philosophers such as Jean-Luc Nancy and Jacques Derrida into videos or creates works that elicit deep philosophical questions from images from nature, such as of the moon, clouds, and mountains. **9**

Also based in France, Koo Jeong-a is another South Korean artist active in the global art world. Koo emphasizes the fluidity of her identity to the point that she provides minimal information about her past life in Korea. In her work, she creates poetic installations and video pieces using trivial objects and materials found in places she has visited.

Other artists that could be mentioned in this transnational context include New York–based Cho Seungho, who was born in Busan but has been active on major media art stages in the United States and Germany. Cho, a recipient of a Rockefeller Foundation Media Arts Fellowship, captures psychological trends and presents them within delicate video artworks that feature highly creative visual effects. Nikki S. Lee, who works mainly in Seoul and New York, came to fame through a photography project that examined the fluidity of cultural identity by performing and challenging various cultural stereotypes with costumes and social milieu. **10** She explores a wide range of different groups, from Asian high school girls to travelers and Hispanic women. Finally, Yang Haegue, who is based in Berlin and Seoul, creates new contexts for everyday objects such as fans, air conditioners, and light bulbs through her installations. By drawing together seemingly unrelated materials into new forms and constructions, Yang's work connects contemporary people's daily lives to ideas of fantasy and the grotesque. Especially interesting in this respect are her works using blinds and moving machines to create new spaces within the exhibition site. Such works show her focus on phenomenological relationships among movement, space, lighting, color, and perception.

THE SOUTH KOREAN ART SCENE AFTER THE BIENNALE BOOM

The proliferation of biennales was an inseparable driving force in the globalization of South Korean art after the 2000s. Inspired by the growth of the Gwangju Biennale, more than ten biennales were established in cities including Seoul, Busan, Daegu, and Incheon. While some of these events have since been discontinued, these biennales served to introduce international art to regions where large-scale exhibitions had been uncommon. Some of the biennales led by local artists associations or local governments in South Korea have arguably grow formulaic over the years and lost their original novelty and creative impetus in the process of seeking differentiation in their medium of focus, such as media art, sculpture, ink painting, or photography. Like many biennales around the globe, such events have often degenerated into a form of civic branding and promotion in an era of competitive market-driven neoliberalism.

Biennials are losing their role in provoking new creative forces in themselves and furthering the discourse of contemporary art. Since the budgets of most biennales are determined by local and central governments, it is too often difficult for organizers to avoid bureaucratic modes of evaluation in gauging an event's success, using metrics such as the number of visitors. It would require further study in the future to evaluate the degree to which these biennales have turned into large-scale spectacles and how this has contributed to the development of South Korean art in the 21st century.

Today, the government remains the major impetus for the globalization of South Korean art. This governmental support is not limited to financing biennales, but also applies to national and provincial art museums and art fairs. The Asia Culture Center, which was established in Gwangju where the Gwangju Biennale is held, is an exemplary state-led project. In 2006 the South Korean government declared Gwangju to be the "city of Asian culture hub" and to date has provided over a trillion won to operate projects for sharing common values by showcasing the diverse art and cultures of Asia. To vitalize distribution in the art ecosystem, the Korea Arts Management Service was established in 2006. This service provides support for alternative art markets, artists' or galleries' participation in international exhibitions or art fairs, the publication of Korean art-related books, and more. It was within this context that Dansaekhwa gained popularity in overseas art markets. It is fair to say that the governmental support of cultural structures and their overall operation has helped spark international interest in South Korean arts.

Globalization is now an ongoing process in the private sector. Major museums in the U.S. and other nations are organizing contemporary Korean art exhibitions and international galleries are coming to Korea: The Pace Gallery, Lehmann Maupin, and Perrotin have established branches in Seoul. The latest news is that the celebrated international art fair, Frieze, will be held in Seoul in the fall of 2022.

South Korean art today seems to have settled down after the initial shockwaves of globalization, at least on the surface. However, it is uncertain

whether the idea of globalization has properly taken root in the South Korean art community. Numerous artists feel isolated from the benefits of a system that revolves around a few celebrity artists and showcase venues. Art students still face disparities in art education depending on the region in which they study. The professional environment for curators and critics is another highly unstable aspect. They are constantly driven into either the market-oriented art world or the practices of institution-centered art administration, leaving little space for autonomy and creativity.

1 Heo Wonsoon, "Segyehwa hangeulbareum pyogi" [Phonetic Transcription of Globalization in Korean], *Kyunghyang Shinmun*, March 7, 1995, 5.

2 Song Misook, "Hanguk yeondae misulsaui sanghwanggwa isyudeul: 1988nyenbuteo 2002neyonkkaji" [The Situation and Issues in the History of Contemporary Art in Korea: 1988–2002], *Johyeongji* 2 (2002): 2.

3 Cho Eunjung, "Oegungmisul gungnaejeonsi 60nyeonjeon" [60 Years of Exhibitions of Overseas Art in Korea], *Art In Culture*, July 2012; Kimdaljin Art Archives & Museum, *Oegungmisul gungnaejeonsi 60nyeon: 1950–2011* [60 Years of Domestic Exhibition of Foreign Art: 1950–2011] (Seoul: Kimdaljin Art Archives & Museum, 2012), 232.

4 Lee Yil, "Asia taepyeongyang jiyeogui hyeondae misure daehayeo" [On Contemporary Art in the Asia-Pacific Region], *Lee il misulbipyeong ilji* [Lee Yil Art Criticism Diary] (Seoul: Mijinsa, 1994), 291.

5 Jung Hun-Yee, "Misul" [Art], in *Hanguk hyeondae yesulsa daegye VI: 1990nyeondae* [Korean Modern and Contemporary Art History VI: the 1990s], eds. Korea Institute of Arts (Seoul: Sigong Art, 2005), 235.

6 Kim Seongho, "Taepyeongyangeul geonneoseo, oneurui hanguk misuljeon: Hanmi du naraui sahoesang jomyeong" [Across the Pacific: Today's Korean Art Exhibition Highlighting the Societies of Korea and the United States], *Seoul Shinmun*, August 24, 1994, 14.

7 "Munhwa sosik" [Culture News], *Dong-A Ilbo*, December 11, 1960, 4.

8 Yongwoo Lee, "Invention of Visionary Language: The Heroes of the Korean Pavilion at the Venice Biennale," in *Korean Pavilion 2013* (Seoul: Arko, 2013), 13–14.

9 Jang Sunwook, "Gwangju biennalle 20segi hanguk misulsa yeonghyangnyeok 1wi jeonsihaengsaro kkopyeo" [The Gwangju Biennale is Considered One of the Most Influential Exhibitions in the History of Korean Art in the Twentieth Century], *Kookmin Ilbo*, August 5, 2015.

10 "World's Top 20 Biennials, Triennials, and Miscellennials," *Artnet News*, May 19, 2014, accessed February 24, 2021, https://news.artnet.com/exhibitions/worlds-top-20-biennials-triennials-and-miscellennials-18811.

11 Kim Moonsoo, "Sokdowa yeongwandoen dongyanggaenyeomeun mul: Haraltu jeman sokdojeon keomisyeoneo" [The Eastern Concept Related to Speed Is Water: Harald Szeemann, Commissioner of the Exhibition Speed], *Yeongnam Ilbo*, August 22, 1997, 17.

12 Jang Junseok, "Jeonsucheonui yesulsegye" [The Art World of Jheon Soocheon], *Gyeonggi Sinmun*, April 10, 2007.

13 Cho Yangmin, "Beniseu biennalle teukbyeolsang susang jeonsucheonssi inteobyu" [Interview with Jheon Soocheon, Winner of the Venice Biennale Special Award], *Dong-A Ilbo*, June 13, 1995, 17.

14 Lim Yeoncheol, "Beniseu biennalle teukbyeolsang susang jeonsucheonssi hangnyeokjungsi hwadan hangye neukkyeo yuhak" [Jheon Soocheon, Recipient of the Venice Biennale Special Prize, said, "I studied abroad because I felt the limitations of Korean art circles' emphasis on academic background], *Dong-A Ilbo*, June 18, 1995, 11.

Korean Art and Public Life Since the 1990s

Shin Chunghoon

BEYOND THE COLD WAR ORDER

The 1990s witnessed a range of profound social and historical transformations. A series of revolutionary changes took place in Eastern Europe and the Soviet Union, marking the end of communism in Europe. In South Korea just prior to the start of the decade, the democratic movement toppled the military dictatorship, achieving formal democracy, including direct presidential election. Such rapid change in domestic and international circumstances heralded a major transition from the Cold War order. This shift also brought a marked change to the Korean art world, destabilizing the Manichean dichotomy of "modernism" and "realism," one which had become stronger in the 1980s when Minjung art activism with a turn to figuration was on the rise and had undertaken a direct confrontation against the mainstream art practice of art-for-art's-sake modernism. A stark example of this change can be found in the fact that during the 1990s artists and critics from both sides of the debate made attempts at organizing exhibitions together. However, just as the exhibition *Young Vision—Suggestion for Tomorrow* at Seoul Arts Center in 1990 was embroiled in a controversy about political pressures brought to bear on it, and the exhibition *A View in the Change of Art* at Kumho Art Museum in 1991 was organized by only 'modernist' critics, these unsuccessful attempts at "détente" arguably confirmed the deeply ingrained structure of the critical divide. Yet changes were under way on a more fundamental level. Given that the Cold War structure of the 1980s within the Korean art world had been maintained by the two opposite sides whose intellectual legitimacy was apparently justified by the other's shortcomings, what emerged in the new era were various attempts to navigate the in-between space. Each faction critically reflected on its own position, emulated the concerns of the other, and strived for its renewal in

conjunction with changes in objective conditions and the zeitgeist. Given that Korean art seemed to have completed a single cycle of a pendulum movement between the conceptual concerns of modernism and realism, artists were given the task to examine the gains and losses of both perspectives and to sublate their own position in reference to the other. If artists had been forced to choose either "art" or "life," now they had to reconsider what it is to produce "art," what its relation to "life" should be, and how to seek a delicate and productive relationship between the two concerns.

With this task in mind, Korean art faced rapidly changing political, economic, social, and cultural conditions in the 1990s. The 1987 June democratic struggle was followed by the Great Workers Struggle of July-September and direct presidential elections in December. This historical unfolding seemed to announce the restoration of democracy, but it did not result in the immediate arrival of democracy. There were noticeable signs of the emergence of a "mass consumerist society," "post-Fordism," or "post-industrial society," yet these did not fulfill the promise of prosperity. In addition, the 1988 Seoul Olympics, the liberalization of overseas travel, and the catch phrase "the world is wide and there is lots to do," all reflected the national excitement about globalization, but this sentiment was defeated by the economic concessions forced through the Uruguay Round of the World Trade Organization (1986–93) and the humiliating bailout plan by the International Monetary Fund (IMF) following the 1997–98 Korean Financial Crisis. The tragic collapse of Seongsu Bridge and Sampoong Department Store in 1994 and 1995 respectively were further viewed as an omen of the catastrophic end that would close out the euphoric 1990s, which had started off with the hope of democratization, globalization, and the

rise of the middle class. Then, on the threshold of the new millennium, Korean society underwent an irreversible shift toward neoliberalism. This historical sketch, as rough as it may be, is offered to suggest that the 1990s was a period as turbulent as any other in the twentieth century.

Yet the expression "turbulent time" fails to explain what distinguishes the 1990s from any previous era. The decade witnessed so-called "First World" signs of prosperity, facilitating the widespread perception that Korea was no longer just a third world country. The country seemed to be positioned in all temporalities—the past, present, and future. However, the growing sense of "simultaneity of the non-simultaneous" soon gave way to a sense of the homogeneity of space-time, in which the simultaneity of disparate things disappeared, and these disparities became homogenized. This new and unprecedented world provided a challenge as well as an opportunity for Korean artists, all the more since the two gravitational forces—realism and modernism—had lost their previous power.[1]

ART AFTER MINJUNG ART AND POST-MODERNISM

The fast-changing political circumstances in Korea and abroad at the turn of the 1990s posed a serious challenge to the Minjung art ("people's art") camp. Surely there was a heightened confident anticipation of social change in the late 1980s due to the ongoing efforts of the pro-democracy movement and workers' struggles. Minjung art also developed innovative approaches in using a variety of mediums, including posters, banner paintings, murals, flags, engravings, placards, funeral materials, publications, floor paintings, stickers, and household items, enhancing the art's site-oriented potential and reorganizing its direction toward empowering "workers" as the historical subject instead of "people" in general. The anticipation of revolutionary change alone, however, does not explain the radical, even militant, turn of Minjung art in the late 1980s. Rather, such a turn can also be explained as an alert response to the evolving sophisticated forms of political control, the "flexibilization" of both capital and labor, and the rise of the so-called postmodernist tendency within art that was largely viewed as compromising and evasive. Entering the decade of the 1990s, however, the fast-changing situations in and out of Korea weighed more towards a sense of urgency than excitement among Minjung artists, which contributed to the art movement's turn away from radicalization and towards demanding self-reflection.

In fact, within the Minjung art camp, previously marginalized qualities such as artistic integrity and technical perfection were subject to serious reconsideration. As the urgency of political engagement dissipated, Minjung art stripped itself of any semblance of historical legitimacy and moral superiority and lay bare its formulaic style and jaded slogans. The changed atmosphere among Minjung art practitioners is evident in Choi Minhwa's statement in 1990, in which the artist urged his colleagues to throw the "blind knife of morality and conscience" and pursue "quality improvement."[2] Indeed, in July 1987, Choi had painted *Your Wakeful Eyes* overnight for Lee Han-yeol's funeral, mobilizing violent forms and cacophonous colors in order to incite people in their raw immediacy of anger and grief. Produced around 1990, however, his *Vagrancy* series presents a pastoral scene, in which the emotional eruption of the 1980s is settled. Within this work, saturated with brown and pink monotones, coyly smiling figures are seated outdoors in nature as they offer a song of recollection and solace to the wind. **1** This is a portrait of the artist himself in which the archetype of a romantic artist, which had been forced out to the political battlefield during the 1980s, returned in the form of a bohemian vagrancy.[3] This sensibility captured the attention of many Korean artists of the time who had also withdrawn from the frontline of the political battlefield, but could neither return to the studio nor proceed to the market.

Choi Gene-uk's series *Beginning of the Painting* differently responded to the demands of the era. His *Thoughts and Painting* (1990) focuses on the artist's studio filled with plaster cast sculptures and canvases and is depicted with swift, bold brushstrokes in black and white monotone. **2** The work seems to offer the artist's own answer about realism in seeking little truths which one could be held accountable for, rather than invoking any grand principle of the vast world.[4] Although Choi later would paint the world outside the studio, his paintings resisted a totalizing subjectivism by presenting the world in juxtaposed heterogeneous fragments, as in the case of *Returning from School II* (1991), *Words from Grandfather* (1991), and *Morning Dew* (1993). Whether relative to Choi Minhwa's conversion or the increased critical attention paid to Choi Gene-uk, such shifts in emphasis within the former practitioners of the Minjung art discourse suggests there was a concerted attempt to realign the relationship between art and the rapidly changing world. For some Minjung artists, this realignment was viewed as returning to "gallery art" in the wake of heyday of the revolutionary "protest art." Rather than a surrender, it was also positively understood as an attempt at renewal. In this regard, Sung Wan-kyung called into question the "conservative understanding of 'gallery art'"

1 Choi Minhwa, *Vagrancy*, 1990,
Oil on canvas, 87×184 cm

2 Choi Gene-uk, *Thoughts and Painting*, 1990,
Acrylic on canvas, 228×182 cm, 182×228 cm

prevalent within Minjung art discourses, and urged Korean artists to understand and appropriate the vitality, compatibility, and flexibility of the art establishment.[5]

The self-reflection and renewal in Minjung art practice also took place in another manner. The expansion of the medium, manifest in the various attempts to employ popular media in artistic practice, was meant to increase public accessibility to dissident political messages. Furthermore, this expansion served to shift the focus of political art toward intervention in the means of visual production without being bound by the false dichotomy of content and form. The emergence of such a perspective owed much to new intellectual and cultural references such as "The Author as Producer" (1934) by Walter Benjamin and the music video *The Wall* (1982) by Pink Floyd. Political art was now not limited to traditional mediums like painting and sculpture, nor to "guerilla" mediums of protest art, such as posters and banner paintings. It rather expanded into the realm of popular or mass media, such as comics, photography, publications, video, film, and animation. This tendency is evident in the following cases: *Workers—Steel, and the Light of Tears: A Photograph Collection of the Great Worker Struggle, November 14, 1988–November 12, 1989* and *Workers of the World, Answer, 1991*, photo books by the Photo Collective for Social Movement that dealt with the defeat of the heroic workers' campaign of the late 1980s so as to transcend documentary photography into the realm of propaganda; *The Sanggye-dong Olympics* (1988) by Kim Dong-won, a video narrating the disruptive process of the city beautification campaign in preparation for the Seoul Olympics and the protests of the people it displaced; and *Labor News* (1989–92) by Labor News Production (Nodongja neuseu jejkdan), which produced and distributed news about labor disputes largely neglected by the mainstream media, as well as video works by Oh Kyung-hwa, comics by Park Jae-dong and Choi Jung-hyun, and photomontage by Park Buldong.[6]

If Minjung art practitioners directed their attention toward artistic sincerity, aesthetic concerns, and mediatic experimentation, all of which recall the long-standing approaches of modernism, the rest of the art world continued to address the changes in contemporary society beyond the narrow confines of the art world. This concern could already be detected in the mid-1980s, when art collectives such as TARA, Nanjido, and Meta-Vox presented their installations composed of materials and objects that evoked mythological motifs, urban debris, and the "remnants of civilization."[7] However, more concrete and persuasive approaches to the fast changing nature of Korean society came from various art collectives,

whose practices came to be called "New Generation Art" (Sinsedae misul) in the early 1990s.[8] Their exhibitions included *Museum, UAO, Golden Apple, Sunday Seoul, Underground, Off & On, Made in Korea, Bio Installation, Show Show Show*, and others. Working in various mediums and genres such as painting, photography, installation, performance, design, and architecture, these groups of artists in their 20s and 30s were drawn to heterogeneous found images and ready-made objects, as manifested in Kho Nak-Beom's mannequin, Myeong Hye-kyeong's plastic bucket, Lee Hyeong-joo's enlarged insects, Jang Hyung-jin's toys for kids, and Choi Jeonghwa's medical devices and fake foods for display. Largely described as "pluralistic" or "post-modernist," these works revealed such qualities as the lack of a shared goal or narrative, disobedience to the establishment, affirmation of popular tastes, a casual approach to art, and sensuous self-indulgence. They were either criticized as having abandoned the progressive zeitgeist of the 1980s or affirmed as foreshadowing the advent of a new society. "Hamburger and Firebomb"—the title of an exhibition review of *Golden Apple*—usefully summarized the two different cultural milieus that nurtured these artists' generation.[9] Indeed, their art making took place under the tension between Minjung culture after its heyday and the consumerist culture on the rise. This new generation of Korean artists seemed to retreat from the streets of Jongno and Myeongdong into the underground of Sinchon and Hongdae. This was considered irresponsible, even escapist, behavior at the beginning.[10] But, as fatigue towards dissident culture grew and as the belief that the simple representation of "reality," "Minjung," and "history" would automatically guarantee political effectiveness became obsolete, a lighthearted approach to art was considered to be more honest and even political than the doctrinaire approach. Subsequently, "New Generation Art" became a major trend in Korean art that the even critics of Minjung art could not dismiss.[11]

BETWEEN EUPHORIA AND FOREBODING: CULTURE, EVERYDAY, MEMORY

In the early 1990s the grand narrative of Minjung art and modernism gave way to new keywords such as "culture," "everyday" and "memory." Although the idea that life matters in art was the lesson from the 1980s, life no longer seemed to be in a historical turmoil as it had been before. Apparently, the 1990s faced the period of relaxation and relief following that of tension and conflict. Yet the idea of Korean art as public intervention, something that had coalesced during the 1980s, emerged to examine and uncover the ideological forces operating in a more invisible and unconscious way within the

changed society.

This approach is manifested in a series of exhibitions, including *City Masses Culture* (1992), *Apgujeong-dong Utopia Dystopia* (1992), and *Self-Reflection on Art* (1992), all of which were organized by members of the Research Society for Art Criticism (1989–93). Given that this collective had established itself in the late 1980s to empower Minjung art through partisan activism, these exhibitions signaled a volte-face in the role of the art movement from revolutionary vanguard to a cultural guerilla. This was a response to the socioeconomic change largely described as "mass-consumerist," "post-fordist," or "post-industrial," in which culture and aesthetics now served to create desire, becoming instrumental to the realization of profit. This understanding allowed Korean artists to view the everyday as new sites of conflict and intervention. It is no coincidence that many works in those exhibitions took the form of photo-text collage or photomontage, employing ready-made images and words from commercial advertisements and public campaigns. For *City Masses Culture*, Hwang Se-Jun created anarchic, profane montages by incorporating images of the Korean flag, a contraceptive device, a toothbrush, and pages taken from the Bible and *The 120 Days of Sodom*, thereby deriding dominating sources of authority such as capitalism, the nation, and religion. Jo Kyoungsook employed the style of advertisements in her *Staged Body* series (1992), in which a photograph of a woman taken from an advertisement is juxtaposed with that of the artist herself simulating the advertisement scene, between which a text narrating women's experience in a cliched manner is inserted. ⎯3⎯ In so doing, the work uncovers and defamiliarizes the very condition that the experience and identity of women are always mediated by representation. These artists here operated less as makers of art objects than as manipulators of signs. Public symbols and media images were disarticulated from their signification in the dominant ideology, and this process turned them against themselves into new subversive signs. Here, the artists as "sign-manipulators" recycled language of the dominant culture rather than introducing that of dissident culture, invited active readers rather than attempted to deliver fixed messages, and hoped to address a wider public through exhibition-related publications, following the normative path of distribution. All these approaches constituted a departure from the practices of Minjung art and a deliberate entry into a renewed critical engagement with the Korean art establishment.[12]

Such montage and collage works offered a possible new breakthrough. Fighting the dominant ideology on its own terrain and with its own weapons was deemed a viable and effective

approach, especially when there seemed to be no outside from which the dominant culture would be transformed or subverted.[13] However, many composite images of the early 1990s remained largely within the binary opposition of friend and foe. Rather than deconstructing it, the opposition fueled the political and critical sharpness of condemnation. This is evident in *New Colonial Monopolitics Capitalism* (1990), an aesthetically subversive and politically agitational photomontage by Park Buldong, in which money and armed forces build up a sky-high citadel of power in order to protect against an uprising from below. ⎯4⎯ This work retained the belief that art could claim to offer a transparent idea of reality and the expectation that art could transform the world by telling the truth about oppression.

Yet such a belief or expectation in art came rapidly under scrutiny. In his *Self-Portrait* (1989) Yoon Dongchun displayed a clear acrylic box containing paints and art magazines inside, on which three sets of objects were placed: a rice bowl filled with a mixture of rice and bugs; a dog's bowl of acorns; and a tiny dish and a con man's dice. In offering up these things, Yoon spoke to the parasitic, outcast, and deceitful status of an artist

4 Park Buldong, *New Colonial Monopolitics Capitalism*, 1990,
Photograph, collage, 91×62 cm

5　Yoon Dongchun, *Ideology—Left-Right Coalition in a Trash Can*, 1994,
　Dyed tissues, trash cans, event barriers, 300×300×900 cm

in contemporary society in a cynical, self-mocking manner. In his *Ideology—Left-Right Coalition in a Trash Can* (1994) Yoon divides the space in half and spreads colored tissue papers on the floor, one side with red and the other with blue; in the middle of each section stands a garbage can filled with tissue papers of the corresponding color. Another garbage can is placed at the center of the work on the border between the two sections of red and blue, stuffed with tissue papers of both colors. **5** The work's area is marked by brass stanchions and velvet ropes as if there is something important taking place inside. Showing there is only the left and the right, no grey zones, this exaggerated spectacle seems to narrate the clarity as much as the rigidity of the bifurcation that denies "in-between spaces" and the impossibility of national unification, as much as the aspiration to unify. It also questions the irrationality of the black-and-white political logic that so many people used to depend on. Such an ironic and cynical approach had been deemed as discouraging and unproductive in the 1980s. But as sincere belief became mere political dogma in the changed social and cultural conditions of Korea, it came to be viewed as honest and responsible.

In the early and mid-1990s, images and objects of everyday life were subject not only to suspicion but also to indulgence. Through his wide range of cultural practices encompassing installation, photography, performance, book design, and interior design, Choi Jeonghwa unpacked his own visual

and material archives that he himself had collected since the mid-1980s. Indeed, plastic colanders from a marketplace, cabaret posters from Yeongdeungpo, tarpaulin tents from a typical street food stall (*pojangmacha*), and cement stairs from shanty towns were presented as unassisted readymades or in a minimally modified manner, showing his affection for cheap and tacky images and materials. **6** His work evoked the suspicion that Choi was engaged in a self-indulgent and nihilistic gesture through his practice, and even fueled the criticism that he was complicit with commodity aesthetics (all the more since Choi won fame for his interior and brand identity design before attracting attention from the contemporary art scene).[14] Proponents of Choi's work, however, found Andy Warhol's criticality rather than Jeff Koons' sleekness in Choi's pop aesthetics, as it is possible to understand his low quality materials, tacky objects, and outmoded design as psychologically charged, historically referential, and politically associative. His work was thus construed as an allegory of the frailty of Korea's compressed modernity, a panegyric on the aesthetic and political potential of vernacular and "anonymous" design, or an illumination that outmoded things can trigger involuntary memories and serve to critically defamiliarize the present.[15]

What can be called kitsch or the vernacular attracted wide attention from Korean artists. Art historian Jung Hun-Yee has succinctly defined the art of the 1990s as a melodrama between two

6 Choi Jeonghwa, *My Beautiful 21st Century*, 1993 (remade in 2019),
Mixed media, dimensions variable

pathological dispositions. On one side there was the "manic" sentiment of Choi Jeonghwa and Lee Bul, who would question the public: "Yes, we are delinquents. So what?," and on the other side there was Bahc Yiso, who put his finger on the pulse of the melancholy and futility that lurked behind the manic sentiment.[16] Despite this insightful distinction, a common denominator was the investment of all these artists in kitsch and vernacular aesthetic devices. Composed of lumber, planks of wood, vinyl, linoleum, and fluorescent lamps, Bahc's installations such as *Don't Look Back—Not Until the End of Development* (1998), *As an Escape* (1998), and *No Title Yet* (2002) looked like messy construction sites. Visitors would simply acknowledge, with neither intellectual pretension nor aesthetic expectation, their being-together with these non-heroic, casual structures, which engendered the experience of putting themselves at ease or consoling themselves. Made with "low" quality materials that are not unfamiliar,

Bahc's "relaxed" structures reveal an unexpected commonality as much as the profound difference between the "conceptual" Bahc Yiso and the "sensuous" Choi Jeonghwa and Lee Bul.

A growing fascination with everyday images, objects, and materials of the modern city shows how the art of the 1990s was engaged with the historical turn of the era. Above all else, this fascination can be understood as a post-Cold War gesture that rejected both "modernism" and Minjung art in terms of refusing any serious, even heroic, stance toward art. And the use of urban detritus and outmoded objects seems to have formed a delicate critique of "planned obsolescence," the periodic redesigning of a product to stimulate repurchasing in the context of mass consumerist society. Moreover, the investment in kitsch and the vernacular should be read as a viable strategy by which to meet the demand for "Koreanness" from the post-1990 art circuit driven by globalization and art biennials, without lapsing into stereotyped

images and ideas of national tradition.

In addition, we can also understand how Korean artists worked with a particular sense of temporality at that moment. In fact, in the 1990s the gaze of Korean people seemed to turn backwards ever more frequently, putting an end to the long-time national and individual tendency to be engaged in a blind sprint towards the future. On the one hand, following the formal end of authoritarian rule, the inauguration of President Kim Young-sam's civilian government (1993–98) gave rise to an eruption of revelations, testimonies and confessions relating to the recent past, a revelation of what was repressed during the oppression of Japanese colonialism and Cold War-period dictatorship. On the other hand, memories distinct from traumas began to occupy in cultural imagination of a new generation, who recalled the past through popular and material culture as much as political and social upheavals. In this regard, whether in terms of repressed memory or bittersweet nostalgia, the past became a popular subject for movies, television series, and music videos, contributing to the burgeoning Korean culture industry in the 1990s. In his *Black Box: The Memory of Cold War Images* (1997) and *Sets* (2000), Park Chan-kyong addressed the dialectics of remembering and forgetting in a world of mediation and simulation.[17] Both installations use slide projection to show various representations of the Korean war and the Cold War regime. The images displayed include those from mass media such as film, advertisements, posters and newspapers and from photographs that the artist himself took at a war memorial and a military training center. These works facilitate reflections on the paradoxical moment at which the increase in historical representation served to promote distance rather than greater access to the past, and fostered feelings of oblivion rather than remembrance. If Park's approach toward memory was cerebral and deconstructive, Bae Youngwhan's was emotional and visceral. On a canvas, Bae arranged hundreds of small, white, round pills in order to write down the lyrics of *The Spring Time of Life*, a 1981 song by

7 Bae Youngwhan, *The Spring Time of Life*,
 1999, Mixed media on canvas, 162×134 cm

the popular modern rock band Sanulrim, and then punctuated the song lyrics canvas with fragments of absorbent cotton tainted with a reddishbrown color (evoking blood or "red pills") and crushed caps of soju bottles. 7 In this work, memories are summoned as wounds, as much as they engender nostalgia, while the overt use of pop culture invites the audience into a critical subculture of breakaway and misconduct.[18]

Korean art in the 1990s saw an engagement with a mass or popular culture that was overflowing in accordance with the underlying socioeconomic changes. But it also may be argued that Korean art took a "post-Minjung" attitude in relation to the emergence of the "postmodern" condition. The materials used for this kind of art were things that are ordinary, tacky, modest, and readily available. The subjectivity of the artists was no longer that of Minjung or workers, nor did they claim to be citizens. Rather, they proclaimed themselves as "vagrants," "punks," and "delinquents," showing their aspiration not to be compromised by the dominant social and political norms while not relying on ideological faith or demanding total sacrifice as before. This self-orientation toward the social or cultural other echoed the model of "the artist as ethnographer," seeking the outside as the Archimedean point of leverage to transform the status quo, and offered a quite different creative approach from that which defined the 1980s.[19]

THE NEW MILLENNIUM IN THE WAKE OF CATASTROPHE: "POST-MINJUNG," PUBLIC ART, AND NEOLIBERALISM

In Korean art, the idea of the "1990s" ends a little earlier than the decade that it literally refers to. The tension between euphoria and foreboding prevalent in the early and mid-1990s came to an abrupt end with the economic crash in Korea that followed in the wake of the 1997 Asian financial crisis. The subsequent IMF relief loan and neoliberal restructuring of the national economy caused an irreversible transformation to Korean society. Of course, the socioeconomic collapse did not simply induce the collapse of artistic production. Although financial difficulties forced art institutions to close or scale down, and artists to quit traveling or studying abroad, the catastrophe rather became a chance for reform. Several alternative spaces appeared at the turn of the new millennium, including Project Space SARUBIA, Alternative Space LOOP, Art Space Pool, Ssamzie Space, and Insa Art Space, and a great number of artists living abroad took this opportunity to introduce their works to the Korean public, as manifested in the exhibition '98 Seoul in Media: Food, Clothing, Shelter

in 1998. However, Korea's massive socioeconomic transformation engendered a structure of feeling that was clearly distinguished from the "1990s," which had started off with the rosy picture of democracy, globalization, and the promise of the middle class. The socioeconomic shock from this catastrophe, the threat of displacement, and the experience of being uprooted now became the major forces driving the production of Korean art at the turn of the new millennium.

In response to the financial crisis, Kong Sunghun moved to Byeokje on the outskirts of Seoul, where he began to paint the dogs bred near his house for human consumption. In one such image, at night, when the dark swallows the light, a dog is pictured reacting to a man who holds a camera as he stands in front of a streetlight. 8 Individual forms are dissolved into the surge of the dynamic of dim light and atmospheric shadow. Rendered with smooth brushstrokes of dark red, brown and black, the chiaroscuro depth and the glossy paint surface make the painting look mesmerizing and artificial. This technique amplifies the sense of anxiety and tension set in a landscape that is both familiar and unfamiliar at the same time. Here, it is plausible that the artist might have felt sympathy for the subject, a dog helplessly left to a tragic destiny. The depth and intensity of emotion the painter used to experience through the ominous nights in a remote area seem to have driven him into a new, dense and subtle painterly style. This was a distinct change from the concern with institutional critique and technological art practice that defined his work during the 1990s.

The socioeconomic catastrophe, however, also increased the demand for socially engaged art practices on a more collective level. Keywords from the 1990s such as "culture," "everyday," "memory" gave way to "politics," "society," and "history." The oppositional legacy of Minjung art activism, which seemed to have passed into history through its canonization within large-scale retrospective exhibitions, including *The 15 Years of Korean Minjoong Art: 1980–1994* (1994) and the first Gwangju Biennale (1995), became reinvigorated. The critical and interventionist mode of Korean art in the post-Minjung era, however, was by no means a simple restoration of Minjung art. Rather, it attended to lessons and strategies developed in the 1990s.[20] This is most evident in the work of the Seongnam Project (1998–99). Organized by Kim Taeheon, Park Yongseok, Park Chan-kyong, Im Heung-soon, Cho Ji-eun, and others for Kim's 1998 solo exhibition *The Destruction and Becoming of Space: Between Seongnam and Bundang.* In this project, the art collective explored the city of Seongnam on the outskirts of Seoul to excavate its tumultuous history and illuminate contemporary processes of urbanization. Seongnam

8 Kong Sunghun, *A Dog*, 2000,
Oil on canvas, 130.3×162.2 cm

was first built as a makeshift shanty town for those evicted from a large-scale slum clearance program in downtown Seoul in the late 1960s. The forced relocation without providing adequate infrastructure sparked the Gwangju Settlers' Riot in 1971, arguably the first urban riot to occur under the Park Chung-hee regime. The new residential area then came to be considered an "old town" in the 1990s, when "Bundang New Town" was built in the southern part of Seongnam to accommodate middle-class residents from Seoul. Focusing on the disparity between the two urban sites in terms of economic, social and cultural conditions, the Seongnam Project addressed issues such as exploitation, eviction, and uneven development. Although this was exactly the kind of thing that Minjung art had sought to deal with, the tone here had changed. By taking the form of text, diagrams, photography, archives, video, and installation, the research-based practice now, here, departed from an accusatory or polemical tone in favor of the fact-finding and poetic gesture common to minimalism and conceptual art. 9 In addition, the Seongnam Project shared an enthusiasm for the vernacular

characteristic of the art of the 1990s, but carried this with a distinctive political undertone. Its photographic documentation entitled *Inhabitants' Art* elevated anonymously designed structures and objects found in the old town, such as temporary awnings, parking barriers, and improvised stairs as objects of both aesthetic consideration and political imagination. By contrast, the Seongnam Project also produced photographic and textual records concerning officially commissioned "public art" in the city, showing that only a few local artists monopolized the commissions and their sculptures followed formal designs which were completely unrelated to the history and character of the local area. In this regard, the collective asked the rhetorical question of which "art" practice better deserved the title of "public art."

In a similar vein, the artist collective flyingCity (2001–) focused on the Cheonggye Stream Restoration Project (2003–2005), a local government-led urban regeneration project promulgated under the banner of the ecological restoration of an urban waterway. Starting with the removal of the 1960's elevated expressway and

9 Seongnam Project, *Seongnam Modernism* leaflet, 1998

10 FlyingCity, *All-things Park*, 2004, SPF wood, styrofoam, AL pipes, inkjet prints on synthetic fabric and all sorts of crafts material, dimensions variable, Part of *Drifting Producers* (2003–2009)

road that had paved over the Cheonggye Stream the project received a warm welcome for its departure from modernist imperatives such as "efficiency," "productivity," and "smooth flow" toward the new millennial concerns of "environmental friendliness," "quality of life," and "historical preservation." However, the collective delved into the hidden continuity between these two dynamics, which was reclaiming of the city center of Seoul for urban elites. *All-things Park* (2004) was a piece of visionary architecture for a "theme park" where visitors would make new artifacts with the help of skilled metalworkers and resourceful street vendors, whose right to the city was threatened by the purported "public" urban project. **10** Suspended above the floor and made of plywood, Styrofoam, wires, and other cheap materials, the structure manifested its utopian aspirations and reflected the "low-tech" industrial environment of the local area. As a voluntary proposal for the city government's schematic plan for redeveloping Dongdaemun Stadium, flyingCity's project did not come to fruition (the site was given to Zaha Hadid for her Dongdaemun Design Plaza (DDP) in expectation of the "Bilbao Effect"). Yet the experimental design provided a viable model for an interventionist art practice in the post-Minjung era.

The public intervention and participation in artistic practice took on renewed urgency at the turn of the new millennium. With the burgeoning of collaborative, archive-based artistic research projects involving local communities, these new practitioners came up with various strategies, including a melancholic collection of discarded objects, an exhaustive cataloging of anonymous designs, and a raucous occupation of public space, as well as various kinds of workshops and publications.[21] Their public engagement and collaborations were not merely conditioned by a local "post-Minjung" impulse; it was also a wider global phenomenon. Indeed, within the global contemporary art scene, there was a widely heralded return to socially engaged art—whether it was labelled "social turn" or "new genre public art"—that emerged against the background of the collapse of communism and the full-fledged launch of neoliberalism.[22]

However, this local emergence of such collaborative, site-specific practices that positioned art in relation to the wider public interest should also be understood in relation to the more specific context of the proliferation of public art discourse and practice in the 2000s. In Korea at this moment, "public art" became a critical buzzword while the practice of "public art" was one of the most noticeable trends. Whether it was art in public places, art as public space, or community-collaborative art, the proliferation of

public art was more than the byproduct of artists' own beliefs or decisions; rather it owed much to greater administrative and financial support from the government and the capital sector for such work. This is most evident in the series of government-sponsored "public art" projects such as the Anyang Public Art Project (APAP; 2002–) by the city government of Anyang; City Gallery Project (2007–2010) by the Seoul Metropolitan Government; and Art in City (2006–2007) and Maeul misul Project (2009–), both organized by the Ministry of Culture, Sports, and Tourism of Korea. These events, promoted under the banner of public value or community interest, seem to be highly meaningful actions in a neoliberal era when all domains and activities are marketized, and in which privatization, deregulation, and cutbacks enforce "survivalism" and negatively affect the progressive development of the social realm.[23] Yet, in this context, it is also worth noting the argument that such public art events and projects serve as a flexible and sophisticated technology of neoliberal governance. According to this line of thinking, cultural practices with good intentions and even progressive aspirations become a marketing tool for local government and furthermore take over the government's role through promoting the ideas of communal self-help and spontaneous creative effort to ameliorate urban decay.[24] Given such critiques, the key issue now is perhaps to revisit the very nature and meaning of "the public," "publicness," and "community," and to reconsider how Korean art is engaged with these renewed ideas.

In this context, the single channel video *New Town Ghost* (2005) by Lim Minouk and the site-specific installation *Sadong 30* (2006) by Yang Haegue are remarkable works. **11 12** In both projects, the artists headed to local areas that had suffered drastic transformation: Lim to Yeongdeungpo, which had been the largest factory district in Seoul but was recently transformed into a "new town" with department stores and high-rise apartment complexes; and Yang to an old district in Incheon, which once had been the city's central part but had now fallen into neglect. Their foray into these turbulent urban spaces sought to mobilize the affective force of sound and "things" rather than the referential quality of archives and documents. In addition, their works are far removed from being efforts to empower the local community and represent its voices. If there were any local associations involved, then those were more likely to be produced by the work itself. In Lim Minouk's video, a short-haired woman holding a megaphone performs a rap about modernization, redevelopment, and gentrification in tandem with a live drummer, one in the back of a one-ton truck that drives around the downtown of Yeongdeungpo.

11 Lim Minouk, *New Town Ghost*, 2005,
Single-channel video, color, sound, 10 min. 59 sec.

12 Yang Haegue, *Sadong 30*, 2006, Light bulbs, strobes, light chains, mirror, origami objects, drying rack, fabric, fan, viewing terrace, cooler, mineral water bottles, chrysanthemums, garden balsams, wooden bench, wall clock, fluorescent paint, wood piles, spray paint, IV stand, dimensions variable (Installation in an abandoned house in Incheon, Korea)

Invoking the anti-establishment modes of hip hop performance and street demonstration at the same time, this work unfolds as the truck circulates around the busy downtown streets, blasting out its message to the general public. In this way, the seemingly rotating flow is imagined to form a circle, bundling together temporarily (and in a "ghostly" manner) the local residents watching the raucous spectacle, some of whom may soon be evicted due to the new town policy. In contrast, in her work Yang Haegue infuses color, light, and life into a discarded house in the old town of Incheon where her maternal grandmother used to live, by placing broken mirrors, flash lamps, light bulbs, origami objects, drying racks covered with cloth, and fans around the site in an ad-hoc dispersed manner. A subtle tension between aesthetic quality of these objects, apparently devoid of purpose, name, or character, and the built environment charged with meaning and memory might have offered a rewarding experience for visitors, who would have had to spend specifically demarcated time and energy to visit this obscure place. The unfamiliar but archetypal experience of this house led to a strange sense of intimacy among visitors, which was further escalated as they read and filled up the guest book.[25]

Given that Korean art had oscillated between modernism and Minjung art, one of its tasks since the 1990s has been to cautiously maintain the delicate relationship between art and life rather than standing on one side or the other. For Korean artists, the lesson has been that art should be neither self-absorbed nor instrumental; rather, it needs to consider a seemingly contradictory way of approaching and involving itself with "life" without compromising artistic autonomy. As demonstrated within this section, Korean artists since 1990 have addressed themselves to various contemporary models of practice that have allowed for nuanced and complex forms of artistic engagement. These efforts include addressing the "here and now" in sensual or conceptual ways, producing reportage and archives or activating nostalgia and melancholy, pursuing art's formal creativity or theoretical complexity, suggesting analytic criticism or imaginative scenarios, or empowering local communities or creating an experimental intimacy. In the latter part of the 2000s, following the global financial crisis and the further accelerated entrepreneurial tendency, the public life of Korean art seems to have entered into a new phase. This new phase remains to be narrated elsewhere.

1 See the following texts on the unfolding of Korean art and its critical practices in conjunction with sociohistorical changes after a turn into the 1990s. Beck Jee-sook et al., *The Battle of Visions* (Seoul: ARKO and KOGAF, 2005); *Hanguk hyeondae misul: Bakha satang* [Contemporary Korean Art in Seoul: Peppermint Candy] (Seoul: MMCA, 2007); Beck Jee-sook et al., *Activating Korea: Tides of Collective Action* (Seoul: Insa Art Space of the Arts Council of Korea/New Plymouth: Govett-Brewster Art Gallery, 2008); Sohl Lee ed., *Majimak hyeokmyeongeun eopda: 1980nyeon ihu, geu jeongchijeok sangsangnyeogui yesul* [Being Political Popular: South Korean Art at the Intersection of Popular Culture and Democracy, 1980–2010] (Seoul: Hyunsil Publishing, 2012).

2 Choi Minhwa, "Jigeum urineun?" [What Are We Now?], *Minjok Misul* 12 (1990); Reprinted in National Art Association, *Minjok Misul: Yeonginbon 1986–1994* (Seoul: Baleon, 1994), 195–197.

3 Lee Youngwook, "Buranggwa wimuui norae" [The Song of Vagrancy and Consolation], exh. cat. for Choi Minhwa's solo exhibition (Seoul: Jahamun Museum, 1992); Reprinted in *Misulgwa jinsil?: Uri misureul bon han sijeom* [Art and Truth?: A Perspective on Korean Art] (Paju: Mijinsa, 1992), 193–199.

4 Shim Kwanghyun, "Jagi seongchaljeok hoehwaui rieollijeum: Jajeongeoeseo hagyogilkkaji" [Realism of Self-reflective Painting: *From Bicycle* to *Returning from School*], exhibition pamphlet for Choi Gene-uk (Seoul: Seoul Arts Center, 1991).

5 Sung Wan-kyung, "'Jeonsijang misul,' dasi saenggakae boja" [Rethinking 'Gallery Art'] (1991), Reprinted in *Minjung misul, modeonijeum, sigak munhwa: Saeroun hyeondaereul wihan seongchal* [Min Joong Art, Modernism & Visual Culture] (Paju: Yolhwadang, 1999), 106–121.

6 Critical awareness about "artistic sincerity" and the "use of popular media" came to light within the following exhibitions at the Seoul Museum that took place during the transition period into the 1990s: *Artists in Focus of 1988* (February 1989), *Donghyanggwa jeonmang* [Trend and Prospect] (March 1990), *Donghyanggwa jeonmang: Barambaji* [Trend and Prospect—A Windbreaker] (April 1991)

7 Seo Seong-rok, *Hanguk misulgwa poseuteumodeonijeum* [Korean Art and Postmodernism] (Paju: Mijinsa, 1992)

8 "Sinsedae misurundong" [New Generation Art Movement], *Seonmisul*, Fall 1991, 63–72; General discussions about the "Post-modern" Group and "New Generation" art movement can be found in Mun Hyejin, *90nyeondae hanguk misulgwa poseuteumodeonijeum: Dongsidae misurui giwoneul chajaseo* [Korean Art of the 1990s and Post-modernism: In Search of the Origin of Contemporary Korean Art] (Seoul: Hyunsil Publishing, 2013)

9 Yoon Jinsup, "Haembeogeowa hwayeombyeong: Hwanggeumsagwaui uimi" [Hamburger and Firebomb—the Meaning of Golden Apple], *Space*, July 1990.

10 See the following about the club culture that became the origin of "New Generation" art. Sungkiwan, "Diaspora of De-Authority: Into the Clubs," in *Secret Beyond the Door—The Korean Pavilion*, The fifty-first Venice Biennale, exh. cat. (Seoul: Korean Culture Arts Foundation, 2005), 186–196.

11 See Nancy Abelmann on the growing fatigue or repulsion toward the dissident culture in the 1990s. Nancy Abelmann, *Echoes of the Past, Epics of Dissent: A South Korean Social Movement* (Berkeley: University of California Press, 1996), 231; See the following about the supportive reaction of the Minjung art practitioners towards New Generation art. You Hongjune, "Jeohanggwa dojeoneseo gyeongnyunui sijaeguro" [From Resistance and Challenge to the Vision of Experience and Knowledge], *The 15 Years*

of *Korean Minjoong Art: 1980–1994* (Seoul: Life and Dream, 1994), 167–168; Sung Wan-kyung, "Hanguk hyeondaemisurui gujowa jeonmang: Jjalbeun noteu" [The Structure and Prospect of Korean Contemporrary Art: A Short Note], 18-19.

12 Kim Jin-Song et al., *Apgujeong-dong: Utopia Dystopia* (Seoul: Hyunsil Publishing, 1993)

13 "In the 90s, we are now in widespread confusion due to the indistinct frontline and obscure prospects. As a result, a sense of defeat and nihilism about social transformation has become part of the everyday. . . ," Lim Oksang, "Chwiimsa: 1993nyeone . . . An Inauguration Speech: In 1993. . . ," *Minjok Misul* 20 (1993). Reprinted in *Minjok Misul: Yeonginbon 1986–94*, 248.

14 See the following for Wolfgang Fritz Haug's critique of commodity aesthetics and the art of Choi Jeonghwa. Shin Chunghoon, "Learning from the Street: Choi Jeonghwa's Design and Consumerist Urban Landscape," *The Eye of the Periods: Anthology of Korean Modern & Contemporary Artists* (Seoul: Hakgojae, 2001), 326–340.

15 On special interest of the Research Society for Art Criticism in Choi Jeonghwa, see Lee Youngchul, "Culture in the Periphery and Identity in Korean Art," *Across the Pacific: Contemporary Korean and Korean American Art*, exh. cat. (New York: The Queens Museum of Art, 1993); Lee Youngwook, "Dosi/chunggyeok/yongmangui areumdaum" [Beauty of City/Shock/Desire], *Gana Art*, July/August 1996; Park Chan-kyong, "Jakga sogae: Choijeonghwa" [Introducing: Choi Jeonghwa], *Mom* [Body], November 1997; Beck Jee-sook, "Tongsokgwa idanui jeulgeoun eummo" [Choi Jeonghwa: Joyful Conspiracy of Vulgarity and Defiance], *Wolgan Misul*, January 1999; Lee Youngjune, "Multiple Choi Jeonghwa," *Imiji bipyeong: Kkaennipmeorieseo ingongwiseongkkaji* [Image Critique: From Perilla Leaf Hair to Satellite] (Seoul: Noonbit Publishing, 2004)

16 Jung Hun-Yee, "1990nyeondaeui misul" [Art of the 1990s], *Hanguk yesulsa daegye VI: 1990nyeondae* [Comprehensive History of Korean Art VI: 1990s], Korean National Research Center for the Arts (Seoul: Sigongsa, 2005), 235–274. Meanwhile, the framework distinguishing "the sensual" and "the conceptual" was promulgated in a conversation for Bahc Yiso's exhibition at Kumho Museum of Art. "Daedam: Bahc Mo, Park Chank-yong, Ahn Kyuchul, Eom Hyeok, Jung Hun-Yee" [A Conversation: Bahc Mo, Park Chan-kyong, Ahn Kyuchul, Eom Hyeok, Jung Hun-Yee], *Bahc Mo*, exh. cat. (Seoul: Kumho Museum of Art, 1995).

17 For issues of past and memory that came up in Korean art in the 1990s, see Beck Jee-sook, "Seolgeojiwa noseutaeljieo" [Dishwashing and Nostalgia], 1992, *Bon geoseul georeogadeusi: Eoneu kureiteoui geulsseugi* [Seeing-Walking-Thinking: A Curator's Writing] (Seoul: Mediabus, 2018), 41–60. On the change in temporality from the future to the past, see Andreas Huyssen, *Present Pasts: Urban Palimpsests and the Politics of Memory* (Stanford, CA: Stanford University Press, 2003).

18 Beck Jee-sook, "Baeyeonghwanui 'seobeuateu'?!" ['Subart' of Bae Youngwhan?!], *Baeyeonghwan gaeinjeon: Yuhaeng-ga 2* [Bae Youngwhan Solo Exhibition Pop Song ver. 2], exh. cat. (Seoul: Kumho Museum of Art, 1999).

19 Hal Foster, *The Return of the Real* (Cambridge, MA.: The MIT Press, 1995).

20 See the following texts for discussions on the legacy of Minjung art at the turn of the century, Seongnam Project, and flyingCity. Shin Chunghoon, "Poseuteu-minjung sidaeui misul: Dosiseong, gonggong misul, gongganui jeongchi" [Art in the 'Post-Minjung' Era: Urbanism, Public Art, and Spatial Politics], *Journal of Korean Modern & Contemporary Art History* 20 (2009): 249–269; Young Min

Moon, "Situating Contemporary Art of South Korea, 1980 to 2016," in *A Companion to Korean Art*, eds. J. P. Park Burglind Jungmann, Juhyung Rhi (New Jersey: John Wiley & Sons, Inc., 2020), 465–496.

21 Activities related to Seongnam Project, flyingCity, Mixrice, and *Gaseumaen-peullane-dosiwa bogoyesul* [Gasman-Flaner-City and Reportage Art] (2000), *Gonggongui kkum, jongno* [Jongro, Public Dream] (2002), the fourth Gwangju Biennale Invited Groups' International Workshop "Gongdongchewa misul" [The Community and the Art] (2002) and exhibitions and academic events such as *Dongducheon: A Walk to Remember, A Walk to Envision* (2007) at Insa Art Space and publishing journal *BOL* are related both directly and indirectly in terms of the involvement of the members.

22 On the 'social turn' after the 1990s, see Claire Bishop, "The Social Turn: Collaboration and Its Discontents," *Artforum*, February 2006, 178–183. For related discussions on the international trend of the social turn and its intersection with "Post-Minjung" art, refer to the following workshop, in which there were several Korean artists, Charles Esche, and Superflex in conversation. Gwangju Biennale Foundation, *The fourth Gwangju Biennale Invited Groups' International Workshop: Community and Art* (Gwangju: Gwangju Biennale Foundation, 2002).

23 On "survivalism" within the regime of neoliberalism, see Kim Hong-jung, "Seobaibeol, saengjon juui, geurigo cheongnyeon sedae: Maeumui sahoehagui gwanjeomeseo" [Survival, Survivalism, and the Young Generation from the Viewpoint of the Sociology of the Heart], *Korean Sociology* 49 (1), 2015, 179–212.

24 Related to this topic, see Cho Seonryeong, "Gonggongiraneun hwansang?: Opeuning patijanggwa maeulhoegwan saieseo" [The Illusion of the "public"?: In Between an Opening Party and a Village Hall], *Munhwa Gwahak*, no. 48, December 2006, 225–234; Kim Jangun, "Sangjinggwa sotong: Jigeum hangugeseo gonggong misureun eodie wichihago inneunga?" [Symbol and Communication: Where is the public art located in S. Korea?], *Misulgwa jeongchijeogin geosui gajangjarieseo* [On the Edge of Art and Politics] (Seoul: Hyunsil Publishing, 2012), 211–231.

25 Yang Haegue, "A Conversation: Haegue Yang and Eungie Joo," *Condensation: Haegue Yang*, The Korean Pavilion, The fifty-third Venice Biennale, exh. cat. (Seoul: Arts Council Korea, 2009), 26–27.

Korean Video Art Since the 1990s

Bae Myungji

The history of Video art began in the mid-1960s, when Paik Nam June and Wolf Vostell initiated the genre using altering images screened through a television-based visual apparatus, and the further development of the medium was accelerated by the appearance of Portapak camera equipment. The new art forms and movements that emerged in the 1960s, such as performance art, Fluxus, conceptual art, minimalism, process art, and the global counter-cultural scene as well as the emergence of institutional critique, also further contributed to the emergence of video art as accepted genre of contemporary art.[1] Within the history of contemporary art, video art has continued to develop from its technological and socio-cultural foundation, and it has become recognized as a genre that celebrates new ideas, experimentation, resistance, opposition, alternativeness, and interdisciplinary exchange.

Sharing in such aspects, Korean video art was developed from the 1970s onward by a group of experimental artists,[2] and continued to evolve throughout the 1980s, as the Korean artworld vigorously discussed the notion of multi-genre practice.[3] Throughout the 1900s, computer-based informatization and globalization emerged as a topical creative concern and digital cameras first began to be commercialized, and from the 2000s, it widely promulgated. On the one hand, Korean video art has been shaped by establishing an inseparable relationship with the development of technological apparatuses and media and, on the other hand, it developed in multifaceted ways amid the wider changes taking place in the landscape of contemporary art and society. In the 1990s and throughout the 2000s, in particular, Korean contemporary art gained global contemporaneity as a result of the expansion of simultaneous flows and links within international art and culture

networks.[4] During this period, Korean video art was presented at major domestic and international biennales and exhibitions, drawing attention from the international art community.

In this context, here we examine the uniqueness and contemporaneity of Korean video art in relation to the technological development and the domestic and international art and cultural landscape since the 1990s. This brief survey of the characteristics of Korean video art after the 1990s and the establishment of its position in contemporary Korean art examines the main concerns that could be said to characterise the genre. These could be said to include the constant desire to experiment with new media and technology and the intent to avoid the binary division of Modernism vs Realism that historically characterised Korean art. These concerns could also be said to extend to a consistent interest in featuring perspectives, the interdisciplinary exchange across genres, and the hope to use art to reveal suppressed narratives in Korean modern history.

VIDEO SCULPTURE, TECHNOLOGY, AND PAIK NAM JUNE

Korean video art gained traction after the mid-1980s, when color television became commercialized. The term "video art" became widely known to the art world and the wider public, especially after Paik Nam June's global satellite broadcast project, *Good Morning Mr. Orwell*, aired in 1984. Paik's video sparked a special interest among the public, which was accustomed to pictures on color TV in the 1980s, and video art began to emerge as a popular social topic.[5] Although terms such as video, media, and film began to appear in the Korean art scene from the late 1970s,[6] and a

series of artists, such as Lee Kangso, Park Hyunki, Kim Youngjin, Choi Byungso, and Lee Hyunjae, had experimented with performance or conceptual art,[7] it was hard to find an artist who deserved the title of video-artist, except for Park Hyunki. In fact, the term "video art" began to be regularly used in the art world only from the mid-to-late 1980s, when a wider variety of artists became interested in the medium as an experimental tool.

Rather than paying attention to the video image in itself, artists in this period used video imagery to be included in a video sculpture or a video installation, as part of a television-based device or an installation-style object. In this case, video was considered part of a sculpture or an installation, rather than an independent medium. The video sculpture that emerged in Korean art circles during this period, however, showed different conceptual and formal qualities from the work created by their Western contemporaries who were associated with the genre. Video art in the West began in the early 1960s in either the contexts of institutional critique and anti-art that challenged the unilateral and hierarchical communicative power of television, or alternative videos that practiced activist documentary. For example, Paik Nam June manipulated a television receiver to alter the images displayed in his series of television sculptures, and Wolf Vostell destroyed a television or buried a television in a grave as part of his *Television Décollage*. Korean video art, however, emerged in the new context of what was deemed as postmodernism in the Korean art community after the mid-1980s, in which artists attempted to experiment with newly developed installation approaches or technological elements in their work, moving away from traditional practices such as painting and sculpture.[8]

In the late 1980s and the early 1990s, a new generation of artists, called the Shinsedae (new generation) artists, appeared on the Korean art scene. Seeking freedom of expression and diversity of medium, these young artists distanced themselves from the ideological rigidity of the Modernism vs Realism debate which was generated in the process of the polarization of Korean contemporary art between Dansaekhwa and Minjung art. Turning away from the idea of producing a painting on a flat canvas, which had been advocated for by virtually all previous generations of Korean artists in the post-war period, the Shinsedae artists experimented with installation, object art, performance art, and video art, and attempted to restore the idea of the communicative power between art and life, everydayness, and narrative structure. At that time, various artist collectives, such as TARA, Meta-Vox, Nanjido, Logos & Pathos, Museum, and Golden Apple, actively experimented with mixed media, installation, object art, and new technology. Centered on video sculpture, Korean video art in the late 1980s and early 1990s emerged in this dynamic landscape amid the surge of postmodernist philosophical ideas in the Korean art world. At this time, the following artists initiated the full-fledged development of Korean video art: Yook Keunbyung of TARA, Yi Wonkon of Logos & Pathos, Lee Yongbaek of Golden Apple, Kim Haemin, Yook Taejin, Moon Joo, Ahn Soojin, Oh Kyung-hwa, Kim Changkyum, Kim Youngjin, Kim Hyunggi, and others. These artists produced video sculptures or video installations, exploring the relationship between reality and virtuality, and discussing such themes as society, history, civilization, environment, and psychopathology.

One of the characteristics of Korean video sculptures from the late 1980s to the 1990s was a series of attempts to link video art's virtuality to ideas of shamanistic transcendence while still considering the idea of the 'dichotomy of reality and fiction' when combining objects and video. Yi Wonkon mentioned that as video images are inserted in the context of real space in the form of an installation, or they become part of a material structure as a conceptual and immaterial thing, they create "interspace," "interreality," or "double consciousness," which are similar to the spiritualistic shamanistic consciousness privileged in Korea's own traditional philosophical culture. According to Yi, this shamanistic world view appears in Park Hyunki's *Video Stone Towers* and in other video installations by Yook Keunbyung and Kim Haemin.[9] This interpretation is convincing, in as much as the term 'medium' can also be used to refer to a 'psychic' person who has the power to connect with the spiritual world of the life and afterlife.

In fact, Park Hyunki's famous video sculpture *Untitled* (TV Stone Tower, 1979), which places a TV, that shows an image of a pile of stones, on a pile of real stones, gets its inspiration from his memory of a ritual site where people devotedly stacked a stone on an existing pile of stones, something Park witnessed as a child refugee constantly on the move during the Korean War.[10] Park is one of the first-generation of Korean video artists, who started making video art in 1978. He mixed video-based performances, installations, and objects until the late 1990s, just before he died. Along with Kim Youngjin, Park watched Paik Nam June's *Global Groove* (1973) at the Library of the U.S. Cultural Center in Daegu in 1974, and from that moment paid attention to the possibility of video media. When he saw a synthesizer that freely combines and divides the screen colors at Korea Broadcasting System (KBS), however, Park was disappointed to find out that the technology for manipulating video

imagery was already being used in South Korea. Thus, rather than paying attention to video imagery itself, he came to establish his signature style of video installation and video sculpture.[11] In the late 1970s, Park moved to Japan and began to study video technology.[12] Later, he participated in the São Paulo Biennial (1979) and the Paris Biennale (1980) with his TV Stone Towers, establishing himself as one of Korea's leading video artists. His video sculptures from the late 1970s to the late 1990s explored rituals or shamanism from a cultural-anthropological perspective. Other examples include his *Untitled* (1991), which juxtaposed natural objects, such as stones and trees, with moving images of them, and the *Mandala* series (1997), which recombined images of the sacred and the secular. All these works posed ontological and philosophical questions about whether reality and illusion, or the religious and the secular can be separated dichotomously, and the veracity of the established cultural and anthropological interpretations surrounding traditional spiritual

rituals and shamanism.

At his solo exhibition in Gallery Doll, in 1988, Yook Keunbyung premiered *The Sound of Landscape + Eye for Field*, a tomb-shaped installation that included a video monitor showing an eye staring at the audience. This work was later submitted to the São Paulo Biennial, in 1989, and Documenta 9 in Kassel, in 1992, and received international attention at all events. As Yook said: "Looking at a cemetery, I felt that the tombs are staring at current life with fierce eyes, like souls whose bodies have disappeared but whose spirits are breathing."[13] In his video installation, the eye in the tomb is considered a spirit of the dead, which connects life and death, East and West, *yin* and *yang*, as a shamanistic force, rather than an invasive panoptic eye that surveils and controls the world. In his 1995 Lyon Biennale entry, *Survival is History* (1995), the eyes appeared again as beings that stare at countless war scenes from world history, and witness and mourn life and death as the origin story of human history.

1 Kim Haemin, *Unreasonable Alibi*, 1999,
 Video installation; two-channel video, color,
 silent; video display device, bulb, dimensions
 variable, 5 min. 7 sec.

2 Yi Wonkon, *A Study for a Fluctuation*, 1987,
 Single-channel video, color, sound, 8 min. 43 sec.

3 Paik Nam June, *Good Morning Mr. Orwell*, 1984,
Installation view of *Good Morning Mr. Orwell* 2014, Nam June Paik Art Center

Kim Haemin also took shamanism as the basis of his video art. Kim saw the transmission and reception of electronic signals, a fundamental property of video art, as similar to a shaman's reception process, because both the image perceived by a shaman and the image screened on a TV appear in virtual spaces. His early work *Sindoan* (1994) is an installation that uses TV monitors to re-organize the exhibition hall into a space of media ceremony, inspired by shamanic ritual spaces scattered around Sindoan, in the Gyeryong Mountains.[14] In addition, his famous work *Unreasonable Alibi* (1999) directly visualizes video art's mediatic property, i.e., images

that are played according to electronic signals. It is also reminiscent of the virtuality of shamanism, in that it summons non-visible souls through the flashing of light. 1

Meanwhile, the proliferation of television, which was a deeply entrenched force within Korean pop culture by the mid-to-late 1980s, not only heralded the transition from the text era to the screen era, but also brought about a major change in the daily life, visual environment, and mindset of people.[15] After his *Communication* (1986), an installation made of dismantled televisions, premiered at the exhibition *Independants*, in 1986, Yi

between the fantasy on-screen and the reality in the off-screen."[16] As he mentioned, this work shows the artist's understanding of a television as a medium of two-way communication, transforming the context of the communicative exchange by moving between the inside and the outside, as well as between virtuality and reality. This concept of a TV as a bilateral interactive medium is reminiscent of Paik Nam June's concept of the "participatory television," which emphasizes communication and participation.

Paik's influence was indispensable in supporting the growing interest in Korean video and technology art in the late 1980s and early 1990s. Paik's *Global Groove* remotely inspired several artists, such as Park Hyunki and Kim Youngjin, in the 1970s, but Paik fully began to more personally exert influence on the Korean video art scene after introducing his *Good Morning Mr. Orwell*, in 1984. Aired on KBS on January 1, 1984, *Good Morning Mr. Orwell* was a transnational video event that connected global cities including Seoul, New York, Paris, and Berlin through a simultaneous satellite broadcast in which more than 100 artists participated, performing in the virtual global spaces created by the transmission. $\overline{3}$ In Korea, this work served as a decisive moment for promoting TV and video as an "intercommunication medium," which enabled increased communication and interaction among various forms of popular culture, avantgarde art, technology, all of which served to blur the notions of art and life. Paik's work also sought to reverse George Orwell's pessimistic view that television would be instrumentalized as a device of surveillance and control. Its successful staging was a dramatic moment that realized Paik's concept of the "electronic superhighway," a transversal path through which global connectivity would be enabled by telecommunications networks, continental satellites, waveguides, coaxial cables, laser light, and fiber.[17] Here Paik presented his concept of "participation television" through massive satellite broadcast events, for example, like *Bye Bye Kipling* (1986). This work was a satellite project that connected New York, Tokyo, and Seoul to celebrate the 1986 Asian Games in Seoul, and was followed by *Wrap Around the World* (1988), another satellite project planned and released to celebrate the 1988 Seoul Olympics. And all these works further facilitated the expansion of video art in Korea in the late 1980s and the 1990s.[18]

Since then, along with the Whitney Biennale Seoul Exhibition (1993), which was led by Paik; the first Gwangju Biennale (1995); and the inaugural exhibition of the Korean Pavilion at the Venice Biennale (1995), globalization and internationalization have emerged as major agendas, and the contemporaneity of Korean contemporary

Wonkon continued on to explore the medium's mode of address and its effects through television-focused video sculptures until the 1990s. Yi's video *A Study for a Fluctuation* (1987) documents a performance of the artist, located behind a TV set, reading words consisting of two syllables from a book, tearing the book apart and creasing the papers, and throwing the crumpled papers out through the TV. $\overline{2}$ As Yi said: "I wanted to recognize television not as a one-way communication model, but as a 'new window' that connects the inside and the outside of the human world. Thus, I wanted to experiment with this fluctuation of TV, i.e., the communication

4 Politician Kim Dae-jung at the 1995 Gwangju Biennale, viewing Paik Nam
 June's *Dolemen*, 1995, Installation view of the first Gwangju Biennale
 InfoArt, 1995

art began to be critically discussed. In addition,
in the mid-1990s, with the spread of computers
and the Internet, the networks and expanded
framework of information communication that
connect the world have rapidly emerged as the
technological basis driving globalization and growth
in the art world. In this context, Paik's insight into
information and communication technology shaped
the 1995 Gwangju Biennale special exhibition
InfoART, which focused on new visual arts utilizing
advanced information science and technology,
such as computers, telecommunications devices,
electronics, and interactive media. 4 The exhibition
was organized by Paik and Cynthia Goodman as
directors, Kim Hong-hee as a curator, and video art
experts such as John Hanhardt, Barbara London,
and Wulf Herzogenrath as the advising committee.
Examining the timely issue of globalization, the
1995 Gwangju Biennale was themed "Beyond the
Borders." Conforming to this theme, the exhibition
InfoART chose the themes of the global scale of
communication and the border crossing between
art and technology, art and society, and art and
life through information art using the brand-new
information technology.[19]

In addition to video technology, Korean art of
the early 1990s embraced cutting-edge technology
in order to produce computer art, interactive
art, holograms, and kinetic art, exploring how
new technology can expand the realm of art. In
this context, the artist collective Art Tech was
formed by, among many others, Kim Jaegwon,
Kim Yoon, Song Joohan, Shin Jinsik, Shim
Youngchul, Cho Taebyung, and Choi Eunkyoung.
Art Tech held several exhibitions exploring the
relationship between art and technology, such as
Art and Technology (1991), *Science+Art Show* (1992),

and *Man and Machine: Technology Art* (1995).[20] These
exhibitions posed multilayered questions. For
example: how contemporary technology and media
development can expand the realm of art; how
the combination of art and science is related to
human life and knowledge; what message is created
as a result of the new medium; and what is the
method of "communication" with the audience via
technology?[21] These philosophical questions about
the relationship between art and technology served
as a driving force to contemplate ideas of new
humanism in the age of electronic media.[22]

FROM TV SCULPTURE TO
VIDEO PROJECTION

In the late 1990s, video art in Korea took a new
turn. It began to shift from video sculptures (or
installation) to single-channel videos based on
video projection, a form of display that centers
on aesthetics of moving images. This paradigm
shift within Korean video art to single-channel
video was related to changes in the 1990s media
environment and changes in the internal and
external environments surrounding Korean
contemporary art at the time.

The development of digital video editing and
storage methods from the mid-to-late 1990s became
the technical foundation for the proliferation of
single-channel videos. In the late 1990s, along
with videotapes that record and play video signals
on magnetic tape, digital video disks (DVDs) and
digital videos (DVs) began to be commercialized
as new play back and storage methods, providing
the technological foundation for digital editing.
This computer-based digital editing enabled
artists to freely develop narratives, allowing free
deformation, copying, superimposing, and deleting
images and sounds.[23] Along with the technological
advances for video art production, artists who
studied film/imaging techniques in Korea and
abroad appeared on the art scene in the late 1990s,
for example, Kim Sejin, Moon Kyungwon, Park
Hwayoung, Seo Hyun-Suk, Shim Cheolwung, Lee
Yongbaek, Hong Sungmin, and Ham Yangah. They
played a considerable role in making single-channel
videos a major trend in the Korean art scene in the
late 1990s. Their video language varied between
using techniques such as montage, morphology,
sound effects, free variation, combination, and
segmentation of images. Such editing techniques
made intermediate and nonlinear narratives
feasible, and their work ranged from video montage
presenting social and historical narratives, to more
complex structural forms that described inner
psychological expressions.[24]

Moreover, the making of single-channel
videos was also stimulated by the new media and

entertainment culture penetrating deeply into Korean society in the late 1990s. Celebrating various image experiments, young video artists recognized sensuous and shallow images, which at the time were widely disseminated via TV commercials and music videos, MTV, animation, cable TV, satellite broadcasting, and Internet personal computer communication, as new vocabulary. MTV imagery, which helped to inspire the production of imagery based on exchange, hybridity, speed, and symbolism, served as important shared sensibility for this generation. Music videos, which were characterized by the abandonment of traditional narrative structure and the destruction of the space–time continuum, had become a source of creative nourishment for young artists.[25] At this time, the new generation of video artists also appropriated visual elements of popular culture, primarily images in advertising. It should be noted that they employed popular video culture primarily as a means of translation and re-contextualization, and not as a means of resistance with a critical perspective. This tendency distinguished these artists from their predecessors in the 1980s, when Korean artists critically viewed popular consumer culture as being derived from multinational capitalism. Post-ideology, cultural hybridization, and a certain flexibility (to embrace both populist and high art) constituted the aesthetic attitudes taken by the new generation of video artists in the 1990s.[26]

The proliferation of video art at this time owed much to institutional support. Various alternative spaces appeared from the late 1990s, such as Ssamzie Space, Alternative Space LOOP, Art Space Pool, and Project Space SARUBIA. These provided a supportive backdrop for the experimental works of video artists, such as Lee Yongbaek, Jung Yeondoo, Ham Yangah, and Park Chan-kyong. In the early 2000s, new media departments were established in art colleges, and new art institutions focusing on media art were opened, such as Art Center Nabi (2000) and Ilju Art House (2000). From 2006, Arko Art Center launched the Korean Single Channel Video Collection (IASmedia/Arkomedia). Along with this institutional support, the Seoul Mediacity Biennale (2000–) has served as a major foundation for video art's proliferation on the Korean art scene.[27] Since then, single-channel video projects, such as the Seoul International New Media Festival (NeMaf), the Ewha Media Art Festival (EMAF), the Incheon International Digital Art Festival (INDAF), and DIGIFESTA, have been established, providing the soil for single-channel video to flourish in Korea.

One of the exhibitions that focused on single-channel videos is *TEUM: Narrative, Single Channel Video* at Art Sonje Center in 1998. Joined by Park Hwayoung, Hong Sungmin, and Seo Hyun-Suk, the exhibition had as its theme the "narrativity" of single-channel video.[28] The "narrative" here, however, is not a linear narrative that unfolds a story in four stages (introduction, development,

5 Park Hwayoung, Seo Hyunsuk, Hong Sungmin, *Fall, Fall, Fall*, 1998,
Three-channel video project, 7 min. loops each. Installation view of TEUM exhibition at Art Sonje Center

turn, and conclusion), but a nonlinear narrative that defies the order of time in a schizophrenic and deconstructive way. Introduced as the centerpiece of the exhibition, *Fall, Fall, Fall* (1998) shows aspects of this nonlinear narrative. 5 Consisting of three video clips, each separately featuring Seo's *The Story of "I"*, Park's *The Other's Story*, and Hong's *Our Story*, this work is based on a narrative structure that superimposes, segments, and disconnects the stories, which are all based on a single story. The different themes within this larger overarching narrative consisted of: "Continuity without beginning, end, and center" in Seo's film; "A double narrative of people/bugs" in Park's film, and; "the divided world" in Hong's film.[29] Such poetic and fragmentary, nonlinear narratives, which resist the continuity of an overall narrative structure and present mismatching images and text, were an new formal concern distinct to Korean single-channel videos in the late 1990s, and reflected the contemporary sensibility of the era, by examining notions of mutually constructed networks and social complexity. For example, held in the same year as *TEUM* (and the precursor of the Seoul Mediacity Biennale), the exhibition *'98 Seoul in Media: Food, Clothing, Shelter* focused on urban daily routines, interactive dialogues, networking, and nonlinearity—the 1990s video artists' non-verbal language of narrative—as concerns representative of the unique character of video at this moment and paradigmatic of the era.[30] The sensuous development of images and nonlinear narrative structures that value the intuitive sensibility of the viewer can be identified as a further unique characteristic of Korean video art in the late 1990s in relation to other contemporary contexts.

THE INTERSECTION OF VIDEO ART AND FILM

After the full-fledged appearance of single-channel video, which established the independent aesthetic of video art in the late 1990s, Korean video art faced a new turning point throughout the 2000s: the intersection and hybridization of video art and film. This new focus included, on the one hand, the creative re-examination of the intersection of video art and film, and, on the other hand, the merging of video art with performance, theatre, and sound art in the context of interdisciplinary art. The tendency here to abandon the unique character of video art and expanding the capacity of the medium through being combined with other mediums, is of course an important aspect of contemporary art in the post–medium era, and it is not limited to video art. By using the term technological or material "support," instead of "medium," and focusing on the re-creation of medium rather than

the uniqueness of the medium,[31] Rosalind Krauss identified the new potential of such art after the late 1990s, as intermediary hybridizing and the mixing of different media reigned supreme within the practice of many significant contemporary artists.

The backdrop of the hybridization of video art and cinema is, first, a result of this post-medium condition. In particular, the development and proliferation of digital technology broke down the boundaries and distinctions between film and video art, which had been distinguished by the uniqueness of the medium of celluloid film and electronically transmitted and displayed signals, respectively, as these two mediums converged into the "digital."[32] In other words, the condition of the post-medium, which originated from the digital technology, served as a fundamental technology support base that enabled film and video art to creatively intersect. Then, from the mid-2000s, the proliferation of digital cameras made it easier to shoot, edit, and manipulate images, and, through video projection, expanded the limits and breadth of the "film narrative," within the context of contemporary art.

"Between cinema and video art," "artist films," "art that resembles film," "a cinematic production directed by an artist," "cinematic videos"—all these terms were frequently used to describe Korean video art from 2000 to 2010.[33] For example, in a special issue titled "Art Challenges the Limitations of Film" in 2010, the celebrated Korean journal *Wolgan Misul* discussed video works by such artists as Moon Kyungwon, Park Chan-kyong, Park Hwayoung, Ryu Biho, Lim Minouk, Jung Yeondoo, siren eun young jung, and Ham Yangah in relation to film, as their videos continuously recognize the cinematic grammar of *mise-en-scène*, fictive narrative, actor performance, shooting, editing, etc.[34] In this respect, since the mid-2000s, Korean video artists have continuously actively or alternatively embraced, interpreted, and criticized film elements, such as traditional cinematic narrative, imagery, and device conditions, creating new discourses for Korean video art.

Furthermore, the advent of Full HD enabled high-resolution, large-scale video projection and high-quality sound to be included in museum exhibition, meant that video installations could sensually immerse the viewers in illusion, and overwhelm their perceptions. Such cinematic video installations enabled the viewers to experience a situation similar to that of visiting the cinema theatre itself, experiences which were completely different from watching 1990s video sculptures, which played low definition moving images on TV monitors. This new viewing experience dismantled the boundaries of between cinema and 'video art.'[35]

One important phenomena of video art, not only in Korea but also around the world in the 2000s, was the advent of narrative-oriented cinematic video installations based on high-quality *mise-en-scène*. Such works allowed viewers to become absorbed in the video in the installation space. Many of these "artist films" created by internationally renowned video artists in the 1990s, such as Matthew Barney, Pierre Huyghe, Philippe Parreno, Douglas Gordon, Issac Julien, Stan Douglas, Steve McQueen, Anri Sala, Apichatpong Weerasethakul, and Yang Fudong, were introduced in Korea after the 2000s via international biennales or curated exhibitions in Korea.

In addition, collaboration, production, and postproduction—methodologies that have been actively practiced since the mid-2000s—provided an environment for video artists to produce 'artists' films.'[36] Rather than an artist completing a video alone, this production method was completed through collaboration with cinematographers, actors, sound artists, writers, and designers, and so they required video artists to play various supervisory roles, like a film director, and, thus, the scale of video and production budgets was greatly increased compared with what it was in the past. Video art that resembles full length cinematic productions began to be presented at various domestic and international film festivals as well as art galleries. This cross-sectional nature of video art, displayed across a white cube and a black box, has constituted a major landscape of Korean video art since the mid-2000s.

Moon Kyungwon and Jeon Joonho can be

mentioned as representative artists who expanded their practice of installing cinematic videos through collaborative production. Introduced at the thirteenth documenta, in Kassel, in 2012, their well-known work *News from Nowhere* (2012) is a large-scale project created through collaboration with experts in various fields, including architects, musicians, poets, designers, scientists, and humanities scholars. Included in this work, the two-channel video *El Fin del Mundo* (2012) is a cinematic video installation created by using movie-making techniques. [6] It is a work that aggregates collaborations in sound, installation, costume design, object art, music, actors' performance, video editing, and cinematic *mises-en-scène*, based on a scenario written by the artists. Its science-fiction narrative, which is centered on a survivor of an apocalyptic disaster and an artist who is about to die, is a contemplation of the social reality of humanity from the perspective of the future and asks questions about human existence and the role of art after a dystopian disaster.

Ham Yangah has been working on cinematic video installations since the mid-2000s. From her *fiCtionaRy* (2002–) and through the wider series of *Dream . . . In Life*, she gradually moved to a (cinematic) narrative in which documentary and fiction are hybridized. *Dream . . . In Life* centers on the narrative created by serendipitously encounter between certain incidents and people, with the story based on conflict, discord, and harmony between individuals and the social system, and several related themes. Among them, produced while Ham was working as an art director for an independent

6 Moon Kyungwon & Jeon Joonho, *El Fin Del Mundo*, 2012,
Two-channel video, color, sound, 13 min. 35 sec.

7 Ham Yangah, *fiCtionaRy*, 2002–2003, Single-channel, color, sound, 4 min. 30 sec.

film production, *fiCtionaRy* brings together the two worlds that a film deals with, i.e., documentary and fiction, within its basic structure. **7** In the scenes that flow from right to left, reminiscent of a cinematic story board, Ham intersects the fictional world, filmed by the independent film director, and the real world, in which the film crews struggle to realize this fictional world. As a documentary reality is always reconstructed by the artist's subjective gaze, *fiCtionaRy* shares the fundamental cinematic attribute of being a 'film fable' in which reality and fiction are bound to intersect and subvert.[37]

CINEMATIC VIDEO AND DOCUMENTARY ART PRACTICES

One of the main contexts within Korean video art in the 2000s in which cinema and video art intersected was the appearance of pseudo-documentary films that unravel Korea's historical collective memories or social crises of the time into cinematic narratives, mixing documentary and fiction. Along with the "political turn," "social turn," and "documentary turn" which constitute some of the major concerns in contemporary art,[38] documentary art practice could also be considered a major trend that penetrated the contemporary art discourse not only in Korea, but also around the world since the 1990s.[39] Various levels of sociopolitical crises after globalization, such as race, migration, labor, inequality, environment,

geography, and politics, have served as source material for documentary art practice in exhibitions and biennials since the 2000s.[40] A critical consideration of the ideology of globalization often appeared as the subject of such documentary works, relating this theme with the postcolonial experience and identity politics.[41]

While documentary orientated practice emerged as a major phenomenon in the art world, the proliferation of pseudo-documentary videos owed much to the renewed attention paid to the longstanding concern with politically engaged art, that considered Korea's local social problems and historical traditions and contemplated the social role of art. Named so-called post-Minjung art or social art, realism in the new millennium critically regenerated the social collective memories of the Korean War, the division of the nation, and the Gwangju Democratization Movement, as well as problems resulting from globalization, such as urban redevelopment and migrant labor.

Park Chan-kyong, Im Heung-soon, Song Sanghee, and Lim Minouk can be mentioned as representative video artists who shared the political-realistic aesthetic concerns of post-Minjung art based on documentary art practice. Taking "conceptual realism" as their basic artistic attitude, their works represent tragic moments in Korean modern and contemporary history via distinctive images of ghosts or recontextualize the incidents or traditions suppressed during the process of modernization of Korea.[42] These

artists adopted methodologies such as interview, collaboration, archiving and historical research to render their work in the documentary narrative tradition.

Park Chan-kyong's *Sindoan* (2008) and *Manshin: Ten Thousand Spirits* (2013) revisit modernity through cinematic narratives and traditional narratives. Both works deal with shamanism: a tradition that has largely disappeared as a result of the state-led modernization project. In these videos, the intersection of the two narratives, modern Korean history and traditional shamanism, forms a dual structure of documentary versus fiction. *Sindoan* reflects on Korea's compressed modernity by revealing the "suppressed traditions" within Korean history, summoning up images of numerous cultural others and places in the Gyeryongsan Mountain and, in Sindoan, which were forcibly demolished in the 1970s and 1980s relative to the desire to stamp out superstitious religious practices during the military government's social development drive. 8 In addition, the narrative of *Manshin* intersects the individual history of the shaman Kim Keumhwa and the public history of modern Korea, from the Japanese colonization period to the Korean War, and into the 1970s. In doing so, the video recounts how the tradition of shamanism was appropriated, modified, and distorted, according to the circumstances of the specific time and space in South Korea. Here, the tradition that obstructs the path of modernization becomes not a subject of cultural anthropology, but a subject of political consideration that requires reflective distance relative to simplistic notions of modernization and development.

At the same time, the video artists who based their work on documentary narratives from the 2000's onward often pay attention to relaying information about the tragic histories and collective memories that run through modern and contemporary Korean history. Famous examples of this concern include: Park Chan-kyong's *Anyang, Paradise City* (2010) and *Citizen's Forest* (2016); Im Heung-soon's *Sung Si (Symptom and Sign)*, *Jeju Note* (2011), *Jeju Prayer* (2012), and *Factory Complex* (2014) 9 ; and Song Sanghee's *The Story of Byeongangsoe 2016: In Search of Humanity* (2016) 10 and *Come Back Alive Baby* (2017). These works draw attention to the modern history of Korea, in particular, the historical trauma resulting from Korea's geopolitical situation, ranging from colonization to Cold War ideological conflict, military dictatorship, nationalism, modernization, and neoliberalism. These works address various historical events ranging widely from the Donghak peasant uprising (1894), to the Jeju Uprising (1947–48), the Bodo League massacre (1950), the Korean War (1950–53), the Vietnam War (1960–75), the East-Berlin Affair (1967), the Democracy Youth Student Movement Association Incident (1974), the Gwangju Democratic Movement (1980), and the Sewol ferry disaster (2014).

These videos summon the presence of the nameless victims who were marginalized, excluded, and killed within this long national history of violence. The aim to restore and remember their voices is the basic logic behind these videos, and the rationale for their documentary narrative. In Park Chan-kyong's *Citizen's Forest*, the spirits of the dead, who appear with their heads cut off, and the wounded soldiers, who appear as skeletons, refer to the sociopolitical others—those who died unfairly in the process of war and massacres, from the Donghak peasant uprising to the April 2014 Sewol ferry disaster. The grandmothers who appear in Im Heung-soon's *Sung Si (Symptom and Sign)/Jeju Note*, and *Jeju Prayer* are the victims of the massacres that took place on Jeju Island in the 1940s following a local uprising against military government oppression. Following a similar concern to expose the hidden history of postwar Korea, Im's *Factory Complex* focuses on female workers who have been marginalized within the process of national economic development since the 1970s. These workers overlap with the young female laborers in Park's *Anyang, Paradise City*, who died due to a fire as they were locked up in a factory dormitory. The desire to expose marginalized forms of local history also thematically drive Song Sanghee's *The Story of Byeongangsoe 2016: In Search of Humanity*, revisiting nomads who lived a miserable life in the late Joseon, and the conscripted workers and 'comfort women' during the Japanese colonial period.

One interesting fact is that the unnamed subalterns who disappeared outside of the public history often appear as ghosts in these videos. They include a skeleton-shaped ghost in the *Citizen's Forest*, a ghost wearing a bandana in *Factory Complex*, and baby ghosts based on characters from traditional Buddhist folk law in *The Story of Byeongangsoe 2016: In Search of Humanity and Come Back Alive Baby*. Erased from history for the sake of the stability of the collective, these sacrificed individuals are summoned to appear as twisted, uncanny, and surreal images.[43] The scenes in which these ghost images appear, demonstrate the characteristics of a "poetic documentary style," which focuses on delivering certain notes of atmosphere, tone, and emotion, instead of transferring knowledge from creator to viewer in a straightforward, didactic fashion.[44] A combination of documentary, based on records and facts, and cinematic video, mixed with fantasy elements, as represented by otherworldly, spiritual characters such as ghosts, form a consistent set of themes in Korean video art throughout the twenty-first century. The imagery

8 Park Chan-kyong, *Sindoan*, 2008,
 Video, color, sound, 45 min.

9 Im Heung-soon, *Factory Complex*, 2014,
 HD video, 5.1 channel sound, 95 min.

conveyed within these works touches upon ideas of legend, the supernatural, and mythology, in direct relation to the tragic modern history of Korea, compelling viewers to examine the overlooked contexts of loss, pain, and trauma inherent to the nation's recent past. These documentary fiction videos share the characteristics of contemporary cinematic video art since the 1990s, which often aimed to reconstruct alternative notions of history based on social and historical truths; but they also resonate with a wider, transnational body of work by non-white and non-Western artists from around the world, who use their artistic practice to directly reflect upon the experienced historical trauma of the global Cold War conflict and colonization.

VIDEO, PERFORMANCE, AND PERFORMATIVITY
One of the major phenomena apparent within Korean video art in the 2000s is the fact that the genre of performance video, in which the

10 Song Sanghee, *The Story of Byeongangsoe 2016: In Search of Humanity*, 2016,
Five-channel video, sound and moving spotlight installation, color, sound, 27 min.

time-based characteristic of video and bodily movement conjoin, enters into the social realm. This tendency can be distinguished from that of the video practices popular in previous periods. For instance, in the works by Kim Kulim, Park Hyunki, and Kim Youngjin in the 1970s and 1980s, the artists narcissistically recorded their own body image, based on video mirror reflection and focused on corresponding individualistic notions of time and concept.[45] Moreover, the performance videos that emerged from the late 1990s onward are characterized by exploring contemporary discourse on the body that surrounds critical gender and identity politics.[46]

Performance videos in the 2000s, however, moved beyond a simple focus on the artist's body toward a wider framework that addressed the artist's relationship with others and the wider environment, creating mutual and interdependent situations through creative practice. After the 1990s performance videos particularly started to embrace the issue of migration (or nomadism) or address the social conflicts and contradictions resulting from globalization. Kimsooja is a representative artist of the former concern. For instance, in her *Bottari Truck* series (1997–2007) she traveled cities of the world on a truck loaded with bottaries (fabric bundles), and in *A Needle Woman* series (1999–2001), she reconceptualized her body as a needle that threaded through the world's crowded urban spaces. These

works embodied emotive ideas related to movement, cultural boundaries, human liquidity, identity, and nomadism, which were popular themes of contemporary art in the 1990s and 2000s. Her famous work *Cities on the Move—2727 Kilometers Bottari Truck* (1997) is a performance video innovatively visualizing the narrative of long distance human and cultural movement. 11 In the video, the artist performs for eleven days, riding around various cities in Korea, the country of her birth. This work was later extended to *Bottari Truck—Migrateurs* (2007), in which the artist, again sitting on a truck, roams around various ethnic communities in Paris, France. The imagery of the packed fabric bundles and lone figure atop the *Bottari Truck* invoked ideas of homelessness, refugee life, and migration, and powerfully addressed the issue of sociopolitical migration generated in the process of globalization, exceeding the celebratory tone of nomadism that permeated the contemporary cultural discourse of the period.[47]

One of the newly emerging forms of performance video in the mid-to late 2000s was site-specific performance video, in which an artist occupies a specific space, performs there, and then documents the undertaking. The context embedded in the site becomes a major factor in determining the content of the performance video. Site-specific performance video often attempted to critically reveal the contradictions of Korean society

11 Kimsooja, *Cities on the Move—2727 Kilometers Bottari Truck*, 1997,
Single-channel performance video from 11 days journey throughout Korea, color, silent, 7 min. 3 sec.

through a combination of conveying the specific social narrative of the site and the situation of the performance performed there.[48] These performances often took place in the sites that had been razed due to urban renewal projects.

Lim Minouk is one of the most representative artists engaged in the production of such site-specific works. In *New Town Ghost* (2005), *S.O.S.—Adoptive Dissensus* (2009), *Portable Keeper* (2009), and *The Weight of Hands* (2010), Lim chose redevelopment projects, such as construction sites and urban ruins, making her collaborative practitioners perform in these spaces and creating videos documenting the performance. Lim's most famous video, *New Town Ghost*, shows a performer rapping, holding a loudspeaker, while a drummer plays a drum, on a truck that roams around the Yeongdeungpo area, which was one of the biggest urban redevelopment districts in Seoul at the time. The rapper's sharp voice and her performance on the truck offer an outcry representative of those who lost their homes due to the project. And, as such, this work provides a strong protest against urban redevelopment, which has indiscriminately destroyed the social-urban fabric of Korea, based simply on the logic of capital-dominated neoliberalism.[49] If *New Town Ghost* takes as its backdrop the development area of Yeongdeungpo, where a state-led 'new town project' was so brutally carried out, *The Weight of Hands*

examines the context of the Han River, which was the outpost of the development of the Four Major Rivers Project, as the site of the art work. *The Weight of Hands* is a performance video of passengers on a tour bus going on a pilgrimage to certain places that are being demolished and are banned from visitation due to redevelopment. In this work, a thermographic camera captured the process of pilgrimage, while a woman passenger singing a sad song on the bus offers a note of mourning and ritual performance, in memory of the existence of the disappeared beings in the ruins of the development site. Critically rethinking the structure of social repression and the context of absence as key components of the compressed modernization process that South Korea has undergone is a unique concern of Korean video art and originates from the local context of the work.

Lee Yongbaek's *Angel Soldier* (2005) is another performance video that is grounded in the regional context of the Korean Peninsula. 12 The video seems to present artificial flowers, however, upon closer inspection, a viewer can find six soldiers, who are disguised in flower-patterned uniforms, walking very slowly while holding guns in their hands. This video evokes not only a digital ontology, in which humans exist as avatar-like signs in the virtual world, but also the world of extreme battlefields in real-life, where survival is very much

12 Lee Yongbaek, *Angel Soldier*, 2005,
 Video installation; single-channel video, color, sound, video 24 min. 17 sec.

at stake.[50] It also addresses the special situation of Korea, which is still in a state of war and division. Surrounded by flowers and guns, these figures in the video are soldiers who thoroughly disguised themselves to survive in the battlefield; at the same time, they are angels who symbolize notions of anti-war protests, humanity, and peace. As double-sided beings traveling between war and peace, they highlight the situation in Korea by simultaneously representing the daily peace of the divided nation and the trauma and tension that underlies this. It is in this context that these "angel soldiers" later appear again as performers in Lee's work at the DMZ International Documentary Film Festival (2012).

By the late 2000s, Korean performance videos expanded creating works on a bigger scale and through a more complicated production process. Such works were a new type of performance video, combining performance, art, theater, music and dance, all artistic genres deeply related to the newly emerging ground of interdisciplinary art in Korea. Interdisciplinary art first garnered substantive national attention in 2005, as the Arts Council Korea launched a new sector named "interdisciplinary art" for the area to support, and it started using the term to refer to multi-genre art that is difficult to categorize into any specific categories, crossing over visual art, theater, music, dance, and performing arts and more. Through the International Modern Dance Festival from 2002, the Springwave Festival in 2007, and Festival Bo:m, which lasted from 2008 to 2015, interdisciplinary art has established itself on the Korean art scene as a creative genre that combines various artistic approaches, especially focusing on theater and performance. In such works, artists created stage-based performance videos, and often collaborated with dancers, choreographers, and musicians, and participated in various performing arts events, such as Festival Bo:m. Their works have been played and displayed in theaters, white cube exhibition spaces, and performance stages.

Along with interdisciplinary art, "performativity" is one of the key concepts addressed in both the discourse and practice of contemporary Korean art in the 2000s. Performativity entails notions of bodily movement, but it is fundamentally a philosophical and linguistic idea. The term "performative" originates from the performative function of language that makes an action implemented, as defined by John Austin. According to Austin, sentences (language) are representative of the uttered performance itself, and the utterance of sentences bring social reality into being and furthermore change it through the fact of the utterance.[51] Since the 2000s, as contemporary art discourse has increasingly come

13 Lim Minouk, *Fire Cliff 2*, 2011,
Single-channel video, color, sound, 63 min. 51 sec.

to emphasize the mutual relationship with the surrounding reality and the actions taken to realize such, rather than aesthetic values per-se, the idea of performativity has gained traction not only in performance art, but also across all genres common to the global art world. Crossing the context of exhibition and theater, artists went beyond simply attempting to produce videos documenting body performance; they incorporated the entire process of performativity. This incorporation creatively encompassed ideas of production, research, archiving, and collaboration within the artmaking outcome, and meaningfully addressed the performative meanings generated as artistic encounters relative to the various social realities pertinent to the work.

Based on theatre performances, Lim Minouk also created many films in conjunction with Festival Bo:m. For instance, Lim's *S.O.S.—Adoptive Dissensus* (2009) showed outdoor performances that took place near the Han River from the perspective of an audience on a cruise ship. Featuring the monologue of a long-term prisoner from North Korea, protesters holding mirrors as resistance against urban development, and a fictive performance by a man and a woman wandering around the area, *S.O.S.—Adoptive Dissensus* presented an idea of the omitted stories within modern Korean history. The aspect of performativity in Lim's videos culminated in *Fire Cliff 2* (2011), a video work that delivered a site-specific performance staged at the Baek Seonghui and Jang Minho Theater of the National Theatre Company of Korea. **13** Here, the element of performance centered around a conversation between a victim of state violence, Kim Taeryong, and a psychiatrist, Jeong Hyeshin. Given that the National Theatre was the site of a former transportation battalion of the Defense Security Command, it served as a mnemonically

charged site for the painful life of Kim Taeryong, the main character, who was imprisoned for nearly twenty years on fabricated charges relating to his involvement in the Samcheok espionage incident in 1979. All the scenes of the performance—including the conversation between Kim and the psychiatrist, Kim's confession of his life experience, scenes that represent past incidents, the audience's reaction, and a video with a thermographic camera—were eventually reconstructed into a single video.

If Lim's videos allow us to reconsider the people and places excluded from the established narrative of the modern history of Korea, Jung Yeondoo's performance videos pose fundamental questions about the truth in our own individual lives. Jung asks fundamental questions about what the truth is in our lives through his performance videos, in such works as *Bewitched* (2001–), *Wonderland* (2004), *Location* (2004–2006), *Documentary Nostalgia* (2007), *Handmade Memories* (2008), and *Cinemagician* (2010). For example, in his video installation *Documentary Nostalgia* (2007), Jung turned an exhibition hall of the MMCA into six studios of a room, an empty urban street, a rural landscape, a farming town scene, forests, and a canal, and he filmed the entire performance there in one long take, lasting 85 minutes. This one take unveiled the entire process of the staff installing and replacing the sets in the video without editing. By revealing the entire process of realizing the fictive nature of the work, instead of making this look real, the film reverses the situation that we believe to be true and blurs the dichotomy between truth and fiction.

Siren eun young jung and Nam Hwayeon take performativity of research and ethnographic archiving as the basis of their performance, theater, and video. jung expanded her practice to performances and videos based on a Korean traditional performance called Yeoseong Gukgeuk (female national theater): a traditional performing art of singing and dancing that started in the late 1940s and flourished throughout and after the Korean War. A unique feature of Yeoseong Gukgeuk is that it is performed only by female actors, who perform all kinds of roles. For this project, jung interviewed the Yeoseong Gukgeuk performers, including Cho Geumaeng, Lee Soja, and Cho Young-sook, for several years from 2008, organized workshops with them, and related the gender performativity that appears in their performance practice to her own video art. In *Masquerading Moment* (2009), *The Unexpected Response* (2010) 14 , *A Masterclass* (2010) *Off/Stage* (2012), and *Act of Affect* (2013), jung captures the borderline moment in which femininity and masculinity coexist, as female actors repeatedly enact bodily performativity by performing male roles and documenting the dramatic 'moment of affect' generated in so

doing. In jung's words, the performativity in her videos encompasses the artist's own repeated performativity in searching and tracing out the historical context of Yeoseong Gukgeuk; the performativity of female actors' bodily training to act the male roles; and a Butlerian notion of gender performativity and violating the norms of such.[52]

If jung's videos are based on her ethnographic research on Yeoseong Gukgeuk and the female actors' own collaborative performance, Nam Hwayeon's videos incorporate a wide range of forms, genres, subjects. These works encompass Nam's wide-ranging research based on the archives of botany, zoology, and historical data from various cultures across time and space, her writing based on such, the dancers' performance based on her written text, and, finally, the video documentation of this dancers' performance. Nam's *Operational Play 2009 Seoul* (2009) documents a performance based on a scenario written using codes for military operations, such as "white falcon," "the desert scorpion," and "black eagle." 15 Her *Ghost Orchid* (2015) and *The Botany of Desire* (2015) investigate the context of orchid hunting in nineteenth century Europe and the historical context of "Tulip Mania" that occurred in the seventeenth century Netherlands. Through these investigations, Nam explores the global migration of plants, the historical relationship between market and capital, and the human desire to collect, via language, performance, and video. Nam's performance videos are completed through complex layers of narrative, text, musical scoring, performance, and video, and created through interdisciplinary collaboration with humanities scholars, dancers, and choreographers. Additionally, the performance aspects of her work take place on 'real' live stages, such as at the Festival Bo:m, and then are displayed in exhibition spaces as video works. Starting from the text, the performativity in Nam's performance video can be seen as, ultimately, traversing John Austin's concept of the performativity of language that makes the action implemented. Here, the artist's performative research in visiting historical sites where the actual events took place, the dancer's actual performance, and the movement and rhythm of video images all combine and connect to shape the success of the work.

From the 1990s to 2000s, Korean video art has changed in conjunction with the transformation of the wider media environment, which has various featured new technologies such as TV, VCR, computer, Internet, popular video culture, digital technology, and changes in contemporary Korean art, Korea's unique social context, and the nation's contemporary art practices. The historical

14 siren eun young jung, *The Unexpected Response*, 2010,
Single-channel video, color, silent, 8 min. 8 sec.

15 Nam Hwayeon, *Operational Play 2009 Seoul*, 2009,
Single-channel video, color, sound, 19 min. 40 sec.

unfolding of Korean video art since the 1990s can be roughly summed up in the following manner. At first, in video sculpture of the early 1990s, video was not considered an independent medium. This concern was surpassed by the use of single-channel videos after the late 1990s when the grammar of video became more apparent. After the mid-2000s, although sometimes blurred or intertwined, the development of Korean video roughly became threefold: Cinematic videos grew under the post-medium conditions of the digital era, documentary videos often focused on Korea's geopolitical issues, and other videos of this sort concentrated more on the multiple layers of performativity through archiving, research, and collaboration. Arguably, what is important now, however, is not the different types and changes in the history of Korean video art, but the active practices of Korean video artists.

Video art in Korea formed important point of influence in the wider contemporary Korean art world in several ways. It offered an established experimental art practice that was celebrated for experimenting with time, action, and concept. As an alternative medium ready used to fill in the gaps in Korea's modern history; and as an interdisciplinary medium that crosses genres between visual art, dance, movies, music, and so on, Korean video art has long achieved global contemporaneity, and the forces driving its constant creative transitions constitute the powerful essence of the genre.

1 Michael Rush, *New Media in Late 20th-Century Art* [1999], trans. Shim Cheolwung (Seoul: Shigongsa, 2003), 91. Michael Rush explains the origin of video art in two types: activist documentary videos, which is related to alternative journalism, and fine art videos.

2 Video art in Korea began in the mid-1970s, with the emergence of a group of artists, such as Kim Kulim, Kim Deoknyun, Kim Youngjin, and Park Hyunki, who used video cameras as tools for artistic expression and produced experimental moving images. Video was a singularly useful medium for such experimental artists to boldly play with the themes that they were exploring in the 1970s, such as time, process, performativity, and conceptualism.

3 Oh Kwang-su, Yoo Jaekil, Seo Seong-rok, and Lee Joon, "Taljangneu hyeonsang eotteoke bol geosinga" [Anti-Genre: How Should We See?], *Wolgan Misul*, November 1990, 66–74

4 Kang Taehee et al, *Dongsidae hanguk misurui jihyeong* [Mapping of Korean Contemporary Art] (Seoul: Hakgojae, 2009), 4.

5 Tracy Min, "Hanguk midieo ateuui chogi damnon yeongu: 1960nyeondae buteo 1990nyeondae kkaji yongeoui byeonhwareul jungsimeuro" [A Study on Initial Discourse in Korean Media Art—Focused on the Change of Terms from the 1960's to 1990's], *Journal of Korean Society of Media and Arts* (Contents Plus): 95–114.

6 The examples include *Midieoroseoui pilleum* [Film as a Media], organized by Kim Deoknyun and Chang Hwajin for the Exhibition *Seoul '70*, in 1977, and *Video & Film Works*, the third part of the fourth Daegu Contemporary Art Festival, in 1978.

7 For more information about the Daegu Contemporary Art Festival, see Kim Okryeol and Park Minyoung, *Gangjeong Daegu Hyondaemisulje* [Gangjeong Daegu Contemporary Art Festival] (Seoul: Minsokwon, 2016).

8 Bae Myungji, "Hanguk bidio ateu 7090: Sigan imiji jangchi" [Korean Video Art from 1970s to 1990s: Time Image Apparatus], in Bae Myungji et al., *Korean Video Art from 1970s to 1990s: Time Image Apparatus*, exh. cat. (Seoul: MMCA, 2019), 29

9 To more detail on this, see Yi Wonkon, "Bidioseolchi eseoui inteoseupeiseue gwanhan yeongu: Syameonijeumgwaui gujojeok yusaseongeul jungsimeuro" [A Study on the 'Interspace' of Video Installation—The Structural Similiary with Shamanism], *Korea Society of Basic Design & Art* 4, no. 2 (2003): 334–343.

10 Yi Wonkon, "Bakhyeongiui bidio doltabe daehan jaego: Jakgaui yugoreul jungsimeuro" [Reconsiderations about Park Hyunki's Video Totem Pole: Focused on the Posthumous Papers of the Artist], *Korea Society of Basic Design & Art* 12 (2011): 452

11 Park Hyunki, "Naui saeroun chulbalgwa BIDIO ATEU" [My New Departure and Video Art], *Art and Technology*, exh. cat. (Seoul: Seoul Arts Center, 1991), 40.

12 While staying in Japan, Park Hyunki met Katsuhiro Yamaguchi, who was a university professor and was able to use the brand-new technology developed by the Victor Company of Japan (JVC). Ibid, 40.

13 Yook Keunbyung, *Eye* (Seoul: Nexus, 2016), 19.

14 Ryu Byunghak, "Gimhaemin midieo ateuui yosulsa" [Kim Haemin, the Magician of Media Art], in Kim Haemin et al., *Gimhaemin bidio yesul jakpumjip* [Kim Haemin Video Art Collection] (Seoul: Leesaik, 2019), 193–194.

15 Kang Sangheon, "Keolleo bangyeong saekgamjohwae deo singyeongeul . . ." [Color Broadcasting: Pay More Attention to Color Matching], *Dong-A Ilbo*, January 7, 1981, 12; Shin Saetbyeol, "Keolleo tibiui sidaewa jeongdongui jeongchihak" [The Era of Color TV and the Politics of

Affect—Focused on Park Wan-seo's Short Story in the 1980s], *Journal of Humanities, Institute of Humanities Myong Ji University* 38, no. 1 (2017): 44

16 Interview with Yi Wonkon at his office, Dankook University on March 26, 2019.

17 In his 1974 report to the Rockefeller Foundation, titled, "Media Planning for the Post-Industrial Age," Paik Nam June mentioned how construction of a new electronic superhighway would change future civilization. Cinthia Goodman, "The Electronic Frontier: From Video to Virtual Reality," in eds. Kim Hong-hee and Cynthia Goodman, *InfoArt: '95 Kwangju Biennale*, exh. cat. (Seoul: Gwangju Biennale Foundation & Sam Shin Gak, 1995), 43.

18 Paik Nam June's exhibitions held in South Korea in the late 1980s and the 1990s include *The More, The Better* (1988), the installation at the MMCA, and *Nam June Paik·Video Time·Video Space* (1992), a retrospective held at the MMCA as a celebration of Paik's sixtieth birthday.

19 Kim Hong-hee, "Jeongbo yesul jeonsigwan sogui asia bidio & meolti midieo yesul" [Asian Video Art & Multimedia in the InfoART Pavilion], *InfoART*, 154. This exhibition was designed in three parts: Interactive in Arts & Toolmaking, Asian Video Art & Multimedia, and Whole World Video.

20 Bae, "Korean Video Art from 1970s to 1990s," 31–32.

21 Kim Jae-kwon, "Daedam: Hangukmisure isseoseo yesulgwa gigyegwahagui johyeongjeong mannam" [Conversation: The Formative Meeting of Art and Mechanical Science in Korean Art], *Art and Technology*, exh. cat. (Seoul: Seoul Arts Center, 1991), 7; Kim Jae-kwon, "Artist's Note" in *Art and Technology*, 35.

22 Kim Hong-hee, "Ingangwa gigye: Tekeunolloji ateu" [Man and Machine: Technology Art], *Ingangwa gigye: Tekeunolloji ateu* [Man and Machine: Technology Art], exh. cat. (Seoul: Dong-A Gallery, 1995).

23 For the digital editing technology in video art, see Kim Yeunho, "Poseuteu dijiteol maeche yesulgwa 2000nyeondae hanguk dijiteol bidioateu yeongu" [A Study on Post-digital Media Art and Korean Digital Video Art in the 2000s], *Contents Plus* 14, no. 3 (2016): 109–120

24 Bae, "Korean Video Art from 1970s to 1990s," 40.

25 For more on this discussion, see Lee Dongyeon, "Imijireul sobihaneun MTV kideu" [MTV Kids Consuming Images], and Beck Jee-sook, "Myujikbidiowa MTVui munhwajeok uimi myeon gaji" [Music Videos and Some Cultural Meaning of MTV], *Wolgan Misul*, September 2000, 92–97.

26 Bae, "Korean Video Art from 1970s to 1990s," 41.

27 This event was titled Seoul International Media Art Biennale from its second event in 2002. From 2014, for its eighth event, it was renamed SeMA Biennale, as the Seoul Museum of Art operates the biennale. The current official term is SeMA Biennale Mediacity Seoul.

28 Kim Sunjung, *TEUM*, exhibition brochure (Seoul: Art Sonje Center, 1998), 2.

29 The Script of *Fall, Fall, Fall*; Kim, *Teum*.

30 Lee Youngchul, "Bokjapseongui gonggan, buryeonsokseongui sigan" [Discontinuity of Time, Complexity of Space], *'98 Seoul in Media: Food, Clothing, Shelter*, exh. cat. (Seoul: SeMA, 1998).

31 Rosalind Krauss, *A Voyage on the North Sea: Art in the Age of the Post-Medium Condition* [2004]. trans. Kim Jihoon (Seoul: Hyunsil Publishing, [2004] 2017), 8, 72.

32 For this discussion, see Kim Jihoon, "Medium beyond Medium: Rosalind E. Krauss's 'Post-medium' Discourse," *Mihak: The Korean Journal of Aesthetics* 82, no. 1 (2016): 73–115

33 Park Man-u, "Yeonghwajeong segyegwangwa yeongsangeoneui peuraksiseu" [A Cinematic Worldview and the

Praxis of Video Language, *Wolgan Misul*, December 2000, 172–179; "Misul, yeonghwaui hangyee dojeonhada" [Art Challenges the Limitations of Film, A special issue in *Wolgan Misul*, December 2010, 89–116.

34 "Misul, yeonghwaui hangyee dojeonhada," 89–116.

35 Cho Seon-ryeong, "Dongsidae bidio ateuui sinematikhan teukseonge daehan yeongu" [A Study on the 'Cinematic' Character of Contemporary Video Arts], *Journal of Contemporary Art Studies* 17, no. 1 (2013): 179, 182–183; Kim Jihoon, "Yeonghwajeok bidio seolchi jakpumeseo yeonghwawa bidioui honjonghwa" [Hybridizations of Film and Video in Cinematic Video Installations], *Journal of History of Modern Art* 39 (2016): 9.

36 Maeve Connolly, *The Place of Artists' Cinema: Space, Site and Screen* (Chicago: Intellect Books, 2009), 10.

37 T. J. Demos, "Yang Ah Ham: A Life of Dreams: The Videos of Yang Ah Ham," in *Art of Communication: Anri Sala, Yang Ah Ham, Philippe Parreno, Jorge Pardo* (Seoul: MMCA, 2011), 48. For the film fables, see *Yeonghwa wuhwa* [La Fable cinématographique], trans. Yu Jaehong (Seoul: Ingan Sarang, 2012).

38 Claire Bishop, "Social Turn: Collaboration and Its Discontents," *Art Forum* (February 2006): 179–185.

39 Maria Lind and Hito Steyerl wrote, "Documentary practices make up one of the most significant and complex tendencies within art during the last two decades." Maria Lind, Hito Steyerl, *The Greenroom: Reconsidering the Documentary and Contemporary Art #1* (Berlin: Sternberg Press, 2008), 16.

40 The examples are documenta in Kassel, in 2002, when the curator Okwui Enwezor introduced non-white, 'minority' artists, such as Shirin Neshat, Isaac Julien, and John Akomfrah.

41 For more details, see Barbara London, "Media Art, Globalism, and Identity Politics," *Video/Art: The First Fifty Years* (London: Phaidon, 2020), 215–242.

42 Park Chan-kyong, "Gaenyeomjeong hyeonsiljuui noteu" [Notes on Conceptual Realism], *Forum A*, no. 9 (2001): 19–24.

43 Shin Chunghoon argues that tradition becomes the subject of "hauntology" in Park Chan-kyong's work, and because the tradition of ghosts has been repressed, it returns in Park's work as the aggressive and destructive forms. Shin Chunghooon, "Parkchankyonge daehan noteu: minjungmisul, yeoksa, jeontong" [Notes on Park Chan-kyong: Minjnug Art, History, Tradition], in *Annyeong 安寧 farewell*, exh. cat. (Seoul: Kukje Gallery, 2017), 37.

44 Lee Sunjoo, "Salmgwa nodongui gachireul bogwonhaneun mijeok silheom wiro gongdan" [Aesthetic Experimentations That Restore the Value of Life and Labor: *Factory Complex*], *Contemporary Film Studies* 23 (2016): 166–167; Yang Hyosil, "Poetic Cinema of the People: The Place Where Anyone Becomes You," in *Im Heung-soon: Toward a Poetics of Opacity and Hauntology*, ed. Helen Jungyeon Ku (Seoul: MMCA and Hyunsil Publishing, 2018), 82.

45 Rosalind Krauss, "Video: The Aesthetics of Narcissism," *October* 1 (Spring 1976): 50–64.

46 The '93 Whitney Biennial in Seoul, which traveled to the MMCA in 1993, can be noted as a meaningful exhibition in relation to the body discourse in the 1990s. The exhibition is also important because it not only sparked geopolitical discussions surrounding race, nationality, and gender under the theme of "borderline," but also imprinted contemporary body discourse on the Korean art scene, through expressions of nudity and homosexuality. The examples include Oh Sang-Ghil's *Torn Flesh* (1999) and *Skin Licks* (1999), IUM's *The Highway* (1997), and Kim Seungyoung's *Self-portrait* (1999).

47 *Cities on the Move—2727 Kilometers Bottari Truck* (1997) is
 a performance video that visualizes the narrative of
 moving and nomadism by presenting the artist herself
 as the subject of the performance. In the video, Kimsooja
 travels for eleven days in a truck loaded with *bottari* to
 various cities in South Korea where she was born, resid-
 ed and left. Hans Ulrich Obrist, "Wrapping Bodies and
 Souls" (interview with Kimsooja by Hans Ulrich Obrist),
 Flash Art 30, no. 192 (January–February 1997), http://
 www.kimsooja.com/texts/ulrich_97.html.

48 Lee Seungmin, *Yeonghwawa gonggan: Dongsidae hanguk
 dakyumenteori yeonghwaui mihakjeok silcheon* [The Spirituali-
 ty in Korean Documentary Films] (Seoul: Galmuri, 2017),
 166–196. Lee Seungmin calls this tendency the site-spe-
 cific performance documentary and counts Lim Minouk
 as the best example.

49 Moon Youngmin, "The Composition of Social Memo-
 ries," in *Activating Korea: Tides of Collective Action*, exh. cat.
 (New Plymouth, New Zealand: Govett-Brewster Art
 Gallery, 2007), 45.

50 Kim Wonbang, "Iyongbaekui jageop: Dijiteol simyul-
 leisyeon sidaeui cheolhagui geoul" [Lee Yongbaek's Work:
 A Mirror of Philosophy in the Age of Digital Simulation],
 Lee Yongbaek: The Love Is gone, but the Scar Will Heal, exh. cat.
 (Seoul: Arts Council of Korea, 2011), 13; "Jeonbokjeok
 himeuroseoui gasangseonge daehan tamgu" [Exploration
 of Virtuality as a Subversive Power], *Lee Yongbaek Solo Ex-
 hibition Angel-Soldier*, exh. brochure (Seoul: MediaLab UBT,
 2006), 9.

51 Austin used the term "performative" in his *How to Do
 Things with Words* (1955) and used it in his later article,
 "Performative Utterances" (1956). Erika Fischer-Lichte,
 Ästhetik des Performativen [2010], trans. Kim Jungsook
 (Seoul: Munji Publishing, 2017), 43–44.

52 siren eun young jung, "Yeoseonggukgeukgwa seongbyeo-
 rui jeongchihak" [Yeoseong Gukgeuk and the Politics of
 Gender], in *Trans-Theatre*, ed. Ahn Sohyun (Seoul: Forum
 A, 2016), 67

The Conceptual Turn in South Korean Art After 1990

Woo Jung-Ah

ART AFTER 1990

South Korean art after 1990 is characterized as 'contemporary' since the sweeping changes that took place within the art world were not a domestic phenomenon, but the outcomes of a series of global shifts that were spreading throughout the world. South Korea, which had been at the forefront of the Cold War, underwent upheavals in all sectors of its society around the year 1990, including democratization, globalization in tandem with the 1988 Summer Olympic Games, the liberalizing of overseas travel, and the arrival of a neoliberal economy in the wake of the Asian Financial Crisis and International Monetary Fund (IMF) bailout. In art and culture, the advent of postmodernism as a discourse of pluralism and deconstructivism ignited intense polemics. Within this context, a new generation of artists described locally as "*shinsedae*" emerged seeking creative freedom from the excessive burden of political ideology and partisan perspectives that had dominated every sector of South Korean society until the end of the 1980s.

Art historians define the years after 1990 in South Korea as time of diversity that moved away from the ideological conflicts that had preoccupied the preceding era. Kim Youngna explained this new orientation in terms of "a flow of experiencing global culture and stepping away from the narrow scope of nationalism," within the larger framework of postmodernism.[1] Charlotte Horlyck stated, "for the first time in Korea's modern history, artworks can neither be categorized according to medium nor linked to a specific stylistic or ideological movement."[2] Yun Nanjie also emphasized the influence of postmodernist discourse and summarized the period as a time of "multiple identity or hybridity."[3] It is significant that the ideological conflicts of the 1980s had been resolved and, with it, the bipolar opposition between

Dansaekhwa (Korean modernism) and the politically engaged Minjung art (People's Art) had been left behind. Art in the 1990s was very much an art of individuals who were not buried in concerns of nationalism or a collective agenda such as the search for "Koreanness" or "class-based partisanship."

This chapter examines the artists who took the lead in the conceptual turn of the 1990s: Bahc Yiso, Ahn Kyuchul, Kim Beom, Gimhongsok, Chung Seoyoung, Oh Inhwan, Yang Haegue, and Rhii Jewyo. Their practice is clearly distinguishable from the sensibilities of the *shinsedae* artists in terms of its intellectually oriented formal structure and critical perspectives. Their works have been described as "conceptual" or "conceptualist" in the most vague and ambiguous sense.[4] One might refer to the conceptual art and conceptualism that emerged mainly in North America and Europe in the mid-1960s as the referential context of these artists' conceptual practices. However, while their work shares a conceptual tendency stemming from the Euro-American discourse, its critical intent is markedly different from that displayed within the mainstream of Western conceptual art. In this chapter, the notion of a "conceptual turn" is proposed in order to contextualize the changes in artistic structure through which the artists' individual and idiosyncratic concerns could be articulated.[5]

WHEN ATTITUDE BECOMES STRUCTURE:[6] BAHC YISO AND AHN KYUCHUL

In a round table discussion of Bahc Yiso's 1995 solo exhibition, Ahn Kyuchul asked about Bahc's process of making art in terms of "conceptual art."[7] Ahn described Bahc's work as "conceptual art" of an "intellectual disposition" in that it shows "a puritan piety" in comparison to the then-current trend

in South Korean art that emphasized sensational aesthetics and visual stimulation, a critique perhaps aimed at *shinsedae* art. Ahn then asked about the relationship between the "thoughts articulated by language and concept" and the "material and form." Ahn emphasized that Bahc used non-traditional low-cost materials for his works and consciously suppressed their aesthetic potential. Park Chankyong added to the conversation that Ahn's work also shows a "conceptual orientation" in that it is "cognitive and informative." He went on to say that despite the differences between Ahn and Bahc, artworks by both have "very sophisticated blueprints" in common. Park evaluated conceptual art as a breakthrough from both Minjung art, which adhered to outmoded social realism as a means of emphasizing political and ideological messages, and Dansaekhwa, which increasingly appeared to be a formalist pursuit depleted of meaning.[8] In their conversation, conceptual art was defined as the practice of considering the relationship between the idea that the artist wishes to convey and a created work as the material outcome. In other words, the linguistic construction of a concept, which corresponds to the 'sophisticated blueprint' completed before production, has emerged as a major stage in artmaking practice.

Bahc and Ahn both served as artists, critics, translators, and educators from the beginning of their careers, and they left many drawings and texts as pre-production planning or as independent works.[9] Consequently, a desk frequently appears as a main theme in their work since writing played a significant part in their art practices. Their work can accordingly be described as linguistic in three aspects: First, texts and letters appear in the work; second, the production process can be transcribed in clear statements based on a logical thought progress instead of a sudden flash of inspiration; and third, their artwork operates as a public statement in a similar manner to speech. Thus, the linguistic structure of an artwork is a category that encompasses both the formal style and the object of reference. Their combination produces meaning as a symbol, which consists of a signifier (the form or appearance of an artwork) and the signified (the content or the meaning). As far as this combination is an individual process of each artist, it tends to be arbitrary. However, Bahc, Ahn and the other conceptual artists in this chapter have strived to secure maximum necessity and causality in this combination in order to legitimize their artwork as public statements.[10]

As Ahn mentioned, the term 'conceptual' has often been used in contrast to 'visual' in reference to artworks that do not apparently privilege aesthetic qualities and figurative representation. However, in the case of these South Korean artists

the non-visuality of their work is not necessarily a result of a concern with "de-materialization," something often associated with conceptual art.[11] Rather, they carefully choose their materials and create forms so that their works seem to be closer to the traditional idea of sculpture or crafts. As artists, they are obsessed with materials because they neither believe in the transparency of language as a symbol representing a concept, nor do they rely on the universality of language. Thus, their art as text is neither a tautological analysis of the definition of art, as in Joseph Kosuth's works, nor purely self-referential, like Lawrence Weiner. Another historical context of being conceptual would be the institutional critique of the 1960s neo-avant-garde, but these Korean artists' concern with such critique is not limited to exposing the socio-economic constraints of the museum, as was the case with Hans Haacke.[12]

Considered the progenitors of the conceptual tendency in South Korean art, Bahc and Ahn can be distinguished from the other artists discussed in this chapter by their generational difference and subsequent political disposition. Bahc and Ahn were sympathetic to the political underpinnings of Minjung art from the beginning of their careers. Thus, from the very outset their public statements, they offered a critical view of the sociopolitical realities of South Korea at the end of the 20th century, including topics ranging from the struggle for democratization to the pernicious effects of globalization. However, during the mid-1980s, when Minjung art was moving toward overt political activism in response to the oppressive social conditions in South Korea and was engaging in an explicit critique of the conservative South Korean art establishment, both left to pursue further studies, Bahc in New York and Ahn in Germany. In this regard, while sympathetic to the agenda of the Minjung movement, Bahc and Ahn were either skeptical or cynical about the political efficacy of art since they missed out on the revolution by being outside Korea at the time. Their political cynicism was informed by the experience of studying abroad and using a foreign tongue: They realized that complete translation was impossible, language was not transparent, and the idea of an absolutely objective statement was nonsensical. Furthermore, both artists were compelled to assume a peripheral identity as minority artists from the developing world, something which they would never have experienced had they remained in Korea. Accordingly, Bahc and Ahn were keenly aware of the hierarchical imposition involved in seeking to represent a group of other people, or in preaching political correctness to others.

More fundamentally, along with the bystander guilt they suffered for being absent at this crucial

moment in South Korea's democratic revolution, Bahc and Ahn also witnessed widespread cynicism and disillusionment within Western societies regarding the realities of democracy and revolutionary ideals. Ahn observed this while living in a society that had experienced the '68 Movement (the West German student movement) twenty years previously.[13] Having directly experienced this time gap in social and political development between South Korea and the West and the time gap between the post-68ers, who lived in a future after the revolution, and the post-89 generation,[14] Bahc and Ahn understood that art that could resolve political problems and resist oppression while criticizing the absurdities within society was a messiah that would never come.

While remaining abroad, both artists contributed to South Korean art magazines by submitting articles that discussed theory and practice in the current art scene. In these articles, they sought to explore the points of convergence between postmodernism and Minjung art and struggled to find art forms in which aesthetics and politics could be fully united. It is notable that despite these discussions about art's social engagement, they remained skeptical about the effectiveness of art as activism and often reflected upon the inevitable failure of the artist as a social transformer. The conceptual turn in South Korean art began with this attitude of cynical reflection.

Their reflective attitude toward the impotence of art was manifested in the ways in which they almost painstakingly created rickety works out of cheap materials on a modest scale. For example, Bahc's *Model of UN Tower* (1996) is one of many studies for his *UN Tower*, which he presented in 1997 at an exhibition themed "power" that was part of the second Gwangju Biennale. [1] The tall obelisk of his 'UN Tower,' which stands straight on a plinth above a stereobate, was a monument that all South Koreans would have been familiar with due to the design of the UN Matchbox, a common household item in South Korea until the mid-1980s. This UN Tower was a proposed monument intended to honor the involvement of the UN in the Korean War, but only ever existed as a trademark design and was never constructed in reality. At the Gwangju Biennale, Bahc cut out a gigantic piece of plywood in the shape of the plinth and the stereobate, but not the tower itself, and installed it like a dividing wall within the exhibition space. This installation was an attempt to reflect the vulnerability of the ideological underpinnings of peace, nation-states, and solidarity, as represented by a fictional UN Tower that stands firmly on the slogans of "anti-communism" and "anti-espionage."[15] Over the process of reaching the final decision to produce a plywood sculpture, Bahc left a number of studies

of *UN Tower* in his notebook, most of which were designed to be small in scale and made from inexpensive materials such as oil-based clay or pencil on paper. From the outset of his creative efforts, Bahc was apparently careful to make his works appear 'clumsy,' that is, not to appear as if they had been created through hard work or intended to be received as great masterpieces of art. Finally, embodied only as a negative space in humble plywood, his UN Tower monument represents the absence, unreality, and ephemerality of the great cause of the South Korean nation that the monument symbolizes.

In 1989, Bahc left a note in his sketchbook after witnessing the Tiananmen square protest on June 4:

> With what words could one decently explain making a painting and having an exhibition about the people who died, who are dying, and who will die under state terrorism? Even if one explains that it is a combination of a petit-bourgeoisie idealism to relieve helplessness and the burden of guilt of being an onlooker in a cultural system that supports political propaganda, one cannot avoid sorrow and frustration. At any rate, we quickly forget. Even if we make a fuss as if we could change the world, after a few weeks or months have passed, we forget everything thanks to the excuse of having to survive everyday life.[16]

At the beginning of this note, Bahc left the dysphemistic phrases "1. Be simple. 2. Draw less and draw ugly." For Bahc, these mottos were perhaps means of coping with the helplessness he felt as an artist in a chaotic era of political violence and represented the ascetic path that any intellectual who criticized the superficial nature of modernism must inevitably choose.[17]

The anti-monumental decision to operate as a 'petit-bourgeoisie artist' also manifests in Ahn's early works. His *Chung-dong Landscape* (1985) is a miniature papier mâché sculpture representing a young man trying to sneak into the US Cultural Center in Chung-dong, Seoul while avoiding the gaze of security guards. [2] While working as a staff editor for the art magazine *Gyegan Misul*, Ahn began to participate in the socially and politically critical art collective Reality and Utterance. Regarding the decision to reject a conservative, formalistic view of art and turn his attention to the issues of his social reality, he recalled that he suffered from "a helpless cynical bystander's severe self-division."[18] As an employee who had to conform to the authoritative institutions of art and journalism, it would never have been easy for Ahn to join an art movement like Reality and Utterance that promoted the art of social revolution and would become a catalyst for

1 Bahc Yiso, *Model of UN Tower*, 1996,
Plasticine, 23×7.5×7.5 cm

2 Ahn Kyuchul, *Chung-dong Landscape*, 1985,
Painted clay and plaster, 24×46×42 cm

Minjung art. As Ahn described the medium, papier mâché paste was a material only for "apartment-dwelling housewives to play with as a hobby." His choice was a realistic decision that reduced "the weight of material and labor" in his practice to a level that he could handle as a full-time worker. It also offered a means of creative self-control, enabling him to consciously profess his downgraded position as "an amateur sculptor."[19]

Ahn's *Our Precious Tomorrow* (1992) takes the form of a chocolate bar with a corner bitten off. [3] The shape and color are certainly those of a chocolate bar, but when we realize that it is made of steel, we feel a strange sensation and even a frightening pain in the mouth and teeth. If we continued eating the bar from the bitten end, a piece on which the Korean syllables *nae-il* (tomorrow) are engraved in neat and sophisticated handwriting, would be left in the end. Twentieth-century South Korean society underwent highly compressed economic development under the military dictatorship and often wielded violence and oppression against individuals under the promise of a sweet and precious tomorrow. Bahc's work *Your Bright Future* (2002) attempts to indicate

how vain is the promise of a better tomorrow.[20] [4] The installation resembles a human being, or just a living entity, but it consists of wooden sticks that are interdependently intertwined as if the whole thing would collapse if a single stick were removed. Attached on top of the vertically upright wooden sticks, beaming round bulbs function like a crowd who has raised their heads grudgingly to shine a light on the heroic protagonist who would lead 'us'—which the artwork refers to "you"—to a bright future. However, the wall in front of the crowd of the lights is empty, and there is nothing there where the shining light falls. Ultimately, what allows this vulnerable structure to stand is not the illuminated empty wall, but the state of solidarity that loosely ties them together. Behind the cheerful titles and shaky appearance of both works, Ahn's *Our Precious Tomorrow* and Bahc's *Your Bright Future* present the incomplete and absurd reality of a purported community that is running blindly toward a common purpose.

Although South Korean art before the 1990s sought to define society and its reality based on notions of collective identity, such as class or ethnicity, the conceptual artists introduced

3 Ahn Kyuchul, *Our Precious Tomorrow*, 1992,
Steel, 1.3×15.2×6.5 cm

here took a more critical perspective, revealing a
multilayered perception as individuals and isolated
entities living in different realities. If the art of
this period can be called 'the art of individuals,'
then these are not optimistic individuals who seek
the joys of liberation. They are vulnerable, weak,
and anxious post-1990 figures who appeared at a
time when the seemingly eternal ideological façade
that had sustained South Korean society during
the dictatorship had collapsed and it was becoming
clear that building a national community as a
unified whole would be impossible.

ABSOLUTELY INDIVIDUAL: KIM BEOM AND CHUNG SEOYOUNG

The Korean exclamation "*eo*" (어) is "a sound uttered
when one is surprised, embarrassed, nervous,
urgent, happy, sad, repentant, or praising" or "a
sound one makes to attract another's attention
before speaking."[21] Chung Seoyoung's *-Awe* (*Eo*,
1996) certainly attracted the attention of others,
especially its viewers. [5] If there was a most-uttered
response to this work displayed at her 2000 solo
exhibition *Lookout*, it would similarly have been "*eo*."
This is because when seeing the Korean syllabic
block *eo* carefully written in a Korean court-
style type font on a piece of yellow oil paper that
was commonly used for flooring in a traditional
house, one might have felt surprised, embarrassed,
or nervous, as no specific meaning was offered.
The work only served to provoke a vague emotive
response based on shared cultural memory and
nostalgia.

In fact, what is used in *Eo* is not the oiled
papers glued layer by layer on to floors in
traditional Korean houses, but a piece of linoleum
with printed patterns imitating the texture, color,
and even the brush marks of such oiled paper.
By this time, linoleum, which is much cheaper,
more durable, and longer-lasting than real paper
flooring, had completely replaced authentic paper
floors. In the exhibition catalog, the linoleum is
captioned as "traditional vinyl floorboards,"[22]
creating an implausible hybrid of vinyl and
tradition. The horizontal line neatly drawn before
the syllable *eo*, which is also neatly written, must
have been drawn with a ruler for accuracy. The
line trembles nervously, however, adding a quite
deliberate smudging of ink. In fact, the English
title of this work is *Awe*, meaning "an emotion
variously combining dread, veneration, and wonder
that is inspired by authority or by the sacred or
sublime."[23] Of course, while Chung's work has
never overwhelmed a viewer, it does nonetheless
stimulate dread and wonder as something that
cannot ever be entirely understood or known by
the viewer. As such, the conceptual ramifications of
eo and *awe* coexist strangely on this vinyl flooring
that seems to betray the irony of modern Korean
historical development in which the incompatible
simultaneously exists.

When describing her work's art historical
context Chung could not think of anything more
than that of "an individual." She said that the 1990s
was an era "in which an individual can exist as an
individual for the first time" in Korean history.[24]
The standard idea of an 'individual' in Korea is that
of a single person who constitutes part of a wider
state, society, or organization. In other words, the
'individual' should contribute to the building of
the state, society, or organization. However, the
individual who speaks through Chung's work is an
absolutely individual being who neither constitutes
anything other than herself nor shares a meaning
with anyone. The artist carefully chooses materials
to convey the vibration and presence of beings that
she sensed or perceived through a particular object.
When manipulating and combining materials to
create a form for an artwork, she painstakingly
thinks through ways to reveal the desired emotions
or perceived phenomena. This means her work
goes through a process that is opposite to de-
materialization. The artist works so hard on the
production of the work that her practice is said to
be handicraft. However, there is the paradox that
this attention to detail testifies to her effort not
to make her materials spectacular or greater than
what they need to be in the context of the work.
The results of this approach can be seen in a piece
such as *Flower* (1999) a Styrofoam installation that is
so sloppy and ridiculously large that one thinks of a
flower only after seeing the title.[25]

Chung also uses "*eo*" quite a lot in
conversations. The "*eo*" in her words indicates
a moment of hesitation while seeking words to

4 Bahc Yiso, *Your Bright Future*, 2002,
 Electric lamps, woods, wires, dimensions variable

5 Chung Seoyoung, *–Awe*, 1996,
 Wood, linoleum, house paint, 140×130×3 cm

articulate her intentions as clearly as possible, and as an interjection to fill the gap between the appropriate word and the next. In fact, even if she carefully chooses words to explicate the meaning of a work, the signified can never be completely spoken in language. Thus, the core of her words arguably remains in the "eo," which exists in between what is spoken and what is not. Because the meaning of the "eo" in its entirety is completely private, so much so that it cannot be shared with others and cannot be delivered in language as a universal means of communication, she has become obsessed with the expressive possibility of the material form of sculpture.

Kim Beom and Chung Seoyoung are often mentioned together because they both examine the idea of a "secrete and private inner reality that exists, even if it is not seen from the outside."[26] Kim's *An Iron in the Form of a Radio, a Kettle in the Form of an Iron, and a Radio in the Form of a Kettle* (2002) demonstrates the existence of objects that defy common sense. ̄6 The iron, radio, and kettle placed on the table switch their roles while maintaining a conventional appearance. As such, the piece offers a condition in which a radio is actually an iron, the iron is actually a kettle, and the kettle is in fact a radio. In 1921, Man Ray attached fourteen nails to a flat-iron and called it simply '*Gift*.' Compared with Ray's aggressive and violent humor in which the iron was subversively re-tooled to destroy rather than flatten clothing in the performance of its function, Kim's radio iron and iron kettle seem to be able to perform their newly given duties as if such a refiguring was a casual matter or an everyday occurrence.

When Kim explained his work, he mentioned the tension that exists between the idea of "what you see is what you see" and "what you see is not what you see."[27] The title of his work addresses the reality of the situation in a matter-of-fact manner, offering a 'literal translation' of the idea that "what you see is what you see." However, the work itself is deceptive in relation to everyday reality, so it maintains a fictive quality of "what you see is not

6 Kim Beom, *An Iron in the Form of a Radio, a Kettle in the Form of an Iron, and a Radio in the Form of a Kettle*, 2002,
Mixed media, 14×30×13 cm, 23.5×13×13 cm, 13×22.5×19 (panel 39.5×57.5) cm

what you see." In response to Kim, Doryun Chong offered that, "representation—an operation that triangulates between a thing, its actual image, and its mental image in the perceiver—is almost always unstable, and it can be argued that Kim's work is preoccupied with the task of pulling these relationships apart."[28] Within the world of Western conceptual art, another reference point for Kim is perhaps the work of Joseph Kosuth. To illustrate the tautological characteristics of the three concepts of language/text, object, and image, he presented *One and Three Chairs* in 1965. In distinguishing the three types of chair—a dictionary definition of the word 'chair,' a real chair, and a representation of the chair—Kosuth displayed a panel with the enlarged, printed text of *chair* in a dictionary, a real chair, and a life-size picture of the chair in the exhibition space. For Kosuth, these three versions offered a tightly bound critique of the structure of representation. In contrast, Kim here rejects the solidarity of the object-idea-image triad at a fundamental level and encouraged his audiences to follow suit.

THE IMPOSSIBILITIES OF RELATIONSHIP AND COMMUNICATION: OH INHWAN AND YANG HAEGUE

Oh Inhwan's *Where He Meets Him in Seoul* (2009) is a work in which the artist ground incense, wrote countless words with the incense powder on the museum's floor, and lit it at the opening of the exhibition. 7 Contrary to vision, olfactory perception is a material phenomenon triggered by molecules, in this case particles of incense suspended in the air. Oh's work decomposes into airborne incense molecules through a real-time process of combustion, following which particles of the incense literally infiltrate the audience's bodies. The work disappears into ashes, but by the end of the exhibition, the burnt traces of the letters remain on the floor, like wounds that can never be entirely erased. These letters spell out the names of gay bars and clubs in the city in which the exhibition was being held. Critic Jung Hyun once called homosexuality a form of "unspeakable

7 Oh Inhwan, *Where He Meets Him in Seoul*, 2009,
 Incense powder, 563×530 cm

love."[29] Here, Oh inscribed in a very physical and destructive way these unspeakable words, words one is prohibited from uttering within our heteronormative patriarchal culture, on the floor of art museums that themselves constitute an authoritative institutional system. However, even if words such as "The 8th Street," "Love Star" or "Why Not?" burn so intensely that they can singe the floor of an exhibition hall, for audiences who are not familiar with the gay community the words may ultimately just be random collections of meaningless letters. In this respect, Oh's work can be understood differently depending on the audience, which exposes the unstable structure of language as it fluctuates between meaning and meaninglessness, symbol and decoration, memory and apathy, misunderstanding and indifference.

At the 2015 Korea Artist Prize exhibition, Oh presented a series of works entitled *Looking Out for Blind Spots* that took advantage of the surveillance cameras installed in an exhibition hall and a corridor at the National Museum of Modern and Contemporary Art, Korea (MMCA).[30] Within this project, *Reciprocal Viewing System* screened videos transmitted by surveillance cameras installed in different exhibition areas on monitors installed at the entrance of each exhibition space. 8 Here, cameras keep their eyes on the audience calmly moving in and out of a clean, white cube, and the monitors on the wall show spotless, tidy exhibition rooms. When a viewer walks into the actual exhibition room, however, they find a space completely distinct from the video images on the monitor. This is because the walls and ceiling out of the range of the surveillance camera are fully covered with colorful pink tape. The "blind spot"—the surplus space that is not caught within the camera's angle, the area resisting the gaze of surveillance, and the residual forces avoiding the dominant reproduction system—is here identified as being much larger than expected and occupies an unexpected space of disorder. In describing this work, Oh called this unmonitored element a "cultural blind spot" and defined it as a "space where desires excluded from the dominant culture can be realized because they escape its surveillance network."[31] This work was particularly meaningful in that this "cultural blind spot" was presented in a national institution, given that even today the rigidity of South Korea's conservative social order firmly persists and chauvinist collectivism and homophobic patriarchy remain utterly entrenched as the dominant social perspectives.

In her 2004 video trilogy, Yang Haegue offers up in a monotone monologue her self-conscious perspective about existing as an 'other' in a foreign country. In *Unfolding Places*, Yang talks about a "hunger for home," that occurs when she feels disoriented and lonely while spending time in a space that exists like an island, such as a Korean restaurant in an unfamiliar land.[32] In *Restrained Courage*, Yang displays her honed sensitivity to subtle cultural differences in relation to the fact that she has lived in a "no-home" (a space that cannot be called home) as a Korean émigré artist and student. The sentiments found throughout Yang's work can be summarized in terms of her isolation as a stranger, her nostalgia for a place she has left, and her desire to belong to a stable community. The experiences of solitude, nostalgia, and desire presented in her work, however, belong fundamentally to very personal and physical dimensions that cannot be communicated or subsumed under the experience of a community. As Yang says, this "deep, deep solitude" can only be "exclusively mine" as it cannot be shared with anyone else.[33]

Yang has stated that she believes in the power of invisible things and the possibility of the unseen life that exists in the everyday spaces around us. Thus, lighting is important to her, and she often uses venetian blinds as a material form in her work since they enable her to visualize things and beings that exist around us but whose existence has been so reduced as to be rendered meaningless.[34] By both blocking light and allowing it to pass through, these blinds separate the interior and exterior of a space, but in a way that is always temporary or incomplete. In addition to visual stimulation through light and blinds, Yang also uses humidifiers, electric stoves, fans, and fragrance dispensers to create a highly sensual environment in her installations.[35] 9 The physical or chemical changes in the room temperature, humidity, and air produce distinct perceptual stimuli that viewers can sense with their bodies but that remain inherently inexplicable through language. Thus, the audience as individuals are all physically experiencing the same phenomenon but their perceptions are heterogeneous. They are fundamentally alienated from each other through their individual sensual responses that cannot be shared. In this respect both Oh and Yang create experiences that are impossible to communicate in words alone since their works are physical events for individuals to experience in disparate ways even in a homogeneous space. At the core of the experience lies feelings of isolation and solitude, but Oh and Yang reveal that the spaces that these isolated and alienated individuals occupy can never be considered trivial or minor.

THE DREADFULLY SECULAR ORDINARINESS OF ART: GIMHONGSOK AND RHII JEWYO

In 2008, *POST 1945*, a performance staged during

8 Oh Inhwan, *Reciprocal Viewing System*, 2015, Installation, dimensions variable
Looking Out for Blind Spots—Docent, 2015, Performance, dimensions variable

9 Yang Haegue, *Yearning Melancholy Red*, 2008, Aluminum venetian blinds, powder-coated aluminum hanging structure, steel wire rope, mirror, infrared heaters, infrared heat lamps, casters, timers, fans, moving spotlights, DMX controller, drum kit, drum stool, drum trigger module, acoustic trigger, MIDI converter, cable, dimensions variable

the opening reception of Gimhongsok's solo exhibition was featured in the society section of daily newspapers rather than the culture section where art exhibitions are conventionally covered. It was reported that for the performance Gimhongsok paid 600,000 KRW (equivalent to approx. $600 USD) to hire a "female employee of an illegal massage parlor" for three hours, and offered a cash prize of 1.2 million KRW to the person first able to find the "whore" among the audience. Indeed, someone discovered the "whore," and the female employee and the audience member in question left the venue with their respective cash payments while the remaining audience members were awash with shock. The newspaper reports, especially those under the provocative headline "Finding a Whore," were filled with emotional statements such as "the eyes of the woman leaving the exhibition were filled with tears." They disturbed and infuriated many people.[36] The same exhibition presented *This is a Rabbit* (2005), with an accompanying caption explained that a North Korean defector had been hired to remain reclining in the gallery in a faux-fur rabbit costume for eight hours per day and received an hourly wage from the artist. **10** While this work sounds disturbing enough, most of the audience at the event must have quickly realized that there was no one inside the rabbit costume and the entire narrative was a fiction. Later it was revealed that the woman hired for *POST 1945* was an actor, but in the middle of the scandal remarkably few people recalled the power of Gimhongsok's unique black humor that unraveled the unethical realities surrounding labor conditions through fictional narratives.[37] Perhaps the artist's fiction was too close to the fact of South Korean society at the time. While newspaper readers unanimously condemned the ethical irresponsibility of art, they roundly failed to face the absurd reality in the country where prostitution still openly exists and vulgar capitalism dominates, allowing human dignity to be easily traded for money. Paradoxically, the critically meaningful integration of art and daily life long pursued by the avant-garde of the last century was here achieved in the 'society section' through journalism.

From the early days of his career, Gimhongsok paid special attention to progressive and radical forms of contemporary art, including performance, audience participation, public projects, and video art.[38] According to him, those who are "not artists but others as the subjects of physical intellectual labor" are the ones crucially engaged in all such art forms. However, despite the crucial contribution of these 'others,' the artist's name alone is still solely recognized as the author and copyright holder of a work. In this respect, he identified how contemporary art is very much subject to the "power

relationship between domination and obedience," whatever the intention of the artwork.[39] These contributors, people whom Gimhongsok calls "in-betweeners"—namely those who contribute to the production of an artwork in various ways, such as through collaboration, participation, employment, casting, invitation, assistance, and appearance—engage in subdivided labor in a wide range of fields that ordinary viewers cannot easily recognize.[40] In his discussion of American conceptual art in the 1960s, Benjamin Buchloh defined conceptual art's "bureaucratic rigor and deadpan devotion to the statistical collection of factual information" as a mere critical imitation of the social condition of the time: a system of industrial production and consumption in a late-capitalist society. Buchloh termed this concern "the aesthetic of administration."[41] In contrast, Gimhongsok does not aestheticize administration but demonstrates that aesthetics has already become highly administrative.[42]

In his 2013 performance *Good Criticism, Bad Criticism, Strange Criticism*, Gimhongsok paid fees to three critics and commissioned them to review his work. Even though it was a normal transaction, it was unfamiliar to have the amounts of the fees specified in the exhibition catalog and disclosed in press reports. Art labor involves highly secular transactions such as commissions, contracts, payments, and deliveries in all areas from physical labor (e.g., transporting works) to creative or academic activities (e.g., writing a critique). Whether the audience views the final work as an aesthetic object or understands it as a political statement calling for social justice and transformation, Gimhongsok here revealed the ethical vulnerability found in the hierarchical relationships between capital and labor, consumption and production, employer and employed, creation and production.

If Gimhongsok's performance presented the labor of socially marginalized people and a mockingly critical perspective with regards to the staging of elite art, Rhii Jewyo's work revealed the artist herself as an 'other' who has not been (or could never be) fully incorporated into the ecosystem of capitalism. In 2010, Rhii hosted the solo exhibition *Night Studio* at her house in Itaewon.[43] Having lived in the house for only about two years, it may not have achieved the conventional status of a long-term 'home.' As she had been residing in several places for short periods of time for a decade while participating in artist residency programs in many different locations around the world, this Itaewon house was a "permanent address" that she had not held for a very long time.[44] In other words, while 'residency' was how she led her life as an artist the system of artist residency programs paradoxically does not

10 Gimhongsok, *This is a Rabbit*, 2005,
 Resin, fabric, foam rubber, wood board 45×90×193 cm, text board: 55×79 cm

allow artists to 'reside' stably anywhere, but only provides a sense of conditional belonging. Thus, Rhii referred to herself a "Commonly Newcomer" (recurring newcomer).[45] For some artists, airline mileage points may be a measure of success, but for others, including Rhii, they just symbolize the state of having no fixed abode.

Night Studio was literally Rhii's home, studio, and exhibition space. Here, Rhii directed wind from a fan toward a huge ice ball delivered every two hours to combat the summer heat. She also blocked the window with a sloppy but threatening *Fence* (2010) by weaving together sharp objects she had collected within and outside of the neighborhood over the course of a year. When an artist occupies the smallest possible unit of affordable housing in a large city like Seoul, while producing works that are not easily sold the artist must strive to survive and work at the same time by embracing the resulting inconvenience and anxiety. The works of *Night Studio* later traveled to Düsseldorf, Eindhoven, and Frankfurt and finally returned to Seoul, but the exhibition space was always in the shape of 'home,'

resembling the environment in which the stored works were initially created to the greatest degree possible. Installed on the floor in an exhibition hall, *Moving Floor* (2013), another of Rhii's key works, also appeared unstable, as different-sized floorboards with damaged edges were laid across the floor. 11 However, when an audience member steps on the floor, which is shaking, creaking, and being pushed around, anxiety becomes a reality based on a palpable sense of physicality.

Rhii's 2019 installation *Love Your Depot* was a prototype for exploring a sustainable creative system within the current unstable employment and residential conditions.[46] 12 As the title suggests, Rhii transformed a large exhibition hall at the MMCA into a museum storage area, broadcasting station, and research center that actually operated over the course of the exhibition. The works of about ten of her artist colleagues, including Chung Seoyoung, Lim Minouk, and Hong Seunghye, were stored in the exhibition hall. In addition, Team Depot, which consisted of ten young artists, produced videos and broadcast them online.

11　Rhii Jewyo, *Moving Floor*, 2013, Mixed media, dimensions variable.
The Museum Für Moderne Kunst (MMK)

12　Rhii Jewyo, *Love Your Depot*, 2019, Installation view of the Pallet in the Depot: Lim Minouk (left), Jeon Woojin (top-center), Hong Seunghye (right).
Installation view of Korea Artist Prize 2019.

If an individual artist had her own warehouse there would be piles of works that have not been sold, while works that move from one exhibition to another would remain there for a time. However, there cannot be a permanent space for works that will never be sold or displayed again, i.e., items that cannot be used within the systems of markets or art museums. However, Rhii paradoxically confirms that beyond sales and exhibitions, there can be no other arena where art is "useful." Rhii's *Love Your Depot* suggests the public nature of the MMCA as a national institution and the solidarity of fellow artists who entrusted their works to Rhii's temporary warehouse as a potential space to suspend judgment on such utility and to instead sustain creation.

THE POTENTIAL OF CONCEPTUAL ARTISTS

The conceptual artists considered in this section do not put their trust in the demagogic language of politicians, the sophisticated language of philosophers, or the universal language of the public. They instead delicately devise their own creative forms, slightly adjust our ideas of the existing world, and dig into narrative structures both real and imagined that rarely reveal themselves and remain hidden behind the forms and objects of everyday life. These artists do not attempt to change other people's thinking, but only the environment around them.

The art made by these people is conceptual in that it reveals how meaning is not a matter of taste, but of power. However, these artists are cautious not to become doctrinal figures who lecture the public about politically correctness or authoritative beings who claim to represent a minority in order to challenge the majority. They try to avoid creating overwhelming spectacles in an art museum to preach on behalf of a legitimate cause. Furthermore, they are wary of creating sentimentalism, which allows people to immerse themselves in exaggerated emotions while still withholding judgment. They often encourage direct participation by the audience, but here it is taken as a given that the audience should engage of their own volition, determine their own actions, and act independently. In such a process, the participants might also experience their identity being reserved or changed, albeit temporarily. They undergo cracks in their everyday self-awareness, distrust the perceptual abilities that they had believed to be reliable, and perhaps learn that there is no absolute form of fixed identity. Such conceptual work structurally represents the precarious and unstable conditions of existence, the vulnerability of individuals, the weakness of agency, and the perpetually unfinished nature of identity.

Boris Groys calls artists "supersocial" because they imitate and establish themselves "as similar and equal to too many organisms, figures, objects, phenomena that will never become a part of any democratic process."[47] The conceptual artists discussed in this section certainly believe in the social role of art and the potential of art to change the world. However, they have never agreed on any definition of society, the nature of the world or of, art, or of the potentiality of anything or anyone. This is primarily because agreement of this type is neither possible nor necessary.

1 Kim Youngna, *1945nyeon ihu hanguk misul* [Moving Reflection, Korean Art since 1945] (Paju: Mijinsa, 2020), 290.

2 Charlotte Horlyck, *Korean Art: From the 19th Century to the Present* (London: Reaktion Books, 2017), 165.

3 Yun Nanjie, *Hanguk hyeondae misurui jeongche* [The Identity of Korean Contemporary Art] (Paju: Hangilsa, 2018), 36.

4 These artists share two other common factors. They received university education in South Korea, studied abroad, returned to South Korea to practice, and had a solo exhibition or participated in major curated exhibitions at the Art Sonje Center. Studying abroad and participating in the Art Sonje Center can be considered as the basis for examining them in terms of commonalities, as studying abroad in the 1980s exposed them to culture shock and experience with the different art practices at a time when information on overseas art was still limited in Korea, and as the Art Sonje Center has a significant position in the transition of art institutions in contemporary Korean art. Woo Jung-Ah, "Ateu seonjae senteo: Dongsidae misureul jeonsihaneun jangso" [Art Sonje Center: A Place to Exhibit Contemporary Art], in *Connect: Art Sonje Center 1995–2016*, eds. Kim Najung and Park Hwalsung (Seoul: Workroom Press, 2018), 23–45.

5 For the historical context of conceptual art in Korean contemporary art, see Woo Jung-Ah, "Hanguk hyeondae misule natanan gaenyeom misurui damnonjeok hyeongseonggwa silcheonui yangsang: S.T johyeong misul hakhoereul jungsimeuro" [The Discursive Construction and the Conditions of Practices of Conceptual Art in Korean Contemporary Art: Focused on the ST Group's Theory and Events], *Journal of Korean Association of Art History Education* 41 (2021): 203–231.

6 This title is borrowed from Harald Szeemann's exhibition: *Live in Your Head: When Attitudes Became Form* (1969). The exhibition is considered the starting point of conceptual art as something based on concepts, processes, and situations rather than on material existence. As I see it, the exhibition and the title aptly summarize the artists' attitudes toward art and its outcome. I first used this tile in one of my articles that discussed Oh Inhwan's work as conceptual art. Here, I would like to perceive this characteristic in the manner commonly used by the group of artists who have emerged since the 1990s in general. Woo Jung-Ah, "Oh Inhwan: When Attitudes Become Structure," *Korea Artist Prize 2015*, exh. cat. (Seoul: MMCA, 2015), 192–201.

7 Bahc Mo, Park Chan-kyong, Ahn Kyuchul, Eom Hyeok, and Jung Hun-Yee, "Dialogues," *Bahc Mo*, exhibition brochure (Seoul: Kumho Museum of Art and Wellside Gallery, 1995), 10–31.

8 Park Chan-kyong later published a series of articles reinterpreting the nature of realism in Minjung art in the contemporary context using the term "conceptual realism." Park Chan-kyong, "Gaenyeom misul, minjung misul, haengdongjuuireul ihaehaneun gibonjeogin gwanjeom: Minjujeok misul munhwae daehan gwansimeul chokguhamyeo" [Basic Perspective on Understanding Conceptual Art, Minjung Art and Activism: Calling for Interest in Democratic Art Culture], *Forum A* (July 1998): 20–23; Park Chan-kyong, "Gaenyeomjeok hyeonsiljuui: Han pyeonjipjaui ju" [Conceptual Realism—Notes of 'An Editor'], *Forum A* (April 2001): 19–24; Park Chan-kyong, "Minjung misulgwaui daehwa" [Conversation with Minjung Art], *Munhwa Gwahak*, December 2009, 149–164.

9 For more on Bahc's and Ahn's careers and political attitudes as writers, see Woo Jung-Ah, "Oriental mainoriti igeujotik: Bangmoui 'hangukjeok poseuteu modeonijeum' mosaek" [Oriental Minority Exotic: Mo Bahc's Search for 'Korean Postmodernism'], *Journal of Association of Western Art History* 45 (2016): 69–95; Woo Jung-Ah, "An kyucheol: Sesange daehan golttolhan gwanchalja" [Ahn Kyuchul, an Intent Observer of the World], in Ahn Kyuchul et al, *Ahn gyucheol: Modeun geosimyeonseo amugeotdo anin geot* [Ahn Kyuchul: All but Nothing] (Seoul: Workroom press, 2014), 54–67.

10 Boris Groys has also used the notion of a "linguistic turn" to discuss how New York–based conceptual art was extended to an international context and developed into the broad range of trends of critical art. Boris Groys, "Introduction: Global Conceptualism Revisited," *e-flux Journal* 29, November 2011, accessed October 29, 2020, https://www.e-flux.com/journal/29/68059/introduction-global-conceptualism-revisited.

11 On "dematerialization" in art during the 1970s, see Lucy R. Lippard, *Six Years: The Dematerialization of the Art Object from 1966 to 1972* (Berkeley: University of California Press, [1973] 2001).

12 For a wider discussion of conceptual art and institutional critique, see Benjamin H. D. Buchloh, "Conceptual Art 1962–1969: From the Aesthetic of Administration to the Critique of Institutions," in *October: The Second Decade, 1986–1996*, eds. Rosalind Krauss et al. (Cambridge, Mass.: MIT Press, 1997), 105–143. The article was originally published in *October 55* (Winter 1989).

13 In particular, Ahn discussed several times in the late 1980s the political gap between the '68ers among German artists and the succeeding generations. Ahn Kyuchul, "Geodaehan sangeopjuuie daehang haneun misul" [Art Against Giant Commercialism], *Wolgan Misul*, December 1989, 55–62; Ahn Kyuchul and Kim Sunjung, "Interview," in *Ahn Gyucheol: Modeun geosimyeonseo amugeotdo anin geot*, 94–95.

14 Translator's note: The author uses '89 to refer to a turning point in global sociopolitical conditions prompted by a series of international events, including the collapse of the Berlin Wall, which signaled the end of the Cold War. Email communication between the author and the translator on June 13, 2021.

15 Sung Wan-kyung, "Mo Bahc," in *97 Kwangju Biennale, Unmapping the Earth: Speed Space Hybrid Power Becoming*, exh. cat. (Gwangju: Gwangju Biennale Foundation, 1997), 310–311.

16 Bahc Yiso, *Bahc Yiso Artists' Notes*, 4 (1989), 15. MMCA Collection.

17 Bahc Yiso, *Bahc Yiso Artists' Notes*, 1 (1984–85), 190. MMCA Collection.

18 Ahn Kyuchul, "Georukan misullobuteoui haebang: Hyeonbalgwa naui mannam" [Liberation from 'Holy Art': The Meeting of 'Hyun-bal' and Me], *Hyeonsilgwa bareon: 1980nyeondaeui saeroun misureul wihayeo* [Reality and Speech: For New Art in the 1980s] (Paju: Yeolhwadang, 1985), 146.

19 Ahn Kyuchul, "Interview," *Forum A* (July 1998): 2–4.

20 *Your Bright Future* was used as the title of the Korean art exhibition held at the Los Angeles County Museum of Art in 2009. The curator, Lynn Zelevansky, evaluated that this phrase, both a hopeful slogan and a false instigation slogan used by North Korea, usefully summed up the irony of the situation in South Korea in the early twenty-first century. Lynn Zelevansky, "Contemporary Art from Korea: The Presence of Absence," *Your Bright Future: 12 Contemporary Artists from Korea*, exh. cat. (New Haven, Conn.: Yale University Press, 2009), 31.

21 Standard Korean Language Dictionary of the National Institute of the Korean Language.

22 Chung Seoyoung, *Lookout*, exh. cat. (Seoul: Art Sonje Center, 200), 22.

23 Awe, *Merriam-Webster*, accessed August 2, 2022, https://

www.merriam-webster.com/dictionary/awe

24 Interview with Chung Seoyoung by the author at Barakat Contemporary, Seoul, May 13, 2020.

25 For more details on each work, see Chung Seoyoung, *Chung Seoyoung: Lookout*, exh. cat. (Seoul: Art Sonje Center, 2000).

26 Kim Beom and Kim Sunjung, "Interview," in *Kim Beom*, exh. cat. (Seoul: Samuso: Space for Contemporary Art, 2020), 148.

27 Ibid., 146.

28 Doryun Chong, "Kim Beom," in *Kim Beom*, exh. cat. (Seoul: Samuso: Space for Contemporary Art, 2010), 27.

29 Jeong Hyeon, "Jaebaechiui jangchideul" [Devices of Rearrangement], in *Oh Inhwan*, exh. cat. (Seoul: Samuso: Space for Contemporary Art, 2009), 50.

30 The discussion below is borrowed from Woo, "Oh Inhwan: When Attitudes become Structure," 31.

31 Oh Inhwan, "Jakgaui eoneo" [The Language of the Artist], in *Korea Artist Prize 2015*, exh. cat. (Seoul: MMCA, 2015), 146.

32 Yang Haegue, *Unfolding Places*, 2004. Single channel video projection, ca. 18 minutes, filmed in London, Seoul, and Berlin. Voice-over: Helen Cho. For the extracted Korean script, see Yang Haegue et al. *Melancholy is a Longing for the Absoluteness* (Seoul: Hyunsil Publishing, 2009), 102–103. The following descriptions of artworks are revised and published from Woo Jung-Ah's "Sangsirui gongdongche hogeun gongdongcheui sangsil: Sungnyemun sindeuromgwa yanghyegyuui sadong 30beonjie daehayeo" [Loss of Community or Community of Loss: 'Sungnyemun Syndrome' and Yang Hague's *Sadong 30*], *Visual 7* (2010): 46–66.

33 Yang Haegue, *Restrained Courage* (Amsterdam, Frankfurt, London, Seoul, Berlin, 2004), 18min., voice-over: Camille Hesketh.

34 Phone interview with Yang Haegue, March 14, 2009.

35 For Yang's early installations, see *Asymmetric Equality: Haegue Yang*, exh. cat., ed. Karen Jacobson (Los Angeles: California Institute of the Arts and REDCAT, 2008).

In terms of the formal appearance of her work, Yang can be distinguished from other artists discussed in this article in that, although she also uses everyday objects, the sensuous and formal characteristics of these objects is clearly revealed, and sometimes the entire exhibition space is spectacularly composed. Yang also mentioned that she has a tendency to be relatively "wary about and obsessed with materials" compared with the "aesthetics of clumsiness" found in Korean art in the 1990s. Phone interview with Yang, May 28, 2020.

36 Kim Soo-hye, "'Changnyeo chajanaemyeon 120manwon jumnida'" ["If you find a whore, you'll get 1.2 million won"], *Chosun Ilbo*, April 18, 2008. http://news.chosun.com/site/data/html_dir/2008/04/18/2008041800063.html.

37 Kim Soo-hye, "Misulgwan sanggeum geollin 'changnyeo'ga baeuyeotdago?" [Was the "Whore" at the Museum Prize an Actor?], *Chosun Ilbo*, May 20, 2008. http://art.chosun.com/site/data/html_dir/2008/05/21/2008052100387.html.

38 Gimhongsok et al., *Peopomeonseu, yullijeok jeongchiseong* [Gimhongsok: Performance, an Ethical Politics] (Seoul: Hyunsil Publishing, 2011); Gimhongsok and Ahn Soyeon, *Gimhongsok: Good Labour Bad Art*, exh. cat. (Seoul: Plato, 2013)

39 Quoted from Gimhongsok's unpublished manuscript written for the Association of Western Art History fall symposium, "Misulgwa nodong" [Art and Labor] on November 11, 2017.

40 Gimhongsok described the "in-betweeners" as being the physical assistants who make three-dimensional sculptural objects and the intellectual assistants who film and edit video or manage casting performers, as well as docents at art museums, curators, and critics. In addition, "in-betweeners" include temporary employees hired for transportation and assembly, as well as supporting actors who appear in the backdrop of a video. From Gimhongsok's unpublished manuscript.

41 Benjamin H. D. Buchloh, "Conceptual Art 1962–1969," in *October: The Second Decade, 1986–1996*.

42 For the context of the transition from the "aesthetic of bureaucracy" to the "bureaucracy of aesthetic," see Miwon Kwon, *Jangso teukjeongjeok misul: One Place After Another*, trans. Kim In-kyu, Woo Jung-Ah, and Lee Youngwook (Seoul: Hyunsil publishing, 2013), 80–83. Originally published in English as Miwon Kwon, *One Place After Another: Site-Specific Art and Locational Identity* (Cambridge, Mass.: MIT Press, 2002).

43 Rhii Jewyo, *Night Studio*, exh. cat. (Seoul: Samuso: Space for Contemporary Art and Workroom Press, 2013).

44 Woo Jung-Ah, "Jewyo Rhii: Artsonje Center," *Artforum International* 52, no. 6 (February 2014): 234–235.

45 "Interview," *Korea Artist Prize 2019*, exh. cat. (Seoul: MMCA, 2019), 187. *Commonly Newcomer* is the title of an exhibition that Rhii had after participating in the Queens Museum's artist residency program.

46 Yang Okkum, "Oneul'gwa majuhaneun bangbeop, olhaeui jakgasang 2019" [Curator's Essay: How to Face 'Today,' Korea Artist Prize 2019], in *Korea Artist Prize 2019*, exh. cat. (Seoul: MMCA, 2019), 15.

47 Boris Groys, "Infinite Presence," in *MMCA Hyundai Motor Series 2015: Ahn Kyuchul—Invisible Land of Love*, exh. cat. (Seoul: MMCA, 2016), 112.

The Collective as a New Form of Art Production Since the 2000s

Helen Jungyeon Ku

THE ADVENT OF NEW ARTIST GROUPS SINCE THE 2000S

In August 1999, the Ministry of Culture and looked forward at the new millennium ahead and designated the year 2000 as the "year of new art." The term *new art* here referred not to a new genre or trend, but to a new form of art produced in line with changes in artistic expressions, more of a 'new category for art' that was emerging with the deconstruction and integration of the conventional genres within each established sector of art. While there has long been an interest in novelty within the field of modern and contemporary art, the 2000s in particular witnessed the emergence of many new events and venues dedicated to genre fusion and technology-oriented arts. This was a result of the institutional support that flowed from the wider cultural desire for the new art for the twenty-first century.

In the urban environment, the old quickly gave way to the new. In order to attain a new visibility of the city landscape, the Seoul Metropolitan Government devised new urban plans under the banners of urban regeneration, urban vigor, and urban ecology. Promulgated in 2002 to seek more balanced regional development within the capital, particularly in the Gangnam and Gangbuk areas, Seoul's New Town Project shifted its focus to downtown revitalization efforts such as the Urban Renewal Promotion Law enacted in December 2005. These New Town and redevelopment projects led to the Yongsan Disaster in January 2009, while the urban natural park construction project that was initiated as a part of the Han River Renaissance Project in April 2008 led to the demolition of Okin Apartment Complex later that year in December. Several art and design projects were organized conjunction with these urban regeneration efforts. One of the major events was the Seoul Design

Olympics held at the Jamsil Sports Complex in October 2008 to celebrate Seoul being appointed as the World Design Capital for 2010. The Seoul Foundation for Arts and Culture also made an effort to transform the city's unused area into art spaces according to a "creative cultural city" masterplan. Art and design were mobilized to revitalize abandoned areas in the city under the rubric of "the public."[1]

The election of a new government in 2008 resulted in an overall restructuring of the art scene and its systems, as the new regime dismissed key figures within the public art world, including the Chairman of the Arts Council Korea. Under these conditions, the presentation of a hopeful conception of the future as was offered in past, was replaced with the idea of newness as being most relevant to the new realities people faced as social anxiety and absurdity became the norm. This concern with novelty took the form of 'art' and 'non-art'. It was manifested in extra-institutional contexts rather than within the system and through the collective activities of artists rather than in the work of individual artists. While alternative spaces in the 1990s had been widely seen as a source of new ideas and approaches, the role of providing new ideas to the South Korean art world, was taken over by collectives in the 2000s[2] as artist groups emerged in various districts throughout the city.

This text provides an account of contemporary South Korean art in the new millennium by focusing on the response by artist collectives to the circumstances of the times as they experimented with new forms of participatory practice. Facing the constraints and anxieties stemming from globalization, the artists of those times made a concerted attempt to contemplate the contemporaneous life and experiment with new notions of publicness. Over time, some collectives

merged and others disappeared. Some became involved with the city's institutions and took a position at the forefront of establishment reform, while others remained outside the system and cultivated their own working environments. Here, the city, greater Seoul, becomes both the condition and subject of art production. The brief account provided here does not attempt to portray a delicate chronology of the collectives nor strictly categorize their activities. Rather, it is an attempt to recall and revisit the changes that occurred in the South Korean art world in the 2000s through the lens of artist collectives and their public practices.

INTERVENING IN THE GAP BETWEEN THE CITY AND THE SYSTEM

The city visibility identified by the city of Seoul in Korea throughout the 1990s was the main subject of its visual arts. *Apgujeong-dong: Utopia Dystopia*, the catalog for an exhibition of the same title from 1992, takes the urban neighborhood of Apgujeong-dong as the subject of a visual cultural study and documents the related works of a number of visual artists and cultural professionals. Kim Suki, director of Hyunsil Publishing and curator of the project, recalls that when he left the Research Society for Art Criticism to establish Hyunsil Publishing in the early 1990s, 'field studies' were significant in the process of expanding the realm of art and exploring non-art. *Cultural Politics of Space: Space Culture Seoul*, published in 1995, is another important example of how visual artists and cultural workers sought to address Seoul as an overarching subject. The book explores how Seoul operates as a social, cultural, and economic space by exposing the inequities faced at an everyday level in the city, how the neven development of regions within the city is driven by consumerism and capitalism, and the stories of the disenfranchised inhabitants of the Bongcheon-dong neighborhood as a means to narrate the city's dynamics. Sociologist Jo Eun, a member of Alternative Culture, wrote her book *Sadang-dong plus 22* (2009), documenting the life of an evicted family over 22 years starting in 1986 when Jo first met the family during a period of field study at the Sadang-dong redevelopment district. This study also led to the publication of *Sadang-dong plus 25* (2012), a follow-up investigating how poverty persists generationally in Korean society.

With the acceleration of urban development after the 2000s, the urban space continued to be perceived as a realm of desire and conflict. For artists, it became a space ripe for intervention and expression. Lim Minouk and Frederic Michon formed the Pidgin Collective to initiate artistic projects based on field and archival research. Under the name Pidgin Archive (the precursor of Pidgin

1 Pidgin Girok, *Rolling Stock—About Some Means of Transport in Seoul*, 2000, Cultural Map for Foreigners at Gwangju Biennale

Collective), they first produced a cultural guidebook for foreigners visiting the Gwangju Biennale in 2000.[3] [1] Their work *Rolling Stock* collects images of all sorts of vehicles can be seen on the streets of Seoul, including carts, street vendor wagons, and trucks piled high with goods. As such, the book focuses on the "rolling" nature of the city, that is, its mobility. Although the book takes on the form of guidebook, it does not provide any of the information about the city that we would conventionally expect. Rather, the book narrates a micro-history visualizing social inequality by charting the changes and development that took place through the urbanization process as Seoul grew into a megacity. In that sense, the book is in accord with Pidgin Collective's objective to break free of conventional modes of production and distribution, moving away from "barcodes" and instead producing publications that exist within distribution outside of the mainstream.[4]

In June 2004, Pidgin Collective presented a container project *Lost?* [2] that served as an office at the site of the *Rolling Space* exhibition taking place at the Marronier Art Center (currently Arko Art Center). Here, Pidgin temporarily installed two containers as a space for encounters between artists and citizens in an unused space at the museum, seeking to "reveal the space as [representative

of] the reality faced by the artist and the artist's life."[5] This space was then used as a shelter for the homeless as a site for political protests. It also served as a civic square. Becoming a site for both tension and leisure, *Lost?* offered a temporary parasitic transformation of the museum by, expanding on its institutional role as a public space and cultivating a relationship with those normally left outside its bounds. Instead of providing services such as free beverages according to some traditional idea of the provision of charity, artists presented performances and events based on impromptu and voluntary participation, such as by punching holes in visitors' clothing or belongings (Lim Minouk), hosting a pirate radio show (Kwon Byungjun), or operating a music café employing immigrant workers (Mixrice). The next year 2005, Pidgin Collective was invited to participate in an archiving project by Insa Art Space. The task they proposed were as follows: To pursue a future-oriented archive accessible to various fields of study, an alternative form of archive subject to a process of perpetual evolution; to make possible future radical projects and provocative collaborations between artists and researchers.[6] In other words, it was meant to be an affective archive, breaking free from mainstream library classification systems such as the Dewey decimal system.

Starting in 2005, the activities of Pidgin Collective were manifested through the education program at Haja Center, an alternative school for teenagers. For example, a Buddhist monk named Jiyool was invited to study a legal challenge recently launched to stop the destruction of endangered salamanders, and urban tours were organized to explore the factory workers' neighborhoods of Yeongdeungpo and Garibong-dong. This inspired

the collective's second container project, the *Scrap Project*. The artists and Haja students invited players from emerging cultural movements to provide a discursive platform for enhancing publicity about various social issues. Based on the activities of invited artists including Oasis Project, Mixrice and flyingCity, they collected and developed new models and tools for stimulating social and political change. The activities of these artists can be construed as the "actions of an archivist,"[7] who proactively documents the new possibilities of the city through provocative collaborations, as reflected in the suggestions for the Insa Art Space archive.

There were also activities to address the relationship between urban space and art institutions. For instance, the *Lost in Town* exhibition by the project group Collapsible Museum in 2006 transformed various corners of Myeongryun-dong 3-ga, from the start of Sungkyunkwan-ro to Waryong Park at Seoul City Wall Trail, into galleries. Founded by Choi So-yeon in 2002, the Collapsible Museum employs the act of "collapsing" in order to fundamentally question the standardized institutional arena perpetuated by museums at a global level. This practice of 'collapsing' is relatively simple. Once a target museum is selected, the group set up a temporary office, or a camp, to help create meaningful accidental interactions with local people. Within these situations, anyone who agrees with the purpose of the Collapsible Museum can participate in the 'collapsing' as a member. In December 2004 in Paris, a *Collapsible Louvre Museum* was co-curated with the help of local artists. They presented a performance of handing out badges inscribed with "-1" (minus one) to visitors under the Louvre pyramid. This was a gesture of removing something (however

3 Collapsible Museum, *Collapsible Louvre Museum* (December 25, 2004, Louvre Museum Paris), Still from the original performance

4 Oasis Project, Artist Center Pre-Squat Excavator Performance (July 17, 2004, Seoul Mokdong Artist Center), Still from the original performance

small it might be) from a museum filled with plundered cultural assets.[8] [3] Based on this process and others like it, the Collapsible Museum has attempted playful interventions at various venues including the Solomon R. Guggenheim Museum, the Whitney Museum of American Art, and the Leeum Museum of Art, all designed to challenge the current museum system. After the Myeongryun-dong project in May 2007, Choi So-yeon and a few members opened Takeout Drawing, a neighborhood cafe and museum, in Seongbuk-dong. Takeout Drawing later moved to the Marronnier Art Center and then to Hannam-dong, where it closed in August 2016 with the *Disaster Inheritance* exhibition after lease disputes with the space's landlord.

One of the most frequently discussed issues in the mid-2000s was that of "art occupation." On August 15, 2004, the project group Oasis occupied the Mokdong Artists Hall, manifesting their highly critical approach by attempting a direct spatial intervention against the institutional system. [4] The Federation of Artistic and Cultural Organizations of Korea (FACO) had initiated the construction of the Mokdong Artists Hall to secure "a general welfare space for culture and art professionals," but construction was halted in 1998 and remained in limbo for about seven years till 2004. When FACO sought to create a rental business using the building, departing from the original purpose, the Oasis Project publicized the issue of the Artists Hall's future and its original intent. The Oasis Project needed "a stage or site upon which to mark out concrete changes through (in)direct interventions into reality, in other words, a public sphere of interaction between art and life."[9] While artists struggled to secure even a minimal amount of space for production, the city of Seoul was overflowing with empty commercial spaces. So, under the phrase "Culture for the Citizens! Studios for the Artists!" they protested the inequality of urban space ownership on the basis that for an artist a studio is a basic right and the instrument that allows an artist to live as an artist.[10] While squatting in the Artists Hall, the Oasis Project published an advertisement titled *Oh! Studio of Your Dreams* in the monthly journal *Cultural Action* and recruited tenants for the building. Those invited to participate in the Savina Museum of Contemporary Art's *The Realing 15 Years* exhibition decorated the space to look like a real estate office. As a result, more than 500 artists applied to buy a space. Although the FACO sued the artists for squatting in the Artists Hall, their illegal occupation, and the selling of the property, the artists were later acquitted for their actions on behalf of their fight for social justice and serving the public good.

On June 30, 2007, the Oasis Project disbanded after publishing *Occupation Manual Book*. Proposed by Kim Kang and Kim Yunhwan, the Oasis Project sought to organize a loose network of numerous artists and professionals in support of the transformation of social space.[11] That same year, the two artists followed other Oasis Project members into the Mullae-dong iron foundry building where they initiated the *Real Estate Project*. Mullae-dong was a run-down area of Seoul that had been awaiting redevelopment since the early 2000s. Once possessing a heavy concentration of iron foundries, many of the buildings in the region were deserted by this point. In parallel, the Hongdae district was undergoing rapid gentrification and many of the artists living there were being forced to find new studios. Kim Kang and Kim Yunhwan served as mediators, recruiting artist tenants and providing consultations about which spaces are available. In 2008, the region was named the Mullae Artists Village, and organizations emerged among the Mullae-dong artists. The Art and Urban Society Research Lab and Project Space LAB39 were organized to as experimental new types of art spaces that studied the character of Mullae-dong and sought to proactively intervene in the city's art and cultural policies. Sometime later, the Seoul Metropolitan Government finally embraced Mullae-dong as a creative hub that had employed the city's unused facilities, and the region entered a new phase when it was transformed to Seoul Art Space Mullae, an official culture and art space run by the Seoul Foundation for Arts and Culture (SFAC).

ART AND EVERYDAY LIFE; ART AND LABOR
Around the year 2000, support programs for emerging artists started to appear in all genres of art. In 2004, the SFAC initiated a civil arts and culture support program intended to explore the potential of experimental, independent, alternative, and hybrid productions on behalf of the citizenry of Seoul. At this time, many unused spaces around the city were employed as residency facilities for artists, meaning this social intervention was distributed around various areas of the city. Various collectives and artists' groups appeared under these conditions. They often attempted to reimagine urban land use and the meaning of urban space while providing alternative visions of an art community outside the institutions of art. Some artists gathered to engage in temporary projects and others operated artist-run spaces for short spans of time. Most of these groups were located in the Seokgwan-dong, Hannam-dong, and Itaewon regions.

Yoo Byungseo, a student at Korea National University of Arts in 2005, founded Micro/weiv in Seokgwan-dong. A combination of "micro," and an alternative spelling of the word "wave." The name signified a network-collective or a small

5 Micro/weiv, *Cherry the Bridge* (May 5, 2007, Imun/Seokgwan-dong, Seoul),
Still from the original performance

6 POST-EAT, *Lease Space Project Parking Lot at Public Parking Lot in Jongno-gu* (November15–16, 2008),
Still from the original performance

movement that engaged in cultural production at an insignificant level. The collective drew attention in May 2007 with a project (or incident) that was referred to as the "Cherry (colored) Pedestrian Overpass" or *Cherry the Bridge*. ⁵ The artists painted a bridge located at the Shin-Imun intersection of Dongdaemun-gu, a cherry red color without seeking prior permission from the local government, even though they was a part of the *Imun/Seokgwan-dong Microplex* art project selected as a SFAC cultural support program.¹² Yoo explained that the "work is a surprise gift to the citizens, for them to see a dull gray bridge turn red overnight. By changing its color to cherry red, the banal pedestrian overpass can be reborn as a new landmark. Also, by decorating benches on the newly transformed bridge, we wanted to present the potential of the bridge to become a site for social encounters."¹³ However, the Dongdaemun-gu Office asserted that they intended to bring criminal charges against the artists if the bridge was not immediately restored to its original state. The pedestrian overpass was restored, and the project was concluded as a minor episode (or short happening). Under the slogan that they consider the urban space to be an artistic playground, the group also rented empty buildings and spaces in the Imun-dong and Seokgwan-dong areas to organize various events including exhibitions, performances, and art markets. They also published *microbot*, an independent zine, by printing and copying a collection of short novels without any particular design.¹⁴ This form of publication is an example of the small-scale independent publishing undertaken by individual artists or designers frequently seen after the mid-2000s.

In a similar vein, POST-EAT sought to annul or reinterpret the context of everyday places in a playful manner. Formed in March 2008 by seven members who had studied painting, architecture, and management at Hansung University and Seoul National University (Kim Jaehwan, Keem Cheongjin, Ma Seungbum, Park Kiljong, Park Eunjin, Yoo Donghwui, and Ho Sangun), POST-EAT implies the act of temporarily borrowing a place, or a "post," by "eat"(ing) it. For their practice they rented a place for a period of time and transformed it into a playful space distinct from its original usage. At the first venue, Hansung University Gallery, they cut colorful cellophane paper into patchwork patterns and pasted them together to cover the gallery walls and floor. In the Lease Space Project, financed by the Insa Art Space New Artist Support Program, they searched for old spaces in Seoul, especially in commercial areas in the Gangbuk region, to temporarily occupy. They also installed a fake air balloon car and inflatable sky dancers in a Jongno-district public parking lot and rented an ordinary office in which they temporarily installed wall mirror balls and mirrors for two days. ⁶ At Art n Dream Gallery, they opened the *21 century Toilet Paper Theory* exhibition and filled the space with toilet paper. For them, the act of "renting" is undertaken to acquire the right to use a certain space and to become its owner. They explained the purpose of their work as follows: "To use the money that we might have used for tea or dessert, or we would have used for entertainment, to instead pay a parking fee or rent a space for a few hours, and have a great time playing an artistic game within it."¹⁵ POST-EAT presented a POST-EAT year-end report storage-emptying exhibition in 2008 at the *Beyond Art Festival* but eventually disbanded in June 2010. While the group's years of activity were brief, a part of the group was further divided off into the collectives Kit-toast and Kiljong Arcade.

With the rapid institutional shifts taking place within the art field in 2008, collectives began to invent new collaborative models. Some artists used the format of the collective as a tool through which to seek survival. Instead of applying for government grants, they formed collectives to reform and experiment within a more autonomous economic system, in which they could survive professionally by earning their own money. Kit-toast and Kiljong Arcade are similar in that they do many projects based on in-house labor and techniques, but each group maintains distinctive traits in the structure and principles of its operations. Kit-toast rented what was originally a toast shop near the Seoul Central Mosque in Itaewon. The group's name is taken from the name of the store that was originally in the space. Formed by members Park Kiljong, Keem Cheongjin, Song Daeyoung and Kim Bokyung, Kit-toast started to utilize craft techniques such as woodworking, knitting, and drawing to produce and sell their own goods. Kit-toast later became a "voluntary economic system" operated by 25hr Sailing, a unit composed of the artist duo Kim Bokyung and Keem Cheongjin, that primarily works in furniture design, interior design, and graphic design as it seeks to "overcome the economic difficulties that artists encounter when working/in order to work."¹⁶

Kiljong Arcade played a major supporting role for other collectives. In the winter of 2010 in an alley of the "Goblin Market" in Itaewon Bogwang-dong, Kiljong Arcade entered business with just a simple sign to indicate its presence. ⁷ While Kiljong Arcade is a project of Park Kiljong, who had been a part of the Kit-toast collective, it literally aimed to function as an arcade. Kiljong Arcade was designed to offer a space that could be shared by a number of artist colleagues, as would be the case with a normal arcade and its commercial tenants. Here, one could witness transactions in non-art labor, a

7 Kiljong Arcade, Building façade, 2012

labor of livelihood different from the creative work unique to artists. On the weekends, one could also participate in performances and dramatic events entitled "Deutmalmah" (an acronym involving the three Korean words respectively meaning listen, speak, and drink). Park Kiljong (aka Park Gagong) acted as the director and manager for Kiljong Arcade, operating a custom order production workshop and general service facility and managing manpower requests while overseeing the needs of his clients. Park uses his website to receive large and small requests and then undertakes whatever work is required of him, documents the entire process, and makes the information public. These engagements are most often trivial tasks, such as moving packed boxes, or changing doorknobs and lightbulbs. Alongside this simple work, he also produced custom furniture optimized for the clients' spaces and tastes. This combination of providing basic labor and sophisticated woodwork design stems from his experience of holding a part-time job at a DIY furniture shop where he had to handle all miscellaneous chores from woodwork to interior construction. Mobilizing all the techniques and knowledge that he had acquired thus far in his life, and collaborating with other colleagues,

Park's Kiljong Arcade is thus positioned as a self-sufficient artistic community and producer of culture, displayed the border between creation and livelihood labor through creative work methods of high potential. In the exhibition *Life: A User's Manual* held at the Culture Station Seoul 284 in 2012, Kiljong Arcade showcased the individual work of its tenants. This project can be considered a platform for artists based on a system of horizontal hierarchy and collaboration.

In 2010, when Kit-toast and Kiljong Arcade were situated in the Hannam-dong Itaewon region, Choi Jeonghwa in curatorial partnership with Art Space Pool opened Pool's exhibition space "qqooll pool" within Choi's cultural space "qqooll," drawing visitors into the corner of an Itaewon alley. Like the compound space that Kiljong Arcade had promulgated—a place where "all possible things" could unravel—qqooll pool was neither an exhibition space nor gallery nor curatorial space nor production space nor shop, but a space where collaborations, activities, and encounters involving people from all walks of life could occur. It was a place where official and unofficial acts of creative labor could be presented, and where a realistic coexistence of art and the everyday, work and life,

could be productively organized.[17] In this way, new creative spaces emerged in Itaewon as individual artists and collectives rapidly moved in. The most definitive of these was Space Hamilton, an art space that occupied a renovated a vintage furniture shop and transformed it into neither a white cube nor an alternative space, but a new type of gallery that did not fall into the conventional category of art space.

INFILTRATING PLACES: NEGOTIATION AND SOLIDARITY

The year 2008 marked an inflection point of for the Korean art scene as the heads of the major art institutions were forced to resign with the inauguration of new president Lee Myung-bak. The dismissal of Kim Yoon-Soo, the director of the MMCA, and Kim Jungheun, the head of Arts Council Korea, and the oppressive action taken against the Korea National University of Arts made the late 2000s one of the most repressive times witnessed in the Seoul art scene during the democratic period.[18] In September 2008, SSamzie Space announced its closure after a decade of operations on the grounds that it "cannot find a new breakthrough." This heralded the end of the first generation of alternative spaces.[19] Residency programs and open studios, the trademarks of alternative spaces seeking to advocate for emerging artists, were slowly being absorbed into the programs of mainstream art institutions. The boundary between commercial galleries and alternative spaces also grew increasingly blurred, and alternative spaces came to be perceived as simply a platform through which young artists could push into the mainstream.[20] Because of the lack of systematic support and the inequality in production opportunities, the new artist generation was left in a position in which it had to cultivate its own career pathways and material conditions for presenting its work and activities.

Reflecting the sentiments, or perhaps the anxieties, of the period, Part-time Suite was was formed by recent university graduates, Lee Miyeon, Park Jaeyoung, and Lee Byoungjae.[21] They opened their first exhibition titled *Under Interior* in the basement of an old building on Chungjung-ro in June 2009. 8 They covered the entirety of the floor with a tarpaulin and filled it with water. The black mold and moisture that quickly spread throughout the walls illustrated the poor conditions found in a semi-basement environment. By employing this semi-basement space, often the only type of space that young college graduates could afford in Seoul, Part-time Suite addressed the patterns of life and realities faced by a new generation of graduates that were unable to afford decent living and working conditions. In September of that

same year the collective presented *Off-off-stage* by temporarily occupying an unoccupied space between buildings on Sinmun-ro in Seoul's Jongno-gu District. Infiltrating this liminal space between immense buildings they foregrounded the empty lot so that it could be wholly experienced by those in the immediate vicinity. For Part-time Suite, a collective meant the minimum unit of a group as well as a platform that discovers new public ideas in a plurality of three. *Loop the Loop*, presented in 2009, was a performance featuring the three members walking perilously along a rooftop rail while, connected to one another via a single rope and depending only on each other's support to keep them secure. 9 This performance was extremely dangerous. When one person walked onto the rail, another took their hand and became the support fixture. As Part-time Suite narrates, "this activity presents the shared fate of together submitting to the risk of falling, documenting a moment of collaboration and trust in one another."[22] Through such projects the young artists of Part-time Suite explored the life and realities that they were forced to face by addressing the sense of professional instability found in basements, vacant lots and rooftop spaces.

While the official art world struggled under the new administration that began in 2008, the government did give enthusiastic support to public and community-oriented art and design. Design projects for urban regeneration were more superfluous than ever, but it seems that at this moment excess was worse than absence since, as many of the new urban projects were of a highly questionable quality. However, one new form of creative practice to emerge in this environment was designers working as researchers. For example, the Design Research School, hosted by the civil cultural network Tea-pot, addressed the issue of "Seoul, the urban space" by discussing the city's modes of time, space, and lifestyle. This investigative practice allowed these designers to take on a new identity as researchers.[23] And the outcome of their work gained material form in the *Design Now* exhibition at the 2008 Seoul Design Olympics, an event for which new design-oriented research collectives were formed. Most significantly among them, Na Joyoung and Park Yeonjoo organized Vaeban Family and were later joined by Shin Dokho, Lee Joonsup and Jung Heehyun. This collective sought to linguistically investigate the speculation that as the term "design" becomes more frequently used in the everyday by the public, the word might antagonistically have an impact on the quality of design itself.[24] Following this concern, *design-opp* was a publication of clippings of sentences including the term "design-wise." This scrapbook proposes that in place of ambiguous terms such as "design" and "design-wise" that were

8 Part-time Suite, Independent Project *Under Interior* installation view, 2009
 Under Interior, 2009, Black waterproof cloth. Fill floor with water, 811×717 cm
 Basement Journal, 2009, Handwritten text with water pen on cotton, wooden frame, rubber and fluorescent lamp, 310×150 cm
 Wet Document, 2009, Lime washed moldy ceiling, wooden frame, rubber and fluorescent lamp, 316×283 cm

9 Part-time Suite, *Loop the Loop*, 2009, Performance documentation, single-channel SD video with sound, 7 min. 32 sec.

being rhetorically used in everyday language, one should instead try substituting them with words that specifically meet the tastes and circumstances at hand. Another publication by the team, *How to Be a Seoul Citizen Without Losing Your Soul*, was a critical investigation of the destruction, reconstruction and redevelopment implemented under the banner of "public design," addressing the ethical conditions of people living in Seoul.

In contrast there was a more activist-oriented design group known as FF. Composed of Min Sunghoon, Choi Boyeon, Jang Wooseok, and Pengdo, FF launched the *I Like SEOUL* campaign, a movement that directly criticized the Seoul city's urban design policies. To support a promotional campaign for its urban policy, "Design Seoul," the Seoul Metropolitan Government had pasted blue posters printed with the phrase "I Like SEOUL" throughout the city. In reaction, the FF group sought to attended to the voices and concerns of real citizens and received entries for new Seoul catchphrases through their website (ilikeseoul.org) and Twitter and Metoday accounts. There were roughly 360 entries. The phrases were printed as stickers that could be placed over the city's promotional posters. "Design Seoul, I cannot help but laugh," "Just leave it alone," "Whether it be street vendors, moon village, or Dongdaemun Station," "Seoul under construction 365 days a year," "Children starve while you design" were some of the phrases. Since the project started out as an illegal campaign, the team was subjected to a police investigation on the charge of destroying public property. All the stickers that they pasted up were taken down, and the project was put to an end. Instead of being disheartened by this outcome, FF took on a more 'legal' campaign, through a form of graffiti based on cleaning away grime rather than adding ink or painted words. For this practice they placed stencils of their chosen phrases on actual surfaces and physical terrain in the environment within designated Seoul Design Streets, such as Daehak-ro and cleaned away the grime using chlorine bleach and toothbrush. In this manner they inscribed the phrases "Progress for Seoul City, Regression for Humanity" in the Daehak-ro area and "Welcome to Seoul, a City that Primarily Emphasizes its Appearance" in front of Seoul City Hall.[25]

One of the main projects of then-mayor Oh Se-hoon was a plan to tear down the old Dongdaemun Stadium and build the Dongdaemun Design Plaza (DDP) to vitalize the local economy. The project took on the format of a city's landmark through spectacle design.[26] DDP was intended to open in time for the Seoul Design Olympics and World Design Capital events in 2010, but the construction was delayed due to frequent changes in the design. During this process, the opinions of citizens were heavily marginalized, and the area's street vendors lost their workplaces. Moreover, the Seoul Folk Flea Market, which was an alternative venue allotted to vendors who had been forcefully removed from their original workplaces because of the Seoul Metropolitan Government's Cheonggyecheon renewal project, was included as a part of the DDP site.

Listen to the City is an artist group of cultural activists formed by Park Eunseon. Since 2008, the group has fought against the logic of capital-driven development that threatens the urban communities that the artists are a part of by centering their work on political activism. Listen to the City published the art-architecture magazine *Urban Drawing* in order to document redevelopment sites and their local history. Under the subtitle "Hidden Architects in the DDP," the third issue of 2013 covered the history and significance of the DDP site and examined the inside story of its construction.[27] Contesting the city government's top-down approach to the process of demolishing Dongdaemun Stadium, Park Eunseon, the director of Listen to the City, proposed a wide-ranging tranche of research on the urban identity of the Dongdaemun area, asserting that "there is a need to create a new sense of place through proactive communication and collaboration with the street vendors."[28]

Such stance can also be found in *Seoul; the City of the Spectacle* (2010). 10 When invited to the exhibition *The Design in the Age of Creative Seoul* at Insa Art Space, Listen to the City envisioned a future image of the DDP in the year 2040 as a site of ruins.[29] In the same vein, in October 2011, they hosted a guerilla open-submission contest titled "Designing a Better Dongdaemun Design Park than Zaha Hadid" in the promotional hall of the DDP as a parody of the Seoul Design Olympics. Listen to the City repeatedly emphasized that the subjects who create the spaces of Seoul are not designers, architects, and city administrators but citizens. In so doing, they documented the character of the contemporary city and its history and made a statement about how the city has been rendered devoid of character due to inept urban development. The efforts of Listen to the City were continued through the practical activism of ordinary people in response to the urban redevelopment crisis. Through this process the group shed light on the useful role of art activists in urban society. In addition, the group aligned with the Art Workers Gathering and Association of Women Artists (AWA) in 2013 to point out the problems inherent in the contemporary art system and raising critical voices against the conditions of artistic production while trying to create a self-organized system on their own.[30]

10 Listen to the City, *Dongdaemun Design Plaza in 2040*, 2011;
 Seoul: The City of the Spectacle, 2010, Computer graphics, 80×200 cm

In 2009, an artist collective emerged from the demolition site of the Okin-dong redevelopment district. Kim Hwayong, who had been living in the Okin 2-dong Apartments for two years, invited artist friends to her soon-to-be-demolished home and hosted a "vacancy project" on the rooftop. They organized an overnight public program where various artists and local residents could come together. This program allowed visitors to explore the apartment building, hold treasure hunts amid the ruins, dine with the residents and view artworks. The Okin Collective was not organized with a specific objective: Rather than solve the eviction problem faced by a colleague and resident of the Okin Apartment, the collective sought solidarity by calling attention to the realities with which we are all confronted with, and highlighting the lamentable fact that the site and building were to be soon demolished. In this regard, documenting and memorializing urban sites that are being demolished constituted the collective's major strategy. After the Okin Apartment project, Okin Collective moved beyond Okin-dong, expanding its acts of intervention, negotiation, and

recontextualization into any place that was given to them as material for their work.[31]

AFTER THE 2010S, "OUR" SOLIDARITY CONTINUES

In December 2009, a noodle restaurant named Duriban near Hongik University, was threatened with forced eviction. The owner couple started a sit-in, and area musicians including Hahn Vad, the Bamseom Pirates, Park Daham, and Hoegi-dong Danpyunsun joined the demonstration. Duriban soon became a site of protest and cultural activism. Artist collectives came to join forces, participating in the stay-in strike through various forms of action including exhibitions, recitals, seminars, movie screenings, and a market. Yoo Byungseo of Micro/weiv joined Group 51 with Vad Hahn, Danpyunsun, and Park Daham to stage a free music festival ("the New Town Culture Party 51+," which ultimately consisted of 63 bands) in the redevelopment zone around Duriban, to commemorate the one hundred-twentieth anniversary of May Day on May 1, 2010. Then, in February 2011, Listen to

the City hosted a film screening at the Duriban protest site. They temporarily brought in their *Project Space Morae*, a container box that had been installed as a mobile gallery at the Naeseong River, to demonstrate their solidarity.[32] These endeavors led to the establishment of the Independent (Jarip) Music Production Union, which sought to secure an autonomous structure of support for music production and build a system for distribution and performance through solidarity and independence. The Okin Collective also invited independent musicians to their Okin Radio Station, to discuss both the Duriban protest and the Jarip Union.

The Duriban struggle enhanced the sense of solidarity among artists and cultural producers and provided an opportunity for them to face the realities surrounding creative professional activity in contemporary Seoul. This was manifested in the words of musician Hahn Vad, who noted that "the situation of a musician being pushed out of the Hongdae district and that of an evicted tenant are no different."[33] After the Duriban struggle, artists engaged in sharing ideas on how to achieve a material basis for art production and survival as an artist, calling for changes in the art scene through the 5.1 General Strike Artist Parade in 2012 and the Art Workers Gathering.[34] When Takeout Drawing was faced with an eviction order in 2015, the various musicians, artists, and researchers that had experienced Duriban merged with the group in voluntary participation and solidarity.

In the 2000s and 2010s, artistic activities around Seoul were stimulated by the precariousness of life, oscillating between the institution and the field, art and non-art, and the ideal and reality while looking for new approaches to creative activity related to art production. Art historian and activist Alan W. Moore explains that as artist collectives attempted to create social change in place of art objects, they also generated situations, opportunities, realizations, and understandings.[35] The artist collectives of the 2000s in South Korea emerged as an inevitable reaction to neoliberal conditions and developed new local approaches to cultural activism through social engagement and solidarity. During this they called for the public responsibility and social function of arts. This collectivity and collective practices have contributed substantively to generating new modes of art production that embrace participation and collaboration, and the legacy of this work continued to deeply impact the changing conditions and flow of South Korean contemporary art after the 2010s.

1 Yoon Wonhwa, *1002 beonjjae bam: 2010nyeondae seourui misuldeul* [The 1002nd Night: Arts of the 2010s Seoul] (Seoul: Workroom Press, 2016), 56.

2 Kim Jangun, "Kollektibeue daehan gieok" [Recollections of Collectives], *Article*, February 2012, 97.

3 The "pidgin" in Pidgin Collective means a hybrid language that is naturally formed to facilitate communication between people who do not share a common tongue. It most commonly takes on the form of combining a foreign language (say English, French, or Japanese) with local vocabulary during the process of colonization. Generated through interactions and verbal contact between two disparate groups, Pidgin an unstable form of language that can disappear or transform once such interactions weaken.

4 Ho Kyoungyun, "Misul, chulpaneuro 'geurida'" [Art, 'Paint' with Publishing], *Art In Culture*, March 2010. Frederic Michon of Pidgin Collective formed AC Mapo with Yo Daham and Yun Sabi, later organizing AC Publishing. They produce their publications by reorganizing publications and images that they archived through collaboration with artists from various fields. AC Publishing's *TIMBER!* exhibition, held at Art Space Pool in 2013, experiments with the form of books as it focuses on knowledge acquired not from the contents, but from the form of a book.

5 Pidgin Archive, *Rolling Space* exhibition leaflet.

6 Beck Jee-sook, "Misul akaibeuwa akaibeu misurui gieok 'chungdong'" [Recollecting 'Impulse' of Art Archives and Archive Art], *Insa Art Space Archive 2007* (Seoul: Arko, 2008), 98.

7 ibid

8 Lee Joonhee, "Misulga choesoyeon, geuui tto dareun ireum 'jeobneun misulgwan'" [Choi So-yeon, Her Other Name the 'Collapsible Museum'], *Culture Art*, April 2005, 64–70.

9 "Oasiseu peurojekteuui sido" [Attempt of the Oasis Project], *Research Space Suyu+Nomo Discussion Paper* (Seoul: Suyu+Nomo, 2006); Kim Kang, *Samgwa yesurui silheomsil* [Squatting, the Lab of Life and Art] (Seoul: Moonhwagwahak, 2008), 229.

10 Kim Joonki, "Jageopsirui jeongchihakgwa jeomgeo peopomeonseu" [Politics of the Studio and Occupation Performance], *Culture Art*, September 2004, 55.

11 Kim Dongil and Yang Jungae, "Sangjing tujaengjaroseoui yesulga: Oasiseu peurojekteu (2003-2007)reul jung-simeuro" [The Artist as Intellectual in Symbol Struggles: Around the Oasis Project (2003-2007)], *The Korean Journal of Cultural Sociology* 14 (2013): 181.

12 Gam Donghwan, Kim Nahyun, Kim Namgeon, Kim Bonyeon, Kim Sunjin, Kim Sunghan, Deuniro gonjiga, Park Sunyoung, Park Sunnhee, Park Jimoo, Baek Jaejoong, Seo Youngjoo, Oh Jinyoung, Yoo Byungseo, Yoo Changchang, Yun Sangjeong, Lee Geumja, Lee Lang, Lee Harin, Lee Hyegyu, Lee Hugyeong, Jung Song, Joo Dongseop, Choi Yeongyu, Han Garam, Han Seokhyun, Han Seungwoo, and Hong Sunghoon all participated in the *Cherry the Bridge* project.

13 Koo Bonjoon, "Ppalganbul kyeojin ppalgan yukgyo" [Red Pedestrian Overpass Runs a Red Light], *Hankyoreh*, May 15 2007.

14 Micro/weiv, "microbot," *Graphic #10: Self-publishing Issue*, Summer 2009, 166.

15 They used the POST-EAT recipe as a collective manifesto. 1. Select a fresh and deliciously space. 2. Contemplate how to cook the space, and tastefully cook the space. 3. Invite guests and dine together. 4. Wash the dishes after the meal. 5. When you get hungry again, return to 1. Source: POST-EAT blog (https://blog.naver.com/post_eat).

16 Jang Hyejin, "Burangwa uul sok, kollektibeu yeondaegi" [Inside Anxiety and Depression, Collective Chronicle], *Public Art*, February 2015, 29. Kit-toast is introduced as follows on kit-toast.com: "A voluntary economic system operated by 25hr Sailing, an artist collective composed of Kim Bokyung and Keem Cheongjin. It takes on furniture/knit design and production, graphic design, publishing, stage design as its main menu while it seeks to overcome the economic difficulties that artists encounter when working/in order to work."

17 Kim Heejin etc, *Puri seonda: 2010 sadan beobin ateu seupeiseu pul saeop yeollyebogojip* [The Grass Rises: 2010 Annual Program Report of the Art Space Pool] (Seoul: Forum A, 2010), 60.

18 Chairman Kim Jungheun, dismissed on grounds of mismanagement of funds, filed a lawsuit against the Minister of the Ministry of Culture, Yu In-Chon, to contest the validity of his dismissal. About a year after his discharge, Kim won the suit when the court ruled that the Ministry of Culture's actions were illegal. Han Yoonjung and Kim Jinwoo, "Munhwabu, gimjeongheon munhwa yesul wiwonjang gigeum gyujeong wiban haeim" [Ministry of Culture, Dismissed Chairman of the Arts Council Korea for Violation of Fund Regulations], *Kyunghyang Shinmun*, December 5, 2008.

19 "Adieu, SSamzie Space!," *Hankyoreh*, September 11, 2008. The year 2008 was considered to mark its the tenth anniversary because while SSamzie Space opened in 2000, its precursor SSamzie Art Project was initiated in 1998. After announcing the closure, SSamzie Space officially closed on March 30, 2009. Prior to closing its doors, SSamzie Space hosted a symposium entitled "The Past of Alternative Spaces and the Future of Korean Art" to study the history and present of alternative spaces and suggest the potential for other alternatives as required to meet the changing times. For this, refer to the SSamzie Symposium booklet *Wae daean gongganeul malhaneunga* [Why Speak of Alternative Spaces?] (Seoul: Mediabus, 2018).

20 Ban E-jung, *Hanguk dongsidae misul 1988–2009* [Korean Contemporary Art 1998–2009] (Seoul: Mimesis, 2018), 110.

21 Lee Miyeon and Park Jaeyoung have worked as a duo since 2013, while Lee Byoungjae runs Seendosi in the Euljiro neighborhood with photographer Lee Yunho.

22 "Malhaneun misul 8hoe pateutaim seuwiteu" [Talking Misul, Episode 8, Part-time Suite], deposition of the first research meeting, September 2015.

23 An Inyong, "Gihoeganeun dijaineoui him" [Power of Curating Designers], *Hankyoreh ESC*, July 2, 2008.

24 Vaeban Family, *Graphic 10: Self-publishing Issue*, Summer 2009, 168.

25 For FF works, refer to An Inyong, "Jeohanghara! Nolmyeonseo jaemiitge" [Resist while Playing and Having Fun!], Hankyoreh ESC, November 22 2010; Eun Yoo, "Frontline Interview: Hatchman Project Team FF," *Weekly Suyunomo*, no. 35 (2010), http://suyunomo.jinbo.net/?p=4849.

26 Jahn Jin-Sam, "DDPe sogabwa: Igeoseun wonboni doel su inneunga?" [Be Fooled by DDP: Can This Be an Original?], *Hwanghae Review*, no. 83 (2014): 427.

27 For the background context of the construction of DDP and various professional opinions, refer to *Eoban deuroingseu 3: Dongdaemun dijainpakeuui eunpyedoen yeoksawa seuta geonchukga* [Urban Drawings 3: The Hidden History of Dongdaemun Design Park and the Star Architect] (Seoul: Listen to the City, 2013).

28 Park Eunseon, "DDP, dosi bijeongcheseonggwa bigonggongseongui pyosang" [DDP, Symbol of the City's Non-Identity and Non-Public Nature], *Munhwa Gwahak*, no. 79, September 2014, 249.

29 *Design in the Age of Creative Seoul* was held at Insa Art Space from June 2 to 24, 2010. Mediabus, FF, Listen to the City, and Yoo Byeongseo participated in this show questioning the Design Seoul policies, including the Seoul Design Olympics.

30 Kim Jangun, "Yesulgaui wichi: Gongdongchewa jakga" [Position of the Artist: The Community and the Artist], *Journal of Modern Social Science* 17 (2013): 8.

31 Okin Collective, *Okin Collective* (Seoul: Workroom Press, 2012), 35.

32 After Duriban, the Second Urban Film Festival was held at Myeongdong Cafe Mari, a renewal site around Myeongdong Cathedral, Sunhwa-dong, Hoehyeon Simin Apartment, which is the last remaining "citizens' apartment," the Okbaraji alley, and other spaces. Project Space Morae seeks to revive the Naeseong River, whose sand and water were blocked due to the Four Major Rivers Restoration Project. It was originally installed at Jogyesa Temple, where Monk Jiyool stays. Refer to the Listen to the City's website (www.listentothecity.org).

33 For the Hongdae Duriban protest and the Independent (Jarip) Music Production Union, refer to *Party 51* (2013), documentary by Jung Yong-taek.

34 Art Workers Gathering is an artist collective in 2012 as an artist-designer group to support the 5.1 General Strike. Its members include Listen to the City, Part-time Suite, Okin Collective, Kang Jungseok, Keem Youngle, Oh Yongseok, Lee Soosung, and Jo Hyejin. They discuss the problems of living as an individual art professional, the problems of dealing with the irrational structures within art institutions and the irregularity of government art policies. From 2020, they researched and published an information package on the system of artist fees to help generate an environment in which art producers are respected. For more information on Art Workers Gathering's activities, see its website (http://artworkersgathering.wix.com/arts).

35 Alan W. Moore, "General Introduction to Collectivity in Modern Art," Paper for *Critical Mass exhibition* (Smart Museum, University of Chicago, April 2002), *Journal of Aesthetics & Protest* 3, accessed June 1, 2021, http://joaap.org/new3/moore.html.

The New Wave of Art: Writing, Movement and Sound

Ryu Hanseung

ARTISTS WHO WRITE

It is not a new phenomenon that visual artists write. They have written for a long time, and they have expressed what they hear and feel in diverse forms of writing, including essays, letters, travel essays, poetry, novels, playwriting, artistic critiques and manifestos that are all naturally connected to their lives or artworks. Since the mid-2000s, however, a new wave of artist writers, never seen before in the field of Korean visual art, has emerged.

For one thing, the number of artworks based on 'writing' has increased significantly. For example, artists write scenarios or scripts in preparation of visual outcomes, pen novels in relation to their visual productions, summarize their working procedures in text, publish those texts in a book format and sometimes attempt new forms of writing in collaboration with theorists. In this way, artists have made various efforts to express ideas about imagery in texts or publish their concepts in a printed form. Some artists often unveil these written works alongside traditional forms of visual art, e.g., paintings, sculptures, photographs, videos and installations, while others regard "writing" as an independent genre or a separate medium for visual art in itself.

The idea of "writing" as an artist's proper field of focus gained momentum in the 2000s in conjunction with the advance of the internet and the IT world. Korea was widely equipped with the broadband system earlier than any other country, so most people had become familiar with online writing mainly through the social networking services of the early 2000s. Therefore, anyone was able to write and publish his or her own written material online without relying on the traditional means of publishing books. It meant that anyone, not just a selected few, could be an author. A great number of personal blogs and homepages appeared and Web novels gained considerable popularity amongst internet audiences. As Koreans gained easier access to a much broader abundance of information than we had before, many began to edit and create their own texts in personal online spaces based on that information. In short, the way that people input, edited, published and shared information dramatically changed. In addition, the extensive distribution of personal computers and editing software, e.g., InDesign or Photoshop, also contributed to the ease of self-publishing,[1] and to an increase in publications by artist-designer collaborations.

Meanwhile, contemporary artists were increasingly required to describe their work elaborately in "verbal" or "textual" language as there were increased opportunities through the exhibition competitions set up by alternative spaces, artist residency programs, or funding for cultural projects. Applications for such often included artists' notes or descriptions of their works in portfolios, and also explanations of their works were required in interviews. These changes made art schools teach students how to construct written portfolios and presentations. Also, artists had to deal with new social issues as society became more complex and interconnected. To do that, they turned to new mediums to address what could not be addressed by using existing means. For example, artists could experiment with new modes of narrativity and performativity through video and performance. And with the onset of the new millennium many artists developed a truly multidisciplinary approach to art.

In addition, since the late 1980s, the teaching of art theory major has gradually gained prevalence in art schools and many critics have emerged accordingly. Some of them have organized research groups in collaboration with artists to

discuss diverse issues and discourses, which were naturally followed by experiments in new ways of writing. One of the most representative groups in this regard was Friendly Enemies (*woojeok*), and the major members of the group included Kim Hyunjin, Kim Jangun, Yang Haegue and Rhii Jewyo, Friendly Enemies engaged in "collective writing," publishing three art magazines together from August 2005. Hyun Seewon, An Inyong, and Hwang Sara inaugurated the independent cultural periodical *Walking Magazine* from August 2006, connecting with artists in diverse ways and documenting the processes. From 2009, art historian Kang Taehee published five series of books titled *Museum in the Book*, which provided a platform through which the artists could publish their writing. Then art critic Lee Daebum asked sixteen artists and theorists to write a novel that included the name Lee Joonho or Joonho, and published a resulting compilation titled *Novel 01 Footnotes without Main Text* (2010).

Under such circumstances, artists produced even more writing directly related to their works. Among other types of text, the format of the novel deserves specific attention because it complemented the parts of their creative process that the artists could not completely express using other mediums (painting, photography, sculpture or installation. The genre of the novel is effective for the artist's expression of a 'narrative,' while it is not a representation of the visual. In reverse, 'visual' art mediums are effective in representing images but relatively ineffective for describing narrative, particularly in relation to the 'inner' voice of character and commentary. In this context, artists began to write and publish novels to complement their paintings, photographs, sculptures or installations. For them, the novel served as a new art medium.

TEXT + NARRATIVE

Park Yoonyoung presented the work titled *Pickton Lake* in her solo exhibition held in March 2005. The subject of the piece is based on the murders of the serial killer Robert Pickton, which took place in Vancouver, Canada.[2] The artist was staying in Vancouver in the early 2000s and, when the police found a clue to the murder cases in 2002, she visited the murder scene by herself and gathered mass media reports from both newspapers and broadcasting systems, while reflecting on the various stories that could possibly be related to the homicides.[3] Afterwards, Park created a narrative by weaving together the investigative materials and other references she had collected and wrote an intertextual novel titled *Short Visit of the Blue Poles and Disappearing*. Based on this novel, she then

1 Park Yoonyoung, *Pickton Lake*, 2005, Ink and color on silk, 210×520 cm

created her visual work *Pickton Lake* in the form of a folding screen.

In this work, her novel functions in three ways. First, the novel, in itself, is a textual outcome that juxtaposes her investigation materials intertextually. Second, it is presented to the audiences as a new art medium. Third, it complements the elements of narrativity that other forms of visual art, including painting, sculpture and installation, could not deliver to the same capacity. As such, audiences who read the novel before seeing the visual outcome receive the message of the work quite differently from those who do not.

In February 2006, Park Yoonyoung presented the work *Journey to Aceldama* composed of a folding screen, a scroll, an electric guitar, amplifiers and speakers, at the Leeum, Samsung Museum of Art. Park locates this work in relation to her novel *The Dark and Unlit Lougheed Highway*. Like *Short Visit of the*

Blue Poles and Disappearing, this novel is also based on multiple references, and its visual representation took the form of a folding screen, which illustrates the story of the novel and serves as a musical score for guitar performances. She planned to play the guitar at the exhibition opening, but it this performance was canceled due to personal circumstances.

Park Yoonyoung was not the only artist who wrote novels at this moment. Park Hwayoung, who had explored a non-linear narrative structure in her early video works, published the novel *Chija & Dando* in October 2007. Its narrative developed around the Mongin Art Space (a businessman's house that was transformed into an art studio) and the local neighborhood. Soon after, the artist produced a video installation titled *Chija & Dando* based on her novel. [2] By utilizing the Mongin Art Space, which exists in the real world, the artist intended for the audience to imagine the visual images of the novel unfolding in the physical exhibition space. Many of the objects that she mentions in the novel also exist in the real house. What we finally encounter in the exhibition are the videos, photographs and paintings which appear in the novel. In taking this approach, the artist overlays the real and the unreal in a subtle way.

Park Jaeyoung, who trained in sculpture, wrote the novel *Bokaisen Studies*, focusing on the fictional animal Bokaisen. The story is that a zoologist discovers a Bokaisen and experiences various episodes while raising the creature. In the solo exhibition held in July 2009, the artist enacted a scene in the novel in which Bokaisen is incubated with an electronic device. [3] Moreover, Park designed the novel to make it look like an antique book and displayed it alongside his visual installation. Throughout the exhibition, he also constantly explained to the audience that Bokaisen was indeed growing. As an aside, it is said that

2 Park Hwayoung, *Chija & Dando*, 2007,
 Acrylic paintings on linen by Chija and assorted objects Chija has left behind, dimensions variable

3 Park Jaeyoung, *Scientific Images: Dr. John's LAB*, 2008,
 Mixed media, dimensions variable

They spend all the fever together.

4 Kim Youngeun, *The Units of the World According to ;Semicolon*, 2011,
Single-channel video, color, sound, 25 min. 54 sec.

5 Jang Boyun, *Sylvan Lake*, 2011, Archival digital C print, 42×65 cm
A Boy's Dream 01, 2011, Archival digital C print, 35×50 cm
Day Swimming, 2011, Archival digital C print, 35×50 cm
October is Coming 02, 2011, Archival digital C print, 20×30 cm

some audiences took his words seriously, believing in the fictitious animal's existence.

Kim Youngeun, who was known for her work as a sound artist, wrote three essays about sound and signs in 2008, and she published a compilation of three writings *Lesson for a Naming Office: Three Treatments*. Immediately after this publication, she produced three videos sequentially: *Oral Ground* (2009), *A Corner Revolving infinitely* (2010), and *The Units of the World According to ;Semicolon* (2011). ⁴ The first video focused on phonetic symbols, the second piece addressed four proper nouns that share the same orthography, and the third engaged with twelve punctuation marks and their sounds.

Jang Boyun has a particular interest in personal stories. In the summer of 2010, in New York, one of her acquaintances gave her an old photo album. In the following year, she visited the previous home of the person in the photographs, searching for traces of that individual's life. Based on this adventurous journey, she wrote the novel *Acquainted with the Night* in the format of a diary. In her solo exhibition held in September 2011, the artist showcased newspapers, maps, itineraries, poems, memorial postcards as well as the photographs from the album and those taken personally. ⁵

Jun Sojung has always been interested in biographical stories. She wrote six short stories based on news reports on small incidents that she had collected since 2008, and created shadow images, like those used in shadow theaters, to work in concert with each story. In her solo exhibition in November 2012, Jun produced fake newspapers with images of her works and short stories and stacked them throughout the gallery. She printed one of the shadow images on a large-scale and attached it to the installation structure. Viewers were free to take the newspapers with them. In addition, the artist composed a song with lyrics about the stories, and during the month following the exhibition's opening, the band Black Night played the song at the venue *PLAYTIME* at Culture Station, Seoul 284.

Sometimes, the artists' novels bring vitality to their visual artworks. Jeon Joonho made a human skeleton out of wood and titled it *The Last Master* (2014). He also wrote a novel of the same name and displayed it together with the skeletal structure in the same exhibition. The story of the novel unfolds as follows: the protagonist encounters a senior colleague with whom he used to work at a Buddhist sculpture workshop thirteen years ago. The former colleague, who once had exceptional skills, is now too old and ill. When the protagonist asks him to collaborate on a project, the ailing craftsman hesitates a little but eventually succumbs to his junior colleague's persuasion, agreeing to work together to carve reproductions of human bones out of wood with all their dedication. After completing

every bone, they hesitated to carry out the last process of assemblage because they both felt that there would be no more work left for them to do. As a fictional story that introduces the background and detailed process of his work, the novel invites the viewers into a dramatic experience of the artwork in order to engage with it more intimately. This may be one of the main possibilities of narrative writing in relation to visual art.

In the late 2000s, novels were not the only forms of writing for artists; others, including scenarios, playscripts and so forth, emerged. Of course, we could find these types of writing before this period. However, this was the first instance in which visual artists actively worked with text, either by creating textual artworks or by including their texts in printed materials. Even if the content is the same, hearing sounds or listening to a person's voice and reading texts of the materials provide the audience with rather different experiences.

In 2007, Nam Hwayeon presented the work titled *Operational Play* based on the motif of an operation code name.⁴ She wrote each word of the code onto separate cards and arranged them into a sort of sequence to create a scenario. When she gained the opportunity to exhibit them, she affixed the screenplay for her scenario on to the inner wall of the exhibition space. While she had initially only written the scenario, it developed into a visual production thanks to the unexpected exhibition opportunity afforded to her as the winner of the 2009 Hermes Art Award. For this project, the artist requested a performer to do a performance based on this scenario in Seoul and asked a local performer in Utrecht, in the Netherlands, to perform the same piece and then recorded both performances to make two videos. During the following April, she presented these videos as a work of performing art at the Arko Arts Theater. Her scenario is mostly composed of subjects and commands. The name of every character is taken from the code names, and the performers execute certain actions as directed by the instructions of the scenario. Furthermore, the performances slightly change depending on the performers' understanding given the different regions and local circumstances of each performance.

Around this time, Jun Sojung held an exhibition tour based on a playscript. While staying in Berlin in 2008, she met Korean nurses and miners dispatched to West Germany. Based on her encounters with them and the conversations they shared, she wrote a playscript for a six-act play titled *Story of Dream–Suni*. In every exhibition she had, she staged one act from the playscript in the gallery. As this performance took place, the artist also played a 2-channel video—one showing

6 Jun Sojung, *Story of Dream: Suni*, 2009,
 Two-channel video, color, sound, 20 min. 36 sec.

drawings related to the story, and the other images showing lines of script rolling up like the end credits of a film. *Story of Dream–Suni* was first made open to the public in the exhibition *Platform 2009: Platform in KIMUSA* (Former site of the Defense Security Command, 2009). ⌐6⌐ Jun Sojung staged Act 4 for this exhibition, Act 5 for her solo exhibition in Strasbrug, France (CEAAC, 2010), and Act 1 at another solo show in Seoul (Seoul Art Space Seogyo, 2011). For the show in France, she staged it as a piece of performance art, casting a Korean immigrant in the main role.

Kim Ayoung produced the video work *PH Express* in relation to the colonial history of Geomundo Island.[5] In Europe, she conducted a broad investigation into the island and wrote a scenario by citing or rearranging statements amassed from the diplomatic documents gathered from the UK foreign office and news reports. She first shot the landscape of Geomundo for the background image of her video, and then filmed the acting scenes with the actors and members of staff. In the video, the roles of the British ambassador, officials, the sea captain and crewman appear, revealing their individual thoughts about the British involvement at Geomundo Island. In the exhibition *ARTSPECTRUM 2012* at the Leeum, Samsung Museum of Art, the artist provided the audience with textual materials in the form of free newspapers. These newspapers include the UK foreign office documents, historical news reports,

some segments of her script and an overview of her artwork.

Having written consistently since the early 2000s, Yang Heague published a book titled *Melancholy is a Longing for the Absoluteness* in August 2009. This book includes several writings from her lectures to her video scripts.[6] She often wrote about her personal situation in the form of lecture notes, and then directed actors or voice actors to recite those texts at exhibition openings, and produced single-channel videos that are notable for their essayist narration. Throughout the early 2000s, as the artist focused on the circumstances in which the narrative of a text is presented on stage, she did not include the textual materials in the exhibition catalogs in most cases."[7] Besides, many artists have published new and unique forms of writing. Some catalogues show a significantly high proportion of text so that they are more like research reports than traditional portfolios that offer a compilation of artist's works. Such text-heavy catalogues often include in-depth information on individual art pieces.[8] While other writings describe artists' theoretical approaches or experimental creative approaches. For instance, Chung Suejin published *Budo Theory: About Visual Theory* (2014) to explain her own theory of painting. Jun Sojung requested art critics to write critiques on 'art that has not yet been created,' collecting their responses in her book titled *EUQITIRC* (2016).

THE EXPANSION OF INTERDISCIPLINARY ART

"Interdisciplinary art" emerged significantly in the mid-2000s Korean art scene. The term usually indicates art practice that crosses the borders between fine art, dance, theater, music and film. Although interdisciplinary art seems to focus on the integration of, or exchanges between, different genres, it does not simply refer to their fusion. As the artists raise fundamental questions and reflect on each individual genre, they often locate new concerns that cannot be expressed through a single genre and, as artists engage in particular aspects of different genres, a new form of art practice emerges naturally.[9] Kim Seonghee, an interdisciplinary art curator, said that this new art form often encompasses "attempts to transcend artistic convention" while traversing diverse genres. In other words, "it is a multifaceted and dynamic concept that comprehensively explains new methods of and attitudes towards contemporary art, overcoming the simple amalgamation of mediums."[10]

In Korea, however, "interdisciplinary art" was "a concept that was also coined in the process of governmental policymaking."[11] In 2005, the Korea Culture and Arts Foundation was converted into a non-governmental organization and renamed the Arts Council Korea. A committee focused on interdisciplinary art was established within the new organization[12] and began to support and discuss the interdisciplinary arts from 2006.

In parallel, since the 2000s artists in diverse creative genres, including the visual arts, dance, performance and design, have tended to appropriate other genres and hybridize their works.[13] In this context, Kim Seonghee, who had led the International Modern Dance Festival for four years from 2002, co-established an international interdisciplinary art event called the Springwave Festival with the art critic Kim Sungwon in May 2007. This event came to be renamed Festival Bo:m in the following year and continued until 2013. As the Artistic Director, Kim introduced a variety of works that encompassed the performing arts and visual arts to the public. Also, diverse forms of interdisciplinary arts were featured in *Jump Now* (2008), the inaugural exhibition at the Nam June Paik Art Center, and *Platform Seoul* (2006–2010; The 2008 exhibition focused on theatricality in art), curated by Kim Sunjung.

Among these events, the annual Festival Bo:m deserves particular attention. It has mostly featured and features performing arts by inviting the participation of experts in diverse fields, such as visual artists, choreographers, theater and filmmaking professionals and theorists. Initially, projects by internationally renowned

7 Jung Yeondoo, *Cinemagician*, 2010,
 Two-channel video, color, sound, 50 min. 31 sec.

choreographers, including William Forsythe, Jerome Bell and Xavier Le Roy, garnered the public's attention, but the works of Korean artists gradually emerged to headline prominence. In particular, Hong Sungmin and Seo Hyun-Suk presented highly creative experimental works crossing the border between genres and laying the foundation for interdisciplinary art in Korea. Interdisciplinary art events often provide visual artists with an opportunity to stage their work. Unlike in a typical white cube gallery space, in the black box of the concert hall artists can use sound and lighting in a more subtle way, and use diverse technological instruments to make special effects. By doing so, they can help the audience to immerse themselves more fully in the work. Given this developmental background interdisciplinary visual artists are now accustomed to selecting venues specifically appropriate to the presentation of their work.

An example of one of the most interesting works staged in the Festival Bo:m is Lim Minouk's *S.O.S.—Adoptive Dissensus* (2009). While most of her other works were displayed in an auditorium, this work took place on a cruise on the Han River and along the riverside where she set various stages. The audiences could then visit those specific sites by taking the cruise. The cruise ship carrying viewers embarked from the docks at Yeouido and headed eastward, crossing the Hangang Bridge. When the cruise ship reached the Jamsu Bridge, it made a U-turn. At this moment, a performance protesting against indiscriminate urban development was staged at the fishing site located near the bridge on the north side of the Han River. When the ship passes by Nodeul Island, the audiences could see couples jumping or wandering around here and there. Around the Yanghwa Bridge, they can hear an impassioned long-term political prisoner speaking about their life. In this way, the work sought to give voice to the history, and the memories or people left behind in the processes of modernization, urbanization or Cold-War era political oppression.

At the April 2010 Festival Bo:m, Jung Yeondoo showed *Cinemagician*,[14] an integration of cinema and magic, in which the act of filming and that of watching the film take place simultaneously. 7 Through this work, the artist explored the immediacy of artistic performance, the tension at the site of performance, and the audiences' reactions. On stage, the protagonist (magician Lee Eun-gyeol) used various visual tricks to create winter, spring and summer landscapes. During his performance, two cameras recorded the scenes. The first camera shot a close-up of the stage with the magician at the center, and this was projected onto a large screen behind the stage. Here, the assistants who changed the landscape were not captured by the first camera. Installed in the auditorium,

the second camera filmed the entire performance from a distance, shooting the magician, the other performers (assistants) and even the back of the firstrow of the spectators in the audience. These recordings were screened as a 2-channel video installation in the exhibition hall.

Siren eun young jung, who worked on her project "the Korean classical opera of women" (known in Korean as *Gukgeuk*) since 2008, presented *The (Off) Stage/Masterclass* in the 2013 Festival Bo:m.[15] This Korean classical opera of women, which was based on performances only featuring actresses, began at the end of the 1940s and rose to the height of its popularity during the 1950s and 1960s. *The (Off) Stage/Masterclass* consists of two parts. In the first part, Cho Young-sook, a first-generation artist of this genre, speaks about her life as a female performer in the Korean classical opera through song and dance. In the second part, Lee Deungwoo, a second-generation actress who performs the role of the male protagonist, teaches a young actress (Kim Yongsook) about the male voice and masculine ways of speaking, walking and using hand gestures within the classical opera genre. Since this initial performance, siren eun young jung has performed *Le Nouveau Monde Amoureux* (2014) and *Anomalous Fantasy* (2016), which is based on the classical story of *Chunhyangjeon* and takes the form of this Korean classical Gukgeuk opera performed by women.

The Festival Bo:m was not the only venue for presenting interdisciplinary art projects. In April 2010, Chung Seoyoung showed *The Adventure of Mr. Kim and Mr. Lee* (curated by Kim Jangun) at the LIG Art Hall. The audiences are invited to enter the makeup room backstage (rather than filling seats in the concert hall) where they confront the deadpan face of a young lady who is disguised as an old woman. Moving to the next room, they find two young men staring at them intensely. Next, as the visitors make their way up to the stage, they see five people, either sitting or standing still, and another person walking a dog. The audiences are free to move around the stage. Last, they push aside the stage curtains, pass through the seats and leave the hall through the entrance/exit. Here, the disguised performers look like living sculptures, while the spectators who walk amongst them and around the hall space seem like the actual actors on stage. In so doing, the roles between the performers and the audiences are reversed.

In addition, Yang Haegue performed the monodrama *The Malady of Death* at the Namsan Art Center in September 2010. The title of the performance came from the short story of the same name by Marguerite Duras (*La Maladie de la Mort*). The story of the novel consists of dialogues between 'you' in the second person and 'he' in the third person. Yang was inspired by the author's words in

8 Moon Kyungwon & Jeon Joonho, *News from Nowhere: Chicago Laboratory*, 2013,
Dimensions variable

the last part of the novel to perform *The Malady of Death* as a play, and planned a staged production of this work. She reconstructed the dialogue between the two protagonists into a monodrama and let the announcer Yoo Jungah recite the script. Before the stage performance, the artist published the Korean version of the artist's book *The Malady of Death* in December 2008. Later, in June 2012, the work *The Malady of Death: Écrire et Lire* was re-staged in the Kassel documenta (13). In this show, the French actress Jeanne Balibar stood on the stage and read the entire English script. In December 2015, she invited novelist Hon Lai-chu and filmmaker Yau Ching to read the Chinese script in Hong Kong, and in January 2016, the actress Irene Azuela read the Spanish translation in Mexico City.

While the above-mentioned works show how visual artists engaged with the performing arts (dance, theater and music), Jeong Geumhyung, who had majored in dance and theater, entered the field of visual art through her performing practices. In her works such as *Vacuum Cleaner* (2006), *Oil Pressure Vibrator* (2008) and *7 Ways* (2009), she presented theatrical and choreographic performances by using objects. *Oil Pressure Vibrator* first appeared at the eleventh Seoul Marginal Theatre Festival, taking the unique form of a lecture performance. On stage, Jeong composedly explained the way in which she learned how to operate an excavator according to the video image on the screen in the background, then she gave a performance in which she reached orgasm by using a toy excavator. In the 2010

Festival Bo:m, she explored the conflict between theater performance and industrial design through the work *Technical Problem*, which was created in collaboration with Lee Chungwoo (art critic) and Jackson Hong (artist and designer).

Lastly, Moon Kyungwon and Jeon Joonho's *News from Nowhere* (2012) shows an active attempt at an exchange between various disciplines, going beyond the aforementioned interdisciplinary forms of art. **8** The work is inspired by a short story of the same title by William Morris, in which the protagonist, situated 100 years in the future, looks back at the UK of the 1890s. Their work shows an imagined vision of world a hundred years after a catastrophe has occured, in which human society is devastated, and everything will have to be rebuilt. It discusses what needs to be reconstructed in each field of society. The purpose of this project is to reinterpret the meaning of beauty through a collaboration with architects, visual artists, fashion designers etc. The work here endeavors to envisage a new future society through dialogues and discussions with scholars from diverse fields about comprehensive social issues, including culture, the economy, education and religion as well as art. *News from Nowhere* consists of the video work *El Fin del Mundo*, in which objects have been made in cooperation with experts from other fields, and the textual work *Voice of Metanoia*, which features the documents of interviews with scholars of diverse disciplines.[16]

COLLABORATION: MOTION AND SOUND

From the mid-2000s, as 'interdisciplinary art' gained traction in the Korean art world, the integration of visual art and performance art came to be a major trend. Artists combined these two genres in diverse ways other than in the form of a staged performance. First, visual artists collaborated with choreographers, musicians and actors, so these individuals would directly appear in the visual artworks or support them in other ways. Second, visual artists introduced gestures, sounds or acting, which are the essential components of dance, music and theater, to create a work of art that focuses on body gestures or sounds. Third, visual artists appropriated certain methods that are essential to dance, music or theater in their works. For instance, Oh Min used the basic structure of a sonata (ABA) in her artwork, and Choi Haneyl created a one-man sculpture company called CHN Sculpture based on the professional model of a choreographer's dance company.

What is most important here is the artists' collaborations with specialists of the genre, which helped to develop their work to a higher level. Such collaborations also result in synergic effects among practitioners and allow for audiences to experience the potential of collective authorship, creativity and anonymity.

Several such collaborative works emerged in the late 2000s.[17] Jung Yeondoo collaborated with magician Lee Eun-gyeol in his works *Cinemagician* (2010) and *Magician's Walk* (2014). Yeesookyung collaborated with vocalist Jung Marie for *Mother Land and Freedom Is* (2009) and *While Our Tryst Has Been Delayed* (2010) and with Korean traditional dance specialist Lee Junghwa for *Dazzling Kyobangchoom* (2011). Choreographer Jung Youngdoo participated as a performer in Kim Sora's *Abstract Walking—A Spiral Movement Gradually Distancing from a Single Point* (2012), Rhee Kibong's *The Cloudium* (2012), Suh Doho's *Hamnyeongjeon Project—East Ondol Room* (2012), and Jun Sojung's *G* (2018). Musician Kwon Byungjun participated in Lim Minouk's *Portable Keeper* (2009) and oversaw of the sound arrangements for some of the works by Kim Sunghwan, Kim Sora and Lim Minouk. David DiGregorio, together with Kim Sunghwan, co-produced the *In the Room series* and *Temper Clay* (2012); DiGregorio also performed as a singer songwriter in Rhii Jewyo's *Lie on the Han River* (2003–2006). Cognizant of these trends, Ilmin Museum of Art opened the exhibition *Brilliant Collaborators* (June 2013), illuminating the practices of Kwon Byungjun, David DiGregorio, Jang Young-kyu (musician), Jung Youngdoo and Choi Choon (architect).

The increased collaboration between artists with choreographers (dancers) and musicians drew attention to sound and motion as major components of many new visual art works. Since the mid-2000s, sound art began to establish itself as an independent genre of art[18] and sound gained greater centrality in video art. The LG Art Center (opened in 2000) and International Modern Dance Festival invited renowned choreographers to showcase their art practices. Some museums held exhibitions that engaged with the body and physical movement. Moreover, audiences were also able to access video and film of a diverse range of performance and dance works on the internet at this time. All these changes contributed to a better understanding of the role and possibility of sound and motion in the visual arts.

Among other artists, Nam Hwayeon particularly brought sound and motion to the forefront of her artwork, for example in *Garden in Italy* (2012), which took its motif from the work of dancer Choi Seung-hee (1911–69). **9** Nam happened to hear Choi singing a song called 'Garden of Italy' (1936). Captivated by Choi's voice, Nam began to collect any material traces of the dancer and archive the genre of dance in Korea in broader terms. Nam reconstructed the collected materials and presented them as a work of performance art in the 2012 Festival Bo:m. Her work consisted of three archival elements. First was the image archive, which included visual materials related to Choi Seung-hee. Second was the sound archive, which blended the music of Tchaikovsky and the lines from the dancers' letters with other sounds. Third was the dancer's motion archive. After exhibiting this archival piece, she continued to collaborate with dancers in *Dimensions Variable* (2013), *The Botany of Desire* (2015), *Ghost Orchid* (2015), *Flash Dance* (2017) and *Orbital Studies* (2018). Nam also invited singer Lee Lang to sing for 'Imjingawa' (2017).

An Jungju works on separating sound from image in his video practice. By so doing, he aims to remind the audience of the importance of sound, as well as image, and explores the social conventions or common-sense ideas related to sound. An produced the 6-channel video called *Ten Single Shots* (2013), in which the artist captured people's responses and movement brought about in reaction to a specific sound. For this project, ten gunshot sounds were collected from the films *The Front Line* (2011), *Aimless Bullet* (1961) and *Tae Guk Gi-The Brotherhood of War* (2004)—particularly those from crucial moments or at the turning points of each story. Then, six dancers (three males and three females) were invited to move to the rhythm of the sounds of the 10 gunshots, while imagining that they are dying on the battlefield. On each channel, one dancer appears, acting in an exaggerated way with dramatic body movements to convey the dancer's struggle in response to the sounds of gunshots, before collapsing on the ground. The

9 Nam Hwayeon, *Garden in Italy*, 2012,
Performance, 60 min.

artist shot these movements in slow motion.

Oh Min, who trained as a pianist during
her undergraduate studies, aims to transfigure
musical structure and form into visual media.
Based on Rachmaninoff's Piano Sonata No. 2, first
movement, her *ABA Video* (2016) incorporated the
three basic parts of a sonata: A (the exposition),
B (the development) and A (the recapitulation).
Akemi Nagao (choreographer) and experimented
with the transfiguration of this structure by
positioning different objects and repeatedly making
certain gestures. Hong Chosun was in charge of
the sound arrangement for this work. Oh Min's
videos are often based on invited collaboration with
choreographers or musicians. Lisa Vereertbrugghen
(choreographer) participated in *Suite (Video 1)* (2012),
and Marina Colomina (choreographer) and Lukas
Huisman (pianist) starred in *Marina, Lukas and Myself*
(2014). Additionally, choreographer Kwon Lyoneun
played the role of the protagonist in *A Sit* (2015).

Kim Ayoung in her work often seeks to
creatively combine sound and narrative, creating
new sound projects by reconstructing fragmented
memories about an incident or a place. Her
representative work and series *Zepheth, Whale Oil*

from the Hanging Gardens to You, Shell (2014–2015)
has resulted in three pieces. **10** This series
originated from her being invited to participate
in an exhibition about the malfunctioning of the
knowledge production system of the twenty-first
century.

For the exhibition, Kim, who is interested in
both writing and algorithms, began a new writing
project with the motif of the oil crisis. First, she
created a story based on literature that mentions
oil (e.g., the Bible) or oil-related historical incidents
(e.g., oil spills) and then transformed the narrative
into an algorithm to develop another story. Though
the algorithm-generated story is legible, it barely
conveys any clear narrative or message, so it seems
somewhat like a communicational malfunction.
The artist composed a score of music for her own
written works by using musical algorithms and
asked the composer Kim Heera to add the score
to the algorithm-generated story. Then, twelve
people sang in chorus for the two versions of the
song, forming the first piece of the series. The
second piece took the form of a musical (musical
theater) and was performed on stage. In this piece,
three actors appear along with seven choir singers,

10 Kim Ayoung, *Zepheth, Whale Oil from the Hanging Gardens to you, Shell 3*, 2015,
 Six-channel sound installation, 39 min. 38 sec., wall diagram

making the narrative element stronger than in the first piece. The third piece is a 6-channel sound installation that was first presented at the fifty-sixth Venice Biennale. As the language of the piece was translated into English, the music was also revised accordingly, and the artist further developed her narrative concern with oil exploration and modernization. Nine voice actors, seven singers and one conductor appeared in the third piece.

Lee Hyungkoo studied the movement of a horse for his work *Measure*. In this project he did not collaborate with a horse expert because he himself had become a specialist in the field. Indeed, before this project, he had transformed himself into a scientist, an archeologist, an entomologist and a physiognomonist and created works related to each field based on a substantial knowledge about each discipline. For *Measure*, which features dressage as a motif, the artist transformed himself into a horse and expressed the movement (the gait) of the animal musically. Dressage is a form of horse riding which showcases the totality of a horse's movement, which includes walking, trotting, cantering, and turning, with the horse's trot has the following sub-categories: walking trot, collected

trot and extended trot. Lee closely observed the horse's motions through studying books and videos and practiced those movements endlessly to get accustomed to them. The keys to the horse's movement are the beat and rhythm, and the title of the work *Measure* means cadence or rhythm.

THE EXPANSION OF MEDIA

As we have seen in the examples above, a new wave emerged in Korean art in the mid-2000s. Text-based art practices significantly increased and visual arts became further integrated with the performing arts. This expanded the range of media works created immensely and generated new diverse forms of art, extensively challenging existing conventional practices.

Perhaps the main outcome of this process was that the established genres of art became less rigid and discrete. Artists crossed borders between multiple genres, created works that could not be classified into traditional categories, and conducted considerable exploration of the human sensory realm that extended far beyond visual practice. Some artists attempted to combine different media.

These new configurations were no longer just a simple synthesis of various media, but a cross-fertilization that hinged on a deep understanding of each medium. Moreover, in many more cases, artists created several versions of one work of art by using different media. As artists approached materials from various directions and collected wide-ranging conceptual references from their intertextual investigations, they found that it was inevitable that they would have to use diverse vessels to contain and convey the multitude of content they were producing. Also, in the process of linking their works to other media, artists often collaborated with experts from other disciplines and recorded those procedures.

A considerable number of works were situated beyond the confines of the traditional white cube gallery space. Instead, works were often performed in concert halls or outdoor sites, to intensify a sense of presence. Audiences were invited to examine artists working processes and sometimes participate in the work, which allowed spectators reconfigure their relationships with the artist. Recently, many artists have opened internet homepages or social networking services to make public the images, videos or critiques of their work, and also published books for promoting their artworks. The general public today therefore has more opportunities to see artworks without going to museums or galleries and has subsequently begun to experience art in a new way.

Contemporary art continues to change. Artists constantly re-define the meaning and role of art as times change and the way people live shifts. We can never be certain of how human lives will change in the future. Nevertheless, artists will continue to present new art forms in accordance with the changing times, even if this means a complete abolition of the boundaries that have traditionally defined art.

1 Ho Kyung-yoon, "Misul, chulpaneuro 'geurida'" [Art, 'Drawing' through Publication], *Art In Culture*, March 2010, 114.

2 Robert William Pickton was accused of the murder of twenty-six people, but he was found guilty of only six charges, and sentenced for life in prison. Pickson himself told an undercover detective that he killed twenty-nine women.

3 Park Yoonyoung links this work to various artworks of different genres including the ballet *Swan Lake*, film *The Elephant Man*, TV series *Twin Peaks*, musical *The Phantom of the Opera*, Ernest Hemingway's short story *Hills Like White Elephants*, Aerosmith's song *Jennie's Got a Gun*, Salvador Dali's *Swans Reflecting Elephants* (1937) and so forth. For example, the artist connects the female victims, killed by Robert Pickton, to the Princess Odette who was transformed into a swan by a sorcerer Rothbart. In *Twin Peaks*, the character 'Bob' influenced a man to murder his daughter. In these ways, Park relates Robert Pickton, Rothbart and Bob to the assailant and disappeared or murdered females to the victim.

4 Nam Hwayeon uses operation orders such as Silver Fox, Cobra, Queen, Killer, Boxer, Rooster 53, Reindeer, Purple Warrior, White Falcon, Desert Scorpion, Blue Tiger, Suicide Kings, Black Eagle etc.

5 The Geomundo Island incident was the illegal occupation of Geomundo island during the Joseon period by the British Royal Navy. The British government claimed that the occupation had been undertaken to preempt Russian annexation of the islands. The title of the work 'PH' stands for Port Hamilton, another name for Geomundo that the British army used.

6 The texts of speaches in this book are *Speech for Storage Piece* (2004) *Opening Speech—a Current Self-Reflection* (2005) *Speaker's Corner* (2004), and *Opening Speech—Shadowless Voice over Three* (2008). The video scripts include Unfolding Places (2004), *Restrained Courage* (2004), *Squandering Negative Spaces* (2006), *Holiday Story* (2007), and *Doubles and Halves—Events with Nameless Neighbors* (2009).

7 Yang Haegue, *Melancholy is a Longing for the Absoluteness* (Seoul: Hyunsil Publishing, 2009), 70.

8 These forms of publications include Moon Kyungwon and Jeon Joonho's *News from Nowhere* (2012), Kim Ayoung's *Zepheth, Whale Oil, Hanging Gardens, Shell* (2015) and *Porosity Valley, Portable Holes* (2018), siren eun young jung's *Trans Theatre* (2016), Oh Min's *ABA 1234* (2016) and Moon Kyungwon's *Promise Park* (2017).

9 An interview with Sung Yonghee (March 11, 2020).

10 Kim Seonghee, "Dawonyesul: Samgwa yeoksae daehan saeroun tamgu bangsikgwa taedo" [Multidisicplinary Art: A New Manner and Attitude in the Study of Life and History], *Dawon yesurui suyonggwa gonggan hwallyong bangan* [An Approch to Multidisciplinary Art and the Use of Space; Symposium held on April 5, 2011] (Seoul: MMCA-Festival Bo:m, 2011), 10.

11 Arts Council Korea, Momggol, "Dawonyesurui hyeon-hwanggwa jeonmang yeongu" [A Study on the Present and Future of Multidisciplinary Art] (Seoul: Arts Council Korea, 2013), 15.

12 In this case, multidisciplinary art refers to an artistic practice that approaches diverse genres of art for the purpose of exploring various aesthetic values. It is mainly related to counter-gentre, integrated gentres, new genre, marginal or underground art, cultural-multidisciplinarity and independent art.

13 Lim Geunjun, "Dongsidaeseonggwa sedae byeonhwan 1987–2008" [Contemporaneity and Genrational Shift: 1987–2008], *Art In Culture*, February 2013, 138.

14 *Cinemagician* was first introduced at the Yokohama Muse-

GLOBALISM AND CONTEMPORARY KOREAN ART

um of Art (August 2009). The second presentation was at Performa 09 in New York (November 2009) and subsequently performed at the Mary Hall of Sogang University (April 2010).

15 While this was performed as two individual works—*(Off) Stage* and *A Masterclass*—it was staged as one combined form at the Festival Bo:m.

16 Takram, MVRDV & The Why Factory, Kosuke Tsumura, Jung Kuho, LUCIS, Toyo Ito took part in the object production. The interviewees are Choe Jaechun, Lee Changdong, Kayoko Iemura, Yusaku Imamura, Goh Eun, Eric Khoo, Toshi Ichiyanagi and Jeong Jaeseung.

17 There had been collaborative projects between gentres. In 1998, IUM presented a crossover performance titled *Image Theater* in collaboration with a choreographer (Kim Hyojin) and a musician (Kim Dongsup).

18 Yang Jiyoon, "Saundeu ateu, saeroun dojeonui yeoksa" [Sound Art, A History of New Challenge], *Art In Culture*, April 2012, 138.

1881–1900

1881

· In September, An Jungsik and Cho Seokjin are sent to Tianjin, China as *yeongseonsa* emissaries and learned the drawing techniques of the West. In 1883, soon after coming back, An Jungsik paints *Banquet Celebrating the Signing of the Treaty between Joseon and Japan*.

1883

· Court painter Kim Yongwon brings a Japanese photographer to open the Chwaryeongguk in Seoul, the nation's first photo studio.

1884

· Ji Woonyoung, who learned photography in Japan, takes a portrait of King Gojong with the assistance of Percival Lowell.
· In the 1880s, the first photo studio is established in Korea.

1890

· In December, British painter Arnold Henry Savage Landor visits Seoul, after arriving at the port of Incheon and paints oil paintings.

1894

· As a result of the Gabo Reform of 1894, the Royal Bureau of Painting (Dohwaseo) is shut down, with the artisanal system of institutional painters abolished. The Gyujanggak library inherits some of the functions of the Royal Bureau of Painting.
· Constance Tayler, the wife of a Scottish diplomat, visits Korea several times and creates paintings such as *Korean Girl in Winter Dress* and *Servants of the Emperor*.

1896

· Kim Kyujin, who studied in Qing China and came back to Korea in 1894, is appointed as an official at the Ministry of the Royal Household (Gungnaebu) in 1896 and later promoted to secretary to the Minister at the Royal Household in 1905, overseeing all affairs related to the Royal Household.

1899

· In May, Dutch-American painter Hubert Vos comes to Seoul and paints *Portrait of Emperor Gojong*, *Portrait of Min Sangho*, and *Landscape of Seoul*.

1900

· In March, Cho Seokjin and Chae Yongshin oversee the reproduction of the portraits of past monarchs of Joseon.
· In April, the Korean Empire participates in the Paris Exposition, showcasing clothes, furniture, ceramics, fork craftwork, and musical instruments.
· In August, Jeong Duhwan opens a store Seopo that sells works of calligraphy works and paintings alongside paper. By placing adverts in newspapers and selling artworks directly to the public, the store was an early instance of the changes in calligraphy and painting distribution.
· French ceramic artist Leopold Rémion arrives in Seoul to establish a craft and design school, but he fails.

1901–1910

1901

· An Jungsik returns from Japan after two years and opens the Gyeongmukdang Hall, his own private studio. The Gyeongmukdang Hall was an early-modern educational institution of traditional art that also served as a gathering place for notable calligraphers and painters, high-ranking officials, and Japanese painters residing in Korea until the late 1910s.

1902

· An Jungsik and Cho Seokjin draw the portrait of King Gojong. An Jungsik and Cho Seokjin are recognized as the last calligraphers and painters who follow the tradition of the Joseon Dynasty period and lead the traditional art community in the early modern period.
· King Gojong's fortieth anniversary memorial monument is erected at the Gwanghwamun crossroad.
· The Agriculture, Commerce, and Industry Ministry establishes a temporary exposition museum to display works of art in glass showcases along with agricultural and industrial products. The awareness that art is an object of suitable for public exhibition and appreciation starts to spread.
· Oh Sechang goes to Japan.

1903

· Lee Doyoung studies under Cho Seokjin and An Jungsik.
· Ko Huidong is appointed as an official at the Ministry of the Royal Household.

1904

· Ji Woonyoung leaves for Shanghai, China to study oil painting.

1905

· The photo of King Gojong taken by Kim Kyujin is delivered to the U.S.
· Lee Jongchan goes to the U.S. to study.

1906

· An Jungsik joins the Daehan Ja-gang-hoe, an organization for the people's enlightenment, to create illustrations for the magazine that the association publishes.
· Ko Huidong learns traditional drawing techniques from Cho Seokjin and An Jungsik.
· In December, Kim Yutak opens the Suam Calligraphy and Painting Gallery. This is acclaimed as Korea's first art gallery specializing only in calligraphy and painting, as they were the first to advertise and trade paintings and calligraphy works as commodities.

1907

· In March, *Dohwa Imbon*, Korea's first government-published textbook for art, is introduced, facilitating the spread of the modern concept of representational painting directly from life, in contrast to traditional Korean painting.

Dohwa Imbon, 1911 (Revised Edition)

· In April, the Agriculture, Commerce, and Industry Ministry establishes Seoul Technical School for education in relation to handicrafts including pottery and carpentry as industrial technologies. The technologies and terminologies common to modern Japanese industrial craft production are accepted.
· Kim Kyujin operates the Cheonyeon-dang Photo Studio to take commemorative or portrait photographs for the public. He contributes to the popularization of photography by running photo advertisements, providing photography education, and introducing the latest equipment and technologies.

1908

· In October, the royal family of the Korean Empire establishes the Hanseong Craft Workshop to produce handicraft items. It is renamed the Craft Workshop of the Yiwangjik (Office of the Royal Household) in February 1911. In 1922, it is renamed Joseon Craft Workshop. In July 1936, it is disbanded due to extreme financial difficulties. This institution accelerates the transition from the declining traditional craftsman-centered production system to the industrialization of crafts.
· In November, Choi Namseon publishes the magazine *Sonyeon*. Articles, photographs, and illustrations are printed in the publication, and it is praised as Korea's first modern general magazine.

1909

· In February, Ko Huidong leaves for Japan to study in his role as an official at Jangnyewon, a royal agency in charge of court ceremonies, rituals, and music, enters the Oil Painting Department of the Tokyo School of Fine Arts. Following Ko Huidong, many modern Korean artists go to Japan to study, and the art schools in Japan serve as the primary channel for them to learn about Western art.
· In June, the Association of Great Korea publishes the first issue of the *Daehan Minbo* newspaper. It publishes a series of illustrations. During the first year of publication, it runs around 300 editorial cartoons and advertisement images. Lee Doyoung, the illustrator of the *Daehan Minbo*, is acclaimed as a pioneer of illustration and editorial cartoons in Korea.
· In October, Lee Jongchan finishes his studies in the U.S. and returns to Korea.
· In November, the royal family of the Korean Empire establish the Yi Royal Household Museum in Changgyeonggung Palace. It collects antiques including ceramics, Buddhist statues, paintings, and handicrafts and is open to the public.

1910

· In January, the school of the Young Men's Christian Association (YMCA) opens the Photography Department within the Industry College. Choi Changgeun, who studied in Hawaii, lectures at the Department.
· In August, the Japanese Government-General of Korea acquires the *Daehan Maeil Sinbo* and retitles it as *Maeil Sinbo*. *Maeil Sinbo* publishes photographs on paper through halftone printing and plays a significant role in promoting photograph appreciation by the public in modern Korea.
· Byeon Gwansik follows his grandfather Cho Seokjin and goes to Seoul.

1911

· In March, Yun Yeonggi opens the Gyeongseong School of Calligraphy and Painting, an art education institute. It provides two separate three-year curriculums for calligraphy and painting, respectively, which implies a change to the traditional idea of calligraphy and painting as a combined art practice.
· In September, Kim Kwanho enters the Oil Painting Department of the Tokyo School of Fine Arts.

1912

· In June, Calligraphy and Painting Society, an art education organization, is established, and distinguished calligraphers and painters of the traditional art community including An Jungsik, Cho Seokjin, Jung Daeyu, and Kim Eungwon participate as professors. The curriculum is split into calligraphy and painting, breaking from the traditional method of education.
· In September, Kim Chanyoung enters the Tokyo School of Fine Arts as the third Korean student, following Ko Huidong and Kim Kwanho.

1913

· In March, Rha Hyeseok enters the Oil Painting Department of the Women's School of Fine Arts in Tokyo (Tokyo Joshi Bijutsu Gakkō).
· In December, Kim Kyujin establishes the Gogeum Calligraphy and Painting Gallery as an annex to Cheonyeondang Photo Studio for the sale of calligraphy works paintings. This fact that calligraphers and painters operated art galleries for trading works of art as commercial goods illustrates their new role and identity.

1914

· In March, Oh Ilyoung, Lee Hanbok, and Lee Yongwoo become the first graduates from the Calligraphy and Painting Society. Kim Eunho graduates in painting in May 1915 and calligraphy in 1917. In April 1918, Lee Sangbeom, Noh Soohyun, and Choi Wooseok graduate. After graduation, they become leading figures of the Seoul art community.

1915

· In March, Ko Huidong graduates from the Oil Painting Department at the Tokyo School of Fine Arts and returns to Korea. He becomes Korea's first "Western-style" painter.
· In May, Kim Kyujin organizes the Calligraphy and Painting Research Institute, standing against the Calligraphy and Painting Society. Unlike the Calligraphy and Painting Society, the Calligraphy and Painting Research Institute receives female students.
· In September, the Japanese Government-General of Korea holds the Joseon Industrial Exhibition in Commemoration of the Fifth Year of Japanese Colonial Rule at Gyeongbokgung Palace. For the first time in Korean history, the official use of terms for distinct art genres such as Western-style painting and Eastern-style painting are implemented.
· In December, the Japanese Government-General of Korea opens the Museum of the Japanese Government-General of Korea in Gyeongbokgung Palace. It collects and exhibits Korean archeological remains and antiques and investigates historical sites. It also plays a role in justifying the Japanese colonial view of history.

1916

· In March, Kim Kwanho graduates from at the Tokyo School of Fine Arts. Afterward, his graduation work *Sunset* receives a special award at the Tenth Ministry of Education Fine Arts Exhibition in Japan.
· In December, Kim Kwanho becomes the first Korean to hold a solo exhibition of oil paintings in the drill hall building of the Pyeongyang Veterans Association.

1917

· In April, Kim Chanyoung graduates from the Tokyo School of Fine Arts and holds a solo exhibition in Pyeongyang.

1918

· In May, the leading figures of the traditional art community hold the promoters' meeting of Calligraphy and Painting Association. The society functions as a coalition of Korean artists with the traditional art community at its center, until its disorganization in 1936.
· Rha Hyeseok graduates from the Women's School of Fine Arts in Japan. She plays an active role as an activist for women and the first Korean female painter who majored in Western-style painting.

1919

· The first exhibition of the Calligraphy and Painting Association is planned but postponed permanently due to the March First Independence Movement.
· Oh Sechang, Kim Bokjin, Kim Eunho, Gilbert Pha Yim, Rha Hyeseok, and Jang Sunhee participate in the March First Independence Movement and all serve time in prison.
· In November, An Jungsik, who was the teacher of major traditional painters in the modern era and helped to bridge the Joseon Dynasty and the modern period along with Cho Seokjin, passes away.
· In November, self-proclaimed oil painters gather to establish the Goryeo Painting Association. They receive guidance from Japanese painters and Ko Huidong. Korea's first generation of oil painters, including Chang Louis Pal, Gu Bonung, and Lee Seungman, all learned from this association.
· In December, the Calligraphy and Painting Association holds a special general meeting to appoint Cho Seokjin as its second president after An Jungsik.

1920

· In April, a few months after An Jungsik's death, Cho Seokjin passes away.
· In June, Kim Kyujin, under the order of King Sunjong, creates spectacular real scenery landscape paintings with extraordinary deep colors for the Huijeongdang Hall in Changdeokgung Palace including *Picturesque Landscape of the Myriad Things on Geumgangsan Mountain* and *Wonderful Views of Chongseokjeong Pavilion*. Oh Ilyoung, Lee Yongwoo, and Kim Eunho create mural paintings on the walls of Daejojeon Hall while Lee Sangbeom and Noh Soohyun produce mural paintings on the walls of Gyeonghungak Hall.
· In June, Calligraphy and Painting Society is disbanded, just eight years after its inception.
· In July, Byeon Yeongro, in his article "A Discourse on Eastern-style Painting" for the *Dong-A Ilbo* newspaper, criticizes imitation-based ink painting, comparing it unfavorably to Western-style oil painting which attempts to depict reality. Closely before and after this article, other articles criticizing traditional painting are published in newspapers.
· In September, Kim Bokjin enters the Sculpture Department of the Tokyo School of Fine Arts.

1921
· In March, Rha Hyeseok holds her first solo exhibition of oil paintings at the Naecheonggak Hall of the *Gyeongseong Ilbo* newspaper office. Due to interest in both oil painting and the work of Rha, more than 5,000 people visited the exhibition, making the exhibition a popular topic of conversation.
· Calligraphy and Painting Association holds its first exhibition in April and publishes *Seohwa Hyeophoe Hoebo*, Korea's first art magazine in October. By doing so, it endeavors to unite the Japanese-colonial-era Korean artists and to reform the art community.

The First Issue of
Seohwa Hyeophoe Hoebo, 1921

· In June, the *Dong-A Ilbo* newspaper holds a welcoming event for Yanagi Muneyoshi, a Japanese art critic.
· In September, Elizabeth Keith becomes the first oil painter to have a solo exhibition in Seoul. Later, she holds her second solo exhibition in 1934.

1922
· In January, Seo Byeongo and other renowned calligraphers and painters in Daegu establish the Gyonam Association for Research on Poetry, Painting, and Calligraphy. It contributes to the interaction of the artists in Daegu and the development of the local art community by providing Calligraphy and painting education and holding exhibitions.
· In March, Calligraphy and Painting Association holds its second exhibition. As the Joseon Art Exhibition is established, Calligraphy and Painting Association's exhibition starts to lose influence. Still, it holds its exhibition fifteen times in total until 1936.
· In June, the Japanese Government-General of Korea holds the first Joseon Art Exhibition. Until 1944, the Japanese Government General holds twenty-three annual exhibitions. These exhibitions have an enormous impact on the national art community as both the sole gateway to success for artists in the modern era, and as a large-scale exhibition that attracts the attention of the public and the press.

The First Joseon Art Exhibition,
Catalog, 1922

· In August, the Craft Workshop of the Yiwangjik is renamed the Joseon Craft Workshop. The Joseon Artistic Handicrafts Gallery is established in Hotel Munpamil on Namdaemun-ro street.
· In September, Huh Baeklyun holds a solo exhibition at Boseong High School in Seoul.

· In November, An Seokju draws illustrations for *A Young Man's Life*, a serial novel written by Na Do-hyang. An Seokju starts to draw illustrations for the *Dong-A Ilbo* newspaper in 1922. Later, he moves to and works for the *Chosun Ilbo* newspaper and resigns in 1934. From 1922 to 1934, he creates work in various mediums including newspaper illustrations and cartoons with a short story, pioneering the field of publication art.
· In December, Lee Gyuchae and Kim Gwonsoo establish the Changsin Calligraphy and Painting Research Institute, the very first calligraphy and painting institute for women in Korea. They teach calligraphy, flower-and-bird painting, Four Gentlemen painting, etc to female students.
· In December, Jang Sunhee is admitted to the Embroidery Department of the Women's School of Fine Arts in Japan.

1923
· In March, Lee Sangbeom, Noh Soohyun, Lee Yongwoo, and Byeon Gwansik form Dongyeonsa Association, intending to research contemporary painting and traditional painting together. These young painters, influenced by developments in new visual media including Western-style painting, Japanese painting, and photos, try to explore making a transition from traditional painting. However, before long, the Association disband itself as they could not continue their activity.
· In April, Paik Namsoon enters the Women's School of Fine Arts in Tokyo but drops out one year later.
· In August, Kim Bokjin and An Seokju organize the Towol Art Research Institute. Earlier, in July, they take on the set design jobs for the Towolhoe theatrical company. The artists create a new genre of art for theatrical stage by engaging with the literary and theatrical communities.
· In September, Park Youngrae, Jeong Gyuik, Kang Jingu, Kim Seokyoung, Rha Hyeseok, and Paik Namsoon play a key role in establishing the Goryeo Painting Association to teach traditional ink painting as well as oil painting. It's renamed the Goryeo School of Art after traditional painters such as Kim Eunho and Byeon Gwansik join. As there are no educational institutes specialized in art in the early twentieth century, small art organizations such as the Goryeo Painting Association focus on art education.

· In September, Kim Bokjin and An Seokju participate in the founding of the PASKYULA. It is one of the early organizations that lead the proletarian literary movement which spreads out rapidly especially among Korean students studying in Japan in the 1920s. Later, it is integrated into Korean Proletarian Artist Federation (KAPF).

1924
· In October, Noh Soohyun starts a four-cut comic strip series *Meongteongguri Heonmulkyeogi* in the *Chosun Ilbo* newspaper.

1925
· In March, Kim Kyujin organizes the calligraphy and painting exhibition at the Joseon Pavilion in the Osaka World Fair.
· In May, Kim Bongryong, who learned about lacquerware inlaid with mother-of-pearl in a traditional craft workshop, exhibits a vase he made in the International Exhibition of Modern Decorative and Industrial Arts in Paris. As craft is established as a modern genre of art production, some start to perceive themselves as artists, not artisans.
· In June, the sculpture category is newly created in the fourth Joseon Art Exhibition. Kim Bokjin who graduated from the Tokyo School of Fine Arts wins the third prize with his work *Three Years Ago*.
· Lee Chongwoo becomes the first Korean artist to study in France. Then, Paik Namsoon, Gilbert Pha Yim, Chang Louis Pal, and Pai Un-soung study oil painting in France, U.S., and Germany.
· In July, oil painters, including Kim Kwanho and Kim Chanyoung, and ink painters, including Kim Yunbo, organize the Sakseonghoe Painting Research Institute in Pyeongyang. It is a representative organization that shows the power of the local art community in the modern era through its ability to organize large-scale exhibitions and influential educational activities.
· In August, Kim Bokjin graduates from the Tokyo School of Fine Arts majoring sculpture. Following him, about ten Koreans major in sculpture in Japan, creating a strong community of sculptors in Korea when they return.
· In August, artists and writers, including Kim Bokjin, An Seokju, and Yim Hwa, form the KAPF, which advocates for the role of art in the supporting of the class struggle and social reform.

· In August, female artists, such as Jang Sunhee and Jung Heero, establish the Gyeongseong Women's Art Association. The association builds the Gyeong-seong Women's Art Institute to nurture female artists.

1926
· In February, KAPF's quasi-bulletin *Munye Undong* is published. One year later, the Tokyo branch of KAPF publishes its own bulletin *Yesul Undong*.
· In May, Lee Sangbeom shows his transition to modern painting by depicting a representational scene from real life through 'Western' perspective and omitting the colophons (*jebal*) in his work *Early Winter*. This work is exhibited at the fifth Joseon Art Exhibition.
· In May, in the fifth Joseon Art Exhibition, Rha Hyeseok's *Queen of the Heavenly Palace in Qingdao* wins a special award.
· In July, the Gyeongseong Women's Art Institute is officially authorized as a formal school and promoted to the Gyeongseong Women's School of Art. Kim Uisik who used to be a drawing teacher becomes the principal and Jang Sunhee who studied at the Women's School of Fine Arts in Tokyo teaches embroidery at the school. It is recognized as Korea's first art school which provides a regular curriculum.
· In October, photographers working in Gyeongseong come together to organize the Gyeongseong Photographers Association. It provides classes to encourage interest and research in art photography. Shin Nakkyun teaches the latest printing process and photography theory in the association.

1927
· In March, Kim Eunho, An Seokju, and Kim Bokjin establish the Changgwanghoe Association. Later, Kim Bokjin is arrested, and the organization is disbanded.
· In June, Rha Hyeseok and her husband Kim Wooyoung leave Busan to travel around the world.
· In December, the Yeonggwahoe Association (Gonggwahoe Association), the first organization of Korean Western-style painters in Daegu, holds its inaugural exhibition in the building of the Joseon Beneficial Association.

1928
· In March, Lim Sookjae, who studied design, graduates from the Tokyo School of Fine Arts. He establishes a design company in Anguk-dong, Seoul, distinctly separating design from the craft production process. From August 16 to 17, he writes two articles titled "Crafts and Design" for the *Dong-A Ilbo* newspaper to illustrate the importance of basic design.
· In April, after graduating from Tokyo Institute of Photography and returning to Korea, Shin Nakkyun teaches photography at the Photography Department of Young Men's Christian Association (YMCA) and writes and publishes books such as *Lessons of Photography, Materials and Chemicals, Introduction to Lighting*, and *Photography Glossary · Appendix of Materials and Chemicals*. The second edition of these books is published in 1929 and the revised third edition is published in 1931.
· In May, Kim Chukeung, Park Gwangjin, Sim Yeongseop, and Jang Seokpyo organize the Nokhyanghoe Association. They explore the expression of local colors and distinct Korean characteristics in terms of material and form. After the Nokhyanghoe Association, various art organizations that advocate their own art theory appear, especially among oil painters.
· In May, the *Bibliographical Dictionary of Korean Calligraphers and Painters* written by Oh Sechang in 1917 is published by the Gyemyeong Club. It is a biographical dictionary of about 1,117 premodern calligraphers and painters, and this text lays the foundation for subsequent research on Korean calligraphers and painters.
· Paik Namsoon leaves for France to study.

1929

· In March, Jeong Haechang holds Korea's first art photography exhibition. He holds four solo exhibitions until 1939, taking around five hundred historically important photos of still life, landscape, and people.

· In March, after traveling around the world, Rha Hyeseok returns to Korea.

· In May, Sim Yeongseop, Jang Seokpyo, Park Gwangjin, and Kim Chukeung finish their studies in Japan and return to Korea to hold the inaugural exhibition of the Nokhyanghoe Association. But, after its second exhibition in 1931, the group holds no more exhibitions.

· Oh Bongbin founds the Joseon Art Museum, his private gallery, and holds the *Gogeum Calligraphy and Painting Exhibition* by showing his ancient painting collection in September. Additionally, he holds the *Exhibition of Treasured Possession of Ancient Joseon Seohwa* in 1930, the *Famous Joseon-era Paintings Exhibit* in 1931, and the *Exhibition of the Landscape Paintings of the Ten Masters of Modern Korean Painting* in 1940, contributing to the promotion of the ancient Joseon-era and modern-era calligraphy and ink painting markets.

· Kim Yongjun forms the Dongmihoe Association with his alumni. This organization aims to identify the future direction of Korean-style oil painting and advocates the Asiacentric art theory in which the source of Western modern art is found within the Eastern ink painting tradition, a theoretical step beyond the established discussion about local color, together with the Nokhyanghoe Association.

1930

· In March, the KAPF holds the Proletarian Art Exhibition in Suwon. Around half of the 140 displayed works are confiscated by the police. It is Korea's first socialist art exhibition.

· In March, Ko Yuseop graduates in philosophy and art history from Keijo Imperial University. He is one of the first-generation of modern art historians in Korea. He collects data and research on the stone pagodas, Buddhist art, and the history of Korean painting, paving the way for the academic field of Korean art historical research.

· In September, Gil Jinseop holds his solo exhibition in Pyeongyang, sponsored by the *Chosun Ilbo* newspaper.

· In October, oil painters in Daegu, including Seo Dongjin, Park Myeong-jo, and Lee Insung, organize the Hyangtohoe Association and hold its first exhibition. This group hosts an exhibition every autumn for the next six years, contributing to the development of the oil painting circle in Daegu.

· In November, after graduating from Yale University in the U.S. and touring Europe, Gilbert Pha Yim returns to Korea with his wife Paik Namsoon to hold an exhibition together at the exhibition hall of the *Dong-A Ilbo* newspaper.

· In December, Kim Yongjun, Gil Jinseop, Gu Bonung, Lee Madong, and Kim Eungjin form Baengman Oil Painting Association in Tokyo. They criticize proletarian art and declare that they will pursue a new form of art by researching the trends of modern Western-style art.

1931

· In May, Rha Hyeseok's *Garden* wins a prize from the tenth Joseon Art Exhibition. Later, the same piece is specially selected in the twelfth Imperial Academy of Fine Arts Exhibition.

· In September, To Sangbong opens the Sungsam Atelier to teach students. In 1933, he opens a class for women and recruits female students.

1932

· In January, KAPF publishes its bulletin *Jipdan*.

· In May, the eleventh Joseon Art Exhibition excludes the calligraphy and Four Gentlemen painting category from the exhibition. But Four Gentlemen paintings are accepted through the ink painting category. This move solidifies the separation between calligraphy and painting as well as the modern art genre classification of the practices.

· In June, Jang Sunhee establishes the Joseon Women's Institute of Handicrafts. It provides women with education in embroidery, sewing, and drawing. In September 1945, the Embroidery Department is created in Ewha Womans University.

1933

· In February, Rha Hyeseok opens the Women's Art Institute in Susong-dong, Jongno-gu, Seoul.

· In March, Kang Changgyu earns a degree in lacquering from the Tokyo School of Fine Arts. He inherits a training in the late-Joseon-period dry lacquer technique, serving as a bridge between the tradition and the modern era.

· Lee Sangbeom opens Cheongjeon Art Studio, his private art school. Alongside the Nakcheongheon Studio founded by Kim Eunho, this school represents the traditional art community in the modern era. Lee Sangbeom's style of landscape painting is recognized as continuing traditional approaches in a modern way and influences the entries of the government-led exhibitions after liberation.

· A permanent art museum is established in Seokjojeon Hall at Deoksugung Palace to exhibit Japanese modern works of art.

1934

· In May, the oil painters of the Dongmi-hoe Association and the Baengman Oil Painting Association, including Kim Yongjun, Lee Chongwoo, Gu Bonung, and Gil Jinseop, form the Mogilhoe Association and held their inaugural exhibition at Hwashin Department Store's gallery (Hwashin Gallery). Painters refuse to submit their works to the Joseon Art Exhibition as they oppose the manner of academism which has been the mainstream of the Joseon Art Exhibition.

· In August, Rha Hyeseok releases her "Confessions After a Divorce" in the *Samcheolli* magazine.

· In October, the *Gyeongseong Ilbo* newspaper and the Joseon Federation of Photography hold the first Joseon Photography Exhibition. This exhibition, which is held annually until 1943, is the most prestigious photography competition in Korea, serving as a gateway to the professional practices of art.

1935

· In May, KAPF disbands, submitting a document for disbandment.

· In October, Rha Hyeseok holds her last exhibition *An Exhibition of Recent Works* at the exhibition hall in the Joseongwan, a trading company and store.

· In November, Jung Hyunwoong draws illustrations for *When the Sun Rises in the Distance*, a serial novel in the *Dong-A Ilbo* newspaper. He leads the development of illustration in the 1930s and provides the public with new visual experiences through realistic portrayal based on representational drawing and the adoption of filmic styles of composition.

· In December, artists including Kim Whanki, Gil Jinseop, Kim Byungki, and Lee Bumseung organize the SPA Research Institute of Oil Painting in Tokyo and hold an exhibition in Seoul. Koreans studying in Japan who pursue the avant-garde modernism of the West start to experiment with abstract painting and surrealism.

1936

· In January, the Mogilhoe Association changes its name to the Moksihoe Association with some members leaving and others newly joining—those who join include Gilbert Pha Yim, Chang Louis Pal, and Lee Madong.

· In March, Kim Whanki and Gil Jinseop form the Baengmanhoe and hold the group's first exhibition. It is acclaimed as an avant-garde organization that pursues a new style departing from the government-led exhibition's academism.

· In August, Lee Sangbeom and Lee Yeoseong who work for the *Dong-A Ilbo* newspaper erase the Japanese national flag on the chest of Son Keechung, the gold medal winner of the 1936 Olympic marathon, from a photograph set for publishing.

1937

· In July, Kim Whanki, Mun Haksu, Yoo Youngkuk, and Joo Hyun participate in the inaugural exhibition of the Free Artists' Association, a Japanese avant-garde art organization, which is renamed the Art Creators' Association after 1940. Kim Whanki submits his work *Air Beacon* to the exhibition in 1937. He continues to participate until the fifth exhibition in 1941 as a fellow member and withdraws in 1942. Until 1943, artists including Lee Kyusang, Song Hyesoo, Lee Jungseop, Jo Woosik, Park Saengkwang, and An Kipoong participate in the exhibition.

· In July, artists including Lee Gyusang, Jo Woosik, Choi Jaiduck, and Son Eung-sung organize the Geukhyeonsa, an oil painters' club, to stage exhibitions at the Daetaek Gallery in Seoul.

1938

· In January, Huh Baeklyun opens the Yeonjinhoe Association, an educational institute for calligraphy and ink painting in Gwangju. It nurtures new calligraphy and ink painters in the traditional mode of education and lays the ground for the traditional art community in Jeolla-do region, a tradition which lasts until today.

· In April, the Korean Art Association in Tokyo formed by Koreans studying in Tokyo holds its inaugural exhibition at the gallery of Hwashin Department Store in Seoul. The association embraces Korean students studying in Tokyo who specialize in all genres, including oil painting, sculpture, craft, and embroidery. It holds an exhibit in Seoul every year. It is a big organization with around 100 members and a major group in the Korean art community in the late 1930s.

· In June, the Yi Royal Household Museum moves to the West Building (New Building) of Deoksugung Palace. The gallery of Seokjojeon Hall exhibiting the Japanese modern artworks and the West Building with the Korean antiques merge within the Yi Royal Art Museum. The West Building of Seokjojeon Hall, which was newly built when the museum opened is currently the MMCA Deoksugung.

· In November, the *Maeil Sinbo* newspaper group publishes the first issue of the *Maesin Sajin Teukbo* magazine. It is renamed *Maesin Sajin Sunbo* in 1940 and published until October 1944. It is Korea's first pictorial magazine with photos.

1939

· In July, the Hwashin Gallery hosts the fifth Exhibition of the Oil Painters' Club. It is entitled the fifth as it is counted in combination with the previous exhibitions held by the Mogilhoe Association, Moksihoe Association, and the Donginhoe.

1940

· In April, Park Rehyun, following artists including Rha Hyeseok and Paik Namsoon, enters the Women's School of Fine Arts in Tokyo. Next year, Chun Kyungja enters the same school.

1941–1950

1941

· In February, the Japanese Government-General of Korea leads the establishment of the Gyeongseong Artists Association. It is the first organization established to encourage artists to conduct pro-Japanese activities after the Pacific War breaks out. Soon, the artists begin cooperating with Japanese war effort in earnest.

· In March, Kim Jongchan, Kim Jun, Lee Jungseop, Lee Qoede, Mun Haksu, Choi Jaiduck, and Jin Hwan, who are Korean oil painters working in Japan, form the New Artists' Association. It pursues a new style of oil painting based on East Asian ink painting approaches and local subject matter.

1942

· In November, the Joseon Artists Association (formerly, the Gyeongseong Artists Association), holds the *Peninsula Behind the War Art Exhibition*. It is a large-scale pro-Japanese art exhibition that calls for wartime regime art to reflect the current situation.

1943

· In February, Korean and Japanese painters jointly establish the Dangwanghoe Association, a pro-Japanese art organization. Nineteen members of the organization coproduce *A Celebration of Conscription in Joseon*, a large-scale painting that praises the Japanese policy of conscription.

· In May, at the twenty-second Joseon Art Exhibition, Park Rehyun's *Make-up* receives the first prize.

· In November, the *Peninsula Behind the War Art Exhibition* is hosted by the Joseon Artists Association to celebrate the implementation of the conscription policy.

1944

· In March, sponsored by the Japanese Government-General of Korea, the *Gyeongseong Ilbo* newspaper holds the *Final Battle Art Exhibition*. It encourages artists to paint military themed pictures as part of an active cooperation with the Japanese war effort.

· In June, the twenty-third Joseon Art Exhibition is held as the last Joseon Art Exhibition.

1945

· In August, immediately after the liberation of Korea, the Korean Art Construction Headquarters, an organization of artists, is established in Seoul. Reflecting this time of political confusion, numerous artists' organizations stage meetings and re-configure amid the ideological confrontation that occurs between left and right wing artists.

· In September, radical artists who are discontent with the activities of the Korean Art Construction Headquarters establish the Korean Proletarian Art Federation.

· In October, the Korean Art Construction Headquarters holds the *Art Exhibition in Celebration of National Independence* in the Seokjojeon Hall at Deoksugung Palace and displays the works of its members. It is the first large-scale exhibition held by Korean artists after national liberation with ninety-seven participants submitting 132 artworks.

· In November, Ko Huidong declares the disbandment of the Korean Art Construction Headquarters, then changes its name to the Joseon Artists Association and becomes the president of the association. Although the organizational doctrine advocates political neutrality, Ko Huidong gets involved in politics, which invites a backlash from its members.

· In December, the National Museum is opened by merging with the Joseon Government-General Museum (in Gyeongbokgung Palace on December 1, 1915). Later, it becomes the National Museum of Korea.

1946

· In January, the *Seoul Shinmun* newspaper publishes the first issue of *Sincheonji*, its monthly magazine. Jung Hyunwoong works as the editor, illustrator, and bookbinder, leading the development of printing art which newly gains attention after the liberation.

· In February, the members, who withdrew from the Joseon Artists Association form the Korean Artist Federation uniting with the Korean Art Alliance. On the same day, artists including Yoon Hee-soon stand against the Korean Artist Federation and establish the Korean Plastic Arts Federation.

· In March, the Dangu Art Academy founded by artists including Lee Ungno, Chang Woosoung, Lee Yootae, and Pae Ryom holds its inaugural exhibition on the anniversary of the March First Independence Movement. It is an organization established following the liberation of Korea in 1945 and pursues the removal of the vestiges of Japanese colonialism and the restoration of Korean traditional painting alongside national culture.

· In March, the North Korean Federation of Literature and Art is founded. At the time of its inception, under the federation are the Literature Federation, the Theatre Federation, the Music Federation, and the Art Federation as well as the Film Committee, the Dance Committee, and the Photography Committee. Around 1948, the remaining units under federation are the Literature Federation, Theatre Federation, Art Federation, Photo Committee, and the Dance Committee.

· In October, the Art Department is established within the College of Art of Seoul National University. Around this time, the traditional art schools within Ewha Womans University and Hongik University open their departments of fine art in 1945 and 1949 respectively, making these universities the center of art education and artistic development.

· In November, the Korean Artist Federation, the Korean Plastic Arts Federation, and the Korea Sculptor Association combine to launch the Korean Art Alliance. To raise public awareness of art, it organizes various projects for the public including traveling art exhibitions.

1947

· In February, Lee Qoede visits North Korea and releases his report on the North Korean art community in the February issue of the *Sincheonji*.

· In August, as part of the North Joseon Art Festival held in Pyeongyang, the First National Art Exhibition of Democratic People's Republic of Korea opens. The exhibition features 525 artworks in total including oil paintings, watercolor paintings, ink paintings, sculpture, and crafts. Among them, 193 works are selected. The next year in August 1948, the Second National Art Exhibition of Democratic People's Republic of Korea is held in Pyeongyang. In August 1949, as part of the 'North Joseon Art Festival for the fourth anniversary of the August 15 Liberation of Korea,' the Third National Art Exhibition of Democratic People's Republic of Korea is held.

· In November, the Department of Education of the United States Army Military Government in Korea (USAMGIK) holds the Korean Comprehensive Arts Exhibition in Gyeongbokgung Palace. It is a large-scale exhibition in the form of a contest, which fills the gap created by the abolishment of the Joseon Art Exhibition in 1944.

1948

· In July, the Joseon Photography Culture Company publishes Korea's first photography magazine *Sajin Munhwa*.

· In November, Lee Qoede's *Distress* is submitted to the third exhibition of the Korean Art and Culture Association and draws attention.

· In August, The Joseon Artists Association is expanded and reorganized into the Great Korean Art Association. Based on anti-communist ideology, it settles as a representative organization of the national art community in the 1950s.

· In December, Kim Whanki, Yoo Youngkuk, and Lee Kyusang organize the New Realism Group and hold their first art exhibition at the Hwashin Gallery. They advocate for fine art amid the bitter ideological conflict of the day and conduct experiments with form based on modernism.

· In North Korea, new special department subcommittees—the Painting Department, the Sculpture Department, the Craft Department, and the Stage Design Department are created under the North Korean Federation of Literature and Art. Later, the subcommittee system is frequently reorganized according to changes in North Korean society and its art community. For example, the Graphics Department is created in 1951 (changed into the Publishing Art Department in the early 1960s), the Painting Subcommittee is divided into the Korean Painting (Chosonhwa) Department and the Oil Painting Department in 1957, and the Industrial Art Department is newly established in the mid-1960s.

1949

· In March, the Pyeongyang Art School, founded in September 1947, is promoted to become the National Art School. The National Art School is one of fifteen universities that are newly established in North Korea between 1945 and 1950. At its inception, it has three departments: painting, sculpture, and descriptive geometry. In October 1952, the National Art School is renamed the Pyeongyang Art University.

· In November, the National Art Exhibition is established in South Korea. It is a government-led exhibition held by the Korean government, the most prestigious art institution since the liberation as well as the venue for the competition among art groups.

The First National Art Exhibition, Poster, 1949

· In November, the second art exhibition of the New Realism Group is held at the Hwashin Gallery, and Chang Ucchin participates in addition to the three existing members.

1950

· In January, Kim Byungki, who came to South Korea in 1947, leads the establishment of 1950 Art Association. Lee Qoede, Nam Kwan, and Kim Whanki become the co-presidents, and fifty figures who represent the left and the right within the Korean art community join the association. On July 1 the same year, its inaugural exhibition is held at the Gyeongbokgung Palace Museum as a contest jointly held by the left and right art factions of the art community.

· In June, the Korean War breaks out. During the Korean War, many artists went to the North or the South depending on their ideology or personal affairs. This results in the rapid reorganization of the North Korean and the South Korean art communities. Artists who went to the North, such as Gil Jinseop, Pai Un-soung, and Lee Qoede, becomes taboo in South Korean society.

· In June, a sculptor Yun Hyojoong erects the Statue of Choe Songseoldang at Gimcheon High School. The statue is based on the photograph of the bronze statue created by Kim Bokjin. It is the oldest statue among extant modern life-sized works in Korea.

1951

· In March, the North Korean Federation of Literature and Art is renamed the Korean Federation of Literature and Art.

1952

· In June, the title of the "Laudatory Artist" is enacted by the decree of the North Korean Supreme People Assembly's standing committee. In July 1961, the title of "People's Artist" is enacted by the decree of the North Korean Supreme People Assembly's standing committee.

1953

· In March, Kim Chongyung's *Standing Woman* is submitted to *The Unknown Political Prisoner*, an international sculpture competition held at the Tate Gallery in London.

· In September, after North Korean Federation of Literature and Art becomes disorganized, it is divided and reorganized into the Writers Alliance, the Artists Alliance, and the Composers Alliance.

· In November, after a gap of three years due to the outbreak of the Korean War, the second National Art Exhibition is held at Gyeongbokgung Palace as the evacuated government returns to the capital.

1954

· In November, the Crafts category is changed into the Applied-Arts category at the third National Art Exhibition. The artists whose work is not accepted at the competition hold their first exhibition of rejects at the Hwashin Gallery, throwing doubt on the fairness of National Art Exhibition's judgment.

1955

· In March, Kim Chungsook, Korea's first female sculptor, leaves for the U.S. to study thanks to the sponsorship by the American Korean Foundation. She is interested in an emphasis on materiality, three-dimensional impressions of space, and use of punctured space and form to create rhythm.

· In May, with Chang Louis Pal taking the lead, the artists who withdrew from the Great Korean Art Association organize the Korean Artists Association and hold its inaugural exhibition. The conflict escalates as the Great Korean Art Association declares a boycott on the assignment of judges for the National Art Exhibition. Later, the art organizations are bisected into the Great Korean Art Association driven by Hongik University and the Korean Artists Association driven by Seoul National University, heralding competition and discord between the two universities.

· In June, Lee Ungno holds his solo exhibition at Dong Hwa Department Store's gallery. Next year, in his book *Oriental Painting Techniques and Its Appreciation*, Lee calls his creative activities "semi-abstract."

· In August, the fourth National Art Exhibition of Democratic People's Republic of Korea is held as part of the National Art Festival for the tenth Anniversary of the August 15 Liberation of Korea in North Korea. Later, on major anniversaries, the National Art Exhibition of Democratic People's Republic of Korea is held annually or once every few years.

· In October, the Art Society of Korea is established with support from the Rockefeller Foundation in South Korea. Originally, it started as part of the support for the National Museum. However, due to legal issues, it is founded as a corporation.

· In November, the Architecture category is added to the fourth National Art Exhibition, and the Applied-Arts category is changed into the Crafts category. Pak Nosoo's ink-and-wash figure painting *Woman, Mystic Sound of Tungso* receives the Presidential Award for the first time in the East Asian ink painting section of the National Art Exhibition. This starts a focus on "the selection of ink" and "the exclusion of coloring" as representative of the mainstream of National Art Exhibition's ink painting category.

1956

· In March, Hyun Ilyeong holds his third solo exhibition of photos at Dong Hwa Gallery. Following his solo exhibitions in Manchuria in 1931 and Pyeongyang in 1933, he starts to express his own unique approach to photography in earnest. He holds nine solo exhibitions in total until May 1972, starting a new chapter of Korean modern photography through his concern to overcome a mere focus on subject matter.

· In April, Kim Whanki arrives in Paris. He creates work that embodies a distinct idea of Korean beauty through traditional subject matter such as white porcelain, the moon, cranes, and mountains, in addition to displaying a modernist interest in abstraction. He leaves Paris and settles in New York in 1963.

· In May, with Moon Woosik, Kim Choongsun, and Kim Younghwan, Park Seobo announces an Anti-National Art Exhibition declaration, holding the *Four Artists Exhibition* at the Dongbang Cultural Center.

Four Artists Exhibition, Leaflet, 1956

· In August, Yun Hyojoong completes a seven-meter statue of President Rhee Syngman, which is removed after the April 19 Revolution in 1960.

· In August, Yi Hyeongrok and Chung Bumtai lead the establishment of the photography organization Shinseonhoe. It pursues photorealism and is the first organization to claims a certain direction for photography in Korea. It can be regarded as the forerunner of the Salon Ars which is founded by Yi Hyeongrok in 1960. The Salon Ars leads a wider group called the Modern Photo Society which consists of thirty young photographers, contributing to the diversity of photography culture in the 1960s through activities to overcome the narrow-mindedness of the realism movement.

· In September, Lee Hangsung runs a publishing company specializing in art education and publishes the quarterly magazine *Sinmisul*.

· In November, Park Rehyun's *Open Stalls*, which receives the Presidential Prize at the fourth National Art Exhibition, demonstrates an experiment in abstract composition in which the figures are simplified geometric forms divided by color fields. The same year, Park Rehyun receives the Presidential Award at the eighth Great Korean Art Association Exhibition for her work *Early Morning*.

1957

· In January, the central committee of the North Korean Artist Federation publishes the first issue of its bulletin, *Joseon Misul*. The editorial committee of the inaugural issue includes Gil Jinseop, Kim Yongjun, Kim Jongkwon, Lee Yeoseong, Mun Seoko, Mun Haksu, Park Munwon, Seonu Dam, Jang Jingwang, Jung Hyunwoong, and Cho Inkyu. The *Joseon Misul* is the essential resource for research into North Korean art from the 1950s to 1960s. Until its discontinuance, it was published quarterly, bimonthly, or monthly by the Joseon Misul Publishing Company and the Joseon Literature and Art Federation Publishing Company.

· In January, leading artists in their thirties and fourties, who haven't participated in the National Art Exhibition during their career, establish the Modern Art Association and hold the organization's exhibition a total of six times.

· In January, Seoul National University and the University of Minnesota hold the *Korean Art—Faculty and Students, Seoul National University*, an art-exchange exhibition, at the museum of the College of Fine Arts of the University of Minnesota. The exchange exhibition between the two universities is Korea's first international contemporary art exchange exhibition. In May the following year, art created by the professors and students of the University of Minnesota is exhibited at the College of Fine Arts of Seoul National University.

· In March, the National Museum and the Art Society of Korea cohost the *Exhibition of International Graphic Art*.

· In April, the *Eight American Artists* (sponsored by the USIA and organized by the Seattle Art Museum) is held at the Deoksugung Museum of Art to introduce contemporary American abstract expressionism to Korean audiences for the first time. Later, more American artists are introduced into Korea on a larger scale, presenting a modernization model for Korean arts.

· In April, the *Family of Man* Exhibition (planned by Edward Steichen of the Museum of Modern Art in New York), sponsored by the United States Information Agency, is held at the Gyeongbokgung Palace Museum. The photography exhibition which tours around a hundred cities globally after 1955 represented a project to universalize the political and socio-cultural specificity of regions by advocating for the greater value of "humanity" amid the Cold War and lead to the spread of photorealism.

· In April, Kim Chung-up's first solo exhibition, the *Exhibition of Kim Chung-up's Architectural Works*, is held at the Exhibition Hall of the Korean Information Center in Seoul. It is a venue for presenting the works of Kim Chung-up Architecture Institute, which had been in existence for about one year.

· In May, Hyundae Fine Artists Association holds its inaugural exhibition at the gallery of the United States Information Service while the Creative Art Association holds its inaugural exhibition at the Dong Hwa Gallery. One month later, the Neoplastics holds its first exhibition at the Dong Hwa Gallery. They start to show a new style of works diverging from academism such as Fauvism, Cubism, and Art Informel.

Hyundae Fine Art Exhibition,
Leaflet, 1957

· In November, the *Chosun Ilbo* newspaper hosts the *Contemporary Art Exhibit.* With its motto being an anti-National Art Exhibition, this exhibition is regarded as a representative exhibition in modern Korean art history planned by abstract artists themselves, not by the government.
· In November, based on the National Pyeongyang Art Museum established in August 1948, the National Central Art Museum opens on November 8, 1957. In 1961, the National Central Art Museum moves to the newly constructed building in Kim Il Sung Square. In August 1964, following instructions from the cabinet, the name is changed to the Joseon Art Gallery.
· In December, the Paek Yang Painting Association, the only Korean group of ink painters that exists in the 1950s, is established and holds its inaugural exhibition. It holds exhibitions overseas, arguing that the term *hangukhwa* (Korean painting) should replace the term *dongyanghwa* (Eastern painting).

1958
· In January, the Bando Gallery is reorganized with its organization and sponsorship provided by the Asia Foundation.
· In January, Lee Hangsung drives a new form of lithography production that is different from the old print tradition and holds his first solo exhibition of lithography. In February, his *Buddha's Spirit* wins a prize at the fifth International Biennial of Contemporary Color Lithography held at the Cincinnati Art Museum.
· In February, the *Contemporary Korean Painting* exhibit is held at the World House Galleries in New York, providing a venue for introducing Korean contemporary painting to the world. It is sponsored by American Korean Foundation and introduces several Korean artists, including some young artists in their thirties.
· In March, Chung Kyu holds the first solo exhibition of woodcuts in Korea. The idea of a "contemporary printmaking" that is created not only as a work of art, but for other purposes including press publishing, appears in the late 1950s. The Korea Prints Association is established by artists including Chung Kyu, Lee Hangsung, Chang Reesouk, and Choi Youngrim.
· In August, the Fifth National Art Exhibition of Democratic People's Republic of Korea was held for the tenth Anniversary of the Founding of DPRK in North Korea.

1959
· Kwon Jinkyu finishes studying at the Sculpture Department of Musashino Art University in Japan and returns to Korea. He consistently pursues figurative sculpture from the 1960s to the 1970s.

1960
· In February, the *Korean Contemporary Artists Exhibition* (the sixth Paek Yang Fine Art Exhibition) is held at the gallery of the National Taiwan Museum of Fine Arts. Subsequently, the second exhibition is held in Tainan City, Taiwan.
· In March, Suh Seok leads the establishment of Mook Lim-Hoe which explores the possibility of abstract ink painting and holds its first exhibition.
· In October, while the National Art Exhibition is held at the Deoksugung Museum of Art, the 1960 Fine Artists Association hosts the *60 Fine Art Exhibition* along the wall of the Deoksugung Palace (near the entrance of the British Embassy in South Korea), in direct opposition to the National Art Exhibition. At the same time, the Wall Art Group established by the students of Seoul National University also hosts the *Byeok Art Exhibition* (Jeongdong Hill).

The First *60 Fine Art Exhibition,*
Leaflet, 1960

1961

· In January, the Paek Yang Painting Association organizes an exhibition that travels around east Asia including Taiwan, Tokyo, and Osaka.

· In March, North Korean Federation of Literature and Art that was disbanded in 1953 is reorganized. Under the North Korean Federation of Literature and Art, there are the Musicians Alliance, the Artists Alliance, the Dancers Alliance, the Film Artists Alliance, the Theatre Practitioners Alliance, and the Photographers Alliance.

· In April, the *Chollima Statue* is installed on Mansudae Hill in Pyeongyang. The team responsible for the work within the central committee of the North Korean Artist Federation as the creators of the statue, receive the title Chollima Sculpture Production Group immediately after the completion of the work. In 1961, this collaborative form of art production becomes widespread in North Korea. Also, during this year the collaborative creative team of the Chosonhwa Department of the North Korean Artist Federation, which consisted of thirteen artists including Lee Seokho, Kim Yongjun, Lee Palchan, Lee Geonyeong, Kim Ikseong, Lee Hanbok, and Park Yeongsuk create *Today's Glory*. It is created to celebrate the construction of the the vinylon factory in Heungnam and was North Korea's first collective work of Chosonhwa.

· In April, Choon Choo Fine Arts Association, the Korean branch of the Congress for Cultural Freedom (CCF), is founded. The Choon Choo Fine Arts Association's contemporary art exhibition along with seminars, forums, and symposiums, and publishes the presentation scripts or the essays in their bulletin, making a significant contribution to the formation of the discourse on Korean contemporary art.

· In September, Kim Tschang-Yeul, Chang Seongsoun, Chung Changsup, and Cho Yongik participate in the second Paris Biennale as the first Korean artists to be invited, and Kim Byungki takes the role of commissioner.

· In November, the tenth National Art Exhibition starts to provide the opportunity to go abroad as a benefit of the Presidential Award, stimulating Korean artists to grow their career abroad.

1962

· In January, the Federation of Artistic & Cultural Organization of Korea (FACO) is established.

· In March, the Hyundae Fine Artists Association and the 1960 Fine Artists Association hold a joint exhibition at the Gyeongbokgung Palace Museum before integrating themselves into the Actuel group, with a common painting philosophy based on Art Informel.

· In June, the inaugural exhibition of the Zero Group is held at the gallery of the National Library of Korea.

1963

· In March, the *Exposition of Music: Electronic Television*, Paik Nam June's first solo exhibition, is held at the Galerie Parnass in Wuppertal, West Germany.

· In September, the Origin Fine Arts Association, a group that seeks a new style of painting departing from Art Informel, hosts its inaugural exhibition at the Korean Information Center.

· On September 20, Kim Kyongseung, Kim Youngjung, Lee Seung-taek, and Lee Jong-gak collaborate to erect a April 19 National Cemetery Memorial in Suyuri, Seoul.

· In September, artists including Kim Kichang, Kim Youngjoo, Kim Whanki, Suh Seok, Yoo Kangyul, Yoo Youngkuk, and Han Yongjin participate in the seventh São Paulo Art Biennial as the first Koreans to be invited, and Kim Whanki receives the honorary award.

1964

· In May, as part of the military government's project that uses visual art to confirm national ideology, the plaster casts of thirty-seven deceased patriots are installed on the Sejong-ro street in Seoul. Two years later, they are removed due to issues including corrosion. This triggers a movement for the installation of the Patriotic Ancestors' Statue.

· In October, the photography category is added to the thirteenth National Art Exhibition. Later, it is separated from the National Art Exhibition from 1971 to 1973 and is held as the *Korea Architecture · Photography Exhibition*. From 1974, it is reintegrated into the National Art Exhibition and held as a competition within the National Art Exhibition seventeen times until the thirtieth National Art Exhibition.

· In December, Mook Lim-Hoe holds its eighth show at the Korean Information Center. This was its last exhibition before being disbanded.

The Eighth *Mook Lim Art Exhibition*, Leaflet, 1964

1965

· In February, Chang Woosoung establishes the School of Oriental Art in Washington, to teach Eastern-style ink painting and calligraphy in the U.S.

· In February, the first Non Col Exhibit of the group Non Col is held at the Press Center of Korea, heralding a new generation of artists. In addition to its exhibition, it publishes a journal titled *Non Col Art*. In 1967, Kang Kukjin, Kim Inhwan, and Chung Chanseung who are members of the Non Col found Sinjeon Group and, subsequently, participate in the *Union Exhibition of Korean Young Artists*.

Non Col Art, 1965

· In August, as part of the normalization of relations between Korea and Japan, the FACO opens its Tokyo branch in Japan, and Quac Insik, an artist residing in Japan, is elected as a branch manager.

· In September, Kwon Okyon, Kim Chongyung, Kim Tschang-Yeul, Park Seobo, Lee Seduk, and Chung Chang-sup participate in the eighth São Paulo Art Biennial (with Kim Byungki as a commissioner) and Lee Ungno receives the honorary award.

· In October, Paik Nam June holds the world's first video art show using videotape recorders at the Café au Go Go, New York.

· In October, Park Chongbae's abstract sculpture *Circle of History* receives the Presidential Award in the fourteenth National Art Exhibition, which presents a new direction for the sculptural community.

· In November, Paik Nam June presents his experimental television work in which he manipulates television scan lines at the *Electronic Art Exhibition* at the Galerie Bonino.

1966

· In September, the ninth National Art Exhibition of Democratic People's Republic of Korea is held in North Korea. The categories of the exhibition include chosonhwa, oil painting, sculpture, publishing art, craft, industrial art, film, and stage design. At the ninth National Art Exhibition of Democratic People's Republic of Korea, the principle of "developing North Korean art based on chosonhwa" is established from a line in Kim Il Sung's speech, "Let's develop our art into a revolutionary art that includes socialist contents in national form."

· In November, an architect Kim Swoo-geun publishes the first issue of the monthly magazine *Space*. With an editorial philosophy based on architecture, urban space, and art, the magazine comprehensively addresses Korean culture to encompass both art and architecture.

· In November, Kang Bongjin's design that follows the guideline of "imitation of and combination with traditional architecture" is selected at the architecture competition for the Comprehensive Museum (present-day National Folk Museum of Korea), which leads to actual construction. Next year, facing a backlash from architects, the competition starts to increasingly reflect the modernization of tradition based on the direct use of traditional motifs.

1967

· In July, Lee Ungno goes to East Berlin to look for news about his son in North Korea and is arrested and imprisoned for his ideological beliefs, an episode which is referred to as "the East-Berlin Affair."

· In July, the national documentary painting project, in which important events in Korean history are portrayed within painting is implemented with the establishment of the Documentary Painting Production Office, and the *National Documentary Paintings Exhibition* is held at the Gyeongbokgung Palace Museum. A lot of artists are employed for this project and a substantial number of large-canvas history paintings are produced.

· In September, Park Rehyun becomes the first Korean female artist to be selected as one of the Korean representatives for the ninth São Paulo Art Biennial.

· In December, the Zero Group, Sinjeon Group, and the Origin Fine Arts Association, which are the organizations of young artists, hold the *Union Exhibition of Korean Young Artists* at the Korean Information Center, presenting found object art, happening, and geometric abstract painting. The members of the Zero Group and the Sinjeon Group lead a street demonstration in front of the City Hall of Seoul and elsewhere, showing criticism against the focus on academism and Art Informel abstract painting in the National Art Exhibition, and undertake a piece of performance art entitled *Happening with Vinyl Umbrella and Candle* (written by Oh Kwang-su).

Union Exhibition of Korean Young Artists,
Brochure, 1967

1968

· In March, the group exhibition *Painting '68* is held at the Press Center of Korea in Seoul, showing the latest trends within the contemporary art community, including Pop Art, op art, and kinetic art.

· In April, the Statue of Admiral Yi Sun-sin created by Kim Se-choong is erected at Gwanghwamun Square, Seoul. Between 1968 and 1972, the government organizes the Committee for Patriotic Ancestors' Statue to canvas for the erection of the statues of deceased patriots.

· In May, Kang Kukjin, Chung Chanseung, and Jung Kangja release their happening work *Transparent Balloon and Nude* at the Music Hall C'est SI BON. Subsequently in October of that year, they presented *Murder at the Han Riverside*. This constituted a revolt against authoritarian academism and demonstrated their commitment to a pursuit of avant-garde art.

· In October, some artists who withdrew from the Korea Prints Association lead the establishment of the Korean Contemporary Printmakers Association, followed by the exhibition *Modern Printing Arts Exhibition for Decade* planned by Lee Hangsung.

· In October, with the seventeenth National Art Exhibition, the host changed from the Ministry of Education to the Ministry of Culture and Public Information, and a calligraphic work received the Presidential Award for the first time in the National Art Exhibition's history.

· The bulletin *Joseon Misul* of the Central Committee of the North Korean Artist Federation which started in 1957 is discontinued in the first half of 1968 and integrated into *Joseon Yesul*. *Joseon Yesul* is an art magazine with its first issue published in September 1956. At first, it specialized in theatre and dance as the bulletin of the Central Committees of the Joseon Theatre Practitioners Alliance and the Joseon Dancers Alliance. However, from its fourth issue in 1968, it transformed into a comprehensive cultural review that encompassed art, music, dance, theatre, film, and acrobatics.

1969

· In July, Lee Ufan, whose article "From Object to Being" won a prize in the art critique competition held by a Japanese art publishing company, publishes an article entitled "Trends in Contemporary Art Exhibitions" in the magazine *Space*, in order to enter into a dialogue with Korean readers. This piece influenced many Korean artists by introducing a way of looking at contemporary art from an East Asian cultural perspective, apart from a Western-centered model.

· In September, the Korean Avant Garde Association (AG) is established and publishes the first issue of its bulletin *AG*. Until 1971, four issues are published with articles from participating artists and critics, introducing the overseas trends of conceptual art and land art.

AG No. 1, 1969

· In October, the planned exhibition of the Reality Group (Oh Kyunghwan, Oh Yoon, and Lim Setaek) is canceled. Its statement "The Reality Group's First Manifesto" (written by Kim Jiha) advocates that "art is a reflection of reality" and spreads widely to herald the emergence of Minjung art in the 1980s.

· In October, the MMCA opens at Gyeongbokgung Palace hosting the opening ceremony of the Eighteenth National Art Exhibition.

The Eighteenth National Art Exhibition, Brochure, 1969

1970

· In March, with Lee Kun-Yong as a key figure, the second meeting is held for the establishment of Space and Time Group (ST).

· In April, Park Myung-ja, who used to work at the Bando Gallery, opens her own gallery, the Hyundai Hwarang.

· In May, the inaugural exhibition of AG is held in the Korean Information Center. Until 1975, the group holds four exhibitions in total.

· In June, Kim Whanki's *Where, in What Form, Shall We Meet Again* wins the first prize at the first Korean Art Grand Award Exhibition hosted by the *Hankook Ilbo* newspaper. At the time, Kim Whanki was working in New York. This is his pointillist work that evokes a feeling of ink-and-wash painting and cosmic fantasy.

· In June, artists including Kim Kulim, Chung Chanseung, Bang Taesu, and Son Ilgwang gather to establish the Fourth Group, an avant-garde performance art organization. While staging various performances including *Street Theatre* and the *Funeral Ceremony of the Established Art and Culture*, they are arrested by the police. The Fourth Group pursue intangible art that doesn't leave a tangible output, presenting happenings.

· In August, the Channel 44 TV station of the U.S. WGBH broadcast live *Video Commune (Beatles Beginning to End)* using the *Paik-Abe Video Synthesizer* (1969) created by Paik Nam June and Shuya Abe.

· In October, following the case of the oil painting category a year ago, the ink painting category is divided into a figurative department and non-figurative (abstract) department at the nineteenth National Art Exhibition. As abstract painters took the lead in using the term *hangukhwa* (Korean painting), a debate arose with the issue of showing Korean "modernity" and "properly Korean identity."

· In November, the *Dong-A Ilbo* newspaper, in commemoration of its fiftieth anniversary, starts to hold the Dong-A International Print Biennale, as Korea's first biennale. The biennale is renamed the Seoul International Print Biennale in 1981 and discontinued in 1992.

· In December, the Myeong-dong Gallery opens. Artists including Kim Kichang, Pak Nosoo, Suh Seok, Kim Insoong, and To Sangbong submit their work to the *Artists in their Thirties* Exhibition which is held as the inaugural exhibition of the gallery. The exhibitions that have been held at the gallery since then include the *Korean Contemporary Art 1957–1972: The Abstraction = Situation, Plastique & Anti-plastique exhibition*, Lee Ufan solo exhibition, Park Seobo solo exhibition, Kim Tschang-Yeul solo exhibition, and Kim Kulim solo exhibition. The gallery publishes the first issue of *Hyundae Misul*, a contemporary art magazine. But it fails to publish a second issue.

1971

· In April, the Space and Time Group (ST) hold its inaugural exhibition at the Korean Information Center. It holds seven regular exhibitions in total until 1980.

S.T., Exhibition brochure, 1971

· In November, "In Search of Encounter: At the Dawn of a New Art" written by Lee Ufan is translated into Korean and included in the fourth issue of the bulletin *AG*.

1972

· From the late 1960s, so-called monumental artworks are actively created in North Korea. Following the *Bocheonbo Combat Victory Monument* (1967) and the *Bocheonbo Combat Victory Monument* (1971), the Mansudae Grand Monument is erected on Mansudae Hill in Pyeongyang in April 1972. Around the time of the creation of the Mansudae Grand Monument, the Mansudae Art Studio is also established in the early 1970s. Around 1973, the Mansudae Art Studio merges with the Central Art Studio that handles painting (chosonhwa), and start to encompass both painting and monuments. Subsequently, within the studio, a photo production team and a handicraft production team are also newly created, turning the studio into a comprehensive creative center.

· In June, the MMCA holds the *60 Years of Modern Korean Art Exhibition*. In compiling a range of modern art from 1900 to 1960, it gathers relevant artworks and material from across Korea for the exhibition.

60 Years of Modern Korean Art, Exhibition brochure, 1972

· In August, Korean Fine Arts Association holds the first Indépendants Exhibition. This is a competition to nominate candidates for the eighth Paris Biennale and the fifth Spain Biennale.

1973

· In February, the *Korean Contemporary Art 1957–1972: The Abstraction = Situation, Plastique & Anti-plastique Exhibition* is held at the Myeong-dong Gallery. It presents Korean Art Informel. Yoo Geunjun, Yu Jun-sang, and Lee Yil participate as selection committee members.

· In October, the Korean Culture and Arts Foundation is officially opened. The subsequent March, the Korea Culture and Arts Foundation Art Center is opened in Gwanhun-dong, Seoul and it becomes the main location for contemporary art exhibition at a time when there was no other dedicated exhibition space. Later in 1979, the Art Center occupies a newly constructed building designed by Kim Swoogeun in Marronnier Park, Seoul, which leads to its reopening in 2002 as the Marronier Art Center. In 2005, the Korean Culture and Arts Foundation turns into the Arts Council Korea, and the museum is renamed as the ARKO Art Center after an abbreviation of the Arts Council Korea.

1974

· In May, the architecture category and the photo category are added again to the twenty-third National Art Exhibition as the second category and the fourth category, respectively.

· In June, after seven years of studying printmaking in New York, Park Rehyun returns to Korea and holds the *PARK, RE HYUN Printing Exhibition*. She exhibits prints and tapestries that she made from 1970 to 1973.

· In October, the first Daegu Contemporary Art Festival is held at Keimyung University's art museum. During the third festival in 1977, installations are exhibited, and events held outside, including around the Nakdonggang River. The Daegu Contemporary Art Festival, held a total of five times until 1979, is the first-ever large-scale avant-garde art exhibition held in a regional area outside of Seoul. This exhibition is a catalyst for other avant-garde exhibitions to start in areas such as Busan and Gwangju.

· In December, the first Seoul Biennale planned by AG. is held at the MMCA.

1975

· In May, the *Korea. Five Artists, Five Hinsek ‹White›* exhibition is curated and held at the Tokyo Gallery. This exhibition prompts a wide debate about the unique characteristics of Korean modern painting based on Korean aesthetic traditions. Kwon Youngwoo, Park Seobo, Suh Seungwon, Lee Dongyoub, and Hur Hwang participate in the discussion, which resonate within the Japanese art community.

Korea. Five Artists, Five Hinsek <White>, Exhibition brochure, 1975

· In December, the first Seoul Contemporary Art Festival is held at the MMCA. In addition, during the next year, the Ecole de Séoul exhibit monochromatic paintings in which figuration is absent and the canvas is covered by only one or two colors, playing a pivotal role in the development of Dansaekhwa. The Seoul Contemporary Art Festival is held eight times in total until 1982 and numerous artists participate in it as it accepted both the three-dimensional (performance and installation art) and the two-dimensional (monochrome painting).

1976
· In March, the first issue of the magazine *Ppurigipeunnamu* is published. Through its excellent features which encompassed art, photography, and design, it improves the level of Korean visual culture. Due to the Policy for the Merger and Abolition of the Press, its publication had to cease with its last fiftieth issue in August 1980.
· In June, around sixty artists participate in and submit 150 works to the Exhibition of Modern Korean Eastern-style Ink Painting held by the MMCA.
· In November, the first issue of *Gyegan Misul*, an art magazine, is published.

1977
· In April, the first issue of the magazine *Misulgwa Saenghwal* is published.
· In August, the *Korea: Facet of Contemporary Art* exhibition, which introduces achromatic-color abstract painting as a collective feature of Korean painting, is held at the Tokyo Central Museum. This Korea-Japan exchange exhibition verifies the modernization and internationalization of the Korean art world.
· In October, the *1977. 11 Men's「Way」 Exhibition. Seoul* is held at the Art Center of the Korea Culture and Arts Foundation. This is an exhibition established by artists who are mainly members of the AG or ST groups. Since the number of participants change every year, the title of the exhibition slightly alter accordingly. They also hold exchange exhibitions overseas such as *85 Exposition de Maniere, Seoul, Paris* in 1985 and the *'90 Seoul International Methodology Show* in 1990.

1978
· In March, the *Founding Exhibit for Realism and Reality* is held at the Korea Culture and Art Foundation Art Center, presenting hyper-realistic painting.
· In March, the *Dong-A Ilbo* newspaper hosts the first Dong-A Art Festival at the MMCA. Byun Chong-gon's *January 28, 1978* receives first prize.
· In June, the *JoongAng Ilbo* newspaper hosts the First JoongAng Fine Arts Prize at the MMCA. Kang Daechul's *Quality of Life—Length and Breadth* receives first prize in the sculpture category.
· In November, the MMCA and the Korean Fine Arts Association co-host the *Korea: The Trend for the Past 20 Years of Contemporary Arts* exhibition, which spotlight the progress of Korean contemporary art from 1957 to 1977 with a special focus on the major groups and movements.

1979
· In October, the Gwangju Freedom Artists Association is founded. Also, small groups of Minjung art start to emerge including Reality and Utterance in Seoul and Point in Suwon.
· The operation of the National Art Exhibition is transferred from the Ministry of Culture and Public Information to the Korean Culture and Arts Foundation.

1980
· In July, the Gwangju Freedom Artists Association host the *Outdoor Exhibition—Ssitgimgut* (a shamanist ritual for cleansing the soul of deceased persons) on the side of Deudeulgang River, Nampyeong-eup, Naju City.

The Second Outdoor Exhibition—Ssitgimgut by Gwangju Freedom Artists Association,
Leaflet, 1981

· In October, the Reality and Utterance group plans to hold its inaugural exhibition at the Korea Culture and Arts Foundation Art Center but fails to do so due to the unilateral cancellation of the space rental contract by the Art Center. The exhibition is held at a different venue, the Dongsanbang Gallery, in November.

Reality and Utterance,
Exhibition brochure, 1980

· In October, the Daewoo Foundation initiates Korea's first academic research support project.
· In November, the Geumgang Contemporary Art Festival—Inaugural Outdoor Exhibition is held on the white sand beach of the Geumgang River, Gongju.

1981

· In January, a comprehensive art festival, entitled the *Winter, Open-Air Art Show at Daesung-ri by 31 Artists*, is held on the riverside near Hwarangpo Dock, Daeseong-ri, Gaypyeong-gun, Gyeonggi-do Province. In August, the YATOO Outdoors Field Art Research Association is established at the Geumgang River, Gongju.

· In March, starting with *'81 The Korean Young Artists Biennial*, the MMCA plans a regular exhibition for young artists under the age of thirty-five. Later, it turns into the *Young Korean Artists* exhibition.

· In June, the Second Contemporary Art Workshop Exhibition is held at the Dongduk Art Gallery with the participation of the Seoul '80, ST, and Reality and Utterance.

· In October, the Thirtieth National Art Exhibition is held, prior to the abolition of the exhibition.

· In November, the Seoul Museum opens. It introduces new figurative painting from France and helps with the institutionalization of Minjung art, contributing to the return of realism within the Korean art scene.

1982

· In January, succeeding the National Art Exhibition, the Grand Art Exhibition of Korea is launched. In the Grand Art Exhibition of Korea, the term *hangukhwa* is used and becomes the common term to refer to traditional Korean painting instead of *dongyanghwa*, the term used in the National Art Exhibition.

· In April, the Ho-Am Art Museum opens.

· In June, the Kukje Gallery opens.

· In October, the *Today's Ink Wash Painting* exhibition is held at the Songwon Gallery. In the preface of the exhibition, You Hongjune mentions the "Ink Wash Painting Movement" dedicated to experimenting with techniques regarding materiality with a focus on paper, writing brushes, and ink, which had a strong influence in the Korean art community.

Today's Ink Wash Painting, Exhibition brochure, 1982

· In October, the inaugural exhibition of the art organization the Imsulnyeon opens.

· In December, the *Contemporary Paper Craft and Paper Composition—Korea and Japan* exhibition is held at the MMCA, presenting works made of *hanji*.

· In December, the *11-person Group Exhibition Drawing* is held at the Publishers Association. This exhibition heralds the formation of October Gathering, Korea's first feminist group.

1983

· In March, the Silcheon group holds its inaugural exhibition at the Kwanhoon Gallery.

· In April, the *Time Spirit* exhibition is held at the Third Museum.

· In July, the preliminary exhibition for the inauguration of the artist group Dureong, is held at the Aeogae Little Theater. Next April, the inaugural exhibition of the Dureong is held at the Kyung-in Museum of Fine Art.

1984

· In January, *Good Morning Mr. Orwell*, a satellite installation directed by Paik Nam June, is broadcast live in several countries including France, the U.S., reaching an audience of about twenty-five million viewers worldwide.

· In May, the Walker Hill Art Center opens, paving the way for trends in American art in the 1980s to be introduced to Korea, including kinetic art and video art. The Walker Hill Art Center later becomes the Art Center Nabi, opening in 2000.

· In June, *The Life Portrayed by 105 Artists* is held at the Kwanhoon Gallery, The Third Museum, and the Arab Art Museum, gathering various factions from the world of Minjung art.

· In August, the Shinmook Group, that consisted of graduates of Hongik University primarily focused on large landscape painting, holds its inaugural exhibition at the Korea Culture and Art Foundation Art Center. A new style of landscape painting, in which the scenery of the everyday is depicted through East Asian ink painting techniques, start to be produced.

· In September, the Samsung Group opens the Ho-Am Art Gallery (formerly the JoongAng Gallery) in the *JoongAng Ilbo* newspaper's building, in addition to the Ho-Am Art Museum which opened in 1982.

· In October, the first issue of *Misul Segye*, an art magazine, is published.

1985

· The Nanjido and the Meta-Vox hold their inaugural exhibition at the Kwanhoon Gallery in February and the Hu Gallery in September, respectively. They emerge as influential small post-modern groups, presenting works that focus on spatial expansion and ordinary objects instead of the painterly planar field.

· In July, the *Power of the Art by the Twenties* (planned by Park Buldong, Son Ki-hwan, and Park Jinhwa) is held at the Arab Art Museum. However, the police confiscate some works and arrest the artists before the exhibition closed.

Power of the Art by the Twenties, Exhibition leaflet, 1985

· In October, the October Gathering (Kim Insoon, Kim Djin-suk, and Yun Suknam), namely Korea's first feminist group, is organized and hold its first exhibition at the Kwanhoon Gallery. It disbands after holding its second exhibition, *From Half to Whole*.

From Half to Whole,
Exhibition brochure, 1986

· In November, in protest against continuous government oppression, Minjung artists gather up with small groups, artists, and theorists to establish the National Art Association.

The First Issue of *Minjok Misul*, 1986.7.10.

1986
· In February, the Min Art Gallery, which later became the headquarters of the Minjung art movement, opens in Seoul.
· In June, for the first time, Korean artists participate in forty-second Venice Biennale. Ko Younghoon and Ha Dongchul participate in the exhibition at the Korean Pavilion in the Venetian Arsenal, and Lee Yil serves as a commissioner.
· In August, the Logos & Pathos holds its inaugural exhibition.

· In October, Paik Nam June's *Bye Bye Kipling*, produced by New York City's public television station WNET, is broadcasted at 10 a.m. simultaneously with the start of the marathon competition at the 1986 Asian Games in Seoul.
· In December, the women's art division of the National Art Association is created. In 1988, the name changes to Women's Art Research Society. Until 1994, it holds the *Women and Reality* exhibition eight times in total.

1987
· In February, the Museum, a group of new generation artists, holds its first exhibition at the Kwanhoon Gallery.
· In June, *Save Han-yeol!*, Choi Byung-soo's large banner painting of patriotic martyr Lee Han-yeol, who was fatally injured by a tear gas shell shot by the police during the June Democratic Struggle, is displayed in front of the Student Union Building of Yonsei University.
· In September, the women's art division of the National Art Association holds the first *Women and Reality* exhibition at the Min Art Gallery. Under the title "Women and Reality. What Do You See?," Forty female artists participate.

Women and Reality. What Do You See?,
Exhibition poster, 1987

· In September, the WomenLink is founded. With its establishment, the artist group Dungji create a banner painting *Toward Equality* to use at women's conferences.
· In November, the Young Architects Association is launched with an emphasis on the social role of architecture. Subsequently, the progressive architecture movements of various groups continued until the early 1990s.

1988
· In March, Ahn Sang-Soo and Gum Nuri open Korea's first cybercafe, Electronic Cafe, at Hongik University to try communication art that connects art with the wider electronic network.
· In May, the first issue of *Gana Art*, a bimonthly magazine, is published.
· In May, *The New Wave of the Photography* exhibition (organized by Koo Bohnchang) is held at the Walker Hill Art Center, showcasing photographs of a new age with a global perspective.

The New Wave of the Photography,
Exhibition brochure, 1988

· In June, Ahn Sang-Soo and Gum Nuri publish the first issue of *bogoseo\bogoseo*, a cultural magazine supporting experiments in the typographical design of Hangul.
· In August, the Seoul Museum of Art (SeMA) opens at the Gyeonghuigung Park Site (on Sinmun-ro street). To celebrate its establishment, the *1988 Seoul Art Exhibition* is held with the participation of 120 artists at home and abroad.
· In August, *The More, The Better*, made with 1,003 TV sets, is installed at the MMCA, Gwacheon.

· In August, the *Olympiad of Art* is held as a sub-program of the Seoul Olympics. It includes the *International Contemporary Painting Exhibition* (at the MMCA), the *International Calligraphy Exhibition* (at the Seoul Arts Center), *The World Invitational Open-air Sculpture Exhibition* and the International Open-air Sculpture Symposium. This is a large-scale event in which more than 300 artists from seventy-two countries including Korea were selected. In the process of selecting artists to represent Korea, various issues and conflicts involving different factions and communities within the Korean art world arose. To prevent these conflicts from ruining the *Olympiad of Art*, the Artists Committee for the Normalization of the Olympiad of Art is established with an announcement of a statement.

· In September, *Paik Nam June's Video Art* exhibition is held at Gallery Hyundai. As part of the exhibition, Paik Nam June's *Wrap Around the World* is broadcast in eleven countries via satellite, following *Bye Bye Kipling* in 1986.

· In September, the exhibition *Minjoong Art: A New Cultural Movement from Korea* was held at Artists Space in New York, This represents the introduction of the Minjung art movement to the mainstream Western artworld. Eom Hyeok of the Research Society for Art Criticism and Bahc Mo (Bahc Yiso) of the Seoro Korean Cultural Network are the co-organizers of the exhibition.

· In September, the *World Peace Gate* (designed by Kim Chung-up) at the entrance of Olympic Park is completed. Kim Chung-up passes away four months before its completion without a chance to see it finished.

· In October, the Ministry of Culture and Public Information lifts the ban on the exhibition of artworks created by artists who are abducted by or who defected to North Korea, with the prerequisite that "this measure is applied only to the artworks released before the establishment of the South Korean government in 1948."

· In November, the exhibition *Let's Burst Out: The Collaboration of Women's Liberation Poems and Painting* (hosted by Alternative Culture) curated by the Women's Art Research Society is held at the Min Art Gallery. This supports agendas such as the depiction of the reality of suppressed women, finding the voice of women, and the implementation of women's liberation.

Let's Burst Out: The Collaboration of Women's Liberation Poems and Painting,
Exhibition poster, 1988

1989

· In January, *Gyegan Misul* starts to be publishing monthly under the new name of *Wolgan Misul*.

· In February, the Research Society for Art Criticism (President: Lee Young-wook) is established. Belonging to the National Art Association at the same time, the members of the society play a significant role in the critiques of Minjung art. They hold regular meetings from March 1988. Until the society is disbanded in 1993, they criticize formalism in art criticism and present theoretical ideas about cultural consumption within mass society. Subsequently, Eom Hyeok, Kim Jin-Song, Kim Suki, and Cho Bongjin, who work under the mass visual media division, established the Hyunsil Publishing.

· In February, the second *Women and Reality* exhibition held in 1988 is featured in the *Artists in Focus of 1988* exhibition selected by the Seoul Museum, in recognition of its focus on women's problems.

1990

· In May, *Mixed Media*, an exhibition that features various experiments on media is held at the Kumho Museum of Art.

· In May, the Golden Apple, a small group of Korean artists of the new generation holds its inaugural exhibition at the Kwanhoon Gallery.

· In June, the MMCA changes the name of the program for discovering new artists, which started in 1981 as the *'81 Korean Young Artists Biennial*, to the *Young Korean Artists* and start to hold the associated show biannually.

· In August, *Sunday Seoul*, an exhibition planned and directed by Choi Jeong-hwa, is held at Sonahmoo Gallery. This example of a young artist's interest in popular culture and 'kitsch' is followed by *Show Show Show* (Space Ozone) and *Ah! Korea* (Jahamun Art Gallery) held the following year.

· In September, the Sub Club, another small group of young artists, holds the *Underground* exhibition.

· In November, the *Young Vision—Suggestion for Tomorrow* (planned by Park Sinui, Shim Kwanghyun, Seo Seong-rok, Im Doobin, and Lee Joon) is held at the Seoul Arts Center. It draws attention as the exhibition is co-planned to include the Minjung art community and the modernist community. However, the exhibition experiences great difficulty due to the government's demand for the removal of the works of Minjung art.

1991

· Two exhibitions centered on media art are held: *UMWANDLUNGEN: The Artistic Conversion of Technology* at the MMCA (directed by Rene Block) in March and *Art and Technology: Formative Encounters of Art and Technology* at the Seoul Arts Center in September.

· In November, the Total Museum in Jangheung holds the first *Horizon of Korean Photography*, an exhibition praised for its dynamic display of the history of Korean photography.

· In December, the Korea National University of Arts (K-Arts), a national university under the Ministry of Culture, Sports and Tourism, is established in Seokgwan-dong and Seocho-dong as a part of the government's policy to foster professional artists.

1992

· In June, Yook Keunbyung participates in Kassel Documenta as the second Korean participant following Paik Nam June.

· Three exhibitions are held addressing the daily environment of transformed society which has entered mass consumption and post-industrial society : *City Masses Culture* (Dukwon Museum of Art) in June, and *Self-Reflection on Art* (Kumho Museum of Art) and *Apgu-jeong-dong: Utopia Dystopia* (Galleria Art Museum) in December.

· In June, The Worker's Party of Korea Publishing Company in North Korea publishes *Kim Jong Il's Art Theory*. It is a collection of art-related teachings and doctrines announced under the names of Kim Il Sung and Kim Jong Il until 1992, containing specific instructions on detailed issues in all fields of art.

· In July, *Nam June Paik·Video Time·Video Space*, a retrospective exhibition of the work of Paik Nam June, is held at the MMCA.

Nam June Paik·Video Time·Video Space,
Exhibition poster, 1992

· In August, the Gwangju Museum of Art opens as the first public art museum by a local government outside the Seoul Metropolitan Area since the enforcement of the Museum and Art Gallery Support Act (June 1, 1992). Over the next decades to encourage the dispersal of the Korean art community from Seoul to other regions, other local governments open art museums as well, including the Busan Museum of Art (1998), the Daejeon Museum of Art (1998), the Gyeongnam Art Museum (2004), the Jeonbuk Museum of Art (2004), the Gyeonggi Museum of Modern Art (2006), the Jeju Museum of Art (2009), and the Daegu Art Museum (2011).

· In October, the seventh *Young Korean Artists: Towards the New Millennium* is curated and held by the curators of the MMCA. The exhibition emphasizes an acceptance of the experiments with new media in the 1990s, such as photography, installation, and Pop Art.

· In December, the 4.3 Group holds *Echoes of an Era* at Ingong Gallery. Following the group's motto, 'to strengthen the artistic and cultural values of the interior of construction,' the exhibition tries to provide a textual explanation for the work selected and thematically enrich the discussion on architecture.

1993

· In March, *The SeOUL of Fluxus* (Art Director: Rene Block) is held to celebrate the opening of the Seoul Arts Center. Furthermore, additional events are held at the MMCA, Kaywon School of Art & Design, Gallery Hyundai, and Wonhwarang.

· The 30 Carat, a small art group formed by the new generation of female artists, holds its inaugural exhibition in April, and *Men's Reality: Shaking Classism* in December

· In June, Paik Nam June wins the Golden Lion award as a representative within the German Pavilion at the Forty-fifth Venice Biennale.

· In July, following the strong recommendation of Paik Nam June, the MMCA holds the Whitney Biennial in Seoul to introduce contemporary art of the time centered on the United States and stress the importance of international biennale.

· In August, Paik Nam June installs his work *Fractal Turtleship* made up of about 350 televisions at Daejeon Expo '93. He also contributes a special article, "The Spirit of Bibimbap and Daejeon Expo '93," inspired by the expo site.

· In October, the Seoro Korean Cultural Network holds *Across the Pacific: Contemporary Korean and Korean American Art* (directed by Lee Youngchul and Jane Farver) at the Queens Museum of Art in New York, which is to be held once again at the Kumho Museum of Art in Seoul in August of the following year. The exhibition is to introduce both Korean Minjung artists and Korean American artists within one show, and raise the Korean art community's awareness of the topics related to the era of globalization such as multiculturalism and immigration.

1994

· Three exhibitions on photography are held: *Photography and Image* (Art Sonje Center, Seoul) in November 1993, *50 Years of Korean Photography: 1945–1994* (Hangaram Art Museum at the Seoul Arts Center) in January 1994, and *Horizon of Korean Photography: Eye of the World* (Gongpyeong Art Center) in August 1994.

· In January, Artinus, an art bookstore, opens in front of Hongik University.

· In February, the MMCA holds *The 15 Years of Korean Minjoong Arts: 1980–1994* to review the significance of Minjung art in an art historical context.

The 15 Years of Korean Minjoong Arts:
1980–1994, Exhibition poster, 1994

· In March, Hanguk Art Museum holds *Woman, the Difference and the Power* (directed by Kim Hong-hee) joined by various female artists, including Yun Suknam, Ryu Junhwa, Yang Juhae, and Lee Bul.

1995
· In March, the MMCA holds the first annual exhibition of Artist of the Year. and selects Jheon Soocheon as the first winner.
· In March, Paik Nam June wins the Ho-Am Art Prize.
· In May, the Art Sonje Center starts its operation as an art museum by holding its first exhibition *Ssack* at a temporary Sogyeok-dong *hanok* site. The exhibition is to show a shift of paradigm within the Korean art community, thanks to the new generation of artists. It features the works of sixteen participants, including Oh Heinkuhn, Choi Jeonghwa, Lee Dongi, Ahn Kyuchul, and Lee Bul. In July, the center holds *Bone: American Standard* organized by Choi Jeonghwa at a house in Seogyo-dong, drawing on the experience of the previous exhibition, which was held at the site of a demolished house.

Ssack, Exhibition leaflet, 1995

· In June, on the one hundredth anniversary of the Venice Biennale, the Korean Pavilion is established in Giardini Park, with Paik Nam June providing a significant role in the construction, and Jheon Soocheon wins a special award for *Clay Icon in Wandering Planets-Korean's Spirit*.
· In September, the First Gwangju Biennale: 'Beyond the Borders' is held. *InfoART*, a special exhibition within the biennale displays video artworks using new information and communication technology such as computers, electronics, and interactive media (Co-directed by Paik Nam June and Cynthia Goodman; Curated by Kim Hong-hee).

The first Gwangju Biennale, Poster, 1995

· The establishment of various private art museums begins with the Sungkok Art Museum (November 1995), then the Kumho Museum of Art (November 1996), the Ilmin Museum of Art (December 1996), and Art Sonje Center (July 1998).

1996
· In June, the MMCA holds *Photography: New Vision*, an exhibition focusing on the possibilities of contemporary photography.
· In August, the MMCA selects Yoon Jeongsup as the Artist of the Year, which is the first case among stage designers.

1997
· In January, Lee Bul submits *Majestic Splendor* as a part of the *Project 57* series of the Museum of Modern Art (MoMA). Although the installation is withdrawn before the opening of the exhibition due to the smell of rotten fish, later the work is selected for inclusion within the fourth Biennale de Lyon by Harald Szeemann. Furthermore, from 1997, Lee Bul displays *Hydra (Monument)* in seven cities for two years as part of *Cities on the Move* project. She is nominated for the Hugo Boss Prize at the Guggenheim Museum in 1998.
· In September, the second Gwangju Biennale is held under the theme of "Unmapping the Earth" (Artistic Director: Lee Youngchul). *Memory, and History: Korean Art and Visual Culture after 1945* (Curated by Kim Jin-Song), the special exhibition of the biennale, shows an expanded concept of art reflecting the history of visual culture and the influence of cultural research.
· In October, eight female artists form the feminist artist group Ipgim.

1998
· In March, the pilot issue of *Forum A* is published, and the magazine goes on to publish fifteen issues until 2005.
· In March, Kim Taeheon's solo exhibition, *The Destruction and Becoming of Space: Between Seongnam and Bundang*, is held at the Sungkok Art Museum, which leads to the formation of the Seongnam Project (1998–99). Later, this project influences a wider creative interest in examining urban development and change within cities, by art groups such as flyingCity and Mixrice.
· In June, Ssamzie Inc. provides a studio space for young artists by remodeling its company building in Amsa-dong, Seoul. Later, the company moves to a building in front of Hongik University in June 2000 and continues its operation until 2008 with ten artist studios, an exhibition hall, and a performance hall.

· In July, the Daewoo Group opens the Art Sonje Center in Seoul following Sonje Art Museum opened in 1991 in Gyeongju. The center's inaugural exhibition *Reflections*, features the works of veteran contemporary artists, including Oh Chiho, Nam Kwan, Kim Whanki, Park Sookeun, and Kim Hyung-geun. In addition, the center announces that it will support experimental works by the next generation of artists. Over the next decades, the art museum becomes a pillar of Korean art community at the turn of the century by holding various individual and group exhibitions of conceptual artists, including Lee Bul, Chung Seoyoung, Kim Beom, Yang Haegue, Kim Sora, Bahc Yiso, Gimhongsok, Oh Inhwan, and Ahn Kyuchul.

· In August, a group of critics led by Kim Seung-gon, one of the first-generation of Korean photography critics, launches *Sajin Bipyung*, the first periodical photography review magazine in Korea. Although the magazine was discontinued after vol. 14 in 2003, the Photography Criticism Award, an award named after the magazine, is still being given in support of young photographers.

· In October, '98 Seoul in Media: Food, Clothing, Shelter (directed by Lee Youngchul, 600 Years of Seoul Memorial Hall) is held in celebration of "The Year of Photographic Image." As the predecessor of Seoul Mediacity Biennale, the exhibition displays a series of video works about interactions and networking in our daily urban lives.

'98 Seoul in Media: Food, Clothing, Shelter, Exhibition catalog, 1998

· In December, the MMCA opens its Deoksugung branch, focusing on the modern art of Korea.

1999
· In February, the Alternative Space LOOP opens in Seoul. Subsequently, the Alternative Space Pool opens in April (founded in February; later renamed as Art Space Pool in 2000). Then Project Space SARUBIA opens in October (after being founded in April). In addition, Space Bandee, the first alternative space in Busan, opens in 1999.

· In August, *Mixer and Juicer* is held at the Korea Culture and Arts Foundation Art Center to review the artistic trends among the new generation of contemporary artists in Korea.

· In August, '99 Seoul Photography Exhibition: The Photograph Looks at Us is held at the Seoul Museum of Art (SeMA) to expand the scope of discussions on photography through photographs in various areas, from press photographs to satellite photographs, seeking to expand the medium beyond the dichotomy of photography as a form of image making for recording or artistic creation.

· In September, the first Women's Art Festival 99: *Patjis on Parade* is held at the Seoul Arts Center (organized by the Feminist Artist Network) to satirize the patriarchal social order and the seriousness of the art community through humor and play.

· In September, the first Cheongju International Craft Biennale is held in Cheongju.

· In October, the first issue of *Art In Culture* is published and Neolook, an online art platform, is established.

2000
· In June, Ssamzie Space holds its inaugural exhibition *Enfants Terribles* (Terrible Children) and Insa Art Space holds its inaugural exhibition *Another Space*.

· In September, the Youngeun Museum of Contemporary Art establishes a creative studio program to support art makers.

· In September, *Media City: Seoul 2000* (The First Seoul Mediacity Biennale; directed by Song Misook) is held at several places including SeMA under the theme of "City: Between 0 and 1" to introduce Seoul as the center of network and media and present a vision for the future.

Media City: Seoul 2000, Biennale postser, 2000

· In September, the feminist artist group Ipgim tries to install *A-Bang-Gung: Jongmyo Seized Project*, a project selected for the government's the New Millennia Art Festival in 2000. However, the event is canceled due to opposition from the familes of Jeonju Yi Clan.

· In October, the Hermes Korea Art Award is inaugurally established and given to Chang Younghae. The award is renamed as Hermes Foundation Art Award in 2008.

· Following the opening of the Ilju Art House in October, the multimedia-centered Art Center Nabi is opened at a company building of SK Group in December.

· In December, *Design or Art*, an exhibition focusing on the boundary between design and art, is held at the Seoul Arts Center (curated by Art Sonje Center).

2001
· In November, *ARTSPECTRUM* is held at the Ho-Am Art Gallery. The Leeum, Samsung Museum of Art takes over *ARTSPECTRUM* from the third event and the exhibition is held seven times in total until 2022.
· In November, Kimdaljin Art Research and Consulting Institute opens in Pyeongchang-dong. The institute begins publishing *Seoul Art Guide*, a monthly art magazine, in January 2002 and establishes the Kimdaljin Art Archives and Museum in 2008.

2002
· In May, the Daum Prize is established to support young photographers under forty-five. The award is given fourteen times until 2016.
· In June, the MMCA opens its first residency for artists with MMCA Residency Changdong. Subsequently, the museum opens MMCA Residency Goyang in 2004 and SeMA NANJI Residency in 2006.
· In August, the MMCA selects Seung H-Sang as the Artist of the Year, which is the first time an architect has been selected, and holds *Seung H-Sang, Urban Void* exhibition.
· In September, the first Busan Biennale: *Culture Meets Culture* is held. As a successor of the Busan Youth Biennale (started in 1981 by local artists), the Sea Art Festival (an environmental art festival started in 1987), and the Busan International Outdoor Sculpture Exhibition (started in 1991), the biennale highlights the authenticity of local arts and contemporaneity of art today.

2003
· In July, *Science + Art Show: Ten Years After*, an academic seminar focusing on the integration between art and science is held at the Insa Art Center.
· In November, the Museum of Photography, Seoul opens in 2004 as the first registered photography museum in Korea.

2004
· In February, the first Incheon Women Artists' Biennale is held featuring about 500 artworks by 103 artists. Later, it is renamed the International Incheon Women Artists' Biennale in 2007.
· In March, the Seoul Foundation for Arts and Culture is established.
· In October, Leeum, Samsung Museum of Art opens in Hannam-dong, Seoul.
· In October, *You Are My Sunshine: Korean Contemporary Art 1960–2004* (directed by Lee Youngchul) is held at the Total Museum of Contemporary Art to review the contemporaneity of Korean art from 1960 to 2004.

2005
· In February, Arario Gallery in Cheonan starts to make exclusive contracts with artists.
· In August, the Arts Council Korea, a private entity for the promotion of art and culture, is founded following the revision of the Culture and Arts Promotion Act. The Interdisciplinary Arts Subcommittee is formed as well, and the council implements projects to support the interdisciplinary art community from the subsequent year.
· In November, the first Anyang Public Art Project (APAP) is staged. Subsequently, many public art projects focused on urban restoration are hosted in collaboration with local communities, including the City Gallery Project of the Seoul Metropolitan Government (2007–2010), Art in City sponsored by the Ministry of Culture, Sports and Tourism (2006–2007), and the Maeulmisul Art Project (MAP).
· In November, *Cubism in Asia: Unbounded Dialogues* is jointly held by the MMCA; the Japan Foundation; the National Museum of Modern Art, Tokyo; and National Gallery Singapore.
· In December, the Arts Council Korea publishes the first issue of *BOL*, a visual arts magazine that continued until its last issue in winter 2008.

2006
· In January, the Korea Arts Management Service is established to promote the sales and circulation of art and support the competency and development of art institutes.
· In January, Paik Nam June passes away in Miami.
· In October, the first Daegu Photo Biennale: *Image Asia in Documents* is held. Based on the regional characteristics of Daegu in the history of Korean photography, the event highlights photography as a medium of contemporary art and Asianness.
· In December, *Somewhere in Time*, the first exhibition of the contemporary art festival, Platform Seoul, is held at the Art Sonje Center. Platform Seoul is held five times in total until 2010.

2007
· In April, the Seoul City Gallery Project is launched with the slogan "City as Oeuvre."
· In April, *Sound Art 101*, an exhibition focusing on sound, is held at Ssamzie Space.
· In May, the first Springwave Festival, an international interdisciplinary art festival, is held (renamed Festival Bo:m in 2008). This event supports the latest trends of hybrid art encompassing painting, modern dance, play, music, performance, and movie.

Springwave Festival, Poster, 2007

· In August, the Mediated Space for Interdisciplinary Art is established in front of Hongik University. It is a project of the Interdisciplinary Arts Subcommittee under the Arts Council Korea to explore interdisciplinary art as a new concept that can reflect the trends of the art scene in real-time.
· In August, *Performance Art of Korea 1967–2007* is held at the MMCA to review the forty year of history of Korean performance art and its significance.

Performance Art of Korea 1967–2007,
Exhibition poster, 2007

· In October, Community Space Litmus is opened in Wongok-dong, Ansan under the slogan of "a space for 'art' that exists outside of art."

2008
· In September, Ssamzie Space announces its closure ten years after its establishment in 1998. Subsequently, in October, a symposium is held under the theme of "The Past of Alternative Spaces and the Future of Korean Art."
· In October, The Paik Nam June Art Center holds its inaugural exhibition, *Jump Now*. The center serves both as a place to commemorate Paik Nam June, a renowned media artist who passed away in 2006, and an experimental exhibition space specialized in media art.
· In October, the Seoul Design Olympiad 2008 is held at Jamsil Sports Complex following the designation of Seoul as the World Design Capital in 2010.

2009
· In June, the Seoul Foundation for Arts and Culture establishes Seoul Art Space Seogyo in front of Hongik University as its creative hub in Seoul. Subsequently, the Seoul Art Space Geumcheon opens in October 2009 and Seoul Art Space Mullae in January 2010.
· In October, the MMCA stages the exhibition *Beginning of New Era* in Sogyeok-dong, at the site where its Seoul branch is scheduled to be built.

Beginning of New Era,
Exhibition poster, 2009

· In October, *The Book Society: Creating a New Culture of Publishing*, an art book fair by small scale art publishers, is held at Art Sonje Center and the Korea Design Foundation. A month later, the first Unlimited Edition is held, an exhibition that is continued until 2020. And the next year, The Book Society is opened in Sangsu-dong, Seoul.

2010
· In July, *Realism in Asian Art*, a joint exhibition by the MMCA and the National Gallery Singapore, is held at MMCA Deoksugung.
· In November, *Correspondence: Chung Guyon, An Architect* is held at the Ilmin Museum of Art.

2011
· In August, *Artist of the Year 1995–2010* is held at the MMCA. The exhibition is a compilation of Artist of the Year exhibitions from 1995 to 2010, joined by twenty-three other artists. The *Artist of the Year* exhibition is revamped as the Artist of the Year Prize the following year.
· In August, Culture Station Seoul 284 is opened, a cultural complex built within the old Seoul Station building.
· In August, GyeonGi Cultural Foundation opens Gyeonggi Creation Center, an art residency, in Ansan.
· The Artist Welfare Act is enacted in November and comes into force on November 18, 2012. The use of standard form contracts in the act becomes mandatory in 2016.

2012
· In March, *Dansaekhwa: Korean Monochrome Painting* (directed by Yoon Jinsup) is held at MMCA Gwacheon.
· In April, the Seoul Museum of Art (SeMA) holds three SeMA color exhibitions to shed light on Korean artists taxonomically: SeMA Green for senior artists; SeMA Gold for renowned artists; and SeMA Blue for young artists.
· In June, the thirteenth Kassel Documenta invites Moon Kyungwon & Jeon Joonho, and Yang Haegue.
· In June, Open Beta Space Vanziha B½F opens in Sangbong-dong, Seoul.
· In July, the Real DMZ Project begins using some facilities of the security tour course near DMZ in Cheorwon as exhibition areas. The project continues until 2022.
· In August, the first exhibition of the Korean Artist Prize is jointly held by the MMCA and SBS. The first winners of the award are Moon Kyungwon & Jeon Joonho.

Korean Artist Prize 2012,
Exhibition poster, 2012

· In November, the Korean Artists Welfare Foundation is established.

2013
· In October, the MMCA opens Art Research Center at its Gwacheon branch.
· In November, the MMCA opens its Seoul branch in Sogyeok-dong.
· In November, Audio Visual Pavilion in Tongin-dong, Seoul opens with its inaugural exhibition, *no mountain high enough.*
· In December, the first public debate of Art Workers Gathering is held at the Audio Visual Pavilion to discuss the environments and systems related to artistic creation, such as artists' fees and the treatment of artists. In addition, the issues of artists' fees and standard form contracts are discussed at the Fourth Art Factory Project held in January 2014, triggering a series of discussions on the "Artists' Fee" system.

2014
· In March, Seoul Museum of Art (SeMA) holds *Nobody* as one of SeMA Gold exhibitions, featuring the work of three female Korean artists living overseas—Min Youngsoon, Yoon Jinmee, and Jo Sookjin.
· In June, the Korean Pavilion wins the Golden Lion Award at the fourteenth International Architecture Exhibition, part of the Venice Biennale. Cho Minsuk, the commissioner of the pavilion of the year, plans *Crow's Eye View: The Korean Peninsula* under the theme of the "tragedy of the divided peninsula."
· In August, the Leeum, Samsung Museum of Art holds *Beyond and Between* as its tenth anniversary exhibition.
· In September, the MMCA Hyundai Motor Series begins. It is a ten-year art project to hold annual exhibitions to support one esteemed Korean artist per year, held by the MMCA in partnership with Hyundai Motor Company. Starting with Lee Bul in the first year, Kimsooja, Ahn Kyuchul, Im Heung-soon, Choi Jeonghwa, Park Chan-kyong, Yang Haegue, Moon Kyungwon & Jeon Joonho and Choe U-ram have all been selected for the exhibition to date.
· In December, Trading Post, a new alternative space, opens in Sangbong-dong, Seoul and holds its first event *Status Check*, a four-day program consisting of performances, screenings, and lectures from thirty-three participating teams.

2015
· In March, the Kimdaljin Art Archives and Museum is reopened in Hongji-dong.
· In April, the SeMA-HANA Art Criticism Award, the first art criticism award hosted by public and private art museums in Korea, is established under the sponsorship of the Hana Financial Group. The award is given biannually since 2015. Furthermore, the Korea Arts Management Service introduces a matching system between visual art critics and media in 2018. And finally, the New Vision Art Critic Award for *Art In Culture* resumed in 2019, after it was established in 2002 and discontinued in 2014, to celebrate the twentieth anniversary of the magazine.
· In May, Im Heung-soon wins the Silver Lion Award at the Fifty-sixth Venice Biennale for his video work, *Factory Complex.*
· In July, the Ilmin Museum of Art holds *New Skin: Modeling and Attaching.*
· In October, the exhibition *Goods* is held at the Sejong Arts Group Building, an event created by visual artists to sell their general and limited edition works as well as derivative work, and discuss the environment and conditions for contemporary artists. Not only *Goods*, but also other events sponsored by the Visual Artists Market project of the Korea Arts Management Service are held as well to test various approaches to artistic creation and sales, including *Perform*, *The Scrap*, *TasteView*, and *Pack.*
· In November, the Asia Culture Center (ACC) opens in Gwangju to support cultural exchange between Asian countries and the creation, production, and circulation of artistic content.
· In December, Goodbye 2014, Hello 2015!, a discussion meeting on the present and future of the new alternative spaces that have gained critical attention since 2013, is held at Trading Post.

2016
· In January, the Seoul Museum of Art holds *Seoul Babel* as a part of its biannual SeMA Blue program to give exposure to young artists.

Seoul Babel, Exhibition poster, 2016

· In March, *Graphic Design, 2005–2015, Seoul* (curated by Kim Hyungjin and Choi Sungmin) is held at the Ilmin Museum of Art to review the trends within graphic design in Seoul during the last decade.
· In November, a number of cases of sexual violence in the art community are reported via social media using a hashtag, #sexual_violence_in_the_art_community. As a result, WOO, a women designers' policy study group is formed voluntarily and the Association of Women Artists (AWA) publishes "Statement on sexual_violence_in_the_art_community." Accordingly, a series of exhibitions, publications, and events on the issue follow, including *Uncomfortable Links: Foreboding of Violence* by No New Work, a collective of female artists, and *The W Show: A List of Graphic Designers*, an exhibition featuring the works of ninety-one Korean female designers. Later, the Feminist Designer Social Club (FDSC) is founded in July 2018.
· In December, the Seoul Museum of Art holds *X: Korean Art in the Nineties*, a SeMA Gold exhibition, to review and study Korean art community in the 1990s.

X: Korean Art in the Nineties, Exhibition poster, 2016

2017
· In September, the first Jeju Biennale: *Tourism* is held. However, the biennale is discontinued in 2021 due to the issues of operation and budget.
· In September, Seoul Biennale of Architecture and Urbanism, the first biennale on urban architecture in Korea, is held. Furthermore, other events on architecture are held in the same period, including the UIA 2017 Seoul World Architects Congress and its commemorative exhibition *The Self-Evolving City*, and *Papers and Concrete: Modern Architecture in Korea 1987—1997*.
· In September, the Ministry of Culture, Sports and Tourism implements a pilot program on payment for artists, also known as an Artists' Fee, to six national and public art museums.
· In December, *The Arrival of New Women* is held at MMCA Deoksugung, focusing on the lives of 'new women' through artworks and through recordings about and by them.

2018
· In January, *Renegades in Resistance and Challenge* (curated by Kim Chan-Dong and Yoon Jinsup) is held at the Daegu Art Museum to review the fifty-year history of Korean Performance Art from the 1960s to 2017 and establish the historical significance of the genre.
· In April, "Again, Right and Together for the Korean Art–Public Seminar I" is jointly held by the Ministry of Culture, Sports and Tourism and the Korea Arts Management Service.
· In July, the Daejeon Museum of Art, a museum devoted to seeking out the convergence between science and art, hosts the 2018 Daejeon Biennale (formerly Project Daejeon) to display the artistic implementation of the integration between technology, nature, and humanity.
· In September, the first Jeonnam International SUMUK Biennale: *Today's Ink Wash Painting* is held.
· In December, the MMCA opens its Cheongju branch.

2019
· In January, *Awakenings: Art in Society in Asia, 1960s–1990s* is jointly held by the MMCA; the National Museum of Modern Art, Tokyo; National Gallery Singapore, and the Japan Foundation Asia Center at MMCA Gwacheon following the previous event in Tokyo. It is an exhibition that illuminates the social, cultural, and political changes within Asian countries from the 1960s to the 1990s and the various aspects of Asian contemporary art as affected by these changes.
· In October, the MMCA holds *The Square: Art and Society in Korea 1900–2019* to commemorate the fiftieth anniversary of the MMCA opening in 1969 and the one hundredth anniversary of March First Independence Movement in 1919. The exhibition covers both the present of Korea and its history throughout the twentieth century.
· In October, *Nam June Paik: The Future is Now*, a retrospective of the work of the eponymous artist, is held at the Tate Modern in London.
· In October, *Locus and Focus: Into the 1980s through Art Group Archives* is held at Gyeonggi Museum of Modern Art. This is an exhibition about small art groups in Gyeonggi-do province in the 1980s.

Gyeonggi Art Project Locus and Focus:
Into the 1980s through Art Group Archives,
Exhibition poster, 2019

· In November, the MMCA holds *Korean
Video Art from 1970s to 1990s: Time Image
Apparatus*, surveying the thirty-year
history of Korean video art from the
1970s to 1990s.

*Korean Video Art from 1970s to 1990s: Time
Image Apparatus*, Exhibition poster, 2019

2020
· In February, *Progressive Ambition: Rewrit-
ing the History of Daejeon Art from the 1970s
to 1980s* is held at Daejeon Museum of
Art to review the development of the
art community in Daejeon from the
1970s to the 1980s.
· In April, *HYUNDAI 50*, a special exhi-
bition commemorating the fiftieth
anniversary of Gallery Hyundai is
held, featuring the works of renowned
Korean contemporary artists and doc-
uments and recordings related to the
gallery's fifty years of history.
· In May, *The Modern and Contemporary
Korean Writing* is held at the MMCA to
locate the role and meaning of calligra-
phy in Korean contemporary art.
· In May, the Busan Museum of Art
holds *Art in Busan in the 1960s and 70s: A
Beginning without an End* to establish the
identity of Busan's art and organize the
history of the art community in Busan.
· In June, in commemoration of the sev-
entieth anniversary of the Korean War,
various exhibitions are held, including
The Museum and the War at the National
Museum of Korea; *Unflattening* at the
MMCA; and *Beyond, There Were the People*
at the War Memorial of Korea.
· In September, Insa Art Space holds
IAS 2000–2020 to celebrate its twenti-
eth anniversary, displaying about 200
published books and video recordings
selected from its archive of 300 indi-
vidual and group exhibitions and 100
events held at the space to date.
· In October, *MaytoDay*, a special ex-
hibition organized by the Gwangju
Biennale Foundation to commemorate
the fortieth anniversary of the May 18
Democratization Movement, is held at
Asia Culture Center, the former Armed
Forces' Gwangju Hospital, and Mugak
Temple Lotus Gallery. Internationally,
the exhibition travels in Taipei, Taiwan
in May; then Seoul, Korea; Cologne,
Germany; and finally, Gwangju, Korea.
· In December, the Artist Employment
Insurance System is implemented to
ensure the livelihood of artists and
correct their lack of support within the
national social security system.

Ahn Changhong	b.1953	안창홍		Gwon Osang	b.1974	권오상
Ahn Dongsook	1922–2016	안동숙		Ha Chonghyun	b.1935	하종현
Ahn Kyuchul	b.1955	안규철		Ha Indoo	1930–89	하인두
Ahn Sangchul	1927–93	안상철		Ham Daejung	1920–59	함대정
An Jungsik	1861–1919	안중식		Ham Yangah	b.1968	함양아
An Sangmok	1928–90	안상목		Han Unsung	b.1946	한운성
An Seokju	1901–50	안석주		Han Yeongsik	b.1932	한영식
Bae Youngwhan	b.1969	배영환		Han, Leran	1898–1947	한락연
Bahc Yiso	1957–2004	박이소		Heo Geon	1908–87	허건
Bak Bangyoung	b.1957	박방영		Hong Seungil	b.1960	홍승일
Bang Hai Ja	1937–2022	방혜자		Hong Sungdam	b.1955	홍성담
Byeon Gwansik	1899–1976	변관식		Hong Sungmin	b.1964	홍성민
Chae Yongshin	1850–1941	채용신		Huh Baeklyun	1891–1977	허백련
Chang Hwajin	b.1949	장화진		Hur Hwang	b.1946	허황
Chang Jia	b.1973	장지아		Hwang Changbae	1947–2001	황창배
Chang Louis Pal	1901–2001	장발		Hwang Gyutae	b.1938	황규태
Chang Sukwon	b.1952	장석원		Hwang Jaihyoung	b.1952	황재형
Chang Ucchin	1917–90	장욱진		Hwang Kyubaik	b.1932	황규백
Chang Woosoung	1912–2005	장우성		Hwang Taenyeon	1927–96	황태년
Cho Hwan	b.1958	조환		Hyung Jinsik	b.1950	형진식
Cho Seokjin	1853–1920	조석진		Im Heung-soon	b.1969	임흥순
Cho Yanggyu	1928–?	조양규		Jang Boyun	b.1981	장보윤
Choe Kyegun	1942–?	최계근		Jang Sunhee	1893–1970	장선희
Choi Byeongsang	b.1937	최병상		Jang Youngsook	b.1951	장영숙
Choi Byungsoo	b.1961	최병수		Jeon Joonho	b.1969	전준호
Choi Eunseok	1921–?	최은석		Jeong Gwancheol	1916–83	정관철
Choi Gene-uk	b.1956	최진욱		Jheon Soocheon	1947–2018	전수천
Choi Jeonghwa	b.1961	최정화		Jin Hwan	1913–51	진환
Choi Kwangho	b.1956	최광호		Jo Kyoungsook	b.1960	조경숙
Choi Kyebok	1909–2002	최계복		Joh Sung-Yong	b.1944	조성룡
Choi Manlin	1935–2020	최만린		Ju Taeseok	b.1954	주태석
Choi Minhwa	b.1954	최민화		Jun Sojung	b.1982	전소정
Choi Wook-kyung	1940–85	최욱경		Jung Chanyoung	1906–88	정찬영
Choi Wooseok	1899–1964	최우석		Jung Daeyu	1852–1927	정대유
Choi Youngrim	1916–85	최영림		Jung Hyunwoong	1911–76	정현웅
Chu Jeokyang	1911–?	추적양		Jung Jaeho	b.1971	정재호
Chun Kook-kwang	1945–90	전국광		Jung Jongmee	b.1957	정종미
Chun Kyungja	1924–2015	천경자		Jung Jungyeob	b.1962	정정엽
Chung Chanseung	1942–94	정찬승		Jung Kangja	1942–2017	정강자
Chung Chong-yuo	1914–84	정종여		Jung Yeondoo	b.1969	정연두
Chung Dongsuk	b.1948	정동석		Kang Ho	1908–84	강호
Chung Kyu	1923–71	정규		Kang Hong-goo	b.1956	강홍구
Chung Sanghwa	b.1932	정상화		Kang Ik-Joong	b.1960	강익중
Chung Seoyoung	b.1964	정서영		Kang Jinhee	1851–1919	강진희
Chung Takyoung	1937–2012	정탁영		Kang Kukjin	1939–92	강국진
Chung Yountaeg	b.1955	정연택		Kang Piljoo	1852–1932	강필주
Gil Jinseop	1907–75	길진섭		Kang Seunghee	b.1960	강승희
Gimhongsok	b.1964	김홍석		Kang Yobae	b.1952	강요배
Gu Bonung	1906–53	구본웅		Kang Yongsuk	b.1959	강용석

Noh Soohyun	1899–1978	노수현
Noh Suntag	b. 1971	노순택
Noh Wonhee	b. 1948	노원희
Oh Chiho	1905–92	오지호
Oh Heinkuhn	b. 1963	오형근
Oh Inhwan	b. 1965	오인환
Oh Jong-uk	1934–95	오종욱
Oh Sook-hwan	b. 1952	오숙환
Oh Taehagk	b. 1938	오태학
Oh Yongkil	b. 1946	오용길
Oh Yoon	1946–86	오윤
Pai Un-soung	1900–78	배운성
Paik Nam June	1932–2006	백남준
Paik Namsoon	1904–94	백남순
Pak Nosoo	1927–2013	박노수
Park Buldong	b. 1956	박불똥
Park Chan-kyong	b. 1965	박찬경
Park Daesung	b. 1945	박대성
Park Eunseon	b. 1980	박은선
Park Hwayoung	b. 1968	박화영
Park Hyunki	1942–2000	박현기
Park Jaeyoung	b. 1981	박재영
Park Jaeyoung	b. 1984	박재영
Park Kiljong	b. 1982	박길종
Park Munwon	1920–73	박문원
Park Rehyun	1920–76	박래현
Park Saengkwang	1904–85	박생광
Park Seobo	b. 1931	박서보
Park Soochul	b. 1947	박수철
Park Sookeun	1914–65	박수근
Park Suk-won	b. 1942	박석원
Park Yoonyoung	b. 1968	박윤영
Park Youngsook	b. 1941	박영숙
Pen Varlen	1916–90	변월룡
Piao Guangxie	b. 1970	박광섭
Quac Insik	1919–88	곽인식
Rha Hyeseok	1896–1948	나혜석
Rhee Chulryang	b. 1952	이철량
Rhee Seundja	1918–2009	이성자
Rhii Jewyo	b. 1971	이주요
Rim Dongsik	b. 1945	임동식
Ryu Kyungchai	1920–95	류경채
Seo Hyun-Suk	b. 1965	서현석
Seung H-Sang	b. 1952	승효상
Shim Kyungja	b. 1944	심경자
Shim Moon-seup	b. 1942	심문섭
Shin Hakchul	b. 1943	신학철
Shin Okjoo	b. 1954	신옥주
Shin Youngseong	b. 1959	신영성
Shin, Iskra	b. 1951	이스크라 신
Shin, Nikolai Sergeevich	1928–2006	니콜라이 신
siren eun young jung	b. 1974	정은영
Son Donghyun	b. 1980	손동현
Son Yeonggi		손영기
Song Burnsoo	b. 1943	송번수
Song Chang	b. 1952	송창
Song Sanghee	b. 1970	송상희
Song Soonam	1938–2013	송수남
Song Youngsu	1930–70	송영수
Suh Doho	b. 1962	서도호
Suh Seok	1929–2020	서세옥
Suh Seungwon	b. 1942	서승원
Sung Jaehyu	1915–96	성재휴
Sung Neungkyung	b. 1944	성능경
To Sangbong	1902–77	도상봉
Won Moonja	b. 1944	원문자
Yang Haegue	b. 1971	양혜규
Yi Wonkon	b. 1956	이원곤
Yim, Gilbert Pha	1901–50?	임용련
Yoo Geuntaek	b. 1965	유근택
Yoo Kangyul	1920–76	유강열
Yoo Seungho	b. 1974	유승호
Yoo Youngkuk	1916–2002	유영국
Yook Keunbyung	b. 1957	육근병
Yoon Dongchun	b. 1957	윤동천
Yoon Jeongmee	b. 1969	윤정미
Yoon Jinsup	b. 1955	윤진섭
Youn Myeungro	b. 1936	윤명로
Youn Young-ja	1924–2016	윤영자
Yun Hyong-keun	1928–2007	윤형근
Yun Suknam	b. 1939	윤석남

1 FROM "CALLIGRAPHY AND PAINTING" TO "FINE ART"

Kim Inhye

is a senior curator at the MMCA (National Museum of Modern and Contemporary Art, Korea). She graduated from the Department of Art History at the Seoul National University, with a Masters thesis on 19th century German Romanticism and Ph.D thesis on "Lu Xun's Modern Woodcut Movement: Between Art and Politics." She started her position at the MMCA at 2002, co-curating several exhibitions that reflects on the Asia-Pacific including *Cubism in Asia: Unbounded Dialogue* (2005) and *Realism in Asian Art* (2010). Kim also curated more contemporary exhibitions including *Tell Me Tell Me: Australian and Korean Art 1976–2011* (2011) and *Deoksugung Project—Architecture and Heritage: Unearthing Future* (2012). Since 2015, Kim's research interest has been more focused on Korean modern art, organizing solo exhibitions of Korean masters such as Lee Jungseop, Yoo Youngkuk, Yun Hyong-keun, and Park Hyunki. She also took on more inventive projects such as *Encounters Between Korean Art and Literature in the Modern Age* (2021), reinterpreting Korean modern art in various perspectives.

Kang Mingi

teaches art history at Chungbuk National University. Her work is focused on the Korea-Japan relations in the Korean modern art scene and the shifting of the Eastern art world as well as artists who lived through that period. She is the co-author of *Understanding Korean Art Culture* (1994, rev. ed., 2006), *Click, Korean Art History* (2011), *Paintings of the King and the Dynasty* (2011), *Artworks of the Joseon Palace* (2012), *The King's Painters* (2012) and has translated Joan Stanley-Baker's *Japanese Art* (2020). More recently, she has published papers including "Masters of the Korean Modern Ink and Color Painting Scene" (2015), "North Korean Art History in South Korea 1900–2015" (Part of *Art in North Korea, its past and present*) (2016) and critiques of Jung Hyunwoong, Chun Kyungja, and Park Rehyun.

Mok Soohyun

teaches modern and contemporary Korean art and visual culture at Seoul National University. Mok's research interest is in the discursive construction of the nation state in Korean history. She received the Kim Bokjin Art Award in 2014 for her study of "The Transformation of National Symbols during the Japanese Colonialism: From the Icon of Patriotism to that of Commercial Emblems." Mok is the author of *Taegeukgi, Oyatkkot, Mugunghwa* (2021) which won the Lee Kyungsung Art Theory Award in 2022. Mok has written several articles about modern Korean art, and joined in *Interpreting Modernism in Korean Art: Fluidity and Fragmentation* (Routledge, 2021)

Seo Yuri

is senior researcher at Institute of Humanities, Seoul National University, Seoul, South Korea and board member of Association of Korean Modern and Contemporary Art History. She researched the popular visual culture of Korea during the modern age and wrote *The Faces of Magazines in Modern Korea: Iconography, History and Politics* (Somyong Publishing, 2016). Her recent interest is in the Minjung (people) Art movement in 1980s' Korea. Seo's publications include, "Black Media, Commune of Sense: Art School for Citizen and Minjung Prints in 1980s" (*Korean Cultural Studies*, no. 79, 2018); "Hanging Pictures in 1980's Korea: Performativity, Place, Transformation of Subjectivity" (*Journal of Korean Modern & Contemporary Art History*, no. 37, 2019) among others.

Kim Hyunsook

is the director of the Lee Ungno Research Institute. She received her PhD with the thesis "Orientalism in Korean Modern Art: with a Focus on Western style Painting." Kim investigates Korean traditional art and ideologies, and how these notions have changed throughout the modernization of the country. She previously served as the president of the Association of Korean Modern & Contemporary Art History, The Korea Society of Art History, was a research professor at Duksung Women's University, adjunct professor at Sungkyunkwan University, and has received prestigious prizes including the Kim Bokjin Art Award and Lee Kyungsung Art Theory Award. Kim has published several books and papers including: *The Artist who wanted to be a Tree, Park Sookeun* (2000); *Lee Jungseop* (2002); and *Park Sookeun* (2002).

Kwon Heangga

is the President of the Association of Korean Modern & Contemporary Art History. Her research focuses on Korean modern art and visual culture. She is the author of several books including *The Eye of the Periods: Anthology of Korean Modern & Contemporary Artists* (co-author, 2011), *The History of Korean Modern Women* (co-author, 2013), and *Image and Authority: Portraiture of Gojong and the Politics of Image* (2015). Kwon's more recent publications include: "The Embroidery and Women's art in North Korea" (2019); "The Embroiderer Jang Sunhee and Chosun Women's Crafts Institution" (2019); and "Modern Male's Body and the Artistic Anatomy: The Anatomical Drawing Notes of Lee Qoede" (2020).

2 ART IN A TIME OF WAR AND DIVISION

Liu Jienne

is a senior curator at the MMCA who writes and teaches Korean modern and contemporary art. She has curated numerous exhibitions but over the past five years, representative projects include *Deoksugung Outdoor Project_Light, Sound, Landscape* (2017) and *Modern Art from the MMCA Collection 1900s–1960s* (2018). Liu has organized major exhibitions with several institutions including the Korea Foundation and has participated at a number of national/international conferences and events such as the Asian Museum Curators' Conference (2012), Human-Space-Machine, Stage Experiments at the Bauhaus (2014) and What do Museums Collect? (2018).

Shin Soo-kyung

is a Research Professor at the Humanities Research Institute at Chungnam National University and the vice president of Association of Korean Modern & Contemporary Art History. Shin has written the art and life of many Korean modern and contemporary artists such as Lee Insung, Lee Jungseop, and Chung Chong-yuo. Her research interest lies in unearthing the artists who defected to North Korea after the Liberation of Korea in 1945 and more recently, focuses on North Korean art. Shin is the author of *Lee In-sung, the Genius of Modern Art in Korea* (2006), and is the co-author of many books including *A Border man between time and art, Jung Hyun Woong* (2012), *The Splendid Achievement of Korean Abstract Painting of Ha Indoo* (2019), and *Art History and Forgotten Artists under the Division* (2019).

Hong Jisuk
is a Professor at the College of Arts at Dankook University, Program Director of Association of Korean Modern & Contemporary Art History, and Academic Director of The Korean Society of Art History. Majoring in Art Studies, Hong has published widely on Korean modern and contemporary art and North Korean art. Selected publications include *The Taste of Fieldwork* (2017), *Art Historians and Critics Going to North Korea—A Study on North Korean Artists* (2018), *Dialogue for Art History Beginners* (co-author, 2018), and *The Conceptual History of the Division of the Korean (Joseon) Peninsula: Culture and Arts 1-3* (co-author, 2018). Hong is also the recipient of the fourth Jung Hyunwoong Research Fund (2014) and Kim Bokjin Art Award (2020).

Park Soojin
is a senior curator at the MMCA. She has curated and written extensively on Korean modern and contemporary art. Her long list of curated exhibitions include *The Art of Ungno Lee Revisited The Centennial Celebration of Ungno Lee's Birth* (2004–5), *Korean Diaspora Artists in Asia* (2009), *Artist of the Year 1995–2010* (2010), *The Centennial Celebration of Lee In-sung's Birth* (2012), *Korea Artist Prize 2014* (2014), *The Sound of Things: Materiality in Contemporary Korean Art Since the 1970s* (2015), *Cracks in the Concrete II From the MMCA Collection: Glimpse into the World Gazing into Eternity* (2018) and *100th Anniversary of Birth Quac Insik* (2019).

Cho Eunjung
is an art historian, critic, curator, and visiting professor at the School of Art & Design, Korea University. She received the Sculpture Critic Prize from The Korean Figurative Sculpture Association (1994) and Art Theorist Award from the Suk-Nam Art Prize (2013). Cho previously served as the president of the Association of Korean Modern & Contemporary Art History and Association of Art Historical Figures, and was the operations director of several institutions including Park Soo Keun Museum and Seongbuk Museum of Art. Cho was also the artistic director of many international exhibitions such as the *2020 Yeosu International Art Festival* and *King Sejong and Music Chiwhapyeong*, and has authored several articles and books such as *Ways of Seeing Sculpture* (2008), *Power and Art* (2009), *Chungok Ko Huidong* (2015) and *Sculpture* (2016).

3 THE TRADITION/MODERNITY DYNAMIC IN THE MODERNIZATION ERA

Park Youngran
is a senior curator at the MMCA. Having an academic interest in art after the 1960s and Korean modern and contemporary art, Park has curated numerous exhibitions. Among her significant and critically acclaimed exhibitions at the MMCA are *Contemporary Korean Prints 1958–2008* (2007–8), *The Modern Korea Rediscovered* (2008), *Bae Bien-U* (2009), *Artist of the Year 2010 Kiwon Park—Who's Afraid of Museums?* (2010), *American Art: Masterpieces of Everyday Life from the Whitney Museum of American Art* (2011), *Kim Hyung-Dae Retrospective* (2016), *MMCA Hyundai Motor Series 2018 CHOIJEONGHWA—Blooming Matrix* (2018), and *Park Seo-Bo: The Untiring Endeavor* (2019).

Chung Moojeong
is Professor in the Department of Art History at Duksung Women's University, Seoul, Korea. Professor Chung served as president of the Association of Western Art History. His recent field of research include modern Korean art, 20th century American art, and artistic exchanges between East and West during the Cold War years. Recently he published several academic papers including "The Asia Foundation and the Korean Art Community of the 1950s" (2019), "The Rockefeller Foundations' Cultural Projects and the Korean Art Community" (2019) and "Chunchu-hoi and Modern Korean Art of the 1960s" (2020).

Kho Chung-Hwan
graduated from the Painting Department in the College of Arts and Design at Yeungnam University. For his postgraduate study, he received his MA from the Department of Aesthetics at Hongik University. He currently works as a curator. He is the author of *Frightening Depth and Beautiful Surface* (Random House Joongang, 2006) and the co-author of *Korean Art Seen Through Criticism* (Daewonsa, 2001). He has curated numerous exhibitions, including: *Representation of Representation* at Sungkok Art Museum; *Criticism's Point of Contention* at Posco Art Museum; *The Skin or Shell of Sculpture* at Moran Art Museum; and *Drawing Sculpture, Castles in the Air* at Soma Art Museum. He has received various awards, such as the Prize of Art Critique from the Chosun Daily Newspaper in 1996; Sungkok Art Award in 2001; and *Wolgan Misul* Encouragement Award for Scholarly Writing in 2006.

Kim Yisoon
is Associate Professor at Hongik University. Her interest ranges from Korean modern and contemporary art to stone sculptures and statues of the Royal tomb in ancient Korean art history. Kim is a widely published author who has written *A Novel Insight into Contemporary Sculpture* (2005), *Modern and Contemporary Art in Korea* (2007), *Royal Tombs in the Korean Empire* (2010), and *Stone Figures in the Joseon Royal Family's Tomb 'Won'* (圜) (2016). She is also the co-author of *Art and the City Meets Modern Times* (2008), *The Eye of the Periods: Anthology of Korean Modern & Contemporary Artists* (2011), *Images of Familial Intimacy in Eastern and Western Art* (Leiden, Boston: Brill, 2014), *Korean Art From 1953: Collision Innovation Interaction* (London: Phaidon, 2020) among many others.

Cho Soojin
is a renowned art historian. Her research focuses on the development of Korean art and its relationship with the contemporary society after the nation's independence in 1945, especially on the process in which its art scene evolved by redefining and incorporating new waves of Western and Eastern art. She gives lectures at many universities, most recently at Ewha Womans University, and has participated in numerous research projects supported by the MMCA, Korea Arts Management Service etc. Cho is the author of *Performance Art: Its Beginning and Development in Korea and the West* (2019) and has published several papers including "The Whole Story of the 'Fourth Group': The Challenge and Frustration of 'Korean' Happening" (2013), "Hyuk-Lim Chun's Different Abstraction: A Postmodern Embodiment of Koreaness" (2015), "Korean Female Performance Artist, Jung Kangja's Dangerous Body" (2017), "Lee Seungjio's *Nucleus* Series: A New Possibility for Korean Modernism" (2020), and "A Research History of Women's Art in Korea: From Modern Times to the 1970s" (2021).

Kim Keongyeon
is senior researcher at the Lee Ungno Research Institute, Lee Ungno Museum, Daejeon, Korea. She examines and writes about tradition and identity represented in Korean modern and contemporary art. As an active participant of the Interview Accounts of Modern and Contemporary Korean Arts History at Arts Council Korea, Kim has published many interview records including *Lee Sookja* (2009) and *Shin Kumrye* (2011). Her most recent writings include *The Social History of Mounting—An Unrecorded Story of Art* (co-author, 2022), and *The Splendid Achievement of Korean Abstract Painting of Ha Indoo* (co-author, 2019), and essays "A Study on Korean Oriental Abstract Painting of the 1970's—On the Role of the Non-figurative in National Art Exhibitions of Oriental Art" (2016), "The World of the Spirit (靈), Sought in the Boundary of Deorientalization of Korean Oriental Painting—A Study on the Artworks of Ahn Sang-chul" (2016), "History of 'Universal Painting'—Orientation: On the Development and Transfiguration of Concept of Oriental Painting in the First Half of the 20th Century" (2019), and "Park Rehyun: A Cosmopolitan Artist in Conversation with Antiquity" (2020).

Kwon Young-jin
is an art historian. Holding a PhD degree at the Department of Art History at Ewha Womans University with the thesis "The Korean Monochrome Painting Movement of the 1970s", Kwon specializes in Korean contemporary abstract painting and contemporary art. Selected publications include "The Creation of 'Korean Modernism': Monochrome Painting of the 1970s" (2010), "The Korean Monochrome Painting of the 1970's: Methodology of Indefinitely Repetitive Actions" (2014), "'Action of non-action' of the Korean Monochrome Painting in the 1970s" (2015), "The National Art Exhibition and 'Abstract Academism' of Korean Art" (2018) among many. She is also the co-author of *Mappings of Korean Contemporary Art* (2009).

4 DEMOCRATIZATION AND THE PLURALIZATION OF ART

Kang Soojung
is a senior curator at the MMCA. Kang holds a PhD with a major in art criticism and is interested in Korean contemporary art as a battle of formality and the role of the public museum as a place of practice. She realizes these visions through exhibitions at the MMCA and practices the correspondence between art and society with artists in diverse fields based on curatorship. Representative projects include *Korean Contemporary Art series, 100 Years of Korean Art 1* (2006) and *The Square: Art and Society in Korea 1900–2019* (2019). Kang has also been actively involved in several international exhibitions including *Art toward the Society: Realism in Korea Art 1945–2005* (2007, The Niigata Bandaijima Art Museum etc), *Artist File 2015 Next Doors: Contemporary Art in Japan and Korea* (2015, The National Art Center, Tokyo) and is currently organizing *The Avant-Garde: Experimental Art in South Korea, in 1960s–1970s* in collaboration with the Solomon R. Guggenheim Museum, New York.

Gim Jonggil
is a leading art crtic, curator and exhibition art director of the DMZ art project of the Gyeonggi Museum of Modern Art. While studying Minjung Art, Gim integrates the philosophical structure of the anthropological imaginary that spans across the Eurasian Continent. He was the recipient of the Kim Bokjin Art Award and has received the consolation prize of Monthly Art Award. Gim produced several exhibitions including *Gyeonggi Millennium Docufesta: Gyeonggi Archive_Now* (2018), *Locus and Focus: Into the 1980s through Art Group Archives* (2019), and is the author of *Post Minjung art Shaman/Realism* (2013) and *Chronology of Korean Contemporary Art 1987–2017* (2017).

Kim Hyeonjoo
is Associate Professor at the Chugye University for the Arts. Her research interests include migration, diaspora, and contemporary art women of Korea. She translated *The Dream of the Audience: Theresa Hak Kyung Cha* (Constance M. Lewallen, 2001) and is main author of the book *Pink Room, Blue Face—YUN Suknam's Art World* (2008). She published many articles, "Feminist Art of 1980s in Korea: The "Let's Burst Out Exhibition" (2008), "The Position of Women's Art in the History of Korean Contemporary Art" (2013), "Solidarity and Art Practice as the Social Engagement by the 'Feminist Artists Group IPGIM'" (2016), "Historiography of Feminist Studies in Korean Contemporary Art History" (2020).

Song Heekyung
is an invited professor of the College of Art & Design at Ewha Womans University. She received her PhD, with *Ahoedo*, private and elegant gatherings of the literati in the late Joseon Dynasty. More recently, she studies and writes on 20th century Korean Painting. Song took part of "Korean Art, Again, Together, Right Now" by Korea Arts Management Service, a colossal project that revisits Korean art. She is the author of several acclaimed books including *'Ahoedo' in late Joseon Dynasty* (2008), *A Promenade of Our Beautiful Art* (2013), *Looking into South Korean History through Korean Art* (2016), and *Confucius, the Superb Master of East Asia* (co-author, 2019).

Choi Bum
is a critic specializing in design and is the head of the Korea Design History Institute. He is a former editor of 'Design' and the design critique paper 'Design Review'. Choi considers design as a cultural landscape representative of Korean modernity. Choi was the recipient of the Republic of Korea Culture and Arts Award (Presidential Commendation) in 2017, and has written many critical essays including: *Contemplating Craft* (2017); *The Conversion of Korean Design and Culture* (2019); and *Korean Design, in Reverse* (2021).

Chung Dahyoung
is a curator at National Museum of Modern and Contemporary Art, Korea and co-curator of the Korean Pavilion at 2018 Venice Architecture Biennale. She focuses on exploring editorial and curatorial work in architecture, design and urbanism. She curated *Figurative Journal: Guyon Chung Archive*, *Itami Jun: Architecture of the Wind*, *Papers and Concrete: Modern Architecture in Korea 1987–1997*. She is an Adjacent Professor of Department of Industrial Design in Konkuk University.

Lim Shan
is currently Associate Professor in the Department of Curatorial Studies and Art Management at Dongduk Women's University. He was a curator of Alternative Space Loop and Art Center Nabi and worked as an editor of *Wolgan Misul*. He curated exhibitions including *Art Meets Architecture: An Investigation on 'In-between'* and *Sound of Community*. He is the author of *Context in Curating 1*, and *A Young Man, Paik Nam June: Aesthetics of Integration in His Early Arts in Germany*. Lim translated Arlene Goldbard's *New Creative Community*, W.J.T. Mitchell's *Iconology: Image, Text, Ideology*, and Erwin Panofsky's *Meaning in the Visual Arts*.

Song Sujong
is a curator and photography critic based in Seoul. Her research interest lies in the unfolding of media and visual culture. Song was the Senior curator of the Museum of Photography, Seoul, commissioner of Dak'Art Biennale and co-founder of the Seoul Lunar Photo. She previously curated exhibitions including *Hurroo Hurroo* (GoEun Museum of Photography, 2013), *Five Views from Korea* (Noorderlicht Photogallery, 2014), *Map of Daily Life* (Art Museum of Lishui, China, 2015), and *Hybrid/Metamophorsis* (Dakar Biennale, 2016). Song is currently the head of the Museum Policy and Research Department at the MMCA.

5 GLOBALISM AND CONTEMPORARY KOREAN ART

Kim Kyoung-woon
is a senior curator at the MMCA. Kim's long list of curated exhibitions at the MMCA include *Young Korean Artists 2002* (2002), *Alchemy of Daily Life* (2004), *Performance Art of Korea 1967–2007* (2007), *Artist of the Year 2009—Sub Yong-sun* (2009), *Korea Artist Prize 2013* (2013), *Lee Kun-Yong in Snail's Gallop* (2014), and *Cho Sung-mook—Taste of Style* (2015). He also has taught in several institutions and universities including Korea National University of Arts. Kim translated *What is Contemporary Art?* by Terry Smith into Korean.

Yang Eunhee
is the director of Space D in Seoul. Yang, a recipient of the first Jung Jeumsik Art Prize (2022) by Daegu Art Museum, has written many scholarly essays on contemporary art and organized large-scale exhibitions including the 2009 Incheon Women Artists" Biennale. Her research interest touches on the issues of globalization, gender, and cosmopolitanism. Among her essays are "Why Was the Incheon Women Artists' Biennale Unsustainable?" (2019) and "Globalization and Cosmopolitanism of Korean Art in the Context of the Venice Biennale" (2017). She has also written books such as *Bang Geun-Taek Pyeongjeon* [A Critical Biography of Bang Geun-Taek: An Art Critic's Journey into the Avant-Garde and the Enlightening] (2021), *22 Keywords of Contemporary Art* (co-author, 2017), *New York, Art & the City* (2007, rev. ed., 2010).

Shin Chunghoon
is a critic and art historian based in Seoul. He received his BA and MA from Seoul National University, and his PhD from State University of New York at Binghamton. He writes extensively on contemporary art, architecture, urbanism, and technology in Korea, with recent essays on Kim Swoo Geun, Kim Ku-lim, Reality and Utterance, Choi Jeong Hwa, Park Chan-kyong, and flyingcity. He is currently an Assistant Professor at the College of Fine Art, Seoul National University.

Bae Myungji
has been working as a curator in the field of contemporary art since 2001 and as a curator at the MMCA since 2015. Her curatorial research delves into Asian art, performance and media art since the 1960s. Bae's major projects at the MMCA include: *Songs from Knee to Chin: A Project by Sora Kim* (2016); *As the Moon Waxes and Wanes-MMCA Gwacheon 30 Years: Interpret-Expansion* (2016); *Reenacting History: Collective Actions and Everyday Gestures* (2017–18); *Awakenings: Art in Society in Asia 1960s-1990s* (2019, in collaboration with The National Museum of Modern Art, Tokyo, National Gallery Singapore, and Japan Foundation Asia Center); *Korean Video Art from 1970s to 1990s: Time Image Apparatus* (2019–20); *Lee Seung Taek's Non Art: The Inversive Act* (2020–21); *DMZ Theater* (2021) and *Hito Steyerl—A Sea of Data* (2022).

Woo Jung-Ah
holds a PhD in Art History. She is an Associate Professor at the Division of Humanities and Social Sciences in POSTECH (Pohang University of Science and Technology), Korea. Woo's research area is the postwar art of Korea, Japan, and the United States with particular interests in collective memory, historical trauma, and identity politics. She has published her studies in numerous academic journals including Archives of Asian Art, Art Journal, Oxford Art Journal, and World Art, and regularly contributes to the exhibition reviews of *Artforum International* and www.artforum.com.

Helen Jungyeon Ku
is a curator, researcher, and editor based in Seoul. Her research interest is focused on the artist's collective practice and form of knowledge production as well as its dissemination. She was a curator at the ZeroOne Design Center, Kookmin University, and the co-director of Mediabus and The Book Society. Since 2017, as a curator at the MMCA , she had carried various projects such as *MMCA Studies: The Transnational Museum* (2019), *MMCA research forum Re-inventing Archive: Design, Architecture, Visual Culture* (2019), *Korean Art 1900–2020* (2020–22) and *Writing Art Histories* (2021). She is currently the Head of Education and Public Programs at the Leeum Museun of Art. She is also the recipient of the tenth Lee Dongseok Curatorial Award.

Ryu Hanseung
is a curator who works in archive at the Art Research Center, MMCA. Ryu has written books including *Young Korean Artists 45: Interviews* (co-author with Kim Jongho, 2006) and *Talk Talk! Talking to the Artist* (co-author with Park Sunyoung, 2014). He also received the prize in art criticism at the Annual Spring Literary Contest of the *Chosun Ilbo* in 2007 with his essay "A new understanding of narrative in contemporary art."

564

pigment print on paper, 100×150 cm. Courtesy of the artist

p.407 Kang Yongsuk, *Dongducheon Commemorative Photograph-1*, 1984, Chromogenic print on paper, 50.9×32.8 cm. MMCA

p.408 Noh Suntag, *StrAnge Ball*, 2004–2007, Pigment print on paper, 50.6×76.6 cm (10). MMCA

p.409 Kim Jangsup, *Beyond the Landscape—Anmyundo II*, 1997, Cibachrome print on paper, 101×145 cm. MMCA

p.410 Kang Hong-goo, *Mickey's House—Clouds*, 2005–2006 (printed 2014), Digital pigment print on paper, 90×259.4 cm. MMCA

p.412 Oh Heinkuhn, *Ajumma Wearing a Pearl Necklace*, 1997 (printed 2000), Gelatin silver print on paper, 45.5×45.5 cm. MMCA

p.412 Yoon Jeongmee, *The Pink Project I—SeoWoo and Her Pink Things*, 2005, Digital chromogenic print on paper, 120.8×120.8 cm. MMCA Art Bank

p.413 Choi Kwangho, *My Family*, 1976, Gelatin silver print on paper, 20×20 cm. Courtesy of the artist

p.413 Kim Oksun, *Happy Together—Oksun and Ralf*, 2002, Digital chromogenic print on paper, 96×114 cm. MMCA

p.418 Lee Bul, *Cyborg W5*, 1999, Hand-cut EVA panels on FRP, polyurethane coating, 150×55×90 cm. MMCA

p.425 Exhibition view of the *Olympiad of Art*, 1988. Art Research Center, MMCA

p.427 Inauguration of the Korean Pavilion at the Venice Biennale, 1995. Image provided by Franco Mancuso

p.430 Jheon Soocheon, *Clay Icon in Wandering Planets—Korean's Spirit*, 1995, TV monitor, VCR, glass, clay figures, mixed media, 380×1,800×800 cm. MMCA

p.430 Kang Ik-Joong, *Buddha Singing Italian Opera*, 1997, Mixed media on canvas, 7.6×7.6 cm each. Leeum Museum of Art

p.432 Lee Bul, *Majestic Splendor*, 1997, Fish, sequins, potassium permanganate, mylar bags, 360×410 cm. Courtesy of the artist

p.432 Im Heung-soon, *Things That Do Us Part*, 2019, HD video, 5.1 channel sound, 100 min. Courtesy of the artist

p.434 Kimsooja, *A Needle Woman*, 1999–2001, Eight-channel performance video, color, silent, each channel 6 min. 33 sec. MMCA

p.435 Suh Doho, *Home within Home within Home within Home within Home*, 2013, Polyester fabric, metal frame, 1,530×1,283×1,297 cm. © Do Ho Suh. Courtesy of the artist and Lehmann Maupin, New York, Hong Kong, Seoul, and London

p.436 Kim Soun-Gui, *Interview with Jacques Derrida*, 2002, Single-channel video, 48 min. 2 sec. Courtesy of the artist

p.436 Nikki S. Lee, *The Hispanic Project 25*, 1998, Digital chromogenic print on paper, 74.8×100.2 cm. MMCA

p.441 Choi Minhwa, *Vagrancy*, 1990, Oil on canvas, 87×184 cm. Private collection

p.441 Choi Gene-uk, *Thoughts and Painting*, 1990, Acrylic on canvas, 228×182 cm, 182×228 cm. MMCA

p.443 Jo Kyoungsook, *Staged Body 6-2*, 1992, Photograph, printed media, 70×50 cm. Courtesy of the artist

p.444 Park Buldong, *New Colonial Monopolitics Capitalism*, 1990, Photograph, collage, 91×62 cm. Courtesy of the artist

p.445 Yoon Dongchun, *Ideology—Left-Right Coalition in a Trash Can*, 1994, Dyed tissues, trash cans, event barriers, 300×300×900 cm. Courtesy of the artist

p.446 Choi Jeonghwa, *My Beautiful 21st Century*, 1993 (remade in 2019), Mixed media, dimensions variable. Courtesy of the artist. Photo: Kim Wooil

p.447 Bae Youngwhan, *The Spring Time of Life*, 1999, Mixed media on canvas, 162×134 cm. MMCA

p.449 Kong Sunghun, *A Dog*, 2000, Oil on canvas, 130.3×162.2 cm. Courtesy of the artist's family

p.450 Seongnam Project, *Seongnam Modernism* leaflet, 1998

p.450 FlyingCity, *All-things Park*, 2004, SPF wood, styrofoam, AL pipes, inkjet prints on synthetic fabric and all sorts of crafts material, dimensions variable, Part of *Drifting Producers* (2003–09). Van Abbemuseum

p.452 Lim Minouk, *New Town Ghost*, 2005, Single-channel video, color, sound, 10 min. 59 sec. MMCA

p.452 Yang Haegue, *Sadong 30*, 2006, Light bulbs, strobes, light chains, mirror, origami objects, drying rack, fabric, fan, viewing terrace, cooler, mineral water bottles, chrysanthemums, garden balsams, wooden bench, wall clock, fluorescent paint, wood piles, spray paint, IV stand, dimensions variable (Installation in an abandoned house in Incheon, Korea). Courtesy of the artist, installation view of *Sadong 30*, Incheon, South Korea, 2006. Photo: Daenam Kim

p.457 Kim Haemin, *Unreasonable Alibi*, 1999, Video installation; two-channel video, color, silent; video display device, bulb, dimensions variable, 5 min. 7 sec. MMCA

p.457 Yi Wonkon, *A Study for a Fluctuation*, 1987, Single-channel video, color, sound, 8 min. 43 sec. MMCA

p.458 Paik Nam June, *Good Morning Mr. Orwell*, 1984, Installation view of *Good Morning Mr. Orwell* 2014, Nam June Paik Art Center. Courtesy of Nam June Paik Art Center Video Archives. © Nam June Paik Estate

p.460 Politician Kim Dae-jung at the 1995 Gwangju Biennale, viewing Paik Nam June's *Dolemen*, 1995, Installation view of the First Gwangju Biennale *InfoArt*, 1995. Courtesy of Gwangju Biennale Foundation

p.461 Park Hwayoung, Seo Hyunsuk, Hong Sungmin, *Fall, Fall, Fall*, 1998, Three-channel video project, 7 min. loops each. Courtesy of the artist. Installation view of *TEUM* exhibition at Art Sonje Center. Photo: Park Hwayoung

p.463 Moon Kyungwon & Jeon Joonho, *El Fin Del Mundo*, 2012, Two-channel video, color, sound, 13 min. 35 sec. MMCA

p.464 Ham Yangah, *fiCtionaRy*, 2002–2003, Single-channel, color, sound, 4 min. 30 sec. MMCA

p.466 Park Chan-kyong, *Sindoan*, 2008, Video, color, sound, 45 min. MMCA

p.466 Im Heung-soon, *Factory Complex*, 2014, HD video, 5.1 channel sound, 95 min. MMCA

p.467 Song Sanghee, *The Story of Byeongangsoe 2016: In Search of Humanity*, 2016, Five-channel video, sound and moving spotlight installation, color, sound, 27 min. Courtesy of the artist

p.468 Kimsooja, *Cities on the Move—2727 Kilometers Bottari Truck*, 1997, Single-channel performance video from 11 days journey throughout Korea, color, silent, 7 min. 3 sec. Dresden State Art Hoffmann collection, Berlin, Courtesy of the artist

p.469 Lee Yongbaek, *Angel Soldier*, 2005, Video installation; single-channel video, color, sound, video 24 min. 17 sec. MMCA

p.470 Lim Minouk, *Fire Cliff 2*, 2011, Single-channel video, color, sound, 63 min. 51 sec. MMCA

p.472 siren eun young jung, *The Unexpected Response*, 2010, Single-channel video, color, silent, 8 min. 8 sec. Courtesy of the artist

p.472 Nam Hwayeon, *Operational Play 2009 Seoul*, 2009, Single-channel video, color, sound, 19 min. 40 sec. MMCA

p.480 Bahc Yiso, *Model of UN Tower*, 1996, Plasticine, 23×7.5×7.5 cm. MMCA

p.481 Ahn Kyuchul, *Chung-dong Landscape*, 1985, Painted clay and plaster, 24×46×42 cm. MMCA